Don't Call Us Girls

Don't Call Us Girls

Women's Activism, Protest, and Actions in the Vietnam War

Barbara L. Tischler

First published in Great Britain in 2024 by
Pen & Sword History
An imprint of
Pen & Sword Books Ltd
Yorkshire – Philadelphia
Copyright © Barbara L. Tischler 2024
ISBN 9781399066068

The right of Barbara L. Tischler to be identified as Author of this work has been asserted by her in accordance with the Copyright, Designs and Patents Act 1988.

A CIP catalogue record for this book is
available from the British Library.

All rights reserved. No part of this book may be reproduced or transmitted in any form or by any means, electronic or mechanical including photocopying, recording or by any information storage and retrieval system, without permission from the Publisher in writing.

Set in Aldine 401 13/16.75
Printed and bound in the UK by CPI Group (UK) Ltd., Croydon. CR0 4YY

Pen & Sword Books Limited incorporates the imprints of After the Battle, Archaeology, Atlas, Aviation, Battleground, Discovery, Family History, History, Maritime, Military, Politics, Select, Transport, True Crime, Fiction, Frontline Books, Leo Cooper, Praetorian Press, Seaforth Publishing, Wharncliffe and White Owl.

For a complete list of Pen & Sword titles please contact
PEN & SWORD BOOKS LIMITED
George House, Beevor Street, Off Pontefract Road, Hoyle Mill, Barnsley, South Yorkshire, England, S71 1HN
E-mail: enquiries@pen-and-sword.co.uk
Website: www.pen-and-sword.co.uk
Or
PEN AND SWORD BOOKS
1950 Lawrence Rd, Havertown, PA 19083, USA
E-mail: Uspen-and-sword@casematepublishers.com
Website: www.penandswordbooks.com

This book is dedicated to my family and to women throughout history who have dared to challenge traditional assumptions and blaze new trails for themselves.

I demand the independence of woman,
her right to support herself,
to live for herself,
to love whomever she pleases
or as many as she pleases.
I demand freedom for both sexes,
freedom of action,
freedom in love
freedom in motherhood.

–Emma Goldman, Union Square address, 20 May 1916

Contents

Acknowledgements		11
Introduction:	Where are the Women?	14
Chapter One:	Foremothers	21
Chapter Two:	The Home Front	59
Chapter Three:	Women in the Struggle for Civil Rights	92
Chapter Four:	Women in the War	154
Chapter Five:	Women Against the War: The American Scene	197
Chapter Six:	The International Scene: Radical Women in 1968 and Beyond	261
Chapter Seven:	A Movement of One's Own	307
Chapter Eight:	Two Steps Forward ...	382
Endnotes		437
Bibliography		467
Index		482

Acknowledgements

This book project began with an email. Kerrin Wilkinson of Pen and Sword Books issued a call for books by and about women. Chloë Gardner spread the word to colleagues on the Remedial Herstory Project (RHP) Board, of which I am also a member. I was happy to accept the challenge of looking at the past half century with new eyes while also re-visiting my earlier interpretation of events. Kelsie Eckert, founder and president of RHP, provided the opportunity to present research on women in Vietnam and transnational feminism at the group's annual retreat in August 2022 and again in 2023. Kelsie has served as an inspiration for my research with the cogent and persistent question, 'Where are the women'?

Kerrin provided supportive criticism and enthusiastic commentary throughout the process of writing and editing this book. She encouraged an international perspective that included people and events that might have been easy to overlook from an apartment in New York City. I learned a lot from the process of leaving my American comfort zone. She and her colleagues devoted their considerable talents to transforming a manuscript into a book. Writing may be a solitary activity, but it takes a team to create a book, and I am grateful for their contributions.

Historians rely on works from the past to generate new ideas and interpretations that will one day themselves be challenged and revised. This is the natural rhythm of historical scholarship. I owe a debt of gratitude to many historians, some of whom are professional friends, and many are unknown to me, for their contributions to scholarship on women during the Vietnam era. I am also indebted to the hundreds of news and feature writers who chronicled the events of the Vietnam era in real time. Their in-the-moment perspectives contributed to my understanding of a period I lived through as a

teenager and young adult but did not understand as history until after the passage of many decades.

A number of individuals contributed to the success of this book. Marta Hokenstad read Chapter Seven with a keen feminist eye and was an enthusiastic supporter of the project at every stage of its development. Karen Capelluto read the entire manuscript from the perspective of an artist, and I enjoyed our conversations about what it meant in the early 1970s to identify as a feminist. Linda Ormont pointed me in the direction of a bus boycott in Baton Rouge, Louisiana in which women played a pivotal role years before the more famous event in Montgomery, Alabama. My good friend, Wendy Lashley, was equally supportive. Her technology skills far outstrip mine, and she offered significant help in solving the mysteries of Microsoft Word. Most important, she shared my enthusiasm for the energy and bravery of women whose stories form the history of Second Wave Feminism.

Parents of grown children quickly realize that the pressures of their daily lives take precedence over the activities of Mom and Dad. For many years, Ben and Dan Tischler have listened patiently as I regaled them with stories about feminists, past and present, amid conversations about school events and Little League games. Thanks, boys, I hope you're proud of me.

Steve Tischler made immense contributions to the success of this book. He cheered me on through many months of research and writing, and I am grateful for our mealtime conversations about how to think about recent history and how to tell compelling stories about women. He's the best thinker and reader I know, and he shared his thoughts with generosity and love. Thank you doesn't sufficiently convey my gratitude.

I am also grateful to generations of women, from Joan of Arc, Emma Goldman, Genora Dollinger, and Rosie the Riveter to Simone De Beauvoir, Helke Sander, Anne Braden, Patsy Mink, and

Acknowledgements

Kathy Boudin among many others, who inspire and challenge us today to fulfil our promise, whatever our personal goals may be. There are many more stories to be told and many more women to be recognized by history and historians. Just don't call them girls.

Introduction

Where are the Women?

This is a book about women at an important moment in world history, when it seemed that pressure on legislative bodies, vocal but peaceful demonstrations, and even a bit of 'improper' behaviour might change the world. In the early 1960s, young people were optimistic about the promise of American democracy and confident that their voices would be heard and that what they had to say would matter. By the mid-1970s, optimism that full civil rights could be attained for African Americans and that a land war in Asia could be brought to an end simply because young people willed it to happen had waned significantly as the impulse to press for equality, reform, and peace for all gave way to what came to be called the 'Me Decade'. This is the story of how women became critical actors in movements for change during the Vietnam era and how the lessons learned contributed to an awareness that women's voices could be raised on their own behalf. It is a story of activism, frustration, leadership, and the emergence of a new movement dedicated to the equality and advancement of women as agents of their own success.

War as an instrument of social change is hardly a new phenomenon. In the case of the undeclared conflict in Vietnam, the winners unified their country under one government and economic system. The United States also experienced profound social and legal changes. The country that could not win a land war in Southeast Asia passed important domestic legislation concerning race, gender, and how the country raises its military force. Some of these changes have lasted into our own time while others have been eroded by another outcome of the Vietnam war – a worldwide resurgence of conservativism that benefits elites and erodes democracy. Looking

back on the 1960s and 70s from the third decade of the twenty-first century, it is easy to see the seeds of contemporary authoritarianism in the reaction against liberal reform and radical social change in the 1960s.

The Vietnam era spans the years 1954 to 1973, from the American takeover of the struggle against Vietnamese insurgents from the French after the disastrous siege at Dien Bien Phu to the equally chaotic and disastrous evacuation of Americans from Saigon. These bookend events enveloped an undeclared jungle war that claimed the lives of millions of Vietnamese soldiers and civilians and more than 58,000 American military personnel, along with civilian missionary, medical, and aid workers from many countries.

The larger context for this study is the international Cold War, of which the Vietnam conflict was an important part. Nationalist leader Ho Chi Minh declared Vietnam's independence from Japan in 1945, but France, the colonial power on the peninsula that included Vietnam, Laos, and Cambodia, sought to re-establish control in the region. The United States provided funding to help French forces hold off increasingly active aggression by the Vietnamese, who took seriously Ho's evocation of Thomas Jefferson when he declared the equality of human beings and the universal right to self-determination. Although the ideals of American democracy tended toward support for anti-colonial efforts around the world, the United States in reality provided significant aid to France in its struggle against the Viet Minh even prior to 1954. The imperatives of the international Cold War against communism demanded that America support France against the nationalist and communist Ho Chi Minh.

The real geopolitical action was not focused in Asia until the success of the communist revolution in China in 1949. Instead, all eyes were on post-war Europe, where American foreign policy experts utilized every tool at their disposal to keep Western Europe in the United

States', not the Soviet Union's, political, economic, and cultural orbit. America's goal was to encourage France to become a leading European member of the North Atlantic Treaty Organization (NATO), thus aligning with the West rather than the Soviet Union, which had formed its own defensive alliance, the Warsaw Pact, with Eastern European satellite countries.

The Vietnam conflict was one aspect of America's war against communism on a world stage. The prevailing wisdom at the time was that the fall of one small country in Southeast Asia to communism would inevitably lead to a communist takeover in a neighbouring nation. This was known as the Domino Theory, and it provided the basis for American foreign policy in Asia. This theory, promoted by government agencies, congressional committees, and the news media, contributed to a worldwide crusade against the 'communist menace'.

In the United States, the domestic Cold War took a variety of forms, ranging from official government repression and blacklisting of suspected communists or sympathizers to a subtle insistence on cultural conformity, mainly for the White middle class. This was the environment in which women who joined the anti-war movement in the 1960s grew up, a life that provided material comfort but required conformity and unquestioning anti-communist patriotism, which young people came to reject as the war in Vietnam continued to take lives and ravage Southeast Asia.

Some women responded to the continuing war by actively serving their country. They were military nurses, Red Cross and USO workers, non-medical military women, journalists, and missionaries. American women in Vietnam were all volunteers. The nurses and USO workers helped to humanize the conflict for soldiers while missionaries brought medical help and comfort to the civilian population. The female journalists who fought for a place in the press corps were among the brave reporters and photographers who

Where are the Women?

risked their lives to bring the story of the war to Americans at home.

Who were the military women of the Vietnam era? We can offer a few generalizations to which exceptions abound. The nurses who volunteered to serve in the United States military were generally young, White second lieutenants, fresh out of college or nursing school and officer candidate training. Several career nurses who had served in Korea or the Second World War continued their service in the jungles of Southeast Asia. They were older and of higher rank and generally served in supervisory positions.

The Vietnam War gave rise to an international anti-war movement in which women played significant but frequently unheralded roles. At first, the anti-war movement focused on the military draft, suggesting a supportive yet subordinate role for women, who protested conscription on behalf of their sons, husbands, and brothers. As the war was recognized in much of the world as a struggle for the liberation of Vietnam, as a civil war, and as a battle against French, and then American, imperialism, women played an increasingly important role as movement organizers and protesters in the streets.

The most prominent groups that engaged in protests against the Vietnam War were organized and run by college students. The best-known opponents of the war were members of Students for a Democratic Society (SDS), which included independent chapters on many American college campuses. In the United States as well as Europe, the anti-war struggle was connected to issues relating to the rights of students at major universities and society in general. In addition to demanding an end to the war, students sought to reform and modernize their tradition-bound campuses with protests in which curriculum changes and more flexible living arrangements were high on the list of demands.

The women of the anti-war movement throughout the world were generally young, although older women played major roles

in early anti-nuclear, and anti-war protests in the United States and Europe. Anti-war activism also involved women from the Committee for a Sane Nuclear Policy (SANE), the American Friends Service Committee (AFSC), the International League for Peace and Freedom (WILPF), and Women Strike for Peace (WSP). These women could hardly be considered hippies or young students, and they were frequently described in the press in terms of their conservative clothing and 'respectable' appearance.

There were many points of connection between anti-war activism and struggles for civil rights and anti-colonialism throughout the world. Many women who marched for civil rights also opposed the war by taking part in demonstrations and acts of civil disobedience. African-American women faced the dual challenge of achieving their full civil rights and ending a war that continued to send their brothers to fight and die in Asia. The military draft reached a plurality of Black, Brown, and poor men as enlisted personnel who fought under the command of predominantly White officers.

The Vietnam era can be viewed through the complex lenses of a White House called 'Camelot', the high moral vision of America's civil rights movement, confidence that a war on poverty and a war against communism could both be won, and demands for student power in institutions as far flung as New York City's Columbia University and the Sorbonne in Paris. It was, to be sure, a time of turmoil and change in American politics and culture. Many Americans felt a strong impulse to use the power of government for reform at home. At the same time, a 'cop on the beat' mentality in support of the Domino Theory placed the United States in the forefront of a post-War campaign against communism.

From the vantage point of a half-century later, the war and the struggle to end it also laid the foundation for today's radical conservatism. This view posits the idea that liberal democracies went off track during this period. From this perspective, the Vietnam era

Where are the Women?

was a period out of phase with the orderly progress of a liberal world, damaged if not destroyed by Black Power, SDS and Weathermen, yippies, hippies, bra-less women, and other less than desirable non-conformists. People who see ignominy, if not actual defeat, in Vietnam, perceive it as a war lost because of the political constraints placed on an otherwise valiant military. They see nothing positive in student strikes and university takeovers, battles on the barricades in European cities, or Chicago's Days of Rage in 1969. The conservative movement that had taken hold by the 1980s was in large part a response to the decline of a safe and secure world order with the United States and its allies as undisputed leaders. To be sure, these are two opposing visions, but it is necessary to keep both in mind as we consider the role of activist women across the political spectrum.

One way to understand the importance of protest against the Vietnam War in a worldwide Cold War context is to remember what Thomas Jefferson wrote to William Smith on 13 November 1787. Jefferson asked, 'What country can preserve its liberties if their rulers are not warned from time to time that their people preserve the spirit of resistance? Let them take arms ... The tree of liberty must be refreshed from time to time with the blood of patriots & tyrants. It is its natural manure'[1]. In the twenty-first century, with insurgent movements coming from anti-democratic and even fascist groups in the United States and Europe, we might well wonder if Jefferson would be as sanguine about contemporary challenges to democratic ideals and traditions.

As for the women, first we find them as helpers and supporters of their men, playing secondary roles in movements that did not recognize their value. Over time, we see women assuming leadership roles that gave them near-equality in movement conferences, on the picket lines, and in jail. Frustration with the absence of full equality in the civil rights and anti-war movements proved to be an impetus for Second Wave Feminism in the early 1970s. In answer to the

question, 'Where were the women'? The answer is 'Everywhere'. This book seeks to locate the women and bring to light the stories of their efforts to create a movement of their own.

Who were the models for the women who saw themselves as trailblazers in the 1960s and early 70s? With few women occupying many pages in standard history texts, the women we meet may not have realized that generations of women before them, their foremothers, had broken legal and cultural taboos to act for themselves, their families, and their people.

Chapter One

Foremothers

During the years commonly characterized as the Vietnam era (1954-1973), women played an active part in protests and militant demonstrations against the status quo throughout the United States, Europe, and the developing world. They joined men on the front lines and frequently risked their own lives to secure equal rights for African Americans and to end the war in Vietnam. During a period of intense disruption of accepted societal norms, women were among the creators of new paradigms of political and cultural expression.

The women who worked to bring about social and political change in the 1960s were not the first brave wonder women to break down political, legal, and cultural barriers. We might ask why we should care about heroines of the past who dared to challenge convention and act, sometimes bravely, sometimes rashly, as independent women who never asked for a man's permission? Did British women who marched in Trafalgar Square to end the Vietnam War in 1968 think of themselves emulating the Suffragists who were willing to risk being jailed or, worse yet, being deemed 'inappropriate'? Were women in the anti-war movement inspired by the Women's Emergency Brigade in Flint, Michigan in 1937, or did female members of the Student Non-Violent Coordinating Committee trace their activist lineage to Black women in the Jim Crow South who kept their families together and served as examples of bravery and resilience? We can't be sure, but we can imagine a clear, if often circuitous, line of influence between the courageous women of the past and the radical women who helped to define feminism by the 1970s. The women of the past, both famous and unknown to us, are the foremothers of the activist women of the Vietnam era. They provide

us with examples of courage in the face of rigid ideas about how a woman should behave and what her function in society should be.

Like their foremothers, women in the 1960s who sought to work outside the home or participate in movements for social change faced popular assumptions that kept them in the home or in low-wage 'women's work'. Prejudgments controlled not only personal relations between men and women but also government policy as it related to definitions of legal and acceptable behaviour. What were these assumptions?

- **Women do not need to work outside the home. When they do work, it's only for 'pin money' because their needs are taken care of by their husbands, fathers, or male relatives.** Despite the persistence of this notion, it was far from true, especially during times of economic depression or war. Poor, single, and widowed women needed to support themselves and their families, as did married women when their husbands' wages were not sufficient to keep the family out of poverty. Married women frequently had to join the work force on the death or injury of their husbands.
- **Women should stay in their proper sphere of labour and should not try to do men's work.** The presumption here was that a woman could be a nurse but not a doctor, a secretary but not a manager, or an elementary school teacher but not a school superintendent. This concept was based on the false notion that some work is done by men, some by women. There is no scientific basis for this idea, except that men are unable to perform the labour of giving birth. Nevertheless, vestiges of this idea remain in our culture today.
- **Women prefer jobs that are 'maternal' in nature and are happy to accept low wages for jobs that utilize their maternal qualities.** This assumes that a woman has only one

'natural' job, that of a mother. It also assumes that jobs that focus on care for children or the sick are worth less to society than the jobs men typically do.
- **Women who work take jobs away from men.** History has shown that women in the workplace do not cause men's unemployment. When the economy is thriving, there are plenty of jobs for both men and women. In tough times, women workers are often the first to be fired because of the presumption that men need jobs more than women, which is patently untrue. Conversely, women can be kept on the job while men are fired in economic downturns because employers often pay women less than men for doing the same work.
- **Women who enter men's workplaces are loose women who are disruptive of the male-orientated nature of the shop floor.** This idea simply supports the notion that women are not as capable of doing 'real' work as men. It also suggests that women's purpose is to serve men, especially as sex objects and that women should accept this role.
- **Women are not 'naturally' drawn to men's work. Women who do men's work are not 'natural' and are inappropriately competing with men.** This assumes that the 'nature' of women is static, that women cannot grow and change, and that women cannot escape an innate nature that consigns them to a limited range of activities.

For centuries women were confined to work in the home because these assumptions were widespread and frequently internalized by women themselves. But there were women throughout history who dared to break the gender paradigm. Many individuals and groups of women served as models for modern activists who assumed the mantle of feminism in the late twentieth century. The emergence of Second Wave Feminism contributed to a trend in academe to take

Don't Call Us Girls

women's history seriously. Historians in the 1970s were inspired to find the stories of women who created a history of their own. In this chapter, we highlight the exploits and accomplishments of women whose stories are still being told. They were the foremothers of the women of the streets, the jails, and the barricades of the 1960s.

France | History includes many examples of women who challenged standards of female propriety to perform transformative deeds. Joan of Arc (Jeanne d'Arc) is a symbol of French heroism and national pride. Joan was born into poverty in the village of Domremy in northeastern France in 1412. Like most peasant women of her time, Joan never learned to read or write, and she was a devout Catholic. During the Hundred Years War, English forces occupied her village, and many of her neighbours fled the invading army. Amid the turmoil of war, young Joan began to hear voices. She believed that the archangel Michael, Saint Margaret, and Saint Catherine of Alexandria had instructed her to lead a military force against the English and reclaim the French throne for Charles of Valois. Hearing the voices of saints convinced Joan that it was her destiny to go into battle against the English. But the forces of tradition threatened to thwart Joan's plans, as her father had arranged a marriage for her. Defying the law and convention, she refused to marry and even went to court to assert her right to remain single. She won her case and then devoted her full attention to preparing for battle.

In May of 1428, Joan cropped her hair, dressed in men's attire, and travelled to Chinon, where Charles maintained his headquarters. Charles provided a small army for Joan's assault on the English forces who had laid siege to Orleans. Her army won the battle of Orleans and witnessed the coronation of Charles VII in July 1429 but failed to take Paris from the English and their Burgundian allies in September of that year.

The Burgundians captured Joan in 1430, accusing her of heresy,

witchcraft, and wearing men's clothing. Under torture, she signed a confession in May 1431, denying that she had ever heard the voice of God. Joan soon recanted her confession, dressed in men's clothing again, and claimed to be guided by heavenly voices. But her captors were no longer willing to tolerate her, and on 30 May 1431, Joan of Arc was burned at the stake in Rouen. Prior to her execution, she declared that 'to surrender who you are and to live without belief is more terrible than dying – even more terrible than dying young'[2]. Joan's death only enhanced her reputation. Twenty years after her execution, a new trial, ordered by Charles VII, acquitted her of the charges of witchcraft and heresy. She was declared a martyr in 1456 and was canonized by the Vatican in 1920. Saint Joan is revered for her non-conforming behaviour as well as her bravery and loyalty to God and to France. She was admired for her piety and her daring acts of bravery in which she exhibited the courage of a male leader.

Early in the French Revolution, the women of Paris abandoned the accepted sphere of female activity in the home to protest the rising price of bread. The riots that ensued were both a fulfilment of a woman's traditional role as a caretaker for her family and a demonstration of the effectiveness of women's radical capabilities. For example, on 5 October 1789, hundreds of Parisian women protested the scarcity and the soaring price of bread by destroying bakeries in the city and marching, along with thousands of male revolutionaries, to Versailles, where they demanded that the King return to Paris. These women certainly hastened the pace of the Revolution, but they initially acted primarily in the interest of their families. In doing so, they fulfilled their role as mothers, but in marching and rioting in the streets, they challenged accepted norms for women. Nearly two hundred years later, women in France and around the world pursued political goals and personal liberation as they fought to be considered equal to the men who manned the anti-war barricades with them.

Olympe de Gouges translated the actions of revolutionary women into words. She began life as a working-class daughter of a butcher whose biological father was likely a French nobleman. Olympe had little formal education, was married by the age of sixteen, and soon gave birth to a son. On the death of her husband, she changed her name from Marie (Gouze) Aubry to Olympe de Gouges and moved to Paris. With her new identity she travelled in intellectual circles and published plays and pamphlets that focused on issues that affected women, especially those who did not have the protection of a family or a husband. She was also a powerful advocate for the abolition of slavery in France's Caribbean colonies, arguing for the dignity of all human beings. She supported women's rights, most powerfully in her 1791 *Déclaration des droits de la femme et de la citoyenne* (Declaration of the Rights of Woman and of the [Female] Citizen) in which she asserted that women should share the same rights of citizenship as men that had been articulated in the revolutionary *Déclaration of the Rights of Man* in 1789.

De Gouges was a voice for women whose status in revolutionary France was far from equal to that of men. In her *Declaration,* she asserted that women should have absolute equality with men. In seventeen articles, de Gouges placed the responsibility for the protection of women's rights in the hands of the national government. The National Assembly took little note of the Declaration, as the government was preoccupied with the dramatic changes taking place in French politics.

De Gouges presented radical views on women, but she was in other respects a political moderate. She supported the Girondins and defended Louis XVI, calling for a popular vote, that would presumably include women, to determine the leadership of France. But the climate of the moment did not support moderation. With the overthrow of the Girondins in autumn 1793 and the ascendance of Robespierre and the Jacobins, there was less acceptance of de

Gouges's political position on either the nature of French government or the rights of women. She was tried and executed by guillotine on 3 November 1793.[3]

A few decades later, France was again in turmoil. In response to restrictive laws promulgated by King Charles X, Parisians fought the French army in the July Revolution of 1830. Working- and middle-class protesters, including many women, set up barricades in the city and fought for three days, known as *les trois Glorieuses,* from 27-29 July. Marie Deschamps was one of the few women in the Revolution of 1830 who was recognized by her colleagues for her leadership on the barricades. When Louis-Philippe, known as the 'citizen king', established a constitutional monarchy, he awarded Deschamps a citation for her bravery.

One of the most memorable evocations of the revolutionary spirit of 1830 was Eugene Delacroix's painting, *Liberty Leading the People* (1830, first shown at the Louvre with a number of other political paintings in 1831). Liberty leads her people, mainly men, into battle. While artists had long used a female figure to represent liberty, the idea that liberty could be an inspirational leader who was half naked and somewhat dishevelled upset some critics but inspired others to praise the political message of the painting. Delacroix's female icon is wearing a liberty cap, a reference to the fighters in the 1789 revolution, and she is carrying a French flag, urging the people to follow her. She may have been more symbolic than real, but *Liberty* represented a woman's capacity to lead a revolution.

If French women of the 1960s did not feel an immediate affinity with the women of 1789 or 1830, they could more easily relate to the bravery of the women in their mothers' and grandmothers' generation who fought the Nazi occupation as members of the Resistance in the Second World War. Nazi forces occupied an increasingly large portion of France, Belgium, and the Netherlands by June of 1940. Women were critical members of the underground movement whose goal

was to destabilize and defeat the Nazi occupiers. While they did not hold many leadership positions, women served as couriers of valuable information about German troop movements. Nazi soldiers assumed that women were not capable of acting as warriors or spies, and they tended not to suspect women passing through their lines. Nazi soldiers were also reluctant to fire on women, which accorded them some small degree of protection. If Resistance women were captured, they were frequently sent to Nazi labour camps. One woman recalled that local Germans assumed that captured female spies 'were voluntary prostitutes who had seen an opportunity to "service" the SS and the "free" workers in the camps'. Because they were young pretty girls in their 20s, they were not taken seriously.[4] But women in the Resistance demonstrated that they could fire a pistol or fashion a bomb with the same result as a male member of the *maquis*.

Many of the resistance women of the 1940s were reluctant to claim credit for their efforts once the war ended. According to Owen Straus, writing about the experiences of his aunt during the war, French President Charles De Gaulle acknowledged only six women on the honorary list of 1,038 *compagnons de la liberation,* the heroes of the liberation of France. Women did not receive broad recognition for their service in the Resistance, but they were granted the right to vote in 1944.[5] The women of the Second World War generation had a long way to go from the right to vote to full participation in French society. Decades after the liberation, many assumptions about women's place in French society would be challenged once again by their daughters and granddaughters on the streets of Paris and on university campuses throughout the country.

Germany | German women in the anti-Vietnam War movement were the intellectual and political descendants of women who helped to overthrow the Kaiser in late 1918. These women were part of a movement that helped to establish a democratic government, the

Weimar Republic. Their bravery served as a model of revolutionary behaviour.

Early in the twentieth century, the Kaiser's Germany banned women from working at night and limited the number of hours women could work, a restriction that did not exist for male workers. During the First World War, women were allowed back into the factories as men were conscripted to fight for the Kaiser. According to historian William A. Pelz, the global armed conflict 'sucked men out of German industry leaving vacancies filled by women. Even before 1914, trade unions had become increasingly packed with women. One female organizer even joked that the day might come where men would have to fight for equal rights in the union'.[6] Violent strikes and street demonstrations followed military defeat and helped to create a revolutionary climate that led to the abdication of the Kaiser and the creation of the Weimar Republic.

Rosa Luxemburg and Clara Zetkin were the most famous female revolutionaries of the pre-Weimar era. One of Luxemburg's most famous quotations, 'Women's freedom is the sign of social freedom', creates a clear connection between the liberation of women as a discrete goal and the freedom of society as a whole. Lesser-known and anonymous women also helped to change Germany in the wake of the country's defeat in the First World War.

With the end of the War, women's revolutionary activities received scant attention from their male comrades in arms. Indeed, the public role of women in the pre-Weimar period was denigrated by right-wing groups as a dangerous aberration from German cultural norms. After Germany's defeat, the right-wing *Freikorps,* for example, advanced the narrative that women had stepped out of their proper role as keepers of the home and family and that they were required, for the good of the country, to return to their kitchens and nurseries.

Women who advocated full economic and political rights were considered dangerous to the goals of the right and were vulnerable

to attack. On 15 January 1919, Rosa Luxemburg was beaten to death, signalling that forces on the right were not hesitant to unleash violence on women as well as men. If the German public could accept the idea that revolutionary women were dangerous to the fatherland, it could accept their arrest, torture, and even murder.

A decade later, during Germany's Third Reich, Nazi policies relating to women were profoundly influenced by Hitler's personal view that women were kinder, gentler, and more emotional than men. He did not consider them equipped to survive the turmoil and pressure of workplaces, business, or politics. In social settings, Hitler preferred women who were quiet, demure, and motherly. He found it difficult to relax around women who were confident, outspoken, well-educated, or professionally successful.[7]

But the demands of total war obliged the Nazis to modify the domestic ideal for women. The need for labour prompted the state to prod women into the workforce (for example, through the Duty Year, a compulsory-service plan for all women) and even into the military itself. The number of female auxiliaries in the German armed forces approached 500,000 by 1945.[8]

Some women were members of the Nazi Party who worked outside their homes, performing clerical or administrative duties, and some were involved in the administration of Nazi labour camps. But in spite of the need for women in the workforce, the Nazi ideal of women placed them squarely in the home in the service of their husbands, their Fuhrer, and their fatherland. German women who protested the Vietnam War soundly rejected that paradigm and created a new image of an independent woman in the 1960s and after.

Britain | Young British women who took to the streets to protest the Vietnam War and demand equal rights for themselves could look to the women who pushed for the right to vote, sometimes peacefully and frequently through militant demonstrations. After

decades of struggle, six million women over age thirty met a property qualification and acquired the vote in parliamentary elections in the United Kingdom in 1918. Millicent Fawcett led the National Union of Women's Suffrage Societies, that lobbied Parliament for the ballot. Her tactics were rooted in the belief that, once men understood the logic of allowing women to vote, government and the country would be more humane. This was a utilitarian argument based on the ideas of John Stuart Mill, who was an advocate of women's suffrage. Of her own political philosophy, Fawcett wrote, 'I cannot say I *became* a suffragist. I always was one, from the time I was old enough to think at all about the principles of Representative Government'. For Fawcett and her followers, it was only natural to plead their case in a rational, polite, peaceful, and ladylike manner, hoping their voices would be heard.

For Emmeline Pankhurst, the time for proper etiquette had long passed in the push for ballots for women. Proudly calling herself a 'hooligan', Pankhurst and her daughters led the radical Women's Social and Political Union (WSPU), founded in 1903, in a militant, women-only campaign to bring female voting rights to public attention. The group's tactics included staging loud protests, smashing windows, engaging in hunger strikes, destroying property, and marching on the Houses of Parliament. A demonstration on 7 February 1907 attracted 3,000 supporters and strained police resources in the effort to keep order. On 28 October 1908, members of the Women's Freedom League, a spinoff organization of the WSPU, chained themselves to the grille in Parliament's Ladies Gallery and unfurled a banner in support of women's suffrage.

Suffragists were not bound by any code of decorum for proper British ladies and were not afraid to go to jail. The suffragist cause attracted American activist Anne Henrietta Martin, who joined Pankhurst in pushing for the vote for women. On 18 November 1910, they were arrested on orders of Home Secretary Winston Churchill

for disturbing the peace. The WSPU and WFL were condemned by many in the press and the public for their willingness to attack political leaders and risk harming innocent bystanders in arson and bomb throwing incidents. At the same time, the women's militancy brought the issue of female suffrage to the front page in ways that lobbying and pleading with members of Parliament could not. The popular magazine *Punch* praised the audacity of the suffragists and argued that the British government needed to be more responsive to the demands of women, despite their militant tactics.

Suffragist activity took place mainly in London, Manchester and Birmingham. Alice Paul, the American founder of the Women's Party who picketed the White House in 1917 and who proposed the first Equal Rights Amendment in 1923, joined the protests in London. She learned many of the lessons of direct action from her British sisters. The WSPU slowed its activity in August 1914 with the advent of war, but Emmeline's daughter, Sylvia Pankhurst, continued to protest actively on behalf of universal suffrage through the East London Federation of Suffragists, which also engaged in more general social work activity, forming nurseries for working mothers, a cooperative toy factory, and a restaurant that served her East London community.

British advocates of women's suffrage saw the connection between gaining the vote and improving the material condition of poor families through education and community support for working-class women. Half a century later, the issues confronting British women were remarkably similar, and protest against the Vietnam War once again brought women's issues to the forefront of public attention. Agitation for women's suffrage hastened the rise of feminism in Great Britain. The Six Point Group was founded in 1921 by Margaret Haig Mackworth, 2nd Viscountess Rhondda. This group was less interested in protective legislation than in the absolute equality of the sexes. The women targeted specific demands and pressed

Parliament to change laws relating to:

- Satisfactory legislation on child assault
- Satisfactory legislation for the widowed mother
- Satisfactory legislation for the unmarried mother and her child
- Equal guardianship for married partners
- Equal pay for teachers
- Equal opportunities for men and women in civil service

Membership in the Six Point Group included many women who had agitated for the vote. They knew how to appeal to public officials by writing letters to government officials, staging marches and rallies, and contacting newspapers. They published a journal, *Time and Tide,* to promote their cause. In the 1930s, the Six Point Group supported the effort to permit married women to work outside the home without the permission of a husband or other male relative. The reforms they supported took decades to realize, and the group stayed active until 1983.[9] The passage of legislation allowing propertied women to vote occurred toward the end of what would later be known as the Great War.

The British public faced another war starting in 1939 with a resolve to stop the spread of fascism. Women once again were critical actors in the war effort as factory workers, searchlight operators, gunners, and farm workers, among other vital occupations that had previously been considered unladylike. British ladies made victory possible, especially as German bombing attacks on the civilian population brought the war home. Men between the ages of 18 and 41 were drafted for the military, with the upper age raised to 51 in 1942. Women between the ages of 18 and 30 were designated as 'liable for service' in agriculture, industry, or specific war-related jobs.[10]

Prior to the First World War, Britain had relied on imported agricultural products, but the outbreak of hostilities disrupted the

supply of food from the Continent. The Women's Land Army (WLA) was established in 1917 to replace male agricultural workers who had gone to war. Women ran this organization and deployed volunteers to work on farms and in dairies throughout the country. The WLA ceased operation with the 1918 Armistice but was reconstituted in 1939 as a volunteer organization. By 1944, 80,000 British women were helping to relieve food shortages and minimize the need to import food. Known as 'Land Girls', the women of the WLA were recruited via posters and advertisements that portrayed agricultural work as healthful and enjoyable, but, in reality, the work was hard.

Land Girls were employed in traditional farm work, but they also performed some unusual but essential tasks. Teams of women were deployed to eliminate rats that posed a major threat to crops. The anti-vermin squads, known as rat patrols, also killed foxes, rabbits, and moles that posed a danger to the crops. The Land Girls also engaged in land reclamation projects, some of which required them to use heavy equipment needed to drain swamps. Women called Lumber Jills provided much-needed wood products in a job that could be especially dangerous. The women who worked the land, many of whom had never worked in agriculture before the war, did men's work and did it well, but they were paid significantly less than men doing the same jobs. While men earned thirty-eight shillings per week, women were paid twenty-eight shillings for forty-eight to fifty hours of labour, with half of that amount deducted for food and lodging. Nonetheless, the women of the WLA served their country in its time of extreme need without complaint.

Women in Britain were also conscripted for service in war industries.[11] They helped to build the ships that were critical in supplying the country with war materiel from the United States, especially after attacks by German U-boats sank many older vessels. They also worked in munitions factories, making bombs, mines, and ammunition. The work was dangerous, and accidents were common.

Foremothers

The presence of women in aircraft factories increased production for the Royal Air Force (RAF) substantially. These planes flew bombing raids from England to the Continent.

Throughout the nation, women helped to enforce critical blackout regulations as air raid wardens. Women were responsible for sounding the air raid sirens, directing civilians to shelters, and assisting in rescue operations. Women also operated searchlights that trained their beams on German planes, making them easier targets for RAF fighters. In addition, British women fired anti-aircraft weapons at invading German bombers. This was not precisely a combat role, but women gunners saved many lives with their true aim. Women were paid only two-thirds of what men earned for the same work. The Six Point Group, which had been active in promoting women's equality after the First World War, lobbied for equal pay for women in the Civil Service during and after the Second World War. British women also served as radio operators and code breakers who intercepted German communications. In July 1940, the British government established the Special Operations Executive (SOE), a secret group of men and women who carried out sabotage missions in Europe in coordination with resistance groups.

Noor Inayat Khan was one of the most dedicated SOE operatives. A radio operator, Khan was the daughter of an American mother and an Indian father who was a Sufi musician and teacher. The family settled in Paris, where Khan was educated and where she began her career as a writer of children's stories. In 1940, after German forces overran France, Khan fled to England, where she volunteered for the Women's Auxiliary Air Force (WAAF). In late 1942, she was recruited to serve as a radio operator for the SOE. She was sent to France, where she used encoded messages to relay communications about the location of weapons and supplies to the French resistance. This was an especially dangerous job, as Nazi forces tracked the British radio operators in France. On average, a radio operator was

able to perform this dangerous task for only about six weeks before being discovered and captured.

Khan worked with the Prosper Resistance Network, using the code name Madeleine. She was effective at her job and pursued her responsibilities with a sense of commitment derived from her religious background that stressed service to humanity over individual accomplishment or comfort. When other radio operators in the Prosper Network returned to England in the summer of 1943, Khan chose to stay in France, changing her location frequently and barely evading capture on more than one occasion. She was betrayed to the Gestapo and arrested in October of 1943.

Khan refused to reveal information about the Prosper Network or the SOE, but Gestapo agents had been able to trick the British into thinking that she was still communicating with operatives in London. When the SOE sent new operators to France thinking they were safe, they were quickly apprehended. A month after her capture, Khan was transported to the Pforzheim Prison in Berlin where she was tortured and kept in chains in solitary confinement. Khan still refused to reveal any information about her work. She was sent to the Dachau concentration camp and executed in September of 1944.[12] Kahn's bravery and commitment were replicated many times over by women whose names we do not know.

When the Second World War ended, most women returned to more traditional roles in their homes as servicemen reclaimed their pre-war jobs. The nation was grateful to the women who had milked cows, killed rats, broken codes, and shot down German planes, but their service was considered a wartime anomaly. It would take two decades and the presence of a younger generation to upend assumptions about the proper role of women in British society.

Vietnam | The tiny country of Vietnam has a long history of resistance to invasion and conquest that included the deeds of

Foremothers

powerful and resourceful women. Ancient struggles against invading Chinese forces featured heroic acts by women who have achieved almost mythic status in modern Vietnam. Although their rebellions were successful for only a short time, these women symbolized the spirit of Vietnamese nationalism that animated Ho Chi Minh and his followers in the twentieth century.

The Trung sisters, Trung Trac and Trung Nhi, were born into a military family early in the first century CE. The sisters held high social status because their father was the general installed by the Han Chinese to administer the affairs of the Giao Chi district in the northern part of present-day Vietnam. He obtained concessions from the Chinese to protect his local community but did not support independence from China. His daughters were not satisfied with a few concessions. They became part of the first movement for Vietnamese independence.

Trung Trac married Thi Sach, a general from a nearby region, at a time when Chinese authorities increased taxes on salt and demanded bribes. Thi organized other Vietnamese aristocrats to protest the new taxes. These regional leaders fought to hold on to the authority they held in their regions, but they were not successful. Thi was captured and executed by the Chinese. After Thi's death, Trac and Nhi helped to organize Vietnamese resistance against Chinese rule. A large Vietnamese army, including thirty-six female generals, defeated the Chinese forces in 40 CE. After the victory, the Trung sisters were named queens of the region, where they ruled peacefully for more than two years.

Eventually, the Chinese attacked. This time, the Trung Sisters were not prepared for battle, but they fought as bravely as they could. One woman, Thi Chinh, was pregnant at the start of the battle. She is said to have given birth on the battlefield but continued to fight with her baby in one arm and her weapon in the other. Morale suffered and defeat seemed certain. One source says the Chinese

brazenly went into battle naked, shaming the female warriors. But there was no confusion about the outcome – the attempt to establish Vietnamese independence was defeated by a vastly superior Chinese force led by General Ma Yuan. Legend says the sisters committed suicide in defeat, throwing themselves into a nearby river. Their fame and honour in Vietnamese society grew after their deaths. Today, the Trung sisters are revered throughout the country as symbols of Vietnamese nationalism.[13]

More than two hundred years later, a young Vietnamese woman, Trieu Tri Thin, also known as Trieu Au, led an unsuccessful but now-famous battle against Chinese soldiers in 248 CE. Like the Trung sisters, Trieu was born into Vietnam's upper class. The Chinese leaders of the Eastern Wu Dynasty inflicted numerous cruelties on the people of northern Vietnam who revolted against their conquerors starting in about 226 AD. More than 10,000 Vietnamese died in the insurrection. Trieu, who was called Ba Trieu or Lady Trieu, followed in the footsteps of the Trung sisters. She recruited an army and defeated Wu's Chinese army in thirty battles and defended her unconventional act of leading an army in battle by saying, 'I will not resign myself to the lot of women who bow their heads and become concubines. I wish to ride the tempest, tame the waves, kill the sharks. I have no desire to take abuse'.

Defeat by an army led by a woman was a humiliation for the Chinese. In 248 CE, Lady Trieu's forces were defeated, and she was killed in battle. In the centuries since her death, Lady Trieu has become a symbol of militant resistance to Chinese conquest and occupation. She has even been called the 'Vietnamese Joan of Arc'. In the twentieth century, Lady Trieu's exploits fuelled the revolutionary enthusiasm of North Vietnamese women.[14]

The United States | In the early decades of the twentieth century, many women rejected their proscribed roles in American society

Foremothers

in favour of independent action on their own behalf. Some were radical advocates of freedom for women – from the right to vote to birth control and free love. Others advocated reforms to remedy the dangerous effects of industrialization and improve the lives of everyday people who toiled in factories and sweatshops, particularly in the garment industry, and later in the emerging trade union movement in the automobile industry. Twentieth century American foremothers transcended traditional constraints based on gender and defined new roles for themselves as modern women.

Like many working-class activists in the early twentieth century, Emma Goldman was an immigrant. Born in what is now Lithuania in 1869, she came to Rochester, New York in 1885 as a teenager. She experienced horrific and dangerous working conditions as a garment worker in that city. Lacking formal education, Goldman educated herself by reading extensively on socialism and anarchism. She developed her personal political philosophy about the relationship of working people to the capitalist system from the headlines of the day and conditions she endured on the shop floor. Shock and anger at the treatment of the anarchists who were executed after a bomb exploded at Chicago's Haymarket Square on 4 May 1886 led Goldman to leave Rochester, her family, and an unhappy marriage for New York City's Greenwich Village. There, she joined the German anarchist movement and became an active public speaker.

Goldman's fiery speeches inspired audiences with their references to the real-world conditions faced by working people and her uncompromising demand for freedom from oppression for all people. She often found humour in difficult situations as she guided her audiences through a litany of evils wrought by the advances of industrial capitalism that oppressed working people. According to historian Candace Falk, editor of the Emma Goldman Papers, Goldman's intention was to reach 'a varied audience through reason and emotion, always ending her talks with a rousing articulation of

a vision of hope for a better world within reach. After her formal lecture, during the question period, her biting wit often left the audience in stitches'.[15]

Throughout the country, Goldman spoke to receptive audiences on matters personal and political and earned both fame and infamy for her views on personal freedom for men and women. She was an advocate for sexual freedom, as well as the total freedom from government restriction posited by the anarchist movement, a position that was far from popular at the turn of the twentieth century. J. Edgar Hoover, the Director of the new Federal Bureau of Investigation, called Goldman 'one of the most dangerous women in America'. As a result of her radical opposition to government, militarism, and restrictions on personal freedom, Goldman was deported to the Soviet Union in 1919. She soon became disenchanted with the direction taken by Soviet leaders who, she said, had betrayed the true spirit of revolution. She eventually settled in Canada, where she died in 1940. Emma Goldman's life and writings, including her magazine, *Mother Earth*, and her autobiography, have served as an inspiration to later generations of women who dared to advocate unpopular political ideas and speak for themselves.[16]

Taking a more traditional approach to reform, many American foremothers reached large audiences by working within the political system. As First Lady of the United States from 1933 to 1945, Eleanor Roosevelt embodied the qualities of the supportive woman who urged the men in her life to perform acts of compassion and reform. A prominent advocate for both civil rights for African Americans and women's rights, she pressed her husband, President Franklin D Roosevelt, to appoint women to cabinet, State Department, and federal judicial positions. To the extent that Franklin was ahead of his time on women's rights, the First Lady was his primary inspiration. But Eleanor was more a reformer than a revolutionary. Her advocacy for women's rights was rooted in her basic assumption that women

possessed 'understanding hearts' that could moderate the natural aggression of men.

The Great Depression was devastating throughout the developed world. Jobs disappeared, stocks were worth next to nothing, and farmers who had been told throughout the 1920s to maximize agricultural production now had no market for their food while people in urban areas starved. Women in the work force, other than a few exceptional doctors, lawyers, professors, and other professionals, were generally segregated in occupations considered 'women's work'. Women could be nurses, secretaries, childcare workers, or domestic workers because these were all occupations that were presumed to satisfy a woman's natural maternal instinct. However, the Depression showed that women could perform all types of work, even that typically done by men.

Even during the depths of the Depression, General Motors (GM), the largest industrial corporation in the world with manufacturing facilities throughout Michigan and the upper Midwest, made profits of at least ten per cent in every year except 1932, despite declining sales. To maintain its profit margin, the company laid off workers, cut the hours of many more, and sped up production in what was already a dangerous working environment. Nelly Besson, a teenager when she worked on an assembly line, remembered that there was no safety equipment of any kind. 'On the press I was on, the day girl lost two fingers. The bosses all said, "Don't tell Nelly", but almost fifteen told me before I got through the gates. When I went in, there was a finger still laying on the press'.[17] Shortly after this incident, Besson was fired from her job at the AC Spark Plug plant that supplied the GM factories, and she joined the Women's Emergency Brigade when the Flint, Michigan sit-down strike began.

The story of the Women's Emergency Brigade (WEB) highlights the willingness of women to engage in militant action to protect male union colleagues while presenting themselves as the equals

of those male workers. The National Labor Relations Act of 1935 (the Wagner Act) had given workers legal authority to organize trade unions, especially in basic industries, but GM placed numerous roadblocks in the way of the fledgling United Auto Workers. Those who discussed organizing or who signed a union card were fired and threatened with violence to themselves and their families. Attempts to strike for better wages and working conditions in 1930, and again in 1934, were crushed by the power of GM.

GM manufactured the engines, frames, and bodies for the popular Chevrolet brand in Flint, Michigan. Every aspect of government, the economy, education and social life in Flint was influenced by the powerful and anti-union General Motors corporation. The sentiment that GM controlled 'everything' in Flint served as an effective deterrent to union activism until the sit-down strike, when frustrated and angry workers refused to leave the Fisher Number One Plant and Fisher Number Two Plant on 30 December 1936.

A sit-down strike was a particularly effective way to send a message to management that work would not continue and that scabs (today euphemistically called 'replacement workers') could not enter the plant to take the place of strikers. Women were asked to leave to avoid any possible implication of sexual impropriety. Women workers and strikers' wives were active in the UAW's Women's Auxiliary. They confined their activities to visiting and encouraging 'strike widows' who were suffering great financial privation because there were no pay checks coming home; collecting funds for the families of striking workers; and providing childcare so that mothers in the brigade could help with union support work. As the strike continued, women like Genora Johnson Dollinger, sometimes called the Joan of Arc of the American labour movement, were offended at being asked to perform tasks that older or less able-bodied men could take on to allow the women to picket the plants and organize deliveries of food and supplies to the striking men. She decided to create an

Foremothers

independent, more militant women's organization to support the strikers.

The Women's Emergency Brigade was officially founded on 20 January 1937. Eschewing its auxiliary role but still stressing that the goal of the organization was to support the striking men, Dollinger declared that 'We will form a line around the men, and if the police want to fire, they'll just have to fire into us'.[18] That opportunity came early. GM used every tactic at its disposal to end the strike and attack the women. Nelly Besson recalled that the company told strikers' wives that WEB members had been brought in to entertain the men in the shop. In response, WEB members began sending 'some of the older women to talk to the wives because the wives were quite belligerent with us at times. They thought we were in there fooling around with their men'. This tactic played on the cultural assumption that women were potential sexual partners being inserted into the workplace as a distraction to the men. The WEB struggled throughout its history against this assumption. WEB women wore no makeup and took on difficult and dangerous tasks to prove their worth to the strikers. On 11 January, the company turned off the heat in the plants affected by the sit-down strike and locked the main gate. The GM security force also took down the ladder that the women had used to pass food and supplies to the workers through the windows. Strikers were able to re-open the gate, and Flint police responded with tear gas. Strikers and bystanders were gassed, and there was even a report of a shooting as the fight continued throughout the night of 21-22 January in what came to be called the Battle of Bull's Run.

The next step by GM was to ask Governor Frank Murphy to call out the National Guard and to apply for a federal injunction to oust the strikers. Throughout the forty-four-day strike, members of the Women's Emergency Brigade answered the call to stand between law enforcement and the strikers in the buildings. They

Don't Call Us Girls

even broke the windows of a factory that was being bombed with teargas to allow fresh air to circulate and lessen the effect of the gas. The women stood firm, and the police were reluctant to shoot them. Their bravery helped to end the strike and to bring about a collective bargaining agreement between the United Auto Workers and General Motors. Nelly Besson summarized the passion felt by the women of the WEB: 'We saw that there was such a need for women that would gladly give their life... We faced teargas and we faced rocks and we faced police and we faced National Guard and General Motors goons and everybody else'.[19]

The strikers' victory on 4 February 1937 opened the way for the UAW to organize workers throughout the auto industry. One celebratory sign read, 'GM Today, Ford Tomorrow'. The United Auto Workers became a major force in American organized labour in the decades after the Second World War. The union's success was due in part to the actions of the women of Flint who protected their husbands, brothers, and children by becoming labour militants. The WEB was disbanded in 1938, and the women returned to their pre-strike lives. The Women's Emergency Brigade in Flint and other auto industry factory towns legitimized women's militant activism, helping to advance the progress of organized labour in general, and women in the workplace in particular, if only for a short time. Forty years later, these same women, by then the older generation of labour activists, disrupted the annual convention of the United Auto Workers with the chant, 'UAW needs an ERA' , a reference to the proposed Equal Rights Amendment to the United States Constitution. WEB women provided a voice in support of greater rights and responsibilities within their union and in American society.

Less than five years later, women were called upon once again to assume non-traditional roles in the male-dominated world of factory work. This time, their country called upon women to help defeat

Foremothers

fascism by putting down their rolling pins and picking up welding tools. The 1920s had seen the withdrawal of the United States from the world stage in a decades-long trend toward isolationism in which the United States could consider itself protected by two oceans and a series of Neutrality Acts intended to keep the country out of war. Sensing the danger of fascism, but unable to subvert the will of a conservative Congress, President Roosevelt devised several ways to help England and other European countries. To make these arrangements possible, the United States would have to upgrade its manufacturing capacity to become the 'Arsenal of Democracy' that FDR described in a fireside chat radio broadcast on 29 December 1940, nearly a year before America's entry into the Second World War.

How could American industries meet the dramatically increased demand for guns, planes, tanks, and other war materiel? Increased demand for goods created an increased demand for workers in basic industries, particularly those whose jobs could be learned with minimal training. FDR's Executive Order 8802, signed on 25 June 1941 after pressure from African-American organizations, prohibited racial discrimination in hiring by companies that held government contracts. FDR did not make a similarly strong statement on behalf of women workers, but, in his Columbus Day Message in 1942, the president did declare that 'In some communities employers dislike to hire women. In others, they are reluctant to hire Negroes. We can no longer afford to indulge such prejudice'. Bringing women onto the shop floor would prove to be challenging, but the results were dramatic, as the idea of the Arsenal of Democracy became a reality. Soon, the image of Rosie the Riveter would capture the heart of America.

The task of recruiting women into basic industries to help meet the needs of the war effort fell to the federal government's War Manpower Commission (WMC). The Commission was established

by Executive Order 9139 as part of the Office of Emergency Management in April 1942. Its purpose was to 'study the national situation with regard to conditions which affected adversely the mobilization and utilization of women in the war effort, and to make recommendations to the Management-Labour Policy Committee on a policy arriving at correcting these conditions whenever practicable'. By August 1942, the Commission had added a Women's Advisory Committee to its list of working subcommittees. The Committee focused on:

1. recruitment, including training, and selection of women;
2. full utilization of employed women workers through adjustments on the job as well as
3. in the community; and
4. reconversion adjustments and post-war planning.[20]

The Manpower Commission was only one of the government agencies concerned with drawing women into defence work. The Office of War Information used pamphlets, posters, magazine advertisements, and radio messages to promote the idea that 'It's a woman's war too'. Selling the idea of supporting 'our boys in uniform' was a massive and important task that was part of a broader campaign to involve women on the home front in supporting the war effort by planting victory gardens, minimizing waste by conserving food, and voluntarily complying with rationing rules. All these activities were intended to support the 'V for Victory' campaign. Potential women workers, the propaganda experts theorized, would have to be convinced that work on the shop floor in an airplane factory was glamorous as well as patriotic.

Female defence workers in the Second World War were often told to bring their femininity to work and to present a ladylike image, even as they did work usually performed only by men. Women were

Foremothers

often pictured in recruitment posters with their nails manicured, make-up perfectly applied, and hair coifed in the style of the day. Even if they wore pants or overalls, women were never shown in dirty or torn clothing. This was certainly a mixed message, as factory work *was* dirty, and it could be dangerous. The influential *Woman's Home Companion* magazine, with a circulation of nearly four million during the war, praised the skills that women in the defence industries were acquiring, while also measuring women in the factories by the standards of beauty of the time. 'American women are learning how to put planes and tanks together, how to read blueprints, how to weld and rivet and make the great machinery of war production hum under skilled eyes and hands. [Women workers were known for their ability to make production run smoothly. In the parlance of the day, the machinery 'hummed'.] But they're also learning how to look smart in overalls and how to be glamorous after work. They are learning to fulfil both the useful and the beautiful ideal'.[21] The emphasis on women's appearance in the early days of the wartime recruitment effort points to a reliance on traditional assumptions regarding women's 'proper' attire. It took some time before safety equipment for women became available, as the manufacturers and the women themselves realized the need for protective gear when working with hot metal, as the welders and riveters did every day.

The most visible recruitment persona was Rosie the Riveter. First painted by J. Howard Miller, who worked for the Westinghouse Corporation, the image of the working woman flexing her muscles in preparation for whatever task might present itself was popularized by Norman Rockwell in the *Saturday Evening Post* in 1943. Rosie is smiling, her hair is tied back in a bandana, and she is wearing working clothes. Just a year after the federal government effort to bring women into the work force began, a rough and tumble Rosie with a slight feminine touch became the symbol of the woman in the factory. Rosie was portrayed as independent and competent, but

she also played the supportive role expected of women. One verse of a popular song about Rosie, released in 1943, reveals one important reason she is working in a factory making airplane wings:

> Rosie's got a boyfriend, Charlie.
> Charlie, he's a Marine.
> Rosie is protecting Charlie,
> Working overtime,
> On the riveting machine.

Rosie represented the supportive, competent, but still ladylike, working woman. Decades later former defence plant worker Margarita Salazar McSweyn reflected on the dual image of Rosie as both worker and proper woman. Speaking to the new feminists of the 1970s, she declared that they should push for rights 'but be a woman first. Some of them think they have to be more man-ish to get where they want, instead of getting where they want to as a woman. Don't make yourself ugly; make yourself pretty... You can get where you want to get as a woman. Fix your hair and fight like a woman – but get what the women should have'.

Most defence plant jobs required no experience and, once hired, women reported to the factories or government training centres to receive training. At centres like the Brooklyn Navy Yard, women learned the terminology of their trades and the proper way to handle the tools they would need to perform their new jobs. Volunteers in government recruitment centres demonstrated some of the tasks that women would perform in the factories, making the jobs look interesting and easy to learn. In the interest of getting the new workers up to speed, some jobs were broken down into component tasks that could be learned quickly, but after a brief training period, some women were prepared to perform the same tasks as their male counterparts. Still, a majority accepted a lesser role in production,

Foremothers

assuming that the men had more knowledge and experience as career employees.

Because of their gender, Rosie and her fellow women workers seldom achieved full parity with male workers who held more complex jobs. Marye Stumpf remembered that, even when many of her male colleagues went off to war, the most intricate and best paying jobs did not go to women. In her department 'they never did put women on the really big number five lathes. The men seemed to be professional machinists; they had a lot of experience and were able to do their own set-ups. Class A machinists were still men. The women got to be Class B machinists, which was as much as we expected to be. We weren't making a career of it like the men. We were doing what there was to do'. This comment suggests that women were eager to play a role in the war effort, even if that role was not fully equal to the part played by male employees. Further, many women understood that their employment in the defence industry, however vital it was to the war effort, would not be permanent.

A major challenge faced by women was active and passive resistance from men who thought women had no place on the shop floor. Charlcia Neuman remembered that her husband did not approve of her going to work in a factory: 'He was one of those men that never wanted his wife to work. He was German and was brought up with the idea that the man made the living; the woman didn't do that. But he found that it was a pretty good idea at the time. It was a necessity ... We couldn't live on what he was making, so that's the way it goes.' Eventually, as more men were drafted into the armed forces and the demand for wartime goods accelerated, men came to accept the presence of female co-workers. The unions granted membership to women, and hourly pay was often the same as that of male workers. But the resistance was strong. Factory worker Helen Studer remembered that the men resented having women on the shop floor 'and in the beginning, it was a little bit rough. You had to hold your

head high and bat your eyes at 'em. You learned to swear like they did. However, I made myself stop because I don't think it's too ladylike. The men you worked with, after a while, they realized that it was essential that the women worked there 'cause there wasn't enough men and the women were doing a pretty good job. The resentment eased. However, I always felt that they thought it wasn't your place to be there'.

Executive Order 8802 could require companies to hire Black workers, but it could not force true racial integration and had no impact at all on the hiring of women. Black workers, both male and female, frequently worked in different locations from their white colleagues. This was especially true in plants located in the South. Former defence worker Fanny Christina Hill recalled the general attitude toward Black workers: 'There were some departments, they didn't even allow a black person to walk through there let alone work in there. Some of the white people did not want to work with the Negro. They had arguments right there. Sometimes they would get fired and walk out the door, but it was one more white person gone... But they [the company] did everything they could to keep you separated. They just did not like for a Negro and a White person to get together and talk'.

African-American female defence workers recognized discrimination in the plants, but they also acknowledged the benefits of having defence work. While most Black women were consigned to domestic work, childcare, or beauty parlour jobs, the opportunity to earn more and contribute to the war effort was enticing. One worker commented years after the war that defence work 'made me live better. It really did. We always say that Lincoln took the bale [of cotton] off of the Negroes. I think there is a statue up there in Washington DC where he's lifting something off of the Negroes ... [but] Hitler was the one that got us out of the white folks' kitchens'. White and African-American women shared in the windfall that

Foremothers

defence work brought them compared to their pre-war jobs. On learning that she would earn sixty-two and a half cents per hour, one woman exclaimed, 'I thought I'd hit the mother lode!'

American women during the Second World War also displayed their patriotism by working for the American Red Cross or the United Service Organization (USO) or by enlisting in the military. Red Cross workers on the home front drove ambulances and tended to soldiers in hospitals and homes throughout the country. Known as the Gray Ladies, these volunteers provided non-medical services, including writing letters or shopping for disabled people. Red Cross women also served abroad, providing recreational opportunities for soldiers in both free-standing and mobile service clubs that travelled close to the front. Female Red Cross workers had to be at least twenty-five years old, have earned a college degree, and have passed a physical exam. Even though they worked near dangerous combat zones, the women were nevertheless seen as doing auxiliary women's work. They were subject to strict codes of conduct and decorum. Regulations even dictated how they wore their uniforms, requiring neatly pinned collars and minimal make-up and prohibiting bright nail polish, earrings, or hair ornaments. From this strict selection process, only one applicant in six was accepted as a Red Cross volunteer during the Second World War.

Women in the USO also provided recreation and entertainment for soldiers on both fronts. We are most familiar with the travelling shows hosted by Bob Hope that featured famous singers, movie stars, and other celebrities such as professional athletes. Women also staffed nearly 3,000 USO clubs at home and abroad. Many were run by women who were called senior hostesses. Junior hostesses were prohibited from wearing slacks, smoking or drinking in the clubs, or dancing 'conspicuously'. They were not allowed to refuse to dance with a soldier unless he was behaving in an 'ungentlemanly' manner. One USO centre in Honolulu became famous for serving banana

splits to troops on a massive scale, using nearly a ton of bananas and 250 gallons of ice cream a day. Women in the USO were in the forefront of bringing a touch of home to soldiers.[22]

During the Second World War, nearly 350,000 women served in the military in non-combat roles. The Women's Army Auxiliary Corps gained status as an independent branch of the Army in 1942. The Navy, Marine Corps, and Coast Guard all employed women in auxiliary forces, and the Women's Air Force Service Pilots (the WASPS), while not specifically a military branch, performed the vital role of flying planes to their combat destinations. Both the Army and the Navy had a separate Nurse Corps in which women served in supportive roles to medical doctors at or near the front, where sixteen women were killed in action. The range of occupations performed by women is impressive: 'Women in uniform took office and clerical jobs in the armed forces in order to free men to fight. They also drove trucks, repaired airplanes, worked as laboratory technicians, rigged parachutes, served as radio operators, analysed photographs, flew military aircraft across the country, test-flew newly repaired planes, and even trained anti-aircraft artillery gunners by acting as flying targets'.[23]

Like their sisters in the factories at home, military women answered their country's call to be competent workers willing to sacrifice their time and energy to the war effort while remaining ladylike. Rosie and her colleagues in overalls, starched grey or white uniforms, or the khaki skirt of the Women's Army Corp (WAC) uniform benefitted from the wartime need for their skills and hard work. They performed a radical task just by walking on to the shop floor or into the recruiting office, but they did so as women who held fast to traditional values of femininity and service to their country – and to their men.

As the war came to a conclusion, many women realized their work outside the home was also coming to an end. A few hoped to remain in service to their country and some did as career Red Cross

workers, Army nurses, or military women involved in the Cold War de-Nazification effort in Germany that utilized their administrative skills. But most women who had served their country 'for the duration' were compelled to return to more traditional domestic pursuits and values that equated patriotism with domesticity. They would miss the challenge and the adventure, but the clear message was that it was time to go home.

For African-American women, few role models appeared in traditional histories or text books prior to the late-twentieth century, although their lives and accomplishments were chronicled in the story-telling culture of family lore derived from many African tribal cultures.

African women made famous in literature or film included Makeda of Ethiopia, the biblical Queen of Sheba, who was known for her marriage to King Solomon, and Nefertiti of Egypt who was admired for her beauty and grace as a queen. Both women of high royal birth were praised for the way they embodied traditional female values of support for and subordination to powerful men. More recent scholarship has revealed the accomplishments of such African monarchs as Amena of Zaria, who expanded the empire of her Hausa people and was known as the 'Warrior Queen' in the sixteenth century. Three hundred years later, Yaa Asantewaa led the Ashanti people in a war to regain control of their traditional tribal lands from powerful European imperialist interests. These women and others defended their people against European exploitation. Their stories are now being told more frequently in histories of Africa, as scholars recognize the value of placing women's lives in the mainstream, rather than the margins, of history.

Academic interest in social history, the everyday lives that contributed as much to the nation as the exploits of heroes and villains, has been and continues to be enriched by both African-American and women's history. But this relatively recent development in

scholarship has been slow to reach America's school classrooms. For generations, female and African American students simply did not see themselves in their textbooks. Writing in the Introduction to *The 1619 Project*, Nikole Hanna-Jones described her exposure to history as a child growing up in Waterloo, Iowa: 'The vision of the past I absorbed from school textbooks, television, and the local history museum depicted a world, perhaps a wishful one, where Black people did not really exist. This history rendered Black Americans, Black people on all the earth, inconsequential at best, invisible at worst. We appeared only where unavoidable: slavery was mentioned briefly in the chapter on this nation's most deadly war, and then Black people disappeared again for a full century, until magically reappearing as Martin Luther King, Jr gave a speech about a dream'. The sense of exclusion also applies to the history of women, specifically Black women, as objects of history rather than as independent people. Hannah-Jones continued: 'We were not actors but acted upon. We were not contributors, just recipients. White people enslaved us, and white people freed us'.[24]

Academic historians, journalists, and film makers have 'discovered' African Americans and women as historical figures in their own right. The previously untold stories of African Americans and women expand our awareness of broader historical currents and enliven a sense of inclusion in a history of their own for students. Sadly, efforts to present a more nuanced, often critical, history of the United States have met with a vicious political backlash. An inclusive American historical narrative has been vilified by a political discourse that describes attention to America's profound failings such as slavery, segregation, and misogyny as 'upsetting' to children and disruptive of a narrative that focuses on centuries of progress from John Winthrop's City on the Hill to the twentieth century's world leadership by a powerful United States. It is on this contested political terrain that African-American and women's history meet as

Foremothers

correctives to the heroic narrative that posits that America can do no wrong, and it is imperative to continue to find history in unlikely places where women were central, if often unrecognized, characters.

African-American foremothers were prominent in the oral histories of capture, enslavement, and survival, their stories shared around kitchen tables or as part of family lore passed from one generation to the next. Some of the most inspirational stories of survival appear in the lives of unheralded enslaved women. These women served the White people who laid claim to their bodies and their families with dignity. They taught their children how to survive in two worlds, White and Black, free and enslaved. The enslaved women who gave their children love and attention in the face of brutality and separation created models of love and resilience for future civil rights workers. The women who kept their families and communities together in slavery and the Jim Crow period were rocks of strength for those they cared for. The men in their lives were subject to sale and jail, and these unnamed women did what was necessary to maintain community in a hostile world before and after the Civil War.

Narratives of enslaved women are frequently buried in archives, diaries, and memoirs. Until recently, we knew little about African-American women who wrote lyrical poetry, fought for the abolition of slavery, advocated full political rights during Reconstruction and the Jim Crow Era, and succeeded in the business world in the early twentieth century. Phillis Wheatley, an enslaved woman in Boston, published one of the first books of poetry in the American colonies and was praised by George Washington for the elegance of her work. Maria W. Stewart was an abolitionist who had the temerity to speak in public at a time when women were banned from appearing before audiences that included men. Her speeches earned Stewart a reputation as a powerful Black abolitionist. Frances Ellen Watkins Harper was a teacher and published author who advocated for equal rights for newly-freed people during Reconstruction. Josephine St.

Don't Call Us Girls

Pierre Ruffin was a prominent suffragist who published *Woman's Era*, the first newspaper for an audience of Black women. And, until recently, we knew little of Madame C. J. Walker, America's first Black female millionaire, who built her financial empire by serving the personal needs of Black women with hair care products just for them. Any of these women could be considered foremothers, whether they were known or unfamiliar, of the activist generation of women in the 1960s and 1970s.

There were a few better-known African-American women whose exploits inspired future generations and who deserve to be called foremothers. Sojourner Truth and Harriet Tubman were amazing women who acted like men when they had to. Isabela Bomfree, who later in life was known as Sojourner Truth, was born a slave in Ulster County, New York, in 1797. She escaped bondage in 1827, the year in which slavery was to end by law in New York State on 4 July. She found refuge in a family of abolitionists who purchased her freedom for twenty dollars and helped her file a lawsuit to gain her younger brother's freedom after his illegal sale to the deep South. Sojourner Truth moved to New York City and worked as a domestic servant. At the same time, she began speaking publicly on behalf of abolition and women's rights. Her style was riveting, as she spoke about the cruelty of slavery from her own experience. She emphasized that, even though she had been enslaved in the North, she did not have a human being's most important right – her freedom.

In 1851, Truth began a speaking tour that took her to a Women's Rights Conference in Akron, Ohio. Historians disagree about the extent of Truth's participation in the conference, but she is said to have delivered what is regarded as her most powerful speech, called 'Ain't I A Woman'? Truth observed that, as an enslaved person, she was able to outwork any man. She showed off her muscular arms to support her contention that she had been required to work as hard as a man, and she asked her audience, 'Ain't I A Woman?' She asked

Foremothers

the crowd if she did not have the heart and feelings of a woman, and did she not experience the pain and sorrow of a woman on the death or sale of a child? Truth's popularity brought her into contact with famous abolitionists like William Lloyd Garrison and Frederick Douglass, and she even met President Abraham Lincoln. In speeches before large and enthusiastic crowds, Truth declared that, in her life as an enslaved person, she had ploughed and reaped, and husked and chopped and mowed. Could any man do more than that? Sojourner Truth was a powerful advocate for women's rights. She spoke to the power of a woman to equal the accomplishments of a man.

Harriet Tubman, born Araminta Ross between 1820 and 1822, learned as a young girl that there was a price to be paid for opposing the will of the master of her Maryland plantation. When she tried to prevent him from beating another slave, he struck her, fracturing her skull. Her injuries, which were characterized by severe headaches and sleeping 'spells', remained with Tubman throughout her life. In 1849, she escaped with one of her brothers and established a new life in the North. Had she only saved the two of them from the horrors of plantation life, Harriet Tubman's exploits would be worthy of legend. But Tubman returned to the South several more times to lead more than seventy enslaved people to freedom. Called Moses, her exploits were likened to those of the Israelite who led his people out of bondage in the biblical book of Exodus. Tubman worked for the Union army as a nurse and then earned fame as a military scout in the final days of the Civil War. The information she provided about Confederate lines and supply depots helped to pave the way for success in a skirmish at the Combahee River in South Carolina. A supporter of women's suffrage, Harriet Tubman was best-known for heroism typically ascribed to men.

Had they been more aware of the experiences of their foremothers in France, Germany, Great Britain, Vietnam, and the United States, the activist women of the 1960s and 70s would have been inspired by

the courage of female role models who had tried to change the world against great odds. It was the bold actions and sacrifices of women in movements for social justice in the 1950s and 60s in the face of prejudice and misogynist assumptions about women's capabilities that contributed to a greater interest in revealing the deeds of women of the past.

The Cold War world in which these women grew up was characterized by restrictions on the lives of young women, and those rules inspired women to reform, resist, and rebel against a society they found confining, a segregated world they found immoral, and a war they were determined to stop. But change did not come immediately, and it is important to look at the world of the 1950s in which the seeds of 1960s social change first germinated.

Chapter Two

The Home Front

The women who answered the call to help defeat European fascism and Japanese militarism in the 1940s by working outside their homes – those who welded the airplane wings, flew planes in preparation for combat, cared for soldiers near the front, and handled countless administrative duties during and after the fighting – got a powerful message once their service came to an end: 'Thank you, ladies. You have served your country by helping the men in your lives. Now it's time to go help them once again by making new homes for your husbands and children in the post-war world'.

The political and cultural environment in advanced industrial countries in the 1950s would not at first seem to have been one in which a generation of women would come of age challenging the authority of their elders and their government in the 1960s. Western European countries, devastated by war, focused on re-building their infrastructure with Marshall Plan support, while the United States, which had been spared the physical destruction of war after Pearl Harbor, worked to maintain its economic, military, and political supremacy. Leaders in France, Germany, England and the United States shared cultural assumptions about the value of women's work: it was most appropriate left in the kitchen and the nursery.

In diverse ways, the women of the French resistance, wartime German mothers, British agricultural and industrial workers, and American factory and military women all contributed to their country's struggle for victory in the Second World War. Women played important supportive roles on both the winning and losing sides of the war. For women who had taken pride in their wartime accomplishments, it is fair to inquire whether their sacrifices brought

them any closer to equality with men as they returned to lives of domesticity in their respective countries. It would take activism on the part of the next generation – the children of the 1950s who became the protesters of the 1960s – to bring women's equality before the world as a modern issue for modern times.

France | With the outbreak of the Second World War, women in France were called upon to take positions on assembly lines in the armament industry. Wives of soldiers had priority for wartime factory jobs because they replaced the wages of their husbands who were at the front. Women performed a variety of skilled and unskilled jobs, but even as they stepped into men's jobs, French schools and government agencies maintained strict gender roles. Young girls learned cooking and sewing while physical education prepared boys for war. The Vichy government promoted female domesticity, and *les mamans de France* were venerated in government literature and popular newspapers and magazines. But the wartime demand for labour far outstripped the impact of government propaganda, and women flocked to the factories, even as they earned low wages and worked under difficult conditions.

Women found somewhat more lucrative work in the administrative offices of the Vichy government and German military facilities. They were grateful to have enough money to feed their families by working as telephone operators, secretaries, or cleaners. Some women engaged in prostitution, and Waffen SS officers were their primary customers. Once the fighting ended and Germany was defeated, women who had worked for the Germans, especially those who had engaged in sexual relations with German soldiers, were labelled collaborators. They were led through the streets of towns and villages and branded by having their heads shaved. In time, the animus against these women faded as the needs of rebuilding France after the war led the vast majority of French women back to the

The Home Front

home as their prescribed source of happiness and fulfilment.

With the wounds of war slow to heal and challenges to colonial rule increasing, French citizens were preoccupied in the late 1940s and the 1950s with the physical and emotional re-building of their nation. The rights of women were not among the major issues before the National Assembly. Laws and regulations governing women's lives remained restrictive, as women's access to property and credit were limited and the national school system retained its rigid, gendered structure. At home, the ideal presented in media messages was female domesticity. The perfect French woman derived her success and happiness from being a successful housewife and mother. French women had earned the right to vote, but there were few incentives for the national government to grant women more opportunities to participate in the economic and political renaissance of the country. The men would handle the job of creating post-War France.[25]

Many aspects of post-war French life contributed to the domestication of French women. From a lack of viable employment opportunities to the absence of women role models in government and economic life, women were expected to remain in the background. They were very much the face of France's fashion industry, not as creators of new designs, but as the sexualized models who walked the runways of Paris fashion shows. French designer Christian Dior revolutionized women's fashion starting in the late 1940s. According to Olivier Galliard, Director of the Palais Galleria who published a retrospective on post-war French fashion in 2014, Dior rejected the shoulder pads and trousers of 1930s and 40s *haute couture*. In his creations of the 1950s, Dior and other male designers changed fashion for modern women. They flattered a woman's figure by cinching the waist, accentuating the bust, and flaring the skirt. Dior's fashion and accessories became so popular in the 1950s that sales from the company contributed significantly to France's GDP.[26]

These creations that emphasized the natural curves of the female body inspired off-the-rack versions of Dior's dresses for middle-class women who had a bit of discretionary income that they could devote to style. Dior's image of the ideal woman dominated the fashion industry, was described effusively in women's magazines, and was internalized by women themselves, who accepted the idea that women should always look their best in the manner of popular fashion models. French girls, like teenage girls around the developed world, grew up understanding the importance of 'good grooming' and maintaining a feminine appearance that would be attractive to men. The paradigm was the French fashion model wearing the designs of Dior, Yves Saint Laurent, Pierre Balmain and other male French fashion creators. French fashion designers were at the height of their popularity, and their styles, designed for the figures of almost no real woman, influenced the cultural patterns of those who attempted to achieve that physical ideal. Popular magazines in the 1950s featured advertisements for fad diets, hair colours, face creams, and products to make women 'beautiful'. The search for beauty preoccupied many young women who appeared to be more concerned with how they looked than what they thought or did. Popular culture promoted the idea that the smart young woman with her head in a book so much that she strained her eyes would never find a man. Cultural commentator Dorothy Parker had quipped as early as 1926 that 'Men seldom make passes at girls who wear glasses'. What began as a casual quip became cultural dogma in the beauty-obsessed decade of the 1950s.

Young girls growing up in 1950s France saw what seemed to be an idyllic America for young people through popular culture and films, but their lives were more circumscribed than those of their teenage counterparts in the United States. Girls and boys lived in a cultural climate influenced by images of American prosperity, suburban conformity, and consumerism, and elements of that culture

did emerge in France. Despite the efforts of the *Académie Francais* to prevent American words like 'les bleu jeans' from entering the French language, the country modernized following the American model after the Second World War.

One aspect of that modernization process was an increase in the number of women attending French universities. Like their American counterparts, these young women experienced the exhilaration of learning to think critically about the cultural climate in which they had been raised. They joined groups that engaged in discussions about how to utilize the power of their numbers to influence the direction of post-war society in France. By the late 1960s, every aspect of French society, from the university system to the status of women's rights, would be subjected to analysis and criticism, and young women would be important participants in the emerging movements for social change, one of which was in response to the dangers of nuclear weapons.

As early as 1937, nuclear energy preoccupied physicists throughout the world who discerned the destructive power of the atom. Scientists shared information about their experiments and how the new form of energy could be developed for wartime use. French scientists were active participants in these discussions. Jean Frederic Joilot-Curie was an esteemed physicist and co-winner with his wife, Irene (daughter of Pierre and Marie Curie), of the 1935 Nobel Prize in Chemistry. The couple installed Europe's first cyclotron in their laboratory and generated a nuclear fission reaction on 26 January 1939.

In 1945, with developed nations competing to join the United States as a nuclear power, Joilot-Curie was named his country's first High Commissioner for Atomic Energy. Seeing the dangers of a nuclear arms race, Joilot-Curie was one of eleven prominent figures who signed the Russell-Einstein Manifesto that marked the beginning of a public response to the Cold War arms race. Scientists and ordinary

Europeans began to voice their opposition to nuclear proliferation, especially after France became the world's fourth nuclear power in 1960.[27] With the development of French nuclear technology came a greater awareness of the dangers of nuclear proliferation. But the de Gaulle government was more preoccupied with developing France's power independent of the United States. The concerns and grievances of young people hardly seemed important.

Germany | The defeated Third Reich faced a complex rebuilding process following the Second World War. Divided into East and West, two Germanies struggled to recover from the physical damage of the war and the loss of military and civilian lives. Before civil society could be re-established, it was necessary to recover basic infrastructure in both the German Federal (West) and Democratic (East) Republics. On the most basic level of restoration, the *Trummerfrauen* (women of the rubble) cleared massive amounts of debris from bomb sites, buried dead civilians, and salvaged what they could from destroyed buildings. In the East, ninety per cent of women were employed in the rebuilding effort after the war. They received job training and access to childcare, but these benefits were temporary. Women in the West were encouraged to return to their homes as quickly as possible, much like their counterparts in France. Women's labour was needed less in the West and more in the East because of the migration from east to west of thousands of men who needed work and were able to travel freely prior to the erection of the Berlin Wall in 1961.

As a result of agreements made at the Yalta Conference early in 1945 and affirmed at Potsdam in July of that year, the Allies pledged that 'all members of the Nazi party ... are to be removed from public or semi-public offices and from positions of responsibility in important private undertakings'. A small American military de-Nazification force remained in West Germany after the war to

work with German civil authorities to prevent the resurgence of the Nazi Party and expunge Nazi propaganda from the popular press. American military personnel, including women, worked with civilian managers in companies such as Bayer and IG Farben that had served the Third Reich by manufacturing war materiel using slave labour. Their job was to train workers in the philosophy of representative democracy more familiar in the United States than in post-war Germany. Ensuring that West Germany would remain allied to the United States and other western democracies was especially important as alliances emerged in a new phase of the Cold War.[28]

The rebuilding of West Germany also called for the creation of a national identity distinct from that of the Thousand Year Reich. This process involved emphasizing men's identity as workers, providers, and respectable citizens rather than soldiers. It also required that women play a domestic role but with full civil and political rights as ordained by the Basic Law of Germany in 1949 and reaffirmed in civil law in 1957. Women did not have full economic rights and still needed the permission of a male relative to engage in economic activity on their own. Women were to be equal, yet different. Such equality would be achieved by restoring a domestic sphere safe from state intervention, where women could once again devote full attention to their most important responsibilities as wives and mothers in *private* families and not in those dedicated to the priorities of the Fuhrer or the *Volk*.

The constitutional guarantee of women's equal rights stood alongside the elevation of the family – with the wife and mother at its centre – as the key building block of West German society. Equal with men in the voting booth, women's difference nevertheless fully justified their special protection in marriage law, family allowances, and maternity legislation.[29] This was the political, economic, and social climate in which the generation of women who would protest

the Vietnam War was raised. Where labour was needed, West German companies relied largely on immigrant men from East Germany rather than issuing a call for women to enter the workplace. In the East, women worked outside the home while their sisters in the West accepted, and even embraced, the ideal of domestic security and satisfaction.

Great Britain | The Second World War fundamentally changed the lives of women in Great Britain who had accepted the challenge of doing men's work, even as commonly-held prejudices deemed them less capable than their husbands, fathers, and brothers. During the war, working women proved society, and themselves, wrong as they laboured in factories and fields to support the war effort. Conscription into the civilian work force of women between the ages of eighteen and fifty who had no children under the age of fourteen was accepted as necessary for victory. The war's end signalled a return to traditional gender relationships. Virginia Nicholson wrote that women workers gained a sense of power during the war that was lost with victory:

'There were women who could talk down aircrews, break codes, track battleships, drive 10-tonne trucks and save lives. No concession was made, however, for the fact that women had to go on running the home. After a 10-hour day in a factory making aircraft wings, a woman would still have to shop, clean, feed her family on rations and "make do and mend". After the war, the home was where they were expected to return'. Attempts to bring childcare centres into workplaces to accommodate the needs of working women after the war proved futile, and the Churchill government resisted calls for equal pay for women. It was as if the destiny of British women, like that of their counterparts in France and Germany, lay in the domestic sphere where domesticity was equated with happiness.[30]

The Home Front

Women were still needed in the post-war work force, however. They were employed in occupations segregated by gender, and the prevailing assumption remained that women worked for extra money rather than for the basic support of their families. Despite the need for their services, women were frequently fired once they married. The newly-created National Health Service did provide jobs for women, but these too were considered women's work with low pay and few benefits.

In their homes, British women worked hard. Most houses were heated by coal fires with no central heating, and refrigerators were a new luxury item. Women had to shop in several different stores for fresh food every day, and they were constantly engaged in cooking meals, cleaning and mending clothing, and maintaining the house. Few people had washing machines or dryers, and housework without these labour-saving devices was demanding indeed. Hardly anyone expected that women's domestic labour would be compensated, except for a household allowance that a husband controlled. British women were expected to be hard-working and successful housewives, patient and calm mothers, and attractive and available mates for their husbands. Children were expected to be good young citizens who were seen but not heard. Women's magazines bombarded readers with full-colour images of attractive women doing housework in dresses and high heels. These images were hardly consistent with the reality of the everyday British housewife.

Like French women, British housewives were receptive to both the image of domesticity and the glamorous image of women in magazines and films. In reality, they could be successful at managing their homes but the ideal of looking like a movie star remained elusive. British women worked, mainly behind the scenes, in a number of groups that opposed the development of nuclear weapons in the 1950s. In November 1957, the Campaign for Nuclear Disarmament (CND) was founded in London with support from scientists,

religious leaders, artists, academics, and musicians. Members of the Labour Party, the British Peace Committee, and the Direct Action Committee also supported unilateral disarmament of England's nuclear arsenal in response to Britain's exploding of its own nuclear device in 1952, making it the world's third nuclear power. In its early days, guided by leadership that included philosopher Bertrand Russell, president, and Peggy Duff, secretary, the CND was not a broad social movement. Its singular goal was to 'get rid of the bomb'.

CND tactics, including peaceful marches and appeals to public officials, were typical of middle-class, moderate movements. Every year between 1958 and 1965, the CND organized a mass march from the Atomic Energy installation at Aldermaston in Berkshire to London's Trafalgar Square. According to Jack Watt, the CND was 'never intended to be a mass movement, but a specific pressure group… While the leadership resisted most attempts to expand outside of the issue of unilateral disarmament, the 'umbrella' radically unified a British society characteristically divided by class, religion, generation and ideology'.

Nuclear disarmament, first unilaterally and then as a goal for all nuclear powers, had activated a broader spectrum of the British public who feared the consequences of further nuclear escalation. The single-issue CND of the 1950s became a more broadly focused organization after the signing of the 1963 nuclear test ban treaty between the United States and the Soviet Union. The CND's new focus on ending the Vietnam War coincided with the emergence of a cohort of students and other activists, many of whom were women, who were poised to demand an end to both nuclear proliferation and war.[31]

United States | During the Second World War, women in the United States also faced challenges and suffered losses, although they did not face the horror of combat in their local communities. They

managed their households with rationed goods, reused and recycled everything they could, planted victory gardens, and demonstrated that they could perform men's work. But American women approached the end of the war with their country's infrastructure intact and the worst privations of the Depression years behind them. With the Allied victory, American women had work to do, but that work was no longer in the Arsenal of Democracy or the military. The most prevalent and powerful voices in American society told American women to go home to take care of their familial responsibilities and go home they did.

The message that post-war happiness and security resided in the nuclear family resonated with women who had seen their men go off to war and who generally assumed their wartime jobs would last only 'for the duration'. In American society at large, it was no longer acceptable for women to work in men's jobs. A woman's destiny, indeed her presumed happiness, lay in the creation of a perfect home life with a husband as the head of the household. Men had also internalized this image. Now that they had secured victory abroad, it was time to have peace at home.

White American women learned valuable lessons in femininity from the magazines that shaped, then catered to, their emotional needs. Women learned in the pages of *Good Housekeeping* and other magazines marketed specifically to them, that their 'job' was to present themselves as feminine, with the right body type, hairstyle, clothing, and social skills to promote their husbands' careers. In all matters, a woman's personal needs and desires were to be subordinated to those of her husband and children. Writers, editors, and advertisers, most of whom were men, assumed that women were married or that they longed to be married. The image of single or divorced women working to support their children hardly existed amid articles on how to find and keep a husband.

Advertisements for everything from cigarettes and mouthwash

(to remedy the newly discovered ailment labelled 'halitosis') to vacuum cleaners featured women in dresses, stockings, and high heels enjoying a nicotine break, fighting bad breath, or cleaning the house. Readers were encouraged to imitate the happy women they saw in the pages of the magazines *Ladies Home Journal*, *Redbook*, and *Good Housekeeping*. Ads featured labour-saving devices such as washing machines designed to make keeping house seem effortless but nonetheless important. In the kitchen, women found new ways to make cooking creative and time-consuming, consistent with the idea that a clean house and a delicious dinner should be the major objectives of a married woman.

During the Second World War, magazines had printed recipes that were quick and easy to make. A new product, the cake mix, consisting of all the necessary dry ingredients in a single box, was highly popular. After the war, cake mix sales declined, as women no longer needed to save time and effort. Cake mix companies fretted about how to boost consumption and maintain profits. Psychologist Ernest Dichter, who coined the term 'focus group' and who was a consultant for the Betty Crocker Corporation, theorized that women needed to be more involved in the creation of the family dessert. Dichter suggested that the icing was as important as the cake. The icing was 'not just a layer of white frosting. Box covers, recipes, and home-making magazines showcased elaborate cake constructions that looked like miniature football fields, or European castles, or three-ring circuses. Women pored over pages-long instructions on how to bake their own wedding cakes using basic cake mixes and tubs of frosting'. Baking, like keeping a beautiful house and raising perfectly behaved children, became a preoccupation of housewives in the 1950s, one that took time and earned praise for the creative married woman.[32]

Popular women's magazines also included 'expert' advice on how to run a household, how to feed a family on a limited budget, how

to raise children, and how to remain feminine and desirable after the arrival of those children. Sex education and female frigidity were frequent topics in 'The Doctor Talks', a regular column in *McCall's* magazine. Because the column was purportedly based on the latest medical advice, it had a significant influence on women who trusted what they read. Readers learned that the success of a marriage had little to do with *their* sexual satisfaction; their job was to fulfil their husbands' needs. Marriage manuals abounded, and their advice focused on a woman's responsibility to make her man happy.

Even when the advice givers did not mention sex explicitly, it was clear that women were expected to be sexually available to their men. Wives were encouraged, for example, to have dinner ready for their husbands when they got home from work, to wear attractive clothing and make-up, and to eliminate noise and clutter. It was important for wives to be sure they 'made the evening his. Never complain if he comes home late or goes out to dinner or other places of entertainment without you. Instead, try to understand his world of strain and pressure and his very real need to be at home and relax'.[33] We do not find in these articles any acknowledgment of the stress for women of maintaining a household, raising children, or preparing perfect meals they could not eat because they were stressed about gaining weight and appearing unattractive to their husbands.

While their wives were bombarded with images of beautiful women in popular magazines such as *Vogue* and *Cosmopolitan*, along with advice on how to be a good wife from popular columns and marriage manuals, their husbands absorbed an equally strong message about masculinity from publications like Hugh Hefner's *Playboy*. The 'Playboy Philosophy' offered an escape for men from domestic life, suggesting that fantasies of the ideal women could be fulfilled by photographs of beautiful Playboy models. Reading *Playboy* seemed harmless, especially as the magazine contained advertisements for upscale luxury items for men, interesting articles, and terrific jokes.

Playboy was an easy target for proto-feminist criticism.

In early 1963, freelance journalist Gloria Steinem was asked by *SHOW Magazine* to take a job as a Playboy bunny and describe life in the New York City Playboy Club. Adopting the pseudonym Marie Catherine Ochs, she applied for a job that called for 'girls' who were 'pretty and personable' between the ages of twenty-one and twenty-five. Steinem lied about her age (she was twenty-eight) and managed to avoid having to provide identification such as a Social Security card or birth certificate. In 'A Bunny's Tale', published in May and June 1963, Steinem revealed a world of 'stuffed bosoms, low pay, and (extremely) high heels'. Bunny Training included instructions on how to wear make-up and squeeze into a bunny costume. Steinem was required to attend a series of lectures, learn the floor plan of the club, and pass a written test. Her pay met New York State's minimum wage requirement of fifty dollars a week, but there were deductions – for her heels and her costume as well as its maintenance, including nylon stockings, which were deemed unsuitable once they had a run. Bunnies also had to submit to a weight check before every shift, and they received demerits if the cottontails on their costumes were not kept clean.

A Bunny's job was to be beautiful but unavailable. Demerits could result from being rude to a customer, no matter how insistent or offensive the man may have been. Bunnies were also subjected to blood tests and gynaecological exams, practices that Hefner ended after the appearance of Steinem's expose. Tips were shared with the club, making a Bunny's income well below that of a Playboy Club customer. Steinem learned how to 'stuff' her costume to create more obvious cleavage using a variety of objects, including Kleenex, foam rubber, lamb's wool, gym socks, silk scarves, Kotex halves, and cut-up Bunny tails. Steinem's articles described the toll the job took on her fellow workers, who were required to wear uniforms that were so tight one could barely move. They endured 'swollen

and blistering feet from hours of working in high heels, and near-constant harassment by drunk businessmen who made up most of the clientele. After one night when roughly 2,000 people came through the club's doors, Steinem estimated there had been maybe ten who 'looked at us not as objects ... but as if we might be human beings'.

Steinem was also required to learn the 'Bunny Stance', 'a model's pose with one hip jutted out' and the Bunny Dip, which she described as a 'back leaning way of placing drinks on low tables without falling out of our costumes'. By the end of each shift, 'Marie' and her fellow bunnies were exhausted and angry at the intimidation they faced from the club and the demeaning treatment they received at the hands of customers. Steinem's articles shed light on the exploitation of women in the Playboy empire and established her credentials as an investigative journalist and as an activist who would soon be at the forefront of the feminist movement in America.

In addition to offering domestic advice to housewives and titillating content to their husbands, magazine experts also provided advice to single women, as in a series in *Ladies Home Journal* in 1954 on 'How to be Marriageable'. Women were advised to lose weight, get new glasses, and update their wardrobe in order to find a husband. The popular Bishop Fulton J. Sheen wrote in *How to Stay Married Though Unhappy*, 'The purpose of life is not pleasure. Rather it is to attain to perfect life, all truth and undying ecstatic love – this is the definition of God. In pursuing that goal, we find happiness'.[34] Once again, a woman's happiness was ignored or assumed to reside only in the happiness of her man. Scientific support for the return to domesticity was provided by sociologist Ferdinand Lundberg and psychiatrist Marynia F. Farnham in their best-selling book, *Modern Woman: The Lost Sex*. Published in 1947 and excerpted in many women's magazines, they argued that a woman's proper place was the home. For Lundberg and

Farnham, domesticity was equal to respectability, and single women were selfish because they prioritized their own needs over those of a husband and children. Indeed, they considered a woman's focus on her own needs to be a sign of mental illness. According to historian Sara Evans, Lundberg and Farnham recommended psychotherapy, government propaganda, awards for good motherhood, cash payment to mothers, and the restoration of such traditional home tasks as cooking, preserving, and decorating.

The authors saw in happy domesticity the key to world peace, arguing that, only through a return to the traditional home, which they described as 'a social extension of the mother's womb,' could the level of hostility in the world be reduced.[35] In a climate of global fear and tension in the 1950s, the job of attaining peace and calm in the world fell to women who would sacrifice their own needs for those of the men in their lives.

Lundberg and Farnham subscribed to a Freudian approach that required women to be keepers of the home, not only for their own good but for the good of the Cold War world. Paid work outside the home, they argued, placed women in an unnatural competition with men that destroyed their identity as women and their sense of belonging as a daughter, sister, or wife in a male-headed family. In short, work outside the home was dangerous to a woman's very identity as the object of her husband's desires. The authors observed that a woman's desire to work outside her household should be kept at a minimum and that 'her femininity be maintained, both for her own satisfaction and for the satisfaction of her children and husband. She is, therefore, in the dangerous position of having to live one part of her life on the masculine level, another on the feminine. It is hardly astonishing that few can do so with success. One of these tendencies must of necessity achieve dominance over the other. The plain fact is that increasingly we are observing the masculinization of women and with it enormously dangerous consequences to the

home, the children (if any) dependent on it, and to the ability of the woman, as well as her husband, to obtain sexual gratification'.[36] For the White middle-class American woman of the 1950s, everyone's needs and desires mattered but her own.

Many work places, particularly in the airline industry, upheld the 1950s and early 1960s code of proper etiquette for women. Stewardesses, today's flight attendants, were ornaments in the flying experience, whose customers were mostly men travelling for business. Stewardesses were not permitted to marry, gain weight, dye their hair, or straighten their teeth with visible braces, and they were required to polish their manicured nails. These restrictions came to an end only with a massive cultural shift in women's fashions in the late 1960s and the campaign to unionize flight attendants.

Former flight attendant Diane Tucker, who worked for United Airlines in the late 1960s, began each work day with an inspection in which she was required to raise her skirt so an 'appearance supervisor' could confirm that she was wearing her girdle properly. Tucker remembered that 'We lifted our skirts and showed our girdle. They didn't ask me whether I had my manual or my flashlight… they just wanted to know if I had my girdle on'.[37] Donald Bain's 1967 satirical tell-all book, *Coffee, Tea, or Me?* chronicled the working life of two imaginary stewardesses, Trudy Baker and Rachel Jones. The book 'revealed' many instances in which the airline professionals who had the responsibility for the lives of passengers were little more than sex objects for first class business flyers. The airlines themselves were well-aware that sex sells, with advertising campaigns such as the National Airlines commercials featuring a beautiful woman inviting consumers to 'Fly Me!'[38]

Some political leaders actively supported the idea that a wife should promote her husband's career by providing a perfect home life consisting of a beautifully decorated house, perfect meals, and children whose every need was met by an educated and supportive

mother who could run the vacuum cleaner while looking like a fashion model. When prominent Democrat Adlai Stevenson spoke to the 1955 graduates of Smith College, he equated women's responsibility to create the American suburban ideal with service to their country. This approach was consistent with ideas espoused by Lundberg and Farnham and echoed the nineteenth century notion of 'true womanhood' in which a woman served as the moral and religious centre of her home. Stevenson declared that a wife could encourage her husband to make good decisions by promoting positive moral values. The assumption was that women were partners in a marriage even though they could not easily own property on their own or open a checking or department store charge account without the signature of a male relative.

In the 1950s, White women in suburbia may have lived the idealized life promoted in women's magazines, but they had a long way to go before they achieved full equality in society. Elements of limited legal equality were 'given' to African-American women and women from other underrepresented groups who had few advocates for their rights until the emergence of the Civil Rights Movement. While African-American women enjoyed a limited measure of legal equality, they had limited economic equality and little protection from the authority of their husbands and male relatives.

For owners of manufacturing companies concerned about diminished post-war demand and millions of discharged soldiers who expected to return to their former jobs on the shop floor, the course of action was clear – find a way to encourage women to return to their homes and lives of domestic tranquillity. After a brief period of post-war recession, the American economy boomed in the 1950s. Once demand for consumer products rose beyond pre-war levels, women were not called back into the factories. Instead, increased demand meant higher wages and plentiful overtime shifts for unionized male workers who had apparently forgotten the role

The Home Front

women had played in organizing unions in Flint and elsewhere in the late 1930s. There was plenty of work for men, including work in the construction of new communities for the new nuclear families that were growing rapidly. Women's work remained segregated by gender and compensated at a low rate.

The nuclear family with a male head of household needed a place to live after the war. William J Levitt's construction company capitalized on the demand for inexpensive, no-frills housing designed for returning soldiers that could be purchased through the GI Bill of Rights that included low-rate home mortgages. The key to Levitt's success was mass production and advance planning. Each team of construction workers performed only one task and travelled from site to site. His workers were able to build as many as thirty-six houses in a single day to meet the intense post-war demand. Communities like the Levittowns of Long Island and suburban Philadelphia created acres of identical tract houses on what had once been farmland or forest. Most houses had one storey and no basement, two bedrooms and a kitchen whose main window looked out onto a small backyard so mothers could keep an eye on their children at play. Malvina Reynolds's 1947 ballad, *Little Boxes*, placed the new houses built for returning veterans and their families in context – they were simple (featuring only one or two styles per development); easy to build (made of 'ticky-tacky'); and advertised as just right for young families with a husband who commuted to work, a stay-at-home wife, and children who were being raised to be as much alike as possible. Over time, families would customize their domains by planting trees and building fences, adding porches and full garages, and even building additional rooms for children while their aging grandparents often continued to reside in crowded city apartments.

Conformity was the path to comfort in the post-war world. For White families in a thriving economy, the road to the middle class was a cul-de-sac named after a flower, a bird, or a president. Birth rates

climbed dramatically, and new elementary schools and community parks popped up in the suburban villages for children who needed a place to learn and play as their parents, teachers, and Little League coaches inculcated the values of American exceptionalism, prosperity, and world leadership.

African-American families were excluded by law or restrictive covenants from Levittowns and other suburban developments. In 1948, the United States Supreme Court declined to declare restrictive covenants unconstitutional but said they were unenforceable under the equal protection clause of the Constitution's Fourteenth Amendment. Home purchase and rental agreements often explicitly prevented the sale or rental to people who were not 'Caucasian'. In a decade in which civil rights activism and demands for equality rose to public awareness, segregation still predominated in communities that were supposed to represent the American Dream. Levitt himself defended the practice of denying housing to African Americans by saying, 'We can solve a housing problem or we can solve a racial problem. But we cannot combine the two'.[39]

The tract houses of suburban developments provided a safe haven for White families who left behind aging housing stock, dirty streets, and perceived increases in crime in major cities. The suburbs offered backyards and new trees in communities where families came together at school functions, local parades on holidays, and sports events. But many Americans did not feel completely safe. With the explosion of a Soviet nuclear device in autumn 1949, an arms race was underway. Some people responded by building bomb shelters in their basements or backyards, and children in some public schools were issued military-style dog tags and engaged in 'duck and cover' drills that provided a false sense of security that a wooden desk would protect them from an atomic blast.

Domestic tranquillity in the country that led the Free World was the goal of political leaders too. As he left office in January

of 1953, President Harry S. Truman emphasized the imperatives of American anti-communism. Truman asserted that not only had the United States been significantly responsible for bringing an end to the horrors of the Second World War, it had succeeded in formulating 'positive policies, policies of world leadership, policies that express faith in other free people. We have averted World War III up to now, and we already have succeeded in establishing conditions which can keep that from happening'. Truman reminded the American people that the struggle against international communism took shape in the United Nations police action commonly called as the Korean War. Foreshadowing the Domino Theory that would be articulated by Truman's successor, Dwight D. Eisenhower, Truman said, 'If we let the Republic of Korea go under, some other country would be next. And all the time, the courage and confidence of the free world would be ebbing away'.

Anticipating President Kennedy's appeal to Americans to 'pay any price, bear any burden' to maintain American power and influence in the world, Truman said he 'never doubted that you, the people of our country, will do what is necessary to win this terrible fight against communism'. This was the language of the Cold War in which Americans were called upon to mobilize against a new enemy. Truman concluded his speech with an expression of confidence in the American people to fulfil the nation's destiny of wealth, progress, and aid to the world:

'I have a deep and abiding faith in the destiny of free men. With patience and courage, we shall someday move into a new era – a wonderful golden age – an age when we can see the peaceful tools that science has forged for us to do away with poverty and human misery everywhere on earth'.[40] We might wonder if Truman, the president who had ordered the dropping of atomic bombs on Hiroshima and Nagasaki, understood the irony of his declaration that America's destiny was to bring peace and prosperity to the people of the world.

Don't Call Us Girls

The stage was set in the 1950s for many women to fear being seen as non-conforming, should they marry too late or not at all or pursue a career in a man's world. Women and men learned from government and media sources that subversive forces, both in and outside the United States, were bent on destroying American capitalism and American democracy. To be labelled a communist, a fellow traveller, or even a supporter of liberal causes was to be subjected to harassment, black listing, and a loss of connection to family and community. Cultural and political conformity went hand in hand and affected people of all races and socio-economic classes in the 1950s. Black or White, no one wanted to be called a red.

The connection between economic growth, personal happiness for the White middle class and the imperative to prove that American capitalism was better than Soviet communism was writ large at the opening of the American National Exposition at Sokolniki Park in Moscow on 24 July, 1959. In an event that journalists dubbed the 'Kitchen Debate', Soviet First Secretary Nikita Khrushchev and American Vice President Richard Nixon debated vigorously, touting the virtues of their respective societies. Nixon had a long history as a domestic cold warrior. He had won election to the Senate in 1950 by questioning the loyalty of his opponent, Helen Gahagan Douglas. He called her the 'Pink Lady', who was 'pink right down to her underwear'. Given the pervasive fear of any possible 'red' or communist tendencies, it was not surprising that Nixon won that election.

As Vice President, Nixon represented the United States at the Exposition and was eager to promote the benefits of capitalism. He proudly displayed a model house filled with modern conveniences that were said to be accessible to an average American working family. Khrushchev complained that some of the gadgets were frivolous and did not work as well as traditional tools for everyday kitchen tasks such as opening a can. On 25 July, the two leaders debated the merits

of their respective economic systems in the model kitchen. Neither came away a clear victor, but *TIME* magazine declared that Nixon had 'managed in a unique way to personify a national character proud of peaceful accomplishment, sure of its way of life, confident of its power under threat'.[41] In the Cold War, every aspect of life, from washing clothes to squeezing orange juice, became a tool in the struggle against communism.

But change was in the air, and troubling questions regarding basic societal structures, laws, and practices could no longer be swept aside. Much of that change was a direct result of early protests against segregation and calls for equal rights for African Americans in the South. Americans heard young black leaders like Martin Luther King, Jr quote nineteenth century abolitionist Theodore Parker that the arc of the moral universe is long, but it bends toward justice. The challenge was to make that statement come true in the world's wealthiest democracy. Calls for civil rights and social and political equality activated some young people who saw in the Civil Rights Movement a realization of the 'city on a hill' characterization of America's mission. This idea suggested to young Americans that the new president had a responsibility to make the American experiment work for everyone because the whole world was watching.

In January of 1960, ten months before the election that ended the Eisenhower years, historian Arthur M. Schlesinger, Jr published *The New Mood in American Politics* in *Esquire* magazine. Schlesinger deplored the consumerism of the 1950s that had triumphed over a collective social conscience. He argued that Americans should not measure their success by their wealth and possessions alone in a world that needed moral as well as military and political leadership:

'Materialism – the belief that the needs of life can be fulfilled by material opulence – is not enough', he argued, noting that, 'under the spell of materialism, our nation has allocated its abundance to private satisfaction rather than to public need, with the result that the

wealthiest nation in the world suddenly seems to be falling behind in education, falling behind in science, and falling behind in our capacity to stir the minds and hearts of men'.

Schlesinger predicted that the new decade of the 1960s would see a renewed commitment to the public interest and a renewed trust in government as the agent for positive social change. The Sixties, he predicted, 'will probably be spirited, articulate, inventive, incoherent, turbulent, with energy shooting off wildly in all directions. There will be a sense of motion, of leadership and of hope'.[42]

In a speech in Denver, Colorado on 14 October 1960, candidate John F Kennedy echoed the same theme, predicting that, as the world's most powerful democracy, the United States was entering an optimistic age in which men and women could be agents for positive social change. He observed that the country was 'at the beginning of an era when the inroads of poverty, hunger, and disease will be lessened and when men and women everywhere will have it within their power to develop their potential capacities to the maximum'.[43]

The 'Ask not what your country can do for you, ask what you can do for your country' spirit of Kennedy's inaugural address emanated from the optimism that Schlesinger had predicted. Kennedy had run as someone new, placing his opponent, Richard Nixon, as a representative of the politics of the Eisenhower years. During President Kennedy's thousand days in office, young people saw a bit of themselves in their president. They got into shape with fifty-mile hikes, joined the Peace Corps to bring American technology and ideology to the less developed world, and watched as Jackie Kennedy took them on a televised tour of the newly renovated, modern-yet-classic White House. Young people in countries allied with the United States were quick to accept the new president's optimism that the future belonged to them under the leadership of the youngest man ever to serve in the White House.

Young women responded to the Kennedy call to do good in the

world. It is useful to ask what benefit accrued to women during the brief Camelot years. In many respects, the early 1960s bear a striking resemblance to the 1950s rather than to the last years of the decade. Women were still hampered by laws and traditions that limited their educational, economic, and professional progress. In 1961, Kennedy appointed a twenty-six-member commission to recommend ways to improve the status of women. The President's Commission on the Status of Women was led by Eleanor Roosevelt and included men and women educators, economists, and other professionals from both major political parties. It issued a report in 1963 and was then disbanded.

The Commission heard from representatives of two major schools of thought regarding what American women needed. Some experts advocated the passage of the Equal Rights Amendment which had lain dormant since the 1920s, while others pressed for specific legal remedies such as pay equity, equal access to education, and access to credit without the permission of a male relative. In its report, the Commission made a number of recommendations, specifically about education, but the report made it clear that women were still regarded as the guardians of the home:

'Widening the choices for women beyond their doorstep does not imply neglect of their education for the responsibilities in the home. Modern family life is demanding, and most of the time and attention given to it comes from women. At various stages, girls and women of all economic backgrounds should receive education in respect to physical and mental health, child care and development, and human relations within the family.

The teaching of home management should treat the subject with breadth that includes not only nutrition, textiles and clothing, housing and furnishings, but also the handling of family finances, the purchase of consumer goods, the uses of family leisure, and the relation of individuals and families to society'.[44]

Women's proper place in Camelot meant becoming a more efficient housewife, but soon the young women who had shared Kennedy's optimism about an American future would look to their own lives and discover that they needed to find a liberated future for themselves.

Rhodes Scholars in the cabinet, Harvard intellectuals among the president's advisors, classical music performances, and high style for visiting dignitaries presented an image that was quickly named Camelot. But not every aspect of Kennedy's Thousand Days was so refreshing and optimistic. The trappings of liberalism in the domestic sphere masked an adherence to Cold War anti-communism in foreign policy. The United States continued to play the role of guardian against world communism. Stressing the irreconcilability of what Kennedy called 'freedom under God versus ruthless, godless tyranny', the young president declared at his inauguration: 'In the long history of the world, only a few generations have been granted the role of defending freedom in its hour of maximum danger. I do not shrink from this responsibility. I welcome it'.

In order to eradicate communist influence throughout the world, Kennedy declared that the Free World needed to 'Pay any price, bear any burden, meet any hardship, support any friend, oppose any foe, to assure the survival and success of liberty'.[45]

The young American president and his wife were popular with Europeans, but by the time Kennedy made his famous trip to Berlin in the summer of 1963 in which he declared himself to be one with the German people, European-American relations were badly strained. Writing at the time, correspondent Helen Pick noted that Kennedy 'could scarcely have chosen a worse moment for his European trip. The White House makes few bones about that. Nevertheless Mr. Kennedy has never wavered from his decision to go … He has not been deterred by the civil rights crisis at home, Britain's political troubles, the untimely elections in the Vatican, or the long, drawn-

The Home Front

out efforts to find a new Italian Government. There has been strong advice against the trip ... Some of his own officials ... have argued that the trip at best will yield nothing positive and at worst will draw attention to the bankruptcy of America's European policy, which is still reeling from the impact of General de Gaulle'.[46] Kennedy's trip did help to shore up the NATO alliance and convince European nations that the United States was committed to supporting the European alliance against the Warsaw Pact. His assassination on 22 November 1963 placed a new leader in the White House and a foreign policy that was more focused on Southeast Asia.

The research of a Columbia University psychologist who had interviewed more than 200, mostly White and middle-class Smith College graduates about the trajectories of their lives stunned the American public. Had the Smith alumnae pursued careers? Had they earned an 'Mrs' degree along with a Bachelor of Arts? Most important, were they happy and fulfilled? Betty Friedan's *The Feminine Mystique*, published in 1963, challenged the popular assumption of the 1950s that a woman achieved true fulfilment in her role as a wife and mother. Based on data derived from her questionnaires and interviews, Friedan described the 'problem that has no name', a combination of malaise and dissatisfaction with the ideal of suburban life. She asserted that the educated women of Smith, and women like them, had brains that were good for more challenging tasks than helping children with fourth grade maths homework.

Echoing Virginia Woolf's idea that a woman needs a room of her own and with financial independence, Friedan critiqued the open floor plan of many suburban houses in which a woman had no place to go where she was not in full view of, and available to, her children. She argued that housework should not take a full day and that women were capable of taking on managerial and leadership roles that had been dominated by men. In other words, the woman

who could run a successful Parent Teacher Association event had the skills to manage a corporate department.

Friedan summarized the critical nature of women's 'problem', arguing that it was urgent 'to understand how the very condition of being a housewife can create a sense of emptiness, non-existence, nothingness, in women. There are aspects of the housewife role that make it almost impossible for a woman of adult intelligence to retain a sense of human identity, the firm core of self or 'I' without which a human being, a man or woman, is not really alive. For women of ability, in America today, I am convinced there is something about the housewife state itself that is dangerous'.[47] The book was an instant success. Friedan's work resonated with millions of women and encouraged mostly White, professional women to create the National Organization for Women in 1966. Friedan served as NOW's first president.

In the spirit of energy and change anticipated by Schlesinger in the early 1960s, young Americans began to challenge the authority that was still assumed to reside in their elders. From the early Civil Rights and Free Speech Movements to questions about the legitimacy of the war in Vietnam, newspaper stories featured young students questioning college rules, challenging segregation, and speaking out against the military draft. Americans of college age comprised a large cohort within the population that would later be called the Baby Boom generation. Throughout the developed world, they were the babies born after a horrific war, now grown into young adulthood. This was a generation that had grown up with the new medium of television, and they quickly learned to utilize that medium to articulate an anti-authoritarian, countercultural message to frequently bewildered adults.

Student and faculty radicalism posed many challenges to the prevailing Cold War consensus that it was necessary to contain communism abroad and maintain a quiet cultural conformity at home.

At first, students organized protest events and recruited supporters around specific issues rather than offering a broad political platform. Harvard's TOCSIN was an organization whose name referred to an alarm bell. Members staged demonstrations calling for an end to nuclear testing and saw themselves as sounding the alarm against a bleak nuclear future. It was a precursor to Student for a Democratic Society at the university. Organizers of the University of California at Berkeley's SLATE party, whose name was a reference to its slate of candidates and not an acronym, ran successful candidates in student elections. SLATE members declared themselves to be in favour of 'taking college politics out of the sandbox'. SLATE candidates left their comfortable campus to picket San Francisco hotels that discriminated against African Americans and boycotted local merchants who refused to hire Black workers. In May 1960, SLATE made headlines when Berkeley students protested at local hearings of the House Committee on Un-American Activities. Many students, including a number of women, were dragged down the steps of the San Francisco City Hall and were taken to jail for voicing their opposition to the Committee's anti-communist witch hunts. Women engaged in acts of resistance such as protesting or occupying buildings but were seldom the leaders or policy makers of the emerging student protest groups.

By the late 1950s, protests against nuclear weapons inspired the creation of new groups that focused on disarmament. The National Committee for a Sane Nuclear Policy, dubbed SANE, was founded in 1957 to spark debate about nuclear testing. It soon grew to 130 chapters and 25,000 members and was one of the first organizations to oppose the Vietnam War. Women Strike for Peace (WSP) grew out of anti-nuclear demonstrations that took place in several countries on 1 November 1961. As many as 50,000 American women marched in cities throughout the United States under the banner 'End the Arms Race – Not the Human Race'. Dagmar Wilson and

Bella Abzug founded WSP in the aftermath of that march. Future demonstrations were so successful that WSP and SANE were credited with encouraging the United States government to sign a Nuclear Test Ban Treaty with the Soviet Union on 11 October 1963.

Dagmar Wilson continued to protest nuclear proliferation throughout her life while pursuing a successful career as an author of children's books. Bella Abzug supported a variety of liberal causes in her law career and in Congress. Dubbed 'Battling Bella' because of her strong presence, and recognizable because of the big hats she wore, Abzug served three terms in Congress, where her campaign slogan was 'This woman's place is in the house – the House of Representatives'. Abzug joined forces with Shirley Chisholm, Catherine East, and Gloria Steinem to found the National Women's Political Caucus (NWPC) in 1971. This non-partisan organization remains active today. It recruits, trains, endorses, and supports women who seek public office.

The early 1960s saw the emergence of organizations in the United States that identified themselves as the New Left. In 2021, critic and *New Yorker* magazine essayist Louis Menand described the New Left, which, he wrote, was born 'in the early nineteen-sixties as a revolt against the modern university, and it died less than ten years later, in the auto-da-fé of Vietnam. Although it helped mobilize opinion on issues like civil rights, urban poverty, the arms race, and the war, the New Left never had its hands on the levers of political power. But it changed left-wing politics. It made individual freedom and authenticity the goals of political action, and it inspired people who cared about injustice and inequality to reject the existing system of power relations, and to begin anew'.

Menand discussed the connection between the sit-ins in Greensboro, North Carolina that inspired many students to participate in the struggle for full civil rights for African Americans and political action that included protests against the Vietnam War.

The Home Front

One student who recognized that connection was Tom Hayden, a University of Michigan graduate who was active in college politics. Hayden attended the 1960 conference of the National Student Association at the University of Minnesota. While at the conference, he met with members of the Student Non-Violent Coordinating Committee (SNCC) whose bravery in the face of southern racism and violence inspired him. Hayden recounted that the SNCC activists 'lived on a fuller level of feeling than any people I'd ever seen, partly because they were making modern history in a very personal way, and partly because by risking death they came to know the value of living each moment to the fullest. Looking back, this was a key turning point, the moment my political identity began to take shape'. Conference attendees debated whether to support the actions of the Greensboro lunch-counter protesters. Some NSA members worried that the organization should not support illegal actions because, technically, the students who sat in at the Woolworth's lunch counter were trespassing. This line of thinking raised the issue of whether it was acceptable, even imperative, to break the law in the interest of a higher form of justice represented by the struggle for civil rights.

Like Tom Hayden, Casey Cason, future New Left activist and supporter of women's liberation, also derived inspiration from the actions of the Greensboro civil rights protesters. She recalled, 'I am thankful for the sit-ins if for no other reason than that they provided me with an opportunity for making a slogan into a reality by making a decision into an action. It seems to me that this is what life is all about. While I would hope that the N.S.A. Congress will pass a strong sit-in resolution, I am more concerned that all of us, Negro and white, realize the possibility of becoming less inhuman humans through commitment and action with all their frightening complexities. When Thoreau was jailed for refusing to pay taxes to a government which supported slavery, Emerson went to visit

him. "Henry David", said Emerson, "what are you doing in there?" Thoreau looked at him and replied, "Ralph Waldo, what are *you* doing out *there?*"[48]

Protests and civil rights demonstrations like the 28 August 1963 March on Washington for Jobs and Freedom all contributed to the development of a New Left student movement. Descended from the Student League for Industrial Democracy (SLID), Students for a Democratic Society established branches on college campuses. The military draft, an issue that had particular relevance to college students, proved to be a galvanizing issue that helped to create an organization that was centralized but most effective locally, hierarchical but broadly democratic, and at first predominantly male but eventually more inclusive. SDS activities and protests influenced the development of the anti-war movement throughout the world. Starting in 1962 with a handful of members and a general manifesto, the Port Huron Statement, this group would dominate New Left politics before splitting into factional discord. Kirkpatrick Sale noted that, while student groups wanted to operate at the university level, raising local grievances, and building its constituency among the students, they did so '*not* to change the educational system on the campus, *not* to achieve academic reforms, *not* even to get more power in the hands of students within the university setting. It did so because it saw among the American student body the possibility of creating a generation of committed radicals, and thus to change the entire political and social structure of the country. Student power was merely a method, a tool, a prod, a way to awaken students to the realities of the nation by turning them on to the realities of the campus, to make connections between the demands for democratic control within the university and the same demands in the body politic'.[49] This was a tall order indeed, especially as universities were still bastions of cultural conservatism in a rapidly-changing world. Students would be the force for change in the university and in the world.

The Home Front

By the early 1960s, life in the United States and Europe was anything but completely placid, completely conforming, completely calm, or completely unified. Efforts to re-build infrastructure and economies in Europe and the expansion of middle-class prosperity in the United States were soon undermined by the contradictions that lay beneath the seemingly calm surface. National liberation movements in former colonies that put an end to European empires and struggles for civil rights in the United States revealed that all was not well. Even before the American public became aware that there was a war brewing in Southeast Asia, the United States had assumed the impossible task of putting down a nationalist insurgency in a country thousands of miles from home. Americans would soon learn where the tiny country of Vietnam was located, and they would soon come to understand how difficult their undeclared war in that country would become.

There was also trouble brewing at home. *De facto* segregation in the North and segregation in the South supported by the force of law kept people of colour in a subordinate place. That situation was no longer tolerable. Black and White women found a place, at first a secondary one, in the freedom struggle in organizations like the Southern Christian Leadership Conference and the Student Non-Violent Coordinating Committee. Like their foremothers, the women who worked for civil rights or who protested to end the Vietnam War strained gender boundaries and created new paradigms of behaviour for independent women. At first, they spoke for others and supported men in the movement. In doing so, they became aware of their ability to speak and act for themselves.

Chapter Three

Women in the Struggle for Civil Rights

Women represent the heart and soul of African-American families, churches, small businesses, and community organizations. They inspire others to follow their example of commitment and service to family, church, and the community at large. Even when men assumed leading roles as speakers, preachers, politicians, and community advocates, women provided support through their personal networks. Many Black men achieved status and success because they could rely on the skill and energy of Black women.

From the late nineteenth century onward, African-American women became increasingly active in the struggle for freedom and equality. A few White women such as Jane Addams, founder of Chicago's Hull House Settlement, saw ending the horror of lynching as essential in a civil society, but Progressive Era reform in the United States was not strongly identified with achieving equality for African Americans. The children of people who had only decades before been enslaved knew they needed to fight for freedom on their own. Many African-American women formed their own organizations, including church groups and women's clubs, to promote the image of African Americans as respectable citizens who could meet, and even exceed, White standards of propriety, demeanour, and style. At the same time, Black women were aware that support from sympathetic White reformers could help their cause. Female teachers, small business proprietors, ministers' wives, and church women were committed to ending racism and lynching. They communicated the needs of African Americans to White reformers by demonstrating their dedication and high moral purpose.

By the early twentieth century, the model of 'uplift' for African

Women in the Struggle for Civil Rights

Americans had extended to participation in organizations whose White members promoted civil rights without overtly challenging laws and practices in the Jim Crow South or racism in the North. By mid-century, groundwork had been laid for a powerful but non-violent confrontation with those laws and practices in the early Civil Rights Movement. Most of the well-known figures in the movement were male ministers from Southern Black churches and most of the Black women were brave, supportive, and largely unknown until the 1960s, when they began to show their talents as activists and protest organizers. As the sense of urgency for full equal rights grew and as the federal government offered some relief in landmark Civil Rights and Voting Rights legislation, the backlash against the non-violent movement by white racists North and South frequently put Black and White women in physical harm. As women faced equal risk by taking part in marches and protests, they also faced a lack of respect for their talents and sacrifices from their male colleagues.

Segments of the movement became more militant and self-consciously Black, perhaps even more 'male' in character. White members were told their benevolent assistance was no longer required, and groups like the Student Non-Violent Coordinating Committee functioned as an all-Black organization by the late 1960s. Soon thereafter, women in the Civil Rights Movement, like their sisters in the movement to end the Vietnam War, began to articulate their grievances in terms of their identity as women. It was time for a movement of their own. This chapter will trace the transition from the idea of uplift propounded by 'respectable' Black women in the late nineteenth century to Black feminists who demanded respect.

In the antebellum South, where men, women, and children of colour were property, it fell to women to maintain family and community cohesiveness in the face of physical abuse and the constant threat of separation. Mothers taught their children how to appear to show deference to White people while maintaining their dignity and

humanity. In the decades following the Civil War, women often caried the burden of holding their families together in circumstances where husbands had been arrested, jailed, and even lynched. Women washed, starched, and ironed the clothing of their White employers during the week, but on Sunday, they would don their own white dresses and appear in church as the keepers of decorum and faith. The preacher preached, but the women saw to it that every member of the congregation could experience the passion of faith.

Between 1880 and 1920, members of Black Baptist churches came together to discuss issues of race and class as they worked to find a place in a White society that did not accept them. The National Baptist Convention (NBC) was a Black organization comprised of two million members by 1896. Women created their own organization within the NBC to raise funds to build schools, provide food and clothing for the poor, and establish social welfare projects in the Black community. Their focus was on self-help. The women of the NBC also advocated for broader opportunities for African Americans, including voting rights, women's suffrage, equal employment opportunities, and equality in public education, but they did so with a language that suggested these were benefits to be granted by White people rather than rights to which African-Americans were entitled.

Although NBC women worked with both White women and Black men, they created their own realm of activism that included the founding of the National Women's Convention as well as their own school for girls. Under the direction of Nannie Helen Burroughs, the National Training School for Women and Girls in Washington, DC taught domestic skills and offered religious training to help young women become models of industry, high moral character, and respectability. This model of a school that taught self-sufficiency and promoted good character was similar to that created by Booker T. Washington's Hampton Institute in Virginia that taught vocational

skills to African-American boys and girls. The NBC women did not solicit help from the White community, priding themselves on their ability to establish and maintain a school on their own.[50] These women who pressed for social change while maintaining a high standard of respectability showed that they could work, pray, and inspire young people in their congregations. They were leaders in their own sphere of influence, even though they rarely ascended to the pulpit.

It would take decades for a new generation of women to see themselves as activists for freedom. By the mid-twentieth century, younger women were appalled at the lack of real progress in the Jim Crow rule in the South and *de facto* segregation and racism in the North. They also confronted the expectation that they would be content to help rather than lead. In the 1950 and 60s, young women, Black and White, participated in the movement for dignity and equality for all human beings – the Civil Rights Movement. Many came from families of faith and many were the children of ministers. They called upon their churches to place their congregations in the vanguard of civil rights activism, and many were disappointed at the silence on integration and equality from those men who preached the word of God. But they fought apathy and the complacency of a 'take it slow' philosophy. Their frustration with existing organizations and with the men who led them encouraged women to see civil rights as part of a struggle that would become theirs only when they were brave enough to break away and see themselves as deserving of a movement of their own.

Black leaders and White philanthropists sometimes worked together to assist help African Americans. In the early decades of the twentieth century, Black boys and girls whose children would lead a nation-wide Civil Rights Movement benefitted from the leadership of Booker T. Washington of the Tuskegee Institute, of which he was then president, and the generosity of Julius Rosenwald, the

wealthy Jewish president of Sears Roebuck. Through the Rosenwald Foundation, these two men raised funds to build school buildings and housing for teachers. This was the beginning of a collaboration between Black and Jewish supporters of equal rights.

The goal was to provide clean and functional buildings for African-American children, mainly in rural areas. Parents, many of whom were poor share croppers, contributed what they could to provide schools for their children. At a time when educational opportunities were limited for girls, Black or White, the Rosenwald Schools served boys and girls equally, albeit in separated classes. Many Rosenwald School students graduated from college and entered professions. Between 1912 and 1932, the Foundation financed more than 5,000 schools that served 700,000 children. Most of the schools closed in the years following the *Brown* decision that declared school segregation unconstitutional.

Rosenwald graduates were active in early protests against Jim Crow segregation. Newell Quinton attended the Sharptown Colored School in Maryland. He then attended Morgan State University, along with six of his seven siblings. He and two of his sisters protested at Baltimore's Northwood Theatre, which refused to admit Black movie goers. Two of his sisters were arrested but could not afford to post bail. According to historian Rona Kobell, 'Some of their white friends at Goucher College, heard about the arrests and conspired to get arrested too. The Goucher women reasoned their parents wouldn't stand for them getting locked in jail, and the warden would have to let out the Morgan State students too. The plan worked', and many Rosenwald alumni and their children were active supporters of civil rights. Among the most famous was Congressman John Lewis, who attended the Dunn's Chapel School in Pike County, Alabama. Poet, civil rights activist, and feminist Maya Angelou attended the Lafayette County Training School in Stamps, Arkansas. Angelou summed up her experience, saying, 'I thought my school was grand'.[51]

Women in the Struggle for Civil Rights

Early efforts to end Jim Crow and provide full equality for African-Americans were frequently led by White Progressive Era reformers. On 12 February 1909, a group of progressive, mostly White civic leaders, men and women, gathered in New York City to respond to pervasive violence against African Americans that included lynch mobs that murdered Black men and women by hanging or burning them. Writers, activists, and reformers were aware of a particularly disturbing statistic: in the year prior to their meeting, ninety-seven Americans, eight of them white and eighty-nine Black, had been lynched, primarily in the South. The goal of this new organization was to mitigate the worst effects of segregationist laws and put an end to lynching by informing the public of the horrific practice that persisted in the Jim Crow South.

Part of the inspiration for the new organization was the work of Ida B. Wells-Barnett, an African-American advocate for women's suffrage and African-American rights and a leading researcher on the subject of lynching. She convinced her friend and fellow reformer, Jane Addams, to take a stand on race relations. Addams, whose work in the Settlement House Movement had not previously concerned matters of race, was drawn to the NAACP as a founding member because of the brutality of lynching. After signing a petition to President McKinley decrying lynching, Addams said, that lynching 'further runs a certain risk of [a man] brutalizing each spectator, of shaking his belief in law and order, of sowing seed for future violence'. Through her communication with Wells-Barnett, Addams became more aware not only of the brutality of lynching, but also of the profoundly damaging nature of racism in American life. She and Wells-Barnett worked together, although unsuccessfully, to integrate Chicago's public schools, and Addams because a life-long supporter of the NAACP.[52]

In a powerful speech before the National Negro Conference (NNC), Wells-Barnett debunked the fiction that lynching protected

White women, asking her audience, 'Why is mob murder permitted by a Christian nation? What is the cause of this awful slaughter? This question is answered almost daily – always the same shameless falsehood that Negroes are lynched to protect womanhood'. Wells-Barnett refuted the popular views of those who claimed lynching had a positive social motive. John Tempe Graves, an apologist for lynching, had declared that 'The mob stands today as the most potential bulwark between the women of the South and such a carnival of crime as would infuriate the world and precipitate the annihilation of the Negro race'. Wells-Barnett responded that, 'This is the never-varying answer of lynchers and their apologists. All know that it is untrue. The cowardly lyncher revels in murder, then seeks to shield himself from public execration by claiming devotion to woman. But truth is mighty and the lynching record discloses the hypocrisy of the lyncher as well as his crime'.[53]

Ida B. Wells-Barnett was one of only a few African Americans who founding of the National Association for the Advancement of Colored People (NAACP), which was created to promote equality of rights and 'eradicate caste or race prejudice among citizens of the United States; to advance the interests of colored citizens; to secure for them impartial suffrage; and to increase their opportunities for securing justice in the courts, education for their children, employment according to their ability, and complete equality before the law'. [54]

In the first issue of the NAACP's newspaper, *The Crisis,* published in 1910, W.E.B. DuBois, wrote with a sense of great urgency about the mission of the NAACP: 'Now is the accepted time, not tomorrow, not some more convenient season. It is today that our best work can be done and not some future day or future year. It is today that we fit ourselves for the greater usefulness of tomorrow. Today is the seed time, now are the hours of work, and tomorrow comes the harvest and the play time'.[55]

For more than a century, the NAACP has utilized lobbying, legal

action, publicity, and non-violent demonstrations in support of civil rights. In its early years, a banner flew from NAACP office windows all over the country, declaring, 'A Man Was Lynched Yesterday'. The banner flew high, but lynching continued.

A year after the founding of the NAACP, a similar group of advocates for racial equality, led by George Edmund Hayes, the first African American to earn a PhD from Columbia University, and Ruth Standish Baldwin, a New York City philanthropist, coordinated the merger of three existing organizations – the Committee for the Improvement of Industrial Conditions Among Negroes in New York (founded in 1906), the National League for the Protection of Colored Women (founded in 1906), and the Committee on Urban Conditions Among Negroes (founded in 1910) – to create the National League on Urban Conditions Among Negroes. Known as the Urban League, this umbrella organization supported African Americans who moved from the rural South to urban areas, specifically New York City, during the Great Migration. Throughout its history, the Urban League has collaborated with policy groups to improve the economic circumstances of African Americans. It has consistently been dedicated to research, support, and uplift rather than direct action to oppose segregation and racism. The actions of the Urban League provided substantive aid to those migrating to northern cities who sought to escape both economic privation and lynching. The Urban League was an example of the Progressive Era reform efforts of the early twentieth century. Its middle-class membership was dedicated to providing help for others. But unlike other Progressive reform groups, the Urban League was not staffed by women and did not promote women to leadership roles until later in the twentieth century. The Urban League aided migrants from the South, but lynching continued.

During the Second World War, an interracial group of students founded the Congress for Racial Equality (CORE), which promoted

non-violent direct action in response to the persistent problem of racism in the United States, including lynching. CORE and the Fellowship for Reconciliation (FOR) supported direct action such as marching and picketing in the 1950s and 1960s. CORE also offered advice to new groups on how to stage non-violent boycotts, sit-ins, marches, and rallies. By the late 1960s, facing dissension in its own ranks, dissatisfaction with the slow progress of the non-violent movement, and the continuing violence to which civil rights workers were subjected, CORE took a more radical turn and announced its support for Black Power and political and economic self-determination for African Americans. But lynching continued.

Throughout the twentieth century, the story of African-American progress was written in the activities of committees of dedicated and respected Black and White civic leaders that grew into a church-based movement based on non-violence practised by a plethora of local and regional groups committed to attacking segregation and racism directly. By the 1950s, non-violent direct action, especially in the face of brutal attacks by the Ku Klux Klan and other segregationist gangs, raised the conscience of America, but the progress of the Civil Rights Movement was not without great cost. After being arrested in Detroit for protesting on behalf of integration and witnessing racial violence in the South, Viola Liuzzo, a White woman, determined that she could no longer stand by and watch the forces of segregation subvert American democracy. According to one biography, she told her husband there were 'too many people who just stand around talking', that she had to help, and that she was going to Selma, the origin point of the Selma to Montgomery (Alabama) march in support of voting rights. She asked a friend to explain to her children where their mother had gone and to tell them she would call home every night. When her friend warned that she could be killed, Liuzzo replied simply, 'I want to be part of it'.[56]

On 21 March 1965, Viola Gregg Liuzzo, a member of Detroit's

NAACP chapter and the mother of five children, joined Dr King and 3,000 marchers in the final and successful march from Selma to Montgomery. Mrs Liuzzo was inspired by the Southern Christian Leadership Conference's non-violent approach to protest, and she, like the rest of the country, had witnessed the violence of 'Bloody Sunday' two weeks earlier, when marchers were attacked and brutally beaten on the Edmund Pettis Bridge in their second attempt to reach Montgomery to focus attention on the absence of voting rights for African Americans. The third march reached a successful conclusion in Montgomery on 25 March. That evening, Mrs Liuzzo, accompanied by Leroy Moton, a Black teenage marcher, were driving back to Selma on Alabama Highway 80 when she was shot by members of the Ku Klux Klan. One of the men in the car from which the shots were fired was an FBI informant. This facilitated the quick capture of Eugene Thomas, Collie Leroy Wilkins Jr and William Orville Eaton.

While people of good will around the world decried the murder, racist comments suggested that Mrs Liuzzo had brought her death upon herself and that her activism on behalf of African Americans rendered her subversive, perhaps even a communist. Almost immediately, FBI Director J. Edgar Hoover attempted to discredit Mrs Liuzzo, asserting that she was a drug addict and that she was having an affair with Moton. Opponents of civil rights questioned her motives – how could a White mother leave her children to march for voting rights for Negroes? The three Klan members were acquitted by an all-White jury on state murder charges, but they were later convicted of federal charges for violating Mrs Liuzzo's civil rights. Eaton died before the conclusion of his federal appeal, while Thomas and Wilkins were sentenced to ten-year terms, of which they served seven years each. In the case of Mrs Liuzzo's murder, there was no mob and no public hanging, but it is clear that she was lynched because she dared to cross Alabama's colour

line when she allowed a Black man a seat in her car.[57]

On 29 March 2022, President of the United States Joseph R. Biden Jr signed the Emmett Till Anti-Lynching Act into law, making lynching a federal hate crime and providing for thirty-year prison sentences for persons convicted under the new law. Named for the fourteen-year-old Emmett Till, who was kidnapped and brutally murdered in Money, Mississippi in 1955, the law, sponsored in the Senate by Kamala Harris and Cory Booker, fulfils the promise of the first Congressional anti-lynching bill proposed in 1900. It ensures that future murders based on race will be prosecuted by the federal government. At the bill's signing, now-Vice President Harris reminded the world that, 'Lynching is not a relic of the past. Racial acts of terror still occur in our nation and when they do, we must all have the courage to name them and hold the perpetrators to account'.[58] The path to the 2022 federal legislation making lynching a federal hate crime was created by the brave acts of thousands of men and women, Black and White, who faced social ostracism in their communities, violent attacks, and even murder as they sacrificed their personal safety in the cause of racial justice.

The women of the Civil Rights Movement generally served in the background of the major events of the 1950s and 60s. Without their hard work, struggle, and sacrifice, those events might not have taken place and the United States might not have moved, however slowly, on a path toward equality for African Americans. Black and White women in the movement shared a commitment to equality. The frustration of being regarded mainly as helpers ultimately contributed to a new women's agency that created a movement of their own.

Well into the twentieth century, segregationists and members of White supremacist organizations like the Ku Klux Klan were successful in keeping African Americans in an impoverished and subordinate place, especially in the South. After the First World

Women in the Struggle for Civil Rights

War, Black soldiers returned to appalling abuse and attacks in many southern cities, and civic leaders feared that the violence would impede their minimal progress on racial issues. Men and women organized committees to promote racial cooperation through meetings, publications, and research, and Black women's clubs promoted education and uplift in many urban African-American communities.

The Committee on Interracial Cooperation (CIC) was founded in 1919 in Atlanta, Georgia. Led by liberal White men who opposed lynching, peonage, and other aspects of segregated life in the Jim Crow South, CIC founders brought their religious and ethical training to bear on their work, but they did not regard challenging segregation itself as part of their mission. John Hope, president of the historically Black Morehouse College, was one of the few African-American men who joined CIC in its early years. CIC set up nearly eight hundred independent committees throughout the southern states. In 1921, the organization established a Women's Committee that included prominent White women and a few African-American members, including Lugenia Burns Hope, wife of the Morehouse College president.

Writing letters to public officials and holding meetings to support better treatment for African Americans were tasks that were consistent with women's activities in Progressive reform groups. By appealing to the better nature of male leaders, the CIC Women's Committee hoped to influence policy while remaining firmly within the bounds of southern female respectability. Underlying the abuses heaped upon African Americans in the Jim Crow South was the day-to-day reality of lynching faced by both men and women. Southern women, Black and White, played an active role in the anti-lynching crusade.

The Association of Southern Women for the Prevention of Lynching (ASWPL) was founded in November of 1930 by White women in

the South as an outgrowth of the CIC. ASWPL leader Jessie Daniel Ames was involved in a number of Progressive causes, and she was the founder and first president of the Texas League of Women Voters. The ASWPL published pamphlets, wrote letters to public officials, and sought 'no lynching' pledges from law enforcement officers, all while remaining respectable southern women who did not rock the boat. The women of the ASWPL rejected the inter-racial approach of CIC, arguing that White women would be most effective at influencing other White women to work for racial harmony without fundamentally challenging the status quo. Support for ending lynching grew, and the ASWPL expanded to 109 separate chapters with a total membership of four million women throughout the South.

The anti-lynching cause gained publicity and support when First Lady Eleanor Roosevelt joined the Washington DC chapter of the National Association for the Advancement of Colored People in 1934. The First Lady felt her appropriate role was to influence her husband to support anti-lynching legislation in Congress. President Roosevelt feared reprisals from southern senators, and he refused to end lynching by federal action, despite his personal belief that lynching violated the biblical commandment, 'Thou shalt not kill'. FDR was popular with African Americans but Eleanor was loved. An editor for the *Baltimore Afro-American* newspaper declared that 'in our day, there has never been a mistress of the White House so energetic, so brave and so fired with enthusiasm of service to the common people'.[59] Lynching and a climate of terror in the South persisted, even as the numbers declined somewhat by 1942. The ASWPL ceased its lobbying activity and disbanded. The CIC discontinued its activities as an independent organization when it merged with the Southern Regional Council in 1944. But lynching continued.[60]

The trajectory of the Southern Regional Council (SRC) reveals the difficulty that a group committed to anti-violence can have in articulating its definitive position against racism. The SRC held

conferences and published a newsletter that reached academics, journalists, and the general public. With a focus on regional economic planning as a way of challenging segregation, the SRC did not directly confront or condemn southern racism. Opinions varied regarding the best way to foster an improved New South, with advocates of a more moderate position arguing that taking an affirmative stand against racism would split the organization and drive away White support.

Lillian Smith, a White author whose most famous novel, *Strange Fruit* – about a love affair between a Black woman and a White man in rural Georgia – led the SRC faction that declared it was time to adopt a more principled position in opposition to racism. This group held that segregation 'in and of itself constitutes discrimination and inequality of treatment', which was a controversial position at the time. Smith was uncompromising, and her position made liberal White people in the organization uncomfortable. *Strange Fruit* was banned in Boston and Detroit as well as from the US Mail. 'Separate but Equal' was still the law of the land prior to the 1954 *Brown* decision that prohibited segregation in schools. Smith called *Brown* 'every child's *Magna Carta*'. After the Court's ground-breaking ruling, lines of opinion and action on integration hardened in the South. Liberal White southerners to whom the organization had originally appealed were not prepared to go beyond limited reforms for African Americans in a segregated context. There were clear limits to southern White liberals' support for full African-American citizenship.[61]

The time had come for more direct action to combat segregation. Events in the South brought several White women to prominence in the early Civil Rights Movement. These women were deeply involved in improving their communities through membership in local churches, campus ministries, and the Young Women's Christian Association (YWCA). Even though most of these groups were initially segregated, future White activists learned that they could successfully

challenge the South's long-held assumptions about the imperative to keep the races separate in all aspects of public life. These young women began to articulate the idea that it was possible for Southern society to undergo a fundamental transformation with regard to race.

In conversations at the YWCA and other community organizations, White women soon challenged the false chivalry that had created the southern myth of the dangerous and predatory Black man. Perceptions changed as the women became involved with Black and White activists in local campaigns such as the Montgomery Bus Boycott. Virginia Foster Durr was an Alabama native who had been schooled in the traditions of her region and her race, accepting segregation as a fact of life. Her views changed when she attended Wellesley College in Massachusetts and came into contact with African-American women. Durr returned to Alabama when her family could no longer afford to pay her Wellesley tuition. There she met and married attorney Clifford Durr. In 1933, the couple moved to Washington, where Clifford worked for the New Deal and Virginia joined the Women's National Democratic Club.

Virginia Durr was one of the dignitaries, including Supreme Court Justice Hugo Black, anti-nuclear activist Mary McLeod Bethune, and Alabama Governor Bibb Graves, who participated in the inaugural meeting of the Southern Conference for Human Welfare (SCHW) on 20 November 1938. This organization was committed to promoting economic development in the South during the Depression. The SCHW had support from President Roosevelt, who realized that some New Deal programmes did not provide adequate support for southern communities and many discriminated against people of colour. The SCHW promoted economic development in general and did not explicitly challenge southern racism. Nevertheless, the interracial composition of the conference attendees received negative publicity from local newspapers.

Durr's activities in the SCHW's Subcommittee on Civil Rights,

which later became the National Committee to Abolish the Poll Tax, left her vulnerable to red baiting, as both organizations received support from people with Communist Party connections. In the early 1950s, Durr was called to testify before Senator James Eastland's Internal Security Subcommittee on her pro-labour and civil rights activities. She refused to testify beyond giving her name and stating that she was not a communist. Although she was not cited for contempt, Durr remained a person of interest to the federal government and the KKK because of her civil rights activities, which included meeting with integrated groups of women. The Klan published the license plate numbers of the women who attended these meetings, making them targets for harassment and social ostracism.

Virginia Durr's formal civil rights activism began when she and her husband moved back to Montgomery, Alabama. In the local chapter of the NAACP, Durr met both Rosa Parks and E.D. Nixon, the prime movers in the Montgomery Bus boycott of 1955/6. Nixon was a member of the Brotherhood of Sleeping Car Porters who had connections with many of Montgomery's notable pastors, including the young Dr Martin Luther King Jr. Durr hired Mrs Parks as a private seamstress and supported her attendance at the Highlander Folk School in Monteagle, Tennessee, where Parks met other activists and learned about organizing grassroots movements. Since 1932, Highlander had served as a training ground in ethics and social justice for civil rights workers, union members, and political organizers. The school fell under suspicion in the late 1950s as domestic cold warriors assumed that civil rights activism was tantamount to communist organizing and recruitment.

The story of Rosa Parks's refusal to give up her seat on a city bus to a White person has inspired students learning about the early Civil Rights Movement for decades. Mrs Parks was definitely brave, but there were other women in Montgomery and elsewhere who

laid important groundwork for her action that attracted worldwide sympathy and support for the eventual boycott.

In 1953, Black citizens in Baton Rouge, Louisiana were frustrated with local laws and customs that consigned Black riders to the back of city buses. Olivia Huey, a baker who depended on city transport to get to work, called the situation humiliating for Black people. With the threat of a boycott by the city's Council on Human Relations, the Baton Rouge City Council passed Ordinance 222 that allowed Black riders to fill buses from back to front as long as they did not take seats from White riders. Drivers ignored the new law and often ejected riders, mainly women, from their buses. The ordinance was soon declared inconsistent with Louisiana's state segregation laws. The Black community responded with a mass meeting on June 17 at which an elderly Black woman gave a stirring speech in which she offered to provide rides to work or school for anyone who needed them. The next day, Baton Rouge's Black community launched an eight-day transportation boycott. Alamena Freeman said that every day she 'drove up and down the road taking people wherever they needed to go'. The boycott resulted in a new ordinance that allowed White people to have the two front seats guaranteed to them and Black people to have the two rear seats guaranteed to them. Every other seat would be filled on a first-come-first-served basis. Women played an important role in this early non-violent action that was so effective that Martin Luther King emulated the boycott four years later in Montgomery.[62]

In Montgomery, Jo Ann Robinson was a teacher. Like Mrs Parks, she was a 'respectable' member of the Montgomery African-American community. A member of the Women's Political Council (WPC), a group dedicated to enfranchising Black citizens, Robinson was enraged when she was verbally attacked by a Montgomery bus driver for sitting in the White section of his bus. When Mrs Parks was arrested, Robinson coordinated the effort to distribute thousands

of leaflets urging Montgomery's Black citizens to boycott the city transit system. In response to Robinson's work for the boycott, she was attacked by police officers, one of whom threw a rock through the window of her home while another poured acid on her car. She worked tirelessly behind the scenes and set an example of dedication and resilience for younger women in the Civil Rights Movement as well as African-American women in the early feminist movement.[63]

The Durrs and Mr Nixon posted bail for Mrs Parks on her arrest for refusing to give her seat on a Montgomery city bus to a White man, and they participated in the conversations that led to the NAACP's decision to challenge her arrest and begin a boycott of Montgomery's transportation system. Mrs Parks was a model of the respectable Black woman. She was married, employed, and unfailingly polite. Unlike teenager Claudette Colvin, who had refused to give up her seat and her rights on a Montgomery bus nine months earlier, Mrs Parks, NAACP leaders reasoned, was a person whose arrest could generate sympathy for the civil rights cause in fund-raising outside Montgomery. With support from the NAACP, local ministers, the Montgomery Improvement Association, and the Montgomery Black community, the boycott was publicized by the Women's Political Council, whose members convinced their neighbours of the righteousness of walking to work and school.

The issue of respectability was important in the events surrounding the Montgomery Bus Boycott. When Claudette Colvin was arrested on 2 March 1955 for not giving up her seat to a White woman, she was only fifteen years old with little of the institutional backing that supported Mrs Parks. A year after her arrest, Colvin was one of four women plaintiffs in the district court case of *Aurelia S. Browder v Montgomery Mayor William A Gayle*, which ruled that segregation on Montgomery's city buses was unconstitutional, a ruling that was upheld by the United States Supreme Court. But by the time the challenge to the law came to trial, she was a pregnant teenager. In

the 1950s, it would have been difficult to assert that a teenage unwed mother represented the high moral ground of the non-violent Civil Rights Movement. Colvin herself said that Mrs Parks had the 'right look' to serve as a symbol of Black solidarity in Montgomery. Mrs Parks was fingerprinted and jailed after her arrest on the evening of 1 December and released on bail within a few hours. On 5 December, she was tried in Montgomery City Court for disorderly conduct, found guilty, and fined $1,400. Although her appeal was denied, she served no jail time, and she became the symbol of the respectable working people who sacrificed their time and energy to boycott city transit as they walked to work and school in the name of civil rights.

Claudette Colvin's experience was dramatically different. With no NAACP or other support, she was very much on her own. After she was forcibly dragged from the bus, she recalled that she was put into the back of a patrol car, where the police officers 'swore at me and ridiculed me. They took turns trying to guess my bra size. They called me nigger bitch and cracked jokes about parts of my body. I recited the Lord's Prayer and the twenty-third Psalm over and over in my head, trying to push back the fear. I assumed they were taking me to juvenile court because I was only fifteen. I was thinking, Now I'm gonna be picking cotton, since that's how they punished juveniles – they put you in a school out in the country where they made you do field work during the day'. Colvin's mother and her pastor raised her bail money. At trial, she was found guilty of violating Montgomery's segregation law, disturbing the peace, and assaulting a police officer, a charge she denied. On appeal, the first two charges were dropped, and she was sentenced to indefinite probation for the assault.

Claudette Colvin's contribution to the spirit of resistance that led to the Montgomery Bus Boycott is only now finding its way into the history of this important event in the Civil Rights Movement. Most accounts of the Bus Boycott make little or no mention of

Women in the Struggle for Civil Rights

Claudette Colvin's experience and the terror she experienced at the hands of White police officers. Bringing her story back into the Civil Rights Movement narrative reminds us that young Black women faced special dangers in the Jim Crow South if they dared to violate social customs that restricted their actions. We need her story, just as we need the full story of Rosa Parks's encounter with southern customs and criminal justice. The recent effort in the state of Florida to remove any mention of race from Mrs. Parks's story does violence to truth, history, and the deeds of a brave woman. In an example of justice delayed but nonetheless appreciated, the charges against Claudette Colvin were vacated in December of 2021. At the age of 83, she could finally declare, 'I am no longer a juvenile delinquent'.[64]

After the successful boycott and court victory in Montgomery, the Durrs were active supporters of the Freedom Riders in 1961 and 1962, many of whom stayed in the Durr household. This did not make the couple popular in Montgomery. They were forced to send their two youngest children to boarding school outside the South because of repeated harassment. By 1966, the Civil Rights Movement had become radicalized, and the Student Non-Violent Coordinating Committee, which the Durrs had supported in its early years, now claimed agency for itself as a totally Black organization. Although marginalized from the more militant movement of young people, Virginia Durr remained a staunch supporter of African-American equality and full civil rights.[65] Important as the actions of Virginia Durr proved to be in advancing the cause of civil rights, she never aspired to leadership. The young women she inspired would soon have different goals for themselves in the movement.

The themes of breaking the code of respectable White southern womanhood and making a commitment to social justice and the law through activism are also embodied in the life and career of Anne Braden. A native of Louisville, Kentucky, a city in the upper south where racial harmony was maintained on the surface because

Black people 'knew their place' and seldom challenged popular assumptions about race, Anne was raised in Anniston, Alabama, a city whose residents made no apology for their support of inviolable racial segregation. Anne began to question the morality of segregation while attending Randolph Macon Women's College in the 1940s. She returned to her hometown to serve as a reporter for the *Louisville Times* and married trade unionist Carl Braden in 1948.

The couple began attending meetings at a local church to discuss the 'Negro Problem'. When Anne stated that people should be treated equally irrespective of their skin colour, she was advised that opinions like that could label her a communist. This was a common line of thinking in the South – agitators for equality *had* to be influenced by communist ideology. In Cold War America, equating civil rights agitation with the 'communist menace' was a powerful and threatening allegation to use against a political enemy. In the South, hostility to civil rights agitation went hand in hand with the domestic anti-communist crusade of the 1950's. Anne and Carl Braden worked for the election of Progressive Party candidate Henry Wallace in 1948 and then worked for the Farm and Equipment Workers Union, devoting their talents to supporting workers at the local International Harvester plant. They became even more engaged in the struggle for civil rights that would soon become a national movement.

In 1951, Anne Braden got into what the late John Lewis called 'good trouble' when she protested the execution of Willie McGee, who had been convicted of raping a White woman. McGee's case had received national attention. In July 1950, a young attorney from New York City, Bella Abzug, represented McGee in his final appeal before the Supreme Court. Justice Harold Burton awarded McGee his fourth stay of execution, but the full court refused to hear the case, and McGee was executed on 5 May 1951. The police officers who took Braden into custody for her protest were appalled that

she would betray her Southern heritage by supporting a Black man. When she was accused of not being a 'real southern woman', her response was, 'No, I guess I'm not your kind of southern woman'. She had reached a turning point in her commitment to civil rights – the time for conversation had come to an end. It was time for Braden's actions to speak for her.

In the aftermath of the Second World War, White Americans sought peace, quiet, and home ownership in the new suburbs. Generally, these communities were closed to Black couples by tacit agreements, as the Supreme Court had declared restrictive housing covenants to be unenforceable, but not illegal, in 1948. The practice of redlining by banks denied home mortgages to Black applicants and ensured that many desirable city neighbourhoods would remain White. On 15 May 1954, Anne and Carl Braden purchased a home at 4010 Rone Court in Shively, a Louisville suburb, which they immediately sold to Charlotte and Andrew Wade, a Black couple. The Wades were the model of respectable Black citizens. Andrew was employed as an electrician and Charlotte was a homemaker. When the Wades moved in, their neighbours broke their windows with gun shots and burned a cross on their lawn. A few weeks later, the house was destroyed by dynamite.

But the harassment was not over. Community sentiment ran high against the Bradens, who were accused of being communists. Both Anne and Carl were tried in a Kentucky State Court for sedition in October 1954. The prosecution asserted that the Bradens had conspired with the Wades to purchase the home, blow it up, and (somehow) overthrow the government of Kentucky. Carl was found guilty, and he served eight months of a long sentence. A year after the bombing, the United States Supreme Court ruled in a case from Pennsylvania that only the federal government could prosecute someone for sedition. This effectively negated Carl's conviction, and the charges against Anne were dropped. Nevertheless, Carl

lost his job as a copy editor and the Bradens were denounced as disloyal southerners. Both Anne and Carl Braden then worked as field organizers for the Southern Conference Educational Fund, an organization committed to gaining White support for the movement.[66] The Bradens put their lives and livelihood in jeopardy in the interest of racial justice. They never considered themselves to be leaders of a movement; they were just good people doing righteous things in the name of racial justice.

Anne Braden was a woman ahead of her time. For young women new to the movement, she represented the notion that radical change toward racial equality was possible, albeit at great personal cost. Historian Sara Evans wrote that Braden represented an apparently fearless radicalism:

'She had already been where they were afraid to go, taken stands they were summoning the courage to take, and done so in the fifties when there was no "movement" to back her up. Furthermore, for women, Anne Braden provided a model of a woman whose life was totally immersed in the struggle for racial equality'.[67]

As a White woman from the South who battled segregation, Anne Braden was a symbol of resistance to the misogyny and racism of the southern White power structure. She represented 'a challenge to southern mores and assumptions about appropriate behaviour for a proper southern lady. She also spoke out against the customs that dictated an unchanging, oppressed status for African-American citizens'. Braden earned the respect of African-American civil rights leaders who themselves had been subjected to the brutality of racism. According to Rev Jesse L. Jackson Sr, 'When the civil rights struggle engulfed the South, Anne Braden was one of the courageous few who crossed the color line to fight for racial justice. Her history is a proud and fascinating one ... Anne Braden is indeed a "subversive Southerner" – a label she can wear with pride because she spent her life fighting to build a

New South, where all people could live together in freedom and equality'.[68]

Anne Braden and her husband understood the difficulty of the struggle, and they admired the commitment of the young people who were working to end segregation. Braden said her mission in life was 'to get women out of the kitchen and involved in things'. She inspired women, in spite of their relative lack of status in movement organizations, to find their place, not in the kitchen, but in civil rights history.

The connection of southern Black ministers to the cause seems clear, but the relationship of southern White women to their churches as a path to civil rights activism was anything but obvious. Time and again, young White women in organizations like the YWCA were drawn to a Christian approach that demanded that the principles of love and compassion espoused by churches be part of one's everyday life. It was important not only to speak tolerance but to live equality and justice. If this goal could not be realized in their churches, which remained segregated, perhaps it could come to pass in southern towns.

Most White churches in the South were slow to respond to the call for justice and equality. Many Black churches stepped up to provide support for the burgeoning movement. The largest and most important church-based organization in the early Civil Rights Movement was the Southern Christian Leadership Conference, originally called the Southern Negro Leaders Conference on Transportation and Nonviolent Integration. Established in 1957 in the wake of a successful bus boycott in Montgomery, Alabama, the identity of this group is clear from its name. The religious leaders who sought to 'save the soul of America' were ministers in mainstream Black churches. By definition, these leaders were men. Led by Dr Martin Luther King, Jr, the SCLC quickly became a strong regional organization that coordinated the activities of smaller church and community groups. Relying on its constituent churches for material

and moral support, the SCLC saw establishing racial justice as an imperative. At the founding of the Conference, Dr King wrote that he and his colleagues came together 'because we have no moral choice, before God, but to delve deeper into the struggle – and to do so with greater reliance on non-violence and with greater unity, coordination, sharing, and Christian understanding'. SCLC staff members provided training in the philosophy and strategy of non-violence as it pressed demands for full rights as a moral necessity.[69]

The names of the African-American men who led the early, church-based, non-violent Civil Rights Movement are familiar. Martin Luther King Jr, Ralph David Abernathy, Fred Shuttlesworth, and Wyatt T. Walker are just a few of the men whose inspiring oratory and brave acts are memorialized in the history of the struggle for African-American equality. The names of African-American women such as Daisy Bates, Ella Baker, Fannie Lou Hamer, Diane Nash, Constance Curry and many others are becoming increasingly familiar in the civil rights history of the 1960s.

Daisy Bates was a well-known advocate for civil rights in Little Rock, Arkansas. She and her husband, Lucius Christopher 'LC' Bates, published a weekly newspaper, the *Arkansas State Press*, that was respected and circulated widely in the Black community. She was a member of the Little Rock NAACP and was elected president of the Arkansas chapter in 1952. In May 1954, the Supreme Court declared that school segregation violated the equal protection clause of the Fourteenth Amendment to the Constitution, and the Bates' newspaper began a campaign to integrate Little Rock's schools.

In the autumn of 1957, the NAACP was determined to mount an effort to integrate Little Rock's Central High School. Nine high school students, all with good grades and no history of trouble in school or with the law, volunteered to attend in September. When they arrived on 4 September, they were met by an angry mob. Arkansas Governor Orville Faubus, once a moderate on integration

but now an advocate of rigid segregation, ordered the Arkansas National Guard to prevent the students from entering the building. Unable to enter and surrounded by angry Little Rock residents, eight of the students were spirited away from Central High School in speeding cars driven by supporters. One student, Elizabeth Eckford, had become separated from the group on her way to school and was now trying to make her way home alone. As Elizabeth walked down a crowded street, she faced a torrent of racial epithets and threats of physical harm by White students. Elizabeth's White classmates welcomed her to Central High School with racism and hate. She walked alone, looking straight ahead, speaking to no one. Finally, a White woman took her aside and walked with her to a city bus so she could return to her home. A photograph of this stoic young girl appeared in newspapers throughout the country. To many, the image of Elizabeth pursued by an angry mob of White teenagers was an inspiring symbol of African-American resilience.[70]

With support and counselling from Mrs Bates, all nine students returned to Central High School on 24 September. Faubus withdrew the Guard, leaving only the local Little Rock police to prevent violence, which proved ineffective, as the police were outnumbered and not at all committed to protecting the Black students. There was even a cry from the mob to lynch at least one of the Black students. The 'Little Rock Nine' gained national publicity when President Eisenhower was unable to convince the governor that he needed to obey federal law by allowing the students to enter the school. Because Arkansas challenged federal power in the name of states' rights, Eisenhower responded by sending the 101st Airborne Division to protect the nine students, enforcing both the equal protection clause of the Fourteenth Amendment and the *Brown* decision. Federal troops remained at Central High School for the full school year to prevent violence.

Dr King understood the importance of the situation, urging Mrs

Bates to maintain a non-violent stance 'despite being terrorized, stoned, and threatened by ruthless mobs ... World opinion is with you. The moral conscience of millions of White Americans is with you'. Even after the situation at Central High School was resolved, Daisy Bates continued to advocate for equality for all Americans. She served on the executive committee of the Southern Christian Leadership Conference. In August of 1963, she was the only woman invited to speak to 250,000 people at the March for Jobs and Equality, although she was not one of the event's major speakers. [71] Bartes told the crowd, 'We will sit-in and we will kneel-in and we will lie-in if necessary until every Negro in America can vote. This we pledge to the women of America'.[72]

Other than Daisy Bates, the SCLC had few female leaders. Ella Baker was one. She came to activism as a social worker during the Depression, when she witnessed the privation caused by economic collapse and came to realize the importance of direct action against racism. Born in Norfolk, Virginia, Baker grew up in North Carolina and graduated from Shaw University in Raleigh. She moved to New York City and was instrumental in organizing the Young Negroes Cooperative League, an organization dedicated to pooling the resources of its member groups to help provide economic independence to poor people. She investigated unfair labour practices, especially the economic inequality suffered by Black women. As part of her economic research, she once posed as a domestic worker to gather information about the conditions of Black women who worked in the homes of wealthy White people.

While in New York in 1941, Baker was named an NAACP. assistant field secretary. Her work took her to the Jim Crow South, where she endured dangerous conditions but helped to build connections and confidence in the movement. She eventually became disenchanted with the NAACP's slow-moving, hierarchical approach to problem-solving, preferring a method that eschewed theory for action.

She left the NAACP in 1946 but continued to press for school integration in New York City. Baker returned to the NAACP in 1952. In 1955, she was inspired by the resilience of the Black citizens of Montgomery who had elected to boycott the city's transportation system rather than accept segregation. In collaboration with Stanley Levison and Bayard Rustin, she founded In Friendship, a group that raised money in the North to support local civil rights activities in the South. Baker was also instrumental in the formation of the Southern Christian Leadership Conference and was the first female to occupy a leadership position. She headed the Atlanta chapter, serving with Dr King, who was the president. The SCLC had no tradition of female leadership, making Baker a genuine pioneer.

Ella Baker left the Southern Christian Leadership Conference to work with student activists who founded the Student Non-Violent Coordinating Committee (SNCC) at Shaw University in April 1960. She was an inspiration to, and a profound influence on, young people in the movement, supporting their efforts to form an organization that was democratic in process and independent in structure from SCLC rather than a constituent, dependent subgroup. She encouraged the students to develop local 'group centred leadership' and not rely on a single charismatic leader.

As Baker helped the SNCC students define their organizational and strategic goals, young women who had already participated in sit-ins and other demonstrations helped move SNCC toward militant non-violence. Diane Nash and Ruby Doris Smith took part in protests in Rock Hill, South Carolina, where they served jail sentences after their arrests rather than rely on bail to obtain their freedom until trial. The 'jail-no-bail' approach helped to solidify the commitment of the SNCC workers and inspired others, including Dr King, to accept the consequences of protesting for racial justice. This approach contributed to a near-split in the ranks of SNCC organizers, some of whom wanted to focus primarily on voter registration while Nash

and her colleagues were willing to be more confrontational in their approach to segregationists and law enforcement. As a militant Black woman, Nash experienced frustration in not seeing more direct action in the early days of SNCC. She is regarded today as a brave protest leader who demonstrated that young activists were willing to take major personal risks in order to achieve full and equal rights.

Baker was able to prevent SNCC from dissolving over these differences. A firm believer in democracy and decentralized leadership, Baker proposed a compromise in which Nash and her followers continued to pursue direct action while others in SNCC launched a voter-registration drive in Mississippi. To accomplish this goal, Baker helped SNCC members organize the Mississippi Freedom Democratic Party (MFDP) to challenge Dixiecrats (White Democrats who supported segregation) in the state. This was a new and bold initiative, as civil rights leaders had not previously engaged directly in electoral politics as a way of confronting segregation. The Party held its state convention in Jackson on 6 August 1964, with Baker as the keynote speaker. She stressed the importance of education and avoiding the influences of (White) popular culture so that young people could develop their own African-American identity. Baker was passionate in her assertion that Black parents had to confront the Dixiecrats and the segregationists 'on the basis of knowledge that we gain ... through sending our children on certain kinds of courses, through sitting down and reading at night instead of spending our time at the television or radio, just listening to what's on'.

From its inception in 1960 to the creation of the MFDP and the Mississippi Freedom Summer, SNCC grew and matured, in large part through the efforts of women who followed Baker's activist model. Young women in SNCC also followed the precedent of Bernice Robinson and Septima Clark, who established citizenship schools in South Carolina through the SCLC. Inspired by lessons

learned at the Highlander Folk School, Robinson, Clark, and others created a model of community organizing that SNCC women embraced. Robinson continued her community work as the field supervisor for adult education for SCLC, and Clark advocated for literacy programmes as essential to citizenship and equality.

The discrimination experienced by Septima Clark was especially painful because she was deprived of both her livelihood and her passion for education. In 1955, Clark was among several NAACP members who filed a successful class action lawsuit against the City of Charleston, South Carolina to equalize the pay of Black and White teachers. The following year, the state legislature passed a law that prohibited government workers from membership in civil rights organizations. Clark was faced with the loss of her NAACP activism or her job. She refused to leave the NAACP, and her contract was not renewed in 1956. Following her dismissal, Clark led workshops at the Highlander Folk School and in 1961 became the director of the SCLC's Citizenship Education Project. Her work reached many South Carolina citizens who learned to read and write and to organize in their communities for basic civil rights, especially the right to vote.

Known as the 'Queen Mother' of the Civil Rights Movement, Clark recognized that, although she had helped others to work for their rights and although she had inspired younger women to persevere when circumstances were tough, she and other women in the movement were not recognized for their talents. She felt that Dr King did appreciate the work done by Black women, but she commented that the men in the SCLC 'didn't respect women too much'.

Nevertheless, Septima Clark demonstrated the qualities that the next generation of new feminists would need – she was brave and determined and resourceful in the face of discrimination. In 1976, after she had been elected to the Charleston School Board, the governor of South Carolina acknowledged that the termination of her employment twenty years earlier had been a miscarriage of justice,

and she was awarded a pension to acknowledge her past service.[73]

Within SNCC, Diane Nash was a proponent of direct action and working directly with people in their communities to guarantee their rights. When Nash married SNCC leader James Bevel and gave birth to the couple's first child, she devoted more attention to her growing family than to the immediate needs of the movement. Ruby Smith became SNCC's full-time southern campus coordinator in 1962, the organization's administrative secretary in 1963, and then its executive secretary until her death from cancer in 1967.[74] Women continued to serve behind the scenes as well as in more public roles. The office workers and field organizers were the heart and soul of SNCC, but their work was frequently not recognized or valued. By the mid-1960s, the women who dedicated their lives to SNCC's 'beloved community', in which the fight for political and social justice bound people together in a common cause, did not yet have the language to articulate their frustration with their lack of agency within SNCC. But time and experience would help these women and others to articulate their grievances.

Feminist author Susan Brownmiller recounted an incident that revealed both sexism in SNCC and the emerging racial divide that eventually led to the departure of White workers. She and Jan Goodman volunteered to work in Meridian, Mississippi, a truly dangerous place for civil rights workers in 1964: 'Between us, we had a good ten years of organizing experience, hers in Democratic primaries and presidential campaigns, mine in CORE, the Congress of Racial Equality, and both of us together in voter registration drives in East Harlem. The night we arrived in Meridian, a field secretary called a meeting, asking to see new volunteers. Proudly, we raised our hands. "Shit!" he exploded. "I asked for volunteers and they sent me White women"'.

Brownmiller and Goodman continued their voter registration efforts in the face of segregationist hostility and violence toward

Mississippi's Black citizens and the wariness of their Black colleagues in SNCC about the sincerity of White people in the movement.

Throughout the 1950s and 60s, as news of civil rights protests began to reach the headlines, the organization most familiar to Americans was the NAACP. Proud of its integrated origins and efforts to combat lynching, the NAACP included chapters throughout the country whose members wrote letters, lobbied public officials, and encouraged civic awareness and responsibility in local African-American communities. The NAACP was hardly in the forefront of civil rights protest activity. Nevertheless, it was an important representation of the 'respectable' Civil Rights Movement. Former NAACP National Secretary Mildred Bond Roxborough remembered that 'without the women we wouldn't have an NAACP'. She recalled the efforts of women who organized local branches 'before it became fashionable or popular for women to travel'. She noted that women 'subsequently held positions in the NAACP nationally as program directors and leaders of various divisions'.[75]

By the mid-1960s, tensions within the freedom movement were apparent. Some Black activists understandably resented the presence of middle-class White students who had the privilege of returning to their safe homes and campuses at summer's end. In 1966, SNCC asked its White members to leave the organization so they could continue the southern campaign alone. Years before the separation, Ella Baker realized that there were fractures in the beloved community. She said in 1963 that she understood that, as SNCC grew, profound differences of opinion would emerge, and the organization might face a splintering into several groups, each with a different approach to ending segregation. Baker realized that SNCC was on the cutting edge of creating a new world in which equality and respect for African Americans would not be questioned. She also knew that the struggle to achieve a true beloved community

would be long, difficult, and not without significant obstacles. That new world would have to be one in which community members, not leaders, would define the direction of the movement freedom. Baker believed that whatever their level of educational attainment, ordinary people had the ability to understand their needs and how to accomplish their goals, enabling them to participate in changing the world for the better.

Baker did not remain in SNCC after the separation in 1966, but she remained supportive of direct action and community growth. She summarized her career in the movement: 'You don't see me on television. You don't see news stories about me. The kind of role that I tried to play was to pick up pieces or put together pieces out of which I hoped organization might come. My theory is, strong people don't need strong leaders'. Baker's definition of leadership was cast in terms of action rather than position or title. It was fitting that younger activists in SNCC referred to Ella Baker as 'Fundi', which in Swahili is a person who teaches a skill to the next generation.[76]

Many members of that generation were women who worked in the field rather than the national organization. Bernice Johnson Reagon helped to lead the Albany, Georgia Movement. Reagon, Ruth Harris, and Ruth Gaber joined the SNCC Freedom Singers whose work helped to spread the message of the movement to the public through song. Prathia Hall and Peggy Diamond worked in SNCC's Southwest Georgia Project. In Cambridge, Maryland, Gloria Richardson Dandridge led protests against segregation, and Victoria Jackson Gray worked in Hattiesburg, Mississippi coordinating the Mississippi Freedom Democratic Party's attempt to send an MFDP member to the Senate.[77] Not all of these programmes met with success, and some women faced challenges from their colleagues as well as from the pervasive climate of racism in the Deep South. But the women were there. They were energetic and brave, and they helped to create and maintain SNCC's 'beloved community', if only

for a short time. Within a few years, the male-dominated model of decision-making and a general climate of sexism in SNCC would become apparent, but, in the early years, SNCC's energy attracted women to the movement, where their talents were essential, if not appreciated.

The complexities of a sophisticated political campaign brought the wisdom of the people admired by Ella Baker to the national stage. Fannie Lou Hamer grew up in poverty in rural Mississippi. The youngest of twenty children, she began picking cotton at the age of six and left the plantation on which her parents were sharecroppers at the age of twelve.

Although she did not have much formal schooling, Hamer was able to read and write, which set her apart from many of her peers. In 1961, she was subjected to a 'Mississippi appendectomy', an unnecessary hysterectomy that doctors regularly performed on poor Black women. This procedure was commonplace in rural Mississippi.

Soon after the degrading operation that left her sterile, Hamer became involved in efforts to register African Americans to vote. As a SNCC organizer, she led seventeen people from her community to the courthouse to register on 31 August 1962. They were denied on the basis of Mississippi's literacy test and harassed on their trip home because their bus was 'too yellow'. This unnecessary stop for a frivolous reason (the colour of the bus) demonstrated the lengths to which some rural southern law enforcement officers would go to harass people of colour and their White allies. The owner of the plantation where Hamer and her husband worked fired her. Soon after, they moved to the town of Ruleville in Sunflower County.

Hamer continued her voter registration activities and was arrested on 9 June 1963 for sitting in a Whites-only restaurant at the bus station in Winona, Mississippi. Hamer was beaten nearly to death in the Winona jail. She described the experience:

'It wasn't too long before three white men came to my cell. One of

these men was a State Highway Patrolman and he asked me where I was from. I told him Ruleville and he said, "We are going to check this". They left my cell and it wasn't too long before they came back. He said, "You are from Ruleville all right", and he used a curse word. And he said, "We are going to make you wish you was dead'".

Hamer was then beaten with loaded blackjacks (heavy leather pouches filled with balls of lead or a steel rod designed to inflict serious pain and injury). Later that day, she overheard one of the police officers say, 'We could put them SOBs in the Big Black [River] and nobody would ever find them'. She never fully recovered from the injuries she suffered that day. Fannie Lou Hamer's experience highlights the dangers that Black people faced in the Deep South. Jail was a dangerous place. Standard wisdom held that, if someone went to jail, it was uncertain whether he or she would return alive.

Hamer intuitively understood the relationship of her struggle to humanity's need for greater freedoms that were denied based on gender as well as race. In 1971, she told a convention of the NAACP Legal Defence fund that, throughout her life she had worked 'for the liberation of people because when I liberate myself, I'm liberating other people'. She also recognized that the White woman in America now knew that 'her freedom is shackled in chains to mine and she realizes for the first time that she is not free until I am free'.[78] Hamer spoke to what women activists recognized as the 'double jeopardy' of barriers imposed because of both race and gender. Over time, women activists also began to consider the issue of class, which added to the challenges faced by Black and White women alike. Hamer's work reflected a profound understanding of these important, yet very personal, analytical categories. Today, the concept of intersectionality, the related nature of class, race, and gender as aspects of discrimination, is accepted among scholars as a useful analytical framework that helps us to understand the conditions experienced by poor women of colour.

The Mississippi Freedom Summer, which Hamer helped to organize in 1964, brought hundreds of students to Mississippi to register voters and engage in community work that included training mothers in child nutrition and creating schools to teach African-American history. Black and White college students, many of whom were trained in the principles of non-violence at Miami University in Oxford, Ohio, worked in freedom schools in some of Mississippi's poorest communities. Their success encouraged local residents to work in and eventually run the Freedom Schools and community organizations, giving them the confidence to stand up to police and KKK violence.

Women participants in the Freedom Summer faced pervasive sexism. They were presumed to be more appropriate for work as cooks, typists, or teachers rather than community organizers. Expressing her dissatisfaction with the extent of sexism in the Mississippi movement, one anonymous woman declared, 'We didn't come down here to work as maids this summer'. The male activists in the Freedom Summer knew full well that teaching in a Freedom School lacked the 'macho adventurism' of voter registration work in remote communities,[79] even though office or school work made the women as vulnerable as the men to racist attacks.

Marian Wright Edelman helped to shape the Freedom Schools and went on to have a long career as a feminist activist and founder of the Children's Defence Fund. After graduating from Yale Law School in 1963, Edelman worked for the NAACP's Legal Defence Fund in New York for a year, after which she opened a law office in Jackson, Mississippi. Edelman was the first Black woman to pass the Mississippi bar.

While she was well-qualified to provide legal help to Freedom Summer workers, Edelman's had a passion for schools. She said that the schools were 'designed to keep Black children out of harm's way and give them a richer experience than Mississippi public schools

offered them'. With few resources, the Freedom School organizers had to rely on local community resources. According to Edelman, classes were held 'in church basements, on back porches, in parks, and even under trees. I remember visiting a Freedom School under an old oak tree in Greenwood, Mississippi and hearing Pete Seeger sing'. Freedom School curricula included important subjects for Black children. Edelman said that schools 'provided reading instruction, a humanities curriculum including creative writing, a general mathematics and science curriculum, and even French. They also taught subjects the public schools did not, including Black history and the nature of their constitutional rights'. More than 3,000 children and adults were served by the Freedom School that were staffed mainly by women like Marian Wright Edelman, who took the skills they learned in Mississippi to Second Wave feminist organizations.[80]

The Freedom Summer gained national attention in June 1964, when CORE workers Andrew Goodman, James Chaney, and Michael Schwerner disappeared after being stopped by the police near Philadelphia, Mississippi. The bodies of the three were discovered in an earthen dam in the area weeks after the young men's disappearance. The murders received considerable press coverage because of the horrific nature of the crime and because two of the young men, Andrew Goodman and Michael Schwerner, were White activists who had come to Mississippi from New York. James Chaney, a 21-year-old Black man, was from Meridian, Mississippi. White America was shocked out of its complacency. Until the summer of 1964, it was possible to think of the violence inflicted on civil rights workers as something far away. The violent death of three men, whose only crime was helping Black people to register to vote in Mississippi, provided the context in which the savagery of racism in the South was exposed. Folk singer Phil Ochs told Mississippi to 'find yourself another country to be part

'Joan of Arc Kissing the Sword of Deliverance' by Dante Gabriel Rossetti, 1863. Joan of Arc was accused of many crimes, including dressing like a man. (Flickr)

Eugene Delacroix's 'Liberty Leading the People', 1831 portrayed valiant women heroes in the French Revolution of 1830. (Louvre Museum)

Left: British suffragists were attacked with posters that proclaimed that giving women the vote would bring about the end of traditional gender roles, especially with regard to housework. (London School of Economics Library)

Below: The Trung Sisters are memorialized in Vietnam for their bravery against the forces of the ancient Chinese Han Dynasty. (Dick Lee, Flickr)

Sojourner Truth was a freed slave who was famous for her 'Ain't I a Woman?' speech. She spoke for the rights of women and formerly enslaved people. (Smithsonian National Museum of African-American History and Culture)

Emma Goldman was an American revolutionary who supported full equality for women. She was deported to Russia as a radical in 1919. (Library of Congress)

Women in Britain were recruited into the Women's Land Army that produced much-needed food for the duration of the Second World War. (UK Government Artistic Works)

Noor Inayat Khan was part of the British Special Operations Executive (SOE) as a wireless operator who relayed crucial information about German troop movements. She was executed by the Gestapo in September 1944 in the Dachau Concentration Camp. (Imperial War Museum, UK)

The working woman in the United States during the Second World War was symbolized by the character of 'Rosie the Riveter.' She inspired many women to help the defense effort by taking factory jobs. (pixabay.com)

During the Second World War, women held factory jobs as men went off to war. These aircraft workers were pictured in 1942 learning the trade.
(United States Department of Agriculture)

Yves Saint Laurent created this design for Christian Dior's fashion studio in the 1950s. Many American women flocked to department stores to purchase inexpensive versions of Paris couture creations. (Wikimedia Commons)

In 1948, the *Ladies Home Journal* targeted American housewives with advertisements for the latest home appliances, suggesting that a new washing machine was the key to domestic happiness. (Internet Archive)

Housing developments like Levittown promised comfortable suburban living at a low price for returning veterans and their families. (Library of Congress)

Vice President Richard Nixon faced off against Soviet Premier Nikita Khrushchev in Moscow's Skolniki Park on 24 July 1959. Instead of debating nuclear policy, they sparred over which country offered a better life for its citizens. (National Archives)

Left: As a teenager, Claudette Colvin refused to give up her seat to a white bus rider, several months before Rosa Parks took the same action in Montgomery Alabama. (Wikimedia Commons)

Below: NAACP activist Rosa Parks tested Montgomery's segregated bus policy by refusing to give up her seat to a white passenger. She was arrested, and her case inspired a successful year-long boycott of the city's bus system. (Wikimedia Commons)

of'. Amid the violence of that brutal summer, President Lyndon Johnson signed the ground-breaking Civil Rights Act on 4 July.

Fannie Lou Hamer began to devote her energies to electoral politics with the formation of the Mississippi Freedom Democratic Party, an organization dedicated to registering Black voters and challenging the racist southern Democrats. Mississippi's regular (White) Democrats did everything in their power to exclude Black voters. White primaries, poll taxes, tests of constitutional knowledge, and intimidation helped to keep Black voters away from the polls on election day. Hamer was joined in leading the MFDP by two women whose efforts furthered the Party's progress. Victoria Gray, a committed voter registration organizer in Hattiesburg, Mississippi, once said that the Civil Rights Movement attracted two types of people, 'those who are in the movement and those who have the movement in them. I have the movement in me … and I know it always will be'. Annie Devine was less known, but her ability to convince rural people of the importance of registering to vote was essential to the success of the MFDP. Victoria Frey described Devine as 'a behind the scenes giant, a God-given giant who came and dwelt and worked on the back roads in the rural places'.[81]

Thanks to the heroic organizing efforts of these three women and their male and female colleagues, the MFDP held its own primaries in 1964 and prepared to send a delegation to the Democratic National Convention in Atlantic City. The MFDP argued that it, not the segregationist White Democrats, represented Mississippi. The MFDP was engaged in a bold strategy to challenge the segregationist policies of the Democratic Party in Mississippi. They attracted the attention of members of Students for a Democratic Society who were committed to achieving civil rights and bringing about an end to the war in Vietnam. The July 1964 issue of the SDS *Bulletin* included a statement of support for the MFDP: 'Be it resolved that Students for a Democratic Society urges its members and friends to support

and assist the efforts of the MFDP to obtain its rightful place in the Democratic Party organization, and exhorts all freedom-loving people to lend their resources to this great effort'.[82]

Support from SDS was important for the MFDP as it solidified the connection between groups of students whose goals were similar. Both SDS and the MFDP challenged traditional assumptions about 'appropriate' student behaviour and the legitimacy of efforts to bring about basic social and political change. Hamer spoke before the national Democratic Party convention in Atlantic City, detailing the abuses to which she and other MFDP members had been subjected. She appeared on national television, and the nation was once again shocked by her revelations of brutality in the South. She asked, 'Is this America, the land of the free and home of the brave, where we have to sleep with our telephones off the hooks because our lives be threatened daily, because we want to live as decent human beings in America'?

When the convention's credentials committee offered the MFDP two seats as part of the Mississippi delegation, Hamer and her colleagues rejected the offer as demeaning and undemocratic. She summed up the feelings of the entire MFDP delegation when she declared, 'We didn't come all the way up here to compromise for no more than what we'd gotten here. We didn't come all this way for no two seats, 'cause all of us is tired'. Hamer continued to press for voting rights and racial equality. In 1971 she helped found the National Women's Political Caucus, which provided support for women to enter electoral politics.[83]

Many younger White women were inspired by the words and deeds of Ella Baker and Fanny Lou Hamer, whose courage and heroism served as a model for women drawn to the cause of equality. There were a number of White women activists whose names may not be familiar but who nevertheless contributed significantly to local activism that sparked the success of the movement as a whole.

Women in the Struggle for Civil Rights

Constance Curry was born in Paterson, New Jersey in 1933 and grew up in Greensboro, North Carolina. She recalled the first time she spoke out against a racist act:

'I remember first "speaking out" about race when I was in the fourth grade in Greensboro. We were going down the cafeteria lunch line, and a tall boy named Douglas referred to one of the women servers as a "nigger". I told him he shouldn't do that, that the woman was just as good as his mother. Later on, during play period, he knocked me down and I fell into a puddle. I had on a new brown and yellow raincoat, and the mud splattered on the yellow'.[84] This would not be the last time Curry suffered the consequences for doing the right thing.

After her first year at Agnes Scott College in Decatur Georgia, Curry attended a conference of the United States National Student Association, an experience that piqued her interest in studying political science. She briefly worked on the International News Service (INS), a college group that shared information from students on several campuses. The INS had been founded by the USNSA, which soon became known by its shorter name, the National Student Association. Curry and other young people were attracted by the NSA's goal to guarantee 'to all people because of their inherent dignity as individuals equal rights and possibilities for primary, secondary, and higher education, regardless of sex, race, religion, political belief, or economic circumstances'. Although the NSA was predominantly White, its ideals were similar to those of southerners who opposed segregation and racial violence.

In 1953, two years before she graduated college, Curry organized a regional NSA meeting in Atlanta, a city that was officially segregated. She remembered that a local YWCA was the only organization that would make a room available for an inter-racial meeting. Curry came face to face with racism and the realization that she needed to change her own behaviour at the meeting's lunch break. She remembered

that the moment when the consequences of racial segregation 'first hit me personally was lunch hour at that Saturday meeting. It was against the law for Blacks and Whites to eat together, so the YMCA could not permit a lunch gathering. When noon came, the Black delegates, some of whom were my friends from the national congresses, walked down the steps of the Y and headed toward Auburn Avenue and the Black restaurants. The rest of us walked down the steps and headed in the other direction. I realized then that segregation took away my personal freedoms as surely as if they were bound by invisible chains'.

For Constance Curry, the personal was rapidly becoming political. In 1955 she graduated with honours from Agnes Scott College and pursued graduate study in Bordeaux, on a Fulbright Fellowship, and at Columbia University, after which she took a position as a field secretary for the Collegiate Council of the United Nations. While she held that position, Curry stayed in touch with NSA colleagues and the work the organization was doing to influence White college students to become more aware of segregation. Through its seminars and conferences, the NSA was planting important seeds of White activism for civil rights.

In 1960, Curry became the first field director of a new group within the NSA, the Southern Human Relations Project, which was later named the Southern Project. Her job was to organize conferences and small integrated discussion groups to bring Black and White students together. That spring, the Southern Project was among many groups that organized thousands of students to protest segregated restaurants and public facilities. Curry was at the first organizational meeting of SNCC at Shaw University. She and Ella Baker were designated 'adult advisors' to the student SNCC members. Curry described her emotions at the founding of SNCC: 'The Raleigh meeting was the first time that I stood in a circle, joined hands, and sang "We Shall Overcome." For me, that song

always elicits tears no matter the lapse of time or the occasion of the singing'.

Curry, Baker, and Jane Sternbridge, a White student from the Union Theological Seminary in New York, staffed the SNCC central office in Atlanta, taking phone messages, writing pamphlets, and helping students learn the basics of community organizing. Sternbridge remembered that the first donation SNCC received in its first summer was a check for $100 from Eleanor Roosevelt. On 15 October 1960, SNCC sponsored a conference called 'Nonviolence and the Achievement of Desegregation' at which Ruby Doris Smith was the keynote speaker. The conference programme noted that Smith 'comes to us with her deep concern for her native South and all its people. She comes with a great history of lonely stands, courageous words, and unending fights for the integrity and dignity of every human being'. Smith was highly respected because of her particularly effective field work in the Southern Regional Council. She was considered an elder of the movement who was the only woman to serve as SNCC's Executive Secretary on the departure of James Forman. Smith remained active in the SNCC until her untimely death from cancer at the age of 25 in October of 1967. Ruby Doris Smith's rise to prominence in SNCC raises the question of how many other women who were equally talented found themselves playing supportive rather than policy-making roles because of prevailing assumptions that women were helpers rather than natural leaders.

As Constance Curry helped to organize SNCC in the early 1960s, she maintained contact with NSA colleagues, encouraging them to support the non-violent civil disobedience to which the students, Black and White, were committed. Julian Bond, SNCC communications director and editor of *The Student Voice*, recalled that Curry 'was a bridge between the overwhelming number of Black sit-in students and White students who were predisposed to join

with us. And she got us into the NSA network. It was an invaluable resource for recruiting, money, and political support [and] provided the basis later for Friends of SNCC groups on college campuses. She publicized the sit-in movement within the NSA network, interpreted it, and created an audience for us that might not have been there'.

Over time, the bridge between Black and White activists, young students and slightly older organizers, could not hold. Differences about strategy and the viability of nonviolence and tensions between Black and White movement members created dissension within SNCC. Tensions between the SCLC, representing the older, more integrated movement, and SNCC, which promoted more direct confrontations with American racism, also became more pronounced. In 1964, Curry was ready to leave both the NSA and the SNCC Executive Committees, but she was not ready to leave the South or civil rights activism. She took a position with the American Friends Service Committee (AFSC), a venerable Quaker organization headquartered in Philadelphia. Her first assignment was to work with Mississippians for Public Education, a small group of White women dedicated to promoting peaceful integration under a court order in Jackson, Biloxi, and Leake counties. She noted that their goal was to 'prevent another Little Rock'.

Curry was frequently branded an outside agitator and a communist because she represented the AFS and was in Mississippi to promote integration under the law but against the will of many Mississippians. She was frequently followed by spies from the Mississippi State Sovereignty Agency who characterized Curry as a 'blonde atheist who talks about communism all the time'. It was true, she was blonde. The battle for school integration in Mississippi took many years, many court battles, and numerous organizations contributing to the effort. In autumn 1964, Curry returned to Atlanta to help coordinate the efforts of the AFSC and the NAACP Legal Defence Fund.

For civil rights workers, it was standard wisdom that driving in the

Deep South was dangerous, especially at night. The brutal murders of Goodman, Schwerner, and Chaney in the summer of 1964 and Viola Liuzzo in March of 1965 were testament to the truth of that warning. In August of that year, Curry and a colleague realized they were being followed by a local sheriff in Wheeler County in southeast Georgia. He stopped them in a small town, where a crowd, including the mayor, gathered and expressed their fury at the two women 'nigger lovers'. Curry remembered that what most angered the crowd was that her friend 'was from Mississippi. In their eyes, this lovely, blonde white woman was a traitor – indeed their worst nightmare. The sheriff pointed to a nineteen-year-old, barefoot boy wearing only denim overalls. "See Bernie? He just got out of the mental institution and of all the things he hates, nigger-lovers is first". The mayor then came up and said that the sheriff and several patrol cars were going to escort us to the line of neighbouring Telfair County but that he could not guarantee our safety from then on and we were never to set foot in their county again'. Needless to say, the women's retreat from Wheeler County was fast but under the speed limit. In spite of this harrowing experience, Constance Curry continued her work on behalf of school integration, even as SNCC moved toward Black Power and a separatism of its own.

(Martha) Sue Thrasher was one of the young White women influenced by the bravery of Ella Baker, Fannie Lou Hamer, and Constance Curry. She was born in rural Tennessee. She loved the land but not the financial instability of farm life. Her parents worked both on and off the farm. As one of four children, she had her own chores that helped to maintain the family's meagre income. Thrasher began her higher education at Lambuth College, a small Methodist school in Memphis, and then transferred in 1961 to Scarritt College for Christian Workers, an integrated institution in Nashville. At Scarritt, she became involved in civil rights activity and joined the Student Non-Violent Coordinating Committee.

Scarritt College emphasized community service in its curriculum, and this focus attracted Thrasher in the early 1960s. When Abel Muzorewa, a young Methodist minister from Rhodesia came to study at Scarritt, Thrasher was appalled that his wife was denied membership in the city's second largest Methodist church because of her race. She started a petition drive to force the church to change its policy, to no avail. Thrasher described the incident as unbelievable, saying that she thought 'the church felt rather proud of itself for allowing Blacks to even visit the church on Sunday but remained unwilling to accept African Americans [or Africans] as full members'.[85]

The lessons Thrasher learned as a member of SNCC led her to participate in local actions against store lunch counters that refused to serve African Americans, even though they were free to make purchases in the stores. Since February of 1960, students from Fisk University, Tennessee State University, and the Baptist Theological Seminary had engaged in sit-ins at local Kress and Woolworth lunch counters organized by the Nashville Student Movement and the Nashville Christian Leadership Conference. These protests, led by Fisk students John Lewis and Diane Nash, forced an agreement with local merchants in which six lunch counters were opened to Black customers, a few at a time. Nashville was the first southern city to take steps, however small, toward integrating its downtown restaurants. The 1960 protests served as a model for future civil rights activism in Nashville and throughout the South.

Thrasher was inspired to found the Southern Student Organizing Committee (SSOC) in early 1964. She served as SSOC's first executive secretary and its only female officer. The SSOC organized chapters on many campuses and served a membership of mainly White students who were committed to creating a more just society, starting with their own colleges. SSOC members pushed for integration of their campuses and the towns in which they

were located. In 1964, they joined the voter registration drive of Mississippi's Freedom Summer and founded the White People's Project to provide information and support for White allies who often felt alone in their communities because of their support for civil rights. The Project also launched early protests against the Vietnam War. From its location on southern campuses, the SSOC worked closely with SNCC in its early days as well as SDS, earning it the nickname 'The Southern New Left'. Where SSOC had been a training ground for Thrasher and a few other White women, they remained a small minority within the organization. SSOC women were treated as assistants to the 'natural' male leaders of the organization.

A racially inclusive organization, SSOC maintained chapters all over the South until its dissolution in 1969. By the late 1960s, as groups like SNCC offered powerful arguments for a Black-only movement,[86] Thrasher maintained her commitment to integrated action. She and some of her SSOC colleagues founded the Institute for Southern Studies in 1970, a non-profit research group. This was an important move that signalled a shift from activism in the streets to spreading the philosophy of integration through research and writing. Southern White women like Thrasher and other progressive southern students sought to break free of outmoded assumptions about race and tired traditions that prevented the region from making economic and political progress. At its founding, the SSOC published a statement that made clear its intentions as a modern southern institution:

'We hereby take our stand to start with our college communities and to confront them and their surrounding communities and to move from here out through all the states of the South – and to tell the Truth that must ultimately make us free. The Freedom movement for an end to segregation inspires us all to make our voices heard for a beginning of true democracy in the South for all people.

We pledge together to work in all communities across the South to create nonviolent political and direct-action movements dedicated to the sort of social change throughout the South and nation which is necessary to achieve our stated goals'.[87]

Dorothy Dawson Burlage connected her commitment to civil rights with the anti-war movement as an activist in both the North and the South. Born in San Antonio, Texas in 1937, Dawson moved to Jackson, Mississippi, a segregated city, as a child. She grew up in a conservative religious household and had contact with few African Americans other than the servants in her parents' home. Even as a child, Dorothy sensed the contradiction between a church that preached love and compassion and a society that upheld segregation as public policy and racism as societal creed.

After a year at Mary Baldwin College in Staunton, Virginia, she enrolled at the University of Texas, where she participated in demonstrations and petition campaigns directed at instances of racism at the school, including the removal of an African-American actress from a leading role in a school musical because of her race. She was active in the local YWCA at this time. A major influence on her thinking about race, the YWCA was one of the few buildings in Austin where interracial meetings could be held. It was there that many demonstrations against Jim Crow laws and segregation on campus were planned. Though YMCA members were mostly White, there were African Americans in major leadership roles.

In 1958, Dorothy moved into the Christian Faith and Life Community on campus. The Community, led by Methodist minister Joseph Mathews, was interfaith, interracial, and firmly dedicated to a theology that brought together the principles of Christian faith and a life dedicated to social justice. In a dormitory that housed both Black and White women, community activists trained residents for lay leadership. It was there that Dawson and her roommate Casey Cason (later Casey Hayden) met and developed

friendships with Black residents. She continued to challenge the segregation and racism of her upbringing. As she remembered:

'The University of Texas had just been desegregated when I started college, but the public facilities, many of its programmes, and all the dormitories were still segregated. As a result, I decided to move off campus into a private dorm because it was interracial. At that time in my life, it felt like a very radical step away from my upbringing – gigantic in fact – and it served to break down the barriers of segregation with which I had grown up'.

After graduation, Dawson was invited to work for the YWCA but elected instead to attend Harvard Divinity School to study philosophy and ethics. In Cambridge, she organized protests in support of SNCC and helped to found the Northern Student Movement (NSM), whose main focus in 1961 was fund raising for the Freedom Riders and SNCC's voter registration campaign. To draw attention to Southern segregation, the NSM picketed Boston's Trailways Bus Terminal. After only a year in graduate school, Dorothy Dawson spent nearly a decade as a civil rights activist in the South. She recalled that her heart was truly in the South:

'Racism was my battle. I had grown up in the South and I was passionate about desegregation and correcting the wrongs that were being perpetrated against African Americans. I had been taught good values in church, even though they contradicted what I learned by growing up in a segregated society. Those values resonated with those of the civil rights movement – social justice, peace, the brotherhood of man, the love of one's neighbour, care of the persecuted and needy, and the equality of all people in the eyes of God. I was at home in the southern freedom movement and inspired by its concept of the Beloved Community, the idea of living in a society without violence and not defined by race or color. Thus, I spent about ten years, in several southern states, working in

the civil rights movement as a campus and community organizer'.

Working in Atlanta and Nashville, Dorothy cooperated with the SSOC in organizing White students to support the struggle for racial equality in the South. Drawn to the connection between race and class, Dorothy attended the meeting in Michigan in 1962 at which the Port Huron Statement was written and approved, marking the official founding of Students for a Democratic Society. SDS operated in another world, a northern and intensely political world, in which the war in Vietnam, the military draft, and class struggle took their place along with segregation and racism as reasons to protest and change the world. Dawson's world of organizations–SNCC, SSOC, SDS – may have seemed complicated, but her mission was straightforward. She intended to bring together the Christian spirit of love with the justice she found in protest movements.[88]

The organizations that had inspired Sue Thrasher, Dorothy Dawson and other young White women created supportive relationships among local organizers and activists. With the entry into the South of northern Black and White students in the 1964 Freedom Summer, the goals of the movement became broader in scope and included challenging Mississippi's delegation to the 1964 Democratic National Convention. White and Black activists learned to live together and face danger together. Gradually, the White presence in the movement seemed too prominent and the non-violent movement too passive and too slow. Black organizers, especially in SNCC, began to call for a Blacks-only movement, which came to pass in 1966, when Stokely Carmichael called for 'Black Power' and White members were asked to leave the Committee. This was the moment at which SNCC became more radicalized in its goals and tactics.

SNCC had begun as a companion organization to the SCLC, whose underlying philosophy was derived from Christian churches and the success of Mohandas Gandhi's non-violent protests for

Indian independence from England. Almost from the beginning, the organization was divided between organizers who promoted protests and those who favoured focusing on voter registration. In 1966, Stokely Carmichael unseated John Lewis as SNCC chairman. He called for a more militant stand in the organization based on Black Power, which meant the ability of Black people to define their own destiny. The more militant SNCC became, the more it was subjected to infiltration and harassment from law enforcement agencies, ranging from local police forces to the FBI. By the early 1970s SNCC had disbanded.[89]

As SNCC leaders took the organization in a militant direction, Huey P. Newton and Bobby Seale founded the Black Panther Party for Self-Defence in Oakland, California on 15 October 1966. The new organization included many women, but their roles remained subordinate to the jobs held by men. Even the term 'Pantherette' used to describe female Party members implied women's lesser status. Male Party members patrolled city streets, armed with law books and a knowledge of proper police procedures. Their goal was to ensure that Oakland police did not violate the rights of local citizens when they were subjected to traffic stops or arrest. The Party also founded schools and a breakfast programme staffed largely by women to help the Black community and inculcate young potential members with the philosophy of Black militancy. Like SNCC, the Panthers were vilified in the press and law enforcement agencies as dangerous radicals whose goal was to destroy America.

The Black Panther Party's masculine ethic, with a focus on self-defence and the use of firearms, nevertheless attracted women who supported the group's militant stand against racism. Angela Davis argued that women needed to be tough in order to participate in the BPP and survive in American society at large. She wrote in her autobiography that for Black women, 'the solution is not to become less aggressive, not to lay down the gun, but to learn how to set the

sights correctly, aim accurately, squeeze rather than jerk the trigger, and not be overcome by the damage. We have to learn how to rejoice when pigs' blood is shed'.[90] Tanika (Matliaba) Lewis, a high school student, was the first young woman to join the organization: At age sixteen, Lewis walked into the Panther office and declared, 'Y'all have a nice program and everything. It sounds like me. Can I join? 'Cause y'all don't have no sisters up in here'. When Seale responded in the affirmative, her next question was, 'Can I have a gun'? The answer was also yes.

Lewis became a fixture in the Oakland Panther organization, working on the newspaper and teaching classes, but she was not always respected by her male colleagues and felt she had to prove herself as a strong woman who could out-perform the men. Lewis remembered that, 'the guys came up to me and said, "I ain't gonna do what you tell me to do cause you a sister". I invited them to come on out to the weapons range and I could outshoot 'em'. In spite of the efforts of some women to prove their toughness, male Panthers gained a reputation for treating women badly, even engaging in sexual and other physical abuse. But New York Panther member Assata Shakur joined the group in spite of its reputation for sexism. She said the Black Panther Party 'was the most progressive organization at that time [and] had the most positive images in terms of ... the position of women in the propaganda ... I felt it was the most positive thing that I could do because many of the other organizations at the time were so sexist, I mean to the extreme ... There was a whole saturation of the whole climate with this quest for manhood ... even though that might be oppressive to you as a human being ... For me joining the BPP was one of the best options at the time'.

Eldridge Cleaver, who had been convicted of rape prior to joining the Party and who considered rape to be a political act, contributed to the Party's misogynist reputation. When Cleaver ran for president

in 1968 on the Peace and Freedom Party, he demanded that women should withhold sex from men who refused to vote for him, calling this 'pussy power'. Acts like this notwithstanding, Kathleen Cleaver, the Party's communications secretary, claimed that the organization was not misogynist in comparison to the world the BPP inhabited. When shea was asked by a reporter from the *Washington Post* to describe a woman's role in the Party's political and social revolution, she replied, 'No one ever asks what a man's place in the Revolution is'.

Sexist or not, the Black Panther Party utilized the talents and the labour of women to maintain its programmes in urban areas. 'Pantherettes' supported the revolutionary activity of the men. They supervised breakfast programmes and ran community schools, while providing advice and assistance for community members. In spite of law enforcement harassment and infiltration, murders of Panther leaders, trials, and internal disputes, the Black Panthers, including its women members, contributed to the cohesion of their communities and the militance of the movement for Black equality in the late 1960s.[91]

Tactics such as boycotts and non-violent demonstrations had served the Civil Rights Movement well in its early years. As the violence of segregationists increased, so did the militance of movement groups who asserted that progress through polite demonstration and calls for legal change were too slow. By the late 1960s, the two approaches to demanding equality yielded different results in vastly different ways. Until his break with the Johnson administration over Vietnam in 1967 and his assassination in 1968, Dr King and his followers could claim the high moral ground that raised the consciousness of Americans and contributed to the passage of the 1964 Civil Rights Act and the 1965 Voting Rights Act. The more militant approach and the violence inflicted on SNCC by law enforcement contributed to an ideology of separatism.

Direct action in the form of confronting racism head-on seemed

like the only viable response when peaceful demonstrations, victories in court, and even the passage of major federal legislation did not create a direct path toward equality.

Malcolm X understood the disparity between civil rights goals and the actual lives of African Americans. He wrote that he was 'one of the 22 million Black people who are the victims of democracy, nothing but disguised hypocrisy'. He declared that the movement's strategy had to move toward militance, declaring that there was a 'new strategy coming in. It'll be Molotov cocktails this month, hand grenades next month, and something else next month. It'll be ballots, or it'll be bullets. It'll be liberty, or it will be death. The only difference about this kind of death – it'll be reciprocal. I find you can get a whole lot of small people and whip hell out of a whole lot of big people. They haven't got anything to lose, and they've got everything to gain. And they'll let you know in a minute: "It takes two to tango; when I go, you go"'.[92] Confronting racism directly was at the heart of SNCC's organizing strategy in the South and the altercations with law enforcement involving the Black Panther Party. By 1968, in spite of gains in legal rights, racism remained entrenched in many places, and attacks on civil rights workers were common. In response, the movement had changed, but its influence was felt in other struggles for equality.

The basic tenets and strategies of the Civil Rights Movement, along with the philosophy of direct action, proved to be effective in the struggle for decent pay and working conditions of the United Farm Workers led by Cesar Chavez and Dolores Huerta. Starting as a labour organization, the UFW emerged in the 1960s and 70s as an advocacy group for Chicano (Latinx) civil rights. Huerta was a co-founder of the Community Service Organization in Stockton, California in the 1950s. This group pushed for better working conditions for the Chicano population of farm workers in the region and sought to register those who were American citizens to vote.

Women in the Struggle for Civil Rights

The emphasis on economic development and political participation mirrored the push for economic gains and political rights in the South. Huerta soon became involved in efforts to organize farm workers, many of whom were women, who experienced horrific conditions in the fields and orchards of central California.

In 1962, Huerta and Chavez founded the National Farm Workers Association. In 1965, the NFWA became the United Farm Workers Union, which was accepted into the AFL-CIO in 1972. Huerta served as the union's vice president from its founding to her retirement in 1999.

In a long career of labour organizing, Dolores Huerta worked for the same entitlements for her members that civil rights workers demanded. She pushed for rights, including the right to vote, the right to organize a union, and improved working and living conditions for Latino farm workers, many of whom were similar to those under which Black sharecroppers in the South laboured. She accomplished her goals by leading strikes against grape growers and consumer boycotts of lettuce and grapes as part of a strategy to make the plight of the farm workers visible to the public. By enlisting popular support, Huerta's use of the boycott of table grapes raised public awareness of life in the fields in the same way that the bus boycott in Montgomery and the Freedom Rides made Americans aware of segregation and violence in the South.

Huerta also encouraged state and federal legislation to ban pesticides that were harmful to both workers and their children, many of whom suffered from debilitating birth defects. Huerta demanded dignity for workers and the work they do. While the work of the men and women in the United Farm Workers brought the plight of migrant farm workers to the attention of the American public, many women in the movement were angry at their exclusion from leadership in the movement. They took their organizing skills beyond the issue of civil rights for the Chicano

and Latino populations to found a movement for Chicanas. Like their sisters in the Civil Rights and anti-war movements, Chicana and Latina women were denied the opportunity to develop activist networks and utilize their stills as organizers. In 1970, after attending the National Chicano Issues Conference and finding women's issues unappreciated, Francisca Flores and other Chicana women founded the *Comision Femenil Mexicana Nacional (National Commission on Mexican Women)* specifically to address health, safety, and child care issues related to women and to organize against racism and discrimination faced by Mexican women in the workplace and in American society at large. The Commission is committed to supporting grass-roots community organizing by Chicanas themselves who are most familiar with the needs of their community. Flores and her colleagues followed a path similar to women in the Civil Rights and anti-war movements who faced frustration with male-dominated leadership and were able to organize like-minded women to found their own movement.[93]

SNCC leaders like Carmichael asserted that dignity could be realized only through separation from White allies. For the young White women who had committed themselves to direct action in SNCC, the call in 1966 for separation was devastating. Some women in SNCC left protesting and organizing behind, and some turned their attention to the movement to end the Vietnam War. Eventually, some White women from the Civil Rights Movement found a new voice in Second Wave Feminism. The groundwork for 1960s and 70s feminist activism was laid in both the civil rights and anti-war movements. Two SNCC members, Mary King and Casey (Cason) Hayden were instrumental in bringing the issue of women's equality to the attention of their male colleagues in the organization.

Mary Elizabeth King was born in New York City and raised in New Jersey. Like many of the young women in the early Civil Rights Movement, she came from a religious background, as her father was

a Methodist minister. As a college student, King learned about the student sit-ins in the South and organized campus conversations to raise awareness of the necessity of fighting segregation and racism. She was part of a student group that travelled to Nashville and Atlanta to meet with leaders of the new Civil Rights Movement. At that point, she knew that her place 'was with the movement; there was no turning back ... I knew that's where I belonged'.

After graduating from Ohio Wesleyan University in 1962, King was recruited by Ella Baker to work for the YWCA in Atlanta as a human relations intern. She travelled throughout the region, organizing workshops on college campuses to help students to understand the importance of direct action. Admiring Baker's leadership in the freedom movement, King wrote that, 'If there is any one person that I think deserves the credit for SNCC's philosophical framework, it's probably Ella Baker. She profoundly influenced many of us with her beliefs, which had been constructed through a lifetime of organizing'. King, too, dedicated her energies to fighting racism, but where Baker was content to lead as an individual in spite of pervasive sexism in the movement and in American society, King would become part of a generation that argued for greater respect and autonomy for all women.

Starting in June 1963, King worked with Julian Bond on SNCC's communications efforts, putting her academic background in English literature to effective use. She helped to produce a newsletter promoting SNCC's message and activities that was distributed outside the South. King and Bond encouraged local and national news outlets to report on the violence that SNCC workers experienced throughout the South, noting that, 'Whatever small protection we [SNCC workers] had come through news reports that brought our actions to the attention of the nation and broke the cover of secrecy'. The job was difficult, as many editors feared printing civil rights 'propaganda', being labelled 'communist', or losing readers. King remembered that, 'After the death of President Kennedy, I spent

five days trying to find one reporter who could report on the fact that Bob Moses had told me that the bodies of five Black men had turned up in the Homochitto River near Natchez'. The murder of Black men in Mississippi in 1963 did not sell papers, and SNCC had difficulty gaining press recognition for its actions and the violent responses of the KKK or southern law enforcement.[94]

One of Mary King's closest SNCC associates and friends was (Sandra) Casey (Cason) Hayden, a native Texan. When Cason transferred to the University of Texas at Austin as a junior, she lived in the Christian Faith and Life Community, along with other women who were drawn to civil rights activity, and she was a member of the university's Religious Council's Social Action Committee. Like other activists, Cason's belief in equality emanated from her religious faith, and she soon became a participant in sit-ins to integrate theatres and restaurants in Austin. In August of 1960, Casey attended the National Student Association's national convention in Minneapolis. There, she met Al Haber and Tom Hayden, early members of Students for a Democratic Society, who were impressed with her ability to speak powerfully on behalf of student activism for civil rights. In October of 1960, she joined the new Student Non-Violent Coordinating Committee. She later joined SDS. In 1961, she married activist Tom Hayden, and the two remained active in efforts to bring civil rights to African Americans and to force an end to the war in Vietnam.

Hayden saw her mission as a White woman to be intimately connected to the day-to-day struggle of African Americans. 'As a White Southerner', she said, 'I considered the Southern freedom movement against segregation mine as much as anyone else's'. One of her first jobs with SNCC was working with Ella Baker and Mary King in SNCC's campus human relations project, where the women encouraged White students to get involved in the freedom struggle. In 1963, she travelled to Mississippi to launch a literacy project at

Tougaloo College. On her decision to direct the literacy project rather than taking a position as a field worker in Mississippi, she said, 'Being a White woman meant that wherever I was, the movement was visible, and where there was visibility, there was danger'.

In 1964, Hayden helped to organize the Freedom Summer but was unhappy with SNCC's male-dominated power structure that, despite the rhetoric of the 'beloved community', operated in a hierarchical way that ignored the voices and ideas of women who had demonstrated their commitment and effectiveness in the field. It was common for male leaders throughout the Movement to dismiss women. For example, Roy Wilkins of the NAACP told women workers that they were 'ignorant of the political process, should listen to their [male] leaders and just return home', a sentiment that was common despite the competence, dedication and sacrifices made by women activists.

Hayden was not alone in observing that SNCC leadership devalued the contributions of women. Gwendolyn Zohara Simmons was one of three women who led the Mississippi Freedom Summer as a field director. She remembered that she had to struggle to obtain the same resources and respect as men and that she frequently came into conflict with male SNCC leaders: 'We had to fight for the resources, you know. We had to fight to get a good car because the guys would get first dibs on everything, and that wasn't fair ... it was a struggle to be taken seriously by the leadership, as well as by your male colleagues.'[95] Many women in SNCC and other organizations envisioned a movement that was democratic and inclusive, a vision that did not fit with the organizational paradigm established by male leaders in which gender equality extended to work but not to status or position. Stokely Carmichael's comment that 'The position of women in SNCC is prone', although delivered in jest, nevertheless revealed underlying tensions in the organization based on gender inequality. Women in SNCC were not recognized for their value to the movement and were frequently referred to simply as 'girls'.

Needless to say, this did not sit well with women, but they did not yet have a language with which to articulate their frustration.

The Mississippi's Freedom Summer met with violence and only mixed success. In November of 1964, SNCC staff members met at Waveland, Mississippi to evaluate past programmes, accommodate the large number of new volunteers, and consider their options for future projects. Conference participants were invited to submit proposals for consideration by the whole body, and Hayden, King, and other women wrote Position Paper No. 24 in which they articulated some of the grievances of SNCC women. Known as the Waveland Memo, it was presented anonymously, but recent scholarship revealed that King and Hayden wrote the document, along with Emmie Schrader Adams and Elaine DeLott Baker. The Waveland Memo provided evidence of sexism within SNCC. It included eleven points:

1. Staff were involved in crucial constitutional revisions at the Atlanta meeting in October. A large committee was appointed to present revisions to the staff. The committee was all men.
2. Two organizers were working together to form a farmers' league. Without asking any questions, the male organizer immediately assigned the clerical work to the female organizer although both had had equal experience in organizing campaigns.
3. Although there are women in the Mississippi project who have been working as long as some of the men, the leadership group in COFO (Council of Federated Organizations) is all men.
4. A woman in a field office wondered why she was held responsible for day-to-day decisions, only to find out later that she had been appointed project director but not told.
5. A fall 1964 personnel and resources report on Mississippi projects lists the number of people in each project. The

section on Laurel however, lists not the number of persons, but 'three girls.'
6. One of SNCC's main administrative officers apologizes for appointment of a woman as interim project director in a key Mississippi project area.
7. A veteran of two years' work for SNCC in two states spends her day typing and doing clerical work for other people in her project.
8. Any woman in SNCC, no matter what her position or experience, has been asked to take minutes in a meeting when she and other women are outnumbered by men.
9. The names of several new attorneys entering a state project this past summer were posted in a central movement office. The first initial and last name of each lawyer was listed. Next to one name was written: (girl).
10. Capable, responsible and experienced women who are in leadership positions can expect to have to defer to a man on their project for final decision-making.
11. A session at the recent October staff meeting in Atlanta was the first large meeting in the past couple of years where a woman was asked to chair.

The Memo expressed empathy for African-American men who hated being called 'boy' and likened that to the experience of women being slotted into menial labour because of their gender. The Memo also declared that a woman in SNCC 'is often in the same position as that token Negro hired in a corporation'. This was a bold statement, one that was perhaps more rhetorically effective than factually accurate. The authors of the Waveland Memo realized that their evidence might not provoke much more than conversation, but it was a start. The Memo concluded: 'Maybe the only thing that can come out of this paper is discussion – amidst the laughter – but still

discussion. (Those who laugh the hardest are often those who need the crutch of male supremacy the most.) And maybe some women will begin to recognize day-to-day discriminations. And maybe sometime in the future the whole of the women in this movement will become so alert as to force the rest of the movement to stop the discrimination and start the slow process of changing values and ideas so that all of us gradually come to understand that this is no more a man's world than it is a white world'. It would take another year and another memo for the issue of sexism to be taken even minimally seriously within the leadership of SNCC.[96]

On 18 November 1965, King and Hayden distributed 'A Kind of Memo', later published as 'Sex and Caste', which they sent to forty women in SNCC. In it, they formulated an analysis of the issues in the movement similar to what Betty Friedan had described for suburban wives in 1963 as 'the problem that has no name'. Women in American society at large were considered less competent and rational than men. When they acted with confidence and skill, they were told that they were inappropriately competing with men. Women were told that their place was with home and family. If they sought professional growth outside the home, they were told that they were ignoring their husbands and children. The message was clear that women's greatest joy should come from helping others. Even when they left home to work for the dignity and rights of others, they were assigned to make coffee and take notes at meetings. Women were told that they did not comprehend politics. When they took on the political establishment, they were accused of being communists or, worse yet, dupes of the communist conspiracy.

The authors of 'Sex and Caste' attributed women's situation to a hierarchical system that trapped them in both their work and personal lives. Women in the movement, they wrote, 'seem to be caught up in a common-law caste system that operates, sometimes subtly, forcing them to work around or outside hierarchical

structures of power which may exclude them. Women seem to be placed in the same position in personal situations too. It is a caste system which, at its worst, uses and exploits women'.

King and Hayden did not offer solutions to the specific problems in SNCC outlined in the Waveland Memo. They were most concerned that men in the movement did not take women's issues seriously and that women did not as yet have an effective language with which to articulate their grievances and propose solutions for themselves. They observed:

'A very few men seem to feel, when they hear conversations involving these problems, that they have a right to be present and participate in them, since they are so deeply involved. At the same time, very few men can respond non-defensively, since the whole idea is either beyond their comprehension or threatens and exposes them. The usual response is laughter. That inability to see the whole issue as serious, as the strait-jacketing of both sexes, and as societally determined, often shapes our own response so that we learn to think in their terms about ourselves and to feel silly rather than trust our inner feelings. The problems we're listing here, and what others have said about them, are therefore largely drawn from conversations among women only – and that difficulty in establishing dialogue with men is a recurring theme among people we've talked to'.[97]

The answer would be a long process of consciousness raising and legal battles to bring women into the main currents of American society and politics as full participants. Soon, the term 'feminism' would be heard around the world, and young people would engage in a multi-faceted effort to end a war, reform society, and acknowledge the worth of women. In the meantime, Americans, at first mainly men but eventually women too, found themselves involved in a land war thousands of miles away, in a place called Vietnam.

Chapter Four

Women in the War

We frequently describe war as the domain of men – from generals and infantry troops to grave-diggers. Fighting is the business of men, and women are not supposed to fight. Women support soldiers in combat, maintain life on the home front, and mourn the dead. The ethos of war demands that a soldier 'fight like a man'. To show fear is to be a 'pussy' or a 'little girl'.' But history tells us that women have always had a part in war, however small, marginal, or underreported. And women have always mourned the dead.

During the Vietnam War, Vietnamese women, especially in the north, were warriors as well as mothers, while American women were expected to be supportive actors, both at home and in combat zones. Over time, American nurses, intelligence officers, journalists, and others began to challenge the patriarchal and misogynist stereotype that women were less capable of performing military duties than men. In challenging popular assumptions about women's abilities, they demonstrated bravery under fire, earning recognition and grudging respect. With respect came the confidence to speak for themselves about the inequities they faced and, eventually, the courage to fight for their rights under law and in society as a whole.

America's war in Vietnam lasted nearly twenty years and created millions of casualties – dead, wounded, or damaged by Agent Orange, drugs, or the effects of combat. Even before the undeclared conflict in the region began, Vietnam had been ravaged by war and conquest. Brutal struggles with Chinese conquerors date back to the first century AD, and Japan frequently asserted its claim over the region. In the summer of 1941, Japan invaded what was then called French Indochina and ruled Vietnam with extreme cruelty.

The Vietnamese were accustomed to resistance, and in December of 1944, Vo Nguyen Giap formed a small group of communist guerrillas known as the Viet Minh who challenged Japanese rule. Some of Giap's fighters were women who trained with firearms and absorbed the same lessons in communist theory and Vietnamese nationalism as the men.

As Japan prepared to surrender to the United States in the Second World War, the women of the Viet Minh helped to raid Japanese food storage facilities to feed starving villagers. By the late summer of 1945, Ho Chi Minh had become the leader of the Viet Minh and had established the capital of Vietnam in the northern city of Hanoi. Ho declared Vietnam's independence on 2 September 1945, but the French refused to recognize the independence of its former colony in Southeast Asia. France committed troops to the region and a war for the future of Southeast Asia was underway.

Ho's *Declaration of Vietnamese Independence* recognized women in its reference to Thomas Jefferson's assertion that 'all men are created equal'. Ho included women in his definition of 'people', which was indeed revolutionary in a small country founded in part on Confucian ideas of acceptance and obedience, especially for women. Lady Borton asserted that Ho's language in the *Declaration* was intentional and that he knowingly 'changed "All men are created equal" to "Each *person* is born equal". By changing the American quotation's language and its intent, Ho Chi Minh expanded Việt Nam's Declaration to include women and ethnic minorities. This change, as well as the openness associated with it, encouraged women to support Ho Chi Minh's government'.[98] A sense of equality energized North Vietnamese women to fight against France and then the United States. Women felt they were an integral part of Ho's nationalist and communist revolution.

Ho's forces faced many obstacles, especially after the French recaptured Hanoi and tried to reclaim all of Vietnam. Once the French

reasserted their claim to power in Southeast Asia, American support shifted from nominal diplomatic support for Ho's nationalist goals to monetary aid for France as it attempted to put down Ho's insurgency. Despite losses that strained Vo Nguyen Giap's guerrilla army as well as the civilian population, the war against the French ended on 7 May 1954, when Viet Minh forces laid siege to the French at Dien Bien Phu. The defeat marked the end of French colonial rule in Indochina. Giap's victory was facilitated by local tribeswomen who carried pieces of artillery that had been disassembled for reassembly at the top of the mountain. Women provided food and other vital supplies to the Viet Minh forces and helped to evacuate Viet Minh dead and wounded.

There were a few women stationed with the French forces who tended to the wounded and helped to evacuate them after the surrender. Lieutenant Genevieve de Galard was a French Air Force flight nurse who arrived in Indochina in May of 1953. She served as a *convoyeuse*, tending to wounded soldiers on evacuation flights. In March of 1954, her transport plane was damaged and made an emergency landing, stranding her at Dien Bien Phu. She was the only nurse present as the French surrendered and casualties mounted. Her dedication to her patients helped to overcome prejudices against having women in a combat zone, but her contributions were clearly in the realm of traditional women's work. Besides, she had no way to escape Dien Bien Phu, as the Viet Minh had destroyed the only runway.

Galard was not the only woman who provided aid to the soldiers at the isolated outpost. At Dien Bien Phu, there were two *Bordels Mobiles de Campagne* (Mobile Field Brothels) populated by women from Vietnam and Algeria. It was common practice for the French military to provide regulated brothels for soldiers, and the women who worked in the primitive setting of Dien Bien Phu were, like Galard, stranded and under siege. Galard and the women from the

brothels nursed the wounded as the siege dragged on. They fed the soldiers and tended to their wounds in the garrison's hospital unit located underground. They wrote letters to soldiers' families and provided comfort to the dying in extremely difficult and dangerous circumstances. After the surrender, thousands of French troops were marched to prison camps, and hundreds more died in the Vietnamese jungle. Galard served for the entire siege, a total of seventy-four days. For her bravery and dedication, she received the *Legion d'honneur* from the French government. Her service was also honoured by the United States Government with the Medal of Freedom, presented by President Eisenhower on 29 July 1954. At the Rose Garden ceremony, the president called her 'the woman of the year'.[99]

When French rule in Vietnam came to an end, the United States stepped in to put down the Vietnamese struggle for independence. In the Cold War climate of the 1950s, it was more important for the United States to support France's goal of maintaining an anti-communist government in Vietnam, thereby keeping France as a NATO ally, than to support the independence of a former French colony. Vietnam was one of the dominoes described in the theory that, if one country in the region fell to communism, others would fall in sequence.

In July of 1954, just two months after the fall of Dien Bien Phu, the Geneva Accords established the 17th parallel as the line of demarcation between North and South Vietnam. Ho's forces controlled the North, while Ngo Dinh Diem served as president of South Vietnam in 1955 with the support of the United States. American diplomats knew Diem was a brutal and corrupt dictator with little chance of success, but they saw no better option for South Vietnam. Diem used repressive measures against the country's Buddhist minority and nationalist forces that wanted to hold elections called for in the Accords, confident that Ho would emerge victorious in a united Vietnam.

Don't Call Us Girls

From 1954 on, it was America's war, and by the start of the Kennedy administration it was a test of the country's resolve to 'pay any price, bear any burden to assure the survival and success of liberty' while advancing the interests of the United States. American troops arrived in Vietnam originally as advisors to the hapless Army of the Republic of Vietnam (ARVN), which was reorganized under central government control in December of 1955. Beset by corruption and inadequate leadership, ARVN troops needed training and weapons. Called advisors, American military personnel in Vietnam were not supposed to engage in combat, but enemy shells and bullets did not discriminate between official military units and advisors. Although the numbers at first were small, American advisors were killed by enemy fire in Vietnam as early as 1956.

In 1965, the ARVN created the Women's Armed Forces Corps (WAFC). Major Ho Thi Ve commanded the all-female unit, which instructed women recruits in military procedures and drills as well as physical conditioning, first aid, and weapons training. Enlisted women were required to have five years of schooling, and priority for positions was given to the widows of soldiers killed in action. Starting in October of 1966, after the first successful year of training enlisted women, the WAFC began training female officers in leadership, military strategy, public speaking and military law. Officer candidates were required to have completed eleven years of schooling, and their tour of duty was typically four years. Both officers and enlisted personnel were confined to jobs that fell within the limits of acceptable roles for women in South Vietnamese society, such as security or office work. An ARVN pamphlet published by the Vietnam Council on Foreign Relations titled 'South Vietnam's Women in Uniform' stated that 'the role of the Asian woman is a passive one.

'Kept in the background, girls are raised to be feminine and dependent, to stay at home caring for husband and family. Twenty

years ago, the idea of a female soldier was even more far-fetched than that of a woman doctor or lawyer. But years of war have brought women into a man's world, partly by necessity, partly by choice'. Despite the difficulties of food shortages, government mismanagement, an army with weak leadership, and the assumption that a woman's proper place was with her husband and family, many women did contribute to the South Vietnamese war effort by joining the army or a militia unit.

The South Vietnamese Rangers was a specialized unit of the ARVN open to women. Its soldiers were trained in specific military roles, and they fought bravely. Madame Ho Thi Que was trained as a medic and held the rank of master sergeant in the 44th Ranger Battalion, which was also called the Black Tigers. She was called the 'Tiger Lady of the Mekong Delta'.

Ho was a fierce fighter, but she also tended to the wounded and dying and helped the families of soldiers killed in action to receive government benefits to which they were entitled, earning the fond nickname Big Sister from her comrades in the Rangers, who remembered her for both her temper and her kindness. Many Rangers had felt her wrath when she caught them stealing a chicken or looting a villager's belongings. She often reverted to swearing, shouting, and sometimes even slapping the culprit. But at other times, her compassion and understanding were the soothing balm that comforted a wounded or dying soldier. Ho felt a deep sense of responsibility for all her Ranger brothers and sisters. Opposing Viet Cong soldiers referred to Ho as 'Madame Death' for her fierce exploits on the battlefield. Armed with a pearl-handled Colt .45 pistol, she was visible as the soldier who wore a helmet with black and yellow stripes, the emblem of the Black Tiger regiment.[100]

Women were eventually permitted to receive specialized training in areas such as intelligence, social work, the signal corps, and administration. In the mid-1960s, a few ARVN women were

trained at Fort McClelland in Anniston, Alabama in roles that were specialized but decidedly supportive in nature. For example, women in the Air Force could serve as telephone operators or social workers but not as fighter pilots. In a few instances, women were permitted to undergo airborne training in which they learned how to parachute out of airplanes, but it was clear that the so-called 'daredevil girls' would not actually serve in combat. One commander went so far as to say that these women engaged in this dangerous training for 'fitness and fun'. Even in limited support roles, women were eager to defend their country, and more than 4,000 women served South Vietnam in uniform.

South Vietnam remained a conservative society with respect to the position of women, even as demands of war forced some relaxation of traditional mores and rules. After the Tet (Lunar New Year) Offensive of January 1968 in which North Vietnamese forces led by general Giap attacked one hundred locations in the South, including the United States Embassy, which was thought to have been impenetrable, attitudes about utilizing women in the military modified a bit. But prejudices still existed about women's proper place in Vietnamese society. An attempt to draft women ages eighteen to twenty-five died in the South Vietnamese National Assembly because of opposition by conservative representatives who did not want to see women in the military at all.

This reminds us that women were volunteers, not conscripts, who often faced opposition from male relatives regarding their decision to serve. One young woman described her brother's opposition to her serving in a militia unit: 'He did not want me to join the armed forces. He worked in military communications and he rarely came home to visit my mother. I lived with my mother and younger sibling. Every time he came home, I had to hide my uniforms in my neighbour's house. The jeep sent to take me to work had to pick me up at another place instead of in front of my house. I had to change

at my neighbour's. I did not dare wear the uniform in his presence. Once I had lunch at my friend's house and her parents said, "Thuy, you look very tanned lately because of your parachute". My brother said immediately, "Let's go home, it is late". Once we got home, I received a terrible beating'.[101] South Vietnamese women did have the opportunity to receive weapons training in the People's Self-Defence Agency, whose units were considered local militias. Nearly 100,000 were trained in potential combat roles outside the regular military. Although these women were trained to shoot, they were still considered support personnel.

Life could be very difficult for the wives of conscripted South Vietnamese soldiers. In Vietnamese culture, both North and South, family ties are extremely important. Records from what was then the South Vietnamese Defence Ministry reveal that civilian women often wrote letters to military officials pleading to have their husbands transferred closer to home so they could meet family obligations, particularly the raising of young children. We do not have precise figures as to how many women were successful in bringing their soldier husbands closer to home, but we do know that the number of desertions from the ARVN was high, in part because of the conflict between serving one's country as a conscripted soldier, and providing for one's family.

On the home front, women in South Vietnam supported the war effort by conserving food and donating supplies to the military. Women were trained as nurses, an essential function but one still defined as women's work, while some volunteered for the International Red Cross or other humanitarian relief organizations. Civilian women could also become more politically and socially engaged by reading popular magazines that featured articles about South Vietnamese progress toward democracy as well as fashion, advice columns, and short stories. The goal was to provide an alternative to North Vietnamese propaganda that stressed the

unification of the country and the defeat of United States forces. *Phu Nu Mou*, translated as 'New Woman,' was among the most popular of these journals. Vietnamese women's magazines, like those they imitated in the United States, appealed to middle-class women. One issue that aroused the interest of women in Saigon was helping rural women whose villages were destroyed by combat. The magazines encouraged the government to provide help for rural families to avoid the growing problem of prostitution in the cities and near American military bases, as young rural women had few other options to help support their families whose land could no longer support crops because of mines or chemical defoliants. [102]

Life in South Vietnam had been difficult under the French, and it remained just as hard after the United States took over the fight in 1954. The French had controlled the cities and the Viet Minh had dominated rural areas. In South Vietnam, governments came and went, and corruption was the consistent characteristic of all of them. Le Lieu Browne was a Vietnamese woman who grew up during French colonial rule and worked for a time in the Diem regime, which ended with Diem's assassination in October of 1963. She recalled that after Diem's demise, 'the military generals competed with one another to take power and there was one coup after another.

These Vietnamese generals had no experience in administration. They were even more corrupt than Diem… It wasn't good to have generals as presidents. They gave me no hope. But the American build up also left me sceptical. If the French who colonized our country for a century could not win our support, how could the Americans, the newcomers with a different culture and language, hope to win the war against the Communists? We seemed to return to the situation in the fifties in which the government controlled the cities and the Viet Cong controlled the countryside. Corruption and police harassment made people distrust the government and sympathize more with the Viet Cong. But still, I didn't think the Viet

Cong would win. I just thought that the war would go on forever'.[103]

Military leaders in North Vietnam realized early in the war that women's participation would be necessary for victory. Inspired by an ancient Vietnamese saying that, 'When war comes even the women have to fight', women answered the call to unite and defend their country. At the same time, North Vietnamese women were struggling for greater personal autonomy and rights. The numbers are imprecise, but it is likely that at least 1.5 million women served in formal armies or militias. The most prominent of these was the National Liberation Front of South Vietnam's military which was called the Viet Cong, founded on 20 December 1960. The VC, as American soldiers called them, fought a guerrilla war in the South, using primitive booby trap devices and land mines as well as traditional weapons to impede the progress of the American military. North Vietnam's regular army also included women.

American soldiers in Vietnam between 1954 and 1973 held two negative stereotypes of Vietnamese women. One was that of the Mama-san, an older woman who could be a domestic worker, a beggar, or the owner of a brothel. Most important from a soldier's point of view, Mama-san was dangerous. She might appear to be selling trinkets but would have a weapon – a pistol or a grenade – hidden in her clothing. Soldiers never knew whether the old woman in the marketplace was friend or foe. Another danger lay with the image of the Vietnamese prostitute. She might be a source of pleasure, but she could transmit a disease or slit the throat of a patron. The real women of Vietnam, North and South, most of whom fit into neither stereotypical category, proved to be brave and loyal soldiers. Those who were loyal to Ho could be dangerous to American soldiers, too.

Women in North Vietnam were experienced in running organizations devoted to their interests. Founded in 1930, the Vietnamese Women's Union promoted (and continues to promote to this day) women's advancement in society and politics as well

as gender equality. Members founded schools, medical clinics, and charitable organizations that utilized the talents of women to promote their interests and those of their families. The organization also advocated for reduced rents and equal wages for men and women doing the same work. By the early 1960s, the Women's Union pressed for education for women so they could assume prominent positions in government. At the organization's Second Congress, the Vietnam Women's Union stressed women's education 'to confidently promote women's cadres and develop their abilities in taking part in the management of production and in state management'.

For Women's Union members, the liberation of women was a precondition for the betterment of Vietnamese society.[104] In 1965, a delegation from Women Strike for Peace met with representatives of the North Vietnamese Women's Union in Hanoi. The American women were inspired by the Vietnamese women who contributed to the revolutionary nationalist struggle against a major world power. The motivation of the women who fought against the French and then the United States in Vietnam ranged from patriotism to revenge for attacks on their villages.

The North Vietnamese government promised greater freedom for women in recognition of their new status as female soldiers. Women, like their male colleagues, were imbued with a strong spirit of nationalism. Despite centuries of conquest and colonization, North Vietnamese women took pride in the idea of a unified Vietnam. They were inspired by communist ideology that stressed self-determination and independence from imperial powers such as France or the United States. In North Vietnam, civilian women were encouraged to manage their households in their husbands' absence, run their family farms to raise food for their families and surpluses for soldiers and poor people, and join their local militia and learn to fight. They saw the struggle for Vietnamese unification and independence as revolutionary for the nation and for themselves as women.

Truong My Hoa was a young woman born into a revolutionary family. She was drawn to Ho's vision of a united Vietnam under communist rule. She wrote that her involvement in Vietnam's revolution began in 1960, when she was just 15 years old, 'when the Saigon regime took its guillotine throughout the South to behead patriotic revolutionaries and even non-revolutionary common people. I realized in my heart that we had no alternative but to struggle against the Diem government and its henchmen. That was the only way we could achieve peace, independence, and unification. Because of Diem's terror in the countryside, my mother took us to Saigon. There, right in the gorge of the puppet regime, I became a revolutionary. I participated in propaganda aimed at mobilizing high school and college students. We urged them to resist military conscription and the invasion of our country by American imperialists'.

Like many women revolutionaries, Hoa was captured and interrogated by South Vietnamese officials. She described her experience after her arrest on 15 April 1964:

'The Saigon Military Tribunal accused me of disrupting order and political stability. I was officially sentenced to eighteen months of confinement, but they kept prolonging the sentence and held me in prison for eleven years. I was released on March 7, 1975. Over the years I underwent a lot of interrogation and torture.... Always they asked me if we were going to talk, or not, and they slandered our political loyalties. They tried to make us salute their flag and condemn Communism. They tried to make us say, 'Down with President Ho!' And, of course, they wanted to know about our revolutionary organizations and bases. But we would rather die than bow to their will'.[105]

North Vietnamese women helped to protect the Ho Chi Minh Trail, a complex network of roads and narrow paths that ran between North and South Vietnam for more than six hundred miles. Built

over many decades, the Trail was the major supply route for Viet Cong forces. Women organized transportation along the trail, which was the primary conduit for heavy equipment, supplies, and troops travelling from north to south. Women repaired the roads after bombing attacks, helped to build new roads to expand the Trail's network, and guarded the Trail with automatic weapons. They also served as emergency medical workers and combat soldiers. Tran Thi Tuyen was a young nurse who helped to build a field hospital on the Trail. Conditions in the jungle were dangerous, and the Trail was frequently subjected to bombing raids that disrupted the flow of supplies. At the age of only sixteen, Tran helped to care for the wounded until she returned to her village to recover from malaria.

Women were the primary fighters in the Thanh Nien Xung Phong, the Youth Shock Brigades. Founded in July of 1950, the Brigade members, girls, and young women between the ages of thirteen and twenty-two, fought in some of the most dangerous battles, especially along the Ho Chi Minh Trail. They were fully committed to the cause of communist revolution and Vietnamese reunification and independence. One veteran of the Brigade recalled that before a battle 'they always left first for the frontline to open the roads, to prepare the front, and then to participate directly in the battle, and mostly it was they who came back last, after having cleaned up the battlefield and buried those who died at the front'.[106] The Youth Shock Brigades were testament to Ho's commitment to bringing young people into the battle for the future of Vietnam.

Most women warriors in the North served under male commanders, and most remain unrecognized by name. One exception is Le Thi Hong Gam, a young woman sharpshooter. Legend says she shot down an American helicopter by herself. Another was Dang Thuy Tram, a physician who served as a field surgeon with the Viet Cong and the People's Army of Vietnam. Her diaries, published after her death in 1970, revealed the horrific conditions under which male

and female medical professionals operated, including a lack of basic supplies and the danger of frequent bombing raids. Without question, the work of the women fighting the United States was important in ending the war.

American soldiers in Vietnam frequently complained that it was difficult, if not impossible, to tell friend from foe, particularly with regard to women and children. The friendly prostitute or old woman selling vegetables in the market might turn out to be a Viet Cong fighter or a spy. Women were particularly effective spies, in part because of the assumption that women could not be effective in such a dangerous role. Appearing shy and obedient helped to make women effective spies. Lady Borton ascribed some of the qualities that helped women to be ideal spies to Confucianism, which emphasized a subservient role for women in society. Vietnamese women had learned to be 'present but seemingly innocuous, unaware, silly if they were younger or dim-witted if older. They were experts at acting and at being ignored. This made them perfect spies'.[107]

Women were especially adept at gathering information from conversations in the marketplace. For example, Nguyen Thi Hoa sold hats in the Hue market, picking up bits and pieces of valuable information from overheard conversations, which she communicated to Viet Cong officers. Hoa was a member of the eleven-member Perfume River Squad, an all-female network known for their strategic contributions as both spies and combat fighters to North Vietnamese victories in the South. The Perfume River Squad's espionage efforts contributed to the success of the Tet Offensive and was lauded in poetry by Ho Chi Minh. Women also encouraged young people to eavesdrop on family conversations, and they gleaned valuable information while working on American military bases as housekeepers, waitresses, or other support personnel.

Many female spies and informants were arrested and tortured, but their morale remained high. When Vi Thi Thang was arrested

after she was unsuccessful in assassinating a South Vietnamese spy, she was sentenced by a South Vietnamese military court to twenty years of hard labour in the Con Bao prison. Her response revealed her confidence in the revolutionary cause. She asked the military authorities, 'Will your government last long enough to imprison me for twenty years?' If the South Vietnamese authorities did not fully comprehend the value of women warriors and spies, leaders in the North acknowledged the importance of women's contributions to the war effort with commendations like the Hero of the People's Armed Forces award that recognized 'exceptionally outstanding achievements in combat, combat service and work representing revolutionary heroism in the cause of national liberation, national defence, and the protection of the people'.

This was high praise indeed. Two women received this recognition. Colonel Dinh Thi Van began intelligence work in the 1950s, established a network of spies for the North, and talked her way out of captivity when she was captured by South Vietnamese forces. Li Thi Thu Nguyet, a member of Biet Dong Saigon (Saigon Special Force), blew up an American Boeing 707 on 25 March 1963, when it landed in Honolulu on a flight from the Tan Son Nhut air base in Vietnam. While the explosives timer malfunctioned and caused the explosion a few minutes after the American advisors had left the plane, this event was a major propaganda victory for Ho's revolutionary forces. For this exploit, Li earned the nickname Chim Sat, the Iron Bird.

In preparation for the 1968 Tet Offensive, women drove oxcarts loaded with coffins. The Americans couldn't figure out why so many people seemed to be dying. They discovered too late that the coffins concealed rifles and ammunition. Other women loaded rice into hanging baskets suspended from shoulder poles and pretended they were going to market, when in fact they were actually transporting medicine and grenades. Still others filled

their small river boats with medicine, rifles, and ammunition.[108]

A few months after Tet, Ngo Thi Thuong made a personal contribution to the war effort. Her regular job consisted of bringing food and supplies to soldiers in the South, but one day in June of 1968, when she was transporting goods, 'three US airplanes discovered us and began to shoot at us. So we took our guns and fired back. When I shot the first time, I didn't hit the plane. So I lay down and placed the rifle against a tree and aimed. When I shot the second time, I shot right at the gas tank, and the whole airplane exploded, and crashed into the next hill... Then I saw something falling from the sky – I thought it was a bomb, but actually, it was the pilot parachuting down. So I ran, followed the parachute. When the pilot landed, he had already untied one side of his parachute, but I came and put my gun right to the guy's neck, and said, "Stay still". He raised his hands, and I told my friends that they should cut up the parachute rope, so we had something to tie him with'. For Ngo Thi Thuong, shooting down an American plane and capturing the pilot was seen as an extraordinary feat for a woman, but she considered her actions to be little more than business as usual. At the time, she did not receive any special recognition for her heroism. But thirty-six years later, Thuong received a call from General Giap, praising her brave actions.[109]

Viet Cong and North Vietnamese women were also instrumental in the propaganda effort aimed at American soldiers. Trinh Thi Ngo broadcast messages to American troops intended to lower their morale and encourage them to desert. Known as Hanoi Hannah, she followed in the footsteps in the Pacific Theatre of the Second World War's Tokyo Rose, whose broadcasts were infamous among American soldiers. Trinh also called herself Thu Huong, which means Autumn Fragrance. She read prepared scripts from the Voice of Vietnam for thirty minutes each day, hoping to convince American troops of the futility of their efforts in her country. In one

broadcast, she exhorted American soldiers to 'Defect GI. It is a very good idea to leave a sinking ship... You know you cannot win this war'. She even provided some political analysis of the war, as in this June, 1967 broadcast: 'It seems to me that most of you are poorly informed about the going of the war, to say nothing about a correct explanation of your presence over here. Nothing is more confused than to be ordered into a war to die or to be maimed for life without the faintest idea of what's going on'.[110]

The lives of two women, Madame Ngo Dinh Nhu and Nguyen Thi Binh, represent many of the divergent characteristics of South Vietnamese society. The woman known as Madame Nhu, whose birth name was Tran Le Xuan, served as South Vietnam's First Lady between 1956 and 1963. Vietnam's President, Ngo Dinh Diem, never married, and Madame Nhu was married to his brother Ngo Dunh Nhu, the corrupt director of South Vietnam's secret police. Her family had amassed immense wealth from its relationship with the French colonial government, and she was accustomed to the trappings of wealth garnered from deals with the French colonial government. Madame Nhu was called the 'Dragon Lady' because of her sharp tongue and her cruelty toward the South Vietnamese people. She abandoned her Buddhist faith for Catholicism and mocked the Buddhist monks who set themselves on fire to protest her brother-in-law's oppressive treatment. She referred to these events as 'barbecues' and told reporters that they should clap their hands whenever a monk sacrificed himself in the name of religious and political protest.

Madame Nhu's goal was to promote herself and her vanity projects such as statues of the Trung sisters while maintaining her luxurious lifestyle. She browbeat the American administration into paying for an all-women's paramilitary force that served her, not the nation, and there were stories that both Diem and Lyndon Johnson were afraid of her. Madame Nhu and her husband represented the excess,

corruption, and authoritarian rule that ultimately destroyed South Vietnam.[111] Like South Vietnam itself, Madame Nhu represented corruption and the antidemocratic values that predominated in the country. Her reign ended when Diem was assassinated in October of 1963.

Nguyen Thi Binh was also from South Vietnam, but, unlike Madame Nhu, she devoted her life and diplomatic career to improving the lives of the Vietnamese people. Binh served as the Minister of Foreign Affairs and chief negotiator for the Provisional Revolutionary Government of South Vietnam at the Paris peace talks between 1968 and 1973. Binh was born in Saigon and grew up in a revolutionary family that supported an independent Vietnam. As early as her student days, she was a vocal opponent of the French colonial government. Binh led an anti-French demonstration in 1950 and was held in a French prison from 1951-53. After the departure of the French, Binh continued to oppose the occupation of her country. At the Paris peace talks, she was a persuasive speaker who pushed the drawn-out peace process toward a conclusion. Binh was the only woman to sign the peace agreements. She recalled her emotions as she affixed her name to the final document, saying that it was a great honour 'to represent the Vietnamese people and revolutionary soldiers in the direct struggle against invaders and to sign the successful agreement after the Vietnamese people's eighteen years of just war. I thought about my family, my husband and children, my relatives, compatriots and comrades, my international friends and overseas Vietnamese. My tears flowed again. That was surely the deepest experience in my diplomatic life'.[112]

When the war ended, the Vietnamese women went home. They returned to lives of managing their households and raising their children, but the war could not be forgotten, and the desire for peace was strong. Le Thi My Le, who served in a youth brigade and led a group of ten other soldiers, reflected on her experience:

'I still dream about the war sometimes. I dream about when a bomb is about to explode, and I shout to my unit to lie down. I have seen so many things, saw eight out of ten people in my unit become wounded or die at once. War is cruel. Cruel. When you have a war, people and families are divided – between husband and wife, parent and child. Now my wish is that there is no war in the world, that we can help each other lead our lives instead of fighting. That is my message. I want peace'.

Nguyen Thi Hoa, who had served as a conduit for valuable information to the North Vietnamese forces from her stand in the market in Hue, saw progress for women in a united Vietnam after the war, despite trade embargoes, a struggling economy, and ostracism from much of the world community: 'The war did change the position of women in society. After the war ended in 1975, the country tried to set a new standard for women. We called this the Woman of the New Life; they are faithful to the family, but they also have a chance to study and to be successful. Now, we can contribute to building society and also take care of raising our children. The war made me a better mother, taught me a new way to raise my children – as a liberated woman'.[113]

By mid-1968, the United States had deployed approximately 500,000 military personnel in Vietnam. During the Vietnam era, about 285,000 women served in a variety of support, non-combat military roles at home and throughout the world, with as many as 11,000 serving in Vietnam and Japan, the Philippines, and Guam as early as 1956. They were volunteers, not subject to conscription. After basic training, military nurses, most of whom were in the Army, attended Officer Candidate School and began their careers as second lieutenants. Like their male counterparts, they first served as advisors who trained Vietnamese military personnel. By 1963, the Army Nurse Corps had become a significant presence on military bases and in field hospitals as the number of casualties increased. In

addition to serving in the Army, female nurses served on two Navy hospital ships in the South China Sea. Women Air Force medical personnel were assigned to planes that evacuated severely wounded service members to hospitals outside of Vietnam.

American nurses volunteered for service in Vietnam for a variety of reasons, ranging from patriotism, a desire to escape a 'boring' existence in a suburb or small town, a personal call to do meaningful nursing work, or as a way to pay for their nursing training. On occasion, military recruiters were less than forthcoming about the need for nurses in Vietnam, falsely suggesting to recruits that they would not be sent to Southeast Asia, but most knew where they were going. Even so, it was nearly impossible to train them for the severity and brutality of the fighting, the gravity of soldiers' wounds, or the conditions in field hospitals. One woman who served at the primitive hospital unit at Cu Chi from late 1969 to late 1970, a particularly dangerous time in which casualty numbers were very high, summarized her reasons for volunteering. She wanted to do something to help American soldiers, but she also had other motives: '[T]here was the Kennedy thing, "What can you do for your country"? I was part of that era, of that generation, and I thought, "this is perfect, I can serve my country, I can express my feelings about the war, I can get out of New York, and there's lots of adventure. Plus, it pays for my last year of nursing school"'. Most American nurses were young, White, and the daughters of Second World War veterans. Although some opposed the war, their sense of patriotic duty and a desire to help fellow Americans took precedence over anti-war sentiments.

Unlike the North Vietnamese women who fought the United States, the American women who volunteered to serve their country in Vietnam were not required to manufacture ammunition in an underground defence plant or pick up a weapon and join male soldiers on the battlefield. Indeed, Army nurses often complained

that they received no weapons training or instructions as to what to do when their hospitals came under enemy attack. American women were not asked to serve for the survival of their country as were the women warriors of North Vietnam. Instead, they served an ideal of democracy that the United States sought to bring to the world. These American volunteers expressed a strong commitment to their country and to service in their chosen professions. They excelled as medical personnel, journalists, and missionaries. Nurses often described the bond they felt with their patients. They frequently transcended the requirements of traditional nursing to provide extraordinary care for soldiers under the worst conditions.

American nurses were eager to help the sick and wounded in Vietnam, but they were generally under-prepared for what awaited them in country. About sixty per cent of military nurses had less than two years of nursing experience prior to their service in Vietnam, and many had worked for less than six months in any medical setting. Most had never worked in an emergency room, which would have provided almost comparable experience to working in a field hospital in a war zone. Lieutenant Marsha Four, who served at the 18th Surgical Hospital at Camp Evans north of Hue, remembered how 'green' she was when she arrived in Vietnam. She had come directly from her nursing training to the military and had no experience 'in emergency room nursing, no trauma nursing, very limited/almost non-existent intensive care training. I was a totally, totally green nurse. To say "challenging" doesn't come close to the feelings that I had about being incompetent. Their lives were in my hands. I was responsible for them. And I'm not talking about somebody who's got a broken arm'.

When nurse Mary Sweat arrived at the 67th Evacuation Hospital in Qu Nhon from her home in Kansas in 1970, she was frightened at what she faced, remembering that 'The air was so smoky. It seemed so foreign. You say to yourself, "Do they shoot you wherever you are?

You just had no idea what to imagine'". Her medical unit stabilized critically wounded soldiers so they could be transported to larger hospitals in the Philippines, Guam, or Japan. The stress of seeing severely wounded men shipped out and never seeing them recover likely took a severe toll on doctors and nurses who were committed to healing.

Unlike the well-equipped hospitals on large military bases, field hospitals were in areas subject to heavy enemy fire, and casualty numbers were high. Shifts were not determined by the clock but by the presence of wounded. Typically, medical personnel worked in twelve hour shifts six days each week, but when the number of wounded increased, nurses and doctors could work for days with little sleep. Nurses could be responsible for the care of as many as fifty patients at a time in a dangerous and stressful environment. Some nurses described their tour of duty in Vietnam as consisting of work, sleep, and more work. These conditions, along with the emotional stress of seeing young men die day after day contributed to depression and post-traumatic stress disorder once nurses returned to the United States.

The Veterans Administration did not acknowledge the impact of post-traumatic stress disorder on soldiers until 1980. In the decades since then, as more and more women have served in combat zones, more resources have been made available to provide treatment of this disorder among women veterans. In Vietnam, housing conditions could range from standard military Quonset huts to primitive tents, and personal supplies such as toothpaste and shampoo were difficult to obtain. Conditions in the hospital units ranged from primitive to dangerous, especially in locations like Cu Chi, which saw frequent incoming mortar fire. The hospital beds were made of iron with no cranks to lift the patients: 'so if you wanted to lift the head of the bed, you had to lift it up'. Grace Moore remembered that hospital staff 'used sandbags

for traction and a hose to clean the floors, there was no running water'. Even the most basic medical procedures could lead to severe infections. Conditions in field hospitals rendered wounded soldiers vulnerable to infection, making recovery difficult to manage. The job of military nurse required flexibility, resilience, and a willingness to take responsibility for medical decisions.

Civilian nurses in the United States served as assistants to doctors and were seldom encouraged or even permitted to make medical decisions or perform difficult procedures such as removing shrapnel from a wound. In Vietnam, hospital work, especially in the operating room, required nurses to perform beyond their training. This could be liberating for nurses who were more comfortable in military fatigues than starched white uniforms and who saw themselves as professionals capable of playing an active role in their patients' medical care. Most nurses in Vietnam served the standard one-year tour of duty, while some remained for two years because of their dedication to the soldiers they served.

Most recruiting advertisements for volunteer military nurses were directed at young White women. At first, the posters and pamphlets emphasized the 'romance and adventure' of serving in faraway places. Eventually, the recruiters realized that professional nurses wanted professional responsibilities. One ad in 1969 proclaimed, 'Today's Army Nurse can do more. Heading up her own staff. Making her own decisions. Specializing in the field of her choice'.[114]

Nurses, like doctors and front-line soldiers, suffered from significant stress in the workplace every day. There was no front line, no enemy in recognizable uniforms, and no safe havens. The enemy could be anyone or anywhere.

The constant presence of danger and death contributed to a 'live today because there might be no tomorrow' culture among military personnel. Lynda Van Devanter, in her 1983 memoir, *Home Before Morning*, was unapologetic in her description of the need for alcohol

and drugs to block the pain. She and her colleagues partied as hard as they worked 'and when we slept, it was frequently because we had passed out from too much alcohol or too much exhaustion. We were loud, boisterous, and unruly, almost relentless in our pursuit of anything that would block out the faces and moans of dying boys ... The booze came through regular Army supply channels. We bought it at the PX, along with our stereos, tape decks, and snacks. The pot came through irregular channels that were as strongly established. For a dollar, it was possible to get pure Montagnard gold, packaged like regular cigarettes'.[115] It was not surprising that sex, drugs, and alcohol were commonplace in Vietnam. Nurses in a war zone far from home experienced new autonomy on the job and new freedom in their off hours, away from the stereotype of the 'girl next door'. They could make decisions about aspects of their professional practice as well as their behaviour away from the wards. When hospitals took mortar fire, nurses could be wounded, although only one nurse, Lieutenant Sharon Ann Lane, was killed directly by enemy fire on 8 June 1969. Nurse Grace Moore remembered the danger she faced when she arrived at the 12th Evacuation Hospital in Cu Chi in May of 1968: 'They put us in Army-green school buses that had chicken wire in the windows ... It was hot, and I reached up to put the windows down, and the driver hollered "Don't put those windows down.! If we have incoming the chicken wire will protect you from shrapnel"'.

Nurses were also in danger from attacks by sappers and the actions of Vietnamese spies. According to historian Paula Bailey, sappers infiltrated even well-defended areas and then were able to act as snipers or to place explosives in the area. Sappers were not always male. Some Vietnamese women who worked as maids in the nurses' quarters were also quite proficient at aiding the VC, if they were not actually VC themselves. In one instance, a maid was discovered smuggling eighty pounds of explosives into the nurses' quarters.

Other maids carried maps of the compound to the VC.

Nursing in Vietnam, as in the profession in general, was 95 per cent white, but African-American nurses did serve in Vietnam. African-American nurses had cared for wounded soldiers as early as the Civil War, but it took the desegregation of the military by President Truman in 1948 to make it possible for African-American nurses to work in integrated units. Lieutenant Colonel Martha Baker entered the Army Nurse Corps as a newly minted second lieutenant in 1951. Stationed in Maryland, Baker described an early experience with racism in the community near her base. She entered a local store 'in my Second Lieutenant Uniform ... so proud of my bars. And the storekeeper would say, "You can't come in". It hurt, but I couldn't do anything about it'. Baker served in Washington, D C, Okinawa, and Vietnam in a distinguished career that ended with her retirement in 1971.

The career of Elizabeth A. Allen illustrates the particular challenges faced by African-American nurses in Vietnam. Allen, a captain in the Army Nurse Corps, understood that 'there were a lot of frontline African-American troops, and they needed somebody too'. She was patriotic but not blind to America's racism. Her motivation to serve was based on her dedication to medicine. She said, 'It's not for me to decide as to the rightness or the wrongness of the war, my decision was what was the best possible care I could give'.

On Allen's arrival in country, she was offered the opportunity to serve at the 3rd Field Hospital in a 'white uniform position' but chose instead to be stationed at the 12th Evacuation Hospital at Cu Chi, one of the most remote field hospitals, saying, 'I didn't come to Vietnam to take care of officers'. Allen got her first look at the Vietnamese landscape from the helicopter that flew her north. She 'boarded a combat-loaded helicopter and flew into the war. As my eyes scanned the scene below, the African American door gunner, who just wanted to talk, pointed down to the jungle and said, "Captain, we got this

shit called Orange that we spray, and within two days, this whole jungle is wiped out"'. At the time, she had no idea that she was seeing the damage caused by the defoliant that devastated the landscape and caused neurological damage to civilians, soldiers, and their future children.

Shortly after Allen's arrival at Cu Chi, the hospital was attacked. Her White roommate was rescued, but she was left to fend for herself as the mortars continued to rain down on her. This reaffirmed her conviction that there was no one who would protect her. Allen described Cu Chi as a very lonely place for a young African-American woman: 'Army regulations said that there could be no fraternization between ranks, and most African American troops were enlisted. So, from having nobody to talk with, to having the wrong kind of products to care for my hair and skin, I felt isolated and disregarded. And the constant stream of wounded Americans was a gruesome introduction to the realities of war'. But Allen persevered, cared for her patients, and served her entire career as an Army nurse, retiring as a major.[116]

About twenty per cent of nurses serving in Vietnam were men at a time when the profession was overwhelmingly female. While most functions that the nurses performed were gender-neutral, some of the preconceptions, even prejudices, of the time dictated that certain roles were best played by men. Women were not only non-combatants, they were presumed to be incapable of performing physically difficult or dangerous work. For example, Captain John Alexander said that conditions in training areas in country were primitive at best: 'The living conditions and the travel and the field were not conducive to putting females into these positions. Oftentimes, we would not shower for days on end. This would have been difficult for women'. There was no scientific basis for the assumption that women needed to shower more than men, and no one asked the women if they would be willing to endure the same

unsanitary conditions as the men. But cultural assumptions held by men determined the extent of women's equality in the military workplace. Female nursing leaders also displayed a protective instinct regarding the safety of their nurses. Lieutenant Colonel Rose Straley did not send women to remote areas. In her judgment, 'austere conditions in the field warranted that we assign a male nurse'. But as the war progressed, nurses and women volunteers with even less training such as Red Cross or USO workers were sent to aid soldiers in remote and dangerous landing zones.[117]

Nurses soon became accustomed to seeing wounds like none they had seen in stateside hospitals. They quickly learned that help for the wounded went far beyond caring for physical damage. Grace Moore remembered seeing mortal wounds, severe infections, and bodies blown to pieces. She remembered that there was nothing that could have prepared her for what she saw in Vietnam: 'I don't care what you saw in basic training, what you learned in basic training. If you see somebody with their arm or leg blown off, you don't see that, as a rule, in a civilian hospital. We didn't just take care of their physical wounds. Any nurse who has served in any war zone would tell you that'. In spite of horrific conditions, Moore said nurses provided more than medical care for wounded soldiers'. We were their emotional support system. We were their mother, their wife, their girlfriend, their sister. You listened a lot, did a lot of hand-holding, comforting'.[118]

American military nurses in Vietnam advanced their medical skills and provided compassionate care for the wounded and dying. They developed strong bonds with their colleagues, doctors, and the soldiers they nursed back to health. But on their return home, many nurses felt limited by the role they were expected to play in stateside hospitals where they were required to give up the autonomy they had exercised in hospitals in country. The last contingent of American military nurses left Vietnam on 29 March 1973. Coming home was

not easy for any veterans, male or female. They were accused of killing women and children, especially after reports of the civilian massacre at My Lai on 16 March 1968 came to light. When nurse Dottie Snow returned to the United States, she enrolled in college classes and found herself blamed by her professor for an 'immoral war' that killed babies. She experienced visual over-stimulation from popular psychedelic neon art in public places. Agent Orange had turned the Southeast Asian landscape brown or grey, and the colours at her local mall seemed extraordinarily bright. The world had changed dramatically.[119]

Vietnam veterans enjoyed no parades or celebrations, and the women who served often felt invisible. By the late 1960s, the anti-war movement in the United States and Europe had exerted a powerful influence on popular culture, especially on college campuses, and veterans who used their GI Bill benefits to earn a degree faced an alien environment. Organizations like the Veterans of Foreign Wars and Vietnam Veterans of America paid little attention to women veterans. Women were permitted to join the VFW in 1978 and the Vietnam Veterans of America in 1983, although many women had no interest in joining these organizations. In 1983, the Veterans Administration set up an Advisory Committee on Women Veterans in belated recognition of the contributions of women in the armed services.

Naval officers and enlisted women served on hospital ships in the South China Sea. A pilot programme in 1972 implemented by Naval Chief of Operations, Admiral Elmo Zumwalt, placed thirty-two enlisted women and two officers on the USS *Sanctuary*. This represented a major change in Navy policy that proved to be very effective and laid the groundwork for more women to serve abord Navy ships. The *Sanctuary*'s commanding officer was impressed with the women's patriotism, dedication, and the high quality of their work, declaring that they could serve on his ship

in perpetuity. Enlisted Navy women who worked mainly in the United States helped to service planes and troubleshoot problems with aircraft engines. They endured the same dirty conditions as their male colleagues. Nine Navy women officers served in Vietnam, performing administrative, personnel, and communications duties.

Commander Elizabeth Barrett was the highest-ranking Navy woman serving in Vietnam and the first to command 450 enlisted men. She worked hard and earned the respect of her men. But old stereotypes die hard. Lieutenant Mary Anderson Shupak, who served as a personnel officer from 1971 to 1972 in Saigon and Cam Ranh Bay, remembered the frustration of being a female Navy junior officer in Vietnam. She was not allowed to live in the Bachelor Officer Quarters (BOQ) because it was considered inappropriate for a woman to live in the same building as men. 'Consequently', she wrote, 'I lived on the other side of the base with the US Air Force nurses. The difficulty was that I had to call Washington DC frequently to check on the orders for the enlisted personnel. This meant driving outside the base at 3:00 am to get to the naval facility on the other side. I constantly saw flares and heard bombs as fighting went on nearby. Despite the danger, I was not allowed to carry a weapon because I was considered a non-combatant. It always struck me as strange that they were more concerned about my living in the BOQ than about my safety on those early morning trips near the battlefield'.

Despite the challenges the Navy women faced because of their gender, most Navy women officers and enlisted personnel were proud of their service to their country. They were trailblazers who helped make it possible for women to become Navy pilots and ship commanders in the years after the war.

Proud as they were of their accomplishments, American military women were aware that their service was regarded differently by military leadership than that of the men and that the difference spoke

Women in the War

to a second-class status not consistent with their worth. Over time, as anti-war sentiment permeated the ranks, both men and women began to speak out against the war and conditions in the military that impinged on their rights as citizens. Women in the military recognized that many of their grievances derived from stereotypes about women and the attitude of the military brass toward them as soldiers.

Hundreds of women served in Vietnam as missionaries. Like their colleagues in the ranks of military nurses, these women were dedicated to providing spiritual guidance and material aid in the form of food and medicine. Working with the civilian population, missionaries faced significant danger. They faced significant danger in the field, but, as civilian women, they could not rely on military protection. While most missionaries served in schools and hospitals without incident, the capture and murder of missionary nurses Beatrice Kosin and Evelyn Anderson reveals how dangerous their work could be. They came to Laos with the Christian Missionaries of Many Lands and were captured in the village of Kinghock by North Vietnamese troops on 28 October 1972. They, along with two male missionaries, were taken prisoner. The men were rescued, but the two women were held, tied together back-to-back, in a small hut for five days. A planned rescue mission was scrapped because peace negotiations were underway and American military authorities thought a rescue mission was 'potentially inflammatory' and might embarrass the North Vietnamese. The women's captors had no further use for them, so they set the hut on fire. Kosin, who was 34, and Anderson, who was 22, were burned to death.[120]

There is only one woman on the list of American prisoners of war. Dr Eleanor Ardel Vietti was a physician and a missionary. She worked in a Vietnamese leper colony and was captured on 30 May 1962 by the Viet Cong. Although Vietti was not a member of the armed forces, her capture was an act of war. There were occasional reported sightings

of Vietti treating wounded Vietnamese soldiers, but these were not confirmed. In 1991, she was presumed to have died.[121]

Countries allied with the United States sent female nurses to Vietnam as part of their military forces or non-governmental humanitarian organizations. Australian nurses were part of the Royal Army or Royal Air Force Nursing Corps. They also served as Civilian Aid Nurses as early as 1964. Australia was responsible for providing medical aid under its SEATO (South East Asia Treaty Organization) obligation. Like their American counterparts, the Australian nurses felt unprepared for the conditions they faced in a remote jungle war. For example, they were told to wear drip-dry uniforms made of nylon, which stuck to their bodies in the humid climate and never really felt dry. They did not have adequate equipment, few knew how to treat burn or shrapnel wounds, and almost none of the nurses knew any of the languages spoken in Vietnam. Medical units were small, sometimes with only one doctor available. The Australian nurses left clean, well-equipped hospitals at home to find the deplorable conditions in which they attempted to bring help to primarily civilian wounded. As for conditions under which the Canadian medical units worked, nurse Mair Jones described the surgical units as filthy and the housing accommodations for nurses unacceptable.

The first medical team from New Zealand arrived at the Binh Dinh Provincial Hospital in Qui Nhon in 1963 and was charged with treating civilian casualties. The number of nurses was consistently small in these remote hospitals, so the nurses trained local Vietnamese nurses and military medics in basic trauma care. Starting in 1967, New Zealand sent an all-male group to the hospital at Bihn Dinh to follow up on the medical and preventive care work with local populations begun by American units in the region. Viet Cong activity was intense and resulted in the death of a medic, New Zealand's only casualty in the Vietnam War.

South Korea sent the largest non-United States contingent of nurses to Vietnam. In the first decade of the war, more than 550 Korean military nurses, the vast majority of whom were women, were deployed to Vietnam to support South Korean troops. The Korean military established its own hospitals to care for Korean wounded, and it sent its own doctors, nurses, and other medical personnel to those facilities. Soldiers who needed specialized medical care for severe injuries were evacuated to the Philippines or Japan, eventually to be sent home. South Korean nurses described their service in terms of their dedication to duty and establishing a meaningful comradeship with their colleagues, but they also faced discrimination as women because of the constraints of traditional Korean society that required women to remain committed primarily to home and family.

As women and medical professionals, the Korean nurses who served in Vietnam transcended even greater barriers and prejudices than their American counterparts.[122] The needs of soldiers in the field far outstripped the capabilities of a purely medical organization. Soldiers, whether they were wounded or not, missed their families and hoped to experience any touch of home that a visitor to the battlefield could provide.

Between 1962, when the first Red Cross field directors arrived in Vietnam, and 1973, when the last workers departed the war zone, 1,120 young women, all college graduates eager to serve, provided comfort and support to service personnel in Vietnam. During the height of the conflict, commanding General William Westmoreland described the Red Cross as a 'hotline to the folks back home, an oasis in the heat of battle, and a comfort during hospitalization'. More than half of the Red Cross workers who served in Vietnam participated in the Supplemental Recreational Activities Overseas (SRAO) Programme. These women ran recreation centres, the first of which opened in Danang in September of 1965. They also brought games, quizzes, puzzles, and audience participation activities

to remote locations in the field. Red Cross women travelled more than two million miles by jeep, truck, plane, and helicopter to bring a story and a smile to soldiers in landing zones and combat bunkers far from their bases. This was dangerous work. Five members of the Red Cross were killed in Vietnam, and more were injured. The last Red Cross woman killed in Vietnam was Sharon Wesley, who was helping to evacuate babies from Vietnam in 1975 during Operation Babylift when their plane was shot down outside Saigon. Wesley had elected to remain in Vietnam after the evacuation of American troops to assist in the effort to find homes for orphan babies in both Vietnam and the United States.

Red Cross 'Donut Dollies' in their familiar blue dresses faced many privations during the war. They experienced the same stress of working in a combat zone and the same sadness at the sight of dead and wounded soldiers and civilians. Red Cross worker Joanne Puffer Kotcher came close to death no fewer than six times during her tour as a Red Cross worker in Vietnam. In one case, a Viet Cong sniper fired three shots at her because her light blue uniform stood out among the men in fatigues. She said to herself, 'Thank the Lord for people who can't shoot straight'. As a front-line Red Cross worker, Kotcher sometimes found herself in foxholes with 'her' soldiers. She was not a medical worker, but she was important to the soldiers whose morale she helped to bolster. In a dangerous environment, her goal was 'to inspire soldiers by reminding them of the people they left back home'. Kotcher went to Vietnam as an optimist, but the dangers and horrors of the war changed her. When she returned home, scenes from everyday life seemed foreign to her and she 'felt like a stranger in my own homeland'. Nevertheless, Kotcher, like most of the other six hundred Red Cross women who were part of the SRAO programme, felt proud of her service.

Donut Dolly Linda Jagger described a typical day in Vietnam that began at 5:30 am, when she would board a UH-1H Huey helicopter

and depart with a large canvas mobile kit. 'Each day', she recalled, 'we went to service clubs, units, mess halls, hospitals or off into the bush, where the war and men who fought in it, became an intimate part of our lives. Working 10- to 12-hour days, six days a week. It was only when we were in our billets that we would cry, scream, or let ourselves talk about our experiences … In 1970, US troops were fighting some of the fiercest battles of the war. I remember standing in the middle of a large field, surrounded by tanks. The day before, one of these tank units had lost some of their men. There I was, trying to cheer them up. Our task seemed ludicrous. But slowly, something began to happen. First, there were a few smiles, then, a couple of wisecracking jokes. Gradually, the men got caught up in the program'.

In addition to providing care for soldiers in the field, the American Red Cross offered personal counselling to soldiers on bases in Southeast Asia, wrote letters and made phone calls for injured soldiers, and provided help to veterans and military families on the home front. At the end of the war, the Red Cross facilitated the repatriation of prisoners of war in 'Operation Homecoming'. Joyce LeGrande, who served in the field in both Korea and Vietnam, remembered a recent visit to a Vietnam memorial. She wondered if any surviving veterans remembered the Donut Dollies. One vet gave her a hug, saying, 'We remember you. We remember the Donut Dollies'.[123]

The International Rescue Committee also sent medical personnel to Vietnam, initially to perform surgeries on children with cleft palates. The goal of the Committee was to 'win the hearts and minds' of the civilian population by helping children have a more normal life. By 1970, there were at least a dozen other non-governmental agencies serving in Vietnam, including Catholic Relief Services, CARE, and the Mennonite Committee. Volunteers included women whose focus was on disease treatment and prevention and physical therapy

for the civilian populations. The most significant injuries to civilians occurred because of napalm attacks or land mines in open fields. As the war devastated the civilian population, Catholic and Buddhist nuns established orphanages to care for children whose parents were casualties of war. Military medical personnel often travelled to villages to treat civilians, especially children, in an effort to win over villagers. This effort was part of the military's Medical Civic Action Programme, or MEDCAP. The programme estimated that it had more than forty million medical interactions with Vietnamese civilians to provide help and encourage local villagers to view the United States military in a positive light. After the war, the United Nations became involved in rescue efforts and medical care for refugees.

The United Service Organization, or USO, is popularly remembered as a provider of glamorous entertainment to soldiers abroad under the leadership of master of ceremonies Bob Hope. Hope's USO career spanned fifty years, starting on the radio in 1941. His variety shows brought a touch of vaudeville, irreverent humour, popular music, and beautiful women to Vietnam, where Hope took his troupe nine times. Actress Ann Margaret was a mainstay of Hope's USO shows, and she endeared herself to military personnel by her presence and support for them, irrespective of the politics of the war. USO shows brought American entertainment to troops in Vietnam on a large scale. The organization brought entertainment to small, remote locations, sometimes on the back of a flatbed truck. One such show was presented by country singer Roy Acuff, a favourite of many troops.

Behind the scenes, the USO provided even more personal services to soldiers. The first USO centre was opened in Saigon in April of 1963. At the height of the war in the late-1960s, there were twenty-two USO clubs in Vietnam, each of which included hot showers, a barber shop, an overseas telephone line, and a snack bar. Whether they

were working at a local club, in a remote landing zone, or on a ship in the China Sea, the women of the USO brought entertainment, holiday parties, music, and games to soldiers. The USO clubs were an oasis for soldiers who were prohibited from going to Vietnamese clubs, bars, and other local sites for fear of enemy attacks. Each USO centre was staffed by young female volunteers whose job was to help soldiers forget the war in their off hours. Like the Red Cross, the USO recruited young women with college degrees. Their volunteer obligation was usually eighteen months, and they were required to wear a USO uniform, which included a mini skirt. Pants were prohibited, and perfume on the job was mandatory. USO workers who travelled to remote locations saw the worst effects of the war, and those who worked at the urban centres knew their job was to help young men seeking a momentary escape from those horrors. As if to highlight the women's role in bringing a bit of cheer into the lives of the soldiers, Sam Anderson, who served as the Executive Director of the USO in Vietnam, routinely told the volunteers, 'Your job in Vietnam is to be happy. Never let the men see you cry'.

USO women in Vietnam faced danger, and their challenge was to face that danger with a smile. Pamela Krause, who was the Assistant Director of the Saigon USO club, spoke about what it was like to experience mortar fire. She could hear the shells coming overhead: 'I was always told to hide under the bed during a raid, but I couldn't – all my possessions were stored under my bed. All you can do in a situation like that is close your eyes and pray'. Krause travelled with a military escort to the most remote units to deliver food and personal items to the troops. During her three-year deployment, Krause hosted an Armed Forces Radio Saigon programme, 'What's New at the USO?' She read letters from home in a popular segment called USO Mail Call. In 1968, Krause's work earned her a medal and commendation from Army General Creighton W. Abrams.[124]

American women served their country in a variety of ways not specific to medicine or personal care. Officers and enlisted personnel of the Women's Army Corps were clerks, air traffic controllers, and intelligence officers, among many support positions. Although Army nurses were in Vietnam as early as 1956, the Air Force was reluctant to send women to a war zone. Soon, there was a desperate need for nurses and support personnel, and the Air Force was forced to change its policy. Air Force women served primarily in Saigon, occupying support positions formerly held by men, beginning in 1967.

Service in Vietnam was problematic for African-American soldiers, many of whom were reluctant to fight what they saw as an imperialist war against people of colour. At home, organizations like the Black Panther Party loudly opposed the war and, on 4 April 1967, Dr King voiced his opposition in a speech at New York's Riverside Church, breaking ranks with the Johnson administration. But many African Americans, men and women, either accepted conscription or volunteered to serve in Vietnam. Black women faced the double discrimination of race and gender, but they worked beside their White colleagues as an expression of both patriotism and care for their brothers in arms. Decades later, Brigadier General Hazel W. Johnson, the retired chief of the Army Nurse Corps, acknowledged the contributions of minority women, saying at the dedication of the Women's Memorial: 'You represent the patchwork quilt of diversity which is America – race, creed, colour, and ethnicity'.

Discrimination was rampant in the military, and African-American women were well-aware of the barriers they faced to both attaining rank and achieving acceptance. Senior Intelligence Officer Doris Allen saved more than one hundred lives with her intelligence reports on enemy troop movements in Quang Tri Province, yet she faced prejudice 'against me as a woman, as a WAC, me as a soldier with the rank of specialist, me as an intelligence technician, me as a Black

woman'. In spite of the discrimination, Allen felt her experience in the Army was 'overshadowed by a wonderful camaraderie'. Some African-American women did receive commendation for their work. Specialist Grendel Alice Howard served for thirty-four months in country, nearly three times the tour of duty of conscripted 'short time' soldiers. She was recognized with the Army's Bronze Star and Commendation Medal, both with gold leaf clusters, signifying that she had earned the award more than once. Black female veterans returned to a country divided over the war and race relations.[125]

Like the military women who served in Vietnam, members of the Red Cross, USO, and other non-governmental organizations received barely a thank you on their return home. They were expected to settle back into domestic life and put the war behind them. These women were proud and capable., but many suffered invisible wounds of war in silence. Post-traumatic stress disorder was not at first recognized in women veterans, but eventually the Veterans Administration acknowledged the disorder in women and began to provide health care and support services for women who had served in Vietnam.

As women began to articulate their grievances about their status in the war, a new movement was percolating at home, a movement focused on women's lives and women's needs. Civilian women were not yet ready to call themselves 'feminists', but, by 1970, they were receptive to the language, the style, and the demands of the new movement that would soon be known as Second Wave Feminism.

People who lived far from the war zone learned about battles won and lost and the human side of war in Vietnam through the work of correspondents who reported for newspapers, magazines, and television networks. In the case of a declared war, belligerent governments set clear rules as to who could obtain press credentials, where reporters could travel to obtain information, and people with whom they could speak. But the conflict in Vietnam was never a

declared war, and there were fewer rules to guide or restrict journalists. Some reporters described the journalistic landscape as like the wild west. Reporter Denby Fawcett noted that, in Vietnam, 'There was no forever there, just one surprise after another'. Journalists from all over the world reported on the unexpected from Vietnam in what Elizabeth Becker called 'the most open war for journalism before or since'.

The women who sent dispatches and photographs from Vietnam were not the first females to report from the battlefield. Their immediate predecessors were women like Marguerite Higgins, whose fame as a journalist came in 1939, when she was the first reporter to write about German troops preparing to invade Poland in the first attack in what became the Second World War. The women who paid their way to fly to Vietnam to break in as freelance journalists or talk their way into jobs with major papers or wire services knew that they could face death as easily as their male colleagues. They knew that German Jewish photographer Gerda Taro had died pursuing images during the Spanish Civil War. In 1937, she was knocked off the running board of a truck while photographing a battle.

American journalist Elizabeth Becker observed that her generation of reporters 'became the bridge between two eras: the pioneers of World War II and the women of the modern era, who by the 1991 Gulf War took it for granted that they could cover wars'. Becker noted that women sometimes got the chance to report on the war because the papers and television networks 'were so desperate for reporters on the spot that they would employ a woman'. Women reporters sought the excitement and meaning of working in a war zone. Becker remembered that 'if we had stayed in America or Europe or Australia, we would have been confined to covering society, food, fashion and the home'. War was much more exciting, and history was being made in Vietnam. Australian journalist Kate Webb left her job at a Sydney newspaper and flew to Saigon on her own, while reporter

Women in the War

Jurate Kazickas won $500 on the popular TV quiz show 'Password' to pay for her transportation to Vietnam. And French camerawoman Catherine Leroy pursued her craft in Vietnam as a freelancer, having seen images of the war in *Paris Match*. Leroy and her camera made a parachute jump with the 173rd Airborne Division during Operation Junction City. When Hue was under attack in February of 1968, she was captured and was able to send images from behind enemy lines to *Life* magazine. Webb stayed in country after the fighting shifted to Cambodia and was captured and imprisoned twice.

The career of Dickey Chapelle reveals the initiative and resilience of women journalists in Vietnam. Chapelle began her reporting career taking photographs for *National Geographic* magazine during the Second World War. She convinced the Navy to allow her to work with Marine units on Okinawa and Iwo Jima, gaining the respect of the Marines for her bravery and her tenacity in seeking out images that told the story of the fighting. After the war, Chapelle reported from Cuba, Algeria, French Indochina, and the Dominican Republic. She was imprisoned and escaped death in Hungary in 1956, writing in her autobiography, *What's a Woman Doing Here?* that, 'The wreckage resulting from man's inhumanity to man – whether from the time of Ghengis Khan or Adolph Hitler – was the litany I wrote and the subject I photographed'. In 1965, Chapelle returned to Vietnam but was killed by a mine near Chu Lai on 4 November of that year. Dickey Chapelle was the first American female journalist to lose her life in the jungles of Vietnam.

Sexism prevailed among military leaders and fellow journalists. Military brass found excuses to deny women access to dangerous zones. One general told Dickey Chapelle that she could not be embedded with male soldiers because there were no bathroom facilities for women. He said he did not want his men to have to 'pull up their pants' because there was a woman in the area. Her response was, 'That won't bother me one bit. My subject is to cover

the war'. Ann Morrisey Merick was ABC's first female television field producer in the Vietnam War, one of only a few women TV producers in Southeast Asia. In 1967, she and several other female reporters won a battle with Gen. William Westmoreland, who tried to ban female reporters from covering the war in combat situations. She negotiated a successful lifting of the ban, paving the way for women to pursue the stories of the Vietnam War.

Women did not always get credit for their work. Sylvana Foa reported for United Press International, a news service that provided copy for newspapers throughout the United States. She was the first to report that the American Embassy in Cambodia was directing bombing raids against North Vietnam, something the Nixon administration vehemently denied. Not surprisingly, her reporting earned Foa expulsion from Cambodia. When *New York Times* writer Sidney Schanberg posted the same story several days later, he did not acknowledge Foa for the initial scoop, something he finally did thirty-two years after the event.

At times, female journalists received credit, praise, and even awards for their work. As a young freelance journalist, Gloria Emerson visited Vietnam in 1956, calling it 'the most beautiful country I had ever seen'. She reported for *The New York Times* starting in 1970, the only woman to do so, decrying the corruption of the country, the deception of the military, and the toll the war exacted on the civilian population. Like many reporters, she attended the daily military briefings in Saigon and was among the reporters who began to refer to these events as the 'Five O'Clock Follies'. She recalled that these events were ludicrous: 'It was painful to see. Some briefer, a colonel, would get up there and you'd watch his trial by fire as reporters would taunt him. He was hardly responsible for the mess, but they gave such duplicitous information and figures, and after a while it was just part of the heavy sadness of it all. It was impossible even to laugh at them and their loony tunes'.

Emerson was unsparing in her criticism of United States military leaders who told lies and deceived the American public. She wrote about the desperate lives of civilians, the drug culture among American soldiers, the growing dissent and reluctance to fight among GIs, and the beginnings of a military anti-war movement. She was respected as a reporter, and her articles about everyday people in Vietnam rather than soldiers and battles earned a George Polk Award for excellence in foreign reporting. In 1977, Emerson published *Winners and Losers*, which won a National Book Award the following year. She could be acerbic and critical, but her dispatches brought the human side of the war to *Times* readers.

Frances FitzGerald was perhaps the best-known female correspondent in Vietnam. In her reporting for *The New Yorker* magazine, FitzGerald consciously focused on the people of Vietnam. She concluded that, despite its weapons and power, the United States could not prevail. Her reporting came not from military briefings or battlefield visits but from time spent in villages listening to stories from villagers' everyday lives. FitzGerald was criticized for her family's wealth, her Radcliffe College degree, and the presumption that she was a dilettante in a war zone. But she asked difficult questions, not about bombing raids or Cold War imperatives for Americans, but about the effect of the war on ordinary Vietnamese people. In 1972, she published *Fire in the Lake*, which won a Pulitzer Prize, a Bancroft Prize, and the National Book Award. Her book remains both popular and influential as an early expose of the flaws in American involvement in Vietnam.[126]

Women were part of the dynamic of war in Vietnam. Vietnamese women were soldiers fighting for their nation, North or South. American nurses and military personnel, along with those from allied countries, served the wounded in a foreign land. Volunteers from non-governmental organizations were committed to humanitarian projects for the Vietnamese people. And reporters brought the war

to the world in prose and pictures. It is fair to say that the answer to the question, 'Where were the women in Vietnam'? is 'Everywhere'.

American women returned home to a country that seemed to be at war with itself. The Civil Rights Movement of sit-ins, freedom songs, and appeals to Congress to take the high moral ground had been eclipsed by militants no longer willing to wait for White America to grant civil rights as a gift rather than concede that rights for African Americans should be a self-evident reality. Similarly, the marches and banners of the early movement to end the war in Vietnam had been replaced by massive demonstrations and university take-overs, along with acts of violence that shocked the nation. It was in this context that women who had served in Vietnam returned to new ideas about women and increasingly strident demands for equality with men in all aspects of life. The civil rights and anti-war movements would fuel the new feminism and engage women who had fought for and served others now to act for themselves.

Chapter Five

Women Against the War: The American Scene

Before there was a war in Southeast Asia, there were destructive atomic weapons that could destroy the planet in an instant. Opponents of weapons proliferation also feared the environmental consequences of nuclear fallout that could destroy human life just as certainly, if more slowly. Women spoke out against a potential nuclear holocaust as mothers concerned about the welfare of future generations. In the early anti-nuclear movement, women were active behind the scenes and on the front lines in protests against the dangers of the atomic age. When the Vietnam War raised the fear that a civil war thousands of miles from home could trigger nuclear extermination, these women were ready and willing to protest on behalf of their sons who were being called to fight in a land war in Asia. Their daughters would soon be unwilling to accept subordinate roles in the anti-war movement and were pioneers who were not afraid to call themselves feminists.

Women's peace activism began early in the twentieth century. Founded in 1915, the Women's International League for Peace and Freedom opposed the violence and destruction of the First World War. In the United States, WILPF grew out of the Women's Peace Party led by Alice Paul, Jane Addams, and Carrie Chapman Catt. Paul had chained herself to one of the gates at the White House to protest American involvement in the First World War. In the 1920s, WILPF opposed the Treaty of Versailles because it 'created the conditions for future warfare'. In the wake of the Second World War, WILPF aided European refugees fleeing the devastation of war and the Holocaust. As part of its humanitarian mission, WILPF focused in the 1950s other public health ramifications of nuclear testing and

197

its attendant fallout. In the 1960s and early 1970s, WILPF mobilized women to protest the carnage in Vietnam.

Early women peace activists hoped that the concerns of women would be addressed as part of a broader movement agenda. They were soon frustrated at the lack of attention to women's issues in groups led by both men and women. Anne Henrietta Martin was an American suffragist early in the twentieth century who marched for the cause in Britain and served as the first national chairwoman of the National Women's Party at home. In July of 1914, she was tried and convicted of picketing the White House, for which she served a short term in the Occoquan Workhouse in Lorton, Virginia, following in the footsteps of many suffragists who were sentenced to perform agricultural labour at the facility.

In 1918 and again in 1920, Martin ran for the United States Senate from Nevada, the first woman to declare her candidacy for a seat in the upper house. Undaunted by her failure to garner support for a political career, Martin remained an active feminist. She wrote articles in British and American journals that focused clearly on the issue of women's rights. Martin was an early supporter of the WILPF, but she left that group because of its diminishing focus on issues specific to women. Martin felt that women should not allow themselves to be absorbed into broader political organizations as second-class supporters of issues defined by men. She was a radical feminist dedicated to the cause of equal rights until her death in 1951.[127]

In the late 1960s, a younger generation of female activists would find ways to express their frustration with movements for social change that were unresponsive to the needs of women. These women pushed for changes in groups dedicated to civil rights and ending the Vietnam War and would eventually lay the groundwork for a new feminist movement of which Martin would have approved.

Marjorie Swan was a Quaker woman committed to non-violent

action. In the 1940s, Swan worked for the National Committee on Conscientious Objection (NCCO), performing mainly secretarial and administrative tasks in support of the men who refused induction into the Army as a matter of conscience. She eventually took over the position of Washington DC Secretary, making her the *de facto* leader of the organization. Swan was deeply engaged in a study of Gandhian pacifist philosophy. She defended Gandhi and was arrested while protesting his imprisonment outside the British Embassy in Washington DC. Swan also participated in sit-ins at segregated restaurants in Washington as a member of the Congress of Racial Equality. For her, the principle of non-violence applied not only to her work in opposition to war, but also to her commitment to full and equal rights for African Americans.

Mary Stone McDowell was a member of the Women's Peace Party who defied the government and her employer in the name of pacifism. McDowell was a highly praised teacher of Latin and Greek at the Manual Training High School in Brooklyn. As a Quaker, she was an avowed pacifist who refused to sign a loyalty pledge required by the New York City Board of Education during the First World War. She also refused to engage in mandatory Red Cross work or to encourage her students to purchase Liberty Stamps. An editorial comment on McDowell's activities from *The New York Times* in January of 1918 reveals the climate of war hysteria in which teachers were regarded as representatives of the government's war effort, a role a Quaker could not play: 'A Friend [a Quaker], at this time, is distinctly out of place as a teacher in a public school – that if well advised such a teacher will resign, and that if not docile to good counsel, he or she, as the case may be, should be dismissed'. When asked if she would do everything in her power to help the United States prosecute the current war, McDowell replied, 'No'.

She was fired from her job on 13 March 1918 for insubordination and 'conduct unbecoming a teacher'. The City's Board of Education,

the State's Commissioner of Education, and the New York State Supreme Court (a trial court) all upheld that decision. After the war, McDowell was reinstated, and the school apologized for having fired her. She returned to the Manual Training High School and taught there until 1931, then taking a position at the Abraham Lincoln High School in Brooklyn. She continued her anti-war activities, opposing the Second World War as a member of the Fellowship of Reconciliation and the War Resisters League. McDowell founded the Pacifist Teachers League to support faculty members who did not wish to sign loyalty oaths.

In the 1950s, McDowell joined the Tax Refusal Committee of the Peacemakers, a group founded a few years earlier and dedicated to opposing nuclear proliferation through demonstrations and the refusal to pay taxes to support the defence establishment. She refused to pay a portion of her federal income tax, arguing that to do so would support the government's war effort. She summarized her position in a letter to the Internal Revenue Service, noting that, 'War preparations and threats of atomic war cannot give us security. True patriotism calls for world-wide cooperation for human welfare and immediate steps toward universal disarmament through the United Nations. Accordingly, I still refuse to pay the seventy per cent of the tax, which I calculate is the proportion of the tax used for present and future wars. The portion used for civilian welfare I am glad to pay'. McDowell donated the portion of the tax debt that she refused to pay to the government to charity.

Other women activists followed Mary McDowell's example and refused to pay federal taxes as a method of protest. Marian Coddington Bromley was a White activist who served as A.J. Muste's secretary at the Fellowship for Reconciliation. She also conducted workshops on race relations for integrated groups, participated in CORE protests, and was a co-founder of the Peacemakers in 1948. Members of Peacemakers refused to fight in a war, make or distribute

weapons, submit to the draft, or pay taxes that would be used to finance war. Bromley refused to pay her federal taxes, arguing that it was immoral to finance violence and war. In 1963, she and her husband, Ernest, wrote a handbook on how to protest by refusing to pay taxes. Juanita Morrow Nelson was an African-American activist known for her radical pacifist views and her leadership in CORE in Cleveland, Ohio. She was arrested in 1950 for protesting segregation at Cincinnati's Coney Island Amusement Park. Morrow was a co-founder with the Bromleys of Peacemakers and a tax refuser who was prosecuted but never convicted and never forced to pay her tax bill.[128] The anti-tax protests of McDowell and others provided a model for activists in the 1960s who opposed paying for war.[129] In April of 1964, folk singer Joan Baez declared that she had refused to pay 60 per cent of her federal tax bill to protest the War in Vietnam.

In April of 1958, on the heels of a unilateral test ban by the Soviet Union, the Committee for a Sane Nuclear Policy announced days of protest at the United Nations designed to pressure the United States to follow suit and put an end to the nuclear arms race. WILPF members were prominent among the demonstrators. In 1961, the group held a joint meeting with women from the Soviet Union to discuss ways to break down the barriers of Cold War ideology between the two countries. Even though the delegates had no authority over government policy, their efforts were visible to officials in both countries. WILPF joined other peace organizations in 1963 in calling for an end to the Vietnam War. The organization re-issued its call to women to work to end the war in 1965 in celebration of WILPF's fiftieth anniversary. Fifty-two WILPF local branches collaborated with Dr Martin Luther King, Jr in 1967's Vietnam Summer, an effort to educate Americans about Vietnam and encourage women to protest the war.[130]

In the 1950s, Quaker women demonstrated against nuclear proliferation as a manifestation of their pacifist religious beliefs.

Don't Call Us Girls

As the United States and the Soviet Union continued to develop increasingly sophisticated and powerful weapons, protesters placed themselves in harm's way and faced prison time for their peaceful acts of civil disobedience. In 1958, Marjorie Swan and her husband George helped to found the Committee for Nonviolent Action (CNVA) to press for an end to the production and use of nuclear weapons. They spent the summer protesting outside Fort Mead near Omaha, Nebraska, the site of the Nebraska Ordnance Plant. She returned to Fort Mead in the summer of 1959. Wearing pearls and dressed for a PTA meeting rather than a protest, she ducked under the fence and told the assembled reporters and law enforcement officers: 'I know many of you ask why I take this action. Particularly, why a mother who has the responsibility of raising four children? Do I not feel guilty in disgracing them by going to prison and in leaving them without my care for a number of months? I can only say that the guilt I may feel now, and the pain at leaving my husband and children, is nothing compared to the guilt and the pain I will feel – if I am still alive – at seeing my children blasted to death by an H-bomb'. Like many women of her generation, Swan described her activism in the context of her identity as a mother.

Swan understood the consequences of her protest. At Fort Mead, she was arrested and sentenced to serve six months in a federal prison, leaving her children at home. Swan's actions as both a mother and an activist received a positive reception in an article in *Redbook*, a popular women's magazine. The anti-nuclear movement remained small, but the coverage of Swan's story suggested understanding, if not approval, of her actions – what mother would not take action to protect her children? Swan emerged as an all-American mother who continued to engage in protest throughout her life, including anti-Vietnam War activism in the 1960s and opposition to nuclear power in the 1980s.[131]

The story of Lillian Willoughby's activism is similar. A mother

of four children, she trespassed onto the grounds of a Nevada nuclear test site in 1957 and observed at the time that her love for all humanity 'compels me to make a non-violent protest against the immorality of nuclear explosions and all war'. Willoughby and her husband, George, were Quakers and pacifists who also refused to pay taxes in the 1960s, observing that they would not allow their money to support the 'old men' who were 'foisting things like military buildups, selective service, and governmental secrecy upon the nation'. Willoughby led an eight-day sit-in at the Atomic Energy Commission to protest atomic testing and to support her husband, who had been arrested for sailing his boat, the *Golden Rule*, into the Pacific Nuclear Test Zone.[132] Trespassing on government or private property, refusing to pay taxes, and staging demonstrations that attracted public attention were all tactics used by women as they opposed the war in Vietnam. Women learned how to protect themselves and how to go limp when they were carried to police vans.

The image of women being carried off by law enforcement officers illustrated the bravery of the women who protested for a cause. Women Strike for Peace began as an anti-nuclear protest organization that later gained recognition for its efforts on behalf of young men who refused to submit to the military draft. On 22 September 1961, Dagmar Wilson, a children's book illustrator with no training or experience in movement organizing, called a meeting of a few friends at her home in the Georgetown section of Washington. DC. The subject of the meeting was the increasing threat of underground and atmospheric nuclear testing. Mrs Wilson's friends were ordinary citizens who feared for the survival of the planet. The women felt that existing peace and anti-nuclear organizations such as SANE were well-meaning but ineffective, relying too heavily on petitions and meetings in which people talked a lot about ending the arms race but did relatively little to bring the issue to the attention of

political leaders. WSP women felt that the male leaders of SANE acted with too much deliberation and not enough action, given the nuclear emergency.

On that Friday afternoon, Mrs Wilson and her colleagues resolved to organize a protest throughout America that would highlight women's concerns about nuclear proliferation. They left the meeting and went to work, making phone calls and circulating chain letters that called for protest meetings on 1 November. This was a period of increasing tension between the United States and the Soviet Union. The disastrous Bay of Pigs invasion had taken place in April of 1961, and the Soviet Union built the Berlin Wall in August of that year. Amid increasing hostility, both nuclear superpowers persisted in testing new destructive devices, and both countries violated the agreed upon moratorium on nuclear testing. The issue was not just weapons testing. There was also concern about the fallout and dangerous substances such as strontium-90 that were contaminating rain, soil, and crops. There was a sense of urgency and a feeling that President Kennedy's campaign promise to end nuclear testing was obscured, even buried, by a continuation of Cold War foreign policy.

With these events providing context for their protest, the women recruited by Mrs Wilson planned rallies throughout the country under the banner of Women Strike for Peace. Fifty thousand people marched in 60 American cities on 1 November. Fifteen thousand rallied at the Washington Monument, led by Dagmar Wilson, now a co-founder with Bella Abzug, of the new organization. America's First Lady Jacqueline Kennedy and Nina Khrushchev, wife of the USSR's First Secretary, wrote to the group, 'As mothers, we cannot help but be concerned about the health and welfare of our husbands and children'. Two months later, President Kennedy acknowledged the women strikers, calling them 'extremely earnest' in their approach to nuclear proliferation.

As WSP members warned of the consequences of nuclear testing,

Women Against the War: The Ammerican Scene

Rachel Carson's influential book, *Silent Spring,* was published in August of 1962. Her warning about the dangers of nuclear fallout and her call to action to end the pollution that could someday bring irrevocable harm to the planet strengthened the cause of anti-nuclear activists. This book also helped to lay the groundwork for future environmental protest and activism that would contribute to government action in the form of the Clean Air and Clean Water Acts of 1970 as well as the Superfund Program that cleaned up the most polluted and contaminated sites. Women Strike for Peace was effective in keeping nuclear testing in the public eye, and members were adept at organizing women to oppose continuing above-ground weapons testing.

WSP members took their case to the highest levels of international negotiations on nuclear weapons. Mrs Wilson led a delegation to Geneva in April of 1962. According to Dennis Hevesi in his obituary for Dagmar Wilson, the group's goal was to raise their voices 'before delegates to a 17-nation disarmament conference. They met with the conference's co-chairmen, an American and a Russian, and handed over bundles of petitions with more than 50,000 signatures calling for an end to nuclear testing.' Coretta Scott King, the wife of the Rev Dr Martin Luther King, Jr, was a member of that group. In August 1963, the United States, the Soviet Union, and Britain signed the Limited Nuclear Test Ban treaty banning atomic testing in the atmosphere, in space, and under water.[133]

Mrs King identified herself as a mother of four who was intent on protecting all the world's children. Her opposition to nuclear proliferation and the Vietnam War began with her concerns as a wife and mother. As the war escalated, her opposition came more specifically from an awareness of the connections among race, class, and the violence endemic to war. By 1967, Mrs King's politics came to resemble those of African-American women on the political left earlier in the century such as Eslanda Goode Robeson. Like

her husband, performer and activist Paul Robeson, Mrs Robeson opposed racism, colonialism, and American involvement in Vietnam through the lens of race and class rather than gender alone.

Other African-American women understood the connection between their oppression based on race and gender and America's attempt to thwart the victory of communist forces in Vietnam. Lorraine Hansberry, a well-known playwright who identified as a communist, declared herself to be 'sick of poverty, lynching, stupid wars and the universal maltreatment of my people and obsessed with a rather desperate desire for a new world for me and my brothers'. As an exchange student in France, Angela Davis had learned about the North Vietnamese struggle for national unity and the opposition of many South Vietnamese students to their government's repressive policies. She understood the connection between a war against communist and nationalist forces in Vietnam and racism at home. Davis said African Americans should 'look towards Vietnam because they [the North Vietnamese and the Viet Cong] are on the frontlines on the battlefield in the fight against repression'. Increasingly, women were essential to the success of that anti-colonial struggle. In the United States, African-American women on the Left began to take their place among vocal opponents of the war.[134]

The 1962 meeting in Geneva that led to a bi-lateral nuclear test ban treaty was a major victory for the 'ordinary' mothers of WSP who, like many Americans at the time, were optimistic that society's major problems, including pollution and nuclear proliferation, could be solved by people of good will. Mrs King appeared at a WSP protest in front of the United Nations in New York in early November of 1963 at which WSP members marched under a banner that demanded 'Let's Make Our Planet a Nuclear Free Zone'. Mrs King also spoke out against the Vietnam War at rallies sponsored by SANE and other anti-war groups.

Eight months after their success in Geneva, WSP members were

called to testify before the House Committee on Un-American Activities. Fourteen women brought their children to the hearing, making it clear that they advocated for the health and well-being of their children and not an 'un-American' conspiracy. They succeeded in getting the Committee to back away from any further action by a presentation that emphasized their identity as patriotic American mothers. But the Committee was not through with WSP. In December of 1965, Mrs Wilson and two other WSP members were summoned to a secret hearing about their efforts on behalf of a pacifist Japanese professor who was applying for a visa to lecture in the United States. All three were found in contempt of Congress because they refused to testify in a secret hearing. Their convictions were eventually overturned.

At first, members of WILPF and WSP approached opposition to nuclear proliferation and the Vietnam War from what historian Gerald Gill called 'the gender-specific instincts of women as the givers and nurturers of life'. Their goal was to make the case to American women that ending the arms race and the Vietnam War were vital causes for all mothers. Over time, the WSP narrative shifted from one of maternal responsibility to a more global advocacy for children worldwide with the slogan, 'Not My Son, Not Your Son, Not Their Sons', a sentiment that was especially apt when applied to WSP's draft counselling activity. As the need for additional troops to serve in Vietnam increased and as the draft became a critical issue for young men of draft age, the WSP found a new mission to provide assistance to potential draftees who had reservations about fighting a distant war.

WSP began to provide support and draft counselling and was soon recognized as a militant anti-war organization. Historian Amy Swerdlow, who was an active member of WSP during the 1960s, wrote that the organization was a network of 'thousands of middle-aged mothers, who built on the female culture of the 1950s, as well

as their own long-held political commitments to peace and social justice, to organize a militant female opposition to the draft for Vietnam'.[135] As women who had been housewives and mothers in the 1950s, the members of Women Strike for Peace presented a different image from a new cohort of anti-draft protesters who were young, mostly male, loud, and not always well-groomed. WSP women were female, middle-aged, middle-class, and respectable. In an October 1966 article entitled 'Suppose They Gave a War and No One Came' in *McCall's* magazine, author and WSP member Charlotte Keys expressed pride in her son's decision to evade the draft. She took responsibility as a mother for inculcating socially responsible values in her child, writing that she and her husband were surprised 'when we inculcate our moral standards, that the children may live by them... We stand by our son, and we learn from him'.[136]

In their draft counselling effort, WSP members played a maternal role to the young men who refused to fight in a war they considered immoral. Unlike many younger women in anti-draft organizations who were told they had no say in deciding strategy or policy because they did not face conscription and, besides, they were 'girls', the women of WSP were respected and honoured by the young men they counselled. As the adults on the picket line, WSP lent a measure of credibility to the early anti-draft movement. By 1967, WSP began to take an even more clearly defined stand on the draft. In a 'Statement of Conscience' delivered to Selective Service Director Lewis Hershey, the group articulated its position on the correctness of draft evaders' actions: 'We believe that support of those who resist the war and the draft is both moral and legal. We believe that it is not we but those who send our sons to kill and be killed who are committing crimes. We do, however, realize that there may be legal risks involved, but because we believe that these young men are courageous and morally justified in rejecting the war regardless of consequences, we can do no less'.[137]

Women Against the War: The Ammerican Scene

Through marches, rallies, and confrontations with law enforcement, WSP members supported individual draft evaders and developed their moral position against the draft and the wider war. After a particularly confrontational march to the White House on 20 September 1967, during which WSP members broke through police lines but were eventually turned back, the organization issued a press release describing the events of the day: 'The women broke through the police lines, strengthened by their conviction that they were fighting for the lives of their sons, the survival of the people of Vietnam, and the right to petition the President. Neither billy clubs nor bruises will deter us. We will not be stopped'.

Throughout the most active period of WSP's anti-nuclear and anti-draft activity, photojournalist Dorothy Marder documented the group's efforts to end nuclear proliferation and stop the draft. At a time when most photojournalists were men and all journalists were obliged to report both sides of an issue in the name of objectivity, Marder stood out as an unapologetic feminist, a peace activist, and a supporter of gay rights. Her photographs focused on the otherwise ordinary women who marched for the children of the world, and her coverage was personal because Marder herself was active in WSP. In bringing the images of real women to the press and the public, Marder's work furthered the idea that the courageous acts of WSP members were legitimate and effective political actions.

Women who opposed the war in Vietnam demonstrated their militance and willingness to face consequences similar to those faced by male protesters. In May of 1968, the Supreme Court ruled that burning a draft card was not protected speech under the First Amendment to the Constitution. A month later, eleven women joined a group of men who burned their draft cards in protest. The women were arrested along with the men for supporting an illegal action in obedience to a higher moral law that moved them to oppose the Vietnam War. Many expressed their pride at having taken risks

similar to those of male protesters. Of course, women could not be drafted, but they could be called to account for trespassing or other violations, and their symbolic support of draft card burning invigorated the anti-draft movement at a time when draft calls were increasing.[138]

WSP assumed an active role in draft counselling, joining the War Resisters League (WRL), which had been founded in 1923 by activists who had opposed American involvement in the First World War, and the Fellowship of Reconciliation, a humanist-pacifist organization founded in 1914 in England. The Fellowship came to the United States in the following year, with Progressive reformer Jane Addams as a founding member. For a time, helping young men to find alternatives to conscripted service was the major focus of this coalition of 'adult' anti-war groups. Although they were not subject to the draft, WSP women protested conscription along with their male colleagues, lovers, and friends.

WSP later supported amnesty for military deserters, which was granted by President Ford on 16 September 1974. President Carter's Proclamation 4483, the Granting Pardons for Violations of the Selective Service Act, made amnesty for those who had refused to be conscripted a reality in 1977. But these presidential acts took place after the war had ended. Facing the draft, exile, or prison, young men in the 1960s experienced the disruption of their lives. For those who volunteered for military service or allowed themselves to the drafted, their choices were life-threatening, and the counselling provided by WSP helped many to clarify their thinking about the war and their personal role in it.

Historically, women often have been expected to promote peace and security at home, and they were mocked, reviled, or, worse yet, ignored when they had the temerity to voice opposition to the violence of war. Jeannette Rankin represented Missoula County, Montana in Congress starting in 1916. She was one of only fifty members to

vote against the war resolution in the First World War. After some time out of public life, she regained her seat in the House in 1940. Rankin was a pacifist and active member of WILPF throughout her career and was the only House member to oppose the declaration of war on Japan in December of 1941, declaring, 'As a woman I can't go to war and I refuse to send anyone else'. She was branded unpatriotic by men and women alike who respected neither her opposition to the war nor her right to speak her mind on the subject.

In May of 1967, when women's voices in opposition to the war were only beginning to be heard, Jeannette Rankin was invited to speak at a meeting of Atlantans for Peace. From that gathering, the idea of a women's march on the Capitol was born. On 15 January 1968, the opening day of the spring session of the 90th Congress, 5,000 women gathered at Washington's Union Station to begin their march. Calling themselves the Jeannette Rankin Brigade, the marchers included women drawn to direct action by Rankin's Atlanta speech and members of Another Mother for Peace (AMP), founded in 1967 by television writer Barbara Avedon as a non-partisan organization. AMP's goal was 'to educate women to take an active role in eliminating war as a means of solving disputes between nations, people and ideology'. Arguing that war was ineffective and obsolete, AMP members sent letters to public officials calling for an immediate end to the war. Through Avedon's contacts in Hollywood, AMP accumulated a mailing list of a quarter of a million people who received the group's anti-war message. AMP also sent Mother's Day cards to members of Congress with a message of peace:

For my Mother's Day gift this year
I don't want candy or flowers
I want an end to killing
We who have given life

Must be dedicated to preserving it
Please, talk peace.

This conveyed the message of maternal activism that resonated less with younger women than with the generation that made up most of the Rankin Brigade.[139] A generational rift among activist women was about to emerge.

The Rankin Brigade was not permitted to reach its goal because Capitol Police invoked an 1882 law prohibiting marches on Capitol grounds, and the women chose not to cross police lines in what would certainly have led to a violent confrontation. The participants protested the war in a decorous manner without risking arrest, while still garnering publicity for their cause. Rankin was in the front ranks of the march. As a former member of Congress, she was allowed to present a peace petition to the House, which went unanswered while Congress continued to authorize sending troops to fight in Vietnam. From the perspective of the WSP, WILPF, and Rankin herself, who was eighty-nine, the march was a success, mainly because of the publicity it generated.

But a contingent of younger feminists argued that the Rankin Brigade protesters had accepted the misogyny of American society by portraying themselves as mothers who were expected to lobby for peace rather than challenge the existence of male chauvinism that creates war. Members of New York Radical Women published a document written by Shulamith Firestone in which she characterized the actions of the Rankin Brigade as 'ultimately futile. It is naive to believe that women who are not politically seen, heard, or represented in this country could change the course of a war by simply appealing to the better natures of congressmen. Further, we disagreed with a women's demonstration as a tactic for ending the war, for the Brigade's reason for organizing AS WOMEN. That is, the Brigade was playing upon the traditional female role in the classic

manner. They came as wives, mothers, and mourners; that is, tearful and passive reactors to the actions of men rather than organizing as women to change that definition of femininity to something other than a synonym for weakness, political impotence, and tears'.[140]

Firestone and the New York Radical Women were correct to characterize the women of the Rankin Brigade as traditional, conventional, and non-threatening. There was a time when even that approach to protest seemed radical, but times were changing. The younger women who broke from the Rankin Brigade protest asserted that it was their right to present themselves as radical protesters with loud voices, non-negotiable demands, and profane language, just like their male colleagues. More than two hundred young women organized a protest of their own, which had been planned for months by the New York Radical Women. They invited the leaders of the Rankin Brigade to attend a ceremonial 'burial' of the traditional woman who 'passed with a sigh to her Great Reward this year of the Lord 1968, after 3,000 years of bolstering the ego of Warmakers and aiding the cause of war'. The invitation, designed by Firestone, advised women not to bring flowers to the event:

'Do be prepared to sacrifice your traditional female roles. You have refused to hanky wave boys off to war with admonitions to save the American Mom and Apple Pie. You have resisted your roles of supportive girlfriends and tearful wives, receivers of regretful telegrams and worthless medals of honour. And now you must resist approaching Congress playing those same roles that are synonymous with powerlessness. We must not come as passive supplicants, begging for favours, for power cooperates only with power. We must learn to fight the warmongers on their own terms, though they believe us capable only of rolling bandages'. New York Radical Women did not confine its critique to the Rankin Brigade march. It issued a statement of principles in 1969 in which the group asked not 'if something is reformist, radical, revolutionary

or moral. We ask: is it good for women or bad for women? We ask not if something is political. We ask: is it effective? Does it get us closest to what we really want to do in the fastest way'?

Clearly, a movement in which women's issues were subordinated to other political priorities would not be acceptable to New York Radical Women. By 1970, the organization had split into smaller groups, the most prominent of which was Redstockings, which expressed scepticism of all political ideology. The group placed more emphasis on human emotion, which, they felt, was missing in traditional political organizations dominated by men. Redstockings declared that its members were 'critical of past ideology, literature, and philosophy products as they are of male supremacist culture'.[141]

The division between older and younger women activists was evident at the Rankin Brigade protest. The WSP and WILPF women ignored the invitation to participate in the Burial of True Womanhood. The younger women, dressed in mini-skirts and determined not to stage a polite protest, left the Rankin brigade march and held their own burial ceremony by torchlight in Arlington National Cemetery. In their appearance and rhetoric, the younger women rejected the role of grieving mother or 'respectable' adult. One of their banners declared, 'Don't Cry – Resist!' In addition to 'burying' a large dummy of a faceless woman, the young feminists decorated the funeral bier with women's 'necessities' such as hair curlers, S & H Green Stamps, hairspray, and garters. Younger radicals had now distanced themselves from traditional protests and ideology based on motherhood espoused by the previous generations. Metaphorical daughters separated themselves from their mothers. In the crucible of the anti-war movement, Second Wave Feminism was coming to life.[142]

When WILPF and WSP women marched as mothers in conservative dress, they could count on a measure of public support, even respect. Once they raised their voices to oppose the Vietnam War, they were

vulnerable to criticism and the loss of the support they had once enjoyed. The more determined women were, the less support they received from the press. Rankin Brigade participants were called impatient women breaking the rules. The president of radio station WWDC in Washington observed that all the kicking and pushing was an outgrowth of the women's decision 'to defy the police and push the barricade. Under the circumstances, WWDC rejects the tiresome cries of police brutality. To try to make the police the scapegoats of these demonstrators does no credit to their cause'.[143] The women who began to call themselves radical feminists made themselves heard, but it was the Vietnam War and protests against it that captured the public's attention.

For all its good work and the gratitude expressed by the young men who were helped by WSP draft counselling, the women of WSP realized that they were up against a major adversary in the United States government and that their position in the growing peace movement was one of relative powerlessness. Amy Swerdlow observed that, when mothers confronted the military state, they 'soon learned that they are fighting against male dominance over foreign policy. For many of the key women of WSP the recognition and abhorrence of gender dominance and inequality in the political arena gave rise to an examination of all manifestations of gender inequality. For many there was no turning back to gender blindness'.[144] For WSP women, organizing on their own behalf was a logical next step, but it would take time to activate women of all ages and create a feminist movement. Members of Women Strike for Peace could be brave in the face of physical confrontation, but they left direct action and militance to others.

That made the actions of Alice Herz, a long-time member of Detroit Women for Peace, even more shocking. On 16 March 1965 at about 9:00 pm, Herz covered herself with a flammable liquid and set herself ablaze at the corner of Oakman Boulevard and Grand

River in the city. Bystanders put out the flames, but Herz died of second and third degree burns after ten agonizing days in the hospital. Following the example of Buddhist monk Trich Quang Duc, who set himself on fire in Saigon in June of 1963 to protest the abuse suffered by Buddhists at the hands of the Diem Regime, Alice Herz became a martyr in protest against the War in Vietnam at the age of eighty-two.

Alice Herz was born in Hamburg, Germany on 25 May 1882. From an early age, she expressed her commitment to social justice. In 1916, Herz joined the Women's International League for Peace and Freedom. Her life as a writer was disrupted by the untimely deaths of her husband and son in 1928 and the ascension of the National Socialist Party in 1933, when she and her daughter Helga left Germany and settled in France. After the fall of France in 1940, the two women were placed in an internment camp. They were able to emigrate to the United States in 1942, and they settled in Detroit. Alice worked as a part-time German teacher at Wayne State University, and Helga was a librarian. Both women applied for United States citizenship but were denied. Alice's re-application was approved in 1954. A strong commitment to pacifism led Alice to join both SANE and WILPF, and she helped to organize Detroit Women for Peace. Her pacifism was noticed by the Detroit Police Department's Subversive Squad, although she was not considered dangerous, just an active and noisy marcher.

Toward the end of her life, Herz expressed frustration with the marches, protests, and letter-writing campaigns that characterized the peace movement at the time, especially for women. Alice's daughter said her mother believed that 'a purely power policy based on overwhelming strength is morally wrong and will have disastrous results. She fears war and the suffering it will bring'. In 'Pacifism Sparked Her Fiery Sacrifice', the *Detroit Free Press* described a note that was found in Alice's pocketbook that said her action was a protest

Women Against the War: The Ammerican Scene

against 'the use of his high office by our president L.B.J. in trying to wipe out smaller nations'.[145]

The martyrdom of Alice Herz received relatively little attention in the American press or among peace activists. Eight months later, when Quaker seminarian Norman Morrison set himself ablaze in front of the Pentagon, public attention was aroused. Morrison was young, and he had brought his one-year-old daughter, Emily, the youngest of his three children, with him, handing her off to a bystander moments before his death. The *Evening Star* provided an eye-witness account of Morrison's suicide by United States Army Major Richard V. Lundquist: 'He suddenly appeared to light up and burst completely into flame, silhouetted against the dusk. Some people yelled at him "drop the baby"… the next thing I knew, he went over the wall and people were beating out the flames with their coats. I scrambled up the wall with several others and picked up the baby'.[146]

Morrison became a hero in Vietnam. On the forty-fifth anniversary of Morrison's death, *The Guardian* reported that his sacrifice was well known in Vietnam. His wife, Anne, received letters of support and thanks from ordinary people in North Vietnam, whose government had issued a commemorative stamp with Morrison's face on it and named a street in Hanoi after 'Mo Ri Xon'. She also received condolences from President Ho Chi Minh.[147] The actions of a young man received far more attention in the American press than an equally powerful response to the horrors of war by an elderly woman. In the mid-1960s, women were still perceived as lesser participants in the peace and anti-Vietnam War movements.

Herz's action also attracted the attention of the North Vietnamese. A month after her death, North Vietnam's *Vietnam Courier,* an English-language biweekly paper devoted exclusively to coverage of the war, observed that Herz's dramatic protest proved the existence of anti-war sentiment in the United States. The paper also printed a

letter from the North Vietnamese Women's Union, which observed that the war 'stains the honour and tradition of the freedom and equality-loving American people'. WSP members Mary Clarke and Lorraine Gordon, who represented the group at a commemoration in Moscow of the twentieth anniversary of the end of the Second World War, then journeyed to Hanoi, spending three days in an impromptu and unauthorized civilian visit. They stayed in private homes, visited bomb shelters and hospitals, and held informal talks with North Vietnamese leaders.[148] This trip attracted the attention of United States government officials who feared that the visit represented support for the North Vietnamese government.

Clarke and Gordon 's trip took place in secret. They met with representatives of the Vietnamese Women's Union of North Vietnam (VWU) and the Women's Liberation Union of South Vietnam (VLU). This was the first such meeting of Vietnamese and American women intended to bring the attention of the world to the shared mission of ending the Vietnam War. WSP activists supported an end to the war and were outraged by the extent of physical damage to the country and the large number of military and civilian casualties. The North Vietnamese women had a different approach to the war. They regarded engaging in the revolutionary struggle against American forces as part of their moral duty. The Hanoi meeting was followed in July of 1965 by a conference in Djakarta, Indonesia in which the women from WSP, VWU and VLU again shared the experience of war from their different geographical and political perspectives. The WSP women hoped to bring about an end to the war by describing the conflict's negative effects on mothers and children, while the Vietnamese women continued to emphasize the revolutionary nature of their struggle.

In December 1966, four American women activists representing various groups within the anti-war movement accepted an invitation from the Vietnamese Women's Union to travel to Hanoi to see the

Women Against the War: The Ammerican Scene

results of American bombing and to bring information back to the anti-war movement in the United States. Barbara Deming was a member of a socialist group founded by A.J. Muste, the Fellowship for Reconciliation; Grace Mora Newman was an activist from the Bronx, New York and the sister of Dennis Mora, of the 'Fort Hood Three', active duty soldiers who had refused orders to serve in Vietnam; Patricia Griffith was active in WSP in Ithaca, New York; and Diane Nash was a charismatic leader of the civil rights movement who had been active in the Freedom Rides, CORE and SNCC. At Hanoi's Thong Nhat Hotel, the Americans met representatives from Beheiren, the Japanese anti-war movement, trade unionists from Moscow, West German anti-war activists, and a camera crew from Cuba. They visited villages, hospitals, schools, and factories. Before returning to the United States, the women visited two American prisoners who gave them notes to their families and messages urging an end to the war. The women also met with President Ho Chi Minh.[149] Although the Americans did not place their trip in a specifically feminist context, their independent action *as women* flew in the face of assumptions in the New Left that women served the anti-war movement best by following the direction of men.

On her return, Nash commented that the sweethearts, mothers, and wives of American soldiers 'can forget any notion that the Vietnamese people will give in to American aggression. The only way White America will defeat the people of Viet Nam is to murder each and every one of them'. In a 2003 interview, Nash described her impressions of the Vietnamese women she met: 'I had the good fortune to travel to Vietnam during the Vietnam War and I was really inspired by the feminism of the North Vietnamese women. They took feminism very seriously. They were highly organized ... The women there felt that if Americans understood how and why the war was being fought, Americans would be against it – and time showed they were correct'. Nash admired the dedication of

the Vietnamese women to independence and freedom from the influences of foreign powers, especially the United States. She understood that the plight of the Vietnamese people was rooted in circumstances faced by African Americans in a capitalist society.[150]

WSP members Dagmar Wilson, Mary Clarke, and Ruth Krause returned to Vietnam in September of 1967. They observed the destruction caused by American bombing and war crimes committed by American soldiers. The women met with American prisoners of war and later facilitated the sending of messages and packages between PoWs and their families through the Committee of Liaison with Families of Servicemen Detained in North Vietnam (COLIAFAM), led by Cora Weiss. Like WSP's draft counselling work, the efforts of the women to help PoWs and families were humanitarian and based on the primacy of the family.[151] After her trip, Dagmar Wilson said she believed that Vietnamese women would 'play an important role in the international movement to challenge the right of powerful nations to inflict destruction on human beings'. [152]

Not all efforts to establish communication with Vietnamese women were so successful. In early 1966, a small delegation from the Committee for Nonviolent Action travelled to Saigon and held a press conference, but they were immediately driven back to the airport and deported. In response to attempts by Americans to travel to Vietnam and reveal conditions created by bombing raids, the State Department issued a directive that prohibited Americans from travelling to North Vietnam in 1966. On 16 January 1967, the Supreme Court invalidated the State Department edict in *United States v Laub*, a case relating to travel to Cuba. The justices observed that the State Department 'had consistently taken the position that there was no statute which imposed or authorized ... prohibition' of travel, even to countries with which the United States had no diplomatic relations. With no broad authority to prohibit visits to Vietnam, the State Department was forced to take a neutral position

on efforts by American citizens to undertake such travel.

The most prominent organization to oppose the Vietnam War emerged from left-wing activist groups dedicated to educating students on college campuses and organizing workers. The roots of Students for a Democratic Society lay in the Student League for Industrial Democracy (SLID), which was active from 1946 to 1959 and served early in its history as the student wing of LID, the League for Industrial Democracy. The new organization, founded at the University of Michigan on 1 January 1960 and led by its first president Robert Alan Haber, expressed frustration at the older organization's slow progress in bringing about meaningful social change. Early SDS members believed that letter-writing and petition drives and efforts to lobby lawmakers were too slow and not clearly focused on achieving full civil rights for African Americans or ending the draft and the war in Vietnam. SDS advocated large-scale protests and direct action to bring the horror of war home to the American people.

In June of 1962, members of SDS gathered at a United Auto Workers retreat, Camp FDR, located outside Port Huron, Michigan. Their purpose was to generate a position paper that would articulate both the frustration felt by young people with the current state of the nation and a sense of optimism that they could be agents for change in America. The Port Huron Statement, written primarily by Tom Hayden and completed on 15 June 1962, was that manifesto. After a brief introduction, the students described themselves and the values they held as children growing up in America after the Second World War: 'When we were kids the United States was the wealthiest and strongest country in the world; the only one with the atom bomb, the least scarred by modern war, an initiator of the United Nations that we thought would distribute Western influence throughout the world. Freedom and equality for each individual, government of, by, and for the people – these American values we

found good, principles by which we could live as men. Many of us began maturing in complacency'.

The Port Huron Statement then cited increasing racial bigotry and the dangers of military applications of atomic energy as major sources of discontent among young people. The writers observed that the central idea in Thomas Jefferson's *Declaration of Independence* that 'all men are created equal' rang hollow before the facts of African-American life in the Jim Crow South and the big cities of the North. The 'peaceful' intentions of the United States as the world's pre eminent economic and military power contradicted the government's economic and military investments in maintaining the Cold War status quo. Articulating a sense of responsibility for ending American complacency with respect to inequality, the Cold War, and the alienation they felt, the students declared that their mission 'is guided by the sense that we may be the last generation in the experiment with living'. This was a relevant concern among students in the Atomic Age who were concerned about imminent nuclear annihilation as well as the destruction of the planet because of nuclear fallout and pollution.

For the students at Port Huron, one of the essential problems was an erosion of the values that support civil society. They asserted that the conventional moral terms with which they had been raised were no longer relevant. They argued that 'the political moralities – free world, people's democracies – reflect realities poorly, if at all, and seem to function more as ruling myths than as descriptive principles. But neither has our experience in the universities brought us moral enlightenment. Our professors and administrators sacrifice controversy to public relations; their curriculums change more slowly than the living events of the world; their skills and silence are purchased by investors in the arms race; passion is called unscholastic. The questions we might want raised – what is really important? can we live in a different and better way? if we wanted to change society,

how would we do it? – are not thought to be questions of a "fruitful, empirical nature, and thus are brushed aside"'. Placing their faith in the university as the locus of intellectual inquiry and reform, even as they were frustrated with the slow pace of change of any kind in academe, the writers of the Port Huron Statement articulated a plan for a new left, one that was not bound to the hierarchical structures of either older left-wing organizations or traditional American political parties:

1. Any new left in America must be, in large measure, a left with real intellectual skills, committed to deliberativeness, honesty, reflection as working tools. The university permits the political life to be an adjunct to the academic one, and action to be informed by reason.
2. A new left must be distributed in significant social roles throughout the country. The universities are distributed in such a manner.
3. A new left must consist of younger people who matured in the post-war world, and partially be directed to the recruitment of younger people. The university is an obvious beginning point.
4. A new left must include liberals and socialists, the former for their relevance, the latter for their sense of thoroughgoing reforms in the system. The university is a more sensible place than a political party for these two traditions to begin to discuss their differences and look for political synthesis.
5. A new left must start controversy across the land, if national policies and national apathy are to be reversed. The ideal university is a community of controversy, within itself and in its effects on communities beyond.
6. A new left must transform modern complexity into issues that can be understood and felt close up by every human

being. It must give form to the feelings of helplessness and indifference, so that people may see the political, social, and economic sources of their private troubles, and organize to change society. In a time of supposed prosperity, moral complacency, and political manipulation, a new left cannot rely on only aching stomachs to be the engine force of social reform.
7. The case for change, for alternatives that will involve uncomfortable personal efforts, must be argued as never before. The university is a relevant place for all of these activities.

The Port Huron students were eager to create a new version of politics that nevertheless maintained a connection to traditional American values. Although SDS proved to be a radical organization that espoused fundamental changes in American society, along with withdrawal from Vietnam, the Port Huron Statement signalled only a moderate departure from Cold War liberal politics. But the call for participatory democracy, which became the hallmark of SDS, was both radical and new, as it seemed to demand broad involvement in decision-making, both in its own organization and in society at large. The challenge was to see if SDS could put participatory democracy into practice by including its women members as legitimate agents of social and political change in full cooperation and equality with men.

Where was the issue of women's role in American society in the Port Huron Statement? Primary author Tom Hayden acknowledged years later that women do not appear in the statement at all. Indeed, photographs of the participants reveal just five women among the attendees at the retreat. Historian Sara Evans noted the unrecognized and underappreciated contributions of those few women to the drafting of the Statement: 'Casey Hayden played a vocal role. A number of women participated in drafting sections of the statement – Judith Cowan on foreign aid and economic development;

Theresa del Pazo on economics. Mary Varela joined vigorously in a debate on religion. Sharon Jeffrey pushed for broader integration of issues. But when men in attendance are asked to recall women who were there, they have to rack their brains to remember'.[153] The process of analysing major social issues and helping to write the Statement had a positive effect on some of the women who took part in the retreat. Barbara Haber recalled that the experience helped her to see a future that did not have to include traditional marriage and life as a housewife. She wrote that, after Port Huron, she was 'beginning to feel some confidence that at last, I had escaped the suburban housewife fate that awaited me and other women in those days'.[154]

The intellectual work of SDS was generally not the province of women. In contrast to the community work of SNCC and the Black Panthers, which emphasized activism in local communities, SDS leadership in the group's earliest days prioritized theoretical discussion regarding the location of SDS in (or outside of) the traditions of American radicalism. Without much thought, the male leaders of SDS accepted the prevailing stereotypes relating to women's ability to participate in substantive policy discussions and did not consider that women could take on important roles in movement leadership. Women generally accepted a secondary role in SDS because they did not yet see themselves as immediately affected by the issue of the draft and did not yet see themselves capable of assuming leadership roles in a group whose goals included ending the draft. In a 1985 interview at Columbia University, Cathy Wilkerson remembered that 'The men in our organizations demanded that we assert and re-assert constantly our loyalty to them, and not to the independent women's movement. Women within SDS had to renounce separatism, you know, every five minutes in every discussion of women's issues or they would not be allowed to continue'.[155]

In the spirit of the Port Huron Statement that emphasized

broad-based social reform in a democratic society, SDS leadership announced the formation in September of 1963 of community projects in urban areas under an umbrella organization, the Economic Research and Action Project (ERAP). The goal of ERAP projects was to find specific ways to help poor people in America's cities with the problems they faced every day such as unemployment, housing, food insufficiency, childcare, and lack of proper sanitation. Inspired by Michael Harrington's revelatory book, *The Other America*, published in 1962, volunteer SDS organizers who lived on subsistence allowances were convinced that race and poverty were connected and that 'the ultimate problem of racism could largely be solved if more money could be put into the hands of Negroes'.

The first ERAP project was organized in Chicago in 1963 in an office next door to an unemployment office. The focus of projects in Chicago and Baltimore was employment. They were called Jobs or Income Now (JOIN) programmes. In Newark and Cleveland, the emphasis was on everyday issues such as trash in the streets or rats in the hallways. These projects were called Garbage Removal or Income Now (GROIN). Some projects were successful, while others did not outlive ERAP's two-year lifespan. Throughout the life of the projects, SDS workers struggled with the issue of their own paternalism and the challenges of developing authentic relationships with their neighbours. Rennie Davis, ERAP's National Director, recommended that activists in Chicago should live like poor people, 'drinking and swearing like them'. Some in cities such as Chicago chose to live in the communities they served, hoping to be accepted by those neighbours while others lived in communal houses or apartments separate from the ghetto. Both groups faced the challenge of demonstrating that they were not in the neighbourhood to preach to residents but were eager to help them obtain rights and services to which they were entitled.

ERAP was not widely acclaimed within SDS. Al Haber felt that there

should be more emphasis on research designed to find alternatives to the welfare state than on community action. Nevertheless, there were some successes, especially for women in ERAP, even though the directors of all ten urban projects were men. As if to confirm the stereotype that women were more effective in the 'soft skills' of community organizing, women were frequently successful in organizing local residents to lobby community agencies to provide needed services such as garbage collection. They were able to relate to the problems faced by America's poorest women and children. In general, ERAP was much less hierarchical than the national SDS organization, and women found ways to develop their speaking, writing, and organizing skills. ERAP women were also inspired by the resilience of poor women who kept their families together despite the dual burdens of poverty and a lack of political power.

It is fair to say that working in ERAP helped to radicalize many SDS women. Many women found their place in ERAP projects and were proud of their accomplishments, especially when they were able to organize local women to accomplish a goal that helped their neighbourhoods. The fact that such successes were difficult to achieve contributed to women's sense of frustration at not being asked or allowed to do more. Barbara Haber recalled that many ERAP projects in local communities utilized vital skills that women possessed, noting that women were particularly adept at community building:

'From nuclear and extended families, to neighbourhood groups, to faith and civic organizations, to the grunt work that kept unions and political organizations going – all the backroom work, the uncredited weaving of communal fabric – that has been historically the work of women. We'd grown up absorbing those skills and the unspoken understanding that community building was up to us. Although we aspired to intellectual and organizing roles in our movement work, we intuitively and automatically moved to weave that fabric. And the men expected it of us, were comfortable with us being there,

thought it was where we belonged, and gave us emotional rewards for doing it'.[156]

But eventually, a pat on the head for a job well done would prove unsatisfying for SDS women who had more to contribute to the movement for peace and social change that had initially attracted them to SDS. By 1965, as many of the ERAP projects were closing down, workers in local communities came to realize the enormity of the goal of creating an alternative to the welfare state. The primary focus of SDS at both the national and local levels shifted to opposition to both the draft and the Vietnam War. SDS chapter growth was slow until the war escalated, driving an increased demand for troops and pressure on local draft boards. On 17 April 1965, SDS organized a march that drew nearly 25,000 people to Washington to bring the war to the attention of the American people. At the time, troop levels did not yet exceed 25,000, but that would soon change, and SDS was in the forefront of the anti-war movement.

As SDS became the most prominent force against the war on college campuses, a crisis pitting students against university administrators was brewing at the University of California at Berkeley. Regarded as the jewel in the crown of the University system, Berkeley attracted California's best and brightest young men and women. University life in the early 1960s was characterized by a strict formality in many aspects of student life. Students in class were called Mr and Miss, and officials set curfews for women students. Control of student life lay firmly in the hands of administrators who acted *in loco parentis*. The university also attempted to limit or at least monitor any activity on campus that might be characterized as political. When students sought to distribute flyers announcing civil rights demonstrations and denouncing the Vietnam War in an area just off campus that had long been a locus of student expression, the Berkeley administration shut down the tables and suspended many students who engaged in speech that would have been protected in the public square. The university

then attempted to ban further demonstrations and leafleting. The Free Speech Movement (FSM) was born and would serve as a model for protests against restrictive university regulations in France, Germany, and other countries. The anti-war movement and protests against traditional cultural restraints would prove to be transnational.

Mario Savio, a graduate student in mathematics, was the acknowledged leader of the Free Speech Movement. In marches and rallies in which he encouraged students to be the conscience of the Berkeley community, Savio's argument was simple – preventing students from informing their colleagues about civil rights and anti-war protests constituted illegal prior restraint of speech. After a takeover of the administration building that led to violent police action against the students, the Berkeley faculty voted to support the FSM. Eventually, the university's Board of Regents relented and met the FSM's demands. The FSM was supported by civil rights groups such as CORE and SNCC, and members of SDS were active in FSM demonstrations. Thousands of women participated in FSM demonstrations, and many were forcibly removed from the administration building and even suspended from school. While they were not leaders of the movement, women were active at the barricades.

As the FSM galvanized student support for free speech and a student voice in the running of the university at Berkeley, SDS used the power of the press in its effort to recruit new members and publicize its anti-war position on campuses throughout the country. At the national level starting in 1962, the organization published the *SDS Bulletin*, which printed articles on the activities of the national organization and local chapters. The *Bulletin* was replaced in 1966 by *New Left Notes*, which analysed international socialist movements, events in the local campus chapters, and growing opposition to the war and the draft. Women emerged as campus leaders and popular speakers in SDS recruiting drives. Among the more prominent

women in the national SDS organization who reported in *New Left Notes* were Cathy Wilkerson and Bernardine Dohrn, whose articles, ranging from analyses of the war to discussions of the new feminism, revealed the concerns of SDS in general and SDS women in particular in the late 1960s.

On 18 December 1967, Wilkerson reported in *New Left Notes* on the return from Hanoi of a delegation comprised of representatives from several student anti-war groups. Wilkerson was a national staff member of SDS, an editor of *New Left Notes*, and a participant in the trip. The students had accepted an invitation from the Democratic Republic of Vietnam (DRV) Peace Committee and the DRV Women's Federation. They met with members of both groups and travelled to remote provinces to observe local schools whose operations had been disrupted by repeated American bombing raids. Wilkerson described what she had learned first-hand about American bombing. Representatives of the DRV explained that in the past, any bombing pause, even if it was to last only a couple of days, had been preceded by an increase in the tonnage of bombs during the weeks before and in between the pauses. Thus, the months of December and January, with a pause at Christmas, New Year's, and Vietnamese New Year's in February, were the worst months.[157] This description diverged significantly from the reporting of the major newspapers, magazines, and TV networks to which Americans were exposed daily. In 1967, the mainstream press printed and broadcast what their reporters were told – that bombing pauses at Christmas and the New Year were humanitarian efforts on the part of the American military. Local newspapers and the network nightly news did not report on accelerations in bombing activity prior to the holiday pauses. *New Left Notes* provided an alternative to the positive mainstream news media narrative.

Two months after Wilkerson's description of the bombing raids, North Vietnamese and Viet Cong forces staged coordinated attacks on

Women Against the War: The Ammerican Scene

five cities in South Vietnam, American military bases, and numerous villages and towns in the South during the Lunar New Year. The Tet Offensive undermined the American public's confidence in the conduct of the war, but the military, the Johnson Administration, and many members of the press continued to claim success in the jungle. Newscaster Walter Cronkite declared on 27 February 1968 that the war could not be won, and President Lyndon Johnson announced on 31 March of that year that he would not run for re-election in 1968 in order to work for peace. Peace talks in Paris were stalled because the participants could not agree on the shape of the negotiating table. But the Administration nevertheless continued to assert that victory, or at least a fair resolution of the conflict, was within reach.

On 10 April 1969, Bernardine Dohrn, SDS Inter-Organizational Secretary and contributor to *New Left Notes,* also reported on the contrast between information provided by the National Liberation Front and the assertions of United States government officials regarding the progress of the war. Information from the NLF revealed that as the Spring Offensive began its seventh week, 'the longest sustained action the NLF has ever undertaken, its support based on the masses of Vietnamese and their ability to decimate US forces, is again proven. The scope and coordination of the attacks is enormous: the last week alone, 26 helicopters were downed, 30 US bases were hit on March 26, including a powerful attack on a Mekong Delta base, and on March 21 and 22 over 100 bases and institutions were attacked despite a highly-publicized US counter offensive'. Dorhn reported that, 'Defence Secretary Melvin Laird told Congress that the current enemy drive is destined for failure. He then asked Congress for an increase of $102,000,000 for fiscal 1969 and 1970 to maintain a high level of B-52 raids in South Vietnam'. Dorhn and other SDS reporters reached an audience that already opposed the war, but over time, a growing percentage of the American people came to share Cronkite's view that the war could not be won'.[158]

SDS took a very serious and disciplined approach to ending the Vietnam War through demonstrations and activities that stressed the deleterious effects of the war on both military and civilian populations. In contrast, other anti-war groups were serious about using humour and sarcasm in calling out the absurdity of the war. If Pentagon generals could order bombing raids, then protesters, led by Abbie Hoffman, could exorcise the Pentagon's demons in a ceremony that would include levitating the entire building. Of course, the idea was absurd, but it drew thousands of young protesters to the Pentagon on 21 October 1967. This was no disciplined march where people chanted with a single voice about ending the war, smashing imperialism, or eradicating racism. Rather, as Allen Cohen described it in the San Francisco *Oracle*, it was a free-for-all for many causes: 'At the demonstration every faction had a chance to act out its outrage at the ever-growing horror of the war: the more moderate marched and listened to speeches; the more radical broke through the lines and into the hallowed halls of the Pentagon wherein they were beaten by soldiers; occultists and poets like Ed Sanders and Kenneth Anger threw flowers at the soldiers and marshals, and placed the flowers delicately in the barrels of their rifles'.[159]

The theatricality of the march on the Pentagon attracted significant press coverage, as had organizer Abbie Hoffman's earlier attempt to connect the war, greed, and American capitalism by showering the New York Stock Exchange floor with dollar bills on 24 August 1967.

The exorcism and levitation of the Pentagon, complete with Mayan shamans, was a media success, but there was no group to claim credit for its creation. By December of 1967, a group of men and women, led by Hoffman and Jerry Rubin, came together in San Francisco to organize the Youth International Party (the Yippies), known for its prankster approach to protest and its guerrilla theatre presentations such as nominating a pig for president at a counter-convention in Chicago in August of 1968. Judy Albert Gumbo introduced 'Pigasus

the Immortal' as the Yippie candidate, and Jerry Rubin began an acceptance speech on the pig's behalf. He was interrupted when law enforcement agents confiscated the pig. Although the most prominent Yippie leaders were men, women took an active part in many events designed to call attention to the absurdity of the war. For their absurdist antics, the Yippies were sometimes called 'Groucho Marxists'.

Bernardine Dohrn and her SDS colleagues were serious revolutionaries in the late 1960s and early 1970s. Dohrn joined SDS after graduating from law school in 1967 and was soon elected to a national office. As the Civil Rights Movement intensified and the war escalated, Dohrn travelled throughout the United States, speaking on college campuses and making connections with people in leftist organizations throughout the world. She remembered the exhilaration of those times, when she met with representatives of leftist groups from Germany, Spain and Italy. Activists from these countries had a history of socialist and communist activism, and Dohrn learned about the possibilities of organizing a student left in this country from them.

Dohrn's earliest contributions to *New Left Notes* consisted mainly of political analyses of the war, but as movement women began to articulate specific grievances, she turned a critical eye to the 'woman problem'. Dohrn and a few colleagues were part of a small group of SDS women who reported on 'serious' matters such as the draft and the war. They also used the forum of *New Left Notes* to articulate women's dissatisfaction with circumstances within the anti-war movement and in American society in general.

In March of 1968, joined by fellow SDS member Naomi Jaffe, Dohrn analysed an attack on the emerging Women's Liberation Movement through the lens of the commodification of women's bodies in a capitalist consumer economy. In February of that year, the left-leaning magazine, *Ramparts,* had printed a cover story that

mocked demands for women's liberation. Commenting on the two factions in the Jeannette Rankin Brigade protest earlier in the year, editor Walter Hinkle told readers 'You won't mind twisting your neck to look at the girls on the very left of the Brigade, since they are the prettiest'. The magazine cover featured a headless woman with obvious cleavage and a Jeannette Rankin button pinned to her chest. The headline 'Two Tits, No Head' understandably aroused the ire of feminists, including Dohrn, who couched her analysis as a critique of capitalism itself, as well as the anti-war movement that relegated women to second-class status:

'"Two Tits and No Head" – as the representation, in glossy color, of the Women's Liberation Movement – is an example of *Ramparts'* success in making a commodity out of politics. Over the past few months, small groups have been coming together in various cities to meet around the realization that as women radicals we are not radical women – that we are unfree within the movement and in personal relationships in society at large. ... We are coming together not in a defensive posture to rage against our exploited status vis a vis men, but rather in the process of our own autonomy, to expose the nature of American society in which all people are reified (manipulated as objects). We insist on a recognition of the organic connection of the unfreedom of all groups in society. ... Women suffer only a particular form of the general social oppression, so our struggle to understand and break through society's repressive definitions of us are struggles which have to attack the foundations of that society – its power to define people according to the needs of an economy based on domination'.

Jaffe and Dohrn continued that women's liberation, in the anti-war movement and in society, depended, not on competition with men or each other, but on re-defining important economic and social relationships. They asserted that a strategy for the liberation of women does not require the further exploitation of women through

equal access to jobs, 'but meaningful creative activity for all; not a larger share of power but the abolition of commodity tyranny; not equally reified sexual roles but an end to sexual objectification and exploitation; not equal aggressive leadership in the Movement, but the initiation of a new style of non-dominating leadership'. With this article, Jaffe and Dohrn brought the same political analysis of American society to a discussion of women's role in SDS and in society that male SDS leaders used to critique America's war.[160]

But Jaffee and Dohrn's critique did not represent the prevailing view of women's liberation within the SDS hierarchy. In March of 1969, a *New Left Notes* article denigrated the concept of an independent women's movement. The unidentified author even asserted that women who sought their own movement were 'failing' at the task. The article stated that, instead of integrating (not submerging) the struggles of women into the broader revolutionary movement, 'these women are failing at their own middle-class images. The focus only on sexual exploitation and the tyranny of consumption does not develop a mass understanding of the causes of oppression, and it does not accurately point at the enemy'.[161]

The *New Left Notes* writer underestimated the extent to which women were placing their role in society at the centre of their analysis and the degree to which their message would be attractive to women around the world. Second Wave Feminism would face charges that it was a predominantly White, middle-class movement, but feminist organizations that represented the interests of particular groups defined by race, class, sexual orientation, and sexual identity emerged to broaden the reach of the feminist movement.

Within a few months of the *New Left Notes* article, SDS began to define its struggle in terms that included women's liberation. For example, the 30 June 1969 issue included an article entitled 'The Fight for Women's Liberation is Basic to Defeating Imperialism'. The 22 December 1969 issue printed a 'Resolution on Women's Liberation'

for the next SDS conference. 'Strengthen the Fight Against Male Chauvinism' in the 20 July 1970 issue pointed to a shift in direction for SDS to a more affirmative stance on women's issues. Relatively few Americans read the analyses of Wilkerson, Jaffe, Dohrn, and other writers in *New Left Notes* or recognized the subtle shift toward acknowledging the importance of women's liberation, as the paper circulated almost exclusively among people who were already committed to the anti-war and women's liberation causes.

The wider American public was moved to look at the human cost of the war in Vietnam through visual images that appeared in mainstream media sources. One of the most prominent of these was a photo of a naked nine-year old girl who was part of a group of children running away from a South Vietnamese napalm attack. The photo was taken by Nick Ut, a Vietnamese-American photographer who worked for the Associated Press. He took the photo on 8 June 1970 in the village of Trang Bang. The image of the young Phan Thi Kim Phuc circulated throughout the world and drew attention to the horror of the war for children. It also earned a Pulitzer Prize in photography for Ut.

On 6 June 2022, Ms Kim Phuc described her ordeal in *The New York Times* fifty years after the photo was taken:

'I grew up in the small village of Trang Bang in South Vietnam. My mother said I laughed a lot as a young girl. We led a simple life with an abundance of food, since my family had a farm and my mom ran the best restaurant in town. I remember loving school and playing with my cousins and other children in our village, jumping rope, running and chasing one another joyfully. All that changed on June 8, 1970. I have only flashes of memories of that horrific day. I was playing with my cousins in the temple courtyard. The next moment, there was a plane swooping down and a deafening noise. Then explosions and smoke and excruciating pain. I was 9 years old. Napalm sticks to you, no matter how fast you run, causing horrific

Women Against the War: The Ammerican Scene

burns and pain that lasts a lifetime. I don't remember running and screaming Nong qua, nong qua ("Too hot, too hot"!). But the film footage and others' memories show that I did'.

After he took the photograph, Ut grabbed the young girl he did not know, wrapped her in a blanket, and carried her to the village where she could receive medical help. Ms Kim Phuc endured numerous surgeries and eventually settled in Canada. She lived with vivid memories of war and the intimate knowledge of what it is like 'to have your village bombed, your home devastated, to see family members die and bodies of innocent civilians lying in the street'. That devastation was memorialized in black and white for people all over the world. Over many decades, Ms Kim Phuc has turned her terrible experience into a life dedicated to peace. She wrote that the scars of war remain with her: 'You don't grow out of the scars, physically or mentally. I am grateful now of the power of that photograph of me as a 9-year-old, as I am of the journey I have taken as a person. My horror – which I barely remember – became universal. I'm proud that, in time, I have become a symbol of peace'.

The war also came home to American living rooms in a photograph taken at Kent State University on 4 May 1970. The image of the young woman looking up in anguish and despair as she knelt near the body of a protester who had just been killed by a bullet from an Ohio National Guardsman shocked the nation. The student was Jeffrey Miller, and John Fito, another student who was returning to campus after taking wildlife images for a class project, took the photograph. The young woman who saw Miller die was Mary Ann Vecchio, a fourteen-year-old who had recently run away from her home in Florida. Her horror and grief appeared in newspapers and on television news broadcasts all over the country. For many Americans, the Kent State photo symbolized the impact of war in their own back yard. For students, the idea that one could be shot from a great distance by a person their own age wearing a National Guard uniform was terrifying. The

image made many Americans all the more convinced that the war had to end, but some were now reluctant to take to the streets to risk the fate of the four murdered students at Kent State.

Peace was the goal of anti-war organizations, but it was difficult to overcome differences within the ranks over ideology, strategy, and tactics. In June of 1969, SDS held its final national convention in Chicago. The tension that dominated this meeting resulted in the formal separation of the organization into factions. The Revolutionary Youth Movement (RYM) soon became Weatherman, an organization committed to militant direct action to disrupt the everyday operations of government and force an end to the Vietnam War. Another faction, the Worker Student Alliance, part of the Progressive Labor Party, proposed that students and workers form an authentic American labour party. The traditional SDS that had brought the issue of the war to public attention no longer commanded the main stage in the anti-war movement.

By 1969, both Bernardine Dohrn and Cathy Wilkerson were allied with Weatherman. Within a few weeks of the Convention, Wilkerson offered a sharp critique of Weatherman's statement of its basic principles, which failed to include any mention of women's rights. Wilkerson contributed an article to *New Left Notes* on 8 July 1969, which was later published as 'Toward a Revolutionary Women's Militia'. She presented a blueprint for what was necessary for men and women within the anti-war movement to accomplish together: 'It is crucial that men and women both begin to fight against the vestiges of bourgeois ideology within themselves, to break down existing forms of social relationships. Only by developing forms in which we can express love in non-exploitative and non-competitive ways will men and women develop their full human and revolutionary potential for struggle'.

In language that echoed the analysis of Jaffe and Dohrn the previous year, Wilkerson made it clear that struggling for equality within the

Women Against the War: The Ammerican Scene

prevailing capitalist system would provide insufficient remedies. It was time to create an entirely new societal paradigm in which women are not 'demanding equality with men under the current conditions, but are demanding a whole new set of values, socialist values, by which people relate to each other in all forms of individual and collective relationships. It is true that while we fight these battles for socialist practices, we can't be clear as to the exact content of the demand. These struggles must be seen as the beginning of a long, protracted struggle for socialism, and we will only gradually be able to perceive the positive content of the demands'.[162]

With Weatherman, now called the Weather Underground, the predominant faction in SDS and the Progressive Labor Party faction expelled, the focus shifted from theoretical analysis to direct action that included protests, so-called 'jail breaks' at high schools and colleges in which students liberated themselves from class, attacks on police cars, and bombing attacks. On 6 March 1970, three members of the Weather Underground, Ted Gold, Diana Oughton, and Terry Robbins, were killed in a Greenwich Village townhouse owned by Cathy Wilkerson's family when a bomb they were assembling exploded. Wilkerson and Cathy Boudin, who were present in the townhouse, along with Bernardine Dohrn, who was not present in the townhouse, went underground for more than a decade. The attacks on state, local, and federal government buildings continued, and the war in Vietnam raged on.

Even as SDS was transformed as an organization, demonstrations against the war continued on college campuses and in the streets of America's cities. The outbreak of major demonstrations at Columbia University that turned violent in April of 1968 emanated out of a variety of student frustrations. The university's war research for the Institute for Defence Analysis in cooperation with the Department of Defence as well as its research for weapons development angered students who believed that such research illegitimately supported

American involvement in political conflicts abroad. In addition, Columbia's decision to construct a new gymnasium in Morningside Park in Harlem, adjacent to the mains campus, prompted charges of racism. The new building would encroach on public park land used by Harlem residents with public access to the proposed facility limited to a door on the lower level. While supporters of the gym said building in the park would not displace Harlem residents, opponents argued that the motivation behind the project was inherently racist because it was based on the assumption that 'White Columbia' could use land that properly belonged to the African-American residents of Harlem. Opponents called the proposed building an example of 'gym crow'.

Columbia SDS chapter president Mark Rudd articulated important political and community concerns while hoping to increase the membership of the organization. His SDS platform was summed up by the slogan, 'How to Get the SDS Moving Again and Screw the University All in One Fell Swoop'. The issues behind the protests animated students, both those who were radical and others who were simply concerned. Columbia SDS became front-page news in New York and throughout the world.

In 1968, Columbia's undergraduate college was an all-male institution. Women who joined SDS and the protests over Columbia's affiliation with IDA and the location of the gym came from neighbouring Barnard College and other institutions in the New York City metropolitan area. Hundreds of Barnard women shared Columbia students' opposition to the war and war research, and many saw the new gym as a racist mistake on the University's part. They also objected to restrictions on their non-academic life, such as rules governing where and with whom they could live. Barnard women joined the 23 April protests, and many found themselves occupying administrative offices in Low Library and Hamilton Hall. Once installed as part of a student occupying force, women

Women Against the War: The Ammerican Scene

found themselves generally assigned to clerical tasks or housework. Objections to being consigned to 'women's work' constituted a first step toward women's liberation, and some women used sarcasm to make their point. A sign above a typewriter in Fayerweather Hall proclaimed: 'TO ALL WOMEN: You are in a liberated area. You are urged to reject the traditional role of housekeeping unless, of course, you feel that this is the role that allows for creative expression. Speak up! Use your brains'.

There were few women in the strike leadership, with only seven of seventy on the Strike Coordinating Committee and none on the Strike Executive Committee. Strike participant Meredith Willis remembered that speaking time in the Mathematics Hall strike meetings went to those who 'could talk longest, loudest, and with the most references to Marx'. Demands by women for a greater voice in strike strategy and tactics were rebuffed. After the strike ended, more than one thousand students and faculty members participated in a Liberation School. One of the most popular courses focused on women as an oppressed class. Writing a year later in *New York* magazine, Gloria Steinem recalled that class discussions debunked the inaccurate and destructive parallel myths about 'women and Negroes that both have smaller brains than white men, a childlike nature, natural "goodness", limited rationality, supportive roles to white men, etc'. Discussions also focused on 'the paternalistic family system as prototype for capitalist society (see Marx and Engels); the conclusion that society can't be restructured until the relationship between the sexes is restructured'. Men were not permitted to participate in this course, and it served as an important opportunity for women to state their grievances in the immediate aftermath of the strike.[163] Women did not yet have the power of numbers or the voice of a feminist theory of their own with which to make their case. That would happen in the years soon after the Columbia uprising. Columbia College finally admitted women

students in 1984 and was among the last of the country's major all-male universities to do so.

White students who found themselves in Hamilton Hall soon learned that the Students' Afro-American Society had their own goals focusing on university practices they saw as racist. SAS members, echoing the ideology of 'Black Power for Black People' that had led SNCC to ask its white members to leave the organization in 1966, asked White students to leave Hamilton. Carolyn Eisenberg, then a Columbia graduate student in history, stated that she and her colleagues were 'kind of shocked and disoriented. The moment when black students said, "We want you guys to leave", didn't feel that great. But the animus toward Columbia was so dominant that that kind of took over'. With negotiations between the university and disparate student groups apparently making little progress, Columbia President Grayson Kirk called in the police to put an end to the occupations. The result of the 'bust' was a bloody confrontation that yielded seven hundred arrests and more than one hundred injuries. Women were treated just as brutally as men when the New York City Police Department cleared the buildings. One male protester recounted 'a very vivid memory of one cop sauntering up to one of the women and battering her head. He just kept slamming into her. Everybody got beat up, some much worse than others'. The 1968 Columbia protests led to some student participation in university governance. They also helped to radicalize women students who articulated grievances of their own and founded a movement to address those issues.[164]

In spite of their active participation in demonstrations and their willingness to face the same consequences as male demonstrators, including being tear gassed, beaten, and arrested, women were not always taken seriously by their male colleagues in the movement. Barbara Haber acknowledged that there were moments when women were recognized and supported for their movement work,

but experiences in which women were condescended to, 'ignored, or punished for our outspokenness or ambition far outweighed them. For many of us, our most painful negative moments had come within our political world. SDS and the *Port Huron Statement* had raised our expectations. And what would later come to be called sexism was more deeply hurtful and less tolerable in our chosen community and from our comrades, friends, and lovers'.[165]

The 'invasion' of the all-male United States Military Academy at West Point by Vassar College women in October of 1969 was an effort to make the case against the war to the next generation of Army second lieutenants. The women, 'armed with facts, reason, and charm', brought anti-war petitions to West Point cadets, hoping to garner some signatures: '200 Vassar students armed with flowers and calls for peace entered the military campus on October 15. Many cadets scoffed at the effort and spread rumours that Vassar girls were there to 'offer their bodies in exchange for signatures on anti-war petitions'. Army cheers drowned out Vassar freedom songs as cadets outnumbered the protesters nearly four to one. In the end, Vassar women managed to discuss the war with some cadets, but the event was largely considered to be a failure. No cadets signed anti-war petitions or acknowledged sympathy with anti-Vietnam thoughts, and the front page of the October 17 issue of *The Miscellany News* declared, 'West Point Invasion Fails, Cadets Maintain Stronghold'.'[166]

The Vassar women were neither committed *politicos* nor devotees of Abbie Hoffman bent on engaging in absurdist street theatre to highlight what they saw as the absurdity of war in Southeast Asia. Rather, they were women who hoped to engage in conversation about the war. They hoped to end the conflict by redirecting public opinion against it. Their failed attempt illustrates the frustration of the anti-war movement by 1969 and the turn by some to aggressive direct action and by others to political satire through absurdist art.

By the mid-1960s, masculine and feminine images appeared in

Don't Call Us Girls

works of art designed to convey a critique of American consumer society and the war it supported. Pop artist Claes Oldenburg, who was a 1950 Yale graduate, decided in early 1969 to collaborate with architecture students to present the university with a sculpture that would reflect contemporary concerns. The unanticipated, and undesired, gift, 'Lipstick (Ascending) in Caterpillar Tracks', featured a 24-foot-high tube of lipstick resting on a mock-up of a military tank. University administrators were not at all happy with the location of the statue in Beinicke Plaza overlooking the president's office and near a memorial to Yale students killed in the First World War, but they did not remove it. According to architectural historian Mya Dosch, 'Lipstick claimed a visible space for the anti-war movement while also poking fun at the solemnity of the place. The sculpture served as a stage and backdrop for several subsequent student protests'.

Women were admitted to Yale as undergraduate students in the fall of 1969, and 'Lipstick' was a natural location for demonstrations demanding equality at Yale and an end to the war. Students covered the tank with graffiti and flyers. Dosch observed that, with 'Lipstick' in such a public space, Oldenberg's sculpture provided a critique of both the hyper-masculine rhetoric of the military and the blatant consumerism of the United States. He wrote that, 'by bringing both domestic and military objects into a public space, Lipstick ... blurred the lines between public and private, and between the War in Vietnam and culture of the United States... In addition to the feminine associations, the large lipstick tube is phallic and bullet-like, making the benign beauty product seem masculine or even violent'. The juxtaposition implied that the American obsession with liberty and consumption both fuelled and distracted from the ongoing violence in Vietnam.

When the statue began to deteriorate, Oldenburg removed it and had a more permanent version forged of steel in 1974. A new

Women Against the War: The Ammerican Scene

location in Morse College became the statue's new home. 'Lipstick' was a prominent example of Oldenburg's Pop Art style that often conveyed political as well as satirical messages. Oldenburg expressed his views on the purpose of his art: 'I am for an art that is political – erotical – mystical that does something other than sit on its ass in a museum ... I am for an art that imitates the humor, that is cosmic, if necessary or violent, or whatever is necessary'.[167]

Photographs of anti-war protests on the Yale campus and in New Haven reveal that women took part in marches and carried banners, mainly calling for an end to the war and the return home of American troops. Yale women in the early days of coeducation at the university also focused on gender equality in university life, an issue that activated a radical impulse in a small but influential minority of the Yale Sisterhood and other women's groups on campus. Starting in 1969, when women and their male supporters gathered at the 'Lipstick', they articulated their opposition to the war as well as the profound need for change at Yale.

By 1969, as the war dragged on and the death toll of American soldiers rose to 45,000, student protests continued, and women were key participants in marches and rallies intended to force policy makers in Congress and the White House to bring an end to the fighting. The first National Moratorium Day took place all over the country on 15 October 1969. A month later, a second Moratorium brought 500,000 people to the streets to demand an end to the war. The Second Moratorium event followed the March Against Death on 14 November, when marchers carried signs bearing the names of soldiers killed in country and Vietnamese towns that had been destroyed in the name of 'pacification' of the civilian population. The protests were large, but they were peaceful.[168]

Protests against the War in Vietnam also took place in high schools. Students walked out of classes, attended Moratorium days, and raised their voices in teach-ins and other events sponsored by SDS

and other anti-war groups. Some young students, including Mary Beth Tinker from Des Moines, Iowa, staged their own individual protests. On 16 December 1965, Mary Beth, her brother John, Chris Eckhardt and a few other students came to their Des Moines middle school wearing black arm bands to express a silent protest against the American bombing of North Vietnam. The local school board had heard about their action and passed a ban on the wearing of armbands. The students were told that if they did not remove the armbands they would be suspended. The small dissident student group stayed home until after the winter holiday. When they returned to school, they complied with the armband edict but wore black clothing for the remainder of the school year. With legal representation from the American Civil Liberties Union (ACLU), the students' parents filed a lawsuit, asserting that their children's First Amendment right to free expression had been violated and that they were entitled to equal protection from state action under the Fourteenth Amendment.

Mary Beth Tinker and her fellow students lost their case in the United States District Court for the Southern District of Iowa. They took their case to the United States Court of Appeals for the 8th Circuit and lost again. In JOHN F. TINKER and Mary Beth Tinker, Minors, etc., et al., Petitioners, v. DES MOINES INDEPENDENT COMMUNITY SCHOOL DISTRICT et al., the Supreme Court decided on 24 February 1969 that the students' First Amendment rights had been violated by the school board and that neither students nor teachers 'shed their constitutional rights to freedom and expression at the school house gate'. Justice Abe Fortas delivered a powerful opinion in the 7-2 decision: 'In our system, state-operated schools may not be enclaves of totalitarianism. School officials do not possess absolute authority over their students. Students... are possessed of fundamental rights which the State must respect, just as they themselves must respect their obligations to the State. In our system, students may not be regarded as closed-circuit recipients of

only that which the State chooses to communicate. They may not be confined to the expression of those sentiments that are officially approved. In the absence of a specific showing of constitutionally valid reasons to regulate their speech, students are entitled to freedom of expression of their views'. *Tinker v Des Moines* was a victory for free speech within the walls of public schools. It was also a victory for the anti-war movement. The case remains identified with Mary Beth Tinker, a middle school girl who wanted President Johnson and the United States military to hear her protest against bombing and her call for peace.[169]

The years after the Tet Offensive in January of 1968 until the final cessation of hostilities in 1973 felt like a lethal stalemate. Soldiers, even those who supported the war, began to fear becoming the last guy to die in Vietnam, while negotiators in Paris failed to take the first step toward a resolution of the conflict as they bickered over where each side would sit at the negotiating table. The most radical anti-war protesters in the Weather Underground had to face the death of three of their own who died making a bomb in a Greenwich Village townhouse for the purpose of bringing the war home to Americans. Students at Kent State University in Ohio faced National Guard bullets that killed four of their own during a protest march on campus in May of 1970. As President Nixon promised 'peace with honour', that goal seemed to be elusive as casualty numbers continued to rise.

SDS was no longer a dominant voice in the anti-war movement, and many women had become disaffected from the organization they had helped to build. According to Barbara Haber, women's liberation, which demanded root changes in gender relationships, took centre stage. She wrote that many of her colleagues 'continued to work in antipoverty and other mixed-left projects. Naming sexism and making it visible in SDS did open spaces for some women to function more effectively, but by and large our concerns were not addressed.

Our working and personal relationships with our male comrades were increasingly stressed and unstable. More and more women opted out of the mixed – or male, as it was often called – left and devoted themselves to creating an independent women's movement'.[170]

Beyond the anti-war movement in the late 1960s, the United Farm Workers organized by Cesar Chavez and Dolores Huerta brought the working conditions of migrant Chicano farm workers to the public's attention. The union appealed to housewives to boycott lettuce and grapes in support of the workers. Chicanos comprised ten per cent of the population of the United States but twenty per cent of the American deaths in Vietnam. On 29 August 1970, 20,000 young men and women organized by the Chicano Moratorium Committee Against the Vietnam War marched in East Los Angeles. A confrontation with police erupted during the march and three people were killed and more than 200 were arrested. While women were not themselves drafted into the military, they bore the loss of male relatives and members of their community. The Chicano Moratorium was the first major event that yielded major press coverage of the Chicano community since the Zoot Suit Riots of the early 1940s. Professor Lorina Oropeza described the importance of the Moratorium to the civil rights struggle of the Chicano community: 'You had young activists recognizing that this was an unjust war, and recognizing it was taking an unjust toll on people of color in the United States'.[171]

The concept of civil rights was broadening to include members of under-represented groups in American society that were beginning to articulate their own grievances. Opposition to the Vietnam War galvanized numerous and diverse voices and demands for greater equality in American society. Having marched for the rights of others and for an end to an unjust war, women throughout the world now had the language with which they could speak on their own behalf.

Women, from Vietnamese fighters to American nurses, were

Women Against the War: The Ammerican Scene

important actors in North and South Vietnamese society and the American war in that small country. Women in the military faced some of the same frustrations as their male colleagues – the constant danger of enemy attacks, an unseen enemy, primitive working and living conditions, loneliness, and the frustration of an endless war. Most of the American women in Vietnam nevertheless supported the war effort or at least kept their opposition to American involvement personal and quiet.

Opposition to the war within the military began to take shape as the civilian/student anti-war movement placed the war in a broader social and political context. GI anti-war newspapers emerged as a sounding board for those grievances. These papers were produced by GIs for GIs in the United States, Germany, Japan, and a few other countries where military personnel were stationed.

Challenges to military authority that ranged, even in wartime, from obscene comments on latrine walls to draft riots and refusals to serve, were not new in the 1960s and 70s. American soldiers had long complained about the oppressive nature of the military and its meaningless regulations. GIs also complained about the idea that promotion was based as much on favouritism as merit and the unwillingness of the brass to grant soldiers basic constitutional rights. To these grievances, women could add sexual harassment and being treated as second class citizens whose main function was to serve military men. The politics reflected in the GI anti-war papers was represented in the initials, F T A. Army recruiters were said to promise young potential recruits 'fun, travel, and adventure'. Anti-war protesters used the initials to refer to the slogan, 'Free the Army,' or more colloquially, 'Fuck the Army'. Male soldiers developed bonds among themselves that excluded women. The cultivation of ritual handshakes, calling each other 'brother', and speech peppered with expletives and military jargon were all part of a style that characterized those who had served in country. Military women

often used the vernacular of the men simply to get along in a male environment and succeed on the job.

To read the mainstream press during the war is to get an impression of female soldiers as brave and dedicated but also as 'girls' whose main function was to make life more bearable for officers and enlisted men. Under the headline '41 WACs Are First to Serve in Vietnam: 3,000 GIs in Area Suddenly Spruce Up', United Press International (UPI) ran a story in January of 1967 that described life in Vietnam for a group of female clerk-typists in terms of the male soldiers who surrounded them:

'After their arrival this month, the WACs appeared on the parade ground for a command formation. When the GIs marched onto the field, there was chaos as more than a few got out of step while watching the girls. ... After the girls' arrival, one company of GIs which had exercised each evening in dirty fatigue uniforms and t-shirts suddenly appeared in sharp-looking track uniforms ... [One soldier commented] "Take that first sergeant for instance. ... First sergeants are supposed to be mean and nasty. But she's the cutest one in the bunch"'.

A few months later, the *Philadelphia Bulletin* printed an article about service women under the headline, 'Our Soldiers in Skirts Are Going Off to War' that described one young female officer as 'a petite pretty brunette with short cropped hair'.

In contrast to the mainstream media, GI anti-war newspapers exposed what they saw as a climate of repression in the military. For example, GIs understood the First Amendment right to free expression guaranteed to civilians did not apply to men and women in uniform. GIs were threatened with prosecution under Article 15 of the Uniform Code of Military Justice for engaging in protest while in uniform or publishing anti-war flyers or newspapers on the base. They could also be prosecuted for distributing papers on base but not for possessing copies. Soldiers were frequently threatened

Women Against the War: The Ammerican Scene

with Article 15 prosecution when GI papers were found in routine searches of their possessions. Many papers, such as *Aboveground* from Fort Carson in Colorado, reminded their readers on the front page: 'This publication is your property and cannot be legally taken from you'. Understanding the growing dissent in the military and the importance of the papers to fuelling that dissent, *The Pawn*, a paper from Fort Dietrich in Maryland, sarcastically told its readers: 'GIs: Caution. Reading this paper may be hazardous to your Discipline, Morale, and Loyalty'.

The GI anti-war press provided a forum for enlisted women to express their frustrations about military life. Angered at being treated simply as adjuncts to the male military ethos and increasingly aware of the harassment they faced as women in the military, they demanded to be taken seriously as soldiers. Many women expressed disillusionment because they had been promised educational, travel, and other benefits for enlisting. They asserted that the recruiting pitch aimed at women was a lie and that patriotic military women were far from 'gung ho' about the war. On occasion, male writers supported the women's cause, as in the following excerpt from *AFB*, the American Servicemen's Union paper at Chanute Air Force Base in Illinois:

'The WAFs stationed at Chanute are continually oppressed and discriminated against by the brass. They are referred to, and treated in, materialistic ways, as decorations for the 'dreary' offices of the brass, and a release for the airmen on a Friday night. The brass refer to WAFs as prostitutes and sex objects, and cannot seem to think of women as normal human beings capable of experiencing emotion and frustration just as you and I feel it as men'. The author argued further that military sexism had its roots in 'the capitalist economy of this country' and that unequal treatment 'dehumanizes both men and women'. He argued that 'anything that divides people serves only the pigs, whether it's racism, male chauvinism, or inter-squadron rivalry'.

Many of the contributors to the GI anti-war papers complained that women were treated as inferior soldiers because of pervasive sexism in the military from the top down. One medical technician, Spec 4, wrote to *Fragging Action* at Fort Dix, New Jersey about the problems of being a military woman, citing frequent weight checks, the absence of basic weapons training because, 'As the story goes, one very hip sister threatened to do in her CO', and the difficulty of attaining higher rank: 'Well, where do the promotions come in? The hard part about a woman in the green machine is that if you don't kiss the right ass or fuck the right people, forget about any more rank'.

Military women were expected to serve men. *Helping Hand,* the anti-war paper at Mountain Home AFB in Idaho, described lectures on sex that were presented to new recruits. The easy availability of oral contraceptives, without a medical examination or warnings as to possible side effects, and the fact that a pregnancy could be 'handled with discretion by the Air Force' received attention in this article. The author wondered why the Air Force was not more candid about its 'true' purpose for recruiting women:

'If WAFs are on this or any other base entirely for the purpose of servicing GIs, then there should be some kind of warning that recruiters give to potential WAFs. Each girl who is thinking of joining the service with the intent of serving her country should know that the recruiter she is talking to is really a pimp for the United States Air Force. The eighteen-year-old girl, fresh out of high school and patriotically motivated, should be made aware of how the military is planning to use her'.

The Air Force was discreet but clear about its willingness to help WAFs prevent conception or terminate a pregnancy. Official policy mandated that, once a female member of the Air Force became pregnant, she had to accept immediate discharge. This policy did not sit well with Captain Susan Struck, a nurse in Vietnam who found

herself pregnant in 1970. She decided to have her baby and fight the Air Force's rules governing both her body and her continuing employment. Seven months into her pregnancy, Struck's base supervisor at Cam Ranh Bay ordered her sent back to Washington State to give birth and leave the Air Force. Struck received a total of seven discharge notices, and she ignored all of them.

Struck was the only Air Force officer at the time to give birth while on active duty. Between 1969-1971, at least four thousand women in the Air Force accepted discharge rather than terminate their pregnancies or fight the military. Many other women terminated their pregnancies rather than risk discharge. Struck was represented by Ruth Bader Ginsburg of the American Civil Liberties Union, who argued that she was being treated differently than expectant fathers, a violation of the equal protection clause of the Constitution's Fourteenth Amendment. Struck lost her case in Federal District Court, and the Ninth Circuit Court of Appeals in San Francisco ruled on 15 November 1971 that the Air Force had sufficient cause to fire Struck because of 'a compelling public interest in not having pregnant female soldiers in the military establishment'.

Despite these setbacks, Struck continued to fight the Air Force bureaucracy. After the loss in the Court of Appeals, Ginsburg filed a brief to submit the case to the United States Supreme Court, which granted her petition for *certiorari*, which meant that the Court was willing to hear the case. During this period, Struck was passed over for promotion several times and consigned to duty on a remote base in Minot, North Dakota. With the Court's willingness to hear Struck's argument, it became clear to the Air Force that defeat was possible in court and that other women could sue for damages. On the advice of the United States Solicitor General, the Air Force voided Struck's discharge and changed its rules to eliminate the automatic dismissal of pregnant service members. Struck remained in the Air Force, maintained close contact with her daughter, Tanya, who was

raised by friends, and retired from the Air Force as a Lieutenant Colonel. The case of Susan Struck's resistance to the military's effort to control her reproductive rights helped to change official policy, granting greater autonomy for women in the military.[172]

Women in the enlisted ranks were more involved than officers in the emerging critique of the war and resistance to military policy and regulations. Enlisted women, wives of servicemen, and civilian anti-war organizers often marched in demonstrations, attended consciousness-raising groups off base, and took part in other symbolic acts of resistance. Women at Fort Bragg in North Carolina organized a small group to study American history, which they defined as 'worker's history, third world history, and women's history'. The Fort Bragg women also instituted courses in such skills as emergency first aid, basic auto mechanics, self-defence, and carpentry.

Women's groups in the military were especially fragile and often did not survive for more than a few months. Enlisted women who spoke publicly on women's issues, like male GIs who opposed the war, were subject to harassment and frequent transfers, a technique used effectively by military brass to rid a unit of outspoken soldiers who opposed the war. Like participants in women's groups in the civilian population, military women who met to discuss their problems often had no common political perspective. These groups often disintegrated, not over common complaints, but over strategic and tactical debates over how to organize women and for what purpose.

Military women were also haunted by the issue of lesbianism. Homosexuality was cause for less-than-honourable-discharges, and many gay women feared being too outspoken on political issues. According to organizers from the United States Servicemen's Fund (USSF), when they met with gay women, 'We talked about class, the war, women. The problem ... is that they are not in a position to

Women Against the War: The Ammerican Scene

move politically – they don't want to get kicked out of the Army'.

Women who did not identify as gay feared charges and innuendo that they could neither accept nor refute, not wanting to draw attention to themselves.

It was not surprising that women in the military were often wary of meeting in groups. One WAC wrote in *Bragg Briefs* from Fort Bragg North Carolina that the tactic of dragging people off their jobs to question them in front of colleagues and threatening them with a dishonourable discharge was working: 'WAC company has got us WACs so uptight and paranoid about being reported to the CID (the Criminal Investigation Division) as gay, that we avoid sitting together in the dining room or on buses. It gets pretty lonely when you can't even be close friends with other WACs for fear of being labelled gay. Don't let them scare you from relating to your WAC sisters'. Many women used existing GI anti-war papers to express their grievances and correct the record on the issue of what life was really like for them in the service.[173]

FTA politics and opposition to the war in Vietnam found expression in anti-war coffee houses that sprang up near military bases. These non-military entertainment venues featured music, poetry readings, a chance for service members to relax, and opportunities to express political sentiment without fear of reprisal. The coffee houses provided an alternative to the USO entertainment centres that were, by definition, apolitical if not explicitly pro-military. The coffee houses were the primary venues for the 'FTA Shows', whose actors included Holly Near, Country Joe McDonald, and Donald Sutherland. The most famous member of the FTA troupe was actress Jane Fonda.

There is little in Fonda's early career that would point to anti-war politics. The daughter of actor Henry Fonda, Jane Fonda had won an Academy Award for her role in *Klute* and was known for her jet-setting lifestyle before she became a political activist and wife of SDS leader Tom Hayden. Coming to political consciousness

at age 30, Fonda told *Life* magazine, 'I never felt politics touched my life. But, as a revolutionary woman, I'm ready to support all struggles that are radical'.[174] Before she became committed to anti-war activism, Fonda was arrested with a group of Native Americans who attempted to take over Fort Lawton, an army installation near Seattle, Washington. She posted bail for Black Panther leader Huey P. Newton and visited activist Angela Davis in jail. At a speech at Michigan State University, Fonda even declared that the best path forward for America was communism.

Recognizing the intractability of the war, Fonda sought ways to support the peace movement. In February of 1971, she helped to organize the Winter Soldier Investigation, three days of war crimes testimony sponsored by Vietnam Veterans Against the War. Later that year, Fonda announced that the FTA Troupe would perform a new show written by Jules Feiffer and directed by Mike Nichols called 'FTA', 'Fox Trot Alpha' or 'Free the Army'. The show premiered at the Haymarket Square GI Coffeehouse in Fayetteville, North Carolina, just outside Fort Bragg. The FTA troupe also performed at Mountain Home, Idaho and Killeen, Texas, in addition to a tour of Hawaii, Okinawa, and the Philippines. Contrasting the FTA shows to the entertainment offered by traditional Hollywood stars, Fonda declared: 'It has become disconcerting for many of us in Hollywood to see that Bob Hope, Martha Raye, and other companies of their political ilk have cornered the market and are the only entertainers allowed to speak to soldiers in this country and in Vietnam'. The FTA shows filled a gap for many GIs who were drawn to the anti-war message of FTA politics and discourse provided in the coffeehouses. The FTA shows filled an important need for validation of the growing population of anti-war service members.

When the FTA troupe proposed to present a show inside Fort Bragg, the commanding officer, Lieutenant General John J. Tolson III declared the show to be detrimental to discipline and morale.[175]

Fannie Lou Hamer helped to lead the Mississippi Freedom Democratic Party in an effort to gain representation at the 1964 Democratic Party Convention. (Library of Congress)

The Freedom Rides of 1960 and 1961 attracted young people, both Black and White, who faced arrest and violence as they challenged segregation in the South. (Wikimedia Commons)

White protesters hurled insults and threatened violence against the Little Rock Nine, the African-American students who integrated Central High School.
(Library of Congress)

Daisy Bates was instrumental in the integration of Little Rock, Arkansas's Central High School, in 1957. (National Parks Gallery)

Joan Baez performed at the 28 August 1963 March on Washington for Jobs and Freedom, but no women gave major speeches. Daisy Bates was invited to make only brief remarks. (USIA)

Women joined the March on Washington on 28 August 1963 as advocates for jobs, education, and equal rights. (Library of Congress)

Young women volunteers were essential to both the North and South Vietnamese war effort in the 1960s. These women served in the People's Defense Force of Kien Dien. (United States National Archives and Records Administration)

Ho Thi Que was known as the Tiger Lady for her bravery. She also displayed compassion for her soldiers and their families. (Flickr)

Madame Nhu, who served as the First Lady of South Vietnam, with President Lyndon Johnson on 12 May 1961. (LBJ Presidential Library)

Actress Raquel Welch dances with soldiers at a USO show in Vietnam featuring comedian Bob Hope in December 1967. (Unknown)

Left: Activist Angela Davis was placed on the FBI's Most Wanted List in August 1970. She was eventually tried and acquitted of kidnapping, murder, and conspiracy charges and returned to her position as a philosophy professor. (Wikimedia Commons)

Below: Women were active in the community schools created by the Black Panther Party to teach Black history and culture.
(Stephen Shames)

Right: This poster depicts women demanding the release of six female members of the Black Panther Party from the Niantic State Women's Farm in Connecticut in 1969. (Library of Congress)

Below: Women were involved in early protests against the Vietnam War. This silent protest took place outside the Pentagon in January 1965. (Library of Congress)

In 1963, Jane Fonda was known as a Hollywood starlet and daughter of the famous actor Henry Fonda. (Wikimedia Commons)

Jane Fonda and Donald Sutherland led a troupe of entertainers who produced the FTA (Fun, Travel and Adventure, or Fuck the Army) shows to highlight opposition to the Vietnam War. This is a ticket to an FTA show in Monterrey, California in May 1971. (Wikimedia Commons)

Five hundred GIs attended the show off base. Their reactions were mixed, many saying that they had hoped to see the sexy *Barbarella* rather than the newly-politicized Fonda, who sang lyrics like, 'Nothing could be finer than to be in Indo-China making money'. A documentary film, 'FTA,' directed by Francine Parker, included scenes from the show, backstage banter, and statements on the importance of opposing the war by GIs. The FTA troupe published a statement of purpose that included women among the people for whom FTA politics were created:

'The GI movement exists on nearly every United States military installation around the world. It is made up of American servicemen and women who have come to realize that if there is to be an end to the US military involvement in South East Asia – an end to the war – it is they who must end it. In response to the invitation of servicemen and women within the GI movement we have formed the FTA Show in order to support their fight to end discrimination against people because of race, sex, class, religion and personal or political belief'.[176]

Fonda and then-husband Tom Hayden helped to organize the Indochina Peace Campaign, supported the Black Panthers and United Farm Workers, and campaigned for George McGovern, earning her the nickname Hanoi Jane that prompted death threats and the appearance of anti-Jane Fonda senntiment in both the military and civilian population.

It wasn't clear whether it was Fonda's celebrity, her intensity, or the content of her revolutionary pronouncements that frightened the military brass, but the State Department and members of Congress were quick to cry treason. She was no ordinary entertainer hoofing and singing for the troops. Her message of resistance tapped into a deeply felt and growing anti-war sentiment among enlisted personnel and officers. The troupe's Pacific tour reached nearly 64,000 members of the armed forces. Military leaders and government officials were

watching. As the tour made its way through the Pacific, reporter Vivian Gornick observed that government agencies like the Central Intelligence Agency, military police, and local law enforcement personnel followed the troupe's every move. She wrote that, 'One of the most incredible elements in the entire Asian tour of the FTA was the miracle of frightened attention that it received from the US military'.

In July of 1972, Fonda travelled to North Vietnam to film the everyday reality of the war from a North Vietnamese perspective. She and her crew filmed destruction in Hanoi and in rural farms and villages. Her activity drew attention from the State Department as well as various pro-war groups that denounced Fonda as a traitor. They were offended by the image of an American arriving in Hanoi wearing black pyjama-like clothing similar to that worn by enemy fighters. Fonda's documentary contradicted official United States government pronouncements about the progress of the war, which made her evidence suspect to many. She visited villages and prisoner of war camps, spoke in favour of the North Vietnamese cause on Radio Hanoi, and released photographs of herself with enemy fighters around an antiaircraft gun. It was difficult for many Americans to empathize with Fonda's portrait of the North Vietnamese people:

'I cherish the memory of the blushing militia girls on the roof of their factory, encouraging one of their sisters as she sang a song praising the blue sky of Vietnam – these women, who are so gentle and poetic, whose voices are so beautiful, but who, when American planes are bombing their city, become such good fighters. I cherish the way a farmer ... offered me, an American, his best individual bomb shelter while US bombs fell nearby. The daughter and I, in fact, shared the shelter wrapped in each other's arms, cheek against cheek. I was on the road back from Nam Dinh, where I had witnessed the systematic destruction of civilian targets – schools, hospitals, pagodas, houses, and the dike system'.

Women Against the War: The Ammerican Scene

After her return from Vietnam, Jane Fonda underwent yet another metamorphosis – from revolutionary to supporter of less political humanitarian causes and workout queen. In her 1978 film, *Coming Home,* Fonda played a military wife who never questioned the ideology of the Vietnam War until she fell in love with a disabled veteran and underwent a cinematic transformation.

Like the real Jane Fonda, the character developed her personal ideas through the men in her life. The film was popular, but audiences in the wake of the 'Me Decade' wanted to forget about Vietnam, not re-fight the war on film. Today, web sites remain that feature negative commentary from veterans and others who will not let the 'Hanoi Jane' image fade into the back pages of history. In a 1988 interview with Barbara Walters for *20/20*, Fonda had an opportunity to apologize to her detractors: 'I would like to say something ... to men who were in Vietnam, who I hurt, or whose pain I caused to deepen because of things I said or did. I was trying to end the killing and the war, but there were times when I was thoughtless and careless about it and I'm very sorry that I hurt them. And I want to apologize to them and their families'.

It is clear from the volume of anti-Jane material on the internet that the apology has not been accepted. Jane Fonda may have found redemption with the movie-going public that identified with her apolitical characters who found themselves in highly charged political situations and nearly always did the 'right' thing; and she has certainly found success with her holistic approach to fitness and health, which has brought her wealth and even more celebrity than the accident of her birth into a famous family or the quality of her talent. But for many Americans she will always be 'Hanoi Jane'.[177]

American women found diverse ways to articulate their concern for the future of a world endangered by nuclear weapons; a desire to protect young American men from conscription into an army that would send them to fight an imperialist war halfway around the

world; and opposition to the war itself as well as the society that had created it. Ordinary and famous women petitioned governments, marched, wrote cogent analyses of the relationship between the war and capitalist society, engaged in militant, even violent, actions mainly against property intended to arouse public opinion against the war, and even brought the destruction of the war home on film. Women raised their voices, sometimes with men and sometimes in opposition to the trappings of male culture in the movement and the military, to sound a warning about the deleterious effects of both war and gender inequality.

Chapter Six

The International Scene: Radical Women in 1968 and Beyond

The undeclared war in Vietnam was a political and military crusade spearheaded by the United States to halt the spread of communism in Asia. Based on the Domino Theory that held that the fall of one country to communism would inevitably lead to the loss of neighbouring nations, America's battle against Vietnamese nationalist and communist forces demanded the commitment of the country's youth to do battle in a land war in Asia. But a significant portion of the young population in the United States and allied countries was committed instead to ending the war. These young men were determined not to participate in a war they considered to be both immoral and unwinnable. They were supported by women in countries around the world who were equally committed to halting nuclear proliferation and to ending the Vietnam War.

The anti-war struggle was part of a broader challenge to the authority of institutions and leaders that took shape throughout the world, even in countries with no military commitment in Vietnam. From draft resistance to demands for relevant curricula and co-ed dormitories in their universities, students were united in their challenge to the cultural mores of the past. Their elders were shocked and determined to maintain their traditional authority, but young men and women were in the vanguard of movements for change throughout the world. Student protest against the Vietnam War was an integral part of a broader movement that included workers in some countries. As an outgrowth of socialist and communist efforts to change the power relationships inherent in modern capitalism, the New (Student) Left became a powerful force in the effort to end the Vietnam War.

Michael Vester, leader of the Sozialisticher Deutscher Studentbund (the German SDS) recalled that young radicals in the early 1960s 'sensed that a new political opening had occurred, following the advance of decolonization and John Kennedy's election which, at that time, encouraged hope for new, progressive majorities in many countries'.

Peaceful cultural transformation seemed possible in examples such as in the non-violent Civil Rights Movement in the United States and the English and German groups that led Easter marches to protest nuclear proliferation. This was the optimism of Arthur Schlesinger's new mood in politics and John F. Kennedy's Camelot. International student movements invigorated prevailing left politics and engaged a young generation in conversations about both the theory of political revolution and strategies for bringing about meaningful change.[178]

Members of anti-war movements outside the United States voiced their opposition to the Vietnam War for a variety of reasons. Some regarded Vietnam's struggle against French colonialism as part of an international trend toward independence among former colonies; some protested United States involvement in Vietnamese politics, arguing for self-determination; some were appalled at the human cost of the war as civilians were killed and maimed by bombing and napalm while American soldiers died or came home physically and emotionally damaged; and some opposed the conscription of young American men as less-than-willing soldiers. In many countries, the conversation about how to oppose the war included debates about the degree to which militance, even violence, provided the best approach to drawing attention to the horrors of the war. The transnational conversation around the Vietnam War was part of a trend away from the Cold War politics of the immediate post-Second World War period.

Historians Chris Dixon and Jon Piccini described the diversity of international anti-war movements, observing that, in Denmark,

The International Scene: Radical Women in 1968 and Beyond

'anti-Vietnam protests emerged from pro-Cuba solidarity networks. Striking Fiat workers in northern Italy, remapping the anti-colonial onto their own industrial conflict, declared "Vietnam is in our factories". Elsewhere, Vietnam inspired a discourse regarding militant decolonization among First World radicals seeking independence in Northern Ireland and Canada's Francophone regions'.[179] Over time, a common language, strategies, and tactics based on the experience of anti-war groups in the United States emerged in the transnational anti-Vietnam War movement.

The international Cold War was fought beyond America's borders. The democracies of Europe that had helped to defeat fascism in the Second World War now found themselves situated between two superpowers, the United States and the Soviet Union, each with its own network of defensive alliances, NATO and the Warsaw Pact. Western European governments moved to the centre, avoiding the ideological constraints of left and right.

With significant American help in the form of the Marshall Plan, centrist European governments experienced a twenty-five-year period of significant economic growth. Consumer spending increased, as economies created products and services previously unimagined. Young people experienced enhanced opportunities for education, employment, and consumption. By the 1950s, most of the restrictions of the war years such as rationing were no longer necessary, and the physical infrastructure of Western Europe and Japan were rebuilt and modernized. Within a decade, a new population cohort, born in the aftermath of the War and dubbed the Baby Boom generation (born between 1946 and 1964), took its place as the largest demographic force in the population. That cohort became the college students and activists of the 1960s who called into question every truism about societal structure, authority, and order. Many countries would never be quite the same.

By the late 1950s a New Left had emerged in various European

countries. On 25 February 1956, Communist Party First Secretary Nikita Khrushchev denounced the repression of Joseph Stalin's regime, making it necessary for Communist parties to repudiate their loyalty to Stalin. Khrushchev declared that Stalin had abused his power by imprisoning and killing millions of Russians during the purges of the 1930s. He also held Stalin responsible for additional purges of members of non-Russian ethnic groups within the USSR as well as anyone who criticized him. Khrushchev began his speech by stressing the dangers of rule by an individual leader: 'Because not all as yet realize fully the practical consequences resulting from the cult of the individual, [or] the great harm caused by violation of the principle of collective Party direction and by the accumulation of immense and limitless power in the hands of one person, the Central Committee considers it absolutely necessary to make material pertaining to this matter available to the 20th Congress of the Communist Party of the Soviet Union'. [180]

With his scathing denunciation of Stalin, Khrushchev enhanced his status as the Kremlin's leader. The speech also contributed to a period of relative liberalization of Soviet policies toward dissidents and Communist Parties in both the USSR and the so-called satellite countries. Sensing a weakening of the USSR's power, dissidents in Poland and Hungary led popular uprisings. The Soviet Union invaded Hungary in 1956 and put down the revolt in a show of military might that shocked the world. This demonstrated that any liberalism associated with the 'Khrushchev thaw' was limited. But Khrushchev's speech and the loosening of centralized Soviet control contributed to a climate in which young activists sensed that they could lead a movement based on de-centralization and participatory democracy. This became a defining quality of many organizations in the New Left.

The international movement to limit atmospheric nuclear testing emerged after the atomic devastation of Hiroshima and Nagasaki in

The International Scene: Radical Women in 1968 and Beyond

August of 1945. Expectations ran high for positive uses for nuclear energy, including novelty gadgets like atomic ice makers. The all-nuclear home was a concept that captured the science fiction imagination but never gained mass popularity. Scientists throughout the world expressed doubt that nuclear energy had such peaceful applications. In September of 1949, an international arms race was underway when the Soviet Union detonated its nuclear bomb. The American scientists who had created the first nuclear devices now expressed concern over the effects of nuclear fallout as well as weapons, but their concerns were drowned out in the public square by international enthusiasm for the new source of power, despite its dangers.[181]

It is perhaps a truism that a younger generation will reject the wisdom of its elders. The generation that came of age in the 1960s was a large one with a significant claim to political legitimacy in a period of social change. Anthropologist Margaret Mead helped to explain the actions and beliefs of young people whose behaviour frequently baffled and angered their elders. Reflecting on the 'Generation Gap' in 1969, Mead wrote that, young people who were rebelling all around the world against governments and entrenched educational systems 'are like the first generation born in a new country listening to their parents' tales of the old country and watching their parents grapple, often clumsily, often unsuccessfully, with the new conditions'. Particularly for young women, the accepted truths of the 'old country' were unsatisfying, even restrictive. They sought new freedoms for themselves in a new political and social era.

Mead reminded parents that the younger generation possessed knowledge that their parents could not understand. She observed that nowhere in the world are there any elders who know 'what the children know, no matter how remote and simple the societies in which the children live. In the past, there were always some elders who knew more – in terms of experience, of having grown up

within a system – than any children. Today there are none. It is not only that parents are no longer a guide, but that there are no guides, in the older sense of the term, whether one seeks them in one's own country, or in China, or in India. There are no elders who know what those who have been reared in the last twenty years know about what the next twenty years will be'.

While the older generation still retained power in society, Mead described parents as immigrants in time, immigrants from an earlier world, living in an age essentially different from anything we knew before. 'Adults,' she argued, 'still hold the seats of power and command the resources and the skills which have been used in the past to keep order and organize large societies. We control the educational systems, the apprenticeship systems, the career ladders up which the young are required to climb, step by step'.

Finally, Mead reminded adults that the experiences of the past were not always the most relevant guides to a better future. Her analysis of the younger generation of the 1960s suggested that it truly was unique because of the political and economic circumstances in which young people came of age. That new generation required new ideas, not the wisdom of the past: 'As long as any adult thinks that he, like the parents and teachers of old, can become introspective, invoke his own youth to understand the youth before him, he is lost. But once the fact of a deep, new, unprecedented, worldwide generation gap is firmly established, in the minds of both the young and the old, communication can be established again'. The Generation Gap became the term of art to describe the differences in perspective of the activist generation of the 1960s and their parents around the world.[182]

We find not only a generation gap but also a gender gap in the anti-nuclear and anti-war movements of the 1960s. The participation of women in organizations that opposed nuclear proliferation and America's war in Vietnam, the frustration of those women with

The International Scene: Radical Women in 1968 and Beyond

male-dominated hierarchical structures, and an absence of respect for their ideas and their labour contributed significantly to demands for an independent movement that would devote its energies primarily to women's issues. The birth of women's organizations in individual countries facilitated transnational conversations in which women shared ideology, tactics, successes, and their setbacks. Women around the world began to demand a more respected voice in the participatory democracy of the New Left throughout the world as part of their demand for 'gender emancipation'.

France | France faced the late 1960s with a strong economy and an efficient political system, but trouble lay under the surface of one of Europe's most stable democracies. President Charles de Gaulle had led France's conservative government since 1959, navigating the political waters to avoid the extremes of both left- and right-wing internal challenges. France's colonial empire began to crumble after the Second World War, and the nation had to re-define its place in the world. France's attempt to re-assert itself as a colonial power in Southeast Asia met with a militant response that was debilitating for French military forces and embarrassing for the French government. After the defeat at Dien Bien Phu in 1954 that led to the Americanization of the Vietnam War, many in France realized, according to historian Robert O. Paxton, that 'they had spent scarce resources in exchange for little more than casualties, frustration, and one more reminder of lost prestige'.

In the late 1950s, there were communications between the National Union of French Students and the Algerian National Liberation Front about Algeria's struggle for independence from French rule. The prospect of losing its North African colony was inconceivable to many proud French citizens. After a guerrilla war of attrition that lasted more than seven years and caused the deaths of 27,000 military personnel and more than 5,000 French civilians, the French

government was forced to abandon its North African colony in 1962 after 130 years of French rule.[183] France could no longer claim to be a colonial presence throughout the world.

Although France was a nation at peace after the independence of Algeria in 1962, university students, an increasing number of whom were immigrants from former French colonies in Africa and Southeast Asia, took note of the victory of an underdeveloped colony over a powerful, industrialized nation. Inspired by the Algerian insurgents as well as the Vietnamese communists who were locked in a struggle with a militarily dominant United States, students in French universities began to examine their place in a changing world. Their first target was the part of the world they inhabited, the university.

Frustration was apparent in what was described as a general *malaise* in French society in the early 1960s, in spite of the country's economic progress and peace. A reporter for *Le Monde* declared in March of 1968 that many in France were bored and complacent in spite of the fact that their economy was sound and their conservative president had held power for ten years. Julian Bourg argued that France in 1968 was, in many ways, a slow-to-modernize society that was 'culturally conservative. It was still a very Catholic country with not a lot of diversity. Education was very hierarchical, impersonal, and students at a time of growing global consciousness were really asking the question, "Is there more to life than just getting a technical degree and getting a job for the rest of our lives"'?[184]

By the mid-1960s, French students began to articulate a loud and powerful critique of the country's antiquated and restrictive educational system. The universities, some more than 1,000 years old, were rigidly hierarchical, placing the interests of faculty members and administrators above those of students, whose numbers were growing. Further, the universities tracked students into occupations in business or government bureaucracies based on examination

The International Scene: Radical Women in 1968 and Beyond

results and dismissed a large percentage of students who did not earn the highest marks on those exams. It was clear that the French university system might serve the needs of the government or the business class, but it did not serve the needs of its consumers, the students. Students felt a sense of frustration and lack of purpose, especially in a system in which their futures were determined by the results of a single exam.

For young people, especially young women, every aspect of life in post-war France was controlled by the rules and standards of their parents' generation. Josette Proud'homme, a student in 1968, described her world in which everything was patriarchal, 'starting in the family, where you couldn't speak at the dinner table unless spoken to. You couldn't go out with friends, and never with boys. Everything was forbidden everywhere. You had to obey orders in the factories, in the schools. We were suffocating. There was this enormous need to talk and share. Everyone was fed up'.[185] Until students raised their voices in protest, most people did not realize that there was a generation demanding greater freedom in their lives. In a student population that had grown from 175,000 to 500,000 in only a decade, that demand would now have to be taken seriously.

Young French women complained with good reason that they lived in a man's world. A married woman could not open a bank account or work outside the home without her husband's permission. Women were prohibited by law from wearing trousers, which, since 1800, had been considered characteristic of cross-dressing. Contraception was legalized only in 1967 but was not subsidized by the government insurance system until 1974, making oral contraceptives effectively unavailable to most women for seven years. Sex before marriage was considered dishonourable for women, but not necessarily for men. A French woman's place was definitely in the home, obeying her husband and taking care of her children.

French students were inspired to speak out against the restrictions

on their lives by the Free Speech Movement that began at the University of California at Berkeley. In a speech on the steps of Sproul Hall to 4,000 students on 1 December 1964, FSM leader Mario Savio had likened the university to a machine whose progress had to be curtailed in order to humanize the university. Savio declared that students were the agents of change who had the potential, by virtue of their numbers, to stop the machine. He told his audience: 'There's a time when the operation of the machine becomes so odious, makes you so sick at heart, that you can't take part! You can't even passively take part! And you've got to put your bodies upon the gears and upon the wheels… upon the levers, upon all the apparatus, and you've got to make it stop! And you've got to indicate to the people who run it, to the people who own it, that unless you're free, the machine will be prevented from working at all!'[186]

Aware of their lack of power in the French university system, students at the University of Strasbourg felt that it was their responsibility to take on the *malaise* of modern life and combat the stultification of the contemporary university. Strasbourg, like Berkeley, was an elite institution whose graduates were prepared for positions in the business, banking, and government bureaucracies. In 1966, members of the Situationiste Internationale, a loosely-organized avant-garde group of artists dedicated to disrupting and reimagining politics and society through art, published, in collaboration with students at the University of Strasburg, *On the Poverty of Student Life Considered in its Economic, Political, Psychological, Sexual and Especially Intellectual Aspects, with a Modest Proposal for its Remedy,* distributing 10,000 copies of the document at Strasbourg's opening convocation.

The pamphlet, written by Tunisian Situationist Mustafa Omar Khayati, encouraged students to use whatever intellectual means was at their disposal to inspire and create rebellion against the university. The Situationists utilized street theatre and whatever outlandish spectacle they could produce to highlight the contradictions between

The International Scene: Radical Women in 1968 and Beyond

modern France's economic progress and its archaic societal rules. At Strasbourg, the group sought to shake up a complacent student body by highlighting the absurdity of the rules that governed the university and French society as a whole. The distribution of *On The Poverty of Student Life* caused a scandal, especially when the Situationists put up posters with such anti-authoritarian slogans as 'BOREDOM IS COUNTER-REVOLUTIONARY', 'TRADE UNIONS ARE BROTHELS', and 'PROFESSORS, YOU MAKE US GROW OLD'.

On the Poverty of Student Life was instantly popular among students and some younger professors. The pamphlet asserted in the opening paragraph that the French student was 'the most universally despised creature in France, apart from the priest and the policeman'. Echoing Mario Savio's theme of the university as a machine, the pamphlet argued that modern capitalism assigns everyone a specific role in a generally passive cultural environment. 'The student', asserted the Situationists, 'is no exception to the rule. He has a provisional part to play, a rehearsal for his final role as an element in market society as conservative as the rest'.

The Poverty of Student Life then described the typical student as 'blind to the obvious – that even his closed world is changing'. Part of that change was manifest in the economy of consumption that was displacing political demands for societal reform. Echoing Karl Marx's assessment of religion, the students referred to France's thriving economy as 'the opium of cultural commodities' and went on to assert that, 'In the cultural spectacle he [the student] is allotted his habitual role of the dutiful disciple ... Thought is forbidden, and he is obliged to discover modern culture as an admiring spectator'. Finally, the statement called for students to assert themselves and create not just a new university, but a new society: 'The student, if he rebels at all, must first rebel against his studies, though the necessity of this initial move is felt less spontaneously by him than by the

worker, who intuitively identified his work with his total condition. At the same time, since the student is a product of modern society just like Godard or Coca-Cola, his extreme alienation can only be fought through the struggle against this whole society'.[187]

The activities of the Situationists – posting slogans, infiltrating and taking over meetings of the National Union of French Students, and staging impromptu protests on campus and in the streets – were reminiscent of cultural protests in the United States. Covering campus walls with graffiti and posting flyers were popular ways of communicating political messages in American universities. Giant cardboard caricatures popularized by the Bread and Puppet Theater Company appeared at many marches and rallies protesting the Vietnam War in the United States. The San Francisco Mime Troupe presented political satire to audiences in California starting in 1959 and used the Vietnam War as the subject for many of its productions. And Abbie Hoffman's attempt to levitate the Pentagon on 21 October 1967 was a powerful example of absurdist street theatre. New Left students throughout Europe were aware of the variety of protest methods, from the serious to the absurd, used by American opponents of the Vietnam War, and they put their knowledge to effective use in the streets of Paris and other European cities.

The Poverty of Student Life established a theoretical foundation for student grievances at the Nanterre campus of the University of Paris in March of 1968. An elite school with a reputation for preparing the next generation of French leaders, the campus was built in an industrial suburb of Paris on the grounds of a former military depot and near railroad tracks, factories, and a shanty town occupied by North African immigrants. The *Faculté des Lettres et Sciences humaines* opened in 1964 to relieve the overcrowding of the main Paris campus, where students sat on the floor in many overcrowded lecture halls. The buildings were new and architecturally bland, lending an aura of sterility to the campus. Nevertheless, in its first

The International Scene: Radical Women in 1968 and Beyond

few years, the Nanterre campus was considered paradise compared to the main campus in Paris, but there were grievances taking form in the student population about the curriculum and the rigid control of student life, especially for women.

In March of 1967, students occupied a 'girls' dormitory in protest over regulations preventing men and women from visiting each other's rooms. They were forcibly removed by the local police. The dormitories became the locus of student activism as the academic year progressed. In the fall of 1967, the new cohort entering the campus at Nanterre was significantly larger than those entering classes in previous years. More than 5,000 students entered the campus, and their numbers changed the character of the environment, which now seemed crowded and restrictive. Student life in French universities was governed by regulations that seemed more appropriate to the nineteenth century than the twentieth.

Students also objected to the autocratic teaching style of most of their professors, as well as the fact that students had no say in matters relating to either their behaviour or their academic life, even though they were the 'consumers' of the education industry's academic product. In addition, national education administrators imposed the Fouchet Plan, which would have required students to spend more than four years working toward their degrees, a financial hardship for working-class students. The *Union Nationale des Étudiantes Francais*, a large and popular student group, began to voice criticism of the regulations at large protest meetings.

In what came to be known as the 22 March Movement at Nanterre, students occupied a faculty lounge in the administration building. Female students participated in the demonstrations and built barricades, along with their male colleagues. One young woman described a 'remarkable wind of freedom' that contributed to a growing sense that liberation from the old ways of the university was possible for students in general and women in particular.

Administrators called local police, and the ensuing battle led to disciplinary action against several students. By the end of March 1968, the administration had suspended classes at the Nanterre campus. The arrest of a Nanterre student for breaking a window at an American Express building in Paris in protest against the Vietnam War sparked additional student activism. Although the protest movement at Nanterre was loosely organized, Daniel Cohn Bendit emerged as a symbol of student radicalism at the university.

On 8 January 1968, Cohn-Bendit had denounced the French Minister of Youth and Sports, Francois Missoffe, as a fascist at the opening of a new swimming pool at the Nanterre campus. A few weeks later he vilified the dean of the Nanterre campus as a *flic*, or a Nazi. In February of that year, Cohn-Bendit attended a conference in West Berlin on the European anti-war movement in the wake of the Tet Offensive. There, he met Rudi Dutschke, a leader of the German student left organization, Sozialistischer Deutscher Studentenbund (SDS). Cohn-Bendit earned a reputation as a leader of the student movement who was admired by young radicals for his fiery rhetoric and red hair (he was called Dany the Red).

By May of 1968, Cohn-Bendit, the leader of the 22 March Movement at Nanterre, had been called before a university disciplinary committee. The meeting had to be re-located to Paris, as administrators had closed the Nanterre campus. Cohn-Bendit and the other students who were subject to disciplinary action were supported by a small but vocal group outside the building where the hearing was taking pace. University administrators called the police to quell the disruption. This was the first time in hundreds of years that police had entered the courtyard of the Sorbonne. Their presence and the violence of their response to the students intensified the anger of the protesters. Shortly after the disciplinary proceedings, Cohn-Bendit left Paris. He was not permitted to return to France and thus became that much more of a symbol of revolt. By 10 May

The International Scene: Radical Women in 1968 and Beyond

1968, the locus of the protest and the police violence had shifted to the cobblestone streets of Paris's Latin Quarter.

The Sorbonne protests, which included support for the Nanterre students who had been suspended, presented a broad critique of the university and French society as well as a demand for an end to the Vietnam War. But the movement was divided over its basic approach. Radical students adopted the American SDS approach, demanding not just an end to the war or the draft but also victory for the National Liberation Front. In contrast, Communist-led students remained activists for peace. On 2 May, part of an administration building was set afire and on 3 May, the Sorbonne administration called in the police to clear the campus, resulting in a brutal law enforcement response and four hundred arrests. Students built barricades throughout Paris, and the streets were filled with protesters. In the Latin Quarter, when students picked up cobblestones to throw at the police, de Gaulle ordered the streets paved over with asphalt. There was precedent for the students' action. In 1830 and again in 1848, Parisians had protested by picking up paving stones and throwing them at police forces. In response, when the medieval neighbourhoods in Paris were re-designed by architect Georges-Eugene Haussmann, some narrow streets were widened and paved over to inhibit future protest activity. The cobblestones remained in the Latin Quarter, and the students put them to effective use.

In 1968, British citizen Dick Pitt was living in Paris and joined the Latin Quarter protests, although he was not then a student. He described the radicalizing effect the events of early May had on him, recalling that he was 22, newly married, and living in the Quarter. He feared 'the spread of nuclear weapons. I hated a vicious American war on an impoverished country, a war that the British Labour government slavishly supported. When the tear gas drove us out of the metro on Monday 6 May, we were faced with a choice. On the one side were Darth Vader look-alikes and on the other were young

people dressed like me. It was not a difficult decision to make. I was a pacifist up to the time the police used CS gas on us. We won back the Sorbonne; we took over the Odéon; workers occupied hundreds of workplaces; millions went on strike; for a brief time, we banished the police from the Latin Quarter – we were all incredibly exhilarated. Everything seemed possible. Many of the slogans still conjure up powerful emotions. One I read recently was: "On Wednesday the undertakers went on strike. Today is not a good time to die".[188]

On 6 June 1968, feminists Anne Zelinsky and Christine Delphy recognized the relative invisibility of women in the protest movement and started an organization of their own, *Feminin Masculin Avenir*, which later became *Féminine Marxisme Action*. Students learned about this organization, which was open to both men and women, through flyers on the walls of the Sorbonne. The group encouraged striking students to 'fight the domination of men over women'. They asserted that the student and workers' movements had tolerated demands for women's liberation only on men's terms. Delphy called the sexual revolution a 'trap for women' and a 'simplistic masculine conception'.[189] The creation of a group dedicated to discussing women's concerns represented a step toward promoting the centrality of women's issues in the student movement.

In the student and worker uprising of spring 1968, women were everywhere in small numbers, except in positions of leadership, authority, or visibility. Commenting on images in the film 'Maydays' that documented the events of the spring of 1968, *New York Times* writer Corinne Maier observed that, in all the meetings, 'debates, marches, and street protests, you can see only a few women. Sure, there is a woman working as part of a medical team, obviously a nurse; another woman answers the phone for a student coordinating committee; a third takes care of militants' children at an impromptu nursery at the Sorbonne. Nurse, secretary, babysitter – all traditional roles'. French women were not yet accorded the

The International Scene: Radical Women in 1968 and Beyond

position and visibility that their efforts warranted.

One tactic adopted by the protest movement was to encourage young people, including women, to take factory jobs in order to spread the language of revolt to people on the assembly line. Workers' interests, focusing on wages, factory conditions, and benefits were not the same as the more theoretical and individual issues that animated the students. Nevertheless, by 13 May, trade unionists had joined the protests, leading to a brief general strike of more than eight million French workers. By the end of the month, the unions had negotiated higher wages and a guarantee of the right to organize. Having achieved a victory over the 'bread and butter' issues of wages and working conditions, the workers were ready to return to work. Their commitment to the student revolt was short-lived.

Daniel Cohn-Bendit was denied re-entry into France on 22 May, but the protests continued, resulting in some concessions from the French government. In late May, Prime Minister Georges Pompidou announced government reforms, and the student strike faded into the summer. The next round of street demonstrations expressed admiration for de Gaulle, whose supporters won a resounding victory in the Parliamentary elections in June. University reforms came more slowly, and the issues raised by women became the rallying cry of a French feminist movement that took shape starting in 1970.

Women were among the striking factory workers, but they were not present at the negotiating table when the unions made their demands. The most visible women in photos of the period are young women riding on the shoulders of male protesters waving Viet Cong flags. Not surprisingly, whether they were part of unions or any of the left organizations that participated in May '68, women had nothing close to an equal voice. A few celebrity women provided copy and images for the newspapers. Marie-France Pisier, a well-known actress, hid Daniel Cohn-Bendit in the trunk of her car and took him across

the border to Germany so he could avoid arrest. Novelist Francois Sagan drove her car to the barricades to show her support for the protesters. When asked, 'You've come with your Ferrari, Comrade Sagan'? she is said to have replied, 'It's a Maserati, comrade'.

Women at the Sorbonne continued to raise issues related to their daily lives in meetings designed to plot the future of the movement, but they achieved only minimal success. One female student found that she needed childcare in order to attend sessions of the university's general assembly. With help from other women, she established a childcare centre in two vacant classrooms. The women attempted to get the assembly to recognize and support their work, but the men took little notice and no action. When women gathered in their own small groups, they spoke about the immediate issues of their lives rather than the theory of revolution or class struggle, 'the monotony of everyday life, the loneliness, the clandestine abortions, the husband that we would sometimes have liked to throw out'.[190] Male leaders of the student protests at the Sorbonne told women that their issues were trivial and it was important to conduct a revolution first before attending to the complaints of women. It would take time, but the women of the May 1968 movement would bring their issues to the attention of the public. The personal eventually did become political.

The events of Paris in the spring of 1968 inspired communication across class and generational lines. 'Paris was wonderful then,' said Eleanor Bakhtadze, 'Everyone was talking'. People talked about politics, trade union solidarity, and student demands. The passion of the debates in many a public square contrasted with the brutality of the police response to student protest in the name of cultural revolution. Mark Kurlansky described the mood of the moment in terms of its myriad conversations: 'Students on the streets found themselves in conversation with teachers and professors for the first time. Workers and students talked to one another. For the first time in this rigid, formal, nineteenth century society, everyone was

The International Scene: Radical Women in 1968 and Beyond

talking to everyone. "Talk to your neighbour" were words written on the walls'.

The messages of the moment appeared powerfully in posters and graffiti on the walls of public spaces. Slogans that both reflected and inspired the revolutionary moment included:

We want structures that serves people not people serving structures.
By stopping our machines together, we will demonstrate their weakness.
If we have to resort to force, don't sit on the fence.
When people notice they are bored, they stop being bored.
Under the paving stones, the beach.
Politics is in the streets.[191]

Another popular image that first appeared on 3 May 1968 as a newspaper photograph and later as a poster was an image of 'Red Dany' laughing at a Parisian police officer. An amalgam of snarky humour, a challenge to traditional police authority, and a way to bring the protest to the streets, the image was captioned 'Nous sommes tous indesirables' (We are all undesirables'.)[192]

One of the most popular posters was 'Power is at a Gunpoint'. Some women wrote over the slogan to say, 'Power is at the end of the phallus' and printed posters of erect penises, symbolizing the idea that the sexual liberation desired by students was actually no liberation at all for women, who were expected to be liberated, and sexually available, on men's terms. The issue of sexuality animated the French feminist movement of the 1970s.

The student movement in France in 1968 was powerful, if not immediately transformative. Conservative historian Raymond Aron cited the differences in aims and approaches of the radical students and radical workers, writing that the events of 1968 'placed bourgeois

students with a utopian negation of reality and workers with authentic and legitimate demands on France's centre stage'. Visionary students and hungry workers ultimately took their demands in different directions.

Reflecting on the French feminist movement from the perspective of 2002 feminist Francoise Picq underscored the frustration women felt as members of the French student movement of 1968. She understood that out of that frustration grew a resolve to form a movement for women. Picq wrote that women felt 'unconsidered as individuals in the revolutionary movement, their problems put aside and held up to ridicule. In France, as in the States, they were fed up with playing a subordinated role. They denounced the sexual division of labour among activists: men did the thinking, formulated the theory, organised and made decisions; women worked the mimeograph machines, distributed leaflets. So they followed the example of the American feminists, breaking away from the New Left to form women-only groups. The MLF [*Mouvement de la Libération des Femmes*], wise to the criticisms levelled against the left, valued direct democracy, spontaneity and radicalism. Considering that it was impossible to imagine women's liberation within contemporary structures, it intended to destroy these, and saw reformism as a danger because partial improvements might demobilise activists'[193]

Irene Pereira, a veteran of the early feminist struggles, focused on the divergent goals of men and women activists. Conveying a sense of optimism, she acknowledged the need for both groups to liberate themselves from the old ways and to create new organizations that would promise liberation for both men and women. She observed that, in the early 1970s, women were just beginning to engage in a process of thinking about and acting their own needs:

'Within only two years, it became apparent that women were talking with each other and beginning to speak out at the larger protests by women's. Their voices grew all the more powerful

The International Scene: Radical Women in 1968 and Beyond

because of the relative absence of women's issues as central to the 1968 protests. Seeds of French feminism were sown at the Sorbonne. As with early feminists in the United States and elsewhere, women found their voice in a tentative way at first, often as a result of being marginalized in other movements for social change. But the French women who wanted a greater degree of autonomy in their lives as well as profound societal change moved quickly. By 1970, the French Feminist Movement was a reality'.[194] This sense of frustration that would lead to action was the story in many countries that saw the emergence of a new wave of feminist activity after 1970.

West Germany | As radical women protesters in Paris battled *gendarmes* with cobblestones pulled from the streets of the *Quartier Latin*, their counterparts in Germany created a variety of small issue-orientated organizations that were part of an early women's movement committed to bringing an end to their country's old, repressive order. In the immediate aftermath of the Second World War, women had been a powerful force in the early years of the German Federal Republic. They gained prestige as the *Trummerfrauen* who cleared away rubble from city streets. Women also assumed positions in public life such as the mayor of West Berlin. Historians Hilke Schlaeger and Nancy Vedder-Shults observed that 'the absence of men [in the immediate post-War period because of the loss of so many German soldiers during the Second World War] made possible what the role ascribed to women usually inhibits: men's work became human work. But that situation lasted only until the men returned from the prisoner of war camps, and it left no lasting traces'.[195] Both East and West German officials grappled with Germany's Nazi history. Both the German Federal and Democratic Republics banned symbols of the National Socialist Party. In the West, the United States Army's de-Nazification programme attempted to re-educate members of business and government bureaucracies about

modern democratic values. In spite of this re-education effort, former Nazi Party members ascended to high positions in those same bureaucracies as a manifestation of Cold War ideology that favoured former enemies of the United States over the new Cold War enemy, the Soviet Union.

In spite of a request by President Johnson for the German Federal Republic to send troops to Vietnam, West German Chancellor Kurt Kiesinger felt that contributing troops to America's war effort was not in West Germany's best interests. Instead, he sent a hospital ship, *Helgoland,* that treated Vietnamese civilian casualties for six years from its mooring off the coast of Saigon and Danang. Throughout the conflict, West Germany remained a staunch ally of the United States. The West German student movement, represented by the *Sozialistischer Deutscher Studentbund* (Socialist German Student League-SDS), criticized West Germany's support for the American war effort, even though it consisted mainly of humanitarian relief. German SDS members engaged in street protests as a challenge to the Grand Coalition that ruled West Germany from 1966-1969.

Germany's SDS built its organizational structure in part on the model of the Easter March campaign in England, later called the Aldermaston March. Supported by trade unions, the original Easter March advocated nuclear disarmament and world peace. March participants included university students, and some women served as march organizers. Over time, German SDS members shifted their emphasis from polite anti-nuclear marches to extra-parliamentary opposition in the form of street demonstrations. The Campaign for Disarmament (KFA) shifted its focus by 1965 from mounting anti-nuclear protests to engaging in actions that communicated a specific anti-Vietnam War message. Arguing that neither Americans nor Germans had any role to play in the future of Vietnam, the KFA's most prominent slogan was 'Vietnam for the Vietnamese'.

German university students were politicized by protests that reached

The International Scene: Radical Women in 1968 and Beyond

new heights in 1968. This included a growing number of female university students – twenty-eight per cent in 1965 and nearly forty per cent of all student protesters by 1970. The issues that energized German university students included ousting the remaining fascists in the West German government, opposing the Vietnam War, and denouncing imperialism. An influx of university students from non-Western countries helped to raise the consciousness of German students of a world beyond the borders of their own country. Writer Wolfgang Bittner said German activists of the period, like their optimistic American counterparts in the early 1960s, 'aimed to create a better world'. In a similar vein, filmmaker Gunter Walraff noted that the German student movement had a specific relationship to the needs of women. He argued that 'The double standards for men and women in society were exposed then, greater rights and freedom for women and children were created, more power to students for democratic representation, sexual liberalization – the 1968 generation prompted all of that'.[196] To bring issues to the public's attention, German students followed the example of their American counterparts by engaging in marches, demonstrations, sit-ins, and other forms of civil disobedience. Like members of SDS in the United States, German students at first avoided violent protests but defended damage to property as an acceptable price to pay for social justice.

Bittner and Walraff, both members of the 1968 movement in Germany, saw positive outcomes for women and children from the challenges to traditional authority, as did Gretchen Dutschke, whose husband, Rudi, was a leader of the German protest movement. In an interview in 2008, Dutschke said that, prior to the protests, 'the Nazi authoritarian way of thinking was still strongly anchored in people's minds. The concept of total obedience was still prevalent … People today are far more critical, they're capable of thinking independently, and there's room for creativity'.[197] Even though a few women in

the German student movement were able to raise issues specific to women, those issues were frequently ignored by male organization leaders who did not consider women's concerns to be of significant political import to warrant action or even serious discussion.

German students engaged in protests in the late 1960s around three international issues: the war in Vietnam and the battle against American imperialism; the military dictatorship in Greece; and the oppressive regime of the Shah of Iran. German students were especially outraged at the number of former Nazi Party members who had assumed prominent positions in government and civil society. They saw the presence of Nazis in the West German government as dangerous to democracy, and they disagreed with the imperatives of Cold War anticommunism that required the 'rehabilitation' of Nazis in West Germany. Student protests against former Nazi officials struck at the heart of Germany's past and its prospects for democracy in the future. The Nuremberg Trials had convicted twenty-two Nazis, but many more were prominent members of German society, often with the support of the United States government. Activist students had no patience for the 'lies of their fathers' and were eager to find new models for a democratic Germany. Indeed, one slogan of the German student movement was 'Vietnam is the Auschwitz of our generation'.

One of the most prominent Nazi Party members from the previous generation was Kurt Georg Kiesinger, who served as chancellor from 1966-1969. On 9 May 1968, a group of more than 2,000 students attended a forum at the Technical University of Berlin at which journalist and future Nazi hunter Beate Klarsfeld declared that Kiesinger was a danger to Germany and that she would slap him in the face, which she did at a Conservative Party conference on 9 November as she shouted, 'Nazi, Nazi, Nazi'. The incident made Klarsfeld a hero. In response, the West German government passed an Emergency Law that allowed the executive branch of

The International Scene: Radical Women in 1968 and Beyond

the government to issue decrees that had the force of law without the consent of Parliament, making it possible to deny basic rights such as freedom of speech to individual citizens. While the student movement in general conducted peaceful protests against the law, splinter groups like the Red Army Faction (RAF) engaged in acts of lawlessness and terror such as the kidnapping and murder of Hanns-Martin Schleyer, president of the Confederation of German Employers Association. The German student movement experienced a split similar to the one experienced by American students, with some activists maintaining a commitment to traditional, non-violent, and even polite protests while others were driven to more direct and potentially violent actions.[198]

Other, more intimate issues also got the attention of student protesters. 'Students', according to writer Christoph Zeiler, protested 'against universities' failure to remove professors that were known racists and had served in the Nazi administration; against the authoritarian and paternalistic structures at universities; and in favour of equality among the sexes'. [199] But the latter issue did not generate support for women's liberation, even in the radical student movement. Originally a faction of the Social Democratic Party (SPD), the German SDS expressed less faith than its parent organization in the ability of workers to be agents of meaningful social change. SDS separated from the SPD and charted its own path. On 22 June 1966, inspired by the direct action of the Student Non-Violent Coordinating Committee and the Free Speech Movement in the United States, 3,000 students blocked the entrance to the Henry Ford Hall of the Free University of Berlin to protest new regulations that would have limited students to no more than eight semesters of enrolment and would have given administrators more discretion to suspend students for disciplinary infractions. The sit-in featured speeches, discussions, and street theatre, all of which reflected the influence of the American student movement.

University administrators reluctantly rescinded the new rules. Students realized they had power in their numbers.[200]

Berlin's Free University was the locus of student activism in the late 1960s. Founded in 1948 in the western sector of the divided city, the Free University served students from both East and West Berlin until the erection of the Berlin Wall in 1961. In 1965, East German students comprised 5 per cent of the Free University population. Even though Germany did not experience an immediate post-war baby boom, the universities were crowded. Many East German students were avoiding conscription in their home country. These young men joined radical organizations on campus. In addition to focusing on international political issues, SDS members were concerned with the antiquated structure of the university that placed students in a rigid, subservient role in relation to their professors. They sought to change the world by reforming life in German universities.

The young women who joined radical student organizations were also deeply involved in protesting the Vietnam War, even though they were not highly-regarded by movement leaders. In the spring of 1967, Free University SDS members took to the streets to protest a visit to Berlin by the Shah of Iran. A police officer shot and killed Benno Ohnesorg, a student at the University. Twelve thousand students attended Ohnesorg's funeral, which historian David Caute called 'a decisive event in the radicalization of the German student movement'. Less than a year later, student leader Rudi Dutschke was shot and seriously wounded by Josef Bachmann, who was influenced by the right-wing Springer newspapers. SDS leader Michael Vester described the Springer media organization as 'a fount of reactionary attacks on the radical student movement'.[201] In response to Dutschke's shooting, students attacked Springer's offices and burned the paper's delivery trucks. The killing of Ohnesorg and the attempt on Dutschke's life helped to galvanize students around creating a movement for meaningful change that

would come about as a result of 'an immediate revolution'.[202]

The founding of the Kritische Universitat (Critical University) in November of 1967 was a step toward creating a more humanized learning environment. The college was founded by radical students and professors from various Berlin universities. Organized around the principle of direct action, SDS women established a kindergarten at the school to release mothers to 'work, study, take a lover, and teach young children anything but the moral lesson to sit down, don't talk, eat what's on your plate'. According to Cinthia Salinas, the storefront childcare centres (*Kinderladen*) challenged 'both the traditional gender order and the conventional public education system that usually only offered childcare half days and was controlled by the Catholic and Protestant Churches'. '[203] One of the founders of the *Kinderladen* was film maker Helke Sander, who described the early negative reaction to her proposal to provide childcare for SDS members who were mothers: 'In the summer of '67 I put up a note at the SDS centre looking for other mothers with small children who were interested in starting a reciprocal childcare network. I was familiar with the idea of 'park aunties' from Scandinavia, similar to what we now call *Tagesmutter* (a woman who provides day care in her own home). You could drop the kids off at the park with another woman from 9 to 11 am, for example. But everybody made fun of my idea, there wasn't a single response!'

Sander then proposed that her SDS working group, Cosimaplatz 2, establish a separate group to study women's issues. She remembered that 'everyone was just smirking away' at her idea. Peter Schneider, one of the group leaders told Sander to 'Go to see Marianne Herzog in the kitchen – things like that interest her too'. If Schneider thought he was dismissing Sander, he was mistaken. Sander, Herzog, and Dorothea Ridder pursued the idea of collaborative childcare. They printed and distributed five hundred flyers to other women. About 100 women attended the initial organizing meeting in December

of 1967. Sander described herself as 'nervous' at speaking in public, but she and her colleagues successfully organized five *Kinderladen* at the first meeting. Their first radical act, like that of many female activists around the world, was rooted in the needs of motherhood. The idea of establishing an organization by women for women took hold in SDS. In fact, Sander described the attempt by SDS men to take over the *Kinderladen*: 'First of all, various men have noticed that we are suddenly doing something that has a future. Because they are more skilled at speaking, they assumed the leadership in some working groups, and many women are still helpless to stop them. They act as if the *Kinderladen* was theirs'.

After Sander and her colleagues presented the idea of the *Kinderladen*, they set up a childcare room at an International SDS Conference on Vietnam at the Free University of Berlin in February of 1968. The conference attracted 4,000 participants from countries around the world, and Sander asked the men to run the childcare facility. She remembered that they 'quickly founded the Central Council, an Anti-Authoritarian Daycare Center and took over the whole movement'. The men set up a political committee to oversee the operation of the centres. This was a familiar dynamic. When women initiated a successful project, men attempted to take it over and take credit for the idea. They claimed the *Kinderladen* as a manifestation of revolutionary thinking, while the women simply wanted to find a solution to the real-world problem of childcare. Clearly, there was a need for the personal to become political within the German SDS, and Helke Sander, who helped to found the Action Council for the Liberation of Women in 1968, helped to advance women's issues within the organization, in spite of a lack of cooperation by the male leaders of SDS.

Sander spoke at the conference of the German SDS in Frankfurt am Main in September of 1968. She demanded to be heard: 'We demand a substantive discussion of our issues here. We will no

The International Scene: Radical Women in 1968 and Beyond

longer be satisfied with women being allowed to say a word now and then, which anti-authoritarian men feel obliged to listen to only to return to business as usual'. She then explained the deleterious effects of the separation between women's needs, which can be described as personal, and the greater needs of revolutionary action, which are labelled political. A woman, Sander said, is still raised for private life, 'for the family, which, in turn, is dependent upon the production conditions that we are fighting against. The role she is raised into, the acquired inferiority, the contradiction between her own expectations and the demands of society create a perpetually guilty conscience for not being able to meet the demands placed upon her or for having to decide between alternatives that mean neglecting vital needs in any case'.

Sander defended the raising of women's issues because, as she said, 'We cannot resolve the social repression of women in an individual way. We cannot wait for some time after the revolution, since a strictly political, economic revolution does not eliminate repression in the private sphere'. She argued that it was high time that the revolutionary movement recognize the needs of women. Calling the SDS leaders 'blockheads,' Sander declared, 'We don't want to go along with all this repression anymore'.

Sander summarized the issue for the male conference delegates, noting that women make up more than half of the general population and are 'seeking their identity. They cannot achieve this by participating in campaigns that do not touch upon their immediate conflicts'. Sander was laying the groundwork for a West German feminist movement but, not surprisingly, the SDS leaders on the stage ignored her speech and moved the meeting to the next item on the agenda. In response, one of Sander's colleagues, Sigrid Ruger, began to throw tomatoes at the SDS leadership.

The 'tomato event' highlighted the frustration of women in the German New Left. The movement in Germany emanated

primarily out of organizations that challenged Germany's support of America's war and the universities that restricted independent student life. Historian Christina von Hodenberg argued that, by 1968, 'women challenged patriarchy in the New Left and beyond'. At the same time, in spite of their eloquent protests, German women in SDS were regarded as 'revolutionary brides who brewed coffee, sewed flags, and typed leaflets for male comrades'. The men in the movement recognized women's involvement in activities that could be characterized as personal, but they were unable or unwilling to perceive women's potential contributions as political.

Sander's speech had made it abundantly clear that the personal could not be separated from the political, observing that German women must 'perceive oppression in our private lives not as private but as politically and economically conditioned. We need to change the whole quality of personal life, and to understand the process of change in terms of political action'. Women were ready to make that connection. By 1968, women feminists in various groups and with no central organization to support them began to bring the personal into the political conversation.[204]

Great Britain | Protests against the Vietnam War in Britain had their origins, as they did in many other countries, in outrage about the consequences of nuclear proliferation during the Cold War between the United States and the Soviet Union. Once the two nuclear superpowers created an arms race, other nations were thrust into the middle of a battle in military, political, and cultural contexts. Both powers hoped to gather support from allied countries. It was no accident that the United States got involved in a land war in Asia to keep France in its political orbit as a member of NATO.

Starting in the 1950s in Britain, anti-nuclear activists staged annual marches from the Atomic Weapons Research Establishment at Aldermaston in Berkshire to London on Easter weekend. Thousands

The International Scene: Radical Women in 1968 and Beyond

of marchers walked fifty-two miles to voice their opposition to nuclear proliferation. Known as the Easter Aldermaston Marches, these protests were organized first by the Direct Action Committee Against Nuclear War and, starting in 1959, by the Campaign for Nuclear Disarmament (CND). Activists in anti-Vietnam War and women's groups participated in the Aldermaston Marches. The tone of the marches was exuberant while also expressing worry at the consequences of nuclear testing, atmospheric fallout, and weapons. CND organizer David Widgery remembered that once a year, 'the march passed through the streets with great clamour and glamour. People with battered top hats playing the cornet out of tune and girl art students with coloured stockings – the whole parade of infamy came through the town. It was terribly enticing – they were passionate, evangelical, calling upon you to do things now, to sit down, to stand up and be counted'.

The issue of nuclear proliferation remained critically important as American and Soviet military forces acquired more weapons of mutually-assured destruction and more nations launched their own research programmes to acquire 'the bomb'. By the mid-1960s, the CND had shifted its focus to opposing the Vietnam War. It joined forces with the Vietnam Solidarity Committee (VSC), founded in 1966 and closely allied with the Bertrand Russell Foundation. The VSC soon became Britain's leading student anti-war group and was the organizer of major demonstrations in London and other cities that highlighted popular support in the United Kingdom for American withdrawal from Vietnam.[205]

Sending British troops to Vietnam would have helped the United States military and would also have reinforced the relationship between two long-time allies. In fact, the extent of British commitment to that alliance was a factor in foreign policy and the survival of Harold Wilson's Labour government. Wilson never committed troops to Vietnam, but he was reluctant to criticize

United States military action there. Wilson's silence sparked severe criticism from anti-war activists and members of his own party. Although the Labour government supported the war in Vietnam diplomatically, the British public was less sure. An April 1965 Gallup poll revealed that a majority of those questioned did not approve of the actions of the United States military, especially the bombing of both civilian and military targets. Only a month later, a similar poll found that seventy-one per cent of those questioned felt that the only appropriate role for Britain was to establish a framework for peace talks. By 1965, anti-colonial and anti-nuclear groups such as the Movement for Colonial Freedom (MCF) and the Campaign for Nuclear Disarmament, which included a number of women, began to sharpen their focus on ending the war.[206]

Anne Kerr, an MP from Rochester and Chatham from 1964 to 1970, was a prominent member of both the Campaign for Nuclear Disarmament and Women Strike for Peace. She was described as 'one of the most Left members of the [Labour] Party'. In Parliament, Kerr called for the abolition of war and the replacement of the Foreign Minister with a Minister of Peace. That proposal met with ridicule, even from fellow MPs who opposed America's war. At a rally in Trafalgar Square, Kerr decried America's 'bloody fascist war'. She attended the 1968 Democratic Party Nominating Convention and was arrested, beaten, and temporarily blinded by members of the Chicago Police Department. Kerr did not describe herself as a feminist, but rather as an opponent of colonialism and an early opponent of the Vietnam War.[207]

1965 was a pivotal year for Britain's anti-war movement. Operation Rolling Thunder increased the bombing attacks on North Vietnamese targets starting in March, and British Prime Minister Wilson faced severe criticism from within the Labour Party for supporting American actions that included the use of napalm. Wilson was involved in some secret peace initiatives, but

The International Scene: Radical Women in 1968 and Beyond

his efforts were ignored by President Johnson. In May of 1965, the British Council for Peace in Vietnam (BCPV) was organized to bring together diverse opponents of the war from trade unions, religious institutions, and political groups. The BCPV obtained 100,000 signatures on a petition that demanded that the government take action to negotiate an end to the war. The goal here was to mobilize public opinion to pressure the Labour Party to discontinue its support of the United States in Vietnam. The increased presence of American ground troops by the summer of 1965 was a clear signal that the United States would not respond to traditional efforts, either at home or in an allied country like Britain, to bring about peace by influencing public opinion. Nevertheless, the BCPV and the CND continued to publicize the immorality and futility of the war.

The British Left took steps to establish a solidarity campaign in December of 1965. The Bertrand Russell Peace Foundation organized a meeting attended by about 200 people to mark the fifth anniversary of the founding of Ho Chi Minh's National Liberation Front. 1966 saw the founding of the Vietnam Solidarity Campaign (VSC), a Trotskyist group supported by the Russell Foundation with the goal of ending the war and supporting a communist victory in Vietnam. The VSC sponsored teach-ins at the London School of Economics in the spring of 1965, modelled after those that had taken place at the University of Michigan. The VSC collaborated with the British Council for Peace in Vietnam and the Vietnam Solidarity Campaign to organize major street demonstrations and vigils against the war, starting in October of 1965. In July of 1967, Dr Benjamin Spock, a prominent American opponent of the war, spoke at a BCPV demonstration in Trafalgar Square. The crowds marched to the American Embassy in Grosvenor Square, which the demonstrators dubbed 'Genocide Square'.

This was a turbulent time in the Labour Party. Membership declined as many members opposed the war. One of the most notable people

to depart was Peggy Duff, a local politician, anti-nuclear activist and organizing secretary of the Campaign for Nuclear Disarmament. Duff was an outspoken opponent of the war whom Noam Chomsky described as 'one of the people who really changed modern history'. Duff publicly left the Labour Party in May of 1967 over Wilson's continuing support of the war.[208]

Women's protest actions were frequently small and personal, as individual women found ways to express anger and frustration at the nuclear arms race and opposition to material support for the war by Britain's Labour government. Margaret Stanton led the Birmingham chapter of the British Campaign for Peace in Vietnam, formerly the British Council for Peace in Vietnam. She was a left-wing activist who opposed the nuclear arms race, South African apartheid, and the Vietnam War. Arnica Young was a member of the Association of Scientific Workers who was also an active member of BCPV. Women with no public *personae* planned small, local demonstrations that attracted the attention of the public and the press. On 18 February 1968, the Associated Press distributed a photo of a group of women marching to Number 10 Downing Street, followed by a lone male police officer. Their banner declared 'The Women of Great Britain Plead for a stop to the Slaughter in Vietnam'.[209] This was a popular message on signs and banners throughout the war. While many younger women were engaged in more radical forms of protest, there were still women who approached the subject of ending the war as mothers.

One of London's largest anti-war rallies and marches took place on 17 March 1968. Ten thousand protesters organized by the Vietnam Solidarity Campaign gathered in Trafalgar Square. After a rally, eight thousand protesters marched to the American Embassy in Grosvenor Square. Actress and political activist Vanessa Redgrave attempted unsuccessfully to present a letter to American officials demanding an end to the United States military presence in Vietnam. Bruce

The International Scene: Radical Women in 1968 and Beyond

Robinson, a witness to the events in Trafalgar Square, said the area was 'full of the flags of the National Liberation Front (the 'Vietcong'), who, only weeks previously had launched the Tet Offensive that had taken a largely rural guerrilla war into the cities of Vietnam, getting as far as the gates of the US Embassy in the capital Saigon. Someone threw red dye into the fountains to symbolize the bloodshed in the war. The march included a group of mothers pushing their babies in prams and carrying a banner that included the familiar message, "Women of Great Britain Plead for a Stop in the Slaughter in Vietnam". Outside the American Embassy, the marchers heard speeches from Tariq Ali, leader of the UK's Vietnam Solidarity Campaign, Redgrave, who announced that she, accompanied by American actress and activist Louise Fletcher, would deliver a letter of protest to the US embassy. The pair then led the 8,000 protesters to Grosvenor Square'.

The march did not remain peaceful. Many of the protesters broke through the embassy's protective barriers. Reporter Jon Henley described the ensuing confrontation after the crowd refused to disperse: 'Protesters hurled mud, stones, firecrackers and smoke bombs; mounted police responded with charges. The violence of the struggle, in the cosseted heart of Mayfair, shocked everyone. By the end of the afternoon, more than 200 people had been arrested'.[210]

London Police Commander John Lawlor saw the situation differently. Asserting that march leaders had lost control over the crowd, he said that the 'demonstration degenerated into a disorderly rabble'.[211] The extent of the violence and the fact that London's Metropolitan Police were ill-prepared for the event led to the founding of the Special Operations Squad, later re-named the Special Demonstrations Squad, a group of operatives who infiltrated local anti-war organizations to gather intelligence on future demonstrations. The 17 March demonstration, the largest in England, was one of many between 1967 and 1969.

On 27 October 1968, protesters again walked from Trafalgar Square

to Grosvenor Square. The *Vietnam Solidarity Campaign Bulletin* claimed victory for the protest and declared that, when the police allowed demonstrators to have control of the streets, the demonstration could remain peaceful: 'The demonstration on October 27th represents a sweeping vindication of the work of our campaign, and a significant contribution to the world-wide movement of support to the fighting people of Vietnam ... The fact the demonstration did not become a riot was due to the fact that the authorities conceded our right to occupy the whole street unhindered'.[212] The more peaceful nature of the 27 October demonstration was also a result of the greater scope of information available to law enforcement because of the work of the Home Office in gathering intelligence about the protest groups.[213] As a result, the police were able to contain the energy of the crowd and avoid violence.

Vanessa Redgrave was by far the most prominent female participant in anti-war protests in Britain. A renowned actress, Redgrave was a member of the Workers Revolutionary Party (WRP), a Trotskyist group in Britain. Prior to her WRP membership, Redgrave helped to lead anti-Vietnam War protests with writer Tariq Ali and physicist Stephen Hawking. Redgrave maintained an active acting career while speaking out against the war and American foreign policy. Although the WRP focused on organizing workers and engaging in public protests, Redgrave ran for a seat in Parliament in the Newham North East district in East London, a working-class area. She did not win the race, but the election enabled her to bring her views to a wider public.

Women were instrumental in the growth of Britain's protest movement against the Vietnam War. We do not see many women in prominent leadership positions, but they took part in marches and rallies, parliamentary debates, and discussions in Britain's major political parties. British women protested the war as mothers, as political radicals, and as young people who simply wanted to put

The International Scene: Radical Women in 1968 and Beyond

an end to a land war in Asia. Their varying perspectives helped to broaden the anti-war struggle and contributed to the diversity of Second Wave Feminism in Britain. Feminist activist Rebecca Johnson described the interaction between marching for peace and developing a new feminist movement as a result of the appearance of conscious-raising groups, 'an import from the United States'. These small, feminist discussion groups 'helped many women to clarify their values and their reasons for becoming involved in Britain's peace movement. In small groups, women could speak freely without male interference or denigration. This process enabled many women to understand that their desire for a voice and a movement came from the shortcomings of the groups they already served'.

It became clear that women's politics were intertwined with anti-war politics in a variety of ways. Some activists argued against nuclear weapons from the point of view of mothers concerned about their children's future. Others linked all military action with patriarchal society. They pointed out that fewer women perpetrate violence than men and that women are less likely to be in positions of power where they command armies or initiate wars. Feminists also made connections between the sexual disadvantage and inequality experienced by women, sexual violence, and military aggression, which was presumed to be primarily male. For these women, peace, politics, and feminism were inseparable'.[214]

But British women in socialist and new left groups, like their counterparts in the United States, experienced the frustration of marginalization. Many of their male colleagues could not abide the notion that women's issues could rise to the level of importance occupied by banning nuclear weapons or ending America's war in Vietnam. Sheila Rowbotham, a socialist and feminist, described her experience when she raised concerns more specific to women than to revolution. In meetings, she was subjected to sexual banter, 'whistling when women spoke, the way in which men divided us

into two, either as comrades or as women they fucked. Once a man told me to stop being so "effeminate".'[215] Over time, as she heard of similar experiences from feminists in other countries, it became clear that women's issues would not be addressed without a dedicated international movement by and for women.

Protesters, both male and female, were connected throughout the world by the commonality of their causes. Indeed, students in the late 1960s were considered the first truly 'international' generation. Students in many countries protested the rigidity of university life, the archaic nature of the curriculum, and the legal restrictions on their everyday activities. They communicated their grievances at international conferences of New Left and student organizations. Women in particular came to realize the extent of their capabilities and were no longer willing to submit to external authority from a professor, a father, or a comrade on the barricades.

As the 1960s came to a close, the idea of a large-scale inclusive organization of women under the feminist umbrella gave way to the formation of smaller, local groups that pursued specific interests. These groups had different objectives, and they pursued individual projects generally without fanfare or government support. Women founded childcare centres, shelters for battered women, and women's community centres. Frequently staffed by volunteers, these grassroots organizations served local needs and contributed to the betterment of women's lives. As successors of large, national efforts, these small groups continue to be effective at mobilizing the skills and energy of women to focus on issues of importance to them.

Mexico | In the late 1960s, many students in Mexico began to look critically at their lives as young adults and university students. They opposed the Vietnam War and cheered the success of the Viet Cong during Tet. They witnessed with interest the upheavals led by students and workers in Paris, demonstrations against government

The International Scene: Radical Women in 1968 and Beyond

and university authority by the German SDS, and the attempt to protect democracy in the Prague Spring. Students in left-leaning political organizations found fault with what they saw as an old-fashioned, repressive society in a country run by a single entity, the International Revolutionary Party. According to journalist Jimena Vergara, Mexican students were intensely constrained and criminalized. She recalled that the police 'repressed and broke up everything: rock concerts, festivals, soccer games, and even art exhibits. These extreme measures hindered cultural expression and free movement, making the police particularly hated in Mexico City. As early as 1965, the Mexican government employed nearly 2,000 agents and informers who spied on student organizations, reported to government authorities on overheard conversations, and intercepted letters between members of student groups. The goal was to assert control over student activity and intimidate groups that might stage protests or criticize the government'.

Women's lives were particularly constrained in Mexico. Strict codes of conduct in traditional families that centred on the absolute authority of the father, along with restrictions on women's sexual behaviour before marriage imposed by the Catholic Church, set severe limits on what women could do. Female university enrolment increased in the 1960s, but many families opposed higher education for their daughters. Concepcion Santillan had to rebel against the authority of her father in order to study nursing and embark on a career. Her testimony echoes that of young women in France, Germany, and the United States: 'Our parents wouldn't allow us to study, we were restricted in what we could do. You could go to school, you could become a secretary, you could become an accountant – you had to be something. But university – no. My father said to me, "You know you cannot go to the university". But my sister and I, we insisted we could. I was not afraid. It was freedom'.

Attending the university provided opportunities for women to

learn in the classroom and to exchange ideas with their colleagues, both men and women. Some of those conversations included utopian visions of how a revolutionary society would look and feel, especially for women. Within protest movements, Mexican women, like their counterparts in Europe and the United States, at first played non-public but essential organizing roles. Dissatisfaction with second-class status within the student movement motivated women to organize a Second Wave Feminist Movement in Mexico in the 1970s.

In the protests of 1968, women helped to build student organizations by writing newspaper articles and leaflets, distributing literature, and organizing students at the grassroots level. Consuelo Valle was a member of Nuevo Grupo (New Group) for which she actively prepared materials for demonstrations and raised money. She remembered her activities in her local community in 1968, which were enlivened by her modern wardrobe: 'Revolutionaries in miniskirts? Little has been written about the participation of women in the movement, but the truth is that we were the most active. We went out to the markets, we got on the trucks, we distributed flyers, we collected money in some little jars that we stuffed and when we arrived at the Faculty, we prepared food with vegetables and fruits that they gave us, for our colleagues who had stayed working. We raised a lot of money because the population liked it very much that "chavitas ye ye" with their pretty miniskirts fought for democracy and for a different country'.

When young Mexicans entered the world beyond their homes by attending the university, they gained confidence from their involvement in protest movements, but the new Mexican woman did not always receive praise for her assertiveness. Consuelo Valle remembered 'professors from the Faculty of Sciences who asked me why I was there, and told me that I was here just to find a husband ... fundamentally, we were there to study and our willingness to confront [sexism] created an environment, at least in this generation,

The International Scene: Radical Women in 1968 and Beyond

that pushed women to become empowered'. The lessons they learned in Mexico's movement for democracy laid some experiential groundwork for the creation of a feminist movement in the 1970s.

A fight between students from two competing schools, Vocational School 2 and the Isaac Ochotereina Preparatoria resulted in a police action that caused considerable violence and the arrest of twenty students. The presence of law enforcement on a school campus heightened tension with the government. In Mexico City, students organized a demonstration for 26 July 1968 to commemorate the beginning of the Cuban revolution. This event was not unusual, as students had been celebrating Fidel Castro's victory in Cuba for a decade. What began as a peaceful demonstration was brutally repressed as police forces fired on the students, causing the deaths of scores of students, both men and women. Protests and clashes with the police, coordinated by the National Council of Striking Students, continued throughout the summer of 1968, and student demands transcended changing the university to changing Mexican life. Specific demands included a release of political prisoners (students who had been arrested in previous demonstrations); repeal of Article 145 of the Penal Code that mandated prison sentences of two to twelve years for the loosely defined crime of 'sedition'; the abolition of police riot squads; the firing of the Mexico City police chief; and accountability for police officers who caused injury to students.[216]

Protester Marie Claire Acosta, a middle-class woman, was aware of her privileged status in Mexican society, but she also recognized that political struggle was about more than privilege. She told an interviewer years later, 'We were going to a public university, we had all of these privileges, but we wanted a democratic space'. By the end of the summer, Mexican President Gustavo Diaz Ordaz was worried that what he saw as 'malcontent agitators' would damage Mexico's reputation and harm tourism for the upcoming Mexico

City Olympic Games, which were being held in a Latin American country for the first time. He also feared that the protests would extend to workers, as they had in Paris, and that a general strike would cripple the city during the Olympics.

Thousands of the 'agitators' convened in the Plaza of Three Cultures in the Tlateloco neighbourhood on 2 October. Ana Ignacia Rodriguez was a law student and leader of the protest. She described seeing a helicopter shooting flares and snipers shooting live rounds into the crowd. 'I froze', she said, 'I never thought they were real bullets'. Although official accounts of the disturbance claimed that only twenty-six students died, the real death toll in what can only be described as a massacre was at least 300, with 700 people wounded. Five thousand students, including Rodriquez, were arrested and jailed. In the wake of the violence, the National Council of Striking Students disbanded. Smaller anti-government protests followed over many years with police forces continuing to respond with force.

In spite of the violence and the decline of the student movement, many women who participated in the demonstrations of 1968 credit their involvement in the movement with their personal growth. Ester Alfaro said that her involvement in the revolutionary protests of 1968 helped her to become 'a new woman, from leaving the protection of my parents, the convent school to confronting myself, everything, my parents. I started to leave my social circle, I learnt to appreciate myself for what I was'. The students of the Tlatloco demonstration continue to inspire students in Mexico today who have used marches and demonstrations to make their voices heard. Samara Vizuet stated that she and her student colleagues must remember and learn from the past: 'We know we are the children of '68. If not for them, the students of today would not be out protesting in the streets'.[217]

Japan | Throughout the world, the story was the same during the Vietnam era. Young women who participated in protests against the

The International Scene: Radical Women in 1968 and Beyond

Vietnam War soon realized that they were also opposed to patriarchal and hierarchical organizational structures that relegated them to tasks like typing leaflets and making coffee. The unwillingness of their male colleagues to see them as equals and to include them in policy discussions was frustrating, but out of frustration came the resolve necessary to create a women's movement through which women's grievances could be addressed and remedied. In an important sense, standing up to government and university administrations helped women to develop their skills as speakers, writers, and policy-makers. Standing up to their male colleagues helped women to acquire the courage to speak for themselves.

In the wake of Japan's defeat in the Second World War, young people began to organize student groups that loosely followed the model of political organizations in their parents' generation. 1948 saw the formation of Zengakuren, an umbrella organization of youth groups with connections to the Japanese Communist Party. As early as 1949, students protested a raise in tuition fees at Tokyo National University. They also opposed what they saw as a 'red purge' in the university that was part of Japan's Cold War experience. Cultural groups with utopian visions of a modern Japan emerged in the mid-1950s. Women learned that they needed to establish their presence and articulate their views through the power of numbers. The catalysts that helped to birth a new feminist movement that would soon be called a Second Wave were similar in countries all over the world. Various protests reflected a demand for change that would bring democracy and a greater degree of freedom to people in far-flung places. More than half of those people were women, and they took advantage of what they learned by demanding liberation for themselves.

In 1966, SDS in the United States published a position paper for consideration at the upcoming convention that declared 'fraternal relations' and support for the emerging Japanese anti-war

movement.[218] By 1968, change was in the air, and women were in both the forefront and the background of movements to liberalize the late-twentieth century world. Not surprisingly, women internationally saw the need to develop their own movements for change. The origins of Japan's New Left can also be found in the history of communism in the Soviet Union. After First Secretary of the Communist Party Nikita Khrushchev denounced Joseph Stalin's 'cult of personality' in a secret speech to party officials in 1956, young communists founded their own organizations that diverged from the old communist guard. These groups, including the Japan Trotskyist League (founded in 1957) and a Maoist group (founded in 1958), espoused the use of militant tactics to advance their positions.

Like many countries in Europe, a defeated Japan received significant help from the United States to rebuild its infrastructure and revitalize its economy after the Second World War. The difference was that Japan was formally occupied by international forces under American command from 1945-1952. Strong relationships established during that time continued well past the departure of the occupation forces. In 1959, the Zengakuren attracted popular attention by highlighting Japan's continuing dependent relationship with the United States. The group invaded Japan's Parliament, the Diet, in the midst of discussions about a new Treaty of Mutual Cooperation and Security between the two countries. The treaty was signed, order was restored in the Diet, but Japan's New Left, residing mainly in youth and student groups, was born.

The most prominent left political movement in Japan that engaged in public, non-violent protests was Beheiren (Betonamy ni Heiwa o Shimin Rengo, the Citizens' Federation for Peace in Vietnam), which was founded in 1965 in response to Operation Rolling Thunder, the United States bombing campaign against North Vietnam. Beheiren's protests were non-violent and included large marches, distributing pamphlets and newsletters, and providing

The International Scene: Radical Women in 1968 and Beyond

sanctuary for American soldiers who had deserted. Beheiren, like New Left organizations in other parts of the world, espoused a non-hierarchical, egalitarian approach in which there was no permanent structure. Beheiren's anti-war mission transcended Japan: on 16 November 1965, the organization placed an ad in *The New York Times* with the message, 'Can bombs bring peace to Vietnam?' The New Left included various groups with differing points of view on protest within the system versus militant challenges to the system itself. By the late 1960s, students in particular were voicing opposition to the Japanese state, Japan's relationship with the United States, and the war in Vietnam, which included opposition to the support the United States received from South Korea, a long-time antagonist of Japan's. Students saw the Japanese state as antiquated in its approach to diplomacy, especially with regard to the nation's relationship with the United States.

When student power and opposition to the war became a major focus of activism by 1968, radical students expressed their outrage with familiar tactics – they stormed and occupied buildings, forced the cancellation of classes, and fought the police. There were many different factions, each of which chose a different colour for the helmets they wore in demonstrations. The Mutual Cooperation and Security Treaty was renewed again in 1970, by which time Japan's New Left had fractured into many splinter groups, some of which advocated violence. The Japanese Red Army engaged in airline hijackings and the murder of twenty-six people at Israel's Lod Airport on 30 May 1972. It was responsible for the deaths of twelve of its members as part of a policy of 'self-criticism'.

Young Japanese women represented a growing fraction of the nation's university population. As they became active in organizations on the student left, they engaged in protests along with their male colleagues but were members of their groups on less than equal terms. Women began to see themselves as capable but unequal

partners, and they began to criticize the male ethos of the Japanese New Left. The female precursor of the Japanese New Left whom we know best is Michiko Janba, who was killed in a demonstration in 1960. A decade later, Hiroko Nagata suffered at the hands of fellow radicals during a period of self-criticism in 1972. But thousands of anonymous women also served New Left causes and raised their voices in opposition to the overwhelmingly male orientation of their movement. According the Chelsea Szendi Schieder, 'Young women became new political actors in the post-war period, their enfranchisement commonly represented as a break from and a bulwark against "male" wartime violence'.

As in many other countries, dissatisfaction with their treatment in the student left led Japanese women to add their voices to the call for a new feminist movement.[219] With the end of America's war in Vietnam, Beheiren, closed its doors, but modernizing and democratizing the Japanese state remained prominent causes in left wing circles in Japan. One of the profound issues that New Left groups in many countries failed to resolve was the importance of women's issues such as childcare, pay equity, and reproductive rights within its ranks or in society at large. By the early 1970s, groups of women began to organize on their own behalf. Out of frustration and anger and with a sense of optimism that women could succeed on their own, Second Wave Feminism became a worldwide phenomenon.

Chapter Seven

A Movement of One's Own

In its broadest contour, Second Wave Feminism around the world originated in women's profound dissatisfaction with their status in movements to secure civil rights for African Americans and to bring about an end to the War in Vietnam. In addition, women who worked in government agencies that were supposed to implement equality promised by title VII of the 1964 Civil Rights Act were frustrated at the condescending attitude of male colleagues and bosses who were willing to consider only the smallest incremental changes in the status of women. Not content with window dressing reform but still not aware of their numbers or their potential influence, women in the workplace, like their younger colleagues in the Civil Rights and anti-Vietnam War movements laboured virtually alone and in near silence until they discovered that there were women with similar grievances who were willing to act as women on behalf of women. The culmination of this dissatisfaction was the eventual creation of a movement by and for women that emerged in the 1970s. The origins of Second Wave Feminism are complex and include a variety of individuals and groups that claimed the title 'feminist' without always agreeing with each other as to what feminism meant. This was true for organizations in the United States and around the world.

Women activists shared their advances and their setbacks across national borders, seeking to define their grievances and refine the language with which they demanded greater equality and agency. Clearly stating those characteristics that defined a feminist was a particularly challenging undertaking, and the very definition of feminism has been disputed and re-cast over the past several decades. But for the organizers who placed the interests of women at the

centre of their activism, the goals of Second Wave Feminism, while varied among many individuals and groups, nevertheless coalesced around the idea that women's needs were important, their voices needed to be heard, and their issues, while personal, deserved to be addressed politically.

Since the 1970s, feminism has become a broad, if not always an inclusive, term that encompasses diverse perspectives regarding ideology and strategies for the achievement of women's equality. Women who promote ideas of equality with men and a demand for equal opportunity within existing structures such as political parties, trade unions, and businesses have been labelled Liberal, or Mainstream Feminists. The philosophical basis of Liberal Feminism is derived from nineteenth century Liberalism that placed a high value on the freedom of the individual as well as the imperative that governments protect individual freedoms. Demonstrating faith in government and traditional institutions, Liberal Feminists work most effectively through established channels like the courts or legislatures. Liberal Feminist goals are pragmatic and orientated, and their methods include marches and rallies, letters to elected officials, and lobbying efforts. Their focus is typically on integrating women more effectively into positions in society that had previously been dominated by men. They are also often in favour of using the power of government to advance women's causes through protective legislation intended to remove barriers such as discrimination that impede women's progress toward equality.

Radical Feminists support re-shaping society in a non-hierarchical and non-authoritarian manner. They reject the male dominance of power structures and advocate the creation of new models for advancing women's power. Radical Feminists reject the idea that reform through traditional structures can bring about the liberation of women. The major force to be overthrown from a Radical Feminist perspective is patriarchy. Radical feminists debated whether it was

more important to challenge the patriarchy or overthrow capitalism. Barbara Ehrenreich put that issue into perspective in 1976, writing that 'There is no way to understand sexism as it acts on our lives without putting it into the historical context of capitalism'. Although the Socialist, Marxist, and Radical Feminists disagreed as to whether capitalism or patriarchy was the more powerful source of women's oppression, they agreed on the profound need to work for women's liberation as they eschewed the institutional and reform focus of traditional Liberal Feminists.

A number of feminist groups took shape around specific issues, and membership in these groups occasionally overlapped. Cultural or Difference Feminists reject the notion that women should be more like men. They argue that there is a 'female nature' or 'essence' that makes women fundamentally different from men, and they reject any notion of male superiority. Emerging in the 1980s out of the debates over 'equality versus difference', these feminists argued that male and female genders had an equal moral status as human beings and an equal claim to rights but that women diminish their unique qualities when they try to be like men. Current re-definitions of gender fluidity and gender itself have rendered Difference Feminism an anachronism.

Anarcho-Feminists who espouse some of the philosophical ideas of Emma Goldman seek to dismantle institutions such as government, private property, and the family. They argue that women cannot be free within these institutions. Individualist Feminists stress personal independence and reject government help in achieving their goals. Amazon Feminists argue that women's power is derived through their physical strength. Lesbian Feminists define their independence as fundamentally based on their sexual orientation and complete freedom from men.

These and other groups evolved as the movement for women's liberation grew and matured and as women with particular ways of describing themselves and their societal goals organized around those

identities. They have contributed to the diversity of the women's movement throughout the world. Within Second Wave Feminism's first decade, it could no longer be said that there was a single way to describe the goals of women. Feminism has become feminisms.

In addition to experiences in civil rights and anti-war organizations, there were numerous theoretical sources of inspiration for the women who created Second Wave Feminism in the 1970s in Europe and the United States. The writings of Mary Wollstonecraft, Virginia Woolf, and Simone de Beauvoir provided a theoretical underpinning for the ideas of the new feminist movement.

In response to eighteenth century theorists who argued that women should be educated only in those domestic skills and social graces that would make them pleasant companions for men, Mary Wollstonecraft wrote in *A Vindication of the Rights of Woman: with Strictures on Political and Moral Subjects* (1792) that women were equal in capacity to men and that they deserved to be treated as rational human beings. She criticized frivolous education for women and asked that her women readers 'excuse me, if I treat them like rational creatures, instead of flattering their fascinating graces, and viewing them as if they were in a state of perpetual childhood, unable to stand alone'.[220] Wollstonecraft then asserted that women should be treated as adults, arguing that a rational education would not only enable women to be better wives and mothers, it would also improve the health of the nation. In its time, *Vindication* did not influence male-dominated parliaments in Europe or legislatures in the United States, which showed no inclination to pass laws promoting women's equality. Women came to realize that they would have to act for themselves outside traditional legislative processes. Wollstonecraft's writing inspired transcendentalist Margaret Fuller, suffragist Elizabeth Cady Stanton, and generations of European and American feminist thinkers. Modern readers concluded from Wollstonecraft's work that a woman's place was in society.

A Movement of One's Own

One hundred thirty-seven years later, Virginia Woolf published *A Room of One's Own*, an essay based on lectures she presented at Newham and Girton Colleges, the women's colleges of Cambridge University. She described her experience of trying to find major women writers whose work could serve as role models for her own writing. In her journey through the stacks in the British Library, she found herself in the history section, where she came upon Professor George Macauley Trevelyan's *History of England*. She recalled that, 'Once more I looked up Women, found "position of" and turned to the pages indicated. "Wife–beating", I read, "was a recognized right of man, and was practised without shame by high as well as low …" "Similarly", the historian goes on, "the daughter who refused to marry the gentleman of her parents' choice was liable to be locked up, beaten and flung about the room, without any shock being inflicted on public opinion"'.

Woolf observed that, in Trevelyan's version of history, women were the objects of men's desires rather than independent human beings who could act on their own behalf. She wondered what conditions would have to prevail for a woman to realize her potential as a writer and concluded that women needed agency to act for themselves. In order to be creative, a woman writer also needed financial independence. In short, give the woman writer 'a room of her own and five hundred [pounds] a year'. This idea resonated with readers in the 1960s who were inspired by her insistence that women were entitled to personal space and financial independence to achieve their goals.

Woolf argued that prejudice against women inhibited their creativity, and she asserted that women were capable of writing serious literary criticism, not just simple poetry or frivolous fiction. Speaking to the young women of Cambridge, Woolf looked in vain to literature and history to find models. Commenting on their invisibility, Woolf noted that she discovered a composite portrait of women in her research:

'Imaginatively she is of the highest importance; practically she is

completely insignificant. She pervades poetry from cover to cover; she is all but absent from history. She dominates the lives of kings and conquerors in fiction; in fact, she was the slave of any boy whose parents forced a ring upon her finger. Some of the most inspired words, some of the most profound thoughts in literature fall from her lips; in real life she could hardly read, could scarcely spell, and was the property of her husband'.[221]

Two decades after the publication of Woolf's *A Room of One's Own*, French theorist Simone de Beauvoir published *The Second Sex*, in which she inquired about the nature of woman. Unlike philosophers who had inquired about the nature of man but were content to relegate the function of women to marriage and the production of children, de Beauvoir asked essential questions. Her work began:

'For a long time, I have hesitated to write a book on woman. The subject is irritating, especially to women; and it is not new. Enough ink has been spilled in quarrelling over feminism, and perhaps we should say no more about it. It is still talked about, however, for the voluminous nonsense uttered during the last century seems to have done little to illuminate the problem. After all, is there a problem? And if so, what is it? Are there women, really? Most assuredly the theory of the eternal feminine still has its adherents who will whisper in your ear: "Even in Russia women still are women"; and other erudite persons – sometimes the very same – say with a sigh: "Woman is losing her way, woman is lost". One wonders if women still exist, if they will always exist, whether or not it is desirable that they should, what place they occupy in this world, what their place should be. "What has become of women"? was asked recently in an ephemeral magazine',[222] DeBeauvoir continued, asking: 'Are women so marginal that they do not deserve serious historical consideration?' She demanded that women occupy an important place of their own in history. Articulating a concept that would become familiar to Second Wave feminists, de Beauvoir observed that man is considered the default,

while women are the 'other'. Arguing in opposition to the ideas of Sigmund Freud and other psychologists, de Beauvoir asserted that women should not be considered only in terms of their value in the reproductive process. She argued that:

'Women are subordinated in public life, religion, and even in the home, when men rule. As long as man occupies the role of subject and women the position of object in society, women can never achieve equality or exercise their creativity. As long as men occupy the public realm and women are confined to the home, they will never be able to compete with men. Men are creators, women passive objects waiting for men to summon them'.

The ideas articulated in these and other philosophical works resonated with women in the United States and in other parts of the world who found themselves continually subordinated to men in movements for justice and social change. Thinkers on both sides of the Atlantic insisted that writing about women was essential and that new ideas brought forth by young feminists deserved to be put into action in politics and society. Some works were extreme, some were sarcastic, but they all spoke to a need for new feminist philosophies that would generate action on behalf of the identity and integrity of half the population.

The United States | In the early Civil Rights and anti-war movements, women accepted auxiliary roles that supported and advanced what they believed to be important political and social justice goals. After years of not being recognized as equals, women protested their second-class status in organizations whose male leaders espoused high goals and aspirations for profound social change, except when it came to the equality of the sexes. Unappreciated by their male colleagues, women first found a voice for their specific grievances and then developed plans for action on their own behalf on many fronts.

Nancy Rosenstock of Boston Female Liberation affirmed the

importance of earlier movements for social change when she wrote that the women who established their own feminist organizations 'began to fight for their rights as part of a broader radicalization of youth that was unfolding starting in the late 1960s'. The variety of organizational, theoretical, and personal lessons learned in the civil rights and anti-war movements profoundly influenced the organized, theoretically nuanced, and personally impassioned women's movement, whose diverse constituent groups shared the idea of liberation from male authority.[223]

Not all organizations, even those that supported the basic idea of female empowerment and independence, were ready to support the formation of new organizations dedicated exclusively to women's concerns. An anonymous writer in SDS's *New Left Notes* argued in 1968 that women's liberation should reside in 'the anti-imperialist movement in this country. No social change can succeed without organizing women politically. Organization around the oppression of women should not be a separatist movement, but should parallel the political issues being dealt with in SDS chapters'.[224] In 1968, the prevailing view in SDS was that revolution should take precedence over liberation for women and that women would be best served if they continued to be active participants in the anti-war movement and remain silent about their personal issues. SDS women proposed a six-part resolution on increasing women's participation in the organization, which passed at the 1968 convention. On first glance, this position seemed to be a positive step forward, but many women recognized that with the current SDS leadership, expanding women's role within SDS meant achieving liberation for women on terms defined by men. Increasingly, that position became unacceptable and women demanded their own movement on their own terms.

There was little doubt that sexism existed in SDS, the Student Non-Violent Coordinating Committee, and the Black Panther

Party. Men in SDS persisted in relegating women to supportive roles. Stereotypes of female weakness and incompetence predominated in SNCC, in spite of the presence of brave and talented female field workers who recruited new members, ran the breakfast and other community programmes, and taught in liberation schools in urban areas. Some women accepted their second-class status and downplayed their desire for greater responsibility and authority within the organization. They believed what they had been told – that the goals of the movement were more important than their personal experience of being de-valued and disrespected. Women who raised these issues witnessed few, if any, steps toward change.

A few men were cognizant of the disparities in treatment of men and women in SNCC, although they did little to ameliorate women's situation. Lonnie King, the founder and leader of the Atlanta Student Movement that staged lunch-counter sit-ins in March of 1960 and pushed the integration of public spaces in the city, was especially impressed by Diane Nash, who had led student protests in Nashville.

In an oral history interview for the Library of Congress, King commented that he did not understand why Nash was not selected for higher office in the national SNCC organization. Nash was, in King's view, 'articulate, she was a beautiful woman, very photogenic, very committed. And very intelligent and had a following. I never did understand how, except maybe for sexism, I never understood how [James] Bevel, Marion [Barry], and for that matter John Lewis kind of leapfrogged over her. I never understood that because she was the leader in Nashville. It was Diane … She's an unsung … a real unsung hero of the movement in Nashville, in my opinion'.[225]

Even as King praised Nash's ability, he could not help focusing on her beauty as well as her intelligence. He forgot to mention that Diane Nash was a committed and brave organizer and leader of sit-in demonstrations who faced the same hazards and violence as the men who sat in with her. Nash was one of SNCC's most

respected women. In the Nashville sit-ins, the Freedom Rides, the Rock Hill protests, and voter registration drives in Mississippi, Nash was militant, resolute, and effective. She eventually brought her talents to the peace movement and, in 1966, she was part of an all-female group that travelled to Hanoi at the invitation of the Vietnam Women's Union. She was a model of a Black feminist who was willing to take risks and risk consequences for a higher goal. Women in civil rights groups and organizations on the left frequently analysed the Vietnam War as a battle against imperialism that was related to the battle against discrimination. They recognized the need to bring the struggle in Southeast Asia home. A female member of the Black Panther Party connected the accomplishments of revolutionary women in Vietnam to the need for women's revolutionary activity in the anti-war movement:

'The Vietnamese women are out there fighting with their brothers, fighting against American imperialism, with its advanced technology. They can shoot. They're out there with their babies on their backs ... and they're participating in the revolution wholeheartedly, just as the Vietnamese men are participating in the revolution, in the national liberation struggle. The success of their national liberation struggle is just as much dependent upon the women continuing in the struggle as it is dependent on the Vietnamese men'.[226]

Male anti-war movement leaders made it clear that ending the war was a far more important political goal than addressing women's significant grievances. Some women even accepted the notion that men were somehow smarter, more politically aware, and more capable than the women who served coffee, typed leaflets, and listened quietly as men strategized and made major decisions. Defined by their jobs rather than their capabilities, women experienced a disconnect between what they accepted as a woman's place in the movement and what the movement itself taught them that they could accomplish.

Margery Tabankin, an anti-war activist student at the University of

A Movement of One's Own

Wisconsin from 1965-69, remembered that part of being a woman in the movement 'was this psychology of proving I was such a good radical, "better than the men". We felt we were motivated by something higher because we didn't have to go to war ourselves. Most guys didn't take women seriously, however. They were things to fuck ... You went through this intense experience [at demonstrations], and you went back and had sex. [But] It [sex] was much more on men's terms'.[227] For women raised to value their willingness to serve men sexually and personally (Tabankin remembered that she had been so taken with organizer Tom Hayden that she did his laundry when he visited Madison), it was difficult to break the pattern of gender subordination. The 'Burial of True Womanhood' of 15 January 1968, in which New York Radical Women left a more traditional demonstration by the Jeannette Rankin Brigade to 'bury' traditional women's roles at Arlington National Cemetery, revealed deep fissures within the anti-war movement.

Political women in the movement sometimes denigrated women's issues as frivolous. In contrast, women activists who increasingly defined themselves as feminists could no longer be assumed to share the same faith in movement politics that had fuelled the anti-war movement just a few years earlier but had given little attention to their grievances.

African-American women began to ask questions about the relationship among efforts to achieve equality in American society; what they saw as a racist war in Vietnam; and their own need to assert an independent identity as Black women. These activists recognized the contrast between their subordinate position in the Civil Rights movement and that of Vietnamese women whose country was being torn apart by the American military. Women whose revolutionary activity was a matter of life and death inspired those who were beginning to conceptualize such liberation struggles as part of their own search for identity.

One barrier to developing a feminist collaboration was the mistrust Black women often felt toward White feminists. In 1971, Toni Morrison wrote in *The New York Times* that Black women look at White women and see them as the enemy, 'for they know that racism is not confined to White men, and that there are more White women than men in this country, and that fifty-three per cent of the population sustained an eloquent silence during times of greatest stress. The faces of those White women hovering behind that Black girl at the Little Rock school in 1957 [a reference to the harassment experienced by Elizabeth Eckford when she walked home alone amid a mob of White people outside Central High School] do not soon leave the retina of the mind'.[228]

Within SNCC, Frances Beal was among the first women to describe the unique challenges she and her sisters faced as women, as Black women, and as Black women in an international freedom movement. Beal's life and career helped to frame the breadth of her political focus. The child of a White left-wing mother and a Black father, Beal grew up during the Cold War and was influenced by emerging civil rights and anti-Vietnam War movements in the early 1960s. As a student in Paris in 1960, Beal met young people from Francophone colonies and learned about the efforts of the Algerian National Liberation Front (FLN) to gain independence from France. This experience helped to spark her internationalist view of the struggles of Black people.

In 1968, Beal organized the Black Women's Liberation Committee within SNCC at a time when the organization was shifting its focus from local organizing and voter registration to a broader conception of Black Power. Along with Mae Jackson, an educator and member of the National Congress of Negro Women, and Gwendolyn Patton, who had been active in voter registration drives and in the Montgomery Improvement Association, Beal encouraged conversations among women about reproductive rights, civil rights,

and issues pertaining to women across national borders. This was a period of increasingly meaningful communication among women that prompted discussions about their status in movements for social change in a feminist and anti-imperialist context. Beal's most influential work was *Double Jeopardy,* a 1968 essay in which she explored the relationship between race and class. She observed that Black men in SNCC, who asserted their manhood by telling Black women to step back into a submissive role, were behaving in a counter-revolutionary manner. Black women, Beal asserted, likewise have been abused 'by the system, and we must begin talking about the elimination of all kinds of oppression. If we are talking about building a strong nation, capable of throwing off the yoke of capitalist oppression, then we are talking about the total involvement of every man, woman, and child, each with a highly developed political consciousness. We need our whole army out there dealing with the enemy and not half an army'.

Beal challenged Black women to resist their oppression by men who would have them assume only submissive, domestic responsibilities. She argued that women had been fooled by romantic promises of happiness in a life of domesticity, writing that there were also some Black women who felt 'that there is no more productive role in life than having and raising children. This attitude often reflects the conditioning of the society in which we live and is adopted (totally, completely, and without change) from a bourgeois white model. Some young sisters who have never had to maintain a household and accept the confining role which that entails, tend to romanticize (along with the help of a few brothers) this role of housewife and mothers. Black women who have had to endure this kind of function as the sole occupation of their life are less apt to have these utopian visions'. [229]

During the late 1960s, female SNCC members hoped to bring a focus on international women's rights to the Black Power Movement.

At the same time, this was a period of organizational decline within SNCC. As local SNCC chapters closed, the Black Women's Liberation Committee became the Black Women's Alliance in 1969 and severed its ties to SNCC. The new independent organization continued to focus on women's issues and expanded its membership to include Native American and Puerto Rican women. The Alliance later became the Third World Women's Alliance (TWWA), which analysed and critiqued American actions, from nation building to foreign aid in developing countries. Their focus on gender, race, and class was framed in anti-imperialist terms and highlighted the relationship between the struggle for Black Power at home and efforts of anti-colonial movements abroad. Starting in 1971, TWWA published *Triple Jeopardy*, a newspaper edited by Beal that stressed the interconnection between First World capitalism and the major struggles that animated women worldwide. In its first issue, *Triple Jeopardy* asserted that 'the struggle against racism and imperialism must be waged simultaneously with the struggle for women's liberation'.

The Third World Women's Alliance broke new ground in expanding women's liberation to encompass women's lives in the developed and developing world. In its world focus, TWWA paved the way for Chicana feminism and Womanism as theoretical approaches to liberation. In this regard, TWWA differed from the feminists who emerged out of SDS who focused mainly on women's liberation in the United States. TWWA also differed from radical groups that refused to work with men or accept men as allies. On the issue of collaborating with White women, TWWA sisters observed that there were differences in goals and objectives between White and Black feminists: 'White women and Third World women have a common struggle against imperialism and both struggle against male superiority. However, TW women face an over-riding problem which exceeds the importance of male superiority. This is of course the problem of white superiority caused by institutionalized racism.

An alliance between TW women and White women must be based on actual struggle against imperialism and racism, not just a verbal acknowledgement of this struggle'.[230]

SDS faced challenges from women to consider issues of participation and leadership, but with little theoretical analysis of the role of women in radical politics, the group was ill-equipped to hear these challenges and act on them. Male SDS leaders often asserted that women's issues were peripheral to the broader goal of ending the war. Nevertheless, the SDS National Council included a workshop on 'Women in the Movement' in December of 1965. Members wrote a position paper that argued that the problem of women's participation in the movement was a universal one that 'reflects not only inadequacies within SDS but one that also reflects greater societal problems, namely the problem of the role of women in American society'.[231] Three prominent SDS women, Barbara Haber, who had come to the anti-war movement from CORE, Cathy Wilkerson, an editor of *New Left Notes,* and Jane Adams, the National Secretary of SDS, all supported the idea that women's issues were important enough to merit the creation of a separate organization. Although SDS women were not able to get the whole National Council to address the problem of women in the movement, their analysis was broad-ranging and refined in the same fire as the one in which SDS had shaped its critique of the war, racism, imperialism, and American society itself.

Unfortunately for those who pushed for a broader consideration of women's issues, a resolution passed by the SDS National Council in December of 1967 subsumed women's issues under the rubric of 'building the anti-imperialist movement in this country', much to the dissatisfaction of women who saw their personal liberation as distinct from anti-imperialism or the movement to end the war. The resolution endorsed the idea of creating discussion groups for women that would focus in 'imperialism, the draft, and the fear women

have of participating intellectually at meetings'. This resolution placed the responsibility for taking the initiative to 'discourage male supremacism in interpersonal relationships' on individual men and women rather than the organization. The tone of the resolution, later disseminated through *New Left Notes*, was particularly offensive to women activists. It trivialized the issue of male supremacism by making it simply one of conflict between individuals. Further, it placed the burden of dealing with sexism on women rather than on SDS as a whole.[232]

The failure of SDS to take women's issue seriously was acutely discouraging to feminists in the movement. The resolution also provoked sharp criticism from activists outside of SDS. Members of the Third World Women's Alliance were critical of what they saw as unnecessary sectarianism in organizations like the small women's working groups within SDS that focused only on the personal oppression of White women in the anti-war movement. Their critique was based on the assumption that their challenges were global rather than confined to a particular set of actors in a particular movement. The trajectory of international Black feminism remained separate from that of the White women who founded numerous women's groups in the 1970s.

As SDS struggled with dissent by women within its own ranks, individual leaders elevated the feminist critique within the organization to a broader analysis of women in American society while supporting the primacy of revolution as both the theoretical and practical goal of the organization.

On 18 March 1968, Naomi Jaffe and Bernadine Dohrn criticized the pervasive sexism in mainstream consumer culture while also taking aim at the movement that defined women through men. This dynamic, they reasoned, was antithetical to the progress of both societal revolution and the political and social liberation of women. They wrote that, over the previous few months, 'small groups have

been coming together in various cities to meet around the realization that as women radicals we are not radical women – that we are unfree within the Movement and in personal relationships, as in the society at large. We realize that women are organized into the Movement by men and continue to relate to it through men. We find that the difficulty women have in taking initiative and in acting and speaking in a political context is the consequence of internalizing the view that men define reality and women are defined in terms of men. We are coming together not in a defensive posture to rage at our exploited status *vis a vis* men, but rather in the process of developing our own autonomy'.[233] Clearly, it was time for a new paradigm that would not only include women but would also make them the primary actors in their own cause.

Nevertheless, Jaffe and Dohrn maintained the standard SDS approach that prioritized revolution over personal liberation. They argued that women's issues needed to be considered in a revolutionary context. Dohrn wrote that many women's groups did not fully embrace revolutionary ideology, arguing that they were 'bourgeois, unconscious, or unconcerned with class struggle and the exploitation of working-class women and chauvinist concerning the oppression of black and brown women ... To focus only on sexual exploitation and the tyranny of consumption does not develop a mass understanding of the causes of oppression, and it does not accurately point at the enemy'.[234] Jaffe and Dohrn stressed the need for a more revolutionary approach that considered both gender and class. At the same time, many women in the movement were beginning to see that their interests as women were no longer aligned with the goals of the anti-war movement. By 1968, individual women were finding a theoretical language with which to respond to charges that they were less than serious and radical in their call for women's equality.

Women in the anti-war movement began to challenge the premise that a broad ranging attack on American capitalism and imperialism

would mitigate the need for ending male supremacy. They refused to accept the idea that women's issues were marginal, but this refusal came at no small price. Women often had to choose between continuing alliances with men and the need to raise critical issues that the movement had failed to acknowledge. Women themselves were often split on the issue of whether it was more important to end the war or put an end to misogyny. The discussion groups formed by SDS women in the late 1960s were the precursors of the consciousness-raising groups that characterized the feminist movement in the 1970s.

Activists who spoke publicly in support of women's issues were attacked with a discourse filled with sexist and near-pornographic images. Coming from comrades in the struggle to end the war and create a new society, this was painful indeed. Ellen Willis noted how difficult it was 'to convey to people who didn't go through that experience how radical, how unpopular and difficult it was just to get up and say, "Men oppress women. Men have oppressed me. Men must take responsibility for their actions instead of blaming them on capitalism. And, yes, that means you". We were laughed at, patronized, called frigid, emotionally disturbed man-haters and – worst insult of all on the left – apolitical'.[235]

A similar theme emerged in the connection of the personal to the political in an open letter written by 'A Berkeley Sister'. *To A White Male Radical* stressed the importance of personal connection in political relationships. This woman veteran of the movement was willing to go her own way to avoid becoming oppressed by the very activists who had so recently struggled with her in the anti-war cause that, for so many men, was defined in specifically masculine terms. She wrote:

'I will not accept your ridiculous role of self-reliance; it is inhuman, counter-revolutionary and opposed to the goals of Women's Liberation. Your reluctance to be close and open when all is said and done indicates that you make a rather limited socialist after all.

Refusing vulnerability, you are refusing friendship. Refusing acts of sharing you seem so sadly alone. Long ago, earlier feminists wanted to be tough like you. Only fifty years later did they realize how they had assumed the role of the oppressor. Like many Blacks they had silently slipped into the oppressor's habits and therefore truly failed. That is why you are an enemy'.[236]

In the early days of the anti-war movement, women sometimes staged events with a female focus. On 23 February of 1966, women from Berkeley held a rally and march to the Army Induction Center in Oakland, California. Their protest was directed at the war itself and the needless deaths of American soldiers and Vietnamese civilians. Messages on the protest signs included 'Stop the War' and 'Bring Home Our Sons, Husbands, and Brothers'. Although many of the protesters were women from WSP who protested the war as mothers, speakers also connected the need for a separate women's movement to that of the growing conviction within SNCC that Black activists needed a movement of their own, free from White influence. The Berkeley women declared that 'parallels can be drawn between the treatment of African Americans and that of women in our society as a whole'. [237] They argued that women and Black activists needed independence from their former allies.

In June of 1967, the same theme was evident at the Women's Liberation Workshop at the SDS national convention. Participants presented an analysis of women's position in the United States, in the movement, and in their closest working and personal relationships with male colleagues:

'As we analyze the position of women in capitalist society, and especially in the United States, we find that women are in a colonial relationship to men and we recognize ourselves as part of the Third World. Women, because of their colonial relationship to men, have to fight for their own independence. This fight for our own independence will lead to the growth and development of the

revolutionary movement in this country. Only the independent woman can be truly effective in the larger revolutionary struggle. We seek the liberation of all human beings. The struggle for liberation of women must be part of the larger fight for human freedom. We recognize the difficulty our brothers will have in dealing with male chauvinism and we will assume full responsibility in helping to resolve the contradiction. Freedom now! We love you!'[238]

The goal was radical – liberation for women. But the mechanism for achieving that goal remained nearly the same, supportive participation by women in the revolutionary movement to end the Vietnam War and radicalize America society. By the late 1960s, the die was cast for activist women who perceived that the tension between mainstream movement participation and articulating grievances of their own could neither be resolved nor ignored. Women who experienced this tension were not content to accept the notion that their personal concerns were any less important because they spoke to issues of self-esteem, sexuality, and female equality.

Fundamentally irreconcilable differences between the anti-war movement and new feminist organizations were evident at a counter-Inaugural protest in January of 1969 sponsored by the National Mobilization to End the War in Vietnam (MOBE). Feminists Shulamith Firestone and Marilyn Webb attempted to speak to the crowd gathered to protest the election of Richard Nixon. Male protesters yelled sexist comments like, 'Take her off the stage and fuck her'. The women proceeded in spite of the catcalls. After the protest, Firestone sent an angry letter to the MOBE's newspaper, telling her male anti-war colleagues, 'In this past decade you have failed to live up to your rhetoric of revolution. You have not reached the people ... There are millions of women out there desperate enough to rise. Women's liberation is dynamite. And we have more important things to do than to try to get you to come around ... Fuck off, left ... we're starting our own movement'.

After the counter-inaugural, Firestone and Ellen Willis started the radical group, Redstockings, which had its origins in New York Radical Women. Redstockings was committed to militant action for women's liberation. Many on the left, even many women, wanted no part of what they saw as the distraction of women's liberation. Marilyn Webb tells of receiving a phone call in which she was threatened with violence if she continued to give speeches like the one at the counter-Inaugural. For Webb, as for many women, this was the end of their involvement in the anti-war movement, as they now devoted their energies to women's liberation.[239]

It should come as no surprise that many women who participated in the anti-war movement described the experience as transformative. Whether that personal experience was uplifting or disappointing, it prepared them to take on the task of creating a feminist movement. One female Harvard graduate said that the war and the anti-war movement 'changed my life – in the way I questioned everything, in the sense of involvement in something greater than myself, and in the sense of my outrage'.[240] This sense of outrage was a major factor in keeping women connected to the revolutionary enterprise and maintaining their optimism that change was possible. These women were intellectually and emotionally prepared to make the personal political in a new movement.

African-American women also sensed the need for Black feminist organizations that would address their needs, which differed in many ways from the concerns of White women. Stressing women's need for education and training in the real world, civil rights activist and feminist Rev. Pauli Murray, the first African American Episcopal priest in the United States and the first African American woman to earn a law degree at Yale University, argued that African-American women could not rely on marriage for either economic or emotional support. Acknowledging that African-American men should have every opportunity to obtain an education and support to meet their

family responsibilities, she wrote that African-American women 'have no alternative but to insist upon equal opportunities with regard to sex education, and employment at every level. This may be a matter of sheer survival. And these special needs must be articulated by the civil rights movement so that they are not overlooked ... The Negro woman can no longer postpone or subordinate the fight against discrimination because of sex to the civil rights struggle but must carry on both fights simultaneously'.[241]

Murray understood the double burden of race and gender faced by African-American women. She cautioned Black women that they should never forget their own priorities within the civil rights movement. A few months after the August March on Washington, Murray presented a speech to the National Council of Negro Women in Washington, DC in which she criticized male Civil Rights Movement leaders for refusing to allow a woman to deliver a major address at the march. Although Daisy Bates had been given a few minutes to speak, Murray thought the women of the movement had been given short shrift. She declared that male movement leaders demonstrated a 'tendency to assign women to a secondary, ornamental or "honoree" role instead of the partnership role in the civil rights movement which they have earned by their courage, intelligence, and dedication. It was bitterly humiliating for Negro women on August 28 to see themselves accorded little more than token recognition in the historic March on Washington. Not a single woman was invited to make one of the major speeches or to be part of the delegation of leaders who went to the White House. This omission was deliberate'.[242]

Throughout her life, Murray advocated for greater recognition of the contributions made by women, famous and anonymous, in bringing civil rights forward as a major issue. Like Frances Beal, the author of *Double Jeopardy*, Murray recognized that African-American women bore the double burden of both Jim Crow and Jane Crow. In 1965,

she and Mary Eastman, an attorney with the Justice Department, published 'Jane Crow and the Law: Sex Discrimination and Title VII' in the *George Washington Law Review* in which they argued that women deserved full equality in the workplace. They cited *Muller v Oregon* (1908) in which the Supreme Court had ruled that women deserved protective legislation that limited their working hours because of their unique status as those who bore and raised children. Such privilege, they argued, is not equality. They argued further that a unique consideration of women as a class resembled the concept of 'separate but equal' that had been applied to African Americans until it was discredited in the 1954 *Brown* decision. Aside from the fact that 'separate' facilities could rarely be considered equal, the separation itself imposed a 'badge of inferiority' on those who were separated, whether they were African Americans or women.

Murray and Eastman concluded with an optimistic assessment of the current possibilities for meaningful change:

'We are entering the age of human rights. In the United States, perhaps our most important concerns are with the rights to vote and to representative government and with equal rights to education and employment. Hopefully, our economy will outgrow concepts of class competition, such as Negro v. white, youth v. age, or male v. female, and, at least in matters of employment, standards of merit and individual quality will control rather than prejudice'.[243]

Murray was keenly aware of the need to advance women's rights as well as civil rights for people of colour. She agreed with Dollie Lowther Robinson, an attorney with the United States Women's Bureau, that what we need is 'an NAACP for women'.[244] A committed feminist, Murray taught American Studies and Women's Studies at Brandeis University from 1968 to 1973. She died in 1985.

A growing body of feminist thought contributed to demands for an umbrella organization that would champion women's causes. In June of 1966, women representing state commissions on the status

of women attended the Third National Conference of Commissions on the Status of Women at the Washington, DC Hilton. Amid workshops intended to inspire minor changes rather than true reform, a tea at the White House whose bland delicacy sone found offensive, and a pervasive attitude among men in business and government that equality for women was simply not important, a few women began to share their frustration at the inability of the Conference to pass meaningful resolutions that could lead to meaningful change. They were especially angered at the Equal Opportunity Employment Commission's unwillingness to eliminate gender-specific designations in employment want ads.

Betty Friedan, author of *The Feminine Mystique*, and Rev. Pauli Murray invited a small group of women to meet on 30 June 1966 in Friedan's hotel room to have an informal sharing of ideas about the future of women's rights in the United States. A few women invited a few more women, and more than thirty crammed themselves into the small room, ostensibly to get to know each other. Instead, Murry laid out a plan for a new women's organization that would lobby for institutional and governmental reform. Some women were outraged that the evening's agenda called for the creation of yet another women's group that might be co-opted into inspiring only incidental changes without advancing women's rights in a meaningful way, and some objected to the fact that evening had an agenda at all. Sharp remarks devolved into yelling matches, and Friedan, never one to accept criticism of her ideas with any degree of grace, ordered at least one woman to leave the room and locked herself in the bathroom in a huff.

In spite of the acrimony of this first gathering, Friedan and Murray succeeded in founding the National Organization for Women. They collaborated on NOW's original Statement of Purpose, whose first paragraph stated that the organization's primary goal was to 'take action to bring women into full participation in the mainstream of American society now, exercising all privileges and responsibilities

thereof in truly equal partnership with men'.[245] From its initial group of 28 founding members, NOW added 21 more dues-paying women and men by October of 1966. From there, membership grew rapidly, highlighting the idea that the time for a women's movement had come.

NOW's founding statement asserted that it was necessary to promote the interests of women as part of a broader campaign for human rights. NOW has grown in membership and influence over the years to become a respected advocacy organization rather than merely a source of radical, anti-male ideology. With chapters in every state and its own Political Action Committee, NOW's purpose is to 'take action through intersectional grassroots activism to promote feminist ideals, lead societal change, eliminate discrimination, and achieve and protect the equal rights of all women and girls in all aspects of social, political, and economic life'.[246] NOW continues to serve as an advocacy organization within the mainstream of American society, promoting the enforcement of existing anti-discrimination laws and access to childcare, job training, and abortion, in spite of setbacks promoted by conservatives. Stressing women's need for education and training in the real world, Pauli Murray argued that African-American women could not rely on marriage for either economic or emotional support. Acknowledging that African-American men should have every opportunity to obtain an education and support to meet their family responsibilities, she wrote that African-American women 'have no alternative but to insist upon equal opportunities with regard to sex education, and employment at every level. This may be a matter of sheer survival. And these special needs must be articulated by the civil rights movement so that they are not overlooked … The Negro woman can no longer postpone or subordinate the fight against discrimination because of sex to the civil rights struggle but must carry on both fights simultaneously'.[247] Murray understood

the double burden of race and gender faced by African-American women. She cautioned women that they should never forget their own priorities within the civil rights movement.

Within a few years of its founding, NOW reached a broad public through the mainstream press. In a *New York Times Magazine* article on 10 March 1968, Martha Weinman Lear coined the term 'Second Wave Feminism' in homage to the early twentieth century feminists who were active both in Europe and the United States. In addition to providing a name for the new women's movement, she observed that women were finding unique ways to protest inequality. Secretaries picketed their companies while chained to their typewriters, and NOW members picketed *The New York Times* in opposition to classified ads that listed jobs for 'Male' and 'Female' applicants. Among NOW's demands were a change in airline policy that required hostesses (today's flight attendants) to leave their jobs at age 32; access to abortion in all 50 states; the passage of the ERA; access to childcare and tax deductions for childcare and household expenses; paid maternity leave; and a revision of divorce laws. These demands were radical in 1968. Some, but by no means all, have been realized in the twenty-first century.[248] In the wake of a conservative backlash against women's liberation and societal liberalism in general, some of those rights have been or are in the process of being rolled back by right-wing state legislatures and a conservatively-biased Supreme Court.

In 1971, *New York Magazine* featured a section edited by Gloria Steinem and a number of other feminists that focused on women's issues. *Ms.* appeared as a stand-alone publication starting in January of 1972. The magazine's name was a clear jab after the kerfuffle over the use of Ms to identify a woman without reference to her marital status. Many men and women were offended by the new title, but it prevailed and exists, along with Miss and Mrs, and the magazine continues to report on women's struggles for equality throughout the world.

A Movement of One's Own

The persistent focus on the personal as the starting point for political action drove a wedge between traditional movement activists and new feminists who refused to accept the hierarchy of the left any more than they were willing to accept hierarchy and patriarchy in society at large. By the 1970s, feminists could find themselves as estranged theoretically from their former comrades in the movement as from mainstream society. According to Ellen Willis, 'a genuine alliance with male radicals will not be possible until sexism sickens them as much as racism. This will not be accomplished through persuasion, conciliation, or love, but through independence and solidarity: radical men will stop oppressing us and make our fight their own when they can't get us to join them on any other terms'.[249]

Some radical feminists in the 1960s argued that women were not inferior to, but were actually superior to, men. In June of 1968, Valerie Solanis self-published the '*S.C.U.M.* [Society for Cutting Up Men] *Manifesto*', which was reprinted in *The Berkeley Barb*, an alternative community newspaper in California. Just as de Beauvoir began with the question of the nature of woman, Solanis explored the nature of man, but instead of concluding that men possess the qualities of body and mind that make them essential to civil society, she said that the male is 'completely egocentric, trapped inside himself, incapable of empathizing or identifying with others, or love, friendship, affection or tenderness. He is a completely isolated unit, incapable of rapport with anyone. His responses are entirely visceral, not cerebral; his intelligence is a mere tool in the services of his drives and needs; he is incapable of mental passion, mental interaction; he can't relate to anything other than his own physical sensations. He is a half-dead, unresponsive lump, incapable of giving or receiving pleasure or happiness; consequently, he is at best an utter bore, an inoffensive blob, since only those capable of absorption in others can be charming. He is trapped in a twilight zone halfway between

humans and apes, and is far worse off than the apes because, unlike the apes, he is capable of a large array of negative feelings – hate, jealousy, contempt, disgust, guilt, shame, doubt – and moreover, he is aware of what he is and what he isn't'.

Solanis argued that men were completely replaceable, but 'until automation could eliminate the need for men, they should be totally subservient to women and should exist in perfect obedience to her will, as opposed to the completely warped, degenerate situation we have now of men, not only not existing at all, cluttering up the world with their ignominious presence, but being pandered to and grovelled before by the mass of females, millions of women piously worshipping the Golden Calf, the dog leading the master on a leash, when in fact the male, short of being a drag queen, is least miserable when his dogginess [sic] is recognized – no unrealistic emotional demands are made of him and the completely together female is calling the shots. Rational men want to be squashed, stepped on, crushed and crunched, treated as the curs, the filth that they are, have their repulsiveness confirmed'.

Solanis argued that no social revolution can be accomplished by men, 'as the male on top wants the status quo, and the male on the bottom wants to be the male on top ... The male changes only when forced to do so by technology, when he has no choice, when "society" reaches the stage when he must change or die. We're at that stage now; if women don't fast get their asses in gear, we may very well all die'.[250] The language here is one of frustration and disgust, asserting that men have failed to end the war and create a more humane society. For Solanis, who is remembered for shooting artist Andy Warhol in New York on 3 June 1968, there was no structural or organizational alternative but to demand that men move out of the way and turn the business of revolution over to women, who were more competent and better prepared to realize the goal of profound societal change.

Feminist activism did not always involve eliminating men from

the picture. A new alternative journal, *off our backs*, appeared on 27 February 1970. *Oob* was written, edited, and published by a women's collective. The publication appealed to feminists in general and lesbians in particular, and it was part of a broader literary movement in the 1960s and 70s to break prevailing taboos about what could appear in print by publishing lesbian erotica. According to the editors: 'The name, *off our backs*, was chosen because it reflects our understanding of the dual nature of the women's movement. Women need to be free of men's domination to find their real identities, redefine their lives, and fight for the creation of a society in which they can lead decent lives as human beings. At the same time, women must become aware that there would be no oppressor without the oppressed, that we carry the responsibility for withdrawing the consent to be oppressed. We must strive to get *off our backs*, and with the help of our sisters to oppose and destroy that system which fortifies the supremacy of men while exploiting the mass for the profit of the few'.

The original *oob* editors encouraged women to share their personal stories of oppression. They noted that women often suffer in silence and are unaware that their plight is shared by many others. The editors exhorted women to 'use this paper to relate what you are doing and what you are thinking, for we are convinced that a woman speaking from the agony of her own struggle has a voice that can touch the experience of all women'.[251] Like other early feminist thinkers who analysed their situation through the lens of Marxist theory, *oob* writers located the source of women's oppression in the political system. They stressed that women needed to get *off their backs* to achieve independence, but they did not advocate eliminating men completely from women's lives. Like many small organizations that began with more passion than a structured plan of operation, *oob* went through its own growing pains, factionalism, and splits, but it survived until 2008 as a vehicle for radical feminist expression.

Most Americans knew nothing about the Burial of True

Womanhood, and it's unlikely that more than a few women read *oob* or the *S.C.U.M. Manifesto*. But the public did become aware of the women's movement through a number of performative protest actions. These public displays were organised to surprise and educate the public about women's issues, and they often were effective media events. Burning a draft card challenged the government's authority to send a young man off to war, while burning a bra, an action pounced upon by the mainstream press as an example of the supposed absurdity of feminism and more apparent in myth than in reality, represented an effort to promote personal female liberation. Both got the attention of the American public.

On 7 September 1968, feminist activist Carol Hanisch and other members of New York Radical Women organized a rally to protest the sexism of the Miss America Pageant in Atlantic City, New Jersey. Since 1921, Miss America had been presented to the American public as the ideal 'American Girl,' young (between 18 and 28 years old), patriotic, minimally talented, smart enough to answer softball questions about her goals and values, and, of course, beautiful in a bathing suit. It was only in 1940 that the requirement that the contest winner be 'of the white race' was eliminated, and the first Jewish Miss America, Bess Myerson, was not crowned until 1945. The pageant was watched on television every year by millions of people during the week after Labour Day.

The Miss America Pageant protest attracted women who had been active in the civil rights and anti-war movements. According to protester Robin Morgan, the women in Atlantic City were 'young radicals, just discovering feminism because we were tired of making coffee but not policy'. Morgan echoed the sentiments of many women activists when she described her disappointment at the reaction of men to women's concerns: 'We thought the male left were our brothers but discovered that was not really the case when we talked about our own rights'. The Miss America Pageant protest

gave radical women an opportunity to be seen and heard (and also maligned) as they articulated early feminist grievances.

At an August press conference, Hanisch invited women to come to Atlantic City to call attention to the materialist values represented by the pageant. They were urged to bring and burn items of female oppression – bras, girdles, curlers, false eyelashes, wigs, and issues of popular women's magazines – and to boycott sponsors of the pageant. The press corps for the event was limited to female reporters – no men were allowed. As it turned out, the Freedom Trash Can was never set on fire at the request of Atlantic City authorities because the boardwalk was flammable, and there is no record of any bras actually being burned. The press focused its attention on the women who did deposit their bras in the Freedom Trash Can, and bra-burning was a frivolous oft-repeated symbol in the press of the new feminism. Nevertheless, incendiary underwear became the prevailing symbol of the Women's Liberation Movement's protest against the cultural oppression of Miss America.

The press release for the protest was anything but frivolous. Organizers castigated Pageant organizers for a lack of diversity among the contestants: 'Since its inception in 1921, the pageant has not had one black finalist. There has never been a Puerto Rican, Alaskan, Hawaiian, or Mexican-American winner. Nor has there ever been a *true* Miss American – an American Indian'. The press release also referred to the pageant winner, not as the ideal of American womanhood, but as a 'walking commercial for the pageant's sponsors', which was accurate, given that the Miss America Pageant was a business enterprise. Noting the popularity of the pageant among millions of television viewers and the version of the American women presented by the contestants, the writers of the press release observed that Miss America 'represents what women are supposed to be: inoffensive, bland, apolitical. If you are tall, short, over or under what weight The Man prescribes you should be, forget

it'. And, noting the bland similarity of all the contestants, the writers called the winner's prize an 'Irrelevant Crown on the Throne of Mediocrity'.[252]

The women who protested in Atlantic City called the pageant a symbol of 'racism with roses' because no African-American woman had received the crown or had even been permitted to enter the competition. Other protesters referred to Miss America as a 'death mascot' for her role in entertaining troops in Vietnam during her reign. The protesters issued a statement, dubbed a 'womanifesto,' in which they criticised Miss America as a 'Mindless-Boob-Girlie-Symbol'. They decried both the commercial nature of the pageant and the measurement of a woman's value by her beauty. Further, they objected to what they saw as a double standard applied to Miss America contestants, who were expected to be 'both sexy and wholesome, delicate but able to cope, demure yet titillatingly bitchy'. A few women, including Hanisch, disrupted the pageant itself by unfurling a Women's Liberation banner while, outside Convention Hall, the protesters' banners included slogans like 'All Women Are Beautiful', 'Cattle parades are threatening to human beings', and 'Welcome to the Miss America Cattle Auction'. The protesters crowned a live sheep 'Miss America'. For many Americans who saw the spectacle on television, the Atlantic City protest was their introduction to the new Women's Liberation Movement.[253]

By 1970, NOW organizers realized that they needed to make a public case for the issues that animated their movement such as parity in the workforce with men, including equal pay, childcare, access to contraception, and the availability of abortion. Betty Friedan and NOW leaders organized the Women's Strike for Equality, a one-day strike on 26 August 1970, in which women would withhold their labour at home and in the workplace to call attention to women's pay inequality. The date commemorated the fiftieth anniversary of the passage of the nineteenth amendment that gave women the right to vote.

A Movement of One's Own

The Women's Strike for Equality consisted of marches and rallies in several cities. In New York, Radical Women and members of Redstockings joined a diverse group of marchers. The *New York Times* described the crowd, noting the presence of 'limping octogenarians, braless teenagers, Black Panther women, telephone operators, waitresses, Westchester matrons, fashion models, Puerto Rican factory workers, nurses in uniform, and young mothers with babies on their backs'. Banners revealed the variety of approaches to liberation, with slogans that included messages such as 'From Adam's Rib to Women's Lib', 'The Women of Vietnam are Our Sisters', 'Lesbians Unite', and 'Abortion on Demand – No Forced Sterilization'. Members of the Third World Women's Alliance also marched in New York with a banner that read, 'Hands Off Angela Davis', who was then a fugitive from justice. Women in Washington DC made the Equal Rights Amendment to the Constitution, first introduced in Congress in 1923 and once again a top priority issue for many mainstream feminists, the focus of their march. In Detroit, women who worked at the *Detroit Free Press* locked men out of their bathrooms because male reporters had two bathrooms while women had only one. And in New Orleans, women at a local newspaper printed photographs of grooms rather than brides in wedding announcements.

TIME magazine observed that the Women's Liberation Movement had come into wide public view at a moment when 'virtually all of the nation's systems – industry, unions, the professions, the military, the universities, even the organizations of the New Left – were quintessentially masculine establishments.' A popular banner captured the spirit of the day, reading 'Don't Iron While the Strike is Hot'.

Friedan never saw herself as an 'organization woman'. Her fame as an author helped to spark the initial growth of NOW, but she was intolerant of those who did not see issues as she did and she had no patience for the give and take of debate in a democratic organization.

She took criticism as a personal assault, and she held grudges. Friedan left NOW in 1970 after the Women's Strike for Equality. She later helped to found the Women's Political Caucus and continued to write and lecture on the importance of women's equality.

Like many protest movements, the Women's Liberation Movement was diverse in its membership and goals. Many African-American women saw their fight against racism as more compelling than the personal concerns of White women. Frances Beal of the Third World Women's Alliance and the author of *Double Jeopardy* declared that the liberation of Black people was fundamentally different from NOW's concerns and that Black women faced two oppressive forces in their lives that had to be overcome – racism and misogyny.

Lesbian women, who generally voiced their demands in terms of sexual orientation, were at first marginalized within NOW with Friedan's 1969 remark that they were the 'lavender menace'. NOW's president feared that including lesbian women in NOW would draw sharp criticism from right-wing and centrist leaders and would hinder membership growth. But lesbian women soon found their voice in feminist organizations of their own, and Friedan softened her attack on lesbians in the interest of greater solidarity with all women. Some women from socialist groups saw more mainstream organizations like NOW as frivolous and antithetical to revolutionary struggle. In spite of these disparate perspectives, the Women's Strike for Equality attracted considerable positive attention for women's liberation. Even though a significant number of reporters still considered 'women's lib' to be a bit of a joke, they could not ignore the crowds in the streets and the power of the women's messages.

Not all reactions to the march were supportive. Men on the march route in New York heckled the women and threw pennies and sexist insults at them. Some women from traditional women's clubs and organizations cast aspersions on the marchers. Mrs. Saul Schary, a

leader of the National Council of Women told *The New York Times* that, 'There's no discrimination against women. Women themselves are just self-limiting. It's in their nature and they shouldn't blame society or men'. Mrs. Schary had no kind words for any of the social activists of the day. 'The women,' she said, 'are doing it *pour le sport*. I think their noses are out of joint. There's been too much emphasis everywhere on youth and drugs and Black Panthers and these women just said to themselves, 'What can we do to get in the act'? And so many of them are just so unattractive'.

Some women from traditional women's organizations expressed much less negative sentiments about the protest. Dr Shirley McCune, the Assistant Director of the American Association of University Women, observed that mainstream women's groups needed to become 'really militant' in order to remain relevant. Young women, she argued 'are turned off by ladies' lunches, teas, charities, and good works to fill their leisure time'. The *Times* also interviewed Muriel Siebert, the first woman to hold a seat on the New York Stock Exchange and the head of her own investment firm, Muriel F. Siebert & Company. She had little patience for some of the cultural trappings of women's liberation, saying, 'I like men and I like brassieres', but she also appreciated the goals of the marchers: she said that there was no reason 'to go to college, get married, and then stop thinking. People should be able to do what they're capable of doing and there's no reason why a woman doing the same job as a man should be paid less'. Members of NOW could not have agreed more.[254]

In addition to protesting the crowning of Miss America and staging the Women's Strike for Equality, members of NOW and other women's organizations found ways to bring women's liberation to the public. One aspect of this process was consciousness raising (CR), which author and feminist Vivian Gornick described as examining one's personal experience in the light of sexism as 'the

theoretical explanation used to account for women's centuries-long social and political subordination'. Following a set of rules laid down by New York Radical Feminists, CR groups in the main consisted of ten to twelve women who gathered once a week, sat in a circle, and spoke, each in turn, on a predetermined topic that seemed relevant to the idea that the personal is political. These experiences were intended to be democratic, with each person having a chance to speak, all opinions receiving respect, and no single person assuming leadership. This was new for many women, who had not previously had the experience of sharing their thoughts with other women in a supportive environment.

Kathie Sarachild presented the concept of consciousness-raising at a Women's Liberation Conference in 1968. The practice soon spread beyond the United States, especially to women's groups in Great Britain and Mexico. This was an example of the transnational sharing of ideas and methods that characterized Second Wave Feminism. By 1971, more than 100,000 American women were participants in these groups that brought women together across class, but not necessarily racial, lines. Women discovered their common values and common grievances. One important outcome of the CR movement was a generalized feeling that women were no longer alone in their struggle for identity and respect. Gornick recounted a conversation with a divorced working-class woman who at first thought she would have nothing at all in common with the middle-class women in her group, saying, 'I'd walked into the room thinking, "None of these broads have been through what I've been through", but at the end of the session, I thought, "They've all been through what I've been through".[255]

The consciousness-raising process eventually encouraged women to transcend their feelings and speak from a political perspective about their experiences. Feelings were important but were identified with weakness. It was standard wisdom that women felt, but men analysed and knew. According to Kelli Zaytoun and Judith Ezekiel,

consciousness raising was collective and inherently political. They argued that, 'The feminism of the consciousness-raising groups meant *seeing* women's oppression, identifying with the group "women", as diverse as it may be, and envisioning a changed future – a meeting between awareness, sisterhood, and vision, for both the individual and the group'. Sisterhood, many argued, required *going beyond friendship* to connect to other women as women working for women.[256]

Access to abortion was a major topic for feminists in consciousness-raising groups and public settings around the world. In the United States, Redstockings sponsored a speak-out on abortion in New York City in March of 1969. Women shared their experience with botched procedures, travelling to foreign countries to have abortions legally, and the embarrassment and tragedy of having to carry to term a foetus that had little chance of survival. These stories reminded women that many people they knew were acquainted with someone who had suffered because of the nightmare of illegal abortions. The process of speaking about such personal experiences helped to bring the abortion issue to a wider public. Throughout the world, women were encouraged to make the personal issue of abortion a political topic that could no longer be ignored.

In February of 1970, members of the United States Senate held hearings on the possibility of lowering the voting age to 18. This proposal succeeded and became the Twenty-Sixth Amendment to the Constitution in 1971. The hearing was disrupted by NOW members who carried signs in support of the Equal Rights Amendment, which they felt was even more important than votes for eighteen-year-olds. A few weeks later, on 18 March 1970, two hundred women from NOW and other feminist groups used a form of protest made popular by both the Civil Rights and anti-war movements. They staged a sit-in at the office of John Mack Carter, editor the *Ladies Home Journal*, a popular women's magazine that offered articles on

home and childcare, recipes, photo essays on fashion and advice columns. The magazine was attacked by feminists for promoting a second-class life for women. The eleven-hour occupation led to the creation of writing workshops to encourage women to contribute to the magazine as well as child care for current female *Journal* staff members. While the demand for an all-female editorial staff was rejected, the magazine's first female editor-in-chief, Lenore Hershey, was appointed in 1973. These events brought women's issues to a broader public and inspired more conversations about the status of women in American society.[257]

NOW transcended its original mission of improving the lives of individual women by expanding its influence into electoral politics. In 1972, NOW supported the presidential campaign of Shirley Chisholm, the first African-American female member of the House of Representatives. A NOW member, Chisholm challenged both Republican incumbent President Richard Nixon and the Democratic Party establishment that had dismissed the Mississippi Freedom Democrats' challenge to White supremacy in the Party in 1964. In 1970, Chisholm had argued that women were still expected to accept second-class status in society. 'The harshest discrimination that I have encountered in the political arena is anti-feminism, both from males and brain-washed Uncle Tom females. When I first announced that I was running for the United States Congress, both males and females advised me, as they had when I ran for the N. Y. State legislature, to go back to teaching – a woman's vocation – and leave the politics to the men'.

Chisholm's biographer, Anastasia Curwood, wrote that Chisholm ran to win the presidential election, although she was aware that her chances were minimal. Her object was to 'create a coalition and then influence the eventual nominee at the convention'. Chisholm hoped that once she reached the convention, she could use her coalition of delegates 'to negotiate with the winning candidate in favour of rights

for women, Black Americans and Indigenous people'.²⁵⁸ A strong supporter of access to abortion, Chisholm was a co-founder of African-American Women for Reproductive Freedom and an advocate for greater rights for poor people. These were important planks in her platform. Although Chisholm did not win the nomination, she had an impact on American politics as a serious female candidate for the highest office in the land. Where Congresswoman Bella Abzug had declared that a woman's place was in the House of Representatives, Chisholm's campaign raised the possibility that a woman could one day occupy a different house: the White House.

Second Wave Feminism in the United States was an amalgam of individuals and groups with divergent perspectives through which they analysed and sought to improve the status of women, including sexual orientation, a topic that had been treated as taboo. Lesbian women formed their own groups, arguing that sexual orientation was as important as gender itself in defining women. Federal and state governments began to include sexual orientation as a 'suspect classification', which meant that schools, employers, and governments themselves could not discriminate against a person in employment, housing, or access to service based on their sexual orientation. Lesbian Feminists had come a long way from Betty Friedan's 'lavender menace' remark that contributed to the creation of an independent Lesbian feminist movement.

In recent decades, the issues of pornography and sex work have divided feminists. Many feminist groups, including Women Against Pornography (WAP), regard pornography and sex work as inherently exploitative and dangerous to women because of the mistreatment, abuse, and violence that often accompanies sex work. They also point to a presumed connection between creating or viewing pornography and the abuse women (and men) who make their living as sex workers are exposed to. In contrast, sex-positive women who support sexual choices for women in general and the autonomy of sex workers in

particular argue that it is not the proper function of government to regulate women's working lives beyond the most basic public health regulations such as those that are present in some jurisdictions where prostitution is legal and regulated. Margo St James founded COYOTE, or Call Off Your Old Tired Ethics, in 1973 in San Francisco to support the rights of sex workers. COYOTE took the position that sex work should be treated like any other occupation and that women should control their own bodies. Members also supported the unionization of sex workers. The group offered medical care, financial counselling, and advice on employment opportunities while working to advance the legalization of prostitution. NOW, a mainstream feminist organization, supported many of the positions advanced by COYOTE.

COYOTE inspired the growth of local organizations of prostitutes, including the Prostitutes' Union of Massachusetts (PUMA) which worked in Boston in the 1970s and 80s. In addition to providing legal, medical, and child care assistance to sex workers, PUMA raised funds, and its public profile, by co-sponsoring an annual Hookers Masquerade Ball. PUMA activists have been described as attentive to the needs of poor women, whatever their occupation. A Boston social worker noted that PUMA 'is one of the few feminist groups [in Boston] that have addressed themselves to the needs of poor women', including alcoholics, battered women, and prison inmates.[259]

Other groups that advocate for female sex workers include the California Advocates for Trollops (CAT), and Prostitutes of New York (PONY), founded in 1976 by Jean Powell to advocate for improved working conditions for sex workers in all aspects of the industry. The National Task Force on Prostitution was founded to serve as a network for the various local groups. Support for sex workers crossed national borders with the founding of the International Committee for Prostitutes' Rights (CPR), which facilitated the sharing of information among myriad groups around

the world.[260] While advocacy groups pushed for de-criminalizing prostitution, a variety of church and missionary groups continued their long history of providing health care and counselling services for sex workers as prostitution became more dangerous as it was identified with numerous instances of violence against women and men. In 2016, the Sex Workers Advocates Coalition (SWAC) was founded to provide protective and health care services for sex workers in Washington, DC. It has become clear that, even after decades of advocacy on behalf of sex workers, the need for protective and health service remains great for this class of workers.

In the decades since the founding of NOW, feminist groups have brought issues relating to the health, welfare, and progress of women to the public's attention. Diverse groups have raised issues relating to domestic violence, prisoners' rights, and the rights of transgender people among many others. Just as important, American feminists have shared their passions, their successes, and their obstacles with established and emerging feminist movements throughout the world.

France | There are a number of comparisons that can be made between the Women's Liberation Movement in the United States and the *Mouvement de la Libération des Femmes* (MLF) in France, formed in Paris in 1968. Women in both countries perceived a need to unlearn the lessons of their cultures about the proper role of women in society as well as entrenched standards of behaviour for women. Members of the large feminist groups in both countries tended at first to marginalize lesbian groups in order not to appear 'too radical' to the general public. The MLF wanted to be seen as representing all women, and some members even characterized lesbians as 'non-women' as a way of distancing themselves from people whose sexual practices differed from their own and from what was considered the norm in French society.

Many French women objected to the low regard in which they

were held by men in the May 1968 protest movement, while others stressed that societal conditions in general were responsible for women's oppression. These differing yet complementary perspectives also gained prominence in the United States and in many countries around the world. Feminists carried on a robust transnational conversation about causes of women's oppression, feminist theory, and tactics that would bring women's issues to the attention of the general public and policy makers in conferences and articles in mainstream media outlets and their own publications. Activist bell hooks observed that women are taught that other women are their natural enemies with whom true solidarity is not possible. The process of defining feminist goals helped women to reject that idea, work together, and trust their instincts.

Writing from a perspective influenced by Simone de Beauvoir's critique of the idea of men as, by default, the 'superior' sex and women as 'The Other', Berengene Kolloy argued that women needed to separate themselves from society's masculine models and develop an independent self-awareness. Participation in the French New Left proved to be antithetical to that goal because women were unable to establish themselves as leaders of the movement. The process of unlearning the lessons of patriarchy could occur only by establishing women's autonomy through consciousness-raising and providing a consistent pattern of women raising their own issues and pursuing their own goals. It was especially important for women to support women when they experienced workplace harassment, divorce, or rape, situations in which men had previously had the advantage in law and in public opinion.[261] Considering the importance of separating themselves from men as a critical feminist practice in the 1970s, Alban Jacquemart and Camille Masclet observed that, as the MLF took shape, 'the principle of women-only activism developed and became established in practice. Faced with hostility from the men who attended the first meetings in the spring of 1970,

feminists opted to exclude them, many of the women having already experienced the sexism of male comrades-in-arms in the past, either during May and June of 1968 or within extreme left groups later'. Men were limited to minor roles in early MLF activities and were even consigned to the end of the line in women's marches.[262]

Women in France protested a rigid patriarchal system, a dogmatic and powerful Catholic Church, and the presumption that women did not need a life in the public sphere, as they were already well cared for by French society. A left-wing government in the 1930s established a national health care system that provided free medical, specifically maternity, care. This created a challenge for women who hoped to transform a system that already afforded them a degree of support and protection not present in other industrialized democracies. Historian Bibia Pavard observed that structural sexism existed 'in political organisations whether unions, political parties or hard left movements. Leadership was a male thing and women who joined the [May 1968] movement were given only subordinate roles. It led women to think about an independent women-only movement'.

The MLF was created primarily to encourage discussions of political and social issues that affected women. French women who took part in the protests of 1968 were frustrated at their lack of agency and the domination of men in the movement, even as men and women alike shut down universities, barricaded the streets, and demanded a loosening of social restrictions in French life. Young women demanded change in revolutionary organizations that did not respond to their call for revolutionary changes in gender roles. As they watched their male colleagues write theoretical treatises and make public speeches, women were relegated to tasks that were not recognized by the public. Faced with centuries of entrenched cultural traditions, women, according to de Beauvoir, needed to 'come to realize their objective condition' and act for women as women. She defined feminists as 'women or even men too – who are fighting

to change women's condition, in association with the class struggle, but independently of it as well'.[263] Historian Dorothy Kaufman-McCall argued that, in movements for change in the 1960s, 'Radical discourse notwithstanding, they were merely acting out new forms of the old sexual division of labour and the old sexual exploitation. Women realized that they needed a movement of their own'.[264] When French women organized protests under the MLF banner, they eschewed leaders and rules, taking part in what might have appeared to be organizational chaos. Liliane Kandel wrote in *Questions féminists* that MLF meetings were characterized by 'resounding conflicts, endless discussions, memorable insults; but also sustained reflection, unpredictable changes of mind, incessant revisions: doors slammed very hard – but they often opened again. For all those who were part of it, it was the chance to live and to experience concretely the meaning of the word movement'.

The French women who were the most active participants in feminist actions were, according to Lisa Greenwald, in *Daughters of 1968*, urban and educated. They generally came from 'upwardly-mobile families. They were frustrated by their limited professional options, by the hostility they endured from leftist men, and by a sense that the contradictions between their ideals and their lives were becoming untenable. It was these women's recognition of what sociologist Margaret Maurani calls "social specificity", (as opposed to "natural differences") that made feminism so popular and gave it its polemical force. Women began to view their oppression as having no natural justification; rather, they saw their continued second-class status in the private sphere as directly responsible for discrimination against them in the public sphere'.[265]

As NOW led the Strike for Women's Equality on 26 August 1970, nine women affiliated with the WLM selected the same date to launch a women's liberation protest in Paris. The women laid a wreath at the Arc de Triomphe, the site of commemorations of the

A Movement of One's Own

unknown dead in France's wars. They intended to call attention, as protester Cathy Bernheim noted, to 'the one person more unknown than the unknown soldier, his wife'. The action was an homage to the Women's Liberation Movement in the United States. This event also marked fifty years since the ratification of the Nineteenth Amendment giving American women the right to vote. The march and wreath laying received wide media coverage in France and was a seminal event in the evolution of France's organized struggle for women's liberation.

The goal that united constituent groups within the MLF was the liberation of women from patriarchal restrictions on their bodies. The most immediate political goal of the MLF was changing the status of abortion in the French Penal Code as a criminal offence and providing access to the procedure. According to the Code, abortion was illegal except to save the life of the mother. On 5 April 1971, the MLF published the *Manifeste des 343* (Manifesto of the 343) in *La Nouvelle Observateur,* a popular weekly news magazine. This document was a both a petition to the national government to change the Penal Code and an act of civil disobedience, as 343 women came forward to declare, 'Je me suis fait avorter' (I have had an abortion) in violation of the law. Composed by de Beauvoir and others, the *Manifeste* was signed by playwright and screenwriter Francoise Sagan and actress Jeanne Moreau, along with other well-known French women and many ordinary citizens. The Manifesto noted that one million French women had abortions every year: 'Condemned to secrecy, they do so in dangerous conditions, while under medical supervision, this is one of the simplest procedures. Society is silencing these millions of women. I declare that I am one of them. I declare that I have had an abortion. Just as we demand free access to contraception, we demand the freedom to have an abortion'.[266]

The language of the *Manifeste* was disruptive of typical female

discourse because of its intimacy and its boldness. Until the publication of this document, it was considered improper for French women to reveal their most intimate stories about breaking the law. This 'self-denunciation' in the public space was radical, frightening, and exhilarating. The *Manifeste,* with its celebrity signatories and its blunt language, represented only the first step toward creating a vocabulary appropriate to the battle for access to abortion. Women spoke out, and the *Manifeste* contributed to an increase in support for the MLF. Shortly after its appearance, Giselle Hamili, a Tunisian-French attorney and activist, founded *Choisir,* a group dedicated to protecting the women who had signed the *Manifeste* from prosecution while continuing to press for free access to abortion.

Other publications, such as *Le Torchon Brûle*, published stories with more detail about women's experiences with illegal and frequently dangerous abortions. One advertisement included a woman's declaration that no man can 'hold my life hostage; you will not choose my sentence; you will no longer speak for me'.[267] Abortion became French women's most intimate and important personal and political issue. Across the Atlantic, the editors of *Ms.* featured a similar petition in the magazine's first issue in July of 1972, signed by a number of women who, like their French sisters, publicly declared that they had had an abortion. The petition highlighted both the importance of the abortion issue in the early 1970s and the transnational nature of Second Wave Feminism.

Debates over the most effective course of action to achieve women's equality led to a split in the MLF. Some women remained with the original organization, broadening their efforts to include working-class women in *Groupes de quartier* (neighbourhood groups) to bring issues and specific campaigns for action closer to women in their own communities. Another group organized itself in 1971 with a commitment to the study of the principles of Lacanian psychoanalysis. Known as *Psychanalyse et politique* or *Psych et po*, it was

led by Annette Fouque, known popularly as just Annette. She had come to Paris to study drama at the Sorbonne and was involved in the university protest movement in 1968. She studied with Jacques Lacan at the *Centre Universitaire Experimentale de Vincennes* (Experimental University at Vincennes), known for the left-wing politics of many of its students and professors. Like many educated French women, Annette was angry at experiencing sexism within the protest movement and was drawn to the emerging women's movement. She signed the *Manifeste des 343* and participated in discussions with other women about their dissatisfaction with existing laws and societal norms. In the early 1970s, the MLF had no leaders, no membership cards, and no formal structure. It welcomed women whose reasons for participating in public demonstrations and private conversations about feminism were diverse.

For Annette, the protests of May 1968 were the beginning of a new era for women. In a lecture on social movements, she described herself as a 'daughter of the anti-authoritarian revolt of May '68'. She and other students of Lacan emphasized the importance of the May '68 protests to the emergence of a women's liberation movement in France in response to a New Left that was decidedly masculine in its rhetoric, stubborn in its rejection of women's ideas. Annette declared that the 'symbolic revolution of '68, one that stressed personal liberation and individual actions' challenged the authority of the university and the state and 'made it possible to overcome the phallocentric paradigm, replacing it with new ideas about femininity and female sexuality'.[268]

Psych et po utilized psychoanalytic principles in its theoretical analysis of the role of women in French society. The group founded *Edition des Femmes*, a publishing house dedicated to publishing works that had been rejected by 'bourgeois' publishers. *Psych et po* opened *Libraire des femmes* in Paris, along with branches in other cities, in 1974. In 1979, Annette, who was then president of *Psych et po*, along

with Marie-Claude Grumbach and Sylvana Boissonnas, registered the organization as *Mouvement de Liberation des Femmes*, the name by which the broader movement had been defined by the press, with the Institute of Industrial and Commercial Property. The loosely structured organization of various small organizations dedicated to women's rights was now dominated by a single organization with a single leader and a single underlying premise that there is a unique female psychology as well as anatomy. Over time, *Psych et po* became increasingly insular and removed from the mainstream of feminist activity, except for its successful publication activity.

Unlike the theorists of *Psych et po*, the feminists of the original MLF subscribed to a social constructionist premise introduced by Simone de Beauvoir and familiar to other Liberal Feminists that, 'One is not born, but rather becomes, a woman'. Christine Delphy was an important theorist in this approach to defining the French women's movement as well as gender itself. She founded *Feminin Masculin Avenir* in 1967 as a discussion group that organized meetings and conversations about feminist theory. Delphy and her colleagues wrote from a materialist theoretical perspective. There were two divergent approaches to defining the new movement, one that placed the origins of the movement in dissatisfaction with women's position in the French left in 1968 and another that focused on the economic and other conditions in society that oppressed women. In the 1970s, French feminists, irrespective of whether they relied on psychoanalytic theory or Marxist materialism, pushed for significant improvements in French society such as pay equity, the ability to engage independently in economic life, and open access to abortion.[269]

French feminists continued to face rejection and ridicule, even as the movement gained popularity and legitimacy. Eli Thorkelson recalled a meeting at the University of Vincennes in the early 1970s during which the women present asked the men to leave so they could discuss issues specific to gender and female sexuality. She

wrote that the men 'balked at leaving the room, instead attacking the women, insulting their intellects, their politics, their credibility, their sexuality, and their legitimacy'. Thorkelson recounted the list of insults the men heaped on the women, which included:

- There is no woman problem.
- Big dicks, big dicks, big dicks.
- You're little girls with complexes and that's all you are.
- If we don't support you, your movement is bound to fail.
- Lesbians.
- They're sex-starved, we'll give them a good lay.
- You're a cunt.[270]

With responses like these that echoed the denigration women had faced in 1968, it was no wonder that members of France's Women's Liberation Movement knew they had a long way to go to achieve their goals.

With abortion the primary issue of the French Women's Liberation Movement, the 1972 trial and acquittal of a woman and her daughter for violating France's 1920 law that criminalized abortion led to the founding of another national organization. The *Mouvement pour la liberté de l'avortement et de la contraception* (Movement for Freedom of Abortion and Contraception, MLAC) was founded in April of 1973. Its membership came from members of left-leaning groups and doctors. On 3 February 1973, 331 French doctors published their own manifesto in which they declared that current law forced women to have illegal and dangerous procedures to terminate their pregnancies and that the decision to have an abortion belonged to a woman alone. The new organization was committed to maintaining solidarity with the working class by pressing for 'freedom from exploitation, oppression and repression from their birth to their death in today's society'. MLAC also helped women to travel to Holland or

England for abortions. Six hundred and thirty-eight doctors signed a petition in which they admitted that they had performed abortions as MLAC called for a decriminalization of access to the procedure for minors and coverage of reproductive health services by government insurance.[271]

The public declarations bore some limited fruit. In December of 1974, the French Parliament passed the Veil Law, named for Health Commissioner Simone Veil, which repealed penalties for ending a pregnancy within ten (later twelve) weeks of conception, but it also included a *clause de conscience* that allowed doctors to refuse to perform an abortion if they personally opposed the practice on moral grounds. This clause placed severe limits on the availability of abortion in the real world. The Veil Law required re-authorization in 1979, and huge demonstrations in favour of abortion rights pressured the government to renew it. The MLF had achieved a partial victory in a public battle about the very private issue of a woman's physical autonomy. The MLAC was so strongly identified with the abortion issue that it ceased to operate after the passage of the Veil Law.

Veil was a staunch feminist. She supported greater representation of women in business and politics and even advocated quotas for women to ensure equity. In the face of sexist opposition to her ideas, Veil responded that 'Women in politics shouldn't be a laughing matter or a joke'. In addition to her active service to the French nation, she became the first woman to serve as President of the European Parliament from 1979 to 1982.[272]

Lesbians in France had to struggle for their own voice within the discourse of French feminism. Monique Wittig was a prominent feminist theorist and a founder of *Gouines rouges* (Red Dykes). This group was a created as a reaction to the sexism faced by women in France's *Front homosexuel d'action revolutionnaire* (FHAR, or Homosexual Front for Revolutionary Action), which was founded in February of 1971. Lesbians were among the original members of

FHAR, but they quickly became disaffected because the organization refused to act promptly on women's issues. On 4 April 1971, a small group of female FHAR members met to discuss their grievances. An angry member of the audience called a member of the group a *Gouines rouges* (Red Dykes) and the name stuck, turning the slur into a badge of honour. The *Gouines rouges* worked to organize women and later joined forces with MLF to integrate lesbian issues into the platform of France's women's liberation movement. [273]

Wittig's contribution to French feminism transcended the founding of *Gouines rouges*. She analysed gender in materialist terms and argued against patriarchy and in favour of greater bodily control for women. She even argued against the classification of people as 'women' as itself an example of oppression. Wittig held that 'The existence of sexes and the existence of slaves and masters proceed from the same belief. There are no slaves without masters and no women without men'. Examining gender as a social construct allows people to examine the material conditions that create oppression based on bodily characteristics. Her writings enlivened feminist debate. She argued that the purpose of women's liberation should be to create a society 'where everyone had bodily autonomy and thus no constructs to restrict them'.[274]

Feminist activism in France since the mid-1970s has focused on sexual harassment in the workplace and on rape. The issues are complex, involving both gender and class. Small groups with specific goals such as assisting women seeking divorce remain active, and French feminist groups continue to publish journals that appeal to their specific constituencies. The movement in France remains both diverse and influential. Carin Dunne, who later wrote *Behold Woman: A Jungian Approach to Feminist Theology,* summarized the continuing impact of feminism in France: 'The forms it has taken, the issues of interest, and its modes of expression have been highly diverse, and it is therefore difficult to reduce to a single definition. But in each of its

phases it has expressed the same protest, founded on the awareness of a particular form of oppression and building solidarity among "the women" in whose name it has fought to change an unjust situation that is neither natural nor unalterable'.[275]

Great Britain | Women's behaviour in Britain was circumscribed, not only by law, but also in cultural practices that would be deemed absurd today. For example, women were prohibited from going to a Wimpy bar (Britain's hamburger joint in the pre-McDonald's era) without an escort after 11:00 pm.[276] This law was considered a 'reform' measure based on the assumption that no woman but a 'lady of ill repute' (a prostitute) would be out in public late at night under any circumstances. With this measure, Wimpy bars were thus protected from the late-night activities of single women.

Women's restricted status was evident not only in the ridiculous effort to protect the moral integrity of the hamburger, but also in ways that had a profound effect on women's lives. For example, as late as 1970, women needed a husband or male relative's permission in Britain to borrow money. Jobs were advertised by gender in the 'help wanted' columns, and only twenty-six of the 650 members of Parliament (MPs) were women in 1970, and fewer still (only nineteen) in 1979, the year Margaret Thatcher was elected prime minister; domestic violence and marital rape were not considered crimes; doctors (most of whom were men) were often ignorant of women's health issues; husbands often retained child custody in the case of divorce; and marriage – allowed only to heterosexuals – was still idealized as the high point of a woman's life.[277] The legal system was slow to act on behalf of women. Married women gained the right to retain money they earned after marriage in 1964, but since most women did not work outside the home, the law granted them only minimal financial independence. Abortion within 24 weeks of conception was legalized in Britain on 27 October 1967,

but two doctors had to consent to the procedure, affirming that it was necessary to preserve the life of the mother. While this measure did provide relief to women who were afflicted with dangerous conditions during their pregnancies, it failed to address the issue of women's bodily agency and choice.

The Sex Discrimination Act, which outlawed only certain types of discrimination based on sex or marital status, was not passed until 1975. Women realized they would have to draw public attention to their grievances through direct action on real-world issues, acting at first as mothers, wives, and workers. Historian Sheila Rowbotham described the connection between British women's steps toward control of their reproductive lives and the need for broader changes in society. She argued that it was 'naïve to expect women to fulfil some abstracted "natural" function in a most unnatural society, particularly when contraceptives were reducing the time women were spending in childbirth'.[278] If women could plan the timing of their pregnancies, they could be more present in the workplace and in public life.

One of the first actions for women's liberation was a strike by 187 female sewing machinists at the Ford Motor Company Limited plant at Dagenham in East London, starting on 7 June 1968. The women sewed automobile seat covers, a job that had recently been classified as unskilled, and given a B rating, even though the women needed to pass a special skills test in order to be hired. The lower classification produced a pay rate that was eighty-five per cent of the pay rate for men who operated similar machines and did similar work. The men's jobs carried a C rating. The women were also paid less than men who did unskilled jobs such as sweeping floors. On 28 June, the strikers marched through the streets of Whitehall, making their way to the office of MP Barbara Castle, who had recently become Britain's first female Secretary of State for Employment and Productivity. She was appalled to learn that many industries in Britain used a dual pay grade system based on gender, and she helped to broker an agreement after the

Dagenham strikers were joined by 195 women from Ford's Halewood Body and Assembly plant. To make their case in public, the women granted newspaper interviews and spoke for themselves on television.

After a three-week strike, the women received a salary increase that amounted to only ninety-two per cent of the men's rate of pay and a review of their B grade by a Parliamentary Court of Inquiry, which did not find in their favour. Their strike and the fact that they spoke out for themselves was instrumental in gaining popular support for the Equal Pay Act that was approved on 29 May 1970. The women of Dagenham did not receive a more appropriate C job grade until after a six-week strike in 1984. Throughout the strike, the women received only grudging support from their unionized male colleagues in the plant, who were more concerned that the plant would be closed and they would be temporarily out of work when the inventory of seat covers was exhausted. Looking back on the strike forty-five years later, striker Gwen Davis said she and her colleagues did not work for 'pin money'. Their wages were needed 'to help with the cost of living, to pay your mortgage and help pay all your bills. It wasn't pocket money. No woman would go out to work just for pocket money, would she? Not if she's got a family'.[279] The Dagenham strikers' victory, even though it did not meet 100 per cent of the workers' demands, was a step forward toward women's equality.

Another partially successful and very public campaign for labour justice came in the three-year effort to gain higher wages for women who cleaned offices at night. The Night Cleaners Campaign highlighted both class and gender as sources of women's oppression. A small group of workers aided by their supervisor, Mary Hobbs, gained the support of the Cleaners Action Group, which included the strikers themselves, advocates of women's liberation, socialists, and a small number of male trade union members. The night cleaners spent more than two years starting in 1970 picketing and leafleting in support of their cause, and they solicited help from the Dalston

A Movement of One's Own

Women's Liberation Workshop of which Sheila Rowbotham was a member. At first, the public campaign on behalf of the night cleaners yielded higher wages, but, when the workers' contract expired and a new company was hired to oversee the operation, the new managers declined to accept the terms of the old contract. The Transport and General Workers Union offered no support to the night cleaners, and the majority of union leaders believed that the 'nature' of women made it appropriate for them to be in the home rather than on the assembly line or in an office cleaning at night. One might well have asked what would a woman would have done if she had wanted to take her late-night food break at a Wimpy Bar.

On 20 August 1976, Jayaben Desai, a worker at the Grunwick Photo Processing Lab in North London, was told by her manager that she would be required to work for several hours after her regular shift. Desai recalled that she told her boss she refused and that, 'What you run here is not a factory, it is a zoo. There are monkeys here who dance to your tune, but there are also lions here who can bite your head off. And we are the lions, Mr Manager! I want my freedom'!

This incident led to one of the most bitter strikes in the 1970s, led by Desai and her co-worker Kalaben Patel. The major issue was the demand by the workers, who were predominantly women of South Asian descent whose families had settled in East Africa during British colonial rule and then moved to London, to address poor working conditions by joining a union. These conditions included having to ask permission to use the toilet and being subjected to public reprimand by managers. Some male workers supported the women, who were called 'strikers in saris' in one press account, but neither the Trades Union Congress nor the Association of Professional Executive, Clerical and Computer staff was willing to support the women strikers. The strike failed.

The failure of the Grunwick Strike highlighted a developing divide in the Women's Liberation Movement over the issue of race.

Although some White feminist groups had supported the Grunwick women, there was a growing feeling that women of colour needed to form their own organizations to solve their own problems. Like the field workers in America's Student Non-Violent Coordinating Committee, feminists of colour politely rejected 'help' from White women, hoping to avoid being patronized and desiring to represent their interests on their own. In 1973, the first Black women's group in Britain was formed and, in the late 1970s, numerous local Black women's groups organized to address issues important to their constituents that included the 'triple oppression' of class, race, and gender. According to Florence Binard, alliances among women of colour were rooted in 'their common experience as victims of colonialism and imperialism'.[280]

According to Florence Binard, the male unionists accepted the stereotype that women worked only for 'pin money'. Nevertheless, many women saw union membership as a necessary first step toward achieving their goals of pay parity with men and improved working conditions. The editors of *Shrew* magazine recognized that unions 'have many limitations, and that these limitations are most obvious in the case of women workers. However, to join a union is still the necessary first step if women are going to get better conditions at work'.[281] British working women understood the benefits of collective action and, at the time, this meant joining existing organizations dominated by men. British feminist organizations were instrumental in opening the ranks of trade unions to working women.

Feminists have long protested the objectification of women represented by beauty pageants; parading women in evening gowns or bathing suits was sometimes likened to a cattle auction where the animals were examined for their physical attributes. The 1968 protests at the Miss America pageant in Atlantic City, New Jersey that resulted in the crowning of a sheep as an alternative beauty queen garnered considerable media attention. Two years later, on 20 November 1970,

A Movement of One's Own

Britain's Women's Liberation Movement members stormed the Miss World pageant at the Royal Albert Hall. The in-person audience and one hundred million worldwide television viewers witnessed protesters throwing tomatoes and flour bombs and shooting water pistols at the stage. Jo Ann Robinson, a prominent British feminist, described her feelings about the Miss World Pageant: 'Feminists found the idea of women being judged by how they looked to be insulting and undermining. They organised the protest in 1970 to challenge the assumptions behind the show, its connections with big business, and the association between the event compère, Bob Hope, and the American intervention in Vietnam. Hope had paid several visits to entertain the troops in Vietnam. The WLM slogan was "We're not beautiful, we're not ugly, we're angry!"'

The protesters did not attack the women taking part in the contest, their enemy was the pageant organizers and the press that publicized the event. Once the protest was underway, the producers disconnected the live feed for the event, but the pageant continued, and Jennifer Hosten of Grenada received the crown as the first woman of colour to be honoured with the Miss World title. After the pageant, Hosten compared her message to that of the protesters. She told reporters, 'I didn't realise it fully at the time but we were all using that contest as a way to get a message across. For me it was about race and inclusion – for them, it was about female exploitation'. The protest received considerable press coverage, but it did nothing to stop or transform the Miss World or other beauty contests. Protest organizer Sally Alexander remembered: 'There was a sense of exhilaration and excitement that we were making a mark and making ourselves heard'.[282]

The British Women's Liberation Movement was advanced through a series of conferences that began at Oxford University's Ruskin College in February of 1970. Ruskin College is dedicated to the education of working people. Its choice as the location of the first

Don't Call Us Girls

Women's Liberation Movement conference is significant because of the socialist orientation of a significant number of feminists. According to socialist feminist Sheila Rowbotham, the conference was also planned as a women's history conference. A year earlier, when a women's history curriculum was proposed at a Ruskin History Workshop, the idea was met with laughter from men at the workshop. Like their counterparts in America's SDS, men at the conference argued that the revolution would have to come first, and that women's issues could wait.

As small groups of women engaged in consciousness raising to help them clarify their personal views, women began to define their organizational goals for the New Feminist Movement. Women met in small groups and spoke freely about issues that affected their daily lives. Even the most personal issues related to marriage, family, and sexuality were regarded as political because they were shared among so many women who sought solutions in the public realm, either through government action or changes in public mores and practices. By speaking in small groups among themselves, British women developed an analytical framework and a vocabulary with which they could articulate their demands in the broader context of a national women's liberation conference.

At the Ruskin College Women's Liberation Conference, six hundred attendees put forth four basic demands:

1. Equal pay and job opportunities
2. Free contraception
3. Abortion on demand
4. 24-hour a day childcare to permit women to work

In 1974, the WLM conference in Edinburgh added:

5. Legal and financial independence for all women, and
6. The right to self-definition for women and an end to discrimination against lesbians.

In 1978, the movement added an additional demand at the Birmingham Conference:

7. Freedom for all women from intimidation by the threat or use of violence, an end to the laws, assumptions and institutions that perpetuate male dominance and men's oppression towards women.

The Birmingham Conference devolved into an argument between factions within the Women's Liberation Movement over the root causes of women's inferior status in society. To many feminists, patriarchy and capitalism were the real enemy and very little could be accomplished in a society founded on masculine values. They were engaged in an acrimonious struggle with feminists who espoused the view that sexuality and violence were the major causes of female oppression. The conference was characterized by bitter, personal arguments, and the Birmingham meeting proved to be the final WLM conference. The Feminist Movement was officially divided into factions based on race, ethnicity, and political philosophy. In addition to mainstream WLM groups, the Organization of Women of Asian & African Descent was founded in 1978 at a conference in Warwick. In 1979, the Southall Black Sisters formed in London. No longer would it be possible to think of British feminism as a single monolithic movement.

Germany | Germany has a long, contradictory history regarding women's rights. Women were granted the right to vote in 1919, but it was not until 1977 that West German law permitted a married woman to work outside the home without her husband's permission. After the Second World War and the division of Germany, the German Federal Republic (West Germany) created the Basic Law, the new country's constitution, in 1949. Friederike Nadig, one of only four women in the *Parliamentarischer Rat*, the group responsible

for drafting the Basic Law, pushed for a clear assertion of women's equality. Article Three reads:

1. All persons shall be equal before the law.
2. Men and women shall have equal rights. The state shall promote the actual implementation of equal rights for women and men and take steps to eliminate disadvantages that now exist.
3. No person shall be favoured or disfavoured because of sex, parentage, race, language, homeland and origin, faith, or religious or political opinions. No person shall be disfavoured because of disability.

While Article Three provides for women's equality, it does not include specific provisions for ensuring participation in the economy or politics, leaving the implementation of equality to future generations of legislators. For example, in the early years of the Basic Law, women who worked in civil service jobs could be fired if they married. Despite slow progress in many areas of women's equality in West Germany, Article Three represents a major step forward for German women's equality, and Friederike Nadig is often referred to as the Mother of the Basic Law. West German feminists organized autonomous groups that had no affiliation with the traditional women's clubs, service organizations, or political parties of previous decades. Younger women were likely to be affiliated with the student left in Germany's many university towns.

Like their colleagues in the United States and France, many of the pioneers of the West German feminist movement learned lessons about organizing and protest in those groups. Hilke Sander is a good example of a radical student filmmaker whose dissatisfaction with women's status in the German SDS led her to demand a movement

dedicated to the needs of women. Katharina Karcher observed that many of the founding mothers of the New Women's Movement had played an active role in student protests, 'identifying with the aims and principles of the New Left: they were fundamentally opposed to the existing political structures, specifically legal restrictions on women's activity in the workplace and in society at large. The goal of these early feminists was to create a society based on anti-authoritarian, anti-fascist, anti-imperialist and anti-capitalist principles'.[283] Sander helped to found *Aktionsrat zur Befreiung der Frauen* (Action Council for the Liberation of Women) in January of 1968. This organization was in the forefront of criticism of male left-wing movement leaders, demanding that they take women's issues seriously.

The abortion issue highlighted the imperative for women to create a movement with their own ideology, organizational structures, and vision of freedom from the misogyny that governed their lives. Law 218 of the German Penal Code was passed in 1871 and prohibited abortion under all circumstances. *Neue Frauenbewegung* (New Women's Group) activists focused on the issue of abortion as essential to women's freedom to make their own reproductive decisions. The group also recruited women to the new feminist movement by focusing on issue such as social equality, monetary compensation for housework, and most important, reproductive health, including access to safe abortions. Local women's groups focused on local issues, but it was the primacy of abortion in the rhetoric of *Neue Frauenbewegung* thinkers that helped to unite women around a common issue and establish Second Wave Feminism in West Germany.

West Germany's Basic Law did not address abortion. As in many other countries, abortion was one of the personal and political issues that inspired women to write letters and collect signatures on petitions to be delivered to politicians, engage in public demonstrations, and mobilize other women to support abortion reform. The struggle to legalize *Fristenlosung*, or the termination of a pregnancy in the first

trimester of gestation, served as a catalyst for a women's movement in the country in the 1970s. A group of women who called themselves *Brot und Rosen-Frauenaktion 70* (Bread and Roses – Women's Action 70) articulated the earliest demands for access to abortion. One of their slogans was *Mein Bauch gehort mir!* (My belly belongs to me!).

On 6 June 1971, the popular news magazine *Stern* published a statement under the banner headline 'We Had an Abortion', in which 374 women declared that Law 218, which banned abortion, was outdated. The statement was the creation of Alice Schwarzer, a journalist who had worked in Paris and befriended Simone de Beauvoir and other French feminists. Schwarzer was inspired by the efforts of French women to publicize the issue of women's rights. The 374 German women who put their names to the *Stern* statement declared that they had had abortions and thus broken the law. This was a powerful public statement from women who were expected to keep their private lives private. The campaign to bring the abortion to the public's attention had the support of the *Sozialisticher Fauuenbund Berlin* (the Socialist Women's Group of Berlin), but the majority of the women who were willing to incriminate themselves did so as individuals rather than as members of an existing organization. The statement revealed that there was no single definition of a West German feminist. Rather, women from diverse educational and socioeconomic backgrounds came together around a political issue that was highly personal to them. The 'scandal' of so many women admitting to having broken the law brought women from all over West Germany to the larger cause of women's liberation. The publishers of *Stern* demonstrated their support for the women by printing the statement on the magazine's title page. Thousands of people, many with no political affiliation, wrote letters and signed petitions in support of the *Stern* women. The West German battle over access to abortion was an example of the transnational communication with feminists in the United States, France, and

elsewhere that facilitated national political action.

The abortion campaign solidified Schwarzer's reputation as West Germany's most influential feminist. In her theoretical writing, Schwarzer attributed the rise of feminism in Germany to conditions in society that prompted women to press for change rather than the revolutionary movement of 1968, which she regarded as a temporary phenomenon that had proved unable to address fundamental issues for women. In 1975, she published *Der kleine Unterschied und seine großen Folgen* (*The Small Things and their Big Consequences*) that was a brief for women's economic and personal independence, especially with regard to reproductive health care. *Aktion 218*, an organization dedicated to reforming or eliminating the old abortion law, collected signatures and, on 22 June 1971, met in Frankfurt attended by about 100 women. *Aktion 218* refined its message to connect abortion reform to the broader issue of expanding women's role in public life. The group sent a statement to Justice Minister Gerhard Jahn of the SPD in which the women declared that *Aktion 218*'s success was proof that women 'no longer understand the *Gebärzwang* [enforced delivery] imposed on them by the state as an individual problem. For the first time, we women demand not to be treated as *Stimmvieh* [election-booth fodder], but instead to express ourselves as active, political citizens'.[284]

A month later, *Aktion 218* sent Jahn 86,000 signatures demanding change, but this outpouring of support did not bring about any policy change. West Germany's 1971 reform law still imposed restrictions on the procedure. Women took to the streets to protest the rejection of *Fristenlosen* in favour of a policy of *Indikationlosung*, which allowed abortion only if it was 'medico-socially', 'ethically', or 'eugenically', indicated.[285] The law allowed some consideration for saving a mother's life and for 'foetal disability'.

Understandably, the limitations embedded in the new law were unacceptable to women who sought full control over their bodies

and their lives. Nevertheless, *Indikationlosung* became the law of the land, which it remains to this day. In September of 1971, Schwarzer published *Frauen gegen den 218 (Women Against Law 218)* in which she recounted her conversations with eighteen women who had had abortions. She also expressed concern that Germany's major political parties would support *Indikationlosung*, thus ignoring the demands of the women of Aktion 218 and all of the women of West Germany. Not surprisingly, Catholic leaders objected to any loosening of legal restrictions that controlled women's role in the home and behaviour in the public sphere. Just as Aktion 218 framed its support for access to abortion in terms relating to women as full citizens, Cardinal Joseph Hoffner of Cologne's statement on abortion not only re-stated the Church's position that human life starts at conception, it also reminded politicians of the political power of the Church. He said that, 'Representatives not prepared to ensure the inviolability of human life, and also that of the unborn child, are unelectable for devout Christians'.

Soon after the codification of *Indikationlosung* in the West, the East German Parliament passed the *Gesetz über die Unterbrechung der Schwangerschaft* (Law on the Termination of Pregnancy) in 1972. It allowed for the termination of a pregnancy within the first twelve weeks. In addition to permitting abortion on a limited basis under national law, the East German legislature allowed women to work on their own and established a number of state-run support programmes for women and families, including childcare facilities that helped women to stay in the work force. It was especially important to maintain a stable work force because so many men had left the Democratic Republic to fill the shortage of male workers in the West.

Women in the West held a Women's Tribunal in Cologne in in June of 1972 in which they castigated political leaders for their lack of support for women's rights. In February of 1974, Bread and Roses – Women's Action 7 imported the tactic of the teach-in from

American anti-war groups in an event that drew 2,000 people to the Technical University of West Berlin on 11 March 1974. West Germany's popular magazine, *Der Spiegel*, printed a statement from 329 doctors and nurses who said they had performed unpaid (but nevertheless illegal) abortions. At the same time, fourteen doctors said they were prepared to break the law by performing an abortion in public to make West German citizens aware of the illegal and dangerous abortions that took place every year in the country. The doctors issued a statement that declared that 'Every day 2,000 to 3,000 illegal abortions are carried out in the FRG (Federal Republic of Germany). Our campaign ought to put an end to the hypocrisy. We demand equal rights for all, the development of non-harmful methods of contraception, and child-friendly living conditions'. Women's 'personal' issues had become broadly political.

The operation took place on 9 March 1974 at the Kreuzberg Women's Centre and was filmed by the public television *Panorama* network. But the procedure did not reach the television audience because of a legal challenge brought by the Catholic Church. *Panorama* executives decided to air footage of an empty studio in protest. In the days after the empty studio showing, women in West Germany staged acts of civil disobedience, including sit-ins, at a number of television studios, but the law did not change.[286]

Starting in the early 1970s, West German feminists produced a wide variety of journals, pamphlets, local newsletters, and lesbian magazines dedicated to specific issues within the broader movement. Small magazines dedicated to sexuality and sexual preference, abortion, and wages for housework appeared in the country's major cities. Many of these journals published only an issue or two, but a few reached the general public in large press runs. These magazines were avenues for communication in a medium that feminists have historically utilized – the written word. In Germany's de-centralized feminist movement, these publications represented the coalition-

based and loosely structured nature of West Germany's feminist movement. The goal of many feminists was autonomy, the separation from the Left student movement as well as creating a distance from Germany's Nazi past, which Dagmar Schultz characterized as 'a deep mistrust of possible personality cults, hierarchies, stifling bureaucracies, and rigid programmatic lines'. This mistrust of past models contributed to a movement that consisted of small groups with distinct interests. In contrast to the United States and, to a lesser extent France, no singular organization such as the National Organization for Women existed.[287]

Courage was published by a collective of lesbian feminists in Berlin, starting in 1976. The women had no experience in publishing and little money, but they wrote articles, printed black and white photographs, sold ads, and distributed copies at a Berlin *Frauenfest* in June of 1977. The first press run of 5,000 copies sold out, and, by mid-1977 *Courage* was reaching more than 60,000 readers in Germany, Switzerland, and Austria. Over time, the collaborative spirit of the magazine was reflected in the participation of its readers, who wrote more than half of the articles on issues ranging from prostitution to lesbian rights. Readers were encouraged to participate in the life of the magazine, and staff members edited contributions with a gentle hand, resisting what they regarded as a bourgeois tendency to edit or refine the work of others. *Courage* published until 1984.

Six months after the appearance of *Courage,* Alice Schwarzer headed the professional staff that introduced *Emma: A Magazine by Women, for Women* to West German readers. Unlike *Courage, Emma* had high production values, famous interview subjects, and articles highlighting the history of women. Schwarzer's goal was to make feminism familiar and acceptable to a wide audience by producing a mainstream journal with content relating to the reform goals of the movement. *Emma* continues to reach a large audience. The editors added a website in 2002.[288] *Courage* also represented the concerns of German lesbians

who constituted one group within *Frauenbewegung* while *Emma* spoke to the interest of a more traditional Liberal Feminist audience.

Even though they were not successful in pressing the case for bodily autonomy and full abortion rights, German feminists frequently utilized confrontational strategies and tactics to bring about societal change. Historian Ute Fervert noted that West German feminists 'disrupted beauty contests, bricked up sex-shops, sat in at churches and doctors' conventions, and organized tribunals on abortion, violence against women, and other central themes in the women's movement'.[289] One radical women's group, *Rote Zora*, engaged in destruction of property, including forty-five arson attacks and bombings, directed at sexist institutions and individuals between 1975 and 1995. The group was especially angered at Law 218 and referred to the language of the law as a Terrorism Paragraph. *Rote Zora* declared that violence could be empowering for women, especially when acts of destruction of property were directed against men who abused their power and authority over women. *Rota Zora* planted a bomb at the headquarters of the German Medical Association in April of 1977. They considered this an act of feminism, while the German government designated *Rota Zora* as a terrorist organization. The women of *Rote Zora* found it 'tremendously liberating to break with the feminine peaceableness [sic] that was imposed on us and to take a conscious decision for violent means in our politics. We experienced that with our actions, we could break through fear, powerlessness and resignation, and we wanted to pass this on to other women/lesbians'.[290] Nevertheless, the approach to feminist activism that included violent acts did not attract the majority of women who saw themselves as Liberal German feminists. Feminist activists in Germany in the early 1970s inhabited a spectrum whose end points were petitions, marches, and speeches within the constitutional system on the one hand and acts of violence that included bombings and arson on the other. The militancy of many

feminists was analysed by Alice Schwarzer, who described hatred of male oppressors as a form of militancy. She asked, 'What would a liberation movement be without hatred? Are we really going far enough? Are we really not cowards? Are we really not deceiving ourselves? Can we show solidarity also with those who are not, or no longer, acting with "prudence" when trying to tackle this blatant injustice? Courage to militancy was never a German strength. Nevertheless, it took hold of women in this period [post-1968]'.[291]

Acting within constitutional and legal parameters or shifting toward militance and violence, German women pursued causes on their own behalf. Despite their efforts, the unified German Parliament did not outlaw discrimination based on 'gender, skin colour, ethnicity, disability, age, and religion' until 2005. In the 1980s, feminists supported a movement for gay liberation, which came to fruition after the unification of the country. In December of 1989, *Emma* published an article about the relationship between lesbianism and feminism by American professor Janice G. Raymond, who noted that the feminist movement 'was the largest challenge to hetero-reality. It questioned the worldview that women exist primarily in relationship to men. It examined the history of women as a history, which showed up particularly in the family – a history, which if it saw women at all, discussed women in their relationships to men and their role in male-determined events'.[292] Such questioning was the basis of feminist self-definition for many women.

British, French, and German women in the 1960s were aware that their ability to vote on an equal basis with men was no guarantee of equality in society or the workforce. There were few women in positions of authority in government or business, and unequal pay was both legal and accepted as 'natural'. The patriarchal idea that women's nature required that they occupy a subordinate position in society was accepted by both men and women. The need for change could not have been more obvious.

Mexico | The transnational nature of anti-war protests, challenges to traditional authority, and a recognition of the need for a movement that would act specifically on behalf of women was evident in protests led by Mexican students. A Mexican women's movement was taking shape at the same time that young activists engaged in militant protests against war, an antiquated and repressive university system, and cultural mores that restricted the lives of young people. British researcher Diane McMeeking was present in Mexico City in September of 1968. She remembered seeing tanks on the streets, an indication of the severity of the government's response to student protest demands. The tanks kept the crowds at bay, and, on 13 September, more than eighty students were arrested. She remembered that, on 14 September, 'the police (or the military) had smashed the windscreens and slashed the tyres of more than 200 cars. In a letter I sent back to England, I wrote: "When we arrived at the car park on Saturday morning, we couldn't believe our eyes – there was glass everywhere. Of course, the students can do nothing about it, but at the moment student feelings in the city are pretty hot and it wouldn't surprise me if in a few months, conditions don't improve, there will be another revolution – and I'm not joking about this"'.[293] Like militant protest, repressive law enforcement action had become a transnational phenomenon.

When young people rallied in the Plaza de las Tres Culturas in the Tlateloco neighbourhood of Mexico City less than a month later on 2 October 1968, they were unprepared for the violence perpetrated by military and police forces. The Tlateloco Massacre took three hundred young lives and imprisoned and tortured many others as the students called for democracy and greater agency in their lives. The treatment of the students also undermined confidence in the government, the police, and other voices of authority in Mexican society. Women participants in the protest challenged the traditional authority of their parents, specifically their fathers, the

paternalism of university administrators, and the intransigence of their government. Women had emerged from the background of the protest movement to take a place in the public sphere. They began to speak for themselves and were convinced that they would never return to the subservient status they had occupied. The time had come for a contemporary feminist movement in Mexico.

The Second Wave feminist movement in Mexico was initially inspired by the events of October 1968 and the transnational connections women had made with feminists in Europe and the United States, but they faced many cultural barriers in their efforts to establish a feminist movement at home. The raising of a feminist consciousness was initially the work of middle-class activists and scholars and was vulnerable to ridicule from many sides. Norma Stoltz Chinchilla observed that, during the early stages of Mexico's Second Wave feminist movement, 'the media, the Catholic Church and many political parties promoted pejorative caricatures of feminists as self-indulgent and egotistical, anti-family and anti-male, and divisive of community and class solidarity. Such stigmas made it difficult to imagine that a feminist movement of any significance would ever take root in Latin America'.

Groups of intellectuals and activists engaged in consciousness-raising conversations inspired by the protests of October, 1968 and the grievances that emerged from women's participation in the movement. Mothers who had seen their children arrested, tortured, or murdered in the Tlateloco riot also joined the new feminist movement. Some of the early protests focused on broad social issues, while others targetd the role of women as mothers. Ana Lau Jaiven helped to found *Mujeres en Accion Solidaria* (Women in Solidarity Action) in 1971. On Mothers' Day of that year, the group staged a protest at the Monument to the Mother in Mexico City. They called their action *Protesta Contra el Mito de la Mujer* (Protest of the Myth of the Mother). The women defied the authorities who denied them a

permit to gather at the monument and staged their protest in spite of the fact that they faced arrest.

Coincidentally, contestants in the Miss Mexico competition were also gathered at the monument for a photo opportunity. The irony of potential Miss Mexicos competing for space with protesting mothers was not lost on the local television station, which showed footage of both groups. Other groups were also organized in the 1970s, including *Movimiento Nacional de Mujeres* (1972), *Movimiento de la Liberacion de Mujeres* (1974), and *Colectivo Cine Mujer* and *La Revuelta* (1975). Issues ranged from abortion and rape to sexuality and prostitution, along with more traditional issues relating to childcare and the ability to work outside the home. In rural areas, so-called Mother's Movements focused on social equality but were also concerned with basic issues such as the availability of electricity and gas in rural areas and food for families.

Mexican feminists were divided over the issue of how to define their objectives beyond the issue of class, education, or their status as mothers. Some looked to traditional channels and the legal system to integrate women more equally into the public sphere. This 'feminism of equality' sought to force political, economic, and social institutions to provide more opportunities for women because they would bring the same positive attributes to their new positions as men. Arguing from a differing perspective, proponents of 'feminism of difference' were less concerned with equality in society than with locating the source of women's equality in gender itself. Their areas of focus were violence against women and the demand to legalize abortion.

The response to numerous conferences, protests, and participation by some feminist groups (and a boycott by others) in the United Nations International Women's Year in 1975 was mixed. The UN efforts, according to Martha Zapata Galindo, 'stirred debate on the relationship of the feminist movement to the state and spurred many

feminists to increase their presence in public spaces and reformulate their strategies for acquiring power'. Mexican feminists, whatever their perspective on equality versus difference, had transcended their fear of police reprisals and public mockery to articulate their demands. *Fern,* a feminist magazine first published in 1976, provided a vehicle through which those demands could reach a broad public. In the late 1970s, lesbian and gay organizations joined with feminist groups to demand equality.

At the same time, women continued to face the obstacle of not having their grievances taken seriously. In 1979, Alan Reding observed that, for some time, 'Mexico's legendary machos were nervously amused. The "girls" were a topic of conversation and the butt of jokes. The government even sought to appease them by eliminating sex discrimination from the statute books. But if the "machos" or the government thought they could laugh away feminist grievances or pass legislation to address only one of their goals, both groups were mistaken. Second Wave Feminism has continued to grow in Mexico with a renewed focus on the needs of working-class women and issues relating specifically to female sexuality'. [294] Mexican feminists discovered that they were not alone. In many important respects, their movement reflected the same issues as feminism in other countries, with many of the same commonalities and variations of approach to ideology and organizing.

Japan | Young Japanese women born in the decades immediately preceding the Second World War appeared to have significant political rights compared to earlier generations. Japanese women voted for the first time in the elections held in 1946 and 1947 during the military occupation by the United States military. Women were granted equal rights under the Constitution of 3 May 1947, and the Labour Standards Law mandated that men and women earn equal pay for equal work. But women in Japan knew

they were not satisfied. Their demands for pay equity, access to childcare, and protection from domestic violence remained unmet. Japan has a long history of women asserting their rights. Starting in about 1923, Japan saw the appearance of the *Modan Gaaru* (Modern Girl). Inspired by flappers in the United States, young Japanese women, many of whom had jobs and disposable income, imitated the fashions and styles of the West. They sought financial independence from their families and the freedom to choose their own husbands rather than depend on arranged marriages. These women did not advocate for societal liberation for women as a class but were instead desirous of their own personal freedom. Japan's Modern Girls and traditional feminists did share the disapprobation of the popular press, as they were accused of contributing to sexual promiscuity and selfishness, qualities the press attributed to foreign influences. In the early twentieth century, the Japanese government was wary of those influences, and the Modern Girl was a threat to the decorous behaviours required of respectable Japanese women. Critics on both the left and the right viewed the Modern Girl as 'hedonistic'.

Japanese women prior to the Second World War were expected to live their lives in service to their families and the state. They were expected to be faithful wives and wise mothers who educated their children to be good citizens. In addition, they were expected to obey their husbands unconditionally. In the immediate aftermath of the War, the Women's Committee on Post-war Policy led by Fusae Ichikawa negotiated more political rights for women, ensuring greater autonomy for them in the political sphere, if not yet in their homes. By 1946, thirty-nine women were elected to the Diet. Women had made political progress but they were still, in many respects, second-class citizens. Various women's groups in the 1950s promoted the Prostitution Prevention Law and also supported the Housewives Association, which 'was fairly militant in its assertion of women's power as consumers within the household. Marching

for better products and economic justice, its members carried giant mock-ups of a rice-serving scoop that symbolized women's role as housewives'. The Japanese housewives of the 1950s shared many of the same concerns as their American counterparts, including nutrition for their children and safer and more efficient labour-saving devices.

After the American occupation ended, Japan experienced an extended period of strong economic growth. Housewives and mothers' groups continued to lobby for improvements in Japanese society, focusing on family welfare. Their effort was to create a 'better, cleaner, and safer Japan'. At the same time, middle-class women in these local groups began to articulate opposition to Japan's cooperation with the United States in the War in Vietnam. By the late 1960s, Japan's Second Wave feminists were younger and university educated. They focused their protest on the Vietnam War and Japanese capitalism. Through consciousness-raising activities, women voiced their opposition to the male leadership of New Left organizations and insisted that issues related to sexuality, the absence of power and agency for women, and the role of motherhood in promoting inequality deserved attention. Most male movement leaders paid little attention to the women's demands.

Chelsea Szendi Schieder began her study of Japanese feminism, *Coed Revolution: The Female Student in the Japanese New Left* with an anecdote that might be considered the birth moment of radical Second Wave Feminism in Japan: 'In April, 1970, at an event attended by anti-war activists, students, vagabonds and other assorted left-wing Japanese in Tokyo, four young women stormed the stage. They wore the helmets then in vogue among radical street fighters, but in place of the names of existing factions, they had adorned their black helmets with the white letters S-E-X. The four women, students at Tama Art University, had planned this debut for their new Thought Group S-E-X as a challenge to the masculine culture of the New Left'.

A Movement of One's Own

Not surprisingly, the women's protest was drowned out when event managers turned up the volume on the ten television screens on the stage. But women were learning how to speak for themselves. The emergence of feminist organizations in the 1970s contributed to a debate in Japanese society about the threat to masculinity that the women posed when they acted in their own interests. Japanese feminists sought more than legal equality. They argued for a transformation of Japanese society in which male and female perspectives were equally acknowledged and respected.

These examples of Second Wave feminism illustrate the variety of influences on women who organized themselves in the 1970s. It also shows the power of transnational ideas and practices. Individual women and their constituent groups realized they had common grievances and common differences of opinion about the most effective ways to address women's issues around the world. Women disagreed as to the extent to which left-wing protest or broader societal conditions provided the origin story for Second Wave Feminism, but they agreed on the need for women-only organizations that would serve their diverse interests. Feminists who experienced a universality of grievances in the movements to which they had devoted their lives and were often frustrated by a lack of response from men to their issues, which they considered to be political as well as personal. But women found diverse yet effective ways within traditional political systems and through other channels to raise their voices to agitate for meaningful change.[295]

Chapter Eight

Two Steps Forward ...

On Friday, 24 June 2022, the Supreme Court of the United States issued one of its final rulings of the term. In *Dobbs v Jackson* [Mississippi] *Women's Health Center*, the Court overturned its 1973 decision in *Roe v Wade* that had permitted the termination of a pregnancy prior to the viability of a foetus, placing this important medical decision generally in the hands of women and their doctors. In *Roe*, the Court had supported a woman's right to make her own reproductive health decisions with state intervention only in the final stages of a pregnancy, when it was presumed that a foetus could survive outside the womb. This created a standard based on foetal viability. Over half a century, thanks to important medical advances, the point at which a foetus could be considered viable shifted earlier and earlier, raising the question of the point at which a foetus should be considered a person, if such a point existed at all. Significant advances in foetal viability contributed to a powerful, often vitriolic debate over whether a foetus is, in fact, an unborn child with inherent rights to personhood. The decision in *Dobbs* left it to the states to determine the availability and regulation of abortion and left the country with no coherent policy on the matter. After decades of protest, women's rights groups in the United States saw *Dobbs* as a devastating setback in women's struggle for reproductive autonomy.

Dobbs also invalidated the Court's 1992 decision in *Planned Parenthood of Southeastern Pennsylvania v Casey* that affirmed the basic principles of Roe and overturned both the trimester test for foetal viability (leaving the determination of viability to the states) and Pennsylvania's statutes that imposed waiting periods, spousal approval, and parental consent for minors as 'undue burdens' on

women seeking to terminate a pregnancy. In *Dobbs*, the Court ruled that decisions regarding abortion should be properly made in the states, thereby determining a woman's access to abortion based on where she lives.

Justice Samuel Alito's conservative majority opinion had been leaked to the public, so the ruling was neither unexpected nor surprising. It was, however, shocking. Women and men took to the streets within hours of the ruling to protest the decision, decry the conservative bias of the Supreme Court, and call for federal government protection of a woman's right to control her reproductive decisions. Legal scholars attacked the Court's abandonment of *stare decisis*, a legal principle that says courts should reject precedent only with great care. Historians attacked Alito's assertion that, in United States, 'an unbroken tradition of prohibiting abortion on pain of criminal punishment persisted from the earliest days of the common law until 1973', as patently untrue. Physicians disputed his claim that a foetus can feel pain as neurologically impossible. And almost all opponents of the decision questioned the principle of originalism, which required that rights be 'deeply rooted in the nation's history'. Americans enjoy many rights that do not appear in the original Constitution, including a woman's right to vote, an African American's right to full citizenship, and everyone's right to privacy. These rights are enshrined in amendments and Supreme Court rulings that speak to the flexibility of basic American constitutional principles.[296]

Justice Alito's opinion represents a profound attack on the constitutional rights of women, particularly in its originalist claim that women have no guarantee to rights that were not protected by the Fourteenth Amendment that was ratified in 1868. In *Dobbs*, Justice Alito adopted the reasoning of his late colleague on the Court, Antonin Scalia, who argued that the Fourteenth Amendment's equal protection clause contains no explicit protections for women and that the concerns of the authors of the Reconstruction Amendments

focused on race, not gender. From the originalist point of view that appears to dominate the current Supreme Court, providing for equal protection for women, pregnant or not, has no constitutional legitimacy. Women, then, are to be considered in light of the law and practice of the late 1860s other than practices and standards of today.

Justice Alito and his conservative colleagues argued that the United States has no tradition of permitting abortion. They cited a voluminous list of laws that prohibited the practice, while ignoring circumstances that allowed women to terminate a pregnancy prior to 'quickening' (a perception of movement of the foetus in utero).

Historically, until the late nineteenth century, women had a measure of control over their reproductive health. There were many instances in which a woman could legally end her pregnancy prior to quickening, even though the practices used to accomplish this goal were often dangerous to a woman's life and health. By 1910, abortion was illegal by state law throughout the United States. While minimal exceptions existed for circumstances in which a pregnancy would endanger a woman's life, the decision to perform the procedure was in the hands of male doctors. A woman who could not find a doctor to help her by breaking the law frequently travelled to a country in which the procedure was legal but performed under unsanitary, even dangerous, conditions. For women who could not afford to travel, there were dangerous 'back alley' abortions, self-inflicted remedies that caused even more harm, or an unwanted pregnancy carried to term.

The ramifications of the pre-*Roe* climate of hostility toward abortion were most profoundly felt by poor women. It is painfully ironic to ponder the extent to which today's radical conservatives want to insert government regulation and the criminal justice system into the most intimate aspects of Americans' lives while, at the same time, they trumpet 'get government off our backs'.

In a lapse in its own originalist logic, the Court's conservative majority that decided *Dobbs* ignored the fact that, historically, laws

As an attorney for the American Civil Liberties Union, Ruth Bader Ginsberg represented Captain Susan Struck in her suit against the United States Air Force over the right to remain in the military during her pregnancy.
(Wikimedia Commons)

Anti-Vietnam War protesters confront National Guard soldiers outside the Democratic Party Nominating Convention on 26 August 1968. (Library of Congress)

Left: Betty Friedan, author of *The Feminine Mystique* and founder of the National Organization for Women. (Library of Congress)

Below: Women's March for Equality, 1970. (Library of Congress)

This mural depicts the contributions of the women in the Black Panther Party. (Stephen Shames)

The Bread and Puppet Theater continues to display its creativity and sense of humour. In the 1960s, the troupe participated in anti-war demonstrations. (Library of Congress)

Simone de Beauvoir was a major influence on the women who created Second Wave Feminism. (Wikimedia Commons)

Women were equal partners in the streets of Paris in 1968. (Wikimedia Commons)

Top left: Gloria Steinem has devoted much of her career to advancing the lives and careers of women. (Wikimedia Commons)

Centre left: The raised fist remains a powerful symbol of feminism worldwide. (Pixabay)

The 'Me Too' Movement has inspired greater awareness of sexual harassment and violence against women in many aspects of life. (Pixabay)

WOMEN'S VOICES

Vol. 1, No. 1 By and For Women on Okinawa

Women's Voices, produced in Okinawa, was one of a few GI anti-war newspapers that focused on issues relating to GI women. (Wikimedia Commons)

This banner, declaring that, 'If men got pregnant, abortion would be sacred' appeared at a National Women's Conference in Houston, Texas in January 1977. (National Archives and Record Administration)

United States Navy nurse, Lieutenant Colonel Joan Brouilette, checks on a patient at The Dan Nang Air Base in 1958. (National Archives and Records Administration)

Representative Patsy Mink of Hawaii was the primary sponsor of Title IX, which provided for equity for women in college athletics (Defense Visual Information Distribution Service)

Congresswoman Shirley Chisholm ran for President in 1972 with support From the National Women's Political Caucus. (Library of Congress)

Above: Phyllis Schlafly founded the Stop ERA Movement. (Library of Congress)

Right: The 'Iron Lady', British Prime Minister Margaret Thatcher, brought Conservative governance to Britain. (Library of Congress)

have restricted women's right to vote, own property while married, serve on juries, run for public office, secure credit in their own name, maintain their property on the death of a husband, secure custody of their children, or enter professions such as law or medicine. In all cases, these laws have disappeared and have been replaced by statutes that aim to protect women's legal and societal equality. The legal concept of originalism has yielded in many areas of American life to a more progressive and realistic legal status for women, although there is still a long way to go before women achieve true equality in American society. Reverting to the legal status of women in 1868 confers a permanent second-class citizenship on American women.

The *Dobbs* ruling is a damaging blow to women's rights in the United States. Despite Justice Alito's declaration that the Court's opinion applies only to the issue of abortion, other rights may soon be under attack. In his concurring opinion, Justice Clarence Thomas wrote that the right to privacy established in *Griswold v Connecticut* (1965) was vulnerable. This could mean that other rights not in the original Constitution – contraception, gay marriage, and homosexuality itself – all of which are protected under the general concept of privacy, could be taken away or significantly diminished in future Court rulings.[297] Further, leaving the issue of specific rights formerly guaranteed under the equal protection clause to the states ensures inequality for women, especially those whose family or financial circumstances do not permit them to move from states with restrictive laws.

The 1960s saw a revival of interest in the Equal Rights Amendment first proposed in 1923 by Alice Paul and Crystal Eastman, both leaders of the women's suffrage movement who had successfully lobbied for the ratification of the 19th Amendment in 1920 that granted the vote to women. Feminists at the time believed that acquiring the right to vote was only a first step in achieving full equality. In a male-dominated Senate, a constitutional amendment stood little chance of

passage, but, in the 1970s, with increased efforts by women's groups and the passage of pay equity and civil rights legislation, the approval of a revised version of the amendment seemed possible. The Equal Rights Amendment introduced in 1972 read:

'Equality of rights under the law shall not be denied or abridged by the United States or by any state on account of sex. The Congress shall have the power to enforce, by appropriate legislation, the provisions of this article.'

With the vigorous support of female members of the House, including Martha Griffiths, who had helped to push Title VII of the 1964 Civil Rights Act that prohibits discrimination on the basis of sex through Congress, and Shirley Chisholm of Brooklyn, the first Black female member of the House, the amendment overcame opposition from male legislators and was passed by both the House and the Senate in 1972.

A constitutional amendment requires ratification by three-quarters (thirty-eight) of the states. In the first five years after the passage of the ERA, the state legislatures of thirty-five states voted to ratify the amendment. During those same five years, five states voted to rescind their ratification, a reflection of increased propaganda by anti-ERA forces that claimed that the amendment would actually revoke women's rights such as alimony and child support after a divorce and exemption from the military draft. Many of those who opposed equal rights for women also asserted that equality of the sexes would lead to mixed-sex public toilets.

That assertion inspired press coverage that struck at the heart of the matter for anti-ERA forces – the right to pee in gender-specific bathrooms. From the insidious to the ridiculous, the battle against feminism was resurrected, and feminists faced charges that their insistence on equality foretold the end of American life as we know it. *Roe* was a positive step forward for women, but it also led to a hardening of ideological lines on the issue of women's equality.

While many women were happy to have increased opportunities in education and the workplace, they were also quick to declare, 'I'm, not a feminist'. In the twenty-first century, the Equal Rights Amendment remains unratified and its future uncertain, in spite of positive ratification votes in Nevada in 2017 and Illinois in 2018.[298]

By 1972, when the passage of the ERA seemed possible, even likely, women throughout the world rejoiced at the success of Australian singer Helen Reddy's song, 'I Am Woman'. The words resonated with women's growing sense of empowerment and their increasing willingness to speak their own minds. Reddy's song became an anthem of the Women's Movement as she sang:

> I am woman, hear me roar,
> In numbers too big to ignore.
> And I know too much to go back and pretend.
> 'Cause I've heard it all before,
> And I've been down there before.
> No one's ever going to keep me down again.[299]

The song reached the top of the pop charts in the United States. But while feminists in the early 1970s were hopeful that the word 'feminism' would soon lose its pejorative connotation, there were powerful forces behind the scenes in countries throughout the world organizing to ensure that the liberalism of the previous decade would be overwhelmed by a conservative movement whose goals included impeding women's further progress in the public sphere and making feminism a dirty word.

As of January, 2020, Virginia was the thirty-eighth and final state to ratify the Equal Rights Amendment passed by Congress in 1972. With massive popular support, the amendment was poised to become part of the Constitution until then-Attorney General William Barr refused to allow it to be certified as valid by the archivist of

the United States. The failure to meet this technical requirement effectively (and permanently) halted the progress of the amendment. In the politically-polarized climate of 2023, a new amendment stands little chance of passage by both houses of Congress, in spite of its popularity.

In spite of significant progress made by women in many areas of life and work, it would be a mistake to think of *Dobbs* as an aberration. The United States Supreme Court has been moving to the right for decades, and the appointment of three justices by former President Donald Trump has only solidified the conservative majority. The *Dobbs* ruling is part of a well-planned and well-financed conservative assault on individual rights, which began even before Second Wave Feminism found its political and social footing. Today, cases like *Dobbs* as well as other efforts to curtail women's liberties demonstrate the need, nearly one hundred years after its initial appearance in Congress, for an Equal Rights Amendment.

The story of women's rights across the globe is a story of successes and setbacks over many decades. Progress made in the 1970s included many benefits for women, and for society as a whole, that were the result of demands made by Second Wave feminists and their supporters in government. Writing to *The New York Times* on 25 June 2022, former *Ms* magazine editor Ellen Sweet pointed to changes in her lifetime that were the result of feminist activism. She wrote that younger women 'might have forgotten or not even known about: credit in our own name, recognition of marital rape as a crime, job listings that don't differentiate by gender, and so much more. At the same time, feminism has grown to include intersectionality and reproductive justice, both terms that acknowledge that the struggle to achieve gender equality must embrace racial, economic and other disparities'.[300]

Frequently, legal advances for women engender resentment, even hostility, which contributes to ineffective enforcement. Two examples

in the United States are the Equal Pay Act of 1963 and Title VII of the Civil Rights Act of 1964. Although both pieces of legislation were enacted in a spirit of democratic reform, they inspired hostility that spoke to a sense that women were being 'given' an advantage over men. In addition, some individuals and institutions did their best to subvert both the letter and spirit of these laws. President Kennedy signed the Equal Pay Act on 11 June 1963, declaring it a 'first step' in the path to pay equity for women who earned significantly less than men for equal or equivalent work. The law was enacted to 'prohibit discrimination on account of sex in the payment of wages by employers engaged in commerce or in the production of goods for commerce'.

In theory, the Equal Pay Act was a success for women, but its implementation proved to be ineffective at best. When the law was passed, women in the United States earned 59 per cent of men's salaries for the same or substantially equivalent work, and that number today is about 80 per cent. According to the American Civil Liberties Union's Legislative Office in 2011, nearly fifty years after President Kennedy signed the bill, equal pay for women has been weakened 'by loopholes, inadequate remedies, and adverse court rulings, resulting in protection that is far less effective than Congress originally intended'.[301]

Scholars have attempted to develop the concept of equal pay for equivalent work to account for differences in occupations and working conditions, but women still have a long way to go to achieve pay equity. The most significant obstacles to achieving pay equity are the presumptions that work has a gender, that women's work has less value than men's work, and that women have no business stepping out of the traditional woman's sphere and entering the working world of men. Given the success of women in 'male' jobs, from Supreme Court Justice to NASA astronaut, it is disappointing that pre-judgments about the nature of work and women's ability

to perform successfully in a wide variety of occupations remain powerful influences in society at large.

Title VII of the Civil Rights Act of 1964 prohibits discrimination in public accommodations. The original law did not include sex in the list of protected classifications. As the law was being debated, a segregationist member of Congress from Virginia, Howard W. Smith, proposed that the title be amended to include sex. He assumed his amendment would kill the bill, but it passed with the amendment intact, thanks largely to the efforts of representative Martha Griffiths of Michigan. At first, civil rights leaders were not happy with the amendment, assuming it would dilute efforts to ensure equality for African Americans, but they ultimately hailed the law passed in July of 1964 as a major victory for the broader cause of equality. It has taken decades and numerous court battles to achieve a greater degree of equality in the work force for women. The inclusion of women as a protected class was a success enabled by a poison pill amendment treated as a joke. Nevertheless, women have used the law to improve their circumstances in the workplace. We can look to the Lilly Ledbetter Fair Pay Act passed during the Obama Administration to ensure pay equity for women as a law that realized at least some of the promise of Title VII.

Before the word 'feminism' entered public discourse to the delight of some and the derision of others, conservatives around the world, many of whom had formerly defined themselves as liberals or even as radicals, took aim at women's liberation as a distraction from the progress made by advanced industrial societies that furthered liberal goals. In the United States, a group of influential authors and public intellectuals abandoned liberalism for a new ideology called neoconservatism. Writing in *The New York Times*, Douglas Martin described the views of neoconservatives in the second half of the 20th century: 'Cutting their teeth on leftist politics in the 1930s and '40s, they settled into anti-communist liberalism in the 1950s

and early '60s. Jolted by the turbulence of the student and women's movements, they later broke from liberals to embrace a new form of conservatism – championing traditional social values, limited free-market economics, and muscular American foreign policies – that reached its zenith in the early 21st century in the administration of George W. Bush'.

One of the most strident neoconservative voices in the post-1960s United States was Midge Decter. A writer and editor, Decter was most closely identified with the neoconservative magazine, *Commentary*, edited by her husband, Norman Podhoretz. Decter assailed liberalism, claiming that it was an elitist ideology that paid no attention to the needs of everyday people. An anti-feminist, she wrote that motherhood was a woman's biological destiny and that women who chose not to bear children were not liberated from their own self-hatred. Decter published tirades against affirmative action and homosexuality, the most famous of which was 'The Boys on the Beach,' published in *Commentary* in September of 1980.

Decter argued that feminism, by empowering women, emasculated men. Her vision of society relied on a masculine presence as the head of a nuclear family with women happily caring for their husband and children. She argued that feminism upended traditional marriage, diminishing the responsibility that men have as heads of their families. This, she saw, had a deleterious effect on the diminishing maturity of men in the new feminized society. Writing in *The Nation* in 2022, Jeet Heer characterized Decter's view of men's and women's roles in the household as she described them in her 2001 memoir, *An Old Wife's Tale*: 'As an ardent anti-feminist, Decter fully approved of the division of gender labour whereby the men are the arrogant bucks who fight to make it while the women are content to become doting old wives'.

Decter's reactionary anti-liberal views with regard to women's place in society resonated with a conservative movement whose seeds

were germinating just as Second Wave Feminism was emerging. Feminists barely had a moment to articulate their basic ideas to each other and the public when they came under a forceful attack so effective that the word 'feminist' was itself an insult and feminists were demonized. Everyday women who supported feminist goals such as political and economic rights and reproductive freedom found themselves saying, 'I'm not a feminist, but ...'[302]

Starting in the 1970s, there was a concerted and powerful campaign to delegitimize the goals of Second Wave Feminism, some of whose principal actors were women. This effort represented a backlash against legal and societal developments that advanced the rights and status of women. In spite of the contentious battles over busing to achieve school integration that occurred in cities such as Boston, Massachusetts and Yonkers, New York, the basic goals of the Civil Rights Movement were accepted, if not fully embraced, in society in general. And eventually schools were at least nominally integrated.

Conservative strategists such as Paul Weyrich, a founder of the Heritage Foundation, were eager to turn the public away from the liberalism of the 1960s and toward politics based on a conservative definition of morality. In collaboration with evangelical salesman Jerry Falwell, Weyrich told Americans it was time they rejected war protesters, hippies, and advocates of women's liberation. The Moral Majority, which symbolized the backlash against liberalism and women's progress against patriarchy, attracted followers, including southern White conservative women who were happy to accept the status quo, or, better yet, return to an America of the past, rather than struggle for change in an uncharted future. In 1991, Susan Faludi published *Backlash*, in which she laid bare many of the legal, institutional, and cultural aspects of American life in which the feminist goal of full equality had not been reached. With no small touch of irony, she noted that the barriers to women's equality had fallen because 'Women have 'made it, 'Madison Avenue

cheers". Women's fight for equality has 'largely been won', *TIME* magazine announces. Enrol at any university, join any law firm, apply for credit at any bank. Women have so many opportunities now, corporate leaders say, that we don't really need equal opportunity policies. Women are so equal now, lawmakers say, that we no longer need an Equal Rights Amendment. Women have 'so much', former President Reagan says, that the White House no longer needs to appoint them to higher office. Even American Express ads are saluting a woman's freedom to charge it. At last, women have received their full citizenship rights'.

Of course, any supporter of Second Wave Feminism in the 1970s and after would recognize Faludi's satirical critique of so many aspects of society. When Virginia Slims cigarettes declared, 'You've come a long way baby', the cheery tone of the commercial rang hollow for women around the world who had endured being abused, insulted, rejected, and, worse yet, ignored for so many years. Faludi described the antipathy to women's equality as a backlash, a historical phenomenon that reappeared every time women made advances in society. 'One element of the backlash was a coordinated campaign to let women know that their lives would not be improved with their new-found freedoms and that they would be in even worse shape if the goals of the 'women's libbers' were realized'. In short, feminism was the cause of women's misery'. Faludi reminded her readers that evidence of women's despair was everywhere, at the newsstand, on the TV set, at the movies, in advertisements and doctors' offices and academic journals'. 'Professional women are suffering "burnout" and succumbing to an "infertility epidemic". Single women are grieving a "man shortage", *The New York Times* reported: Childless women are 'depressed and confused' and their ranks are swelling. *Newsweek* said: 'Unwed women are hysterical and crumbling under a profound crisis of confidence.' The health advice manuals inform: high-powered career women are stricken with unprecedented outbreaks of

'stress-induced disorders', hair loss, bad nerves, alcoholism, and even heart attacks. The psychology books advise: Independent women's loneliness represents 'a major health problem today'.'[303]

Faludi's presentation of the backlash against women was ironic, but her points were well-taken. There is a history of language employed in the media and academic writing that ascribes women's weaknesses and inferiority to their 'nature'. For centuries, women have been told that they respond to difficulties by becoming hysterical; that education will distract them from their true nature as wives and mothers; that women are desperate to marry and have children; and that independent women are inappropriately competing with men in a way that creates psychological problems for them and emasculates the men in their lives. Such languages pervaded Farnham and Lundberg's *Modern Woman, The Lost Sex* in the immediate post-War period when the only path to happiness for middle-class White women seemed to lead to a single-family house in the suburbs.

A gentler but equally insidious aspect of anti-feminist backlash that appealed to women's desire to be loved and cared for was apparent in Marabel Morgan's *The Total Woman*, a 1973 self-help book in the image of the 1950s magazine advice columns directed at women. The book was a follow-up to Morgan's Total Woman classes in which she taught women 'how to be seductive and outwardly submissive so as to get whatever they wanted from their stern or indifferent husbands, most of whom had chronic roving eyes and/or wallets covered in cobwebs'. Her lessons focused on showing women how to use their sexuality to control the behaviour of their men and keep them happy at home.

Why was it necessary for modern women to go to extremes to hold on to their husbands? Morgan's answer was simple – it's a tough world out there. She wrote, 'Many a husband rushes off to work leaving his wife slumped over a cup of coffee in her grubby undies. His once-sexy bride is now wrapped in rollers and smells like bacon

and eggs. All day long he's surrounded by dazzling secretaries who emit clouds of perfume'. What woman would not want to avoid such a calamitous picture of married life?

Morgan argued that the remedy for this dire circumstance was not changing men's behaviour, nor was it providing child care, employment training, or professional education so women could take their place in the work force. Rather, she stressed the importance of using the one weapon all women could possess, their sexuality, to keep their men interested and under control at home.

Women flocked to Morgan's classes, and her book sold over ten million copies, keeping the Total Woman in the public eye throughout the 1970s. Morgan appeared frequently on television talk shows and at churches and women's clubs. She dedicated the book to Anita Bryant, the 1970s spokesperson for the Florida Citrus Commission who turned her celebrity into a crusade against homosexuality based on her personal religious beliefs. Morgan's advice resonated with White Christian women who believed that submission to one's husband was a biblical requirement and a benefit for them. For Morgan and her Total Woman followers, femininity, not independence, was the key to a woman's identity. Only with sexy clothing (no pants suits here!), high heels, perfect makeup, and well-styled hair, was the Total Woman prepared to repress her own desires in favour of those of her man. Once she made the choice to belong to someone else instead of herself, she was assured happiness. Morgan asserted that it is only when a woman 'surrenders her life to her husband, reveres and worships him, and is willing to serve him, that she becomes really beautiful to him. She becomes a priceless jewel, the glory of femininity, his queen'![304]

Morgan argued that following her programme would bring practical benefits and that, rather than serving her husband as a lesser being, a Total Woman actually enhanced her power through carefully-choreographed seductive behaviour. She wrote that a

Total Woman 'is not a slave. She graciously chooses to adapt to her husband's way, even though at times she desperately may not want to. He in turn will gratefully respond by trying to make it up to her and grant her desires. He may even want to spoil her with goodies'. Of course, Morgan created her programme to serve the needs of married women, as she regarded marriage as appropriate and any other status for a women as abnormal.

Marabel Morgan encouraged women to fight for their survival in the hearts of their men, but there was a bigger battle raging for the political soul of America. Weyrich and Falwell understood the power of a woman who could speak their conservative truth, arouse their anger at 'women's lib', and reassure them that they were better off without an Equal Rights Amendment. Susan Faludi analysed the struggle to undermine 1970s feminist advances, arguing that reproductive rights and involvement in public life were both under attack.

This backlash came in large part from feminist anti-feminists: conservative women who had carved out careers and names for themselves – traditionally feminist goals – by attacking feminism. Women like Phyllis Schlafly and Beverly LaHaye (a conservative activist and founder of Concerned Women for America) accumulated power and got out of the house by telling women their place was inside of it. Men in the conservative movement realized that one of the best ways to attack feminism was to get women to do it'.[305] Women fighting women served the needs of conservative men who sought a way to discredit Second Wave Feminism. What better way to do this than to have prominent women discredit the radical, bra-burning, man-hating, lesbian women who called themselves feminists?

The anti-feminist conservative crusade needed a spokesperson with traditional Republican Party credentials who could legitimize their radical mission. That voice for conservativism's Moral Majority

was Phyllis Schlafly. According to author Ilyse Hogue, by the 1970s, Schlafly was already hard at work, mapping an entirely new way to stoke right wing fear, outrage, and political activism. Until that radical conservative force was unleashed in the late 1970s the Republican Party had been solidly supportive of equal rights for women. Both Presidents Nixon and Ford championed the ERA, and most leaders were pro-choice, but Schlafly saw an opportunity to change that.

With racist discourse in the style of George Wallace no longer the effective tool it had once been to rouse the religious conservative electorate, Schlafly understood that women's liberation could be cast as the evil that oppressed women and disadvantaged men. She found in misogyny a powerful weapon to stop women's liberation in its tracks.[306] Schlafly, herself a liberated woman with a successful career, was a Washington University (St. Louis) and Radcliffe College (Harvard University)-educated woman who bore six children while studying for a law degree. Schlafly's husband, Fred, was an attorney for the Olin Corporation, a major chemical manufacturer and supporter of conservative causes. Schlafly's *Eagle Forum* described Fred as an ideal partner who epitomized what it meant 'for a husband to support his wife. He fully supported Phyllis financially, emotionally, intellectually, and spiritually. Fred made it possible for Phyllis to do all of the things that she did: write books and columns, lobby legislatures, speaking and media appearances, and start a movement. Her tremendous success was enabled by her marriage to Fred Schlafly. He was her biggest champion'.[307]

Once the Equal Rights Amendment was passed in Congress, Schlafly tapped into women's anxieties about changes that might happen in their lives if ratification were to occur. Her supporters consisted largely of southern White middle-class women who feared social advances made by African Americans; evangelical women and men who feared that a modern America would be a godless America; and working-class women who had none of the educational

advantages of many feminists and would themselves never make it into the middle class. Her primary weapons were fear and a sense of grievance. Schlafly laid the groundwork for the post-2010 emergence of radical conservatism founded on hatred, first espoused by the Tea Party and later by MAGA ('Make America Great Again') supporters of Donald Trump.

Schlafly propounded her own version of equal rights for women, saying, 'A woman should have the right to be in the home as a wife and mother'. Of course, the Equal Rights Amendment did not preclude a woman's choice to be a wife and mother, but Schlafly's rhetorical excess and willingness to subvert the truth convinced many women that the ERA was inherently bad for them. She frequently began her public speeches by thanking her husband for giving her permission to attend the rally because doing so 'irritates the women's libbers'. A firm believer that biology is destiny, that men and women are fundamentally different, and that their functions in society are frozen in custom and convention, Schlafly believed that twentieth century women held a position of privilege that would be eroded by the ERA. She appealed primarily to White women's sense of security in the comfortable suburban world they had attained or aspired to inhabit. African-American women, many of whom did not feel that sense of security, felt less drawn to Schlafly's position. There is an unstated but clear element of racial anxiety in Schlafly's campaign that appealed to her audiences. With the welfare and economic opportunity programmes of the Great Society providing benefits for African-America women, some White women feared a loss of status in society because of the federal government's aid to Black women, presumably, but not actually, at their expense.

Schlafly appeared to be a grass-roots advocate for women. In fact, she was well-educated and well-connected. In the 1950s, she had worked as a researcher at the American Enterprise Association (later the American Enterprise Institute), a pro-business and anti-liberal

organization whose briefings for legislators fuelled the Cold War anti-communism that dominated politics in the 1950s. Committed to right-wing causes, she self-published *A Choice Not an Echo*, an attack on liberal Republicans like Nelson Rockefeller, an East Coast Republican whose views aroused the suspicion of more conservative Republicans from the west. In 1964, she supported the presidential campaign of Arizona Senator Barry Goldwater, who appealed to conservative voters with a slogan that contained an obvious pun, 'In your heart, you know he's right'.

A prominent voice in conservative politics by the mid-1960s, Schlafly took up the cause of traditional family values, which made it imperative for her to stop the ERA. In doing so, she filled a gap left largely empty by the language of women's liberation that stressed the progress of the individual woman rather than her role as the mainstay of her family. Schafly founded STOP ('Stop Taking Our Privileges') ERA in 1972 and began to publish *The Phyllis Schlafly Report* to spread her message throughout the country. Through her speeches, publications, and lobbying efforts, Schlafly helped to derail the amendment and advance her own career. In the February, 1972 issue of *The Phyllis Schlaffly Report*, she declared that, 'Of all the classes of people who ever lived, the American woman is the most privileged. America respects the family as the basic unit of society... Women are accorded special respect dating from the "Christian Age of Chivalry"; and because the free enterprise system has created remarkable inventors who have lifted backbreaking women's work from our shoulders'. After asserting disingenuously that the ERA would require women to submit to the military draft, promote homosexuality, and mandate co-ed bathrooms, Schlalfy levied her sharpest attack against the amendment: 'It's time to set the record straight. The claim that American women are downtrodden and unfairly treated is the fraud of the century. The truth is that American women never had it so good. Why should we lower ourselves to

"equal rights" when we already have the status of special privilege?'[308]

In 1975, Stop ERA was renamed the Eagle Forum, and Schlafly continued to represent the right wing of the Republican Party. When the Equal Rights Amendment failed to gain the requisite ratification votes in state legislatures, Schlafly hosted a victory party. According to the *Washington Post*, she received a congratulatory telegram from Ronald Reagan, and 'the band played "Ding, Dong, the Witch is Dead"'. *Conservative Digest* editor John Loften, who wore dark glasses and a striped party hat, put it this way: 'We're here to celebrate a death, to dance on a grave'. The assault on feminism, on women's rights, and government efforts to protect those rights was well under way.[309]

Schlafly's campaign was part of a well-organized and powerful political action committee led by Jerry Falwell. The Moral Majority espoused what it called family values rooted in White Christian theology and the conservatism of the Republican Party. In addition to attacking feminists as 'anti-family', the Moral Majority worked to elect a new breed of Republicans who were hostile to the reforms of the 1960s and 70s, including the Equal Rights Amendment. Falwell declared that the Moral Majority was fighting a holy war. He told a church audience in Lynchburg, Virginia in 1980 that, 'We have to lead the nation back to the moral stance that made America great ... we need to wield influence on those who govern us'. [310]

The Moral Majority's apocalyptic rhetoric emphasized the need to return to an America of nuclear families, men in the workplace and women in the home, and well-behaved children who obeyed their parents and never challenged the authority of America's government or institutions, much less that of their parents. Its speakers explicitly blamed Second Wave Feminism for the evils that afflicted America – gay rights, secularism, sexual freedom, the disintegration of the family, divorce, abortion, and the overall moral decline in the nation. The Moral Majority actively campaigned in 1980 for Ronald Reagan,

who was elected President of the United States by a wide margin. It also influenced Republican Party policy, specifically its increasingly strong support for school prayer and against access to abortion. Reagan's version of America was nostalgic and anti-feminist, and his rise to prominence in the Republican Party coincided with the popularity of the Moral Majority.

But not everyone agreed that America was bereft of values and needed to be restored to an idyllic past that probably never existed in the first place. A popular bumper sticker declared at the time that 'The Moral Majority is Neither'. While definitions of morality might differ, it was clear in 1980 that Falwell's group never constituted a majority of the population in the United States. But the influence of the Moral Majority and other well-funded Christian, White, pro-American, anti-feminist groups has only grown more powerful since the 1980 election. That power has come in large part because of backing from wealthy conservatives who were intent on creating a new political landscape. Falwell, Phyllis Schlafly, Pat Robertson, and National Rifle Association spokesman Wayne La Pierre were all part of the Center for National Policy, which has been described as 'a little-known club of a few hundred of the most powerful conservatives in the country', illustrating that the power of a group defined by money can wield influence far in advance of its numbers.[311]

In the 1970s, gay men and women came under particularly strong attack from Christian organizations and the political right. For decades, gay men and lesbians had been subjected to societal scorn, government restriction, and police harassment. They were denounced from conservative Christian pulpits and beaten in carefully orchestrated police raids on their bars and clubs in America's cities. Many homosexual men and women remained closeted, and the conservative backlash against rights for African Americans and women contributed to a climate of extreme tension for homosexuals.

By 1969, gay activists in New York City had had enough and they

fought back. Police officers raided the Stonewall Inn, a popular bar in the West Village because it operated without a liquor licence. The proprietors of Stonewall were unable to obtain such a licence because the New York State Liquor Authority refused to grant them to bars that catered to gay men. As patrons were arrested, they were required to wait outside the bar in handcuffs as there were not enough squad cars or police vans to transport them to the local precinct. The crowd of patrons and neighbourhood onlookers grew. It's not clear who threw the first punch or struck the first blow with a billy club, but the violence that ensued was definitely a riot. The uprising at the Stonewall Inn on 28 June 1969 sparked a powerful movement for gay rights that, by the 21st century, produced such results as the legalization of gay marriage and statutes that outlawed discrimination on the basis of sexual orientation. At the same time, lesbian groups, many of which had been active within and outside of mainstream feminist organizations, assertively called for an end to discrimination on the basis of sexual orientation. Today, the movement for gay rights continues its quest for full societal, as well as legal, equality.

The early steps toward a gay rights movement brought forth a powerful backlash, as religious and other anti-gay groups mounted a concerted effort to inhibit progress toward equality based on sexual orientation. In the 1970s, one of the most powerful and most public voices belonged to Anita Bryant who was known to the public as a popular singer and spokesperson for Florida orange juice starting in 1969. She cultivated a clean-cut image as a mother whose primary concern was the protection of her children. In 1977, Dade County Florida passed a resolution outlawing discrimination on the basis of sexual orientation, and anti-gay forces quickly went to work to 'educate' the public on the presumed dangers of homosexuality. At a local meeting about the resolution, Bryant asserted her right as a mother 'to control the moral atmosphere in which my kids grow

up'. Her 'Save Our Children' crusade was born. Bryant toured the country speaking in churches and other venues about the dangers of gay life. Supported by conservative minister and religious entrepreneur Jerry Falwell, Bryant proclaimed that her mission was to convince the American public that gay rights presented a slippery slope that would result in America becoming an ungodly nation. She promulgated the specious idea that gay people recruit children to become gay. She argued that 'if gays are granted rights, next we'll have to give rights to prostitutes, people who sleep with St Bernards, nail biters'. In 1977, Bryant was voted America's Greatest American by the National Teenage America contestants at their competition in Atlanta, which Bryant visited, to the delight of the future beauty queens. She herself was a former Miss Oklahoma.

Not surprisingly, Bryant's crusade attracted protests. Gay activists picketed her speaking engagements, and she was even hit in the face with a banana cream pie. In response, she said, 'I don't hate homosexuals. I pray for them'. Bryant claimed that major media outlets were ignoring her, but she continued to appear at religious events and even made an appearance on the Today Show on national television. Bryant's ability to spread her message was hurt by negative publicity. Her railings against gays seemed out of touch with the emerging embrace of equal rights in American society, even in the midst of a conservative renaissance. The Florida Citrus Commission allowed her contract to lapse in 1980 after an orange juice boycott reduced sales by 10 per cent, and she was not able to find a record company to produce and market her latest song, 'There's Nothing Like the Love Between a Woman and a Man'. Bryant remains a symbol of homophobia and hatred. Nevertheless, she was inducted into the Florida Citrus Hall of Fame in 1988. In the end, Bryant's crusade actually helped the cause of LGBTQ rights. In 2014, graphic designer and gay rights activist Andrew Wood wrote, 'Thank God for Anita Bryant, because she really brought things to a head through

her hate and intolerance. When she started her campaign, it really brought it into the media. People started really paying attention'.[312]

The battle continues in the courts, even as those rights are now for the present mostly assumed in the court of public opinion. That same campaign of hatred placed the advances made by women in the 1960s and 70s clearly in its sights. Antifeminism relied on popular fear, anger, and anxiety about the entry of women into public life that was presumed to be the domain of men. It was also manifest in jealousy regarding some women's presumed privileges, a defence of tradition, and assertions that men have rights too. Men's Liberation Groups have found a place on the Internet to vent their anger at women. These groups have a dark side whose proponents even advocate violence against women. Donald Trump's 2016 'Lock her Up' chant in reference to Hillary Clinton that animated huge crowds at his campaign rallies is only one manifestation of this anti-female animus.

By the 1970s, circumstances for women who powered the offices of American corporations by operating telephones and typewriters gained the attention of union organizers. There were twenty million women in the American office workforce by the early 1970s. Women faced low pay, especially in comparison to salaries of male workers whose jobs were no more glorified. They also faced subtle and obvious sexual harassment and demeaning treatment from bosses who called them 'girls' and expected personal services and sexual favours from them in addition to their skill at typing letters and taking dictation. Like flight attendants, women office workers were expected to dress to please their bosses. Any complaint or challenge to the status quo could lead to immediate termination.

In 1971, office workers in Boston founded 9 to 5, an organization dedicated to improving the lives of working women through union organizing. Ellen Cassedy, a founder of 9 to 5, remembered that she and her colleagues 'sensed that we had our finger on the pulse of

something big. We considered ourselves to be the heirs of the garment workers at the turn of the twentieth century, immigrants, teenagers, who went on strike by the tens of thousands and transformed the labour movement. Their slogan was Bread and Roses. Our slogan became Raises and Roses'.

Organization leaders spent considerable time listening to the concerns of 9 to 5 members. They developed a strategy that focused media attention on issues of pay inequity, sexual harassment, the absence of medical leave, and the need for medical insurance. They exerted pressure on government agencies that had the power of enforcement in cases of workplace discrimination. 9 to 5 became a national movement and encouraged women to organize new chapters of existing trade unions such as the United Auto Workers and to form independent unions of office workers. Most important, 9 to 5 brought public attention to the plight of working women, especially through the popular film of the same name that was inspired by the workers' success.[313]

Historically, few women, except perhaps the very wealthy, had practical rights in civil society, as they could not vote, hold property, or even retain custody of their children. Women were, in fact, 'covered' by a father, husband, or other male relative who could speak and act for them. If the concept of the *femme couvert* was intended to protect middle-class women, life for working-class women was even more exploitative. During the first decades of the Industrial Revolution, women and children provided cheap and controllable labour in the emerging factories. Their wages were low, the conditions of labour were horrific, and there was no legislation that protected them from the worst abuses, including sexual exploitation, of factory owners.

Arguments against women's suffrage and women's rights in both the United States and Europe were based in large part on the idea that a woman had neither the knowledge nor the mental capacity to participate in politics; that it was against a woman's nature

to participate in the 'dirty' world of politics; and that women did not want to vote and would stay home on election day, anyway. Interestingly, there were women who supported neither suffrage nor women's political and economic rights. In an argument that would be echoed a half century later by Phyllis Schlafly and other opponents of the ERA, some female anti-suffragists claimed that greater rights would erode a (middle-class) woman's privileged position in society.

Hostility to feminism and women's rights has a long history around the world. In Britain, the *Women's National Anti-Suffrage League*, created on 21 July 1908, claimed 42,000 members. In Germany, the *Bund zur Bekampfung der Frauen Emanzipation* (League for the Struggle Against Women's Liberation) was a much smaller group of only 5,000 members of Germany's upper class in 1912, but 20 per cent of those members were women. This group's emphasis on traditional German values foreshadowed the Nazi Party's focus on keeping women in a place defined by men. According to Christine Bard, the Bund's discourse was 'nationalist, pan-German, and anti-Semitic'.[314] '

In Europe, the 1930s and 1940s did not see significant progress for women's rights, even though women in many countries stepped out of traditional roles to work in factories or serve in the military with the expectation that they would return to their 'normal' place in the home when economic and political circumstances permitted. The women who remained at home saw their lives described in terms that emphasized their value to the state. For example, women in Germany's Third Reich were frequently described as mothers who would educate the next generation of German children. In Vichy France and other nations, women served a similar purpose, even as some were active in the resistance to Nazi rule. The daughters of the Second World War generation successfully overturned traditional roles and conceptions of a woman's value, but the changes wrought by women in the 1960s and 1970s came under attack and are still

contested as antithetical to women's 'true' nature.

Reproductive autonomy was and remains one of the most important issues that has animated women for the past century. From Margaret Sanger's crusade to provide contraceptive services to immigrant women on New York's Lower East Side to struggles to ensure that contraception is paid for under insurance plans in Europe and the United States to the recent *Dobbs* decision that deprived women of a right they had possessed since the 1970s, a woman's right to choose whether or not to carry a pregnancy to term is a paradigmatic example of the most personal issue becoming political all over the world.

Just as access to abortion was a catalyst for the emergence of Second Wave Feminism in many countries in the early 1970s, a woman's right to control her reproductive life came under attack by religious and other groups in Great Britain. The Society for the Protection of Unborn Children was founded in January of 1967 in London as a response to debates in Parliament over a law that allowed abortion to protect the life or health of the mother within the first twenty-four weeks of pregnancy. Two doctors had to agree on the necessity for the procedure under specific criteria stipulated by the law. This legislation passed and was effective as of 28 April 1968. The Society began its campaign against abortion and today remains the UK's largest 'pro-life' organization. With sixty chapters throughout Britain, the Society for the Protection of Unborn Children also opposes euthanasia, assisted suicide, and *in vitro* fertilization, according to its website. It draws its resources through a well-organized fund-raising campaign online and through its constituent chapters. The Society holds annual conferences for young people to promote its anti-abortion and anti-contraception message.

The history of anti-abortion activism since the 1970s in Ireland has its roots in the activities of the Catholic Church and anti-abortion activists in the United States. After the ruling in *Roe v Wade*, American

anti-abortion crusaders looked for a victory and saw in Ireland a country that had not yet succumbed to the permissiveness of the sexual revolution. According to Fintan O'Toole, they saw Ireland as 'one island of sanctity, one place where church and state were still so entwined that government could be relied on to enforce religious dogmas as civil and criminal law. If Ireland could continue to hold its head above the rising waters of depravity and decadence, the tide of sexual and reproductive reform then sweeping the Western world could be held back – and ultimately turned'.

The American Catholic Church and anti-abortion organizations sent speakers to Ireland to rail against abortion and scare women who took oral contraceptives by claiming they caused a variety of dangerous, even lethal, side effects. Ultimately, anti-abortion forces influenced Parliament to amend the country's constitution to ban abortion. But the Eighth Amendment to the Irish Constitution did not prevent women from terminating their pregnancies, either by travelling to England or seeking dangerous and illegal abortions at home. The Church won, but women died. O'Toole observed that the goal of the amendment was 'to use the emotive issue of abortion as a bulwark against social change. It was intended to control the future, to project the power of conservative Catholicism forward into the distant decades. It was meant to act as an impossible boundary beyond which Ireland could never go'.[315] But the realities of Irish life subverted the conservatives' goal of banning abortion and contraception, both of which were seen as necessary to women's full participation in the economy and civil society. In 2018, the Irish people voted to repeal the Eighth Amendment.

In France, *Laissez les vivre* (*Let Them Live*), an anti-abortion association, was founded in 1971 to promote 'the specific value of all human life which must be respected from conception until natural death'. For half a century, the organization has encouraged pregnant women to carry their babies to term while distributing

anti-abortion propaganda. *Let Them Live* has opposed legislation supporting abortion at any stage of pregnancy. This extreme position is predicated on two ideas that have gained currency in conservative circles in recent decades: first, that life begins at conception rather than at birth; and, second, that any attempt to terminate a pregnancy at any time *a priori* constitutes murder. This position takes the issue of abortion out of the realm of personal choice and out of the realm of medical practice, as it denies women the right to make their own reproductive choices and contradicts mainstream medical opinion that life begins at birth. In the view of *Laissez les vivre,* abortion is a crime that must be dealt with by the criminal justice system. Since 1975, the group has utilized telephone hotlines throughout France to encourage pregnant women to carry their babies to term. In 1979, *Laissez les vivre* collaborated with the National Association of Catholic Families to bring 40,000 demonstrators to a march from Montparnasse to the National Assembly. Three years later, 30,000 supporters marched from the former location of the Bastille to the Place de la Concorde to protest the Roudy Law that allowed for the reimbursement of abortion costs by the national insurance plan. Since the 1980s, members have participated annually in a March for Life in Paris to publicize their position.

In France, abortion remains legal but not guaranteed throughout pregnancy. The Veil Act of 1975 decriminalized the procedure but permitted it only until the tenth week. The law was renewed permanently in 1979. In the wake of the United States Supreme Court's decision in *Dobbs*, the French Parliament is considering guaranteeing the right to reproductive freedom by amending the country's constitution. In spite of active resistance from anti-abortion groups in France, abortion is now generally accepted on all sides of the political divide. According to Pamela Druckerman, writing in *The Atlantic*, access to abortion in the first weeks of a pregnancy no longer faces 'any significant political opposition in France. On the

centre right, a party seen as representing traditionalist Catholics, Les Républicains, has shrivelled in political significance. Even Marine Le Pen, the leader of the far-right National Rally party, who made some noises against abortion in the past, now sees no advantage in doing so. When asked if she herself would support a constitutional amendment on abortion, Le Pen groused about how France isn't the US and no party envisions changing the abortion law, but conceded, "*Pourquoi pas?*"' Why not?[316]

The conservative American Center for Law and Justice describes itself as 'strongly pro-life' and 'Christian-based'. Founded in 1990 by conservative Pat Robertson, the ACLJ declared that its mandate was to 'protect religious and constitutional freedoms' utilizing a strategy of 'advocacy, education, and litigation' on behalf of individuals and organizations in the United States and abroad. This definition of religious freedom emphasizes the ability for Christians not only to exercise their freedom to worship as they choose but also the right to impose what they consider 'Christian values' on society. Bringing Christianity, or any religious ideology, into the realm of secular society contradicts and undermines the principle of the separation of church and state first articulated by Thomas Jefferson in 1804 and long considered a bedrock principle of American democracy.

The ACLJ, which intentionally crafted its name to be similar to that of the American Civil Liberties Union (ACLU), has affiliates in Israel, Russia, Pakistan, South Korea, and Zimbabwe. The ACLJ devotes itself to issues of national security, judicial nominations, and patriotic expression as well as their version of religious freedom. Sample cases brought by the ACLJ include a challenge to a Kenyan law that permitted abortion and the proposal to build an Islamic Cultural Centre near the site of the World Trade Center in New York City. Since 2011, the ACLJ has been funded largely by the family of director Jay Seculow, at one time a personal attorney for Donald Trump. The family funds the Christian Advocates Serving

Evangelism (CASE). CASE and other conservative organizations supported the appointment of conservative Supreme Court justices during Donald Trump's presidency in the hope that the Court's new super-majority of conservative justices would overturn *Roe* and be receptive to other conservative demands for restrictions on individual freedom, particularly for women, members of underrepresented minority groups, and members of the LGBTQ community.

A 2023 Supreme Court decision that allows individuals to deny services to members of the LGBTQ community on the basis of 'religious freedom' is an example of the attempt on the part of American conservatives to bring religion into the public sphere. A bill passed in the same year in the Texas state legislature permits individual school boards to replace guidance counsellors with religious personnel who would serve as chaplains in schools. The law does not require these chaplains to be ordained nor does it stipulate that they have any formal state certification. In the midst of a mental health crisis that affects school-age children profoundly, this measure, like those that support the new definition of 'religious freedom', brings religion into areas of American life never anticipated by the framers of the Constitution.[317] Legislatures and courts have accepted a completely different version of the Constitution's first amendment that declares that Congress may not impose a state religion on anyone, nor may it inhibit the free exercise of religion. Freedom of religion is now being used to inhibit the freedom of those we do not like.

The Alliance Defending Freedom (ADF) also opposes abortion in Europe and the United States. The organization's website says it is a 'world leader in defending religious freedom, free speech, the sanctity of life, parental rights, and God's design for marriage and family'. The organization has inserted itself into a variety of court cases opposing abortion and supporting doctors who claim their religious or moral principles allow them to refuse to provide

contraception to their female patients. In addition, ADF spends about 300,000 Euros each year on lobbying efforts. Heartbeat International is another conservative Christian organization that lies to women. According to the research group Open Democracy, Heartbeat International volunteers have told women that 'having an abortion can cause cancer and that having a baby can cure serious illnesses, including leukemia'. This group also promotes the use of an 'abortion pill reversal', a dangerous and unapproved procedure designed to reverse a medical abortion.[318] Heartbeat International's extensive propaganda campaign targets and frightens women at a vulnerable time in their lives with false information. Lies and fear are strong motivating forces that attract women to movements whose goals are far from progressive.

Since the 1970s, in addition to demanding access to abortion and contraception, irrespective of marital status, American women demanded equality in a variety of other areas, most notably educational opportunities. In the 1970s, the United States Congress took action, after much contentious debate, to prohibit discrimination in education on the basis of sex. On 23 June 1972, President Richard Nixon signed Title IX of the 1972 Education Amendments into law. Hailed as a landmark piece of legislation, Title IX says, 'No person in the United States shall, on the basis of sex, be excluded from participation in, be denied the benefits of, or be subject to discrimination under any education programme or activity receiving Federal financial assistance'. Like other civil rights legislation, Title IX was vague, as it defined neither participation, benefits, nor discrimination. But there was no question that the addition to the country's body of law on sex discrimination was necessary.

In *United States v Virginia* (1996), a case about gender-based college admissions filed under Title IX, the Court ruled that the Virginia Military Institute's policy of male-only admission violated the Fourteenth Amendment's equal protection clause and was, therefore,

unconstitutional. In the majority opinion written by Justice Ruth Bader Ginsburg, the Court declared that the United States 'has had a long and unfortunate history of sex discrimination'. In the 1970s and 80s, many single-sex institutions open their doors to co-education with little fanfare and no disruption of educational content. Rather, the biggest issue on many newly-integrated campuses was how to house men and women in the same dormitories. This was another issue that passed quickly through the headlines and hand-wringing editorials with students devising creative and respectful ways to inhabit the same dormitories. Decided twenty-four years after the enactment of Title IX, *United States v Virginia* was a step toward gender equality in education, albeit a delayed step.

The Department of Justice described conditions for women in higher education prior to Title IX: 'Before Title IX, women were often excluded from or had only limited access to educational programmes. Seven elite colleges and universities set quotas for the admission of women or prohibited them from attending altogether; those that accepted applications from women often required higher test scores and grades for their admission. Once admitted to schools, women had less access to scholarships; were excluded from "male" academic programmes, such as medicine; and faced more restrictive rules, such as early curfews, than their male peers. Discrimination extended beyond students; women faculty members were more frequently denied tenure than their male counterparts, required to take pregnancy and maternity leaves, or prohibited from entering faculty clubs'.[319]

In the early 1970s, women's groups lobbied for the passage of Title IX and have struggled in the fifty years since its passage to define its terms with greater precision and prevent efforts to weaken its enforcement. Prior to the passage of the law, only one per cent of college athletics budgets went to women's sports. In colleges and universities, the goal of Title IX was to establish greater equity

between athletic programmes for men and women and to improve access, training, coaching, scholarships, and facilities for female athletes.

Representative Patsy Mink is acknowledged as the major sponsor of the bill, which was re-named the Patsy T. Mink Equal Opportunity in Education Act on her death in 2002. Senator Birch Bayh of Indiana and Representative Edith Green of Oregon also played a major role in shepherding Title IX through Congress. From its inception, enforcement was weak, and colleges interpreted providing opportunities for women as a burden that would require cutting men's programmes. In 2022, the United States commemorated the fiftieth anniversary of the passage of Title IX of the Education Amendments of 1972 to the 1964 Civil Rights Act, but full equality in all areas of college life, particularly in sports, remains a goal not yet fully achieved.

In spite of efforts to subvert its original intent and purpose, Title IX has survived where the ERA and *Roe v Wade* ultimately failed. Where the Equal Rights Amendment was the clear target of Phyllis Schlafly's Eagle Forum and the access to abortion guaranteed by *Roe* faced opposition from religious and social conservatives, opposition to Title IX was more subtle. Within a year of the law's passage, Senator John Tower of Texas introduced an amendment that would have exempted 'revenue-producing sports programmes' from compliance with the law. The Tower Amendment did not pass, but it was an obvious attempt to shield sports like football and men's basketball from having to share resources or accept smaller budget increases in order to shift funds to women's programmes. This was the first of a series of attempts to weaken or eliminate Title IX.

In 1976, the National Collegiate Athletic Association (NCAA) sued unsuccessfully to have Title IX declared unconstitutional. In 1977, Senators John Tower, Bob Bartlett, and Roman Hruska re-introduced the Tower Amendment, but the amendment died in committee. The

Supreme Court limited the scope of Title IX to specific programmes that receive federal dollars. While allowing athletic scholarships, the *Grove City v Bell* decision effectively gutted all other aspects of Title IX that attempted to establish equity between men's and women's sports. Congress reversed the Grove City decision by passing the Civil Rights Restoration Act over President Ronald Reagan's veto in 1988, but support for women's athletics remains a very contentious issue. At about the same time, women at Yale filed a lawsuit that led to the creation of specific grievance procedures under Title IX relating to sexual harassment.

Over time, Congress passed additional laws that clarified the scope of Title IX and procedures for implementing its policies, but funding for agency enforcement has remained less than adequate to ensure compliance. A decision in 1996 reveals the extent to which stereotypes about women athletes persisted. In *Cohen v Brown University*, a federal appeals court upheld a lower court decision that Brown University was guilty of discriminating against women by providing unequal access to athletic programmes. Brown's defence was that the university was not in violation of Title IX because 'women are less interested in sports than men'. As recently as 2002, a number of collegiate wrestling associations and the College Sports Council filed a suit claiming that Title IX was unconstitutional. The suit was dismissed in 2004. In the wake of a conservative trend in the federal courts, recent clarifications of Title IX that relate to sexual orientation and gender identity have been the subject of presidential Executive Orders rather than legislation. Title IX remains in place but it is vulnerable to continuing modification and outright attack.[320]

Title IX transcended its original mission of providing greater access to education to transforming the landscape of school and college sports for girls and women. Where women comprised only fifteen per cent of college athletes before Title IX in 1972, they make up forty-four per cent of all collegiate athletes today. Fifty per cent remains an

elusive goal, but the achievements of the law and the positive impact of participation in sports on women and girls represent a genuine accomplishment. Both the strength and weakness of Title IX is its elasticity of interpretation, which has emerged more recently in the law's application to transgender athletes. Although fifteen states have passed laws restricting the participation of transgender girls in sports, the Department of Education has issued guidelines regarding transgender athletes. It will remain for the courts to sort out to what extent and how the law will apply.[321] Representative Mink's legacy lives on. In 2014, President Barack Obama posthumously presented her with the Medal of Freedom, the country's highest civilian honour.

The 1970s saw the passage of laws designed to protect women that revealed the extent to which such measures were needed as correctives to prevailing practices. In Great Britain, for example, Parliament passed the Equal Pay Act in 1970, but it did not go into effect until 1975, delaying women's progress toward equity in the workplace. The Employment Protection Act of 1975 protected women from termination as a result of pregnancy and also established a Maternity Fund to provide limited benefits for pregnant women. In the same year, Parliament passed the Sex Discrimination Act that established the Equal Opportunities Commission to hear grievances about employment discrimination on the basis of sex. The Domestic Violence and Matrimonial Proceedings Act of 1976 made it possible for a woman to obtain an order of protection against a battering husband, and the Housing Act of 1979 provided housing for battered women.

Slow and ineffective enforcement has contributed to a sense of disillusionment among feminists that the state could be a positive change agent, particularly in the area of pay equity and domestic violence, which have remained difficult, if not intractable, problems. Florence Binard observed that, in the workplace, employers delayed

compliance with protective laws, claiming that doing so would affect their profit margins and alienate their male employees who felt that women were gaining an unfair advantage. They soon found ways to 'avoid equality by altering the job contents so that comparisons between men's and women's work could not be done'. It was not until 1984 that wage parity was achieved for the Ford workers in Dagenham and today British women still earn less than men: the gender pay gap is 13.9 per cent'. The Domestic Violence Act did not apply to unmarried women and did not include such violence as marital rape which only became illegal in 1991. Above all, despite further legislation, violence against women in the workplace and at home has remained widespread. [322]

Feminists speculated that electing more women to political office and opening more corporate opportunities in the executive suite would humanize government and business as well as create greater equity in those realms. In the United States, the National Women's Political Caucus was founded in 1971 by Bella Abzug, Shirley Chisholm, Fanny Lou Hamer, Betty Friedan and other women committed to seeking out, training, and supporting women to run for public office. Today, the Caucus endorses and supports progressive and pro-choice candidates. The 2016 presidential campaign of Hillary Clinton represented a step forward in the effort to promote women' political ambitions. Despite her extensive experience in government, including a term in the Senate and a four-year stint as Secretary of State, Clinton's campaign aroused a particular type of gender-based hostility. Her opponent had a reputation for disrespecting women, and he explicitly gave his supporters permission to launch virulent and hateful sexist attacks against Clinton, who won the popular vote but lost in the Electoral College. In 2016, it was possible to wonder how far women had actually advanced in the political realm from the optimism of the 1970s.

Ronald Reagan became President of the United States in 1981

as the nation's pivot toward conservatism was in full swing. Early in his political career, Reagan had supported the Equal Rights Amendment and a woman's right to abortion, which, since 1973, had been protected by the Supreme Court in *Roe v Wade*. When Reagan ran against Jimmy Carter in 1980, the peanut farmer from the small town of Plains and former Governor of Georgia observed that 'Six presidents before me, and counting me, have all been for the Equal Rights Amendment'.[323] But clearly the political tide, along with Reagan's mind, was changing. The new president saw the future in conservative thinking that would restore the America of the past, free of protesters in the streets and loud women in pants suits in the workplace. Reagan's world view placed both men and women, or ladies, in traditional, mutually exclusive roles in society. This included women's role in marriage, which he regarded as focused exclusively on the home, especially when home was the White House. His second wife, Nancy, took her First Lady role seriously, updating the china and the décor and restoring the house to high society glitter after the alcohol-free years of Jimmy and Rosalind Carter. As both candidate and president, Reagan garnered support from the Christian Right and Jerry Falwell's Moral Majority, and he quickly took the evangelical anti-feminist agenda as his own.

He told his followers that it was time to reject the 'mistakes' of 1960s radicalism and 'turn to God and reassert our trust in Him for our great nation's healing. We need to join forces to reclaim the great principles embodied in the Judeo-Christian traditions and in Holy Scriptures'. Men and women alike were drawn to his nostalgic, faith-based vision of what he called 'morning in America'.

The Reagan administration proved to be profoundly anti-woman. Budget cuts in social programmes passed in 1981 that included Medicaid for poor families, Aid to Families with Dependent Children, food stamps, school lunch programmes, and job training initiatives affected single mothers and children directly. One million

poor Americans lost their benefits as their public assistance safety net was cut by twenty-five per cent. Throughout his administration, Reagan was out of touch with the needs and desires of the majority of American women. In a *Rolling Stone* article in 1982, just one year into the Reagan presidency, William Greider provided a cogent answer to the question 'What do women want?' American women who were in the workforce and who did not define themselves in terms of their faith, according to a number of polls, wanted a new political agenda that turns away from the 'mindless masculine reflexes of the Cold War and pursues more egalitarian, life-preserving objectives. Women want the madness of the nuclear arms race stopped. Women want the natural environment protected against man-made depredation. They want better living conditions for children and for the poor. They want handguns forbidden and Social Security increased. They oppose the draft and they oppose military adventures in foreign lands. They do not believe the 'free enterprise' conservatism of the Reagan government will benefit them. Women want an activist government that works to reduce the income gap between rich and poor'. Cuts in social services programmes, a brief but intense military adventure in Grenada, and a return to a masculine Cold War foreign policy ('Mr Gorbachev, tear down this wall'.) demonstrated that what women told *Rolling Stone* magazine they wanted did not reach the ears of the president or his advisors.

There was no room in the Reagan vision of America for such a liberal plan. Instead, Reagan pursued a conservative economic and political path. Women's issues were not on Reagan's agenda. Still, throughout his administration, he believed that 'the gals' loved him. The validation of this idolatry, according to Greider, came from Reagan's wife, Nancy, who 'doesn't threaten his masculinity. She wants only to serve him, at least in their public performances. Everywhere they appear, she stands by his side, beaming up at him with pride, hanging on his every word. For many men, Nancy

behaves just the way they wish their wives would behave (only their wives don't)'. According to psychiatrist Joseph Hertzberg, Reagan has a 'doll-like wife who looks sweet and never says anything. It's perfect'.

Men loved Reagan too. After America had faced a stalemate in Korea and humiliation in Vietnam, many pundits declared that the country had gone soft. Barbara Ehrenreich helped to put Reagan's popularity with men into context: 'Part of the energy from the New Right was what they saw as the decline of masculinity and the softness of America. When men of the right stand up and say it's time to face up to the communists, they think of themselves as real men'. Reagan saw himself as a real man.

As president, Reagan had little interest in advancing the political careers of women, and he appointed very few to positions in the federal government. One notable and history-making exception was his appointment of Sandra Day O'Connor as an Associate Justice of the Supreme Court, where she served from 1981 to her retirement in 2006. The appointment was calculated to appease women without giving the job to a dedicated feminist. O'Connor was a reliable Republican conservative who nevertheless charted her own course on the Court.

Reagan refused to support the Economic Equity Act, which was intended to remove obstacles to women's advancement in the workplace. He and his supporters objected to having the federal government assert any oversight over practices in the business world, arguing for smaller, less-intrusive government. To the extent that the law would have aided women, especially divorced women or single mothers, Reagan saw it as undermining the American family in which women's proper place was in the home. The law did not pass. Reagan was a strong opponent of abortion during his years in the White House, arguing that the rights of a foetus needed to be protected. He did not consider the right of a pregnant woman to be

equally deserving of support. The Reagan years were difficult for American women who expected to advance the cause of women's rights.[324]

In spite of the difficulty of moving a feminist agenda forward in the 1980s and 90s, feminists were successful in raising the issue of violence toward women on an international scale. Violence against women had been a nearly unspoken issue in the early days of Second Wave Feminism. Women throughout the world now found the courage to speak out, and feminist scholar Christine Stansell argued that revelations about violence against women as a central component of oppression, 'whether rape, domestic abuse, or sexual harassment, had surfaced early in feminist consciousness-raising groups in the late 1960s and 1970s. The new activism against violence yielded victories, or planted the seeds of future victories, in the otherwise dismaying period of the backlash against *Roe v Wade* and the Equal Rights Amendment'.

The subject was central to a United Nations conference a on the status of women. Sexual violence had a universal quality, and women from countries all over the world shared their experiences and their outrage.[325] But finding ways to diminish or eliminate domestic violence challenged laws and entrenched social customs, not only in countries where wives were still considered the property of their husbands, but also in the United States, where marital or partner rape was not declared a crime in all fifty states until 1993. Prior to the 1970s, the concept of marital rape was not recognized as criminal activity and was legal everywhere in the country.

One of President Reagan's strongest international allies in the 1980s was a woman. The ascension of Conservative Party leader Margaret Thatcher to the office of Prime Minister in 1979 marked the first time a woman had held the position. Britain's longest-serving Prime Minister in the twentieth century, she was derisively called 'a grocer's daughter', revealing her middle-class upbringing,

and respectfully referred to as the 'Iron Lady' of British politics. Thatcher's Conservative Party was committed to rolling back the social advances for women of the previous decades, and she took on that mission with great energy. Writing in *The Guardian,* Hadley Freeman told her readers that Thatcher was no feminist who smashed Britain's political glass ceiling. Rather, she was the 'aberration, the one who got through and then pulled up the ladder right after her'. Far from promoting the political careers of other women, Thatcher appointed only one woman, Edwina Currie, to a lower-level cabinet position. Currie served as Junior Health Minister from 1986-1988. Thatcher considered men to be 'fun but dumb' and feminist women to be 'strident'. In her article, Freeman described Thatcher as a classic example of a certain kind of conservative woman 'who believed that all women should pull themselves up just as she had done, conveniently overlooking that not all women are blessed with the privileges that had been available to her, such as a wealthy and supportive husband and domestic help'.

Thatcher's government enacted Conservative Party policies that favoured business and validated greed as a positive quality. Personally, she felt she 'owed nothing' to women's liberation that had exerted a major impact on British politics since the 1960s. During her tenure in office, companies were able to avoid compliance with earlier laws that had been designed to protect individual women and advance causes important to feminists. Thatcher did everything she could to avoid being perceived as a feminist. Historian Katie Weaver observed that Thatcher strove to avoid a feminist persona while maintaining a degree of femininity. In an effort to dodge the stereotype that positioned powerful women as shrill, Thatcher 'took elocution lessons... to lower the pitch of her voice' and tried to disassociate herself from 'petulant females'. Yet despite her wish to avoid portraying some of the characteristics associated with women, Thatcher often appeared as a typical wife and mother. She posed

Two Steps Forward ...

for photographs in the kitchen and spoke of cooking, shopping, and spending time with the children in order to encourage the idea that she was the archetype of the 'housewife politician'. The presentation of the 'housewife politician' is arguably *not* a feminist model.

Thatcher never acknowledged that her success was attributable to anything but her own efforts, and she certainly did not consider herself a feminist. Her biographer wrote that 'In Margaret Thatcher's view, her sex is an irrelevancy, and she is annoyed by people who make too much of a fuss over it'. The Iron Lady shaped British politics and society during her administration and after. She left a legacy of pro-business individualism that left women to press for social change on their own.[326]

In the United States, feminist and conservative women have made significant advances in public life. Thanks to legislation that outlawed discrimination on the basis of sex in college and professional school admission, women earned a greater percentage of law and medical degrees and small numbers rose through the ranks in business, although there were very few at the very top of the corporate pyramid.

But in recent years, women themselves have become primary actors in the backlash against feminism. Women have been active as right-wing activists on behalf of what they refer to as 'parents' rights'. Women have challenged traditional school curricula, supported laws that prohibited the teaching of concepts that might be considered upsetting to children such as the horrors of slavery imposed on people of African descent by Europeans and Americans, and opposed any expansion of gay rights or the rights of trans children to receive gender-affirming care prior to adulthood. The concept of parents' rights is predicated on the notion that government involvement in education undermines the desires of parents to inculcate their personal values in their children. It assumes that teachers, school boards, administrators, and federal education officials are part of a left-wing conspiracy

whose goal is to deprive Americans of their individual freedoms. Women who support the removal of classic literature from school libraries and who threaten local school boards with violence, even threatening to bring weapons to school board meetings, are part of a new generation of women activists on the political right.

With increasing frequency in countries around the world, women have run for office as both liberal and conservative candidates. In the United States, the vice-presidential candidacy of Geraldine Ferraro in 1984, Sarah Palin in 2008, and Kamala Harris in 2020 illustrate different models of American political women. Ferraro was a Democrat who represented part of Queens, New York. She was a professional politician with significant experience as a prosecutor and a leader of her caucus in the House. Ferraro was 'one of the boys' in political terms. When Walter Mondale chose her as his running mate, she was hailed as the first female vice-presidential candidate to run on a major party slate, although many media pundits questioned whether the country was ready for a woman who might be called upon to use nuclear weapons against the Soviet Union. 'Is she tough enough'? was a familiar question faced by Ferraro and her supporters. In her acceptance speech at the Democratic convention, Ferraro emphasized the importance of her nomination as the child of Italian immigrants, which resonated with many people of her generation. Her nomination was historic, both for her gender and her ethnic background.

Running against the popular conservative Ronald Reagan who was seeking a second term, Ferraro was criticized as a liberal by conservatives, as a woman by anti-feminists, and as a supporter of abortion rights by the Catholic Church. Her reputation and the campaign suffered with allegations of irregularities in her husband's finances. The couple eventually released their tax returns and Ferraro's husband, John Zaccaro, paid his back taxes, but the scandal refused to disappear completely. After Mondale and Ferraro lost to Reagan and George H.W. Bush, Ferraro returned to work

as a journalist and was later appointed by President Clinton as the United States Ambassador to the United Nations Commission on Human Rights. She died in 2011 and is remembered as a groundbreaking public servant.[327]

When Sarah Palin accepted the Republican Party's invitation to run with John McCain in 2008, she was hardly known outside her home state of Alaska. Her reputation focused on her appeal as a gun-toting 'Grizzly mom' who could 'see Russia from her front porch'. She and McCain described themselves as 'mavericks' who were not political insiders, in spite of McCain's long service in the Senate. Palin was flamboyant and as eager to be photographed with a bible as with a gun. She appealed to White Christian women who feared African Americans, poor people, and Democrats.

Palin's campaign speeches focused on topics such as individual freedom, gun rights, the importance of family, and protecting Christmas. She told audiences to beware of a government that would 'take their guns away' and she decried the use of expressions such as 'Happy Holidays' instead of 'Merry Christmas'. Palin propounded a politics of grievance that appealed to a rising populist tide in the Republican Party. After the Republican ticket was defeated by Barack Obama and Joe Biden, Palin retreated to Fox News where her commentary continued the birther attack on Obama and support for the Tea Party, the movement that threatened to and eventually succeeded in upending the traditional conservative politics of the Republican Party.

In 2011, Palin toured the country in her RV, testing the waters for a possible presidential run. She did not gather support for her candidacy, but she did raise significant sums in the heartland, as *Forbes Magazine* reported: 'She made headlines this summer with a cross-country bus tour, including a stop at the Iowa State Fair during the much-anticipated Straw Poll. The unofficial hostess of the Tea Party has exploited traditional as well as social media to fan the flames

of discontent – and forced the GOP to embrace the insurgency. As a political commentator on Fox News, a reality show host and deft user of Twitter and Facebook, she has largely bypassed traditional media to blast the press and the president – and made an estimated seven million in the last year doing it. Sarah Palin's political journey has taken her from a sparsely populated state to a national campaign. Alaska may put her on the national map again'.[328]

When Geraldine Ferraro faced the American electorate as the Democratic vice-presidential nominee, the conservative political tide had begun to rise and was strongly identified with Ronald Reagan's administration. The Democrats lost by a huge margin in 1984. When Sarah Palin ran with John McCain in 2008, the Tea Party, which animated many Americans on the basis of their disapproval of Obamacare (national health insurance), the size of the national debt, and government rescue efforts in the midst of a recession, was in its infancy. It inspired even more right-wing insurgent politics. By the time Kamala Harris accepted the vice-presidential nomination in 2020, a conservative backlash against all things liberal in American politics was ascendant. It was clear that Harris was breaking barriers, not only as a woman, but as the first Black and South Asian woman to run for the office. In the process, she faced opposition based on her gender and her race, echoing the double jeopardy described decades earlier by Frances Beal. Joe Biden and Kamala Harris won a contested election in a climate of hostility and violence.

It was clear by 6 January 2021, that the rioters who ravaged the Capitol were overwhelmingly male and that their loyalty to the defeated president, Donald Trump, was based on his strongman *persona*. Trump claimed that a Democratic 'conspiracy' had 'stolen' the Electoral College vote from him and that 'alternative' (read 'fake') electors could give him the Electoral College vote over Biden and Harris, thus keeping him in power. The violence generally attributed to dictatorial regimes run by strong men had spread to the United

States. On 6 January 2021, Washington DC was the scene of violence and animosity aimed at the democratic process itself. Rioters called for the murder of House Speaker Nancy Pelosi no doubt because she was a Democrat, but also because she was a woman in power. Americans had previously assumed that the transfer of presidential power would be peaceful. Donald Trump proved Americans wrong.

Democracies in Europe have also been experiencing an upswing in right-wing radicalism. Feminist efforts to push for equality and protection coexisted with a powerful trend toward reactionary politics. In France, the 2017 presidential campaign of Emmanuel Macron promised a commitment to the principle of equality in politics. As President, Macron created the Secretariat of Equality Between Women and Men, a government agency formed to address discrimination against women. However, progress toward the goal of electoral parity, in which half of the candidates in any party are required by law to be women, has been slow. Macron's limited efforts to promote women in politics have been derailed by the Covid-19 pandemic, economic woes, and an upsurge in radical right-wing activism.

Recently, many women have been drawn to the radical nationalist ideology of candidates like Marine Le Pen, who challenged Macron for the presidency in 2017 and in his 2022 re-election campaign, where she lost only narrowly. Le Pen succeeded her father, Jean-Marie Le Pen, founder of the far-right National Front, now called the National Rally, as a member of the French National Assembly. The party's nationalist, anti-Muslim and anti-immigrant positions were evident in Le Pen's 2017 speech on her nomination for president: 'We cannot call ourselves Patriots if we do not stand for national solidarity, which is the expression of a fundamental solidarity between the French people. This is why we will establish a priority for French nationals in matters such as attribution of social housing as well as employment ... I remind the obvious; there are not and

there will never be any other laws and values in France as French laws and French values.. . .We have not given up being French yet. The rise of the people is a historic event ... the tide of history has turned. It will carry us to the top and with us our country, France. Long live the people, long live the Republic, long live France'.

National Rally speakers often rail against a national government that will, they say, take away individual liberties from both women and men. This politics of grievance against the central government is similar to the frustration turned political philosophy currently on the rise in the United States. Women were among the *gilets jaunes* (yellow vest) demonstrations of 2018 which brought people with a wide range of political perspectives to the streets to protest actions taken by the government. *The Guardian* quoted a young woman who was part of the *gilets jaunes* demonstrations. The cashier at a Paris supermarket told the reporter that the elite hasn't got a clue 'what life is like for real people ... We can't make ends meet on low salaries. I'm overdrawn before the end of each month, living on credit, barely able to afford the petrol to get to work or drive my three children. We've never tried Le Pen in power, so why not give her a chance?' Le Pen's candidacy as part of a radical right movement in France that exploits the real-world problems of everyday people and plays on their frustrations demonstrates that extreme nationalism transcends gender.

The resurgence of right-wing politics in Europe and the United States in the past twenty years could well be described as 'angry White men voting for angry White men'. But in recent years, White women have joined the ranks of angry people willing to express their grievances against minorities, foreigners, and immigrants thought to represent a challenge to traditional values and practices. The mere presence of women in radical right-wing movements does not, however, guarantee an end to sexist rhetoric and hostility to women in public spaces. In 2017, Corinna Miazga earned a seat in Germany's

parliament as a member of *Alternative fur Deutschland* (AfD), a right-wing political party that ran on a nationalist, anti-immigrant platform. On her election, one of her party colleagues said she was better suited 'to being a pole dancer than an MP'. When Miazga called out her colleague for his sexist remark, she was criticized for damaging the reputation of the party. This criticism echoed similar comments directed at women in the 1960s who wanted their left-wing, anti-war organizations to take up the 'woman problem', but the mission of the party took precedence over an objective view of women and a willingness to hear and respond to their grievances.

Leaders of many right-wing organizations have blamed immigrants for a variety of crimes and assaults on native-born Germans. This trend has served to augment the Right's attack on immigrants as dangerous threats to German security. These events also provided fodder for the fiction that most domestic assaults and attacks on unrelated women were perpetrated by immigrants, in spite of government studies that prove otherwise. The invocation of White women's fear of the sexuality of immigrant men recalls how American racists exploited the long-standing fear of Black men in the American South.

In Germany, women are beginning to address their under-representation in the alt-right with the formation of *Frauen in der AfD* (Women in the AfD), an organization designed to increase the recruitment of women into the Party. For some party leaders, recruiting women is a matter of expediency, as the party needs new recruits to survive. For others, adding more women to the party will increase its appeal as long as male party members don't succumb to the sexist patterns of the past.[329]

Even though the record of success of Second Wave Feminism is mixed, women have been effective in raising the issue of violence toward women in general and domestic violence in particular as a major issue that governments need to address. According to the

United Nations, half of the 87,000 women murdered in 2017 were killed by a family member or partner. This can be seen as part of the backlash against advances women made in the last third of the twentieth century. In 2019, protesters marched in Madrid to celebrate the International Day for the Elimination of Violence Against Women. Along the parade route, they faced members of the Vox Party, Spain's alt-right political organization, who demanded the repeal of Spain's law that protects women against violence inflicted by men. Party Secretary Javier Ortega declared the law unfair, claiming that, 'There are also men who suffer from women and are killed by their wives', and that lesbian women also inflict violence on their partners. Some countries even repealed or modified their legal protections for women. In Russia, authorities, including the leadership of the Orthodox Church, criticized the term 'violence in the family' as an undesirable product of radical feminism. And Hungary's Fidesz Party limited the role of its agency responsible for gender equity and labelled members of women's organizations as foreign agents who pose a threat to the country's national security.[330]

Despite threats of violence and continuing discrimination, women have made advances in the workplace, politics, education, and their personal lives. However, domestic violence against women has not abated and a generalized climate of sexism still exists, sometime less visible but no less harmful. The #MeToo Movement of the recent decade illustrates the extent to which women are considered objects to be used by men. #MeToo began on social media, including Facebook, Twitter, and Instagram, as a vehicle for women to tell their stories of sexual harassment and exploitation. Coined by Tarana Burke, #MeToo became shorthand for women to join others in revealing their experiences and finding support among others with similar experiences. In addition to providing support for harassment victims and creating a media space in which sexual harassment could be identified and discussed publicly, #MeToo contributed to

the prosecution of many abusers and the resignation from positions of power of many more.

That there is much work yet to be done in the quest for equality is clear from the partial successes of #MeToo. The elimination of sexism and abuse are not the priorities of all politicians and government leaders. In 2016, *Access Hollywood* released a tape from 2005 in which presidential candidate Donald Trump made blatantly sexist, cruel, and nasty remarks about women and how he felt he could treat them. Trump described himself as 'automatically attracted to beautiful [women]... I just start kissing them. It's like a magnet. Just kiss. I don't even wait. And when you're a star they let you do it. You can do anything. ... Grab them by the pussy. You can do anything'. Candidate Trump suffered no political consequences for these remarks, and there were many American women who could forgive, forget, or ignore Trump's character in favour of his MAGA (Make American Great Again) appeal that had the same nationalist, racist, homophobic, and individualistic rhetoric as radical right parties throughout the world.[331]

As the United States Supreme Court prepared to release its decision in the *Dobbs* case, Susan Faludi reflected on the arc taken by feminism in the twentieth and twenty-first centuries. She observed that feminism had been co-opted by commercial culture in which popular images replaced serious analysis and consumer culture had replaced battles at the barricades of previous decades. Faludi argued that what she called 'pop feminism' relied on 'the power of an individual star over communal action, the belief that a gold-plated influencer plus a subscription list plus some viral content can be alchemized into mass action'. We err in relying on this brand of feminism, which de-values the collective action that characterized the Second Wave in the 1970s. Faludi reminds us that it was the Second Wave feminists who pushed governments to secure the right to safe abortion, a right that, in June of 2022, was eliminated in the

United States by conservative forces determined to exert control over the most intimate and personal aspects of a woman's life.

Faludi reminds us that women and their allies today should not despair. There is much ongoing activity that echoes the collaborative movements of the 1960s and 70s. She cites the National Domestic Workers Alliance, for instance, 'whose advocacy and organizing of low-income household labourers led to passage of Domestic Workers Bill of Rights laws in 10 states and two cities. Or Fair Fight Action, founded by Stacey Abrams – a voting reform campaign that helped flip Georgia to the Democrats for the first time in a generation and helped rescue the nation from another term of Trumpism. Or the 'green tide', a multipronged mass movement of Latin American feminists that promotes health equity and economic opportunity to build a wide spectrum of public support to legalize abortion in Argentina, Mexico and Colombia.[332]

The assumption of power by far-right prime ministers Liz Truss in the United Kingdom and Georgia Meloni in Italy demonstrates the primacy of conservative ideology over gender in contemporary politics. Truss ascended to power in the wake of Boris Johnson's personal missteps that led to a no confidence vote in Parliament, but her time in power was short, less than four weeks. Meloni is one in a long line of government leaders in a country known for changing its leadership every few months or even weeks in the years since the Second World War. Both women have offered nationalist platforms that favour the wealthy. For example, Truss's first move was to propose a tax-cutting measure that she called 'the right thing to do, morally and economically'. She claimed that her Conservative Party was the only force in British politics that could restore economic progress to the nation. In Italy, Meloni is set to establish what is being called 'Italy's most right-wing government since World War II'.[333]

If recent electoral victories by conservative women are a cause of

concern for supporters of women's rights and other liberal causes, there may yet be room for optimism after all, as women continue to work for women in spite of the effort of the alt-right to claim ownership of women's issues.[334] The post-movement career of Kathy Boudin illustrates the importance of today's work on behalf of women that has been undertaken by extraordinary individuals who translated the lessons they learned in the anti-war movement and Second Wave Feminism to tackle the problems of today. Boudin was a veteran of both Students for a Democratic Society and SDS's Economic Research and Action Project in Cleveland. We remember her as a member of the Weather Underground and as a member of the group that robbed a Brinks Armoured Truck in 1981, resulting in the death of a police officer. After her release in 2003, Boudin earned a doctorate in social work from Columbia University and helped to establish the Release Aging People in Prison Campaign. Boudin died in 2022, leaving a legacy of radical action to end a war and creative initiatives designed to ensure a better world for women.[335]

The history of the Black Panther Party is marked by the murders of more than twenty of the Party's male leaders at the hands of law enforcement and dissidents within their own movement. Names such as Fred Hampton, Mark Clark, and George Jackson remind us how dangerous it was to challenge the political system and law enforcement at the local, state, and federal levels, each of which deployed massive armed force against targeted Black Panthers who were deemed dangerous and a threat to American society. The deaths of John Huggins and Bunchy Carter also reveal the dangerous nature of fractures within the Black Panther Party itself. Many women survived the Panthers' violent years to continue the work of the organization. In the late 1960s, they had learned valuable skills in community organizing. In spite of receiving little recognition or credit for their talents at the time, these women would continue the valuable work of the Party at the local level.

The story of the Black Panther sisters is one of survival and accomplishment. Some left the Party and others served prison terms, but many remained in or returned to their communities to provide valuable assistance to their neighbours. Fredrika Newton, widow of one of the Party's founders, is the director of the Dr Huey P. Newton Foundation. A retired nurse, she is committed to implementing those elements of her husband's 10 Point Programme for the Party that stress education, self-determination, and community service.

Rev. Cheryl Dawson worked to improve the lives of women in her hometown of Oakland, California and in such far-flung places as Dublin, Ireland and the Republic of the Congo. She was ordained at the Beth Eden Baptist Church in West Oakland and brings her message of love and self-care to women in prison and in her community. Ericka Huggins was the Director of the Oakland Community School from 1973-1981. Today, she continues to educate young people with a message of love and support. Huggins lectures on human relations in general and restorative justice in particular as a way of dealing with non-violent crimes.

The female veterans of the Black Panther Party have established themselves as activists who hope to transform American society through community cohesiveness and solidarity, even in the face of income inequality, an ineffective public educational system, and systemic racism. They stand as models of the transformative power of community activism. The names of 250 women veterans of the Black Panther Party and images of many of these women are boldly painted on the front of a private home at the corner of 9th and Center Streets in Oakland. Created by:

#SayHerName:WomenoftheBlackPantherParty

The mural is a tribute to those who carried groceries and guns in the name of revolution.

The words of activist, author, and professor Angela Y. Davis inspire optimism that many of the positive lessons of the 1960s and 70s

still resonate today. Davis told *The New York Times* that the young feminist activists of today 'know so much more than we did at their age. They don't take male supremacy for granted. One aspect of this shift in leadership models has to do with a critique of patriarchy and a critique of male supremacy'. When we think of civil rights leaders of the past, men's names, Dr King, John Lewis, and Malcolm X, come most readily to mind. The founders of today's Black Lives Matter movement are three women, Alicia Garza, Parisse Cullors, and Opan Tometi, whose style of leadership is collaborative rather than focused on a charismatic leader, male or female.[336] The Black Lives Matter movement has galvanized Americans on both sides of the issue. The intensity of the protests matches the importance of the issues at stake – protection of and support for the lives of African Americans. Perhaps the next stage in feminism will be a Women's Lives Matter movement that will be led by a new generation of feminists.

What can we conclude from a discussion of twentieth and twenty-first century feminism? We began with the question, 'Where are the women?' The answer, 'Everywhere', is both inspiring and unsatisfying. We see today that women can serve as Senators, Vice Presidents, and prime ministers. They can represent liberal perspectives or rabid right-wing conservativism based on hatred and fear. Women today can be doctors and attorneys, but there is still considerable concern over the absence of women in STEM and STEAM professions, which nevertheless pales in comparison to the crisis in countries where girls are not permitted to attend school at all. We know that women are as smart as men, as rational as men, as capable as men, as creative as men, yet we do not see them represented among the world's leaders, executives, scholars, and performers in numbers consistent with the Chinese saying that 'Women hold up half the sky'. To understand the way forward, we need to remember that Chairman Mao followed that statement with a reminder of

Don't Call Us Girls

equal importance: 'But men rule the Party'. Until women are able to fulfil their promise as intelligent, rational, capable, and creative human beings who are also capable of sharing the responsibility for maintaining a household and raising children, the world will have access to only a small portion of their talents. Until that time, we will continue to assert that women and men have much work yet to do. As for the women, look for intelligence, dedication, and creativity. Just don't call them girls!

Endnotes

Introduction
1. Thomas Jefferson's Letter to William Smith (3 November 1787), National Archives, *Founders Online*, www.founders.archives.gov/documents/Jefferson/01-12-02-0348.

Chapter One
2. 'Joan of Arc Famous Quotes', *Kidadl*, www.kidadl.com/quotes/important-joan-of-arc-quotes-from-the-maid-of-orleans.
3. Kathleen Kuiper, 'Olympe de Gouges', *Britannica*, www.britannica.com/biography/Olympe-de-Gouges, Carrie L. Cokely, 'Declaration of Rights of Woman and of the [Female] Citizen', *Britannica*, www.britannica.com/topic/Declaration-of-the-Rights-of-Woman-and-of-the-Female-Citizen, and 'Olympe de Gouges, Declaration of the Rights of Woman and the [Female] Citizen' (text) 'Liberte, Egalie, Fraternite', www.revolution.chnm.org/d/293/.
4. 'She Never Talked About the War', 'Uncovering the Daring Stories of Women Who Resisted the Nazis in Occupied France', *TIME* (4 May 2021) www.time.com/6045666/nazi-escape-women.
5. Ibid.
6. William A. Pelz, 'Women and the German Revolution 1918-1919', Pluto Press www.plutobooks.com/blog/women-war-german-revolution-1918-1919.
7. 'Women in Nazi Germany', *Alpha History*, www.alphahistory.com/nazigermany/women-in-nazi-germany.
8. 'Women in the Third Reich', United States Holocaust Museum, www.encyclopedia.ushmm.org/content/en/article/women-in-the-third-reich.
9. 'Records of the Six Point Group' (Including the papers of Hazel Hunkins-Halinan), Jisc Archives Hub, www.archiveshub.jisc.ac.uk/search/archives/37dab770-ea7e-3e53-b7ad-5f5876b3cef0.
10. www.iwm.org.uk/history/what-was-the-womens-land-army.
11. www.gov.uk/government/news/the-women-of-the-second-world-war.
12. 'Noor Inayat Khan' (1914–1944) BBC www.bbc.co.uk/history/historic_figures/inayat_khan_noor.shtml and 'Noor Inayat Khan: The Forgotten Muslim Princess Who Fought the Nazis', Aljazeera, www.aljazeera.com/features/2020/10/28/noor-inayat-khan.
13. Lakshmi Gandhi, 'How Two Vietnamese Sisters Led a Revolt Against the Chinese – In the First Century', www.history.com/news/trung-sisters-vietnam-rebellion-han-dynasty, and 'Trung Sisters', www.newworldencyclopedia.org/entry/Tr%C6%B0ng_Sisters.
14. Kallie Szczepanski, 'Trieu Thi Trinh, Vietnam's Warrior Lady', Thought Co.

(16 October 2019) www.thoughtco.com/trieu-thi-trinh-vietnams-warrior-lady-195779, and 'Trieu Thi Trinh, The Vietnamese Joan of Arc', Amazing Women in History, www.amazingwomeninhistory.com/trieu-thi-trinh-the-vietnamese-joan-of-arc.
15. Candace Falk's comment appears in 'Emma Godman', American Experience (PBS) www.pbs.org/wgbh/americanexperience/features/goldman-1869-1940/.
16. 'Red Emma (1869-1940): Idealistic Revolutionary', National Library of Medicine, www.ncbi.nlm.nih.gov/pmc/articles/PMC3093260/, 'Emma Goldman', Jewish Women's Archive, www.jwa.org/womenofvalor/goldman, and 'Emma Goldman', Archives of Women's Political Communication (University of Iowa) www.awpc.cattcentre.iastate.edu/directory/emma-goldman.
17. Erin Marquis, 'Women that Would Gladly Give their Life: How the Paramilitary WEB Battled GM at the UAW's First Big Strike', www.jalopnik.com/women-that-would-gladly-give-their-life-how-the-para-1838948989 (16 October 2019). Besson also shared this anecdote in the documentary, 'With Babies and Banners' (1979).
18. Johnson quoted in 'Women's Emergency Brigade', www.encyclopedia.com/economics/encyclopedias-almanacs-transcripts-and-maps/womens-emergency-brigade.
19. Ibid.
20. United States Department of Labor, Women's Bureau Bulletin No. 244, 'Womanpower Committees During World War Two', Washington DC, 1953, p. 8 and p. 9.
21. *Woman's Home Companion* (October, 1943) in Sherna B. Gluck, 'Rosie the Riveter Revisited: Women, the War, and Social Change', Boston, Twayne Publishers, 1987, p. 100. Other quotations from women workers in the Second World War are adapted from Gluck's oral history collection.
22. '13 Things You Probably Didn't Know About the USO During World War II', www.uso.org/stories/111-13-things-you-probably-did-not-know-about-the-uso-during-world-war-ii.
23. 'History at a Glance: Women in World War II', The National World War II Museum, www.nationalww2museum.org/students-teachers/student-resources/research-starters/women-wwii.
24. Nikole Hannah-Jones, The 1619 Project, New York, *The New York Times*, 2021, p. xvii.

Chapter Two
25. Helena Gougeon, 'France's Liberation, Women's Stagnation: France's Societal Advancement Hindered by the Incarceration of Women to Traditional

Endnotes

Gender Roles Following World War II', Honours Thesis, Portland State University, 2017, p. 18. www.pdxscholar.library.pdx.edu/cgi/viewcontent.cgi?article=1442&context=honourstheses.

26. Les Anneés 50, 'The 1950s' Fashion in France, 1947-1957', September 9, 2014, www.ipreferparis.net/2014/09/les-anne%C3%A9s-50-the-1950s-fashion-in-france-1947-1957.

27. 'Joilot-Curie and the Anti-Nuclear Movement', Atomic Heritage Foundation, www.ahf.nuclearmuseum.org/ranger/tour-stop/postwar-france/#.YjEk6JPMLOQ.

28. 'World War II: De-Nazification', Jewish Virtual Library, www.jewishvirtuallibrary.org/denazification-2.

29. Robert G. Moeller, 'The 'Remasculization' of Germany in the 1950s', *Signs* (Vol. 24, no. 1) Autumn, 1998, www.jstor.org/stable/3175673?read-now=1&refreqid=excelsior%3A7e119ea0069f95c712ec5559325388f6&seq=1#page_scan_tab_contents.

30. Virginia Nicholson, 'The 1940s: Britain's Wartime Women Gained a new Sense of Power,' *The Guardian* (3 February 2018) www.theguardian.com/lifeandstyle/2018/feb/03/1940s-britains-wartime-women-gained-a-new-sense-of-power.

31. 'The History of CND Campaign for Nuclear Disarmament', www.cnduk.org/who/the-history-of-cnd/. And Jack Watt, 'Was the Committee for Nuclear Disarmament a Moderate Campaign Group or a "new' Social Movement?' PublisHistory Blog www.publishistory.wordpress.com/2013/09/02/was-the-campaign-for-nuclear-disarmament-a-moderate-campaign-group-or-a-new-social-movement.

32. Michael Y. Park, 'A History of the Cake Mix, the Invention that Revolutionized Baking', *Bon Appetit* (26 September 2013), www.bonappetit.com/entertaining-style/pop-culture/article/cake-mix-history.

33. Melissa Sartore, 'Was Sex in 1950s America as Straitlaced and Boring as You Think it Was?', *Ranker* (21 February 2019) www.ranker.com/list/love-and-relationships-in-1950s-us/melissa-sartore.

34. Laura Mohsene, '1950s Advice to Women Compared to Advice in Modern Women's Magazines', *Medium* (17 September 2020), www.medium.com/fearless-she-wrote/1950s-advice-to-women-compared-to-advice-in-modern-womens-magazines-fa22656c312.

35. Sara Evans, 'Personal Politics: The Roots of Women's Liberation in the Civil Rights Movement & the New Left', New York, Vintage Books, 1980, p. 4.

36. Ferdinand Lundberg and Marynia Farnham, 'Modern Woman: The Lost Sex', New York, Harper and Brothers, 1947, p. 2, www.sites.middlebury.edu/coldwarculture/files/2013/08/Modern-Woman.pdf.

37. Jennifer Gonnermann, 'Highflyer: How a Flight attendant became a Rising Star of the Labour Movement', *The New Yorker*, 30 May 2022.
38. Bruce Salinger, 'What 70s pop phenomenon was most embarrassing?', www.pinterest.com/pin/178807047680282055/.
39. Chloe Wong-Mersereau, 'The Lasting Legacies of Racial Segregation in Suburbia', *The Grassroots Journal*, 25 February 2018, www.thegrassrootsjournal.org/post/2018/02/25/the-lasting-legacies-of-racial-segregation-in-suburbia.
40. Harry Truman's Farewell Address (15 January 1953), Public Papers of the Presidents of the United States: Harry S. Truman, Washington DC, US Government Printing Office, 1966, pp. 1197-1202.
41. 'Better to See Once', *TIME*, 9 August 1959.
42. Arthur M. Schlesinger Jr, 'The New Mood in American Politics', *Esquire* January, 1960.
43. 'American Women: Report of the President's Commission on the Status of Women', 1963, University of Michigan, p. 5. www.babel.hathitrust.org/cgi/pt?id=mdp.39015016913678&view=1up&seq=4.
44. Ibid.
45. John 'F. Kennedy, 'Inaugural Address', 20 January 1961.
46. Helen Pick, 'Why Mr. Kennedy is in Europe – June, 1963', *The Guardian* Archive. www.theguardian.com/world/from-the-archive-blog/2018/apr/20/why-jfk-is-in-europe-archive-june-1963.
47. Betty Friedan, *The Feminine Mystique*, New York, Laurel, 1963, p. 305.
48. Louis Menand, 'The Making of the New Left', *The New Yorker*, 15 March 2021, www.newyorker.com/magazine/2021/03/22/the-making-of-the-new-left.
49. Kirkpatrick Sale, 'SDS: The Rise and Development of the Students for a Democratic Society', New York, Vintage, 1973, p. 295.

Chapter Three
50. 'History of the National Baptist Convention USA, Inc', www.nationalbaptist.com/about-nbc/our-history, *National Parks*, 'Nannie Helen Burroughs', www.nps.gov/people/nannie-helen-burroughs.htm, Library of Congress, 'National Training School for Women and Girls', www.loc.gov/item/2004667312/. And Evelyn Brooks Higginbotham, 'Righteous Dissent: The Women's Movement in the Black Baptist Church, 1880-1920', Cambridge, Harvard University Press, 1993.
51. Rona Kobell, 'Remembering Rosenwald', *National Parks*, Vol 79, Number 3 (Summer 2023), pp. 26-34. www.npca.org/articles/3526-remembering-rosenwald and 'Rosenwald Schools', Encyclopaedia of Virginia, www.encyclopediavirginia.org/entries/rosenwald-schools/#:~:text=Rosenwald%20

Endnotes

schools%20were%20educational%20facilities,accessible%20schools%20for%20African%20Americans.

52. Stacy Lynn, 'Jane Addams, Ida B Wells, and Racial Injustice in America', Jane Addams Papers Project, 23 August 2018. www.janeaddams.ramapo.edu/2018/08/jane-addams-ida-b-wells-and-racial-injustice-in-america/
53. Ida B. Wells, 'Lynching, Our National Crime', *Black Past*, www.blackpast.org/african-american-history/1909-ida-b-wells-awful-slaughter.
54. 'NAACP – A Century in the Fight for Freedom', www.loc.gov/exhibits/naacp/founding-and-early-years.html#:~:text=The%20NAACP%20pledged%20%E2%80%9Cto%20promote,education%20for%20their%20children%2C%20employment.
55. W.E.B. DuBois, 'The Crisis', 1910, in 'DuBois Quotes', Dubois Center Library www.duboiscentre.library.umass.edu/du-bois-quotes.
56. 'Viola Liuzzo', Dictionary of Unitarian Universalist Biography, www.uudb.org/articles/violaliuzzo.html.
57. 'Viola Gregg Liuzzo', Biography. www.biography.com/acola-gregg-liuzzo, Donna Britt, 'A white mother went to Alabama to fight for civil rights. The Klan killed her for it', *The Washington Post*. www.washingtonpost.com/news/retropolis/wp/2017/12/15/a-white-mother-went-to-alabama-to-fight-for-civil-rights-the-klan-killed-her-for-it/, and review of Selma and the Liuzzo Murder Trials: The First Modern Civil Rights Convictions, www.clcjbooks.rutgers.edu/books/selma-and-the-liuzzo-murder-trials-the-first-modern-civil-rights-convictions.
58. Jamelle Bouie, 'This is Why It Took More than 100 Years to Get an Anti-Lynching Bill', *The New York Times,* (April 1, 2022) www.nytimes.com/2022/04/01/opinion/anti-lynching-bill-biden.html?campaign.
59. David Michaelis 'Eleanor Fights Lynching', *American Heritage*, Volume 65, number 5 (summer 2021), www.americanheritage.com/eleanor-fights-lynching#2.
60. Ann Pullen, 'Commission on Interracial Cooperation', New Georgia Encyclopedia, last modified Apr 5, 2021. www.georgiaencyclopedia.org/articles/history-archaeology/commission-on-interracial-cooperation/. On the ASWPL, *see* Nancy Baker Jones, 'Association of Southern Women for the Prevention of Lynching,' Handbook of Texas Online, accessed March 21, 2022, www.tshaonline.org/handbook/entries/association-of-southern-women-for-the-prevention-of-lynching.
61. 'Southern Regional Commission', New Georgia Encyclopedia, www.georgiaencyclopedia.org/articles/government-politics/southern-regional-council and 'Lillian Smith', Piedmont State University www.piedmont.edu/lillian-smith.

62. Karen Henderson and Alana Schreiber, 'How the Baton Rouge bus boycott inspired Dr Martin Luther King', 'Louisiana Considered,' WWNO Radio (16 January 2023) www.wwno.org/show/louisiana-considered/2023-01-16/how-the-baton-rouge-bus-boycott-inspired-dr-martin-luther-king-jr
63. 'Jo Ann Robinson: Heroine of the Montgomery Bus Boycott', Smithsonian National Museum of African-American History and Culture. www.nmaahc.si.edu/explore/stories/jo-ann-robinson-heroine-montgomery-bus-boycott
64. 'An Act of Courage: The Arrest of Rosa Parks', National Archives, www.archives.gov/education/lessons/rosa-parks, www.npr.org/2009/03/15/101719889/before-rosa-parks-there-was-claudette-colvin, Pamela Kirkland, 'Claudette Colvin's juvenile record has been expunged, 66 years after she was arrested for refusing to give her bus seat to a White Person', CNN (16 December 2021), www.cnn.com/2021/12/16/us/claudette-colvin-juvenile-record-expunged, and 'Claudette Colvin, arrested for not giving up her seat for a White woman in 1955 has record expunged: 'My Name Was Cleared: I'm no longer a juvenile delinquent at 82'. CBS News, www.cbsnews.com/news/claudette-colvin-record-expunged.
65. Jane Johnson Lewis, 'Biography of Virginia Durr: White Ally of the Civil Rights Movement' Thought, Co. www.thoughtco.com/virginia-durr-biography-3528652 and Rebecca Woodham, 'Virginia Foster Durr', Encyclopedia of Alabama www.encyclopediaofalabama.org/article/h-1574.
66. 'Anne Braden', Americans Who Tell the Truth, www.mericanswhotellthetruth.org/portraits/anne-braden, 'Anne McCarty Braden', African American Registry, www.aaregistry.org/story/anne-mccarty-braden-born/, and Rick Howlett, 'Remembering the Wades, the Bradens, and the Struggle for Racial Integration in Louisville', 89.3 WPFL. www.wfpl.org/remembering-wades-bradens-struggle-racial-integration-louisville.
67. Sara Evans, Personal Politics: The Roots of Women's Liberation in the Civil Rights Movement and the New Left (New York: Vintage, 1977), p. 48, 50.
68. 'Who was Anne Braden', University of Louisville, www.louisville.edu/braden/about/who-was-anne-braden.
69. 'Southern Christian Leadership Conference (SCLC)', Stanford University, Martin Luther King, Jr. Research and Education Institute. www.kinginstitute.stanford.edu/encyclopedia/southern-christian-leadership-conference-sclc.
70. David Margolick, Elizabeth and Hazel: Two Women of Little Rock, (New Haven: Yale University Press) 2011.
71. 'Bates, Daisy', The Marti Luther King, Jr. Research and Education Institute Stanford University, https://kinginstitute.stanford.edu/encyclopedia/bates-daisy, and 'Daisy Bates', *National Parks*, www.nps.gov/people/dbates.htm.
72. Sarah Pruitt, '7 Things You May Not Know about MLK's "I Have a Dream"

Endnotes

Speech'. *History* (3 August 2023) https://www.history.com/news/i-have-a-dream-speech-mlk-facts.

73. 'Clark, Septima Poinsette', Stanford University, Martin Luther King Jr Research and Education Institute, www.kinginstitute.stanford.edu/clark-septima-poinsette.

74. Student Nonviolent Coordinating Committee www.web.stanford.edu/~ccarson/articles/black_women_3.htm.

75. Interview with Mildred Bond Roxborough, 'Women in the Civil Rights Movement' Civil Rights History Project, Library of Congress www.loc.gov/collections/civil-rights-history-project/articles-and-essays/women-in-the-civil-rights-movement/?fa=subject%3Ainterviews.

76. 'Ella Baker American Activist', Britannica https://www.britannica.com/biography/Ella-Baker; 'Baker, Ella Josephine', Stanford University, Martin Luther King, Jr. Research and Education Institute; 'Life Story: Ella Baker (1903-1986)', www.kinginstitute.stanford.edu/encyclopedia/baker-ella-josephine, Women & the American Story www.wams.nyhistory.org/growth-and-turmoil/growing-tensions/ella-baker/; Sara Evans, Personal Politics, p. 89, and 'Ella Baker Quotes and Sayings', www.inspiringquotes.us/author/4356-ella-baker.

77. Student Nonviolent Coordinating Committee, www.web.stanford.edu/~ccarson/articles/black_women_3.htm.

78. Fannie Lou Hamer's Speech to the NAACP Legal Defence Fund (1971) cited in Deborah H. King, 'Multiple Jeopardy, Multiple Consciousness', *Signs*, Volume 14, number 1 (Autumn, 1988) p. 43.

79. *See* Stephanie Lyn Bateson, 'Gender and Representation in Students for a Democratic Society' PhD Thesis (University of Sheffield, UK (2002), pp. 68-69.

80. 'Marian Wright Edelman, 'From Freedom Summer to the Freedom School', Children's Defense Fund, www.childrensdefense.org/child-watch-columns/health/2014/from-freedom-summer-to-freedom-schools.

81. 'Victoria Gray (Adams)', SNCC Digital Archive, www.snccdigital.org/people/victoria-gray-adams/, and 'Annie Devine', SNCC Digital Archive, www.snccdigital.org/people/annie-devine.

82. 'SDS Resolution' *SDS Bulletin* (July, 1964), p. 3.

83. 'Fannie Lou Hamer', National Women's History Museum, www.womenshistory.org/education-resources/biographies/fannie-lou-hamer; 'Fannie Lou Hamer Arrested and Beaten in Winona, Mississippi', EJI, A History of Racial Injustice, www.calendar.eji.org/racial-injustice/jun/9; and 'Mississippi Freedom Democratic Party (MFDP)', SNCC Digital Gateway, www.snccdigital.org/inside-sncc/alliances-relationships/mfdp/.

84. For this and other quotations from Constance Curry, *see* 'Wild Geese to the Past' in Emmie Schrader Adams, Deep in Our Hearts: Nine White Women in the Freedom Movement (Athens: University of Georgia Press, 2000), pp. 3-35.
85. Sue Thrasher in Deep in Our Hearts p. 226.
86. 'Black Past: Nashville Sit-Ins', www.blackpast.org/african-american-history/nashville-sit-ins-1960/, 'Southern Student Organizing Committee', Britannica, www.britannica.com/topic/Southern-Student-Organizing-Committee; David Garrow, 'Requiem for a Dream' review of two books *Wilson Quarterly*, www.archive.wilsonquarterly.com/book-reviews/requiem-dream; and Sue Thrasher, 'I Want to Be Your Friend, You Black Idiot!!: The Dynamics of Majority Involvement in Minority Movements', http://ssacentennial.uchicago.edu/events/symposium-payne-bios-thrasher.shtml.
87. The Southern Student Organizing Committee (1964) www.crmvet.org/docs/64_ssoc_about.pdf.
88. Dorothy Dawson Burlage, 'Reflections on SDS and Movements for Social Justice' in Howard Brick and Gregory Parker, A New Insurgency: The Port Huron Statement in its Times (Ann Arbor, Mitchiga: Maize Books, Mitchigan Publishing Company, 2015) www.quod.lib.umich.edu/m/maize/13545967.0001.001/1:6.6/--new-insurgency-the-port-huron-statement-and-its-times?rgn=div2;view=fulltext.
89. Jenice L. View, 'Brief Outline of the History of SNCC', Civil Rights Teaching www.civilrightsteaching.org/voting-rights/brief-history-sncc.
90. Angela Davis, An Autobiography (New York: International Publishers, 2006), p. 374 in Shellie Clark 'A Rightful Place in History: The Essential Contributions of African American Women in the Black Power Movement', Academia, www.academia.edu/14095504/A_Rightful_Place_in_History_The_Essential_Contributions_of_African_American_Women_in_the_Black_Power_Movement?email_work_card=title.
91. 'Black Panthers: History, Definition, and Timeline', *History*, www.history.com/topics/civil-rights-movement/black-panthers, and Ashley Farmer, et al. 'Women in the Black Panther Party,' International Socialist Review, www.isreview.org/issue/111/women-black-panther-party/index.html.
92. Malcolm X cited in John Asimakopoulos, 'The Civil Rights-Black Power Era:, Direct Action and Defensive Violence: Lessons for the Working-Class Today' Academia (2010). www.academia.edu/1138062/The_Civil_Rights_Black_Power_Era_Direct_Action_and_Defensive_Violence_Lessons_for_the_Working_Class_Today?email_work_card=view-paper.
93. 'Comision Femenil Mexicana Nacional, Inc. University of California, Santa Barbara Library, www.library.ucsb.edu/special-collections/cema/cfmn, and 'Hispanic Women in History and Activism: Gale's Women's Studies Archive,

www.gale.com/primary-sources/womens-studies/collections/hispanic-women-in-history-and-activism
94. 'Mary King', SNIC Digital Gateway www.snccdigital.org/people/mary-king/, and Mary King, 'SNCC: Born of the Sit-Ins, Dedicated to Action, Remembrances of Mary Elizabeth King,' Trinity College SNCC Reunion, April, 1988, https://www.crmvet.org/nars/maryking.htm.
95. Interview with Gwendolyn Zohara Simmons, 'Women in the Civil Rights Movement', Library of Congress, www.loc.gov/collections/civil-rights-history-project/articles-and-essays/women-in-the-civil-rights-movement/?fa=subject%3Ainterviews.
96. 'Casey Hayden', SNCC Digital Gateway, www.snccdigital.org/people/casey-hayden, and Document 43: (name withheld by request), Position Paper #24, (women in the movement), Waveland, Mississippi, [6-12 November 1964], Elaine DeLott Baker Papers, Schlesinger Library, Radcliffe Institute, Harvard University, www.documents.alexanderstreet.com/d/1006932319.
97. Casey Haden and Mary King, 'Sex and Caste' (November 18, 1965), https://documents.alexanderstreet.com/d/1006932381.

Chapter Four

98. Lady Borton, 'Behind the Scenes, in the Forefront: Vietnamese Women in War and Peace'. *ASIANetwork Exchange: A Journal for Asian Studies in the Liberal Arts*, www.asianetworkexchange.org/article/id/7848/.
99. Matt Fratus, 'The Angels of Dien Bien Phu: How a Flight Nurse and French Army Prostitutes Protected the Wounded in Vietnam' *Coffee or Die* Magazine (07 May 2021), www.coffeeordie.com/angels-dien-bien-phu.
100. pdoggbiker, 'Who Was the Tiger Lady in Vietnam'? Cherrieswriter-Vietnam War Website 16 May 2017), www.cherrieswriter.com/2017/05/16/who-was-the-tiger-lady-in-vietnam.
101. Nathalie Huynh Chau Nguyen, 'South Vietnamese Women in Uniform: Narratives of Wartime and Post War Lives,' *Minerva Journal of Women and War*, Volume 3 Number 2 (Fall, 2009).
102. 'South Vietnam's Women in Uniform' Vietnam Council on Foreign Relations, date unknown in Women's Armed Force Corps (SVN) www.femmes-guerres.ens-lyon.fr/spip.php?rubrique91 and Heather Stur, 'South Vietnam's Daredevil Girls' Women's Armed Force Corps, (1 August 2017), www.nytimes.com/2017/08/01/opinion/vietnam-war-girls-women.html.
103. Le Lieu Browne, 'A South Vietnamese Woman Recalls her Experience in the Diem Regime', American Social History Project, www.shec.ashp.cuny.edu/items/show/958.
104. Elizsabeth B, Armstrong and Vijay Prashad, 'Solidarity: War Rites and

Women's Rights,' *The New Constitutional Review*, Volume 5, number 1 (April 2005), www.jstor.org/stable/41949472.
105. Truong My Hoa, 'A Vietnamese Woman Recalls Her Revolutionary Activities' American Social History Project, www.shec.ashp.cuny.edu/items/show/956.
106. Francois Guillemot, 'Death and Suffering at First Hand: Youth Shock Brigades During the Vietnam War 1950-1975' *Journal of Vietnamese Studies*, Vol. 4, No. 3 (Fall, 2009), www.jstor.org/stable/10.1525/vs.2009.4.3.17.
107. Lady Borton, 'Behind the Scenes, in the Forefront: Vietnamese Women in War and Peace'.
108. Ibid.
109. Ngo Thi Thuong in Elizabeth D. Herman, 'The Women Who Fought for Hanoi,' *The New York Times* (6 June 2017) www.nytimes.com/2017/06/06/opinion/vietnam-war-women-soldiers.html.
110. Don North, 'The Mystery of Hanoi Hannah', *The New York Times* (8 February 2018), www.nytimes.com/2018/02/08/opinion/hanoi-hannah-vietnam-propaganda.html, and Anthony Kuhn, 'Hanoi Hannah, Whose Broadcasts Taunted and Entertained American GIs, Dies' NPR (6 October 2016) www.npr.org/sections/thetwo-way/2016/10/05/496662815/hanoi-hannah-whose-broadcasts-taunted-and-entertained-american-gis-dies-at-87.
111. Peter Brush, 'Rise and Fall of the Dragon Lady' *History Net* (27 April 2011), www.historynet.com/rise-and-fall-of-the-dragon-lady/ and Joseph R. Gregory, 'Madame Nhu, Vietnam War Lightning Rod, Dies, *The New York Times* (20 April 2011), www.nytimes.com/2011/04/27/world/asia/27nhu.html.
112. 'Nguyen The Binh,' 1000 Peace Women https://wikipeacewomen.org.
113. Nugyen Tho Hoa in Herman, 'The Women Who Fought for Hanoi.'
114. Paula Bailey, 'Best and Worst of Times: American Nurses in Vietnam,' www.hsu.edu/uploads/pages/2002-3afthe_best_and_worst_of_times.pdf and 'In-Country: US Nurses During the Vietnam War' Working Nurse, www.workingnurse.com/articles/in-country-u-s-nurses-during-the-vietnam-war/.
115. Lynda Van Devanter, Home Before Morning: The Story of an Army Nurse in Vietnam (New York: Beaufort Books, 1983), pp. 121-2.
116. 'Black History Month: Retired US Army nurse recalls serving in first integrated military hospitals,' 9News, www.9news.com/article/news/local/black-history-month-african-american-retired-us-army-nurse-served-in-integrated-military-hospitals-in-the-1950s/73-c927e1bd-5f17-4a5d-b4e2-341f2327fe16, Elizabeth A. Allen, 'My War – Elizabeth A. Allen' *HistoryNet* (22/1/2013), www.historynet.com/my-war-elizabeth-a-allen/ and Ella St. George Carey, 'Creating Community and Finding Connection: A Black Nurse's Experience in Vietnam, 1966–67' *Nursing Clio* (15 October 2020), www.nursingclio.org/2020/10/15/creating-community-and-finding-

Endnotes

connection-a-black-nurses-experience-in-vietnam-1966-67.
117. Constance J. Moore, 'Male Nurses in Vietnam' Army Nurse Corps www.e-anca.org/History/Topics-in-ANC-History/Male-Nurses-Vietnam.
118. Dana DiFilippo, 'Blood Smells the Same but for Vietnam Nurses the War Never Ends,' WHYY (8 September 2017) https://whyy.org/articles/vietnamnursesdd.
119. Margret Ann LaSalle, 'Vietnam Nursing: The Experience Lives On' *Military Medicine*, Volume 165, Number 9 (September, 2000).
120. '1972: Beatrice Kosin and Evelyn Anderson Missionaries,' (2 November 2011), www.executedtoday.com/2011/11/02/1972-evelyn-anderson-beatrice-kosin-missionaries-laos/.
121. 'Civilian Eleanor Vietti,' Defence PoW/MIA Accounting Agency, https://dpaa-mil.sites.crmforce.mil/dpaaProfile?id=a0Jt00000001UPfEAM
122. Janice Margaret Twomey, 'It Was Florence Nightingale by touch: military nursing tradition and Australian nurses in Vietnam,' University of Wollongong Thesis Collection (2014). www.ro.uow.edu.au/cgi/viewcontent.cgi?article=5255&context=theses, 'Surgical and Medical Support: Vietnam War' www.vietnamwar.govt.nz/nz-vietnam-war/surgical-and-medical-support, Jung-jin Han, 'The Lived Experiences of Koran Female Military Nursing Officers During the Vietnam War,' *Journal of Transactional Nursing* 19 December 2018) www.jstor.org.library.esc.edu/stable/pdf/20670745.pdf?refreqid=excelsior%3Acf8eb9d5de8610d058a8d83cecdab461&ab_segments=&origin=, and Joung-won Alexander Kim, 'Korean Participation in the Vietnam War,' *World Affairs* Vol. 29, No, 1 (April-May, 1966), www.journals.sagepub.com/doi/10.1177/1043659618818713.
123. Danielle Portteus, 'Donut Dolly Recalls Her Vietnam War Experiences' *The Monroe News* (11 September 2018) www.monroenews.com/story/news/2018/09/11/donut-dolly-recalls-her/10792838007/ 'How Red Cross Donut Dollies Supported US Troops During Wartime' www.redcrosschat.org/2020/06/05/how-red-cross-donut-dollies-supported-u-s-troops-during-wartime/ 'Vietnam War and the American Red Cross' www.redcross.org/content/dam/redcross/National/history-vietnam-war.pdf, and 'American Red Cross Women in Vietnam' www.vietnamwomensmemorial.org/pdf/sdickerson.pdf.
124. Danielle Di Simone, 'Meet 3 Trailblazing Women Who Paved the Path in Military History and at the USO' (9 March 2022) USO www.uso.org/stories/3153-meet-3-trailblazing-women-who-paved-the-path-in-military-history-and-at-the-uso, Jeanne-Marie Brailey, 'This is the Untold Story of a USO's Icon in the Vietnam War' *USO* www.uso.org/stories/2053-this-is-the-untold-story-of-a-uso-icon-s-vietnam-war-experience, and Maureen Nerli,

Don't Call Us Girls

'The Unsung Heroes of Vietnam: Those USO Club Women' www.vietnamwomensmemorial.org/pdf/mnerli.pdf
125. 'History of Black Women in the Military', National Association of Black Military Women www.nabmw.org/history-of-black-women-in-the-milit.
126. Elizabeth Becker, 'The Women Who Covered Vietnam, *The New York Times* (17 November 2017) www.nytimes.com/2017/11/17/opinion/women-journalists-vietnam.html, Fiona Pepper, 'During the Vietnam War, three trailblazing female journalists changed the way war is reported,' ABC News (31 March 2022) www.abc.net.au/news/2022-04-01/vietnam-war-three-female-journalists-changed-the-way-war-covered/100882354, George Packer, 'The Women Who Changed War Reporting' *The Atlantic* (6 March 2011), www.theatlantic.com/ideas/archive/2021/03/vietnam-baghdad-women-who-changed-war-reporting/618215/, 'The Women War Correspondents of Vietnam' *National Interest* (29 April 2021), www.nationalinterest.org/blog/skeptics/women-war-correspondents-vietnam-184002, and Harry Press, 'Not Mentioned in Dispatches' *Stanford Magazine* (September-October 2002) www.stanfordmag.org/contents/not-mentioned-in-dispatches.

Chapter Five
127. 'Anne Henrietta Martin', Nevada Women's History Project, www.nevadawomen.org/research-centre/biographies-alphabetical/anne-henrietta-martin/, 'Anne Henrietta Martin, American Reformer and Activist', www.britannica.com/biography/Anne-Henrietta-Martin and Kathryn Anderson, 'Steps to Political Equality: Woman Suffrage and Electoral Politics in the Lives of Emily Newell Blair, Anne Henrietta Martin, and Jeannette Rankin', *Frontiers, a Journal of Women's Studies*, Volume 16, number 1 (1997), www.jstor.org/stable/3347204.ritannica.
128. Marian Mollin, 'Women's Struggles within the American Radical Pacifist Movement', *History Compass*, Volume 7, number 3 (2009), www.academia.edu/11934354/Womens_Struggles_within_the_American_Radical_Pacifist_Movement?email_work_card=title.
129. 'Mary McDowell Resisted Two Wars' *The Picket Line*, https://sniggle.net/TPL/index5.php?entry=13Mar13, 'McDowell, Mary Stone,' what-when-how, www.what-when-how.com/women-and-war/mcdowell-mary-stone-conscientious-objector/, Patricia Howlett and Charles F. Howlett, 'A Silent Witness for Peace: The Case of Schoolteacher Mary Stone McDowell and America at War,' *History of Education Quarterly*, Volume 4, number 8 (August, 2008), www-jstor-org.library.esc.edu/stable/20462242?seq=20, and 'Mary Stone McDowell, Wikipedia, www.en.wikipedia.org/wiki/Mary_Stone_McDowell.
130. *International Disarmament Institute News*, www.disarmament.blogs.pace.edu/nyc-

nuclear-archive/antinuclear-movement-1950s-1960s/sane-the-committee-for-a-sane-nuclear-policy/.
131. *See* 'Protest Against Nuclear War,' Nebraska Public Media, www.nebraskastudies.org/en/1950-1974/the-creation-of-sac/protest-against-nuclear-war/, 'Marjorie Swan Obituary, *The Boston Globe*, www.legacy.com/us/obituaries/bostonglobe/name/marjorie-swann-obituary?id=18629381, and Marian Mollin, 'Women's Struggles within the American Radical Pacifist Movement', *History Compass*.
132. Marian Mollin, 'Women's Struggles within the American Radical Pacifist Movement,' *History Compass* Volume 7, number 3 (2009), and Marian Mollin, Radical Pacfism in Modern America Chapter 3, 'Familialism and the Struggle Against the Bomb' De Gruyter (2007), www.academia.edu/11934354/Womens_Struggles_within_the_American_Radical_Pacifist_Movement?email_work_card=view-paper, and 'War Tax Resisters George and Lillian Willoughby,' *The Picket Line*, https://sniggle.net/TPL/index5.php?entry=05Nov18.
133. Dennis Hevesi, 'Dagmar Wilson, Anti-Nuclear Leader, Dies at 94', *The New York Times* (23 January 2011) www.nytimes.com/2011/01/24/us/24wilson.html.
134. Gerald Gill, 'From Maternal Pacifism to Revolutionary Solidarity: African-American Women's Opposition to the Vietnam War' in Barbara L. Tischler, ed., Sights on the Sixties (New Brunswick, New Jersey: Rutgers University Press, 1992), pp. 177-191.
135. Amy Swerdlow, "Not My son, Not Your Son, Not Their Sons' Mothers Against the Draft for Vietnam' in Barbara L. Tischler, ed. Sights on the Sixties (New Brunswick, New Jersey: Rutgers University Press, 1992), p. 163.
136. Ibid, p. 171.
137. Ibid, p. 173.
138. Burning Draft Card at US Supreme Court, Flickr. www.flickr.com/photos/washington_area_spark/17042761567
139. Another Mother for Peace website, www.anothermother.org/ and Caitlin Brooke Lilley, 'Motherhood is Political – Women in the Peace Movements in North Carolina from 1939-1980,' MA Thesis, University of North Carolina (2014).
140. Shulamith Firestone, 'The Jeannette Rankin Brigade: Woman Power?' www.marxists.org/subject/women/authors/firestone-shulamith/jeanette-rankin.htm.
141. Lindsey German, 'Rise and Fall of the Women's Movement,' *International Socialist*, 2:37 (Winter, 1988), www.marxists.org/history/etol/writers/german/1988/xx/rise-fall.html.
142. Ruth Rosen, 'The Day They Buried True Womanhood: Women and the Vietnam Experience' in D. Michael Shafer, ed., The Legacy: The Vietnam

War in the American Imagination (Boston: Beacon Press, 1990) and Lafayette Matthews, 'The Jeannette Rankin Brigade,' Boundary Stones, WETA's Local History Website, 24 August 2016, www.boundarystones.weta.org/2016/08/24/jeannette-rankin-brigade.
143. Perry S. Samuels, WWDC Transcript Editorial #1 in Swerdlow, 'Not My Son …' p.175, 262.
144. Swerdlow, p. 176.
145. 'Pacifism Sparked Her Fiery Sacrifice', *Detroit Free Press* (18 March 1965) p. 1. www.newspapers.com/image/99209866.
146. William Gold, 'Man Dies a Human Torch at Pentagon-Child is Saved' Evening Star, 3 November 195, Section A. in WETA, 'The Fire of Norman Morrison', www.boundarystones.weta.org/2018/10/25/fire-norman-morrison#footnote-marker-1-1.
147. 'I told Them to Be Brave', *The Guardian* (15 October 2021) www.theguardian.com/lifeandstyle/2010/oct/16/norman-morrison-vietnam-war-protest.
148. Mary Hershberger, Travelling to Vietnam: American Peace Activists and the War (Syracuse: Syracuse University Press, 1998), 2-6.
149. Ibid, p. 78.
150. Gerald Gill, 'From Maternal Pacifism to Revolutionary Solidarity: African-American Women's Opposition to the Vietnam War' in Tischler, Sights on the Sixties, p. 183 and Theresa Anderson, 'Interview with Diane Nash' *Iris, A Journal About Women* (Spring-Summer 2003).
151. Jessica M. Frazier, 'Collaborative Efforts to End the War in Viet Nam: The Interactions of Women Strike for Peace, the Vietnamese Women's Union, and the Women's Union of Liberation, 1965-1968,' *Peace and Change*. Volume 37, number 17 (July 2012), p 349.
152. Dagmar Wilson speech cited in Jessica M. Frazier, 'Collaborative Efforts to End the War in Vietnam: The Interactions of Women Strike for Peace, the Vietnamese Women's Unio, and the Women's Union of Liberation, 1965-1968' *Peace and Change* www.academia.edu/35817321/Collaborative_Efforts_to_End_the_War_in_Viet_Nam_The_Interactions_of_Women_Strike_for_Peace_the_Vietnamese_Womens_Union_and_the_Womens_Union_of_Liberation_1965_1968.
153. Sara Evans, Personal Politics: The Roots of Women's Liberation in the Civil Rights Movement and the New Left (New York: Vintage Books, 1980), p. 113.
154. Barbara Haber, 'Reflections on Women in the Culture of Port Huron', in Howard Brick and Gregory Parker, A New Insurgency: The Port Huron Statement in its Times (Ann Arbor, Michigan: Michigan Publishing Company, 2015) www.quod.lib.umich.edu/m/maize/13545967.0001.001/1:6.7/–new-insurgency-the-port-huron-statement-and-its-times?rgn=div2;view=fulltext.

Endnotes

155. Cathy Wilkerson, Oral History Interview, Columbia University (17 February 1985).
156. Barbara Haber, 'Reflections on Women in the Culture of Port Huron'.
157. Cathy Wilkerson, 'Delegation to Hanoi Returns' *New Left Notes*, Vol. 2, Number 45 (18 December 1967), p. 1, p. 4.
158. Bernardine Dohrn, 'Vietnam Offensive' *New Left Notes*, Volume 4, Number 14 (10 April 1969), p. 4
159. Allen Cohen, *'The San Francisco Oracle*: A Brief History' in Ken Wachsberger, ed, Voices Under-Ground: Insider Histories of the Vietnam era Underground Press (Tempe, Arizona: Mica Press, 1993), p. 158.
160. Naomi Jaffe and Bernardine Dohrn, 'The Look is You', *New Left Notes*, Volume 3, Number 10 (18 March 1968), p. 5.
161. 'Women's Day Issue', *New Left Notes*, Volume 4, number 9 (7 March 1969).
162. Cathy Wilkerson, 'Toward a Revolutionary Women's Militia' *New Left Notes*, Volume 4, number 24.
163. Gloria Steinem, 'After Black Power, Women's Liberation', *New York Magazine* (4 April 1969, reprinted 4 May 2018) www.nymag.com/news/politics/46802/.
164. Rosalind Rosenberg, '1968: Barnard and the Historic Protests,' *Barnard Magazine* (23 April 2018), Karen Matthews, '50 Years Ago Student Protests Shut Down Columbia', Channel 4, New York (22 April 20180, and Blake Slonecker, 'The Politics of Space: Student Communes, Political Counterculture, and the Columbia University Protest of 1968' Master of Arts Essay, University of North Carolina (2006).
165. Barbara Haber, 'Reflections on Women in the Culture of Port Huron'.
166. 'Viet Nam' Vassar Encyclopedia, www.vassar.edu/vcencyclopedia/wartime/vietnam.html.
167. Mya Dosch, 'Protesting the Vietnam War with Lipstick,' Smarthistory https://smarthistory.org/seeing-america-2/lipstick-ascending-sa.
168. 'Nov. 15, 1969: Second Anti-war Moratorium,' Zinn Education Project, www.zinnedproject.org/news/tdih/second-anti-war-moratorium.
169. John F. TINKER and Mary Beth Tinker, Minors, etc., et al., Petitioners, v. DES MOINES INDEPENDENT COMMUNITY SCHOOL DISTRICT et al. www.law.cornell.edu/supremecourt/text/393/503, 'Tinker v Des Moines – Landmark Supreme Court Ruling on Behalf of Student Expression, ACLU, www.aclu.org/other/tinker-v-des-moines-landmark-supreme-court-ruling-behalf-student-expression, and 'Facts and Case Summary – Tinker v Des Moines, United States Courts, www.uscourts.gov/educational-resources/educational-activities/facts-and-case-summary-tinker-v-des-moines.
170. Barbara Haber, 'Reflections on Women in the Culture of Port Huron'.
171. Karen Nikos-Rose, 'What Was the Chicano Moratorium Protest of 1970? *UC*

Davis (31 August 2020), www.ucdavis.edu/curiosity-gap/what-was-chicano-moratorium-protest-1970.
172. 'Struck from the Record' NPR: On the Media (24 June 2022), www.wnycstudios.org/podcasts/otm/episodes/on-the-media-struck-from-the-record, 'Court Backs Air Force's Ouster of an Unwed Pregnant Officer' *The New York Times* (16 November 1971) www.nytimes.com/1971/11/16/archives/court-backs-air-forces-ouster-of-an-unwed-pregnant-officer.html, Jessica Glenza and Alana Casanova, 'They gave her a choice: your baby or your job' *The Guardian* (13 December 2019), and 'Struck v Secretary of Defence' United States Court of Appeals (15 November 1971) www.casetext.com/case/struck-v-secretary-of-defence.
173. All references to the GI anti-war press can be found in Barbara L. Tischler, 'Breaking Ranks: GI Anti-war Newspapers and the Culture of Protest' *Vietnam Generation*, Volume 2, Number 1 (1990), pp. 20-50.
174. 'Nag, Nag, Nag – Jane Fonda Has Become a Nonstop Activist,' *Life* (23 April, 1971).
175. 'Left Face,' *The New Republic* (31 March 1971), p. 9.
176. 'FTA' Wikipedia. The statement is included in *Liberated Barracks*, a GI anti-war newspaper published in Hawaii.
177. Barbara L. Tischler, 'Hanoi Jane Lives: The 1969s Legacy of Jane Fonda,' in Avital H. Bloch and Lauri Umanski, Impossible to Hold: Women and Culture in the 1960s (New York: New York University Press, 2005), pp. 241-258.

Chapter Six
178. Michael Vester, 'The German New Left and Participatory Democracy: The Impact on Social, Cultural, and Political Change' in Howard Brick and Gregory Parker, A New Insurgency: The Port Huron Statement and its Times (Michigan: Maize Books, 2015), www.quod.lib.umich.edu/m/maize/13545967.0001.001/
179. Chris Dixon and Jon Piccini, 'The Anti-Vietnam War Movement: International Activism and the Search for World Peace,' The Routledge History of World Peace Since 1750, p. 9. www.researchers.mq.edu.au/en/publications/the-anti-vietnam-war-movement-international-activism-and-the-sear.
180. Nikita Sergeyevich Khrushchev, 'Special Report to the 20th Congress of the Communist Party of the Soviet Union' (24-25 February 1956). www.history.state.gov/milestones/1953-1960/khrushchev-20th-congress.
181. Francoise Picq, 'The History of Feminist Movements in France', *Thinking Differently* (28 April 2002), www.francoisepicq.fr/the-history-of-feminist-movements-in-france/.

Endnotes

182. Margaret Mead, 'The Generation Gap,' *Science*, Volume 164, number 3876 (11 April 1969), passim.
183. Robert O. Paxton, Europe in the Twentieth Century (New York: Harcourt, Brace, Jovanovich, 1975), p. 543.
184. Kate Keller, 'Fifty Years Later, France is Still Debating the Legacy of its 1968 Protests,' *Smithsonian* Magazine (4 May 2018), www.smithsonianmag.com/history/fifty-years-later-france-still-debating-legacy-its-1968-protests-180968963.
185. NPR, 'In France, The Protests of May 1968 Reverberate Today – and Still Divide the French,' (29 May 2018).
186. Michael Jackman, 'Mario Savio's Bodies Upon the Gears Speech – Fifty Years Later,' *The Metro Times* (1 December 2014) www.metrotimes.com/news/mario-savios-bodies-upon-the-gears-speech-50-years-later-2271095.
187. 'On the Poverty of Student Life,' published by the students of the Internationale Situationiste (1966) www.library.nothingness.org/articles/SI/en/display/4.
188. Dick Pitt's remarks are quoted in Jon Henley, '1968: I Was There,' *The Guardian* (21 May 2008), www.theguardian.com/world/2008/may/21/1968theyearofrevolt.anti-war.
189. Sarah Colvin and Katharine Karcher, eds., Women, Global Protest Movements and Political Agency: Rethinking the Legacy of 1968 (New York: Routledge, 2018) www.routledge.com/Women-Global-Protest-Movements-and-Political-Agency-Rethinking-the-Legacy/Colvin-Karcher/p/book/9780367471828.
190. Maris Campistron, 'Being a Liberated Woman: in May-68, It was Not so Easy,' *L'OBS* (8 April 2018).
191. Mark Kurlansky, '1968: The Year that Rocked the World,' (New York: Random House, 2004), p. 227 and 'May 1968 Graffiti,' Bureau of Public Secrets www.bopsecrets.org/CF/graffiti.htm.
192. Rita Chin, 'European New Lefts, Global Connections, and the Problem of Difference ' in Brick and Parker, A New Insurgency, www.quod.lib.umich.edu/m/maize/13545967.0001.001/1:9.3/--new-insurgency-the-port-huron-statement-and-its-times.
193. Francoise Picq, 'The History of Feminist Movements in France', *Thinking Differently* (28 April 2002), www.francoisepicq.fr/the-history-of-feminist-movements-in-france.
194. Corinne Maier, 'The Hidden Women of Paris,' *The New York Times* (7 May 2018).
195. Hilke Schlaeger and Nancy Vedder-Shults, 'The West German Women's Movement', *New German Critique*, (Winter, 1978), www.jstor.org/stable/3115187.

196. Louise Schaefer, '68 Movement Brought Lasting Changes to German Society,' *DW* (11 April 2008) www.dw.com/en/68-movement-brought-lasting-changes-to-german-society/a-3257581.
197. Gaby Reicher, 'Why Germany's 1968 Movement Has Not Failed,' (interview with Gretchen Dutschke) DW (11 April 2008). www.dw.com/en/why-germanys-1968-movement-has-not-failed/a-42956603.
198. Ibid.
199. Christoph Zeiler, 'Organizing a Student Protest? Take a Look at 1970s Germany,' *The Conversation* www.theconversation.com/organizing-a-student-protest-have-a-look-at-1970s-germany-52424.
200. Michael A. Schmedke, 'Cultural Revolution or Culture Shock? Student Radicalism and 1968 in Germany,' *South Central Review*, Volume 17, number 1 (Winter 1999-Spring 2000), p. 82.
201. Michael Vester, 'The German New Left and Participatory Democracy.'
202. 'Rudi Deutschke Shot,' *New Left Notes* ((5 April 1968), p. 1.
203. David Caute, The Year of the Barricades: A Journey Through 1968 (New York: Harper and Row, 1968), p. 100 and Cinthia Salinas, 'Action Council for the Liberation of Women' (Aktionmsrat zur Befreiung der Frauen), 1967; Towards Emancipation.
204. Helke Sander, 'The SDS – An Overblown, Counterrevolutionary Ball of Yeast Dough', German History in Documents and Images, Volume 9, www.germanhistorydocs.ghi-dc.org/print_document.cfm?document_id=1097, 1968 Helke Sander's Speech (Berlin Goes Feminist), www.feministberlin1968ff.de/leftist-debates/1968-helke-sanders-speech-2/, 'Academic Meets German President to call for Female 1968' Queen Mary University of London (17 July 2018), and Cinthia Salinas, 'Action Council for the Liberation of Women,' and Fuigga Haug, 'The Women's Movement in West Germany,' *New Left Review* (January-February, 1986). https://hist259.web.unc.edu/actioncouncil/.
205. Caroline Hoefferle, 'A Web of Interconnections: Student Peace Movements in Great Britain and the United States', p. 135. *Academia*. www.academia.edu/1444619/A_Web_of_Interconnections_Student_Peace_Movements_in_Britain_and_the_United_States.
206. Sylvia A. Ellis, 'Promoting Solidarity at Home and Abroad: The Goals and Tactics of the Anti-Vietnam War Movement in Britain', *European Review of History* (2 October 2013).
207. Richard Johnson, 'Remembering Anne Kerr, Labour's Forgotten Firebrand,' *Tribune* (19 November 2020), www.tribunemag.co.uk/2021/11/anne-kerr-labour-party-mp-rochester-vietnam-apartheid-chicago-europe-france.
208. 'Peggy Duff,' Women in Peace, www.womeninpeace.org/d-names/2017/6/22/peggy-duff.

Endnotes

209. The Associated Press photo appears on the website of the *Berkshire Eagle*, www.berkshireeagle.com/anti-vietnam-war-protest/image_0dd1fb58-715f-11eb-864c-23652ceb2ded.html.
210. Jon Henley, '1968: I Was There', *The Guardian* (21 May 2008), www.theguardian.com/world/2008/may/21/1968theyearofrevolt.anti-war.
211. '18 March 1968: 300 Arrested After Vietnam Protest,' *The Guardian* (18 March 1968, reprinted 17 May 2010), www.theguardian.com/theguardian/vietnam-war-protests-london-trafalgarsquare./2010/mar/18/all
212. Abhimanya Manchanda, '1968, Grosvenor Square – That's where the Protest should be Made' Encyclopaedia of Anti-Revisionism On-Line, www.marxists.org/history/erol/uk.secondwave/grosvenor-square.pdf.
213. Jac St. John, 'Policing Anti-Vietnam War Demonstrations, 1968,' Special Branch Files Project, www.specialbranchfiles.uk/vietnam-war-story/
214. Sisterhood and After Research Team, 'Patriarchy, Militarism, and the Peace Movement,' The British Library, www.bl.uk/sisterhood/articles/patriarchy-militarism-and-the-peace-movement.
215. Sheila Rowbotham, Woman Consciousness, Man's World (New York: Random House, 1973).
216. Louise E. Walker, 'Ashamed of Being Middle Class: Mexico's 1968 Student Movement and It Legacy' in Howard Brick and Gregory Parker, A New Insurgency: The Port Huron Statement and its Times (Michigan: Maize Books, 2015), www.quod.lib.umich.edu/m/maize/13545967.0001.001/–new-insurgency-the-port-huron-statement-and-its-times.
217. Carrie Kahn, 'What's Changed Since Mexico's Bloody Crackdown on 1968 Student Protests?' NPR (2 October 2018) www.wlrn.org/2018-10-02/whats-changed-since-mexicos-bloody-crackdown-on-1968-student-protests, Jimena Vergara, 'Remembering the Massacred Students of Mexico City', *Left Voice* (2 October 2018, www.leftvoice.org. Manuel Aguilar Mora, '1968 in Mexico, and 50 Years Later,' *International Socialist Review* (issue #111), www.isreview.org/issue/111/1968-mexico-and-50-years-later/index.html, Lulu Barrera and Daphne Beltran, 'The Women of the '68 student movement in Mexico', *Open Democracy* (29 October 2019) www.opendemocracy.net/en/democraciaabierta/las-mujeres-del-movimiento-estudiantil-del-68-en-m%C3%A9xico-en/, and Victor Bachre Parra, 'Consuelo Valle: Revolutionary in Mini-skirts 1968', *Milenio* (5 September 2019) www.milenio.com/opinion/victor-bacre-parra/de-neblinas-don-goyo/consuelo-valle-minifaldas-revolucionarias-1968-ii.
218. 'SDS and the Japanese New Left', *New Left Notes* (August 19196), p. 4.
219. P. A. Narasimhhamurthy,' Gendai Shiso Kenkyukai: the Japanese New Left', *Notes* and *Memoranda*, Volume 4, Number 2 (1 April 1962) www.journals.sagepub.com/doi/abs/10.1177/002088176200400204, 'Beheiren, US-Japan

Relations, and History of Activism in Japan', www.crkraus.com/2013/09/08/beheiren-and-history-activism-in-japan and Chelsea Szendu Scheider, 'Coed Revolution: The Female Student Movement in the Japanese New Left, 1957-1972', Columbia University Academic Commons.

Chapter Seven

220. Mary Wollstonecraft, A Vindication of the Rights of Woman, British Library, www.bl.uk/collection-items/mary-wollstonecraft-a-vindication-of-the-rights-of-woman.
221. Virginia Woolf, A Room of One's Own, Chapter Three: Why aren't there more great women writers to be found in history? www.wohlstadterj.faculty.mjc.edu/E%20138%20Virginia%20Woolf.pdf. and 'The 100 best nonfiction books: No 45 – A Room of One's Own by Virginia Woolf (1929), www.theguardian.com/books/2016/dec/05/100-best-nonfiction-books-no-45-a-room-of-ones-own-by-virginia-woolf-shakespeares-sister-seton-beton.
222. Simone de Beauvoir, The Second Sex, https://www.marxists.org/reference/subject/ethics/de-beauvoir/2nd-sex/introduction.htm.
223. The teleological progression from civil rights to the anti-war movement to the new feminism is a convenient but reductive representation of protest movements in the 1960s and 1970s. Perhaps unintentionally, films such as 'Berkeley in the Sixties' present the history of dissent in this way, thereby muting the importance of events that do not precisely fit this chronological model. Sara Evans, in her pathbreaking analysis of the roots of the new feminism, asserted that, by the early 1970s, 'the women's liberation movement was infused with a vitality that was rapidly ebbing in other parts of the left'. See Sara Evans, Personal Politics, p. 211 and Nancy Rosenstock, 'Second Wave Feminism: Accomplishments & Lessons', *Against the Current* (8 March 2021) www.internationalviewpoint.org/spip.php?article7063.
224. Untitled Article, *New Left Notes* January 1968), p. 2.
225. Interview with Lonnie King, 'Women in the Civil Rights Movement' Library of Congress, www.loc.gov/collections/civil-rights-history-project/articles-and-essays/women-in-the-civil-rights-movement.
226. Interview cited in G. Louis Heath, ed., Off the Pigs! The History and Literature of the Black Panther Party (Metuchen, New Jersey: Scarecrow Press, 1976), 342.
227. Myra MacPherson, Long Time Passing: Vietnam and the Haunted Generation (New York: Signet Books), 552.
228. Toni Morrison, 'What the Black Woman Thinks About Women's Lib', *The New York Times* (22 August 1971) www.nytimes.com/1971/08/22/archives/what-the-black-woman-thinks-about-womens-lib-the-black-woman-and.html.

229. Karla Mendez, 'Honouring the Revolutionary Feminist Legacy of the Third World Women's Alliance,' Black Women Radicals, www.blackwomenradicals.com/blog-feed/at-the-intersections-of-race-gender-and-class-honouring-the-revolutionary-feminist-legacy-of-the-third-world-womens-alliance, Frances M. Beal, 'Double Jeopardy: To Be Black and Female', www.jstor.org/stable/40338758 and Ariane Vani Kannan, 'Third World Women's Alliance: History, Geopolitics, and form, Dissertation, Syracuse University (2018).
230. Kannan, 'Third World Women's Alliance,' p. 52.
231. Albert and Albert, op. cit., 252.
232. Alice Echols, Daring to Be Bad: Radical Feminism in America, 1967–1975 (Minneapolis: University of Minnesota Press, 1989), pp. 121–122.
233. Naomi Jaffe and Bernadine Dohrn, 'The Look is You', *New Left Notes* (18 March 1968), 5.
234. Kirkpatrick Sale, SDS, 526.
235. Ellen Willis, 'Radical Feminism and Feminist Radicalism' in Sohnya Sayres, Anders Stephanson, Stanley Aronowitz, and Fredric Jameson, eds., The '60s Without Apology (Minneapolis: University of Minnesota Press, 1984), 94.
236. A Berkeley Sister, 'To a White Radical' *The Berkeley Tribe* (15-22 May 1970), 8 in Albert and Albert, The Sixties Papers, 518.
237. Cited in Charles DeBenedetti, An American Ordeal: The Anti-war movement of the Vietnam Era (Syracuse: Syracuse University Press, 1990), 146.
238. *New Left Notes*, cited in Sara Evans, Personal Politics, 190-191.
239. See Alice Echols, Daring to be Bad: Radical Feminism in America 1967-1975 (Minneapolis: University of Minnesota Press, 1989), pp. 117-119.
240. Myra MacPherson, Long Time Passing, 543.
241. Pauli Murray, "The Negro Woman in the Quest for Equality. '*The Acorn*', published by Lambda Kappa Mu Sorority (June, 1964) in Gerda Lerner, ed. Black Women I White America (New York, Vintage, 1973), p. 599.
242. Pauli Murray, 'The Negro Woman in the Quest for Equality', speech to the National Council of Negro Women Convention, Washington DC, 14 November 1963, Box 128, Folder 2323, Pauli Murray Papers, 1827-1985, Schlesinger Library, Radcliffe College.
243. Pauli Murray and Jane Eastman, 'Jane Crow and the Law: Sex Discrimination and Title VII', *George Washington Law Review*, Volume 32, number 2 (December 1965) pp. 232-256.
244. Katherine Turk, The Women of Now: How Feminists Built an Organization that Transformed America (New York: Farrah, Straus, and Giroux, 2023) p. 21.
245. 'When and How Was NOW Founded?' www.now.org/faq/when-and-how-was-now-founded.

246. National Organization for Women, www.now.org/about.
247. Pauli Murray, 'The Negro Woman in the Quest for Equality' in Gerda Lerner, ed. Black Women I White America p. 599.
248. Martha Weinman Lear, 'The Second Feminist Movement,' *The New York Times* (10 March 1968) www.timesmachine.nytimes.com/timesmachine/1968/03/10/issue.html.
249. Ellen Willis, 'Up from Radicalism: A Feminist Journal' in Ellen Willis et al., The Essential Ellen Willis (Minneapolis: University of Minnesota Press, 2015) Chapter Three.
250. Valerie Solanis, 'S.C.U.M. Manifesto' in *The Berkeley Barb* (June 7-13, 1968) in Judith Clavir Albert and Stewart Albert, The Sixties Papers: Documents of a Rebellious Decade (New York: Praeger, 1984), 463-4. The full text of the S.C.U.M. Manifesto can be found at www.ccs.neu.edu/home/shivers/rants/scum.html.
251. Carol Anne Douglas and Fran Moira, 'Off Our Backs: The First Decade (1970-1980)' in Ken Wachsberger, ed., Voices from the Underground, Volume I: Insider Histories of the Vietnam era Underground Press (Tempe: MICA press, 1993), 107-113.
252. '100 Women: The truth behind the bra-burning feminists' BBC News (7 September 2018), www.bbc.com/news/world-45303069.
253. See Roxane Gay, 'Fifty Years Ago Protesters took on the Miss America Pageant and Electrified the Feminist Movement,' *Smithsonian* (January, 2018), www.smithsonianmag.com/history/fifty-years-ago-protestors-took-on-miss-america-pageant-electrified-feminist-movement-180967504/, and 'When Feminists Protested Miss America as a Cattle Auction,' *History*, www.history.com/news/miss-america-protest-1968.
254. Linda Napikoski, 'Women's Strike for Equality,' Thought.Co. (24 February 2019) www.thoughtco.com/the-womens-strike-for-equality-3528989, Sascha Cohen, 'The Day Women Went on Strike', *TIME* (26 August 2015), www.time.com/4008060/women-strike-equality-1970/, and Maggie Doherty, 'Feminist Factions United and Filled the Streets for this Historic March', *The New York Times*, (26 August 2020), www.nytimes.com/2020/08/26/us/womens-strike-for-equality.html.
255. Vivian Gornick, 'What We Want Is to Start a Revolution', (review of 'Joanna Scutts, Hotbed: Bohemian Greenwich Village and the Secret Club That Spearheaded Modern Feminism', *New York Review of Books* (18 August 2022), p.42.
256. Kelli Zaytoun and Judith Ezekiel, 'Sisterhood in Movement Feminist Solidarity in France and the United States', *Frontiers, A Journal of Women's Studies*, Volume 37, number 1 (2016) p. 198.

Endnotes

257. Linda Napikoski, 'Significant Feminist Protests,' Thought.Co. (11 September 2019), www.thoughtco.com/significant-american-feminist-protests-3529008.
258. Donna Goodman, 'The untold side of second wave feminism: A multinational, politically diverse movement' Liberation School www.liberationschool.org/feminism-and-the-mass-movements-1960-1990/, and Becky Little, 'Unbought and Unbossed: Why Shirley Chisholm Ran for President', *HISTORY* (12 January 2021), www.history.com/news/shirley-chisholm-presidential-campaign-george-wallace.
259. Michael Kendall, 'The Oldest Profession Organizes', *Harvard Crimson* (15 November 1977) www.thecrimson.com/article/1977/11/16/the-oldest-profession-organizes-pthe-second.
260. 'COYOTE: Background – Women and Labour Movements' Sallie Bingham Center for Women's History and Culture' (Duke University) www.exhibits.library.duke.edu/exhibits/show/theworldsoldestprofession/coyotebackground.
261. Kelli Zaytoun and Judith Ezekiel, 'Sisterhood in Movement: Feminist Solidarity in France and the United States,' *Academia*, www.academia.edu/25609390/Sisterhood_in_Movement_Feminist_Solidarity_in_France_and_the_United_States.
262. Alban Jacquemart and Camille Masclet, 'Women-only and mixed groups in the French feminist movements in the 1970s: a re-evaluation', *Clio* Number 46 (2017) https://www.jstor.org/stable/26795734.
263. 'Towards emancipation? Women in Modern European History,' A Digital exhibition and Encyclopedia www.hist259.web.unc.edu/womensliberationmovement.
264. Dorothy Kaufman-McCall, 'Politics of Difference: the Women's Movement in France from May 1968 to Mitterrand', *Signs* Volume 9, No. 2 (Winter, 1983), p. 283.
265. Lisa Greenwald, 'French Feminism at the Barricade', (an excerpt from 'Daughters of 1968'): Public Seminar www.publicseminar.org/2019/03/french-feminism-at-the-barricade.
266. 'Manifesto of the 343' Wikipedia, www.en.wikipedia.org/wiki/Manifesto_of_the_343.
267. 'Avortement: Des Histoires varies', *Le Torchon Brule* #2 (1971) p. 4 in Maud Anne Bracke, 'Women's 1968 is Not Yet Over: The Capture of Speech and the Gendering of 1968 in Europe', *American Historical Review*, Volume 123, number 3 (June 2018), www.academic.oup.com/ahr/article/123/3/753/5025363.
268. *See* Sarah Colvin and Katharina Karcher, eds., Women. Global Protest Movements and Political Agency: Rethinking the Legacy of 1968 (New York: Routledge, 2018), no pages listed, www.books.google.com.
269. Dorothy Kaufman-McCall, 'Politics of Difference,' p. 284, p. 286.

270. Eli Thorkelson, 'Sexist Anti-Feminism in the French Left, 1970', *Decasia, critical anthropology of academic culture*.
271. Danielle Stewart, 'The Women's Movement in France', *Signs*, Volume 6, number 2 (Winter, 1980), https://www.jstor.org/stable/3173940.
272. Kamilia Lahrichi, '4 iconic French Activists Who Made a Difference in Women's Rights', *Global Citizen* (30 June 2021), www.globalcitizen.org/en/content/iconic-french-feminist-activists.
273. 'April 4: The Gouines Rouges are formed', 365 Days of Lesbians, www.365daysoflesbians.tumblr.com/post/159212860822/april-4-the-gouines-rouges-are-formed-1971.
274. Rashad Khan, 'One is Not Born a Women: Remembering Monique Wittig's Feminism', *Feminism in India* (18 June 2019), www.feminisminindia.com/2019/06/18/monique-wittig-material-feminism.
275. Carin Drossus, 'The Achievements and Uncertainties of French Feminism', *Cairn Info International* Volume 2, Number 8 (October 2018), www.cairn-int.info/dossiers-2018-8-page-1.htm.
276. Florence Binard, 'The British Women's Liberation Movement in the 1970s: Redefining the Personal and the Political,' *Revue Francaise de Civilisation Britannique* (French Journal of British Studies) (2017), p. 2. www.researchgate.net/publication/322164026_The_British_Women's_Liberation_Movement_in_the_1970s_Redefining_the_Personal_and_the_Political.
277. 'Coming of Age in the UK Women's Liberation Movement' Oxford Academic (19 March 2021) www.medium.com/history-uncut/coming-of-age-in-the-uk-womens-liberation-movement-68434c47a2cf#:~:text=The%20decade%20of%20the%201970's,combine%20self%2Drealization%20with%20protest
278. Sheila Rowbotham, Woman's Consciousness, Man's World (New York: Verso Books, 2015), p. 6, cited in Florence Binard, 'The British Women's Liberation Movement in the 1970s: Redefining the personal and the Political' *Revue Francaise de Civilisation Britannique* (2017) www.journals.openedition.org/rfcb/1688.
279. Simon Goodley, 'Dagenham sewing machinists recall strike that changed women's lives,' *The Guardian* (6 January 2013) www.theguardian.com/politics/2013/jun/06/dagenham-sewing-machinists-strike and Linda Napikoski, 'The Dagenham Women's Strike of 1968,' ThoughtCo. (28 October 2019) www.thoughtco.com/the-dagenham-womens-strike-of-1968-3528932.
280. Ibid, p. 5 and Sundari Anitha and Ruth Pearson, 'Remembering the Grunwick dispute', British Librrary www.bl.uk/womens-rights/articles/remembering-the-grunwick-dispute.
281. Florence Binard, 'The British Women's Liberation Movement in the 1970s,' p. 3.

Endnotes

282. 'Jo Robinson Discusses the Miss World Contest', British Library, www.bl.uk/collection-items/jo-robinson-miss-world-contest, Francesca Shillcock, 'What Really Happened at the 1970 Miss World Beauty Pageant?' *Hello!* (8 March 2021) www.hellomagazine.com/film/20210308108439/miss-world-1970-what-really-happened-at-beauty-pageant/ and 'Unstoppable Voices: How the 1970 Miss World Contest Started a Revolution,' Royal Albert Hall (15 October 2020), https://www.royalalberthall.com/about-the-hall/news/2020/october/unstoppable-voices-how-the-1970-miss-world-contest-sparked-a-revolution/.
283. Katharina Karcher, Introduction to Sisters in Arms: Militant Feminisms in the Federal Republic of Germany Since 1968. (New York and Oxford, Berghahn (2019) p. 3 www.berghahnbooks.com/downloads/intros/KarcherSisters_intro.pdf.
284. 'Women's Liberation Movement in Germany' *Frauen Media Turm* (Feminist Archive and Library, www.en.frauenmediaturm.de/feminism-germany-second-wave/abortion-feminists.
285. Ibid.
286. Nathaniel Flakin, 'Red Flag: How Berliners Fought for Abortion Rights in the 1970s,' *Exberliner*, www.exberliner.com/berlin/red-flag-when-berlin-feminists-abortion.
287. Schultz's comment appears in Bailee Erikson, 'Every Woman Needs 'Courage': Feminist Periodicals in 1970s West Germany' *Preteritus*, pp.32-44, www.researchgate.net/publication/277244299_Every_Woman_Needs_Courage_Feminist_Periodicals_in_1970s_West_Germany.
288. Ibid.
289. Ute Fervert, Women in German History, from Bourgeois Emancipation to Sexual Liberation (1997) cited in Katherine Karcher, Introduction to Sisters in Arms: Militant Feminisms in the Federal Republic of Germany since 1968, p. 1. www.berghahnbooks.com/downloads/intros/KarcherSisters_intro.pdf.
290. Katherine Karcher, Introduction to Sisters in Arms, p.8.
291. Ibid, p. 11.
292. Janice G. Raymond, 'Lesben…nur Von Der Taille Abwärts?' *Emma*, December 1989, 1989, 37 cited in Kathryn A. Roy, German Unification: A Feminist Movement, Digital Commons, Connecticut College, p. 44. www.digitalcommons.conncoll.edu/cgi/viewcontent.
293. Diane McMeeking in Jon Henley '1968: I Was There, *The Guardian* (28 May 2008), www.theguardian.com/world/2008/may/21/1968theyearofrevolt.anti-war.
294. Norma Stoltz Chincilla, 'Women's Movements in the Americas: Feminism's Second Wave, *North American Conference on Latin America* (26 September

2007), https://nacla.org/article/women%27s-movements-americas-feminism%27s-second-wave, Martha Zapata Galindo, 'Feminist Movements in Mexico: From Conscious-Raising to Transnational Networks', Feminist Philosophy in Latin America and Spain (Chapter 1), www.brill.com/view/book/edcoll/9789401204439/B9789401204439-s002.xml, and Alan Riding, 'Mexican Feminists Turn Their Attention to Social Issues: Many Marriages are Breaking Up', *New York Times* (2 December 1979), www.nytimes.com/1979/12/02/archives/mexican-feminists-turn-their-attention-to-social-issues-many.html.

295. Barbara Molony, 'Feminism in Japan' Oxford Research Encyclopedia (24 January 2018), www.oxfordre.com/asianhistory/view/10.1093/acrefore/9780190277727.001.0001/acrefore-9780190277727-e-194, Vera Mackie, 'Feminist Politics in Japan', *New Left Review* (January-February, 1988) www.newleftreview.org/issues/i167/articles/vera-mackie-feminist-politics-in-japan.pdf, and Chelsea Szendi Schieder, Introduction to Coed Revolution: The Feminist Student in the Japanese Left, (Durham, North Carolina, 2021), www.academia.edu/44679748/Introduction_Coed_Revolution_The_Female_Student_in_the_Japanese_New_Left_.

Chapter Eight

296. 'The Dobbs v Jackson Decision: Annotated' *The New York Times* (24 June 2022) www.nytimes.com/interactive/2022/06/24/us/politics/supreme-court-dobbs-jackson-analysis-roe-wade.html.
297. Judith Butler, 'What Clarence Thomas Said', *Verso* (27 June 2022), www.versobooks.com/blogs/5380-what-clarence-thomas-said.
298. Alex Cohen and Wilfred Codrington III, 'The Equal Rights Amendment Explained,' Brennan Center for Justice (23 January 2020), www.brennancentre.org/our-work/research-reports/equal-rights-amendment-explained.
299. Helen Reddy and Ray Burton, 'I Am Woman' lyrics.
300. Ellen Sweet, 'Feminism's Journey Over the Decades,' *The New York Times* (25 June 2022), www.nytimes.com/2022/06/25/opinion/letters/feminism-ms-magazine.html.
301. Deborah J, Vagins and Georgeanne Usova, 'The 'Equal Pay Act: You've Come a Long Way, Baby (But Not All the Way)' *ACLU* (10 June 2011), www.aclu.org/blog/womens-rights/womens-rights-workplace/equal-pay-act-youve-come-long-way-baby-not-all-way.
302. Ronnie Grinberg, 'An Overlooked Conservative Writer helps explain Trump's Enduring Appeal', *The Washington Post* (22 May 2022) www.washingtonpost.com/outlook/2022/05/20/an-overlooked-conservative-writer-helps-explain-

trumps-enduring-appeal/, Jeet Heer, 'Farewell to Midge Decter, the Bigot on the Beach', *The Nation* (13 May 2022) www.thenation.com/article/culture/midge-decter-obituary-bigotry/, and Douglas Martin, 'Midge Decter, an Architect of Neoconservatism, Dies at 94', *The New York Times* (9 May 2022), www.nytimes.com/2022/05/09/books/midge-decter-dead.html.

303. Susan Faludi, Backlash, 'Introduction: Blame it on Feminism' www.susanfaludi.com/backlash-chapter.html.

304. Ramona Grigg, 'Marabel Morgan and Why the Feminist Movement Had to Get Moving', *Indelible Ink*, (6 March 2019) www.medium.com/indelible-ink/marabel-morgan-and-why-the-feminist-movement-had-to-get-moving-6577731b44e7 and Marabel Morgan, excerpt from The Total Woman, www.darkwing.uoregon.edu.

305. Amanda Marcotte, 'Nancy Reagan's anti-feminism might be her most lasting legacy', *Salon* (7 March 2016), www.salon.com/2016/03/07/nancy_reagans_anti_feminism_might_be_her_most_lasting_legacy.

306. Ilyse Hogue, 'How Phyllis Schlafly Found the Right Balance of Racism and Misogyny and Charted the Future of the Radical Right', *The Forge* (24 July 2020), www.forgeorganizing.org/article/how-phyllis-schlafly-found-right-balance-racism-and-misogyny-and-charted-future-radical-0.

307. 'Fred Schlafly Award', *Eagle Forum*, www.eagleforum.org/projects/fred-schlafly-award.html.

308. Phyllis Schlafly, 'What's Wrong With 'Equal Rights' For Women?' The Phyllis Schlafly Report, volume 5, number 7 (February, 1972), www.eagleforum.org/publications/psr/feb1972.html.

309. Ryan Bergeron, 'The Seventies: Women Make Waves,' CNN (17 August 2015), www.cnn.com/2015/07/22/living/the-seventies-feminism-womens-lib/index.html, 'Phyllis Schlafly' Britannica, www.britannica.com/biography/Phyllis-Schlafly, 'Life Story: Phyllis Schlafly (1924-2016)', Women & the American Story, www.wams.nyhistory.org/growth-and-turmoil/feminism-and-the-backlash/phyllis-schlafly/, Douglas Martin, 'Phyllis Schlafly, 'First Lady' of a Political March to the Right, Dies at 92,' *The New York Times* (15 September 2016), www.nytimes.com/2016/09/06/obituaries/phyllis-schlafly-conservative-leader-and-foe-of-era-dies-at-92.html, and Lesley Kennedy, 'How Phyllis Schlafly Derailed the Equal Rights Amendment,' *History* (29 March 2021), www.history.com/news/equal-rights-amendment-failure-phyllis-schlafly, and Kim Phillips-Fein, Invisible Hands: The Businessmen's Crusade Against the New Deal (New York: W. W. Norton, 2009), p 61.

310. Eileen Oginitz, 'Evangelicals Seek Political Clout', *Chicago Tribune*, January 3, 1980 in Doug Banwart, 'Jerry Falwell, the Rise of the Moral Majority, and the 1980 Election' *Western Illinois Historical Review*, Volume V (2013) www.wiu.edu/

cas/history/wihr/pdfs/Banwart-MoralMajorityVol5.pdf.
311. See Jane Mayer, Dark Money, *The Hidden History of the Billionaires Behind the Rise of the Radical Right*, (New York: Anchor Books, 2017), p. 286.
312. Jillian Eugenios, 'How 1970s Christian crusader Anita Bryant helped spawn Florida's LGBT Culture War', NBC News (13 April 2022), www.nbcnews.com/nbc-out/out-news/1970s-christian-crusader-anita-bryant-helped-spawn-floridas-lgbtq-cult-rcna24215, Anita Bryant, Georgia State University Libraries, www.exhibits.library.gsu.edu/current/exhibits/show/out-in-the-archives/the-power-of-protest/anita-bryant, 'The Nation: Gaycott turns Ugly', *TIME* (21 November 1977), www.content.time.com/time/subscriber/article/0,33009,915719-1,00.html, and 'Anita Bryant Praises the Lord and Denounces Gays', *Freedom Socialist Party* (Spring, 1977), www.socialism.com/fs-article/anita-bryant-praises-the-lord-and-denounces-gays.
313. Micael Sainato, 'A Lost history: the US women who fought for better working conditions', *The Guardian* (21 January 2021), www.theguardian.com/business/2021/jan/31/9to5-pbs-documentary-women-working-conditions, and Ellen Cassedy, Working 9 to 5', LAWCHA www.lawcha.org.
314. Christine Bard, 'Antifeminism,' Digital Encyclopedia of European History, www.ehne.fr/en/encyclopedia/authors/christine-bard.
315. Fintan O'Toole, 'The Irish Lesson,' *New York Review of Books* (18 August 2022), pp. 19-21.
316. Pamela Druckerman, 'Where France Differs on Abortion', *The Atlantic* (30 June 2022), https://www.theatlantic.com/ideas/archive/2022/06/france-abortion-rights-roe-united-states/661447.
317. American Center for Law and Justice website, www.aclj.org/pro-life/defend-babies-defeat-abortion-at-supreme-court.
318. Greta Hughson, 'Who's Financing the Anti-Gender movement in Europe?' *aidsmap* (27 May 2021) www.aidsmap.com/news/may-2021/whos-financing-anti-gender-movement-europe.
319. United States Department of Justice, 'Equal Access to Education: Forty Years', p. 3. www.justice.gov/sites/default/files/crt/legacy/2012/06/20/titleixreport.pdf.
320. Women's Sport Foundation, 'History of Title IX' www.womenssportsfoundation.org/advocacy/history-of-title-ix.
321. Remy Tumin, 'Fifty Years On, Title IX's Legacy Includes its Durability', *The New York Times* (23 June 2022), www.nytimes.com/2022/06/23/sports/title-ix-anniversary.html and 'Title IX and Sex Discrimination', United States Department of Education www2.ed.gov/about/offices/list/ocr/docs/tix_dis.html.
322. Florence Binard, 'The British Women's Liberation Movement in the 1970s: Redefining the Personal and the Political', *Revue Francaise de Civilisation*

Britannique (2017), www.journals.openedition.org/rfcb/1688.
323. Jill Lepore, 'How to Stave Off Constitutional Extinction', *The New York Times* (1 July 2023) www.nytimes.com/2023/07/01/opinion/constitutional-amendments-american-history.html
324. Francoise Coste, 'Women, Ladies, Girls, Gals', Ronald Reagan and the Evolution of Gender Roles in the United States', *Miranda* (December, 2016), www.journals.openedition.org/miranda/8602, and William Greider, 'Women v Reagan', *Rolling Stone* (19 August 1982), www.rollingstone.com/politics/politics-news/women-vs-reagan-89061.
325. Christine Stansell, 'Global Feminist in. Conservative Age: Possibilities and Pieties Since 1980', *Dissent* (Spring, 2010), www.dissentmagazine.org/article/global-feminist-in-a-conservative-age-possibilities-and-pieties-since-1980.
326. Hadley Freeman, 'Margaret Thatcher Was No Feminist', *The Guardian* (9 April 2013), www.theguardian.com/commentisfree/2013/apr/09/margaret-thatcher-no-feminist, and Katie Weber 'Feminism Under Duress: Was the Thatcher Government Bad for the Women's Movement in the U.K.?', *Women Leading change: Case Studies in Women, Gender, and Feminism*, Tulane University (2016), and Ashley Fetters, 'Margaret Thatcher's Tart Words About Women in Power', *The Atlantic* (8 April 2013), www.theatlantic.com/sexes/archive/2013/04/margaret-thatchers-tart-words-about-women-in-power/274785/.
327. 'Ferraro, Geraldine Anne', History, Art, and Archives, United States House of Representatives www.history.house.gov/People/Detail/13081.
328. 'Sarah Palin, Archives of Women's Political Communication', Iowa State University, www.awpc.cattcentre.iastate.edu/directory/sarah-palin, 'Sarah Palin', *Forbes Magazine*, www.forbes.com/profile/sarah-palin/?sh=3289c80016a4, and T. A. Frank, 'Sarah Palin Has Long Been Ridiculed. I Wanted to Tell a Different Story', *The Washington Post* (12 July 2022), www.washingtonpost.com/magazine/2022/07/12/sarah-palin-reconsidered/.
329. Marine LePen, 'National Campaign Launch', (9 March 2017) Iowa State University Archives of Women's Communication, www.awpc.cattcentre.iastate.edu/2017/09/01/presidential-campaign-launch-march-9-2017/, Taru Spiegel, 'Feminism and Egalite: France Makes Gender Equality a Global Cause', (14 July 2019), Library of Congress www.blogs.loc.gov/international-collections/2019/07/france-makes-gender-equality-a-global-cause-feminism-and-galit-in-france/ and Angelique Crisafis, Kate Donnelly, and Angela Giuffrida, 'The New Populism: From LePen to Alice Weidel, How the European Far-Right Sets its Sights on Women', *The Guardian* (29 January 2019), www.theguardian.com/lifeandstyle/2019/jan/29/from-le-pen-to-alice-weidel-how-the-european-far-right-set-its-sights-on-women.

330. Alisha Haridasani Gputa, 'Across the Globe, a Serious Backlash Against Women's Rights', *The New York Times* (4 December 2019), www.nytimes.com/2019/12/04/us/domestic-violence-international.html.
331. Sherri Gordon, 'What is the #Me Too Movement'? *Verywell Mind* (24 August 2022) www.verywellmind.com/what-is-the-metoo-movement-4774817, and 'US Election: Full transcript of Donald Trump's Obscene Tape', BBC (9 October 2016), www.bbc.com/news/election-us-2016-37595321.
332. Catherine Osborn, 'How Latin American Feminists Won Abortion Rights', *Foreign Policy* (6 May 2022) www.foreignpolicy.com/2022/05/06/mexico-argentina-brazil-abortion-united-states-roe-wade-green-tide.
333. Karen Gilchrist, 'UK's Liz Truss Pledges Tax-Cutting future in Landmark Speech Plagued by Protest and Political Infighting', CNBC (5 October 2022), www.cnbc.com/2022/10/05/uks-liz-truss-pledges-tax-cutting-future-in-speech-plagued-by-protest.html, and Paul Kirby, 'Georgia Meloni: Italy's Far-Right Wins Election and Vows to Govern for All', BBC (22 September, 2022), www.bbc.com/news/world-europe-63029909.
334. Susan Faludi, 'Feminism Made a Faustian Bargain with Celebrity Culture. Now It's Paying the Price', *The New York Times* (20 June 2022), www.nytimes.com/2022/06/20/opinion/roe-heard-feminism-backlash.html.
335. 'Kathy Boudin', *Monthly Review, An Independent Socialist Magazine,* Volume 74, Number 3 (July-August 2022) p, 135.
336. Nelson George, 'Angela Davis Still Believes America Can Change', *The New York Times* (19 October 2020) www.nytimes.com/interactive/2020/10/19/t-magazine/angela-davis.html.

Bibliography

Books

Adams, Emmie Schrader. *Deep in Our Hearts: Nine White Women in the Freedom Movement*. Athens: University of Georgia Press, 2000.

Albert, Judith Clavir and Stewart Edward Albert. *The Sixties Papers: Documents of a Rebellious Decade*. New York: Praeger, 1984.

Andrew, John A. *The Other Side of the Sixties: Young Americans for Freedom and the Rise of Conservative Politics*. New Brunswick: Rutgers University Press, 1997.

Aptheker, Bettina. *Tapestries of Life: Women's Work, Women's Consciousness, and the Meaning of Daily Experience*. Amherst Massachusetts: University of Massachusetts Press, 1989.

Baxandall, Rosalyn, Linda Gordon, and Susan Reverby. *America's Working Women: A Documentary History-1600 to the Present*. New York: Vintage, 1976.

Berkin, Carol and Mary Beth Norton. *Women of America: A History*. Boston: Houghton Mifflin, 1979.

Bibby, Michael. *Hearts and Minds: Bodies, Poetry, and Resistance in the Vietnam Era*. New Brunswick: Rutgers University Press, 1996.

Bloch, Avital and Lauri Umansky, *Impossible to Hold: Women and Culture in the 1960s*. New York: New York University Press, 2005.

Boyer, Paul. *By the Bomb's Early Light: American Thought and Culture at the Dawn of the Atomic Age*. New York: Pantheon, 1985.

Bradley, Mark Philip and Marilyn B. Young. *Making Sense of the Vietnam Wars: Local, National, and Transnational Perspectives*. New York: Oxford University Press, 2008.

Brick Howard and Gregory Parker, eds. *A New Insurgency: The Port Huron Statement and its Times*. Ann Arbor: Maize Books, University of Michigan. 2015.

Buhle, Mary Jo. *Women and American Socialism, 1879-1920*. Urbana: University of Illinois Press, 1983.

Butler, Judith. *What Clarence Thomas Said*. New York: Verso Books, 27 June 2022. www.versobooks.com/blogs?post_author=38137.

Burns, Stewart. *Social Movements of the 1960s: Searching for Democracy*. Boston: Twayne Publishers, 1990.

Carroll, Peter N. *It Seemed Like Nothing Happened: America in the 1970s*. New Brunswick: Rutgers University Press, 1994.

Caute, David. *The Year of the Barricades: A Journey Through 1968*. New York: Harper & Row, 1988.

Chafe, William, *The Unfinished Journey: America Since World War II*. New York: Oxford University Press, third edition, 1995.

Colvin, Sarah and Kathleeen Karcher, eds. *Women, Global Protest Movements and Political Agency: Rethinking the Legacy of 1968*. New York: Routledge, 2018.

Cook, Miriam and Angela Woollacott. *Gendering War Talk*. Princeton: Princeton University Press, 1993.

Davis, Angela. *An Autobiography*. New York: International Publishers, 2005.

DeBeauvoir, Simone. *The Second Sex* (1949). www.marxists.org/reference/subject/ethics/de-beauvoir/2nd-sex/index.htm.

DeBeneditti, Charles. *An America Ordeal: The Antiwar Movement of the Vietnam Era.* Syracuse: Syracuse University Press 1990.

Encyclopedia of Anti-Revisionism On-Line. www.marxists.org/history/erol/erol.htm.

Erenberg, Lewis and Susan E. Hirsch, eds. *The War in American Culture: Society and Consciousness During World War II.* Chicago: University of Chicago Press, 1996.

Evans, Sara. *Personal Politics: The Roots of Women's Liberation in the Civil Rights Movement & the New Left.* New York: Vintage, 1980.

Faludi, Susan. Backlash: *The Undeclared War Against American Women.* New York: Crown Publishing Company, 1991

Flexner, Eleanor. *Century of Struggle: The Women's Rights Movement in the United States.* Cambridge Massachusetts: Harvard University Press, 1959.

Fox, Mary Frank and Sharlene Hesse-Biber. *Women at Work.* Mountain View, California: Mayfield Publishing Company, 1984.

Friedan, Betty. *The Feminine Mystique.* New York: Dell Publishing Company, rev ed, 1983.

Gilbert, Marc Jason, ed. *The Vietnam War on Campus: Other Voices, More Distant Drums.* Westport, Connecticut: Praeger, 2001.

Gluck, Sherna B. *Rosie the Riveter Revisited: Women, The War, and Social Change.* Boston: Twayne Publishers, 1987.

Halberstam, David. *Ho.* New York: Alfred A. Knopf, 1971.

Hannah-Jones, Nikole. *The 1619 Project. New York Times, 2001.*

Heath, G. Louis. *Off the Pigs! The History and Literature of the Black Panther Party.* Metuchen, New Jersey: Scarecrow Press, 1976.

Herr, Michael. *Dispatches.* New York: Avon Books, 1968.

Herring, George C. *America's Longest War: The United States and Vietnam, 1950-1975.* New York: Alfred K. Knopf, 1979.

Hershberger, Mary. *Traveling to Vietnam: American Peace Activists and the War.* Syracuse: Syracuse University Press, 1998.

Higginbotham, Evelyn Brooks. *Righteous Dissent: The Women's Movement of the Black Baptist Church, 1880-1920.* Cambridge: Harvard University Press, 1993.

Kaledin, Eugenia. *Mothers and More: American Women in the 1950s.* Boston: Twayne Publishers, 1984.

Karcher, Katharina. *Sisters in Arms: Militant Feminists in the Federal Republic of Germany Since 1968.* New York: Oxford University Press, 2019.

Kerber, Linda K. and Jane DeHart Mathews. *Women's America: Refocusing the Past.* New York: Oxford University Press, 1982.

Klein, Ethel. *Gender Politics.* Cambridge, Massachusetts: Harvard University Press, 1984.

Kurlansky, Mark. *1968: The Year that Rocked the World.* New York: Random House, 2004.

Bibliography

Lembcke, Jerry. *Hanoi Jane: War, Sex & Fantasies of Betrayal*. Amherst: University of Massachusetts Press, 2010.

Lerner, Gerda, ed. *Black Women in White America: A Documentary History*. New York: Vintage, 1972.

Lundberg, Ferdinand and Marynia Farnham. *Modern Woman, The Lost Sex*. New York: Harper and Brothers, 1947.

McPherson, Maya. *Long Time Passing: Vietnam & the Haunted Generation*. New York: Signet, 1985.

Margolick, David. *Elizabeth and Hazel: Two Women of Little Rock*. New Haven: Yale University Press, 2011.

Matusow, Allen J. *The Unraveling of America: A History of Liberalism in the 1960s*. New York: Harper & Row, 1984.

May, Elaine Tyler. *Homeward Bound: American Families in the Cold War Era*. New York: Basic Books, 1988.

Mayer, Jane. *Dark Money: The Hidden History of the Billionaires Behind the Rise of the Radical Right*, New York: Anchor Books, 2017.

Meyerowitz, Joanne, ed. *Not June Cleaver: Women and Gender in Postwar America*. Philadelphia: Temple University Press, 1994.

Mollin, Marian. *Radical Pacifism in Modern America*. Berlin: De Gruyter, 2007.

Morgan, Marabel. *The Total Woman: How to Make Your Marriage Come Alive*. Mishkawaka, Indiana: Better World Books, 1973.

Moser, Richard. *The New Winter Soldiers: GI and Veteran Dissent During the Vietnam Era*. New Brunswick: Rutgers University Press, 1996.

O'Brien, Tim. *The Things They Carried*. New York: Broadway Books, 1990.

Paxton, Robert O. *Europe in the Twentieth Century*. New York: Harcourt, Brace, Jovanovich, 1975.

Peterson, Christian Philip, et al. *Routledge History of World Peace Since 1970*. New York: Taylor and Francis, 2020.

Phillips-Fein, Kim. *Invisible Hands: The Businessmen's Crusade Against the New Deal*. New York. W. W. Norton 2009.

Powers, Thomas. *Vietnam: The War at Home*. Boston: G K Hall, 1973.

Raskin, Marcus G and Bernard B. Fall. *The Viet-Nam Reader*. New York: Random House, 1965.

Riley, Glenda. *Inventing the American Woman: A Perspective on History*. Arlington Heights, Illinois: Harlan Davidson,1986.

Rossi, Alice S., ed. *The Feminist Papers: From Adams to De Beauvoir*. New York: The Feminist Press, 1978.

Rowbotham, Sheila. *Women's Consciousness, Man's World*. New York: Verso Press, 2015.

Sale, Kirkpatrick. *SDS: The Rise and Development of the Students for a Democratic Society*. New York: Vintage Books, 1973.

Sayre, Nora. *Sixties Going on Seventies*, revised edition. New Brunswick: Rutgers University Press, 1996.

Schieder, Chelsea Szendi. *Coed Revolution: The Female Student in the Japanese Left*. Durham, North Carolina: Duke University Press, 2021.

Shafer, D Michael. *The Legacy: The Vietnam War in the American Imagination*. Boston: Beacon Press, 1990.

Shtier, Rachel, *Betty Friedan, Magnificent Disrupter*. New Haven: Yale University Press, 2023.

Stephenson, Anders, et al. *The '60s Without Apology*. Minneapolis. University of Minnesota. Press, 1984.

Tax, Meredith. *The Rising of the Women*. New York: Monthly Review Press, 1980.

Tilly, Louise A. and Joan Scott. *Women, Work & Family*. New York: Holt, Rinehart, and Winston, 1978.

Tischler, Barbara L. *Sights on the Sixties*. New Brunswick: Rutgers University Press, 1992.

Turk, Katherine. *The Women of NOW: How Feminists Built an Organization that Transformed America*. New York: Farrar, Straus, and Giroux, 2023.

Van Devanter, Lynda. *Home Before Morning: The Story of an Army Nurse in Vietnam*. New York: Beaufort Books, 1983.

Wachsberger, Ken, ed. *Voices from the Underground: Insider Histories of the Vietnam Era Underground Press*. Tempe, Arizona: Mica Press, 1993.

Walker, Keith. *A Piece of My Heart: The Stories of Twenty-Six American Women Who Served in Vietnam*. New York: Ballantine Book, 1985.

Wilkerson, Cathy. *Flying too Close to the Sun: My Life and Times as a Weatherman*. New York: Seven Stories Press, 1007.

Williams, William Appleman and Thomas McCormick, Lloyd Gardner, and Walter LeFeber. *America in Vietnam: A Documentary History*. Garden City: Doubleday, 1985.

Wollstonecraft, Mary. *A Vindication of the Rights of Woman*. (Carol H. Poston, ed.). New York: W. W. Norton, 1975.

Woolf, Virginia. *A Room of One's Own*. (1929) www.theguardian.com/books/2016/dec/05/100-best-nonfiction-books-no-45-a-room-of-ones-own-by-virginia-woolf-shakespeares-sister-seton-beton.

Young, Marilyn B. *The Vietnam Wars, 1945-1990*. New York: Harper Perennial, 1991.

Articles, Theses, and Other Resources

100 Women: The Truth Behind the bra-burning Feminists. BBC News 7 September 2018. https://www.bbc.com/news/world-45303069.

365 Days of Lesbians. https://365daysoflesbians.tumblr.com/.

Abortion-A Legal right? Feminists vs All. Frauen Media Turn, Feministiches Archiv und Bibliothek. www.en.frauenmediaturm.de/feminism-germany-second-wave/abortion-feminists/.

Academia.

Adler, Margo. *Before Rosa Parks, there was Claudette Colvin*. NPR. 1 March 2009.

Against the Current.

Bibliography

Aidsmap website.
American Center for Law and Justice website.
American Red Cross Women in Vietnam. www.vietnamwomensmemorial.org/pdf/sdickerson.pdf.
American Women: Report on the President's Commission on the Status of Women (1963). www.dol.gov/sites/dolgov/files/WB/media/American-Women-Report.pdf.
Anderson, Kathryn. *Steps to Political Equality: Women's Suffrage and Electoral Politics in the lives of Emily Newell Blair, Anne Henrietta Martin, and Jeannette Rankin.* Frontiers: A Journal of Women's Studies. Volume 16, number 1, 1997.
Anne Braden. Americans Who Tell the Truth. www.americanswhotellthetruth.org/portraits/anne-braden/.
Another Mother for Peace website.
Armstrong, Elizabeth B. and Vijay Prashad. *Solidarity, War Ries and Women's Rights.* The New Constitutional Review April, 2005.
Asimakopoulos, John. *The Civil Rights-Black Power Era: Direct Action and Defensive Violence: Lessons for the Working Class Today.* Academia, 2010. www.academia.edu/1138062/The_Civil_Rights_Black_Power_Era_Direct_Action_and_Defensive_Violence_Lessons_for_the_Working_Class_Today.
The Atlantic.
Baily, Paula. *Best and Worst of Times: American Nurses in Vietnam.* Henderson State University. www.hsu.edu/uploads/pages/2002-3afthe_best_and_worst_of_times.pdf.
Barnard Magazine.
Bateson, Stephanie Lyn. *Gender and Representation in Students for a Democratic Society,* Ph.D. Thesis. University of Sheffield, UK 2002.
Beal, Frances. *Double Jeopardy: To Be Black and Female.* www.jstor.org/stable/40338758.
Becker. Elizabeth. *The Women Who Covered Vietnam.* The New York Times. 17 November 2017.
Berkeley Barb.
Berkeley Tribe.
Berkshire Eagle.
Binard, Florence. *The British Women's Liberation Movement in the 1970s: Redefining the Personal and the Political.* Revue Francais de Civilisation Britannique. www.researchgate.net/publication/322164026_The_British_Women%27s_Liberation_Movement_in_the_1970s_Redefining_the_Personal_and_the_Political
Black History Month: Retired U S Army Nurse recalls serving in the first Integrated military Black History Month, 9 News www.9news.com/article/news/local/black-history-month-african-american-retired-us-army-nurse-served-in-integrated-military-hospitals-in-the-1950s
Black Panthers: History, Definition, and Timeline. History. www.history.com/topics/civil-rights-movement/black-panthers.

Black Women Radicals website. www.blackwomenradicals.com.

Bond, Julian. *Mildred Bond Roxborough Oral History Interview.* Civil Rights History Project, Library of Congress. www.loc.gov/item/2015669101.

Borton, Lady. *Behind the Scenes, In the Forefront: Vietnamese Women in War and Peace.* ASIANetwork Exchange: A Journal for Asian Studies in the Liberal Arts. www.asianetworkexchange.org/article/id/7848.

Bouie, Jamelle. *This is Why it Took More than 100 Years to Get an Anti-Lynching Bill. The New York Times.* 1 April 2022.

Brennan Center for Justice website. www.brennancenter.org.

Britannica Online.

British Library On-Line Resources.

Browne, Le Lieu. *A South Vietnamese Woman Recalls her Experience in the Diem Regime.* American Social History Project. www.shec.ashp.cuny.edu/items/show/958.

Brush, Peter. *The Rise and Fall of the Dragon Lady.* History Net 27 April 2011. www.historynet.com/rise-and-fall-of-the-dragon-lady/.

Burroughs, Nannie Helen. National Parks. www.nps.gov/people/nannie-helen-burroughs.htm.

Cairn info International. www.cairn-int.info.

Carey, Ella St. George. *Creating Community and Finding Connection: A Black Nurse's Experience in Vietnam, 1966-67.* Nursing Clio. 15 October 2020. www.nursingclio.org/2020/10/15/creating-community-and-finding-connection-a-black-nurses-experience-in-vietnam-1966-67/.

Chang, Rachel. *Inside Gloria Steinem's Month as an Undercover Playboy Bunny.* Biography 23 March 2001.

Chicago Tribune.

Clark, Sheila. *A Rightful Place in History: The Essential Contributions of African-American Women in the Black Power Movement.* Academia. www.academia.edu/14095504/A_Rightful_Place_in_History_The_Essential_Contributions_of_African_American_Women_in_the_Black_Power_Movement.

Clio.

CNN.

Cohen, Alex and William Codrington III. *The Equal Rights Amendment Explained.* Brennan Center for Justice. 23 January 2020.

Columbia University Academic Commons.

Comision Femenil Mexicana Nacional. University of California at Santa Barbara Library. www.library.ucsb.edu/special-collections/cema/cfmn.

The Conversation.

Decasia, Critical Anthropology of Academic Culture. www.decasia.org/academic_culture/.

Defense PoW/MIA Accounting Agency.

Detroit Free Press.

Bibliography

Dictionary of Unitarian Universalist Biography.
Digital Encyclopedia of European History.
Di Simone, Danielle. *Meet 3 Trailblazing Women Who Paved the Path in Military History and at the USO.* USO. www.uso.org/stories/3153-meet-3-trailblazing-women-who-paved-the-path-in-military-history-and-at-the-uso.
Dissent.
Dosch, Maya. *Protesting the Vietnam War with Lipstick.* Smarthistory. www.smarthistory.org/seeing-america-2/lipstick-ascending-sa.
Eagle Forum.
Edelman, Marian Wright, *From Freedom Summer to the Freedom Schools.* Children's Defense Fund. www.childrensdefense.org/child-watch-columns/health/2014/fromfreedom-summer-to-freedom-schools/
Ella Baker, American Activist. Britannica. www.britannica.com/biography/Ella-Baker.
Ellis, Sylvia A. *Promoting Solidarity at Home and Abroad: The Goals and Tactics of the Anti-Vietnam War Movement in Britain.* European Review of History. 2 October 2013. www.tandfonline.com/doi/abs/10.1080/13507486.2014.933186.
Emma Goldman. American Experience. PBS. www.pbs.org/wgbh/americanexperience/films/goldman.
Encyclopedia of Alabama
European Review of History.
Exberliner. www.exberliner.com/.
Fannie Lou Hamer. National Women's History Museum. www.womenshistory.org/education-resources/biographies/fannie-lou-hamer.
Farmer, Ashley er al. *Women in the Black Panther Party.* International Socialist Review. www.isreview.org/issue/111/women-black-panther-party/index.html.
Feminism in India. www.feminisminindia.com.
Firestone, Shulamith. *The Jeannette Rankin Brigade: Woman Power?* www.marxists.org/subject/women/authors/firestone-shulamith/jeanette-rankin.htm.
Flickr.
Forbes.
The Forge.
Fratus, Matt. *The Angels of Dien Bien Phu: How a Flight Nurse and French Army Prostitutes Protected the Wounded in Vietnam.* Coffee or Die Magazine. 7 May 2021.
FrauenMedia Turm. www.frauenmediaturm.de/.
Frazier, Jessica M. *Collaborative Efforts to End the War in Viet Nam: The Interactions of Women Strike for Peace, the Vietnamese Women's Union, and the Women's Union of Liberation.* Peace. The Routledge History of Human Rights (2019).
Freedom Socialist Party website. www.socialism.com/.
Frontiers, A Journal of Women's Studies.
Gandhi, Lakshmi. *How Two Vietnamese Sisters Led a Revolt Against the Chinese – in the First Century.* History. www.history.com/news/trung-sisters-vietnam-rebellion-han-dynasty.

Garrow, David. *Requiem for a Dream*. Wilson Quarterly. www.jstor.org/stable/4026019.

German History in Documents and Images. www.germanhistorydocs.ghi-dc.org. *The Guardian* (UK).

German, Lindsey. *Rise and Fall of the Women's Movement*. International Socialist. Winter, 1988. www.marxists.org/history/etol/writers/german/1988/xx/rise-fall.html.

Gill, Gerald, *From Maternal Pacifism to Revolutionary Solidarity: African-American Women's Opposition to the Vietnam War*. in Tischler, *Sights on the Sixties*. 1992.

Global Citizen website. www.globalcitizen.org/en/.

Gonnerman, Jennifer. *Highflyer: How a Flight Attendant Became a Rising Star in the Labor Movement*. The New Yorker. 30 May 2022.

Gornick, Vivian. *What We Want Is To Start a Revolution*. (review of Joanna Sluts, *Hotbed Bohemian Greenwich Village and the secret Club that Spearheaded Modern Feminism*. New York Review of Books. 18 August 2022.

Gougeon, Helena. *France's Liberation, Women's Stagnation: France's Societal Advancement Hindered by the Incarceration of Women to Traditional Gender Roles Following World War II*. Honors Thesis. Portland State University, 2017.

Gregory, Joseph R. *Madame Nhu, Vietnam War Lightning Rod, Dies*. The New York Times. 20 April 2011.

Grinberg, Ronnie. *An Overlooked Conservative Writer helps explain Trump's Enduring Appeal*. Washington Post. 22 May 2022.

Guillemot, Francois. *Death and Suffering at First Hand: Youth Shock Brigades During the Vietnam War (1950-1975)*. Journal of Vietnamese Studies, Fall, 2009.

Hamer, Fannie Lou. Speech to the NAACP Legal Defense Fund (1971).

Han, Jung-jin. *The Lived Experiences of Korean Females Military Nursing Officers During the Vietnam War*. Journal of Transactional Nursing. 19 December 2018.

Hayden, Casey and Mary King. *Sex and Caste*. 1965. www.historyisaweapon.com/defcon1/sexcaste.html.

Hello! Magazine.

Henderson, Karen and Alana Schreiber. *How the Baton Rouge Bus Boycott Inspired Dr Martin Luther King*. WNNO Radio. 16 January 2023. www.wwno.org/show/louisiana-considered/2023-01-16/how-the-baton-rouge-bus-boycott-inspired-dr-martin-luther-king-jr.

Hevesi, Dennis. *Dagmar Wilson, Anti-Nuclear Activist, Dies at 94*. The New York Times. 23 January 2011.

History.

History, Art, and Archives, United States House of Representatives. www.history.house.gov/.

History of Black Women in the Military. National Association of Black Military Women. www.nabmw.org/history-of-black-women-in-the-milit.

History of Education Quarterly.

Bibliography

History of the National Baptist Convention USA, Inc. National Baptist Convemntion. www.nationalbaptist.com/about-nbc/our-history.

Hoefferler, Caroline. *A Web of Interconnections: Student Peace Movements in Britain and the United States.* Academia. www.academia.edu/1444619/A_Web_of_Interconnections_Student_Peace_Movements_in_Britain_and_the_United_States.

Howlett, Rick. *Remembering the Wades, the Bradens, and the Struggle for Racial Integration in Louisville.* 89.3 WPFL. www.wfpl.org/remembering-wades-bradens-struggle-racial-integration-louisville.

Howlett, Patricia and Charles F. Howlett. *A Silent Witness for Peace: The Case of Schoolteacher Mary Stone McDowell and America at War.* History of Education Quarterly. August, 2008.

In-Country: U S Nurses During the Vietnam War. Working Nurse. www.workingnurse.com/articles/in-country-u-s-nurses-during-the-vietnamwar/.

International Disarmament Institute News.

International Socialist Review.

Iowa State Archives of Women's Communication.

Jefferson, Thomas. *Letter to William Smith.* 3 November 1787. National Archives/Founders on Line. www.ounders.archives.gov/documents/Jefferson/01-12-02-0348.

JoAnn Robinson, A Heroine of the Montgomery Bus Boycott. Smithsonian National Museum of African-American History and Culture. www.nmaahc.si.edu/explore/stories/jo-ann-robinson-heroine-montgomery-bus-boycott.

Joilot-Curie and the Anti-Nuclear Movement. Atomic Heritage Foundation. www.atomicheritage.org/files/joliot-curie-and-anti-nuclear-movement.

Kannan, Arlane Vani. *Third World Women's Alliance: History, Geopolitics, and Form.* Dissertation, Syracuse University (2018). www.surface.syr.edu/etd/906/.

Kendall, Michael. *The Oldest Profession Organizes.* Harvard Crimson. 15 November 1977. www.thecrimson.com/article/1977/11/16/the-oldest-profession-organizes-pthe-second/.

Kennedy, John Fitzgerald. *Inaugural Address.* 21 January 1961 www.archives.gov/milestone-documents/president-john-f-kennedys-inaugural- address.

Kim, Joung-won, Alexander. *Korean Participation in the Vietnam War.* World Affairs. April-May 1966.

King, Deborah H. *Multiple Jeopardy, Multiple Consciousness.* Signs. Autumn, 1988.

Khrushchev, Nikita Sergeyevich. *Special Report to the 20th Congress of the Communist Party of the Soviet Union.* 24-25 February 1956. www.history.state.gov/milestones/19531960/khrushchev-20th-congress.

Kulper, Kathleen. *Olympe de Gouges.* Britannica. www.britannica.com/biography/Olympe-de-Gouges.

Ladies Home Journal Sit-In of 1970: The Feminists Take Over. Thought Co. 2 February 2020. www.thoughtco.com/ladies-home-journal-sit-in-3528969.

Lapore, Jill. *How to Stave Off Constitutional Extinction.* New York Times. 1 July 2023.

www.nytimes.com/2023/07/01/opinion/constitutional-amendments-american-history.html.
LaSalle, Margaret Ann. *Vietnam Nursing: The Experience Lives On*. Military Medicine. September, 2000.
LAWCHA Labor and Working-Class History Association website.
Le Torchon Brûle.
Left Voice.
Lewis, Jane Johnson. *Biography of Virginia Durr: White Ally of the Civil Rights Movement*. Thought Co. www.thoughtco.com/virginia-durr-biography-3528652.
Liberation School website.
Library of Congress On-Line Resources.
Lilley, Caitlin Brooker. *Motherhood is Political – Women in the Peace Movements in North Carolina*. from www.medium.com/fearless-she-wrote/1950s-advice-to-women-compared-to-advice-in-modern-womens-magazines-fa22656c3121939-1980. MA Thesis University of North Carolina, 2014.
Lynn, Stacy. *Jane Addams, Ida B Wells, and Racial Injustice in America*. Jane Addams Papers Project. 23 August 21 2018. www.janeaddams.ramapo.edu/2018/08/jane-addams-ida-b-wells-and-racial-injustice-in-america/
Marquis, Erin. *Women that Would Gladly Give Their Life: How the Paramilitary WEB Battled GM at the UAW's First Big Strike*. www.jalopnik.com/women-that-would-gladly-give-their-life-how-the-para-1838948989.
Matthews, Lafayette. *The Jeannette Rankin Brigade*, Boundary Stones, WETA's Local History website. 24 August 2016.
Mead, Margaret. *The Generation Gap*. Science. 11 April 1969.
Menand, Louis. *The Making of the New Left*. The New Yorker. 15 March 2021.
Michaelis, David. *Eleanor Fights Lynching*. American Heritage. Summer 2021.
Moeller, Robert G. *The 'Remasculization' of Germany in the 1950s*. Signs. Autumn, 1998.
Milenio.
Miranda.
Mohsene, Laura. *1950s Advice to Women compared to Advice in Modern Women's Magazines*. Medium. 17 September 2020. www.medium.com/fearless-she-wrote/1950s-advice-to-women-compared-to-advice-in-modern-womens-magazines-fa22656c312.
Mollin, Marian. *Women's Struggles Within the American Radical Pacifist Movement*. History Compass. 2009.
Monthly Review: An Independent Socialist Magazine.
Moore, Constance J. *Male Nurses in Vietnam*. Army Nurse Corps. www.eanca.org/History/Topics-in-ANC-History/Male-Nurses-Vietnam.
Murray, Pauli. *The Negro Woman in the Quest for Equality*. Lambda Kappa Mu Sorority. (1964).
Murray, Pauli and Mary Eastman. *Jane Crow and the Law: Sex Discrimination and*

Bibliography

Title VII. George Washington Law Review 34, no. 2 (December 1965): 232-56.
NAACP-A Century in the Fight for Freedom-Civil Rights Era. Library of Congress. www.loc.gov/exhibits/naacp/the-civil-rights-era.html.
The Nation.
National Interest
National Organization for Women website. www.now.org/.
National Public Radio.
National Training School for Women and Girls. Library of Congress. www.loc.gov/item/2004667312/.
NBC News.
Nerli. Maureen. *The Unsung Heroes of Vietnam: Those USO Club Women*. www.vietnamwomensmemorial.org/pdf/mnerli.pdf.
New Georgia Encyclopedia.
New Left Notes.
New Left Review.
New Republic.
Nevada Women's History Project
New York Review of Books
New York Times
New Yorker
Nguyen, Nathalie Huynh Chau. *South Vietnamese Women in Uniform: Narratives of Wartime And Post War Lives*. Minerva, Journal of Women and War. Fall 2001.
Nguyen, The Bin. *1000 Peace Women*. www.wikipeacewomen.org/wpworg/en/?cat=34&paged=11.
Nicholson, Virginia. *The 1940s: Britain's Wartime Women Gained a New Sense of Power*. The Guardian. 3 February 2018.
North American Conference on Latin America.
North, Don. *The Mystery of Hanoi Hannah*. The New York Times. 8 February 2018.
off our backs.
On the Poverty of Student Life. www.library.nothingness.org/articles/SI/en/display/4.
Open Democracy.
Osborn, Catherine. *How Latin American Feminists Won Abortion Rights*. Foreign Policy. 6 May 2022. www.foreignpolicy.com/2022/05/06/mexico-argentina-brazil-abortion-united-states-roe-wade-green-tide/.
Oxford Academic. www.academic.oup.com/.
Oxford Research Encyclopedia.
Packer, George. *The Women Who Changed War Reporting*. The Atlantic. 6 March 2011.
Park, Michael Y. *A History of the Cake Mix, the Invention that Revolutionized Baking*. Bon Appetit. September, 2013.
Pepper, Fiona. *During the Vietnam War, three trailblazing female journalists changed the way the war was Reported*. ABC News 31 March 2022.

Pelz William A. *Women and the German Revolution 1918-1919*. Pluto Press. www.plutobooks.com/blog/women-war-german-revolution-1918-1919/.
Phyllis Schlafly Report.
Pick, Helen. *Why Mr. Kennedy is in Europe – June, 1963*. The Guardian Archives. www.theguardian.com/world/from-the-archive-blog/2018/apr/20/why-jfk-is-in-europe-archive-june-1963.
Picq, Francine. *The History of Feminist Movements in France*. Thinking Differently. 20 April 2002. www.francoisepicq.fr/the-history-of-feminist-movements-in-france/.
The Picket Line.
Press, Harry. *Not Mentioned in Dispatches*. Stanford Magazine. September-October 2002. www.stanfordmag.org/contents/not-mentioned-in-dispatches.
Records of the Six Point Group (including the papers of Hazel Hunkins-Halinan. Jisc. Archives Hub. www.archiveshub.jisc.ac.uk/search/archives/37dab770-ea7e-3e53-b7ad- 5f5876b3cef0.
Red Emma (1869-1940): Idealistic Revolutionary. National Library of Medicine. National Institutes of Health.
Rolling Stone.
Rosen. Ruth. *The Day They Buried True Womanhood: Women and the Vietnam Experience*. In Shafer, D Michael, ed. *The Legacy: The Vietnam War in the American Imagination*. Boston: Beacon, 1990.
Rosenstock, Nancy. *Second Wave Feminism: Accomplishments and Lessons*. International Viewpoint. 8 March 2002. www.againstthecurrent.org/atc211/second-wave-feminism-accomplishments-lessons/.
Rosenwald Schools. Encyclopedia of Virginia. www.encyclopediavirginia.org/entries/rosenwaldschools
Salinger, Bruce. *What pop phenomenon was most embarrassing?* Pinterest. www.pinterest.com/pin/178807047680282055/.
Sallie Bingham Center for Women's History and Culture, Duke University. www.library.duke.edu/rubenstein/bingham.
Salon.
Sander, Helke. *The SDS – An Overblown, Counterrevolutionary Ball of Yeast Dough*. German History in Documents and Images, volume 9. www.ghdi.ghi-dc.org/sub_document.cfm?document_id=1097.
Sartore, Melissa. *Was Sex in 1950s America as Straightlaced and Boring as You Think It Was?* Ranker. 21 February 2019. www.ranker.com/list/love-and-relationships-in-1950s-us/melissa-sartore.
Schlaegr, Hilke and Nancy Vedder-Shults. *The West German Woman's Movement*. New German Critique. Winter 1978.
Schlafly, Phyllis. *What's Wrong with 'Equal Rights' for Women?* The Phyllis Schlafly Report. Volume 5, number 7. February, 1972. www.eagleforum.org/publications/psr/feb1972.html.
Schlesinger, Arthur M Jr *The New Mood in American Politics*. Esquire. January, 1960.

Bibliography

Schmedke, Michael A *Cultural Revolution or Culture Shock? Student Radicalism and 1968 in Germany.* South Central Review. Winter 1999-Spring 2000.

Science Magazine.

S. C. U. M. Manifesto. www.ccs.neu.edu/home/shivers/rants/scum.html.

SDS Bulletin.

The Second Wave of Feminism. Britannica. www.britannica.com/topic/feminism/The-second-wave-of-feminism.

Shillcock, Francesca. *What Really Happened at the 1970 Miss World Beauty Pageant?* www.hellomagazine.com/film/20210308108439/

Sisterhood and After. British Library. www.bl.uk/sisterhood.

Smart History.

Smithsonian Magazine.

SNCC Digital Gateway. www.snccdigital.org/.

South Central Review.

South Vietnam's Women in Unform. Women's Armed Force Corps (SVN) Vietnam Council on Foreign Relations. (no date). www.cfr.org/asia/vietnam.

Southern Christian Leadership Conference (SCLC. Martin Luther King, Jr Research and Education Institute, Stanford University. www.kinginstitute.stanford.edu/encyclopedia/southern-christian-leadership- conference-sclc.

Southern Student Organizing Committee (1964) www.crmvet.org/docs/64_ssoc_about.pdf.

Southern Student Organizing Committee. Britannica. www.britannica.com/topic/Southern-Student-Organizing-Committee.

St. John, Jac. *Policing Anti-Vietnam War Demonstrations, 1968.* Special Files Project. 12 January 2016. www.specialbranchfiles.uk/vietnam-war-story/.

Stonecker, Blake. *The Politics of Space: Student Communes, Political Counterculture, and the Columbia University Protest of 1968.* Master of Arts Essay, University of North Carolina, 2006.

Strauss, Owen. *'She Never Talked About the War': Uncovering the Daring Stories of Women Who Resisted the Nazis in Occupied France.* TIME. 4 May 2021.

Struck v Secretary of Defene.. United States Court of Appeals. 15 November 1971. www.casetext.com/case/struck-v-secretary-of-defense.

Student Nonviolent Coordinating Committee. Martin Luther King, Jr Research and Education Institute, Stanford University. www.kinginstitute.stanford.edu/encyclopedia/student-nonviolent-coordinating-committee-sncc.

Swerdlow, Amy, *'Not My Son, Not Your Son, Not Their Sons', Mothers Against the Draft for Vietnam.* in Tischler, *Sights on the Sixties.* New. Brunswick: Rutgers University Press, 1992.

The Women War Correspondents of Vietnam. National Interest. 29 April 2011.

13 Things You Probably Didn't Know About the USO in World War II. www.uso.org/stories/111-13-things-you-probably-did-not-know-about-the-uso-during-world-war-ii

Thrasher, Sue. *I Want to Be Your Friend, You Black Idiot: The Dynamics of Majority Involvement in Minority Movements*. www.ssacentennial.uchicago.edu/events/symposium-payne.shtml.
Thuong, Ngo Thi and Elizabeth D. Herman. *The Women Who Fought for Hanoi*. The New York Times. 6 June 2017.
Trieu Thi Trinh. *The Vietnamese Joan of Arc. Amazing Women in History*. www.amazingwomeninhistory.com/trieu-thi-trinh-the-vietnamese-joan-of-arc/.
Tinker v Des Moines. www.uscourts.gov/educational-resources/educational-activities/facts-and-case-summary-tinker-v-des-moines.
Tischler, Barbara L. *Breaking Ranks: GI Antiwar Newspapers and the Culture of Protest*. Vietnam Generation. Volume 2, number 1, 1990.
Tribune Magazine (UK).
Truman, Harry. *Farwell Address*. (15 January 1953) Public Papers of the Presidents of The United States. Washington, D C: United States Government Printing Office.
Twomey, Janice Margaret. *It was Florence Nightingale by touch: military nursing tradition and Australian nurses in Vietnam*. University of Wollongong Thesis Collection, 2004.
United States Department of Education website.
United States Department of Justice website.
Vagins, Debirah J and Georgeanne Usove. *The Equal Pay Act: You've Come a Long Way, Baby (But Not All the Way)*. ACLU 10 June 2011. www.aclu.org/news/womens-rights/equal-pay-act-youve-come-long-way-baby-not-all-way.
Verywell Mind website.
Vietnam Generation.
Vietnam War and the American Red Cross. www.redcross.org/content/dam/redcross/National/history-vietnam-war.pdf.
Washington Post.
Wells, Ida B. *Lynching, Our National Crime. Black Past*. www.blackpast.org/african-american-history/1909-ida-b-wells-awful-slaughter/.
Western Illinois Historical Review.
WETA.
Wilkerson, Cathy. Oral History Interview. 17 February 1985. Columbia University.
Women & the American Story, New-York Historical Society. www.wams.nyhistory.org/.
Women in Nazi Germany. Alpha History. www.alphahistory.com/nazigermany/women-in-nazi-germany/.
Women in Peace. www.womeninpeace.org/d-names/2017/6/22/peggy-duff.
Women in the Third Reich. United States Holocaust Museum. www.ushmm.org/collections/bibliography/women.
Women's Sports Foundation website. www.womenssportsfoundation.org/.
Women's Bureau Bulletin No. 244 'Womanpower Committees During World War II. Washington, DC. United States Department of Labor. 1953.

Bibliography

Wong-Mersereau, Chloe. *The Lasting Legacies of Racial Segregation in Suburbia*. The Grassroots Journal. 25 February 2018. www.thegrassrootsjournal.org/post/2018/02/25/the-lasting-legacies-of-racial-segregation-in-suburbia.

Woodham, Rebecca. *Virginia Foster Durr*. Encyclopedia of Alabama. www.encyclopediaofalabama.org/ARTICLE/h-1574.

World War II: De-Nazification. Jewish Virtual Library. www.jewishvirtuallibrary.org/denazification-2.

Zaytoun, Kelli and Judith Ezekiel. *Sisterhood in Movement: Feminist Solidarity in France and the United States*. Frontiers, A Journal of Women's Studies. January 2016 www.researchgate.net/publication/302776833_Sisterhood_in_Movement_Feminist_Solidarity_in_France_and_the_United_States.

Zinn Education Project.

Index

Abernathy, Rev. Ralph David 116, 19, 120 (see Southern Christian Leadership Conference)
Abortion, 278, 331, 332, 343, 338-339, 345, 351-352, 354, 358, 367, 382-400 passim, 407-420, 424, 432-432
Abrams, General Creighton W 189
Abrams, Stacey 432
 Fair Fight Action 432
'A Bunny's Tale' (see Gloria Steinem) 72-73
Abzug, Bella 88, 112, 204, 345, 417
A C Spark Plug plant (Flint, Michigan) 41
Académie Francais 63
Access Hollywood tape 431
Acosta, Marie Claire 301
Adams, Emmie Schrader 150
Adams, Jane 321
Addams, Jane 92, 97, 197, 210
 Hull House Settlement 92
African-American Women for Reproductive Freedom 345
Agent Orange 154, 181
Agnes Scott College 131, 132
Aid to Families with Dependent Children budget cuts 418
'A Kind of Memo' see 'Sex and Caste'
Aktion 218 369, 370
Aktionsrat zur Befreiung der Frauen (Action Group for the Liberation of Women) 367
Albany (Georgia) 124
Aldermaston Marches 68, 282, 290-291
Alexander, Captain John 179
Alfaro, Ester 302
Algeria 156, 193, 267, 268, 318
Algerian National Liberation Front 267, 318
Ali, Tariq 295, 296
Alito, Justice Samuel 383-385
Allen, Doris (intelligence officer) 190
Allen, Captain Elizabeth A. 178-179
Alliance Defending Freedom (ADF) 410
Alternative fur Deutschland (AfD) 429
 Frauen in der AfD 429
Amazon Feminists 309

Index

Amena Queen of Zaria 53
American Association of University Women 341
American Center for Law and Justice (ACLJ) 410
American Civil Liberties Union (ACLU) 246, 253, 389, 410, 451,
 ACLU Legislative Office 389
American Enterprise Association see American Enterprise Institute
American Enterprise Institute 398
American Friends Service Committee 18, 134
American National Exposition at Sokolniki Park 80
 'Kitchen Debate' 80-81
American Red Cross 16, 51, 180, 185-187, 189, 191, 199
 Supplemental Recreational Activities Overseas 185
American Servicemen's Union 251
Ames, Jessie Daniel 104
Anarcho-Feminists 309
Anderson, Evelyn 183
Angelou, Maya 96
Another Mother for Peace 211
Anti-Vietnam War Movement Chapter Four passim, 307, 313, 314, 318, 324, 325
Arlington National Cemetery 214, 317
Armed Forces Radio Saigon 189
Arms race 63, 78, 87, 88, 201, 203, 207, 222, 285, 290, 294, 419
Army Induction Center Protest (Oakland, California) 325
Army of the Republic of Vietnam (ARVN) 158-159, 161
 Women's Armed Forces Corps 158
 Ho Thi Vi (WAFC Major) 158
Army Nurse Corps (United States) 172m 178, 190
Arsenal of Democracy 45, 69
Article Three (West German Constitution) 366
Asantewaa, Yaa 53
Association of Southern Women for the Prevention of Lynching (ASWPL) 103-104
Atlantans for Peace 211
Atlantic magazine 409-410
Atomic Weapons Research Establishment at Aldermaston 68, 290
Auriela S. Browder v Montgomery Mayor William A. Gayle 109-110
Australian Nurses in Vietnam 184
Avedon, Barbara 211

Ba Trieu (Lady Trieu) 38
Baby Boom Generation 86, 263, 286
Baez, Joan 201
Baily, Paula 177

483

Bain, Donald 75
 Coffee, Tea, or Me? 75
Baker, Elaine DeLott 150
Baker, Ella 116, 118, 119, 123-125, 130, 132, 133, 135, 147, 148
 Young Negroes Cooperative League 118
Baker, Lieutenant Colonel Martha 178
Baldwin, Ruth Standish 99
Balmain, Pierre 62
Bard, Christina 406
Barnard College 240
Barr, William 387
Barrett, Commander Elizabeth 82
Barry, Marion 315
Bartlett, Senator Bob 414
Basic Law of Germany (West German Constitution, 1949) 65, 365, 366, 367,
 Article Three 366
Bates, Daisy 116-118, 328
Bates, Lucius Christopher 116
Baton Rouge Bus Boycott 12, 108
Battle of Bull's Run 43
Bayer Corporation (Germany) 65
Bay of Pigs Invasion (April 1961) 204
Beal, Frances 318, 328, 340, 426.
 Double Jeopardy (1968) 319, 326 340
Beheiren (Japan) 219, 304-306
Beloved Community 122, 123, 139, 149
Bernheim, Cathy 351
Berkeley Barb newspaper 333
Berlin Wall 64, 204, 286
Besson Nelly 41, 43, 44
Bethune, Mary McLeod 106
Betty Crocker Corporation 70
Bevel, James 122, 315
Biden, President Joseph R 102, 425, 426
 Emmett Till Anti-Lynching Act 102
Biet Dong Saigon (Saigon Special Force) 168
Binard, Florence 362, 416
Birmingham Conference (1968) 365
Birmingham, England 32, 294
Bittner, Wolfgang 283
Black Lives Matter 435
 Garza, Alicia 435

Cullors, Parisse 435
Tometi, Opan 435
Black Panther Party 141-144, 190, 257, 316, 433-434
 Pantherettes 143
 Black Panther women 339
Black Power 141-155 passsim, 318
Black Tigers (44th Ranger Battalion) 159
Black Women's Alliance 320
Black Women's Liberation Committee (SNCC) 318
Booker, Cory 102
Bordels Mobiles de Campagne 156-157
Borton, Lady 155, 167
Boston Female Liberation 314
Boudin, Kathy, 13, 433
 Release Aging People in Prison Campaign 433
Bourg, Julian 268
Braden, Anne 12, 111-115
Braden, Carl 112-115
Bread Riots, Paris (1789) 25
British Council for Peace in Vietnam 293, 294
British Peace Committee 68
British Women's Liberation Movement 297, 365
Bromley, Mary Coddington 200-201
Brot und Rosen-Frauenaktion 368
Brown v Board of Education of Topeka Kansas (1954) 96, 105, 117, 329
Browne, Le Lieu 162
Brownmiller, Susan 122-123
Bryant, Anita 395, 402-403
 Save Our Children Crusade 402-403
 Miss Oklahoma 403
Burroughs, Nannie Helen 94
 National Training School for Women and Girls 94-95
Bush, President George Herbert Walker 424
Bush, President George W. 391
Bund zur Bekampfung der Frauen Emanzipation (League for the Struggle Against Women's Liberation, (1912) 406
Burial of True Womanhood 213-214, 317, 336
Burke, Tamara 430
Burlage, Dorothy Dawson 138

California Advocates for Trolloppes (CAT) 346
Call Off Your Tired Old Ethics (COYOTE) 346

Camelot 18, 83, 84, 262
Camp Evans 18th Surgical Hospital 174
 Four, Marsha 174
Campaign for Disarmament (West Germany) 282
Campaign for Nuclear Disarmament (Great Britain) 67-68, 291, 292, 294
Cam Rahn Bay 252
Carmichael, Stokely 140-141, 146, 149
Carson, Rachel 206
 Silent Spring (1962) 206
Carter, President Jimmy 210, 418
Carter, Rosalind 418-419
Carter, John Mack 344
Cason, Casey, see Hayden, Casey
Cassedy, Ellen 404
Castle, Barbara 359
Catholic Church, opposition to abortion (United States) 408
Catt, Carrie Chapman 197
Caute, David 286
Center for National Policy 401
Central High School (Little Rock, Arkansas) 116-118, 318
Centre Universitaire Experimentale de Vincennes 353
Chaney, James 128, 135
Chapelle, Dicky 193
 What is a Woman Doing Here? 193
Charles VII (Charles of Valois) 24, 25
Chavez, Cesar 144, 145, 248
Chicana Feminism 320
Chicano Moratorium Committee Against the Vietnam War 248
Chim Sat (Iron Bird see Dinh Thi Van) 168
Chisholm, Shirley 88, 344, 3345, 86, 417
Choisir 352
Chomsky, Noam 294
Christian Advocates Serving Evangelism (CASE) 410-411
Christian Faith and Life Community 138, 148
Christian Missionaries of Many Lands 183
 Anderson, Evelyn 183
 Kosin, Beatrice 183
Churchill, Winston 32, 64
Civil Rights Act 1964 (United States) 129, 134, 143, 307
 Title VII 307, 329, 386, 389, 390
Civil Rights Movement 18, 76, 81, 83, 86, Chapter Three passim, 195-196, 233, 262, 313, 317, 318, 392

Endnotes

Civil Rights Restoration Act 415
Clark, Septima 120-121
Clarke, Mary 218, 220
Clean Air Act (United States) 205
Clean Water Act (United States) 205
Cleaver, Eldridge 142-143
Cleaver, Kathleen 143
Clinton, Hillary 404, 417
Clinton, President Bill 425
Cohen, Allen 232
Cohen v Brown University 415
Cohn-Bendit, Daniel 274, 277, 279
Cold War 15, 16, 19, 53, 58, 63, 65, 74, 79-81, 84, 86, 107, 112, 157, 195, 204, 222, 224, 262-263, 282, 284, 290, 303, 318, 399, 419
Colectivo Cine Mujer (Mexico) 377
Collegiate Council of the United Nations 132
College Sports Council 415
Columbia University 18, 85, 99 132 225, 239-240, 433
Columbia University Afro-American Society 242
Colvin, Colette 109-111
Comision Feminil Mexicana Nacional 146
Commentary magazine, See Midge Decter
Committee for a Sane Nuclear Policy (SANE) 18, 87, 88, 201, 203, 204, 206, 216
Committee for Nonviolent Action 202, 220
Committee for Prostitutes Rights 346
Committee of Liaison with Families of Servicemen Detained in North Vietnam 220
Committee on Interracial Cooperation (Atlanta, 1919) 103
Committee on Urban Conditions Among Negroes, See Urban League
Con Bao Prison 168
Concerned Women for America 396
Confucianism 167
Congress of Racial Equality (CORE) 99-100, 122, 199, 200, 201, 219, 229, 321
Consciousness Raising 153, 254, 324, 342-343, 348, 364, 376, 380, 421
Conservative Movement 421
Conservative Party (Great Britain) 284, 421, 422, 432
Cosimaplatz 2 287
Cosmopolitan magazine 71
Council of Striking Students (Mexico) 301
Courage magazine 372
Cowan, Judith 224
The Crisis magazine 98

Cronkite, Walter 231
Cu Chi 12th Evacuation Hospital 173, 175, 177, 178, 179
Cultural Feminists 309
Currie, Edwina 422
Curry, Constance 116, 130, 131-135
 Collegiate Council of the United Nations 132

Dagenham Strike (Ford, 1968) 359-60, 417
Dalston Women's Liberation Workshop 360-361
Dandridge, Gloria Richardson 124
Dang Thuy Tram 166
Dani the Red 274, see Cohn-Bendit, Daniel
Davis, Angela Y. 141, 206, 256, 339, 434
Davis, Gwen 360
Dawson, Rev Cheryl 434
DeBeauvoir, Simone 12, 310, 312, 313, 348, 351, 354, 368
 The Second Sex 312
Declaration of Independence (United States) 222
Declaration of Vietnamese Independence, see Ho Chi Minh
Decter, Midge 391
 Commentary magazine 391
 Podhortez, Norman 391
 The Boys on the Beach 391
De facto segregation 91
deGallard. Lieutenant Genevieve 156-157
 Bordels Mobiles de Campagne 156-157
DeGaulle, Charles 18, 85, 257, 275, 277
DeGouges, Olympe 27
 Declaration des droits de la femme et de la Citoyennes 26
Delacroix, Eugene 27
 Liberty Leading the People (1831) 27
Del Pazo, Theresa 225
Delphy, Christine 276, 354
Demming, Barbara 219
Democratic Party Convention (1964) 130
Democratic Party Convention (1968) 292
Democratic Party Convention (1980) 424
Democratic Republic of Vietnam 230
Democratic Republic of Vietnam Peace Committee 230
Democratic Republic of Vietnam Women's Federation 230
De-Nazification 53, 64, 281-282
Department of Justice (United States) 413

Der Spiegel magazine 371
Desai, Jayaben 361
Deschamps, Marie 27
Der kleine Unterschied und seine grossen Folger (The Small Things and the Big Things) 369
Devine, Annie 129
Diamond, Peggy 124
Dichter, Ernest 70
Diem, Ngo Dinh 157, 162, 165, 170, 171, 218
Dien Bien Phu 15, 156, 157, 267
Difference Feminists 309
Dinh Thi Van (Colonel) 168
Dior, Christian 61
Direct Action Committee Against Nuclear War (Great Britain) 67, 291
Dixon, Chris 262-263
Dobbs v Jackson (Mississippi) Women's Health Center 382-386, 388, 407, 409, 431
Dohrn, Bernardine 230, 231-236, 238, 239, 322, 323
Dollinger, Genora Johnson 42
Domestic Violence and Matrimonial Proceedings Act 1976 (Great Britain) 416-417
Domino Theory 16, 18, 79, 261
Donut Dollies (American Red Cross) 186
Double Jeopardy (1968) 319, 328, 340
Douglas, Helen Gahagan 80
Draft resistance 261
Druckman, Pamela 409
Du Bois, W.E.B. 98
Duff, Peggy 68, 294
Dunne, Carin 357
 Behold Woman: A Jungian Approach to Feminist Theology 357
Durr, Clifford 106
Durr, Virginia Foster 106-111
 Southern Conference for Human Welfare 106-107
Dutschke, Gretchen 283-284
Dutschke, Rudi 274, 286

Eagle Forum 397, 400, 414
Easter Marches, see Aldermaston Marches
Eastland James 107
Eastman, Crystal 385
Eastman, Mary 329
Eckford, Elizabeth 117, 318
Economic Equity Act (United States) 420

Economic Research and Action Project (ERAP) 226-228
Davis, Rennie 226
Garbage Removal or Income Now (GROIN) 226, 433
Jobs or Income New (JOIN) 226
Kathy Boudin 433
Edelman, Marian Wright 127-128
Ehrenreich, Barbara 309
Eighth Amendment (Irish Constitution) 408
Eisenberg, Carolyn 242
Eisenhower, Dwight D 79, 81, 82, 117, 157
Emergency Law 1968 (West Germany) 284
Emerson, Gloria 194-195
 Winners and Losers 195
Emma magazine 372-374
Emmitt Till Anti-Lynching Act, see Biden, President Joseph
Employment Protection Act 1975 (Great Britain) 416
Equal Pay Act 1970 (Great Britain) 360, 416
 Maternity Fund 416
Equal Pay Act 1968 (United States) 389
Equal Rights Amendment (ERA) 32, 44, 83, 332, 343-344, 386, 387, 388, 393, 396, 397, 398, 400, 414, 418, 421
Evans, Sara 74, 114, 224
Executive Order 8802 45, 50
Executive Order 9139 46

Facebook 426, 430
Faculté des Lettres et Sciences humaines (Nanterre) 272
Falk, Candace 30
Falwell, Jerry 392, 396, 400, 401, 403, 418
Faludi, Susan 392-394, 396, 431-432
 Backlash 392-294
Farm and Equipment Workers Union 112
Farnham, Dr Marynia 73-75, 376, 94
 Modern Woman, The Lost Sex (1947) 73-75
Fawcett, Denby 191
Fawcett, Millicent 31
Fayerweather Hall, Columbia University 241
Federal Republic (West Germany) 64. 281, 282, 365, 371
 Fedesz Party (Hungary) 430
Feiffer, Jules 256
Fellowship for Reconciliation (FOR) 100, 200, 210, 219
Femme Couvert 405

Endnotes

Feminin Masculin Avenir 276, 354
Feminine Marxisme Action 276
Feminism of Difference 309
Fern (Mexico) 378
Ferraro, Geraldine 424, 426
 Zaccaro, John 424
Fervet, Ute 373
Firestone, Shulamith 212, 23, 326, 327
Fito, John 237
Fitzgerald, Frances 195
 Fire in the Lake 195
Five O'Clock Follies 194
Flint, Michigan 21, 41-44, 77
Florida Citrus Commission 395, 403
Florida Citrus Hall of Fame 403
Foa, Sylvana 194
Fonda, Jane 255-256, 257, 259
Forbes magazine 425
Ford, President Gerald R 210, 397
Ford Motor Company 359-360
Fort McClelland (Anniston, Alabama)160
44th South Vietnamese Ranger Battalion (Black Tigers) 159
Fouchet Plan 273
Fouque, Annette 353
Fourteenth Amendment (United States) 78, 116, 117, 253, 383, 413
Fox News 425, 426
Frauen gegen den 218 370
Freedom Riders 111, 139
 Freedom Rides 145, 219, 316
Freedom Trash Can 337
Freeman, Alamena 108
Free Speech Movement 86, 227, 270, 285
Free University of Berlin 285, 288
Freeman, Hadley 422
Freikorps (Germany) 29
French Indochina 154, 193
French Revolution 20
Freud, Sigmund 313
Friedan, Betty 85, 152, 330, 338, 340, 345, 417, 440
 The Feminine Mystique 85, 330
Fristenlossung 367, 369
Front homosexual d'action Revolutionaire 357

FTA 249
FTA Shows 255-258
Fuller, Margaret 310

Galindo, Martha Zapata 378
Gandhi, Mohandas 141, 199
Generation Gap 265-266
Geneva Accords (1954) 157
German Democratic Republic (East Germany) 64, 281
German Federal Republic (West Germany) 64, 281, 282, 365, 371
German SDS see Sozialisticher Deutscher Studentenbund 262, 282, 285, 288, 299, 366
GI Antiwar Newspapers 249-252
 Aboveground (Fort Caron, Colorado) 250
 The Pawn (Fort Dietrich, Maryland) 251
 AFB (Chanute Air Force Base, Illinois) 251
 Fragging Action (Fort Dix, New Jersey) 252
 Helping Hand (Mountain Home Air Force Base, Idaho) 252
 Bragg Briefs (Fort Bragg, North Carolina) 255
GI Bill of Rights 77, 181
Giap, General Vo Nguyen 155, 158, 160, 169
Gilets jaunes (Yellow Vests) 428
Gill, Gerald 207
Ginsburg, Justice Ruth Bader 253, 413
Goldman, Emma 7, 12, 39-40, 309
 Mother Earth magazine 40
Goldwater, Barry 399
Good Housekeeping magazine 69, 70
Goodman, Andrew 128
Goodman, Jan 122-123
Gordan, Lorraine 18
Gornick, Vivian 258, 341
Gouines rouges (Red Dykes) 356, 357
Graves, John Tempe 98
Gray, Victoria Jackson 124, 129
Gray Ladies (USO) 51
Great Society 398
Greensboro, North Carolina Sit-Ins 88, 89
Greenwald, Lisa 350
 Daughters of '68 350
Greider, William 419
Griffith, Patricia 219

Griffiths, Martha 386, 390
Grosvenor Square 293, 284, 295, 296
Group S-E-X (Japan) 380
Grove City v Bell 415
Grunwick Photo Lab Strike (Great Britain) 361-362
Guardian newspaper 217, 422, 428

Haber, Barbara 225, 227, 242, 247, 321
Haber, Robert Alan (Al) 148, 226
Hall, Prathia 124
Hamer, Fannie Lou 116, 125-127, 129-130, 135, 417
Hamili, Gisele 352
Hamilton Hall, Columbia University 240, 242
Hanisch, Carol 336, 337, 338
Hanoi 155, 164, 169, 217, 218, 219, 230, 254, 258, 259, 316
Hanoi Hanna see Trinh Thi Ngo 169
Hanoi Jane see Fonda, Jane 257, 259
Hannah-Jones, Nikole 54
 1619 Project 54
Hansberry, Lorraine 206
Harrington, Michael 226
 The Other America 226
Harris, Kamala 102, 424, 426
Hayden, Casey 89, 138, 146-149, 150-153, 224
Hayden, Tom 88, 148, 221, 224, 256, 257, 317
Hayes, George Edmund 99
Heartbeat International 412
Heer, Jeet 391
Hefner, Hugh 71
Helgoland (German hospital ship) 282
Heritage Foundation 392
Hershey, Lenore 344
Hershey, Lewis 208
Hertzberg, Joseph 420
Herz, Alice 215-217
Herzog, Marianne 287
Higgins, Marguerite 192
Highlander Folk School 107, 121
Hill, Fanny Christina 50
Hinkle, Walter 234
Hitler, Adolf 30
Hoa, Trung My 165

Ho Chi Minh 15, 37, 155, 165, 166, 167, 217, 219, 293
 Declaration of Vietnamese Independence 155
Ho Chi Minh Trail 165-166
Ho Thi Que (Tiger Lady of the Mekong Delta) 159
Ho Thi Vu (WAFC Major, Vietnam) 158
Hoffman, Abbie 232, 243, 272
 Levitating the Pentagon 232, 272
Hogue, Ilyse 397
hooks, bell 348
Hoover, J Edgar 40, 4 01
Hope, Bob 188, 250, 363
Hope, John 103
Hope, Lugenia Burns 103
Hosten, Jennifer 363
House Committee on Un-American Activities 87, 207
Housing Act 1979 (Great Britain) 416
Howard, Grendel Alice (specialist) 191
Hruska, Senator Roman 414
Huerta, Dolores 144-145, 248
Huey, Olivia 108
Huggins, Ericka 434
Hungary 193, 264, 430

I G Farben Corporation 65
Ichikawa, Fusae 379
Indikationlosung 369-370
Individualist Feminists 309
Indochina Peace Campaign 257
In Friendship 119
Institute for Defense Analysis (Columbia University) 239
International Day for the Elimination of Violence Against Women 2019 (Spain) 430
International League for Peace and Freedom (ILPF) 18, 197, 216
International News Service 131
International Red Cross 161, 185
International Rescue Committee 187
International Revolutionary Party 299
Iron Lady (see Thatcher, Margaret) 422, 423

Jackson, Mae 318
Jacquemart, Alban 349
Jaffe, Naomi 233-234, 322-323
Jagger, Linda 186-187

Endnotes

Janba, Michiko 306
Jane Crow 328, 329
Jane Crow and the Law: Sex Discrimination and Title VII 329
Japan Trotskyist League 304
Japanese Red Army 305
Javen, Ana Lau 376
Jefferson, Thomas 15, 19, 155, 222, 410
Jeffrey, Sharon 225
Jim Crow South 21, 93, 97, 103,1111, 118, 222
Joan of Arc 12, 24-25, 38, 42
Johnson, Boris 432
Johnson, Brigadier General Hazel W 190
Johnson, President Lyndon Baines 231, 247, 282, 293
Joilot-Curie, Irene 63
Joilot-Curie, Jean Frederic 63
July Revolution (1830) 27

Kandel, Liliane 350
 Questions feminists 350
Karcher, Katharina 367
Kaufman-McCall, Dorothy 350
Kazikas, Jurate 193
Kennedy, Jacqueline 82, 204
Kennedy, President John Fitzgerald 79, 82, 147, 158, 204, 262, 389
 Inaugural Address (January 1961) 82
Kent State University 237-238, 247
Kerr, Anne 292
Keys, Charlotte 208
Khan, Noor Inayat 35-36
 Prosper Resistance Network 36
 Special Operations Executive (Great Britain) 35
 Women's Auxiliary Air Force (Great Britain) 35
Khayte, Mustafa Omar 270
Khruschev, Nikita 80, 264, 304, 306
Khrushcheva, Nina 204
Kiesinger, Kurt Georg 282, 284
Kinderladen 287-288
King, Coretta Scott 205
King Jr, Dr Martin Luther 54, 81, 101, 107, 108, 115, 116, 143, 201, 205
King, Lonnie 315-316
King, Mary Elizabeth 146-148, 150-153
Klarsfeld, Beate 284

Kolloy, Berengoine 348
Korean War 79
Kosin, Beatrice 183
Kotcher, Joanne Puffer 186
Krause, Pamela 189
Krause, Ruth 220
Kreuzberg Women's Center 371
Kriktische Universitat 287
Ku Klux Klan 100, 101, 102, 107, 127, 148
Kurlansky, Mark 278

LaHaye, Beverly 396
Labour Party (Great Britain) 68, 292, 293, 294
Labor Standards Law (Japan) 379
Lacan, Jacques 352-252
Ladies Home Journal magazine 70, 73, 343
Laird, Melvin 231
Laissez les Vivre 1971 (France) 408-409
Land Girls see Women's Land Army (Great Britain) 34
Lane, Lieutenant Sharon Ann 177
LaPierre, Wayne 401
La Revuelta 377
Latin Quarter Protest (Paris, 1968) 275, 278
'Lavender Menace' 340, 345
Law #218 of the German Penal Code (1871) 287, 368, 370, 373
League for Industrial Democracy 90, 221
Lear, Martha Weinman 332
LeGrande, Joyce 187
Le Monde newspaper 268
LePen, Jean Marie 427
LePen, Marine 410-411, 427
Lesbian Feminists 309, 335, 340, 345, 347, 357, 371, 372, 378, 396, 402, 430
Le Thi Hong Gam 166
Le Thi My Li 171
Le Thi Thu Nguyet (The Iron Bird) 168
Levitt, William J. 77-78
 Levittown 77-78
Lewis, John 96, 112, 136, 141, 315, 436
Lewis, Tanika 142
Liberal Feminists 308, 309, 354
Liberty Leading the People (Delacroix) 27
Library of Congress 315

Endnotes

Lilly Ledbetter Fair Pay Act (United States) 390
Lipstick (Ascending) in Caterpillar Tracks 244-245
Little Rock Nine 117-118
Liuzzo, Viola 100-101, 135
London Metropolitan Police 295
London School of Economics 293
Lumber Jills see Women's Land Army (Great Britain)
Lundberg, Ferdinand 73-74, 76, 394
 Modern Woman, The Lost Sex (1947) 73-74, 394
Luxemburg, Rosa 29, 30
Lynching 92, 97-100, 102-104, 123, 206

McCain, John 425, 426
McCall's magazine 71, 208
McCune, Dr Shirley 341
McDonald, Country Joe 235
McDowell, Mary Stone 199-200
 Fellowship for Reconciliation 100, 102, 200, 210, 239
 Manual Training High School, Brooklyn 199
 Tax Refusal Committee of the Peacemakers 200
 War Resisters League 200, 210
McGee, Willie 112
McKinley, President William 97
McMeeking, Diane 375
McSweyn, Margarita Salazar 48
Macron, Emmanuel 427
Mackworth, Margaret Haig (2nd Vicontess Rhondda) 32
Madame Nhu see Nhu Ngo Dinh 170-171
MAGA (Make America Great Again) 398, 431
Maier, Corinne 277
Makeda, Queen of Ethiopia 53
Malcolm X 144, 435
Mamans de France 60
Manifeste des 343 351-353
Maquis (French resistance in the Second World War) 27-28
March on Washington for Jobs and Freedom (1963) 90, 328
Marder, Dorothy 59, 209
Margaret, Ann 188
Marshall Plan 59, 263
Martin, Anne Henrietta 31, 198
Martin, Douglas 390
Marx, Karl 271

Mary Baldwin College 138
Masclet, Camille 348
Maurani, Margaret 350
May 1968 Movement 278
Mead, Margaret 265-266
#Me Too Movement 430
Medical Civic Action Program 188
Meloni, Georgia 432
Menand, Louis 88-89
Men's Liberation Groups 404
Miami University (Oxford, Ohio) 127
Miazga, Corinna 428
Miller, Jeffrey 237
Mink, Patsy 12, 414-416
 Medal of Freedom 414
 Patsy T Mink Equal Opportunities in Education Act 414
Miss America Pageant Protest 336-338, 341, 362
Miss Mexico contestants 377
Miss World Pageant Protest (1970) 363
Missionaries in Vietnam 183
Mississippi Freedom Democratic Party 120, 124, 127, 129-130,149, 344
Mississippi Freedom Summer 120, 127, 149
Missoffe, Francois 274
Modan Gaaru (Modern Girl – Japan) 379
Mondale, Walter 424
Montgomery Bus Boycott 12, 106-110,
 Montgomery Improvement Association 109, 318
 Robinson, Jo Ann 108
 Women's Political Council 108
Moore, Grace 175, 177
Mora, Dennis 219
 Fort Hood Three 219
Moral Majority 392, 396, 400-401, 418
 The Moral Majority is Neither bumper sticker 401
Morehouse College 103
Morgan, Marabel 394-396
 Total Woman Program 394
Morgan, Robin 336
Morgan State University 96
Morningside Park 240
Morrison, Norman 217
Morrison, Toni 318

Endnotes

Mouvement de la Liberation des Femmes (France) 280, 347-356
Mouvement pour la Liberte de l'avortement et la Contraception (France) 355-356
Movement for Colonial Freedom (Great Britain) 292
Movimento de la Liberation des Mujers (Mexico) 377
Movimento Nacional de Mujeres (Mexico) 377
Ms magazine 388
Mujers en Acicon Solidaria (Mexico) 376
Muller v Oregon (1908) 329
Murray, Pauli 327, 330-331
 Jane Crow and the Law: Sex Discrimination and Title VII 329
Muste, A J 200, 219
Mutual Cooperation and Security Treaty (United States and Japan) 304
Myerson, Bess 336
My Lai Massacre (March 1968) 181

Nadig, Friederike 365-366
Nagata, Hiroko 306
Nanterre Campus, University of Paris 272-275
Nash, Diane 116, 119-120, 122, 136, 219, 315
The Nation magazine 391
National Airlines 75
 'Fly Me' advertising campaign (1968) 75
National Assembly (France) 61
National Association for the Advancement of Colored People (NAACP) 97-99 101, 104, 107, 109, 110, 116, 118, 119, 121, 123, 126, 127, 134, 149, 329
 NAACP Legal Defense Fund 126, 127
 The Crisis 98
National Association of Catholic Families 409
National Baptist Convention 94
 National Women's Convention 94
National Collegiate Athletic Association (NCAA) 414
National Committee on Conscientious Objection 199
National Committee to Abolish the Poll Tax 107
National Congress of Negro Women 318
National Council of Striking Students (Mexico) 301
National Council of Women 341
National Domestic Workers Alliance 432
National Front (France) 427 see National Rally
National Geographic magazine 193
National Health Service (Great Britain) 67
National Labor Relations Act (United States) 42
National League for the Protection of Colored Women 99 see Urban League

National League on Urban Conditions Among Negroes 99 see Urban League
National Liberation Front of South Vietnam 163 see Viet Cong
National Mobilization to end the War in Vietnam (MOBE) 326
National Moratorium Day 245
National Organization for Women (NOW) 86, 330, 338, 343, 372
 Political Action Committee 331, 332
National Rally Party (France) 410, 427, 428
National Rifle Association 401
National Socialist (Nazi) Party 216, 281, 284
National Student Association 89, 131, 148
National Task Force on Prostitution 347
National Teenage America Competition 403
National Union of French Students 267
National Union of Women's Suffrage Societies (Great Britain) 31
National Women's Political Caucus 88, 130, 340, 417
 Abzug, Bella 417
 Chisholm, Shirley 417
 Friedan, Betty 417
 Hamer, Fannie Lou 417
Nazi Party, See National Socialist Party 216, 281, 284
Near, Holly 255
Nefertitti, Queen of Egypt 53
Nelson, Juanita Morrow 201
Neue Frauenbewegung (New Women's Movement, West Germany) 367
Neuman, Charlicia 49
New Left 88, 89, 90, 137, 219, 223, 224, 263, 264, 269, 272, 280, 289, 290, 297, 298, 304, 305, 306, 339, 348, 353, 367, 380,
New Left (West Germany) 290, 367
New Left (Great Britain) 298
New Left Notes newspaper 229-236, 238, 314, 321, 322
New York City Police Department 242
New York Radical Women 212-214, 217, 237, 317, 336, 339, 342
New York Stock Exchange 232, 341
New York Times newspaper 194, 199, 236, 276, 305, 318, 332, 339, 341, 388, 389, 390, 393, 435
New York Times Magazine 332
New Yorker magazine 88, 195
New Zealand Nurses in Vietnam 184
Newman, Grace Mora 218-219
Newton, Fredrika 434
 Huey P Newton Foundation 434
Newton, Huey P 141, 256

Endnotes

Ngo Dinh Nhu (Madame Nhu) 170-171
Ngo Thi Thuong 169
Nguyen, Thi Binh 170-171
Nguyen, Thi Hoa 167, 172
 Perfume River Squad 167
Nichols, Mike 256
Nicholson, Virginia 66
Night Cleaners Campaign (Great Britain) 360-361
 Night Cleaners Action Group 361
9 to 5 (Nine to Five) 404-405
Nixon, E D 107, 107, 109
Nixon, President Richard M. 80-82, 194, 247, 326, 344, 397, 412
North Atlantic Treaty Organization (NATO) 16, 85, 157, 263, 290
Northwood Theatre (Baltimore) Protest 96
North Vietnamese Women's Union 164
Nuclear Proliferation, Chapter Two passim
Nuclear Test Ban Treaty (1963) 88
Nuevo Grupo (Mexico) 300
Nuremburg Trials 284
Nurses in Vietnam 172-180

Obama, President Barack 390, 416, 425
Obamacare 426
Occoquan Workhouse 198
Ochs, Marie Catherine, 72 see Steinem, Gloria
Ochs, Phil 128
O'Connor, Justice Sandra Day 420
Ochoterina Preparatoria School (Mexico) 301
Office Workers 122, 404, 405
Ohnesorg, Benno 286
Oldenburg, Claes 244-245
 Lipstick (Ascending) on Caterpillar Tracks 244-245
Olin Corporation 397
On the Poverty of Student Life 270-271
Oob newspaper 335-336
101st Airborne Division 117
Olympic Games (Mexico City, 1968) 302
Operation Junction City (February 1968) 193
Operation Rolling Thunder 292, 304
Organization of Women of Asian and African Descent (Great Britain) 365
Ortega, Javier 430
Orthodox Church (Russia), opposition to abortion 430

O'Toole, Fintan 408
Oughton, Diana 239

Palin, Sarah 424-426
Pankhurst, Emmeline 31-32
Pankhurst, Sylvia 32
Paris Match magazine 193
Parker, Dorothy 62
Parks, Rosa 107-111
Patton, Gwendolyn 318
Paul, Alice 32, 197, 385
 Women's Party 32
Paxton, Robert O 267
Peacemakers 200-201
Pelosi, Nancy 427
Pelz, William A 29
Pentagon 217, 232, 272
People's Self-Defense Agency 161
Pereira, Irene 280
Perfume River Squad (North Vietnam) 167
Phan Thi Kim Phuc ('napalm girl') 236-237
Philadelphia Bulletin newspaper 250
Phu Nu Mou (New Woman) magazine 162
Piccini, Jon 262
Pick, Helen 84-85
Picq, Francois 279
Pisier, Marie-France 272-273
Pitt, Dick 275
Planned Parenthood of Southeast Pennsylvania v Casey 382
Playboy magazine 71-73
Plaza de las Tres Cultures (Plaza of Three Cultures-Mexico) 302, 375
Pompidou, Georges 277
Port Huron Statement 90, 140, 221-225, 243
Potsdam Conference (July 1945) 64
Prague Spring (1968) 299
President's Commission on the Status of Women 83, 330
Progressive Labor Party (United States) 238, 239
Prosper Network of the SOE (Great Britain) 36, see Khan, Noor Inayat
Prostitutes of New York (PONY) 346
Prostitute's Union of Massachusetts (PUMA) 346
 Hookers Masquerade Ball 346
Prostitution Prevention Law (Japan) 379

Endnotes

Protests Contra el Mito de la Mujer (Mexico) 377
Proud'homme, Josette 269
Psychanalyse et politique 352-353
Psych et Po 352-354
Punch magazine 32

Qi Nhon 174, 184
Queen of Sheba 53
Quinton, Newell 96

Radcliffe College 195, 397
Radical Feminists 215, 308-309, 333,
 New York Radical Feminists 341
Raises and Roses (9 to 5 Slogan) 405
Ramparts magazine 233-234
Rankin, Jeannette 210-211
 Atlantans for Peace 211
 Jeannette Rankin Brigade 211-212, 233, 317
Raye, Martha 256
Raymond, Janice G 374
Reagan, Nancy 418-419
Reagan Ronald 393, 400, 405, 417, 424, 425
Reagon, Bernice Johnson 124
Red Army Faction 285
Redbook magazine 70, 202
Reddy, Helen 387
 I Am Woman 387
Redgrave, Vanessa 294, 296
Redstockings 214, 327, 339, 343
Republican Party 396-397, 400-401, 425
Resistance (France, Second World War) 27-28, 35, 59
Revolutionary Youth Movement (RYM) 238
Reynolds, Malvina 77
 Little Boxes (1947) 77
Ridder Dorothea 287
Robertson, Pat 401, 410
Robeson, Eslanda Goode 205
Robeson, Paul 206
Robinson, Bernice 120-121
Robinson, Bruce 294-295
Robinson, Jo Ann 108
Rock Hill Protests (South Carolina) 119, 316

Rockwell, Norman 47
Rodriguez, Ana Ignacia 302
Roe v Wade 382, 407, 414, 418, 421
Roosevelt, Eleanor 40, 83,104, 133, 183
Roosevelt, President Franklin Delano 40-41, 104, 106
Rosenstock, Nancy 313
Rosenwald, Julian 95-96
 Rosenwald Foundation 96
 Rosenwald Schools 96
Rosie the Riveter 12, 47-49, 52
 Norman Rockwell painting 47
Ross, Araminta, 57 see Harriet Tubman
Roudy Law 409
Rota Zara 373
Rowbotham, Sheila 297, 359, 361, 364
Roxborough, Mildred Bond 123
Rubin, Jerry 232-233
Ruger, Sigrid 289
Ruskin College 363, 364
Ruskin History Workshop 364
Russell, Bertrand 68
 Russell-Einstein Manifesto (1945) 63
 Bertrand Russell Peace Foundation 291, 291, 293
Rustin, Bayard 119

Sagan, Francois 277-278, 351
Saigon 15, 162, 165, 168, 171, 182, 186, 188, 189, 190, 192, 194, 216, 220, 282, 295
Saigon Military Tribunal 165
Saint Laurent, Yves 62
St. Pierre Ruffin, Josephine 55-56
 Women's Era magazine 56
Sale, Kirkpatrick 90
Sander, Hilke 12, 287-288, 289-290, 367
Sanders, Ed 232
San Francisco Mime Troupe 272
San Francisco Oracle newspaper 232
Sanger, Margaret 407
Santillan, Concepcion 299-300
Sarachild, Kathie 342
Saturday Evening Post magazine 47
Savio, Mario 229, 270-271
Scaritt College 135-136

Schary, Mrs Saul 340-341
Schieder, Chelsea Szendi 306, 380
 Coed Revolution: The Female Student in the Japanese New Left 380
Schlaeger, Helke 281
Schlafly, Phyllis 396-400, 401, 406, 414
 Stop Taking our Privileges (STOP) 399
 Phyllis Schlafly Report 399, see Eagle Forum
 Stop ERA 400
Schlesinger, Arthur M 81-82, 86
 The New Mood in American Politics (1960) 81-82
Schleyer, Hanns Martin 285
Schneider, Peter 287-288
Schultz, Dagmar 372
Schwarzer, Alice 368-370, 372, 374
Schwerner, Michael 128-129, 135
SDS Bulletin newspaper 129, 229
Seale, Bobby 141
Second Wave Feminism 23, Chapter Seven passim, 433
 Germany 427, 429
 Great Britain 297-298
 Japan 303, 380-381
 Mexico 300, 376, 378, 380
Secretariat of Equality Between Men and Women (France) 427
Seculow, Jay 410
Selma to Montgomery March (1965) 100-101
Sex and Caste 152-153
Sex Discrimination Act 1975 (Great Britain) 359, 416
 Equal Opportunities Commission 416
Sex Workers Advocates Coalition 347
Shakur, Asata 142
Shaw University 118, 119, 132
Sheen, Bishop Fulton J 73
SHOW Magazine 72
Shrew magazine 362
Shupak, Lieutenant Mary Anderson 182
Shuttlesworth, Rev. Fred 116, see Southern Christian Leadership Conference
Siebeert, Muriel F 341
Situationiste Internationale 270-272
Six Point Group (Great Britain) 32-33, 35
Slate Party (University of California at Berkeley) 87
Smith College 76, 85
Smith, Howard W 390

Smith, Lillian 105
 Strange Fruit 105
Smith, Ruby Doris 119, 133
SNCC see Student Non-Violent Coordinating Committee
Snow, Dotty 181
Social Democratic Party (Germany) 285
Society for Cutting Up Men (S. C. U. M.) 333-336
 S. C. U. M. Manifesto 336
Society for the Protection of Unborn Children (Great Britain) 407
Solanis, Valerie 333-334
Sorbonne 18, 274-278, 281, 353
South China Sea 173, 181
South Korean nurses in Vietnam 185
South Vietnamese National Assembly 160
Southall Black Sisters 365
Southeast Asia 14, 197
Southeast Asia Treaty Organization (SEATO) 184
Southern Christian Leadership Conference (SCLC) 91, 101, 115-116, 118, 119, 120, 121, 134, 140
 Ralph David Abernathy 116
 Fred Shuttleworth 116
 Wyatt T. Walker 116
Southern Conference Educational Fund 114
Southern Conference for Human Welfare 106
Southern Human Relations Project 132, see Southern Project
Southern Negro Leaders Conference on Transportation and Nonviolent Integration 115
Southern Regional Council 104
Soviet Union 16, 40, 68, 201-205, 263-264, 265, 282, 290, 304, 424
Sozialisticher Deutscher Studentenbund (SDS) 262, 274, 299
Sozialisticher Frauenbund Berlin 368
Special Demonstrations Squad (London police) 295
Special Operations Squad 295, see Special Demonstrations Squad
Spock, Dr Benjamin 293
Springer Media (Germany) 286-287
Stalin, Joseph 264, 304
Stansell, Christine 421
Stanton, Elizabeth Cady 310
Stanton, Margaret 294
Steinem, Gloria 72-73, 88, 241, 332
Stern magazine 368
Sternbridge, Jane 133

Stevenson, Adlai 76
Stewart, Maria W 55
Stonewall Rebellion 401-402
Straley, Lieutenant Colonel Rose 180
Struck, Susan 252-254
Student Non-Violent Coordinating Committee (SNCC) 21, 89, 90, 93, 119-120,
 122, 123-153 passim, 225, 229, 242, 285, 316-320, 325, 362
 Bernice Johnson Reagon 124
 Ruth Gaber 124
 Ruth Harris 124
 SNCC Freedom Singers 124
Students for a Democratic Society (SDS) 90, 136, 221-225, 247, 286, 287, 288, 289,
 303, 314, 320-324, 362,364, 433
 League for Industrial Democracy 221
 SDS National Council 321
 Student League for Industrial Democracy 90, 221
 'Women in the Movement' workshop 321, 325
Students' Afro-American Society (Columbia University) 242
Studer, Helen 49
Stumpf, Marye 49
Supreme Court 78, 109, 112, 113, 116, 209, 220, 246, 253, 329, 332, 383, 384, 389,
 409, 411, 415, 418, 420, 431
 Stare Decisis 383
Sutherland, Donald 255
Swan, Marjorie 198, 202
 National Committee on Conscious Objection 199
Sweat, Mary 174-175
Sweet, Ellen 388
Swerdlow, Amy 207, 215

Tabankin, Margery 316-17
Tagesmutter 287
Tan Son Nhut Air Base 168
Taro, Gerda 192
Tea Party 398, 425, 426
Tet Offensive (January 1968) 160, 168, 231, 247, 295
Thahn Niem Xung Phong (Youth Shock Brigade, North Vietnam) 166
Thatcher, Margaret 358, 421-423
Third National Conference of Commissions on the Status of Women (June,1966)
 330
Third Reich 30, 64, 65, 406
 Thousand Year Reich 65

Third World Women's Alliance 320, 322
Thorkelson, Eli 354
Thrasher, Martha Sue 135-138, 140
 Southern Student Organizing Committee 136-138
Thuong, Ngo Thi 169
Till, Emmett 102
TIME magazine 81, 339, 393
Time and Tide journal 33
Tinker, Mary Beth 246-247
Tinker v Des Moines 247
Title IX of the 1972 Education Amendments to the Civil Rights Act of 1964 412-416
Title VII of the 1964 Civil Rights Act 307, 329, 386, 389, 390
Tlatiloco Massacre 375-376
To a White Male Radical 324
TOCSIN (Harvard University) 87
Tokyo National University 303
Tolson, Lieutenant General John J. 256
Torchon Brule 352
Tower, Senator John 414
Trafalgar Square 21, 68, 292-295
Tran, Thi Tuyen 166
Trang Bang 236
Transport and General Workers Union (Great Britain) 361
Treaty of Versailles 25, 197
Trevelyan, George Macauley 311
 History of England (1926) 311
Trich Quang Duc 216
Trieu, Tri Thin (Lady Trieu) 38
 'Vietnamese Joan of Arc' 38
Trinh Thi Ngo (Hanoi Hannah) 169
Triple Jeopardy journal 320
'True Womanhood' 76, 214, 317
Truman, Harry S. 79, 178
Trummerfrauen 64, 281
Trump, Donald J. 388, 398, 404, 410, 411, 426, 427, 431
Trung My Hoa 165
Trung Sisters (Trung Trac and Trung Nhi) 37-38, 170
Truss, Liz 432
Truth, Sojourner 56-57
Tubman, Harriet 56-57
Tucker, Diane 75

Endnotes

22 March Movement (France) 273-274
Twitter 425, 430
Two Tits No Head 234

United Auto Workers (UAW) 42, 44
 UAW Women's Auxiliary 42
United Farm Workers 144-145, 248, 257
 National Farm Workers Association 145
Union Nationale des Etudiantes (France) 273
United Nations 79, 132, 188, 200-201, 206, 221, 377, 421, 425, 430
United Nations Commission on Human Rights 424
United Nations Conference on the Status of Women 421
United Nations International Women's Year 377
United Service Organization (USO) 16, 51-52, 180, 188-189, 191, 256
United Servicemen's Fund 254
United States Department of State (State department) 40, 220, 257, 258
United States Military Academy (West Point) 243
United States Senate 80, 102, 124, 198, 343, 343, 385, 386, 417, 425
United States v Virginia 412
United States Supreme Court 78, 106, 108, 109, 112, 113, 116, 200, 209, 220, 256, 253, 329, 332, 333, 383, 384, 388, 389, 409, 411, 415, 418, 420, 431
 Restrictive housing covenants 78
USS Sanctuary 181
Universitaire Experimentale 353
University of California at Berkeley 87, 228-229, 270, 324
University of Michigan 89, 221, 293
University of Minnesota 89
University of Paris 272
University of Strasbourg 270
University of Texas 138-139, 148
University of Vincennes 353-354
Urban League 99
 Committee for the Improvement of Industrial Conditions in New York (1906) 99
 National League for the Protection of Women (1906) 99
 Committee on Urban Conditions Among Negroes (1910) 99
Ut, Nick 236

Valle, Consuelo 300-301
Van Devanter, Lynda 176-177
 Home Before Morning (1983) 176
Vassar College 243

Vecchio, Mary Ann 237
Vedder-Shults, Nancy 281
Veil, Simone 356
 Veil Law 1975 (France) 356, 409
Vester, Michael 262, 286
Veterans Administration 175, 181, 191
 Veterans Administration Advisory Committee on Women Veterans 181
Veterans of Foreign Wars 181
Vi Thi Thang 167
Vichy Government (France) 60, 406
Viet Cong 159, 162, 163, 166-169, 183, 184, 186, 206, 230, 277, 295, 298 295
Viet Minh 15, 155-156, 162
Vietnam Era 11, 14, 15, 17, 18, 21, 172, 202
Vietnam Council on Foreign Relations 158
Vietnam Courier newspaper (North Vietnam) 217
Vietnam Solidarity Campaign (Great Britain) 293, 294, 295,
 Vietnam Solidarity Campaign Bulletin 296
Vietnam Solidarity Committee 291
Vietnam Veterans of America 181
Vietnam War 66, 86, 93, 154, Chapters Four and Five passim, 261, 262, Chapter Six passim
Vietnamese Women's Union (North Vietnam)163-164, 218, 316
Vietti, Dr. Eleanor Ardel 183-184
Vizuet, Samara 302
Vocational School 2 (Mexico) 301
Vogue magazine 71

Waffen SS 60
Walker, Madam C.J. 56
Walker, Rev. Wyatt T 116 (see Southern Christian Leadership Conference)
Wallace, George 397
Wallace, Henry 112
 Progressive Party 112
Walraff, Gunter 283
War Manpower Commission (United States) 45-46
 Women's Advisory Committee 46
War Resisters League 200, 210
Warsaw Pact 18, 85, 283
Washington, Booker T 94, 95
 Hampton Institute 94
 Tuskegee Institute 95
Washington University (St. Louis) 397

Watt, Jack 68
Waveland Memo 150-153
'We Shall Overcome' 132
Weather Underground 239, 247, 433
Weatherman 238, 239
Weaver, Kate 422
Webb, Kate 192
Webb, Marilyn 326
Weimar Republic 29
Weiss, Cora 220
 Committee of Liaison with Families of Servicemen Detained in North Vietnam 220
Wells-Barnett, Ida B 97-98
Weyrich, Paul 392, 396
Wheatley, Phillis 55
White People's Project (SNCC) 137
Widgery, David 291
Wilkerson, Cathy 225, 230, 231, 236, 238, 239, 321
Willis, Ellen 324, 327, 333
Willoughby, Lillian 202-203
 Atomic Energy Commission Protest 203
Wilson, Dagmar 87-88, 203-205, 220
Wilson, Harold 291
Winter Soldier Investigation 256
Winthrop, John 54
Wollstonecraft, Mary 310
 A Vindication of the Rights of Women (1792) 310
Women Against Pornography 345
Women Strike for Peace (WSP) 18, 87, 88, 164, 203-210, ` 212, 214, 215, 218-220, 292, 325
Women's Air Force Service Pilots 52
Women's Armed Forces Corps (South Vietnam) 158
Women's Army Corps (United States) 190
Women's Auxiliary Air Force 35
Women's Commission on Post-War Policy (Japan) 379
Women's Emergency Brigade (Flint, Michigan) 21, 41-44
Women's Freedom League (Great Britain) 31
Women's Home Companion magazine 47
Women's International League for Peace and Freedom (WILPF) 18, 197-198, 201, 207, 211, 212, 214, 216
Women's Land Army 34
 Land Girls 34

Lumber Jills 34
Women's Liberation Movement (United States) 91, 233, 234, 237, 338, 339, 340, 347, 351
Women's Liberation Movement (France) 353, 355, 357
Women's Liberation Movement (Germany) 374
Women's Liberation Movement (Great Britain) 361, 362-365
Women's Liberation Union of South Vietnam 218
Women's National Anti-Suffrage League 1908 (Great Britain) 406
Women's Peace Party 197, 199
Women's Social and Political Union (Great Britain) 31
Women's Strike for Equality 38-341,
Women's. Tribunal (Cologne, Germany) 370
Wood, Andrew 403
Woolf, Virginia 85, 310-312
 A Room of One's Own (1929) 312
Worker's Revolutionary Party 296
Worker Student Alliance 238
WWDC radio station 215

Yalta Conference (February 1945) 64
Young Men's Christian Association (YMCA) 132, 138
Young Women's Christian Association (YWCA)105-106, 138
Youth International Party (Yippies) 19, 232, 233

Zaccaro, John 424
Zeiler, Christoph 285
Zelinsky, Anne 276
Zengakuren 303-304
Zetkin, Clara 29
Zumwalt, Admiral Elmo 181